Constable to Delacroix

Constable to Delacroix
British Art and the French Romantics

Patrick Noon

*With contributions by Stephen Bann,
David Blayney Brown, Rachel Meredith,
Christine Riding and Marie Watteau*

Tate Publishing

John Lyon's Charity

Front cover:
Théodore Géricault
First Study for the Raft of the Medusa 1819 (no.20, detail)

Frontispiece:
J.M.W. Turner
A Disaster at Sea c.1835 (no.30, detail)

Published by order of the Tate Trustees on the occasion
of the exhibition at Tate Britain, London
5 February–11 May 2003
and touring to
Minneapolis Institute of Arts, Minneapolis
8 June–7 September 2003
The Metropolitan Museum of Art, New York
7 October 2003–4 January 2004

ISBN 1 85437 459 1

British Library Cataloguing in Publication Data
A catalogue record for this book is available from the British Library

Published in 2003 by Tate Publishing, a division
of Tate Enterprises Ltd, Millbank, London SW1P 4RG
www.tate.org.uk

Designed by Atelier Works
Printed and bound in Great Britain by Balding + Mansell, Norwich

Measurements of works of art are given in centimetres, height before
width, followed by inches in brackets

The two typefaces used in this catalogue symbolise the aesthetic dialogue
between England and France at the onset of the nineteenth century.
The typeface used for the text is Bulmer, cut by William Martin for
printer William Bulmer. It is a 'transitional', designed to be narrower
with greater vertical stress than its classical models for greater legibility.
The typeface used for titling is Didot: designed by Firmin Didot, it is
the first typeface to be called 'modern'. Strongly influenced by the
English transitional fonts, its extreme character – the great contrast
between thick verticals and hairline serifs – signals a complete break
with the past.

Contents

Sponsor's Foreword

For the last ten years John Lyon's Charity, a charity which
bears the name of the founder of Harrow School, has worked
in partnership with Local Education Authorities to improve
educational opportunities and facilities for young people
in London, including the creative arts. The Charity is
delighted to contribute further to the cultural life of the
capital by sponsoring the exhibition *Constable to Delacroix* at
Tate Britain, one of our greatest arts institutions. Many local
young people will be able to take advantage of the rich
educational and scholarly opportunities surrounding the
exhibition. There is a programme of conferences, talks and
seminars, as well as this superb exhibition catalogue.

Nick Stuart
Chairman
John Lyon's Charity

Foreword

This exhibition explores aspects of the extraordinary network of cultural interchange that developed between Britain and France in the three or so decades following the end, in 1815, of their long war – a conflict which had raged with only occasional respites since the early 1790s. Sustained hostility in politics was, perhaps remarkably, to give way to mutual admiration in the arts. Focusing primarily, but not exclusively, on painting, the exhibition traces both the impact of French Romanticism on British art, including the sensational display in London of Théodore Géricault's *Raft of the Medusa* in 1820, and also the diverse consequences for the French of their multi-faceted first-hand experience of the work of a number of British artists and writers. Perhaps the range and force of Britain's cultural impact on France in these years will come as some surprise. Though Lord Byron's literary influence on Eugène Delacroix is well known, the prodigious consumption of Walter Scott in France may be less understood; and while John Constable's success at the Paris Salon exhibition of 1824, and his admiration by Delacroix, forms part of our standard histories of British art, the web of connections between Constable, J.M.W. Turner, Richard Parkes Bonington, Paul Huet, Jean-Baptiste Corot and Eugène Isabey, and its expression through French landscape painting during the 1830s and beyond, may prove to be one of this exhibition's most significant revelations. Though there had certainly been moments of productive cross-channel interchange in the previous century, they were readily undermined by political tensions and usually short-lived. The kind of sustained cultural dialogue surveyed by this exhibition was unseen before, and, it may be held, unrepeated since.

The origins of this exhibition project lie in the early 1980s when Patrick Noon, then Curator of Prints and Drawings at the Yale Center for British Art, began to research the possibilities of mounting a major survey of British and French art during the period of the Bourbon Restoration. By the early 1990s this had become a prospective Tate show, and in 1997, when Patrick became the Patrick and Aimée Butler Curator of Paintings at the Minneapolis Institute of Arts, a second venue was secured with the enthusiastic support of the Institute's Director and President, Evan Maurer. We were later pleased to welcome as a further venue The Metropolitan Museum of Art in New York. Throughout the long genesis of the project, Patrick's clear vision and extraordinary attention to detail were guiding forces of great strength. We are immensely grateful to him for bringing twenty years' work to bear on the creation of a fine show,

which will undoubtedly be enjoyed by a wide public in Europe and America and will, I believe, remain through its catalogue a major reference point in the history of the period.

Patrick has worked closely with the exhibition's organiser and co-curator, Christine Riding, to whom the final form of the show owes much. I would like to join Patrick in thanking her for her great organisational skills and to signal her important contributions to the catalogue too, not just as co-editor but as author. Fellow Tate curator David Blayney Brown has also co-curated, co-edited and contributed much to the catalogue, a considerable commitment of time and energy for which we are all very grateful. Rachel Meredith has worked on all aspects of the project with her customary flair and diligence. I should like to thank Professor Stephen Bann, a great authority in the field, for agreeing to write for the catalogue and also for giving helpful advice on several fronts. Jamie Fobert and Hoi Chi Ng of Jamie Fobert Architects for the exhibition design, and Quentin Newark and Stephanie Sandoz of Atelier Works for the graphic design of both exhibition and catalogue. Nicola Bion oversaw and edited the catalogue, which was produced thanks to Tim Holton and Fran Matheson, among others, at Tate Publishing. Of the many other Tate staff who contributed to the project, some of whom are recorded in the Acknowledgements, I would like to draw attention especially to the vital work of Exhibition Registrar Gillian Buttimer and the innovative contributions of Interpretation Curator Sarah Hyde.

There would of course be no exhibition at all without the generous co-operation of lenders of works of art. For this show, no fewer than 87 public and private collections from all over Europe and North America have contributed to the exhibition, and on behalf of Tate Britain, the Minneapolis Institute of Arts and The Metropolitan Museum of Art, I thank them all for their trust and kindness. Finally, it is a great pleasure to salute the John Lyon's Charity, whose financial support made possible the staging of the exhibition in London.

Stephen Deuchar
Director, Tate Britain

Acknowledgements

When Nicholas Serota invited me in 1994 to organise an exhibition on the theme of Anglo-French painting during the period known as the Bourbon Restoration in France, a project I had begun in 1982 seemed, after innumerable digressions, destined for completion. When the exhibition proposal was later embraced enthusiastically by Stephen Deuchar, Director of Tate Britain, and by Evan M. Maurer, Director of the Minneapolis Institute of Arts, from the moment he welcomed me to his Minneapolis staff in 1997, success was assured. I am indebted to the three directors for their commitment and confidence.

Over the years other individuals, in particular Richard Godfrey, Richard Feigen, James Mackinnon, Jane Monro, John Morton Morris, Jill Newhouse and Guy Sainty, have remained devoted to this project. The extraordinary quality of the objects that comprise our exhibition is due primarily to the generosity of the many lenders internationally who have also rallied to its support. The Yale Center for British Art has been exceptionally liberal, and I would like to thank Constance Clement, Timothy Goodhue, Patrick McCaughey, Malcolm Warner and Scott Wilcox for indulging their former colleague.

To the many individuals at Tate Britain and Tate Publishing acknowledged elsewhere in these prefatory remarks, I would like to offer my personal expression of gratitude, but I am profoundly indebted to three in particular: Christine Riding, David Blayney Brown and Rachel Meredith. Their considerable curatorial efforts and their significant creative contributions to the catalogue are much appreciated. It is thoroughly gratifying also to collaborate with The Metropolitan Museum of Art, which in 1976 had organised *French Painting 1776–1830: The Age of Revolution*, an exhibition that directly inspired the present enterprise. Philippe de Montebello and his staff, especially Katherine Baetjer, Kathryn Galitz and Gary Tinterow, have been most generous in their encouragement. At the Minneapolis Institute of Arts, my colleagues in the paintings department, Sue Canterbury and Erika Holmquist-Wall, have suffered my periods of distraction with grace and patience. Laura DeBiaso, Karen Scheibner, Mary Parks and Jennifer Black had the thankless responsibility for myriad organisational details.

Two very able researchers assisted in sifting through the massive primary documentation relating to this subject. Marie Watteau, in Paris, has contributed incalculably and has written for the catalogue. Diane Tsurutani, in Minneapolis, has also sustained this effort in numerous other ways. Words can hardly reward her two decades of inspiration, editing and coaching – 'O dearer far, than light and life are dear'.

Patrick Noon

There are many people who have contributed to the *Constable to Delacroix* project to whom I owe a debt of gratitude. The exhibition designer, Jamie Fobert, from Jamie Fobert Architects, has engaged with the subject with sensitivity and boundless enthusiasm, as has Hoi Chi Ng who assisted him. Thanks are also due to Quentin Newark and Stephanie Sandoz from Atelier Works for their sympathetic response to Jamie's design through the exhibition graphics. At Tate Britain, the project has been guided from the start by Stephen Deuchar, Sheena Wagstaff, Head of Exhibitions and Displays, and her successor Judith Nesbitt. I would like to add to Patrick Noon's comments by extending my heartfelt thanks to the other members of the curatorial team, Rachel Meredith and David Blayney Brown, an acknowledged expert in the field. Both have brought insight and humour to the organisational and curatorial challenges of both the exhibition and the catalogue. It has been a pleasure to work with them. Two further colleagues have been crucial to the project: Sarah Hyde in formulating an insightful interpretation strategy and Gillian Buttimer who has overseen the complexities of transportation and installation with consummate care and attention. Other colleagues at Tate who deserve special acknowledgement are Joanna Banham, Maureen Cross, Will Easterling, Sarah Briggs, Tim Holton, Geoff Hoskins, Ben Luke, Roy Perry, Miquette Roberts, Andy Shiel, Piers Townshend; and David Dance and Mark Edwards from AMEC Facilities and Charlie Falzon of MC Designs.

We are particularly grateful to the following individuals for their advice or assistance in making this exhibition possible:

Susan Absolon, Claude Allemand-Cosneau, Colin Bailey, Joseph Baillo, James K. Ballinger, Stephen Bann, Clare Baxter, Mr and Mrs Bruce Bean, Christoph Becker, Sylvain Bellenger, Shelley Bennett, Roger Berkowitz, Mark Bills, Philippe Borde, Philippe Brame, Michael Brand, Arnauld Brejon de Lavergnée, Etienne Breton, E. John Bullard, Richard Burns, Richard Campbell, Dominique Cante, Joseph C. Canizaro, Jill Capobianco, Antonia Charlton, Michael Clark, Sally Clarke, Karen B. Cohen, Malcolm Cormack, Arturo Cuellar, Jean Pierre Cuzin, Diane DeGrazia, Cara Denison, Simon Dickinson, Douglas Druick, Stephen Duffy, The Marquess of Duoro, Mr and Mrs Alexandre Ebeid, Caroline Elam, Jane Farrington, Larry Feinberg, Marie-Pierre Foissy-Aufrère, Susan Foister, Susan Galassi, Josette Galiegue, Françoise Garcia, Jay Gates, George Goldner, D.S. Gray, Jon Gray, Deborah Gribbon, Antony Griffiths, William Griswold, Stephane Guegan, Torsten Gunnarsson, Anne d'Harnoncourt, Anette Haudiquet, Malcolm Hay, Lee Hendrix, Michel Hilaire, Joseph Holbach, Robert Hoozee, Colta Ives, David Jaffé, Alex Johnson, David Johnson, Lee Johnson, Catherine Johnston, Philip Johnston, James Kelly, Ian Kennedy, Philip King, Michael Komanecky, Myron Kunin, Ling Ling Kuo, Alastair Laing, Lord Lambton, Christopher LeBrun, S.M. Legerton, John Leighton, Serge Lemoine, Jean-Marc Léri, Kathrine Lochnan, Clare van Loenen, Stephane Loire, Anne Lyles, Neil MacGregor, James MacKinnon, Mr and Mrs Whitney MacMillan, Nicole Maglica, Sir Edwin and Lady Manton, Yves Martial, Frederic Mathieu, Bridgitte Maurice-Chabard, Leila Meinatas, Jean-Paul Mercier-Baudrier, Olivier Meslay, Eric Moinet, John Morton Morris, Virginia Murray, Lawrence W. Nichols, His Grace The Duke of Northumberland, Charles Nugent, Edward Nygren, Maureen O'Brien, Sheila O'Connell, Barbara O'Connor, Roberta Olson, Timothy Palmer, Michael Parke Taylor, Claude Pétry, Charles E. Pierce, Jr., Matthieu Pinette, Vincent Pomarède, Earl A. Powell III, Hubert Prouté, Katherine Lee Reid, Francis Ribemont, Joseph Rishel, Christopher Riopelle, Alicia Robinson, Duncan Robinson, Hamilton Robinson, Jr., Rt. Hon. The Lord Rothschild, Francis Russell, Samuel Sachs III, Lawrence Salander, Laurent Salomé, Alan Salz, Scott Schaefer, Anita Schon, Mary Scott, Kate Sellers, Michael Simpson, Peyton Skipwith, Alistair Smith, Randall and Gary Smith, Hammond Smith, MaryAnne Stevens, Sheena Stoddard, Shining Sung, Susan Taylor, Matthew Teitelbaum, Eugene Thaw, Pierre Théberge, Betsy Thomas, Carl Thompson, C. Thomas Toppin, Julian Treuherz, Nicolas Tromans, Ian Warrell, Wheelock Whitney III, Julia Lloyd Williams, Andrew Wilton, James H. Wood, Andrew Wyld and Eric Zafran.

Finally I would like to offer my personal thanks to Patrick Noon, who has been a most generous and inspirational colleague.

Christine Riding

Prologue

Patrick Noon

The Promethean vision of French Romantic painting rested on three pillars of inspiration: Théodore Géricault, with his incisive realism; Eugène Delacroix, with his impassioned imagination; and the Englishman Richard Parkes Bonington, with his clear and luminous palette. Such, at least, was the opinion of the esteemed and seasoned critic Charles Sainte-Beuve. Contemporary, innovative and technically stunning – together these artists would define the parameters of modern genius and affirm for their dazzled generation that 'a painter was, above all else, a painter'.[1]

Sainte-Beuve published his opinion in 1863, the year in which the first *Salon des Refusés* was organised in Paris, as a refuge for the next generation of painters whose equally unconventional works, like Edouard Manet's *Déjeuner sur l'Herbe*, had been rejected for public exhibition by the official Salon juries. The *Salon des Refusés* has subsequently enjoyed celebrity as a milestone in the history of modern art, since it anticipated a succession of similar assaults by younger artists on the exclusivity of the French Academy: specifically, the Impressionist exhibitions beginning in 1872; the *Salon des Indépendants*, from 1884; and the *Salon d'Automne* of the Fauves. However, with their crusade to liberate technique, subject matter and patronage from the oppressive dominion of the Academy, these 'alternative' Salons of the late nineteenth and early twentieth centuries had their roots in the very first independent exhibitions of modern art organised in London and Paris by entrepreneurs in the 1820s, and more significantly in the fleeting but crucial exchanges between the two national schools of painting during the same decade. Both cultural phenomena encouraged French artists like Géricault, Delacroix and Horace Vernet to send their masterpieces to London for public display and their colleagues in Britain to lobby actively for representation in Paris.

The legendary 'British' Salons in the Louvre of 1824 and 1827, furthermore, signalled a rapprochement of exceptional significance and far-reaching ramifications. Visitors to those Paris exhibitions enjoyed, to be sure, a thoroughly miscellaneous view of British painting, but it was the first measurable dose for French artists in decades. What they did imbibe of the immigrant Bonington, of the celebrated landscapist John Constable and of the president of Britain's own Academy, Thomas Lawrence, was novel, challenging and ultimately transforming. The art historical movements of Impressionism and Post-Impressionism, the most highly prized by today's exhibition audiences, trace their genesis to this liberating infusion of British theory and practice half a century earlier. Saint-Beuve's career as a cultural historian had spanned those intervening decades, which undoubtedly explains why, in retrospect, he was comfortable and exact in linking a British landscapist and watercolourist with the two prophets of French Modernism, and in recalling their

international accomplishment in the same year that Manet, Cézanne, Whistler and the other *Refusés* grappled for the public's imagination.

The premise of the present exhibition is quite simple. During the period that began with the restoration of the French monarchy following the Battle of Waterloo in 1815, and ended with the accession of Queen Victoria in 1837, but especially during the decisive decade of the 1820s, a profound engagement between two previously unsympathetic schools of painting resulted in innovations that would radically affect the course of modern art in Western Europe. The hypothesis is neither new nor necessarily disputed. When the two titans of French Romanticism, Géricault and Delacroix, confirm it through their own practices, it seems axiomatic; yet surprisingly, until now it has never been rigorously tested by bringing together the very pictures that were scrutinised by the artists of both nations and which defined the critical discourses of the epoch.

This exhibition has orchestrated such a reunion and thus augmented the exceedingly scarce literature on the subject. The majority of the oil paintings, grouped thematically and chosen for their recognised authority and excellent state of preservation, appeared in the principal exhibition venues during the 1820s and were subject to the most trenchant examination and comparisons. Géricault's *The Raft of the Medusa*, Constable's *White Horse*, David Wilkie's *Chelsea Pensioners* and Delacroix's *Greece on the Ruins of Missolonghi* were the archetypes of a new pictorial sensibility. Another group of exemplary oils by Bonington, Delacroix and their immediate circle, inspired by British literature, were probably painted contemporaneously in the same studio. This primarily technical collaboration between the young British master 'too soon departed' and arguably the most literate and influential French painter of the century was as momentous as would be that of Picasso and Braque at the dawn of Cubism. The inclusion of a section devoted to more intimate watercolours might seem anomalous in an exhibition concerned primarily with oil painting, but the medium was at the heart of the contentious sketch-finish debate between those who placed a premium on the manifestations of heated imagination and those who relished the calculation of a thousand polished details. The bravura of British watercolour painting, as demonstrated especially by the artists of Bonington's generation, inflamed that quarrel in France as it catered to one of the most persistent paradoxes of modern aesthetic theory, the demand for a sophisticated yet seemingly instinctive painting and literature. Indeed, the champion of literary art-for-art's-sake, Théophile Gautier, was enamoured of the 'British medium', and Monet was no less a beneficiary of its ascendancy than was Delacroix.

In assembling these indisputable masterworks for the first time in nearly two centuries, this exhibition furnishes the essential comparative materials for a renewed consideration of British Romanticism as a cardinal force in the evolution of French art. It is certainly significant that so captivating a subject as the origins of modern painting might originate in the unexpected collision of such fiercely competitive yet fundamentally sympathetic spirits.

Colour and Effect
Anglo-French Painting in London and Paris

Patrick Noon

The only thing your talent lacks is to be steeped in the English School … colour and effect are understood and felt only here. Each school has its own character. If we were to succeed in uniting all their qualities, would we not attain perfection?
Théodore Géricault to Horace Vernet, London, 6 May 1821[1]

Géricault was not alone in his admiration for British art and the potential it offered French painters as an avenue away from the tired formulations of Jacques-Louis David's school by 1821. His desire to bring the pictures he had just seen in the exhibition of modern British art at the Royal Academy in London to the Louvre in Paris as 'a practical demonstration' for his compatriots may have come to naught, but Géricault remained, as would Eugène Delacroix shortly after him, completely open to the exhilarating stimulation of British culture.

Following Napoleon's final exile, French fascination with every aspect of Anglo-Scottish civilisation became feverish. Artists and educated tourists criss-crossed the Channel. In the year that Géricault resided in London, twenty thousand British citizens visited France. Most would probably have agreed with Thomas Carlyle that 'to live in Paris for a fortnight is a treat; to live in it continually would be a martyrdom'.[2] Nevertheless, British painters contributed regularly to the provincial and Paris exhibitions, shared studios with French artists, collaborated with Parisian print publishers, pandered to the interest at home for a thorough topographical record of France's natural and fabricated monuments, and established themselves as drawing masters to the French aristocracy. As traditional methods of art instruction were challenged, travel by French artists to London, primarily during the months of the annual exhibitions, became a consequential alternative to the traditional practice of study at the French academy in Rome. Steamboat passage from Calais to London took a mere eleven hours, and the trip could be conveniently booked in advance at Galignani's English-language bookstore in the rue Vivienne. The triumph of the British school at the 1824 Paris Salon inspired a contingent of younger French artists, led by Delacroix and Richard Parkes Bonington, to organise an excursion the next summer.[3] Introductions were secured to Géricault's friend the architect Charles Cockerell; to the important antiquarians Dr Samuel Meyrick and Karl Aders; to the keepers at the British Museum and Westminster Abbey; to the artists Thomas Lawrence, John Constable, David Wilkie, William Etty, Simon Jacques Rochard and Thomas Phillips; and finally to the great collectors Walter Fawkes, John Leicester and the Marquess of Stafford.

Scotland in the 1820s also supplanted all other European countries as the supreme grand tour destination, owing to Walter Scott's (fig.1) *Waverley* novels, to its historical

fig.1
Edwin Landseer
Sir Walter Scott in Rhymer's Glen
1833
Oil on canvas
Private Collection

associations with the French monarchy, and to its mythical past that was as fascinating in its bloody tragedies as anything recounted in Homer. The immensely erudite Amadée Pichot and Charles Nodier capitalised early on this popularity with travel accounts based on their own pilgrimages to Edinburgh. Dozens of other French visitors eventually published their reflections on this country that was paradoxically a centre of enlightenment culture and a misty realm as savage as the North American wilderness. Watercolour painting, universally acknowledged as an 'English medium', also embedded itself in French sensibilities, while illustrated publications, introducing new graphic techniques, like wood engraving and lithography, and a broad range of novel subject matter, were marketed in both capitals to a literate public voracious for the provocative, the instructive and the unfamiliar.

In the aftermath of the Empire and its decimating wars, Anglomania was not, as one British observer noted, to be 'wondered at, for of all the accredited methods of inspiring admiration, there is none so sure as giving the proposed admirer a good sound beating'.[4] As accurate as that claim might be, Britain primarily offered political and social structures that warranted more serious consideration than heretofore granted by the French, as well as an enviable economic infrastructure. As for the fine arts, David, the patriarch of the French academic establishment, was irrevocably exiled to Brussels, and his successor, Antoine-Jean Gros, was impotent in the face of momentous transitions in taste and a groundswell of popular demand for innovation and privately consumable works of art, be they paintings or literature. As Théophile Gautier recalled: 'There reigned in every spirit an effervescence of which we have no idea today; we were intoxicated by Shakespeare, Goethe, Byron and Walter Scott ... we toured the galleries with gestures of frenetic admiration that would make the present generation laugh.'[5] In contrast to the preceding decades, the Restoration art market was driven primarily by the personal tastes of dealers and collectors and not by institutional interests. A moment existed when a society of great sophistication and exclusiveness was prepared to set aside its biases and embrace both novelty and diversity.

The conformity of French style under David had been a point of national vanity, to use Stendhal's characterisation,[6] although it had always struck British artists as curious. Joseph Farington, when visiting Paris during the brief Peace of Amiens in 1802, reflected in his journal, 'I could scarcely have imagined that there could have been so much uniformity in their art ... [Henry] Fuseli claims that all the pictures, better or worse, seem to have come out of the same pot.'[7] The 'colour and effect' mentioned by Géricault and so frequently cited as the hallmarks of the British school were largely the attributes of adept painters whose individual

13

invention transcended received theory and any claim to an absolute standard of taste or universal system of painting. Similarly, modern poetry became synonymous with the interior and reflective styles of Lord Byron and Alphonse de Lamartine, which championed individual expression. To French traditionalists, this seemed undisciplined at best and anarchistic at worst. To anyone else it was the essence of Romanticism.

Extreme prejudices and misgivings persisted on both sides of the Channel. Gautier, the staunch romantic, whose own aesthetic doctrine was profoundly indebted to British theory, nevertheless argued that despite their prodigious materialism and genius for literary and scientific invention, the British were simply 'varnished barbarians', incapable of producing significant visual arts. As a northern race they little understood antique form, and as Protestants they practised a religion as fatal to the plastic arts as Islam.[8] Similarly, the most influential art critic in Paris during the Restoration, Etienne Delécluze, a resolute classicist and Anglophobe, published a lengthy essay, 'On the Barbarism of the Times' (1831), in which he condemned contemporary French society for its preoccupation with individualism, a traditionally Germanic or northern notion. For Delécluze and other conservative intellectuals, heterogeneity was anathema, in the arts at least. And among the principal causes of his perceived new 'barbarism' in French taste and mores,

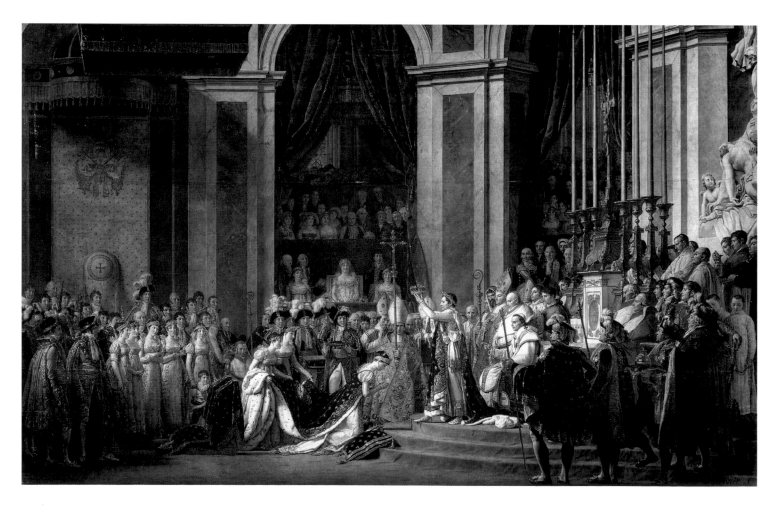

Delécluze cited precisely what Géricault had recommended to Vernet – 'the fashion, the idea of immersing the art of French painting in that of the English school'. Delécluze further lamented the existence of an 'Anglo-French' (his expression) group of artists intent on abandoning antiquity for the Gothic, and Italy for the 'galleries, the routs and the fog of London'. The 'barbaric' Shakespeare was also faulted for the ruination of French theatre. A disastrous attempt to introduce Shakespeare to Paris in August 1822 had precipitated Stendhal's famous defence of Romanticism, *Racine and Shakespeare* (1823). The British *Literary Gazette* imagined a Bonapartist plot when the actors were pummelled with apples, 'the theatre torn to pieces and even defenseless female youth brutally insulted'.[9] The same journal continued the assault later that winter by attacking the paragon of French painting when David exhibited in London a replica of his *Coronation of Napoleon* (fig.2). Nevertheless, an enterprising Briton earned a fortune peddling an engraved reproduction of the *Coronation* to the general public, who were not so invested in the subtleties of theory and the inflamed rhetoric of the press. Similarly, a second campaign to introduce Shakespeare in Paris at the Théâtre-Français in autumn 1827 was a resounding success. Edmund Kean, the romantic embodiment of thespian virtuosity (fig.3), stunned Paris audiences through the summer of 1828 with his signature performances as Shylock, Othello and Richard III, 'filled with that devilishly divine power, limitless, unfathomable, unconscious, which is called demonic and is found to a degree in all great men'.[10] In the battle for French public opinion as to the virtues or failings of British immoderation in all things artistic, Delécluze's most formidable adversary would be Kean's brilliant apologist, William Hazlitt.[11]

The first remarkable events in the *détente cordiale* of the London and Paris art worlds occurred in 1819. It was an astonishing year for British letters that witnessed the publication of the first two cantos of Lord Byron's masterpiece, *Don Juan*, John Keats's magisterial odes, Percy Bysshe Shelley's dramatic *chef-d'oeuvre*, *Prometheus Unbound*, but most significant of all, Walter Scott's *Ivanhoe*, an engaging historical novel and the first to explore French history. A resounding popular success on the Continent, it virtually launched modern historiography in France following its publication in Paris in 1820. By contrast, Géricault's exhibition of arguably the supreme manifesto of Romantic painting, *The Raft of the Medusa* (see no.19), at the Paris Salon that year, had considerably less resonance initially, since it would not be acquired by the state and placed on permanent view until after the artist's death in 1824. In frustration, Géricault accepted an invitation from the impresario William Bullock to exhibit the picture between June and December of 1820 in London, where it was admired

fig.4
Gabriel Metsu
Portrait of a Lady
1667
Oil on panel
Minneapolis Institute of Arts

fig.5
William Skelton, after John Opie
Execution of Mary Stuart (from
David Hume, *The History of
England from the Invasion of Julius
Caesar to the Revolution in 1688*)
1794
Engraving
Yale Center for British Art, Gift of
Mr and Mrs William R. Ginsberg

by the British press and forty thousand customers. The *Literary Gazette*, which would castigate David three years later, asserted unequivocally that the picture was 'one of the finest specimens of the French school ever brought into this country', and that if Bullock persevered in recruiting French masterpieces 'he will do as good a thing as can be done to advance British art'.[12]

Unfortunately, the *Medusa* had negligible positive impact on British painting. It overwhelmed Benjamin Robert Haydon's *Christ's Entry into Jerusalem* (fig.27), showing in an adjacent gallery, and underscored the one universally recognised weakness of the British school, its inability to produce memorable monumental history paintings. As Delacroix confirmed during his visit to London in 1825, the British 'were admirable painters in smaller dimensions', but the desire to 'sparkle' grandly would only lead them astray.[13] The principal reason offered at the time was the absence of state and church sponsorship on the beneficent order of what continued to buoy the French system. In effect, British artists competed in a free-market environment, where novelty of execution and domestic scale were the guarantors of success. Nevertheless, it was a much lamented fact that the British government budgeted annual monetary awards to breeders of racehorses but not a farthing for public art.[14] Stendhal, the moderate critic Auguste Jal and eventually

fig. 4

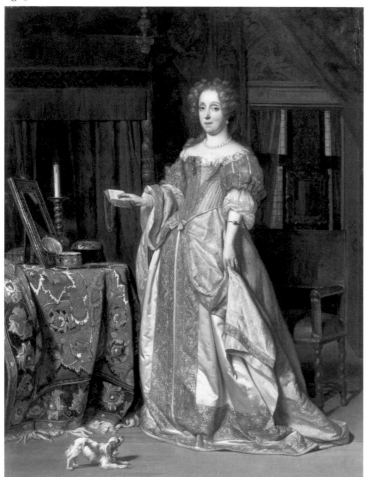

fig. 5

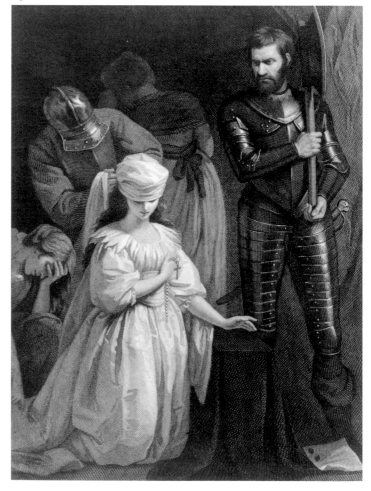

Gautier restored some balance when they credited the British public with the good sense to perceive that painting should be in proportion to the milieu it occupies: 'the honeycomb cell accorded to each human being can barely accommodate an easel picture'.[15] The French ministerial organ of taste, the *Journal des Artistes*, insisted time and again that national schools should be judged on the merits of monumental commissions and not on the quality of pictures painted for temporary exhibitions, which only pandered to popular vagaries. Then as now, the *grand projet* in France tended to hold sway over the legislative imagination. But the suicides of Gros in 1835 and Haydon in 1846 signalled its hazards most poignantly. The British may have had less success than the French at large-scale mythological, religious and allegorical painting, but they would contribute nonetheless to the reinvention of history painting for the modern era.

In the year of Haydon's death, John Ruskin published the second volume of his *Modern Painters*. In a rare confession of bewilderment, he allowed that, as an example of a good history painting, he could only recall 'a black, ignoble, inevitable well of vacancy, with the names of Benjamin West and Horace Vernet in phosphoric horror at the bottom of it … Art, as a recorder of events has hitherto done almost nothing and can never do much. But art as the recorder of character, as the exhibition of the root and the moving powers of history, has done everything.'[16] At first glance, Ruskin seems hostile to the very notion of history painting. But his distinction between history and art is both redemptive and crucial to understanding the intellectual ferment of the era which formed his ideas. Charles Baudelaire would make a similar distinction that same year when he stigmatised Horace Vernet as the 'chronicler of National glory' but the 'antithesis of an artist'. One preoccupation of high Romanticism was the comprehensive reassessment of history painting, its subjects and audience. The abiding question, from orthodox historians to dramatists and painters, was how best to reconstitute the past. Throughout the late eighteenth century, there had been repeated attempts at creating national mythologies, some only remotely factual, like that of the Welsh Bard, others patently spurious, like the Ossian legends. Post-antiquity had been scoured for nationalistic themes in an effort to recover what was primitive in each country's indigenous genius. A seemingly uniform classical ideal was gradually superseded by communal narratives such as René de Chateaubriand's sentimental feudalism, which offered examples of edifying behaviour to be trumpeted in the increasingly brash arena of international propaganda wars. The Napoleonic conflict served to stimulate such impulses.

Having endeavoured to obliterate their real history in the Terror, the French rallied their pictorial arts around 1800 to mythologising Bonaparte, as in Gros's monumental conception of the aftermath of the Battle at Eylau (no.47). But alternative visions were already in the offing. What we now call the 'troubadour style' made its initial appearance in the Salon of 1802 in the works of two Lyonnaise pupils of David, Fleury-François Richard and Pierre Révoil (no.70). This style challenged academic and imperial history painting by promoting an intimate cabinet art remarkable for its porcelain-like surfaces and indebted to the minutely finished and detailed pictures of seventeenth-century Dutch artists like Gabriel Metsu (1629–67; fig.4), whose works could be studied in the Louvre. The originality of this style resided in its strict fidelity to antiquarian details of costume and setting, but also in its effort to illuminate the present by exploring the historical profiles of illustrious Renaissance and medieval antecedents. The Empress Josephine (no.75) was especially enamoured of this type of sentimental history-cum-genre. With the new century also came scores of illustrated antiquarian publications, all claiming for themselves an unprecedented veracity of historical reportage. Joseph Strutt's *Complete View of the Dress and Habits of the People of England* of 1796–9 is typical of the hundreds of volumes that used actual manuscripts and other works of art for their engraved illustrations. In France, such multi-folio illustrated sources culminated in the twenty-six volume *Voyages pittoresques et romantiques dans l'ancienne France*, which Charles Nodier, Isadore Taylor and Alphonse de Cailleux began publishing in the early years of the Restoration (no.10).

Although little general history was written in England during the Napoleonic conflict, David Hume's *History of England* remained a respected text. In 1795, the publisher Robert Bowyer began commissioning painted illustrations to that history, in a scheme similar to Alderman Boydell's contemporary *Shakespeare Gallery*. In both instances, major British artists contributed oils that were exhibited publicly as a patriotic service. Engravings after the prints were sold by subscription. Given this commercial dimension, sensational or maudlin subjects like John Opie's *Execution of Mary Stuart* (fig.5) naturally predominated. As theatre, it would have been classified as pure melodrama, for emotional stimulation rather than character development was its aim. Not surprisingly, the next generation of French painters, but especially Paul Delaroche (no.55) and Alexandre-Marie Colin, repeatedly plagiarised these sources with variable success.[17]

It is an oft-repeated certainty that *Ivanhoe* inspired such seminal historical studies as Augustin Thierry's *L'histoire de la conquête de l'Angleterre* (1825) and Prosper de Barante's *Histoire des ducs de Bourgogne* (1824), not to mention Victor Hugo's first romance *Han d'Islande* (1823). By 1824, bilingual editions of Scott's new novels were published

simultaneously in Paris and London. No other author of this period inspired such an international clamour. When the seasoned German adventurer Prince Pückler-Muskau toured Kenilworth Castle that year, he did so with Scott's 'captivating' novel of Elizabethan intrigue, *Kenilworth*, in hand, and not with Sir William Dugdale's (1605–86) antiquarian masterpiece, *A History of Warwickshire* (1656).

Between 1822 and 1837 nearly 230 paintings illustrating passages from Scott adorned the major exhibition halls in France. In a manifesto supporting this new genre of historical realism, Hugo noted that 'History has told us much, but I would like to believe the novel, because I prefer moral truth to historical truth.'[18] The same view was articulated forcefully by Alfred de Vigny in the introduction to his Scott-inspired historical novel *Cinq-Mars* of 1825:

In recent years, Art has been stamped by history more strongly than ever … but there exists artistic truth [vérité de l'art] *and factuality* [vrai du fait] *… we do not want facts, we want the philosophical spectacle of a man profoundly moved by the passions of his character and his times; … the truth that ought to nourish art is* truth in observing human nature *and not* factual authenticity.

Put simply, the antiquarian and archival pursuit of primary documentation revolutionised historiography, but the art of historical representation called for something more dynamic. In imaginative historical recreations, the artist had to humanise as well as elucidate history. It was this type of subjective intuition that both French and British audiences in the 1820s believed they found in Scott's writings. In the parlance of the moment, they were impregnated with *local colour* or the 'character' of the period they described. In the context of the debate between the classicists of the Racine/Delécluze camp and the romantics of the Shakespeare/Stendhal club, Scott's fastidiously detailed evocations of historical reality through the individual experiences of his characters furnished the modern equivalent of the Homeric epic.

De Vigny's distinction between *vérité de l'art* and *vrai du fait* was meant to differentiate the interpretive genius of the artist from the factual analysis of the historian. It most obviously alluded to the method of Scott, but also to that of a second formidable British literary figure, George Gordon, Lord Byron. To the French, Byron's verse was passionate, anti-aristocratic, extemporised, yet fully descriptive of costumes, exotic paraphernalia and terrain, architecture and social norms: 'Comes the painter upon this sensual and exact recipe, and the painter has only to paint.'[19] From its advent in France in 1815, Byron's poetry was appreciated, according to his devoted translator Amadée Pichot, as purely natural and 'in harmony with the atmosphere of disorder and passion in which we lived'.[20] Like Scott, his new works were translated

almost immediately into French, endlessly gathered into illustrated editions, and transformed into melodramas or operas. If the genius of Scott was narrative, that of Shakespeare and Byron was poetic and dramatic, and if Delacroix was infatuated with all three authors in the 1820s, his interest in Scott scarcely survived his grandest tribute to that author, *Murder of the Bishop of Liège* (fig.39) of 1829. For a talent as volatile as Delacroix, the novelist's descriptive passages too often drowned the reader in detail, whereas the playwright and the poet offered 'the soul of passion and the pith of imagination'.[21]

Although there were far fewer illustrations to Byron than to Scott among the pictures publicly exhibited in France, French painters nevertheless responded with greater originality to Byron's verse, beginning with Horace Vernet and Géricault and culminating with Delacroix's intense exploration of a range of Byronic themes in the 1820s. The most frequently encountered representations in France were many of those favoured by British artists: namely, the tormented prisoner of Chillon, Mazeppa's punishment (no.53), the love scenes with Don Juan and Haidée, and the violent episodes of the Giaour, Sardanapalus and Marino Faliero tragedies (nos.76, 78). Delacroix's choice of pictures for his exhibition debut in London in the spring of 1828 was undoubtedly calculated, since he sent his *Execution of the Doge Marino Faliero* (fig.6) to the British Institution and his *Combat Between the Giaour and Hassan* (no.76) and *Greece on the Ruins of Missolonghi* (no.8) to William Hobday's Gallery of Modern Art. The first two of these were ecstatically received, as much for their subjects as for their 'rich ornamental style' of Anglo-Venetian colouring that Delacroix had been developing, in conjunction with Richard Parkes Bonington and others of their immediate circle in the mid-1820s.[22]

Shakespeare, already deified in Germany, captivated the French in the 1820s. He was less a symbol of modernity, like Scott and Byron, than the eternal embodiment of the British spirit; hence the term 'Shakespearean' became synonymous with romanticism among the reactionary critics who elected to attribute the 'war of extermination against the *classical beauty* of the French school' to the 'savage horrors' of the British bard.[23] Again, Gautier recalled: 'During its first moments of fury against banal classicism, the young school seemed to have adopted the theory of art offered by the scene of Macbeth and the witches in the mist of Dunsinane plain, "The beautiful is horrible, the horrible is beautiful".'[24] A watercolour of that very subject by Delacroix's friend and studio companion, Thales Fielding had indeed prompted Stendhal's spirited defence of the new school in his 1824 Salon. In Fielding's work, as in most French representations of this scene, including Delacroix's version, the harpies dissolve in a vaporous setting.[25] More to Gautier's taste was

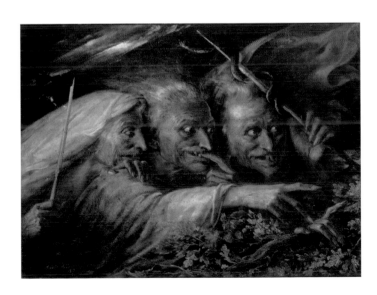

fig.8
Eugène Delacroix
Faust and Mephistopheles
1826–7
Oil on canvas
Wallace Collection

such phantasmagoria as Colin's *The Sorcerers, Macbeth* (fig.7),[26] which horrified the critics at the 1827 Salon.[27] Colin based his composition directly on Fuseli's earlier arrangement of three grotesque heads, *The Weird Sisters*,[28] and he further transgressed, again with intent, all norms of decorum in the hideousness of his characterisations. What would become known that year as Delacroix's 'school of the ugly' had a fanatic partisan in this painter.

Ugliness was the term most used by Delécluze, Charles Farcy and other hostile critics in the 1820s to ridicule the subjects and styles of Romantic painters. Delécluze described Delacroix's *Massacres at Chios* (fig.45) as a sop to those 'who love Macbeth's witches'.[29] If Shakespeare contributed to an aesthetic upheaval brought on equally by an appreciation of Venetian, Flemish and Netherlandish painting, Delacroix's illustrations of 1827–8 for Johann Wolfgang Goethe's consummately Shakespearean *Faust* (fig.8) and Victor Hugo's contemporaneous preface to his own drama, *Cromwell*, formalised it for the new generation. According to Hugo, 'The beautiful has but one type; the ugly a thousand … the ugly is a detail of a grand ensemble that escapes us, that harmonizes itself, not just with man, but with all creation'.[30] For Hugo, the 'grotesque' was the central idea of post-classical thought, but the so-called *horrible idéal*[31] of Delacroix's compelling lithographs for *Faust* derived not from true grotesquerie such as enthralled Hugo's coterie of authors and illustrators, but rather from the artist's ability to transmit the diabolic sentiment of the text through more subtle formal means (fig.8). It is a commonplace of Delacroix studies that these seventeen lithographs constitute a monument to Romanticism as significant as the sprawling pandemonium of his *Death of Sardanapalus* (no.78). The two exactly contemporary works sprang from the same conceptual impulse and are inextricable – formal invention transforming the conventions of literary illustration *sans pareil*. The *Faust* project was, indeed, one of the most original in the history of printmaking but also, despite its commercial failure, an audacious effort to disseminate the artist's credo to a mass audience, something not possible with a single, immobile picture in an exhibition of limited duration.[32]

In addition to the broader range of literary and historical subject matter that was accepted into the shifting definition of history painting during the first decades of the century, contemporary genre was one of those 'vagaries' of popular taste that began to assert its own claims to the moral high ground previously reserved for antiquity. The principal exponent of this new sensibility in Britain had been David Wilkie, whose *Village Holiday* (no.89) exploits Dutch and Flemish art with the earnestness of the contemporary Lyonnaise school; however, Wilkie's model for promoting

fig.8
Eugène Delacroix
Faust and Mephistopheles
1826–7
Oil on canvas
Wallace Collection

the best moral effects in art was common nature, not anecdotal history. His exemplars were the rude folk and succulent paint application of David Teniers the Younger and Philips Wouwerman, rather than the elegantly garbed and minutely described patricians of Gabriel Metsu or Gerrit Dou, who attracted Révoil's followers. In his *Chelsea Pensioners Reading the Waterloo Dispatch* (no.49), a sensation when exhibited in 1822, Wilkie thrust to the forefront the very question of what constituted epic history painting. The scene describes invalid veterans and the wives of active soldiers reading Wellington's account of the defeat of Napoleon and the list of British casualties. The scale was modest, the format panoramic and without dramatic climax. Any hierarchy of subject categories was levelled as the viewer was asked to commemorate a heroic event without a visible hero or, more precisely, a new kind of heroism, as recognised by Géricault, who enthused over studies for the picture when in London. In his previously cited letter to Vernet, he wrote that the 'most perfect' figure, a woman anxiously scanning the list of the dead, brought tears to the eye.

As in Géricault's own *Medusa*, J.M.W. Turner's *Field of Waterloo* (no.48) or Delacroix's *Massacres at Chios*, the heroes of modern art had become the nameless individuals who revelled or suffered according to their allotted circumstances. Comparable are the unremarkable personalities of the principal characters of Scott's novels, to whom every reader could immediately relate, or Byron's eternal victim Don Juan, or the clueless Italian, Fabrizio, in Stendhal's *Chartreuse de Parme*, who stumbles his way through the battle at Waterloo. Even *Greece on the Ruins of Missolonghi* (no.8) paid homage to an abstract and collective ideal and not to individual heroism. But what was unique and appealing to the French in Wilkie's descriptive method was his uncanny ability to multiply and individualise character within a given narrative context.

While maintaining that representations of modern history and domestic life could not arouse the imagination to the same degree as mythology, canonical theorists in France also argued that the Greeks had given plastic form to all human passions, and that with those models alone it should be possible for a painter to express every emotional state. This was in marked contravention of theories then circulating in both London and Paris, such as Charles Bell's influential *Essays on the Anatomy of Expression in Painting* (1806), which is known to have guided Wilkie and Géricault, and that Delacroix described in about 1820 as the most important book on anatomy for artists. Bell insisted that painting could reach the mind of the viewer 'only by the representation of sentiment and passion' deduced from a careful observation of nature. Consequently, the study of anatomy would guard the artist against 'the blind and indiscriminate imitation of the antique', because in imagining an ideal form, 'the Grecian

artist had studiously divested his model of all that could indicate natural character'.[33] Clearly Géricault's intense investigations of dementia for Dr Georget (nos.81, 82) were equally an attempt to get beyond the formulaic expressions of identity and emotion that were the bulwark of his academic training and that are still evident in his *Medusa*, however original that picture might otherwise be.

In discussing the history of the Restoration Salons, the critic Arnold Scheffer recalled that the earliest had been remarkable for the fact that they witnessed the triumph of bourgeois sensibility: 'the public paid little attention to the tedious grand paintings and appeared preoccupied only with genre pictures … David's school had disdained representations of ordinary life … [but] the importance of social relations, domestic mores and family life would return with the peace'.[34] Genre painting was practised on both sides of the Channel with considerable invention by numerous artists, yet only in France was it perceived as threatening. Louis-Léopold Boilly had especially suffered the financial consequences of such bias. Delécluze laid out his own distinguishing characteristics in 1819 when he argued that history painting moved the spectator by means of a noble action to which all else was subordinate, whereas genre painters focused on everyday life and transient details of costume, habits and mores. In shifting towards the attributes of genre, history painting had become for Delécluze a 'gazette du jour'. Adolphe Thiers, however, argued that genre encouraged diversity and was thus more genuine and original.[35] Two years later, he reiterated his personal theory of colour, the modern significance of genre painting and, by association, the pre-eminence of the Dutch and British in this field: 'It is in sketches executed robustly, that we most often find beautiful colour; and, conversely, it is found only rarely in finished works … It is not the painters of history, but the painters of genre, landscape and animals who have been the greatest colourists.'[36]

Stendhal wrote his first Salon review in 1822, published in English in the newly minted journal the *Paris Monthly Review*. He proclaimed the exhibition an acreage of mediocrity. Only Pierre-Paul Prud'hon's sentimental *The Dying Father* interested, because it expressed the predilection of the period for piety and calm, qualities wanting in the art of the Revolution and Empire.[37] Conditions were indeed ripe for the reform of both the methods and the substance of French painting.

'The great modern symphony … is called colour' *Charles Baudelaire*

Only a handful of British names grace the Salon catalogues of the four Restoration exhibitions preceding that of 1824. In addition to single oils by John Glover and John Crome

fig. 9

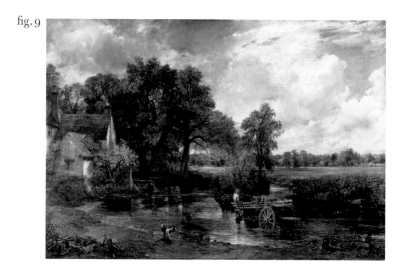

fig. 10

in 1814 and two watercolours by Bonington in 1822, a mere handful of engravings and aquatints represented the school. Wilkie's reputation was well served nonetheless by Abraham Raimbach, who shrewdly submitted his engravings after the Scottish painter's most popular genre pictures to every Salon after 1814. Indeed, engravings circulated by publishers proved most effective in familiarising the French public with British art during the initial years of the Restoration. As William Etty observed in a letter to Thomas Lawrence in 1823: 'They seem beginning to think *we can paint a little* [his italics]. Numerous English engravings are everywhere met with. Vignettes by Stothard, Smirke, Westall, are not only admired but imitated. Wilkie is much in request.'[38] The visibility of British painting in Paris peaked with the three Salons of 1824, 1827–8 and 1831, when nearly forty different artists contributed. During the same period the number of paintings by French artists illustrating British themes and topography vaulted dramatically in response to the extraordinary popularity of British authors and British history, especially the life of Mary Stuart, and the Commonwealth, with its parallels to modern interregnum France. The sudden appearance of an assessable corpus of work that was alien, in every sense of the term, shocked academics just as it encouraged younger artists struggling for independence.

Most British paintings sent to Paris were from the less esteemed orders of subject matter and media – portraiture, landscape and watercolour. The sympathetic Géricault was represented posthumously in 1824 with sporting pictures, a peculiarly British taste that would soon attract adherents among younger French painters. At the conclusion of the so-called 'British Salon' of 1824, Lawrence was made a Chevalier of the Légion d'Honneur on the strength of two portraits, and although the state purchased no British pictures from the exhibition, the French hosts awarded gold medals of excellence to three landscapists, Constable (fig.9), Bonington and Copley Fielding.

The magnitude of published criticism regularly generated in France by the Salons was without parallel in Britain. Stendhal argued in 1822 that a surfeit of French critics was suffocating genius. The preponderance of writing on British art was so negative and contentious in the 1820s that a casual reader might imagine all of France reviling a band of unwelcome parvenus, but this was decidedly not the case. Every British artist who visited Paris had nothing but praise for the general reception of their work. But critics controlled the print media, and they were divided into polemical camps. The moderate liberals included Stendhal and Adolphe Thiers, historian and future president of the Republic, who wrote for the two most widely circulated papers, *Le Globe* and *Le Constitutionnel*; Auguste Jal and Gustave Planche, who published separate volumes of astute criticism; various

anonymous writers for *Le Figaro*, which had Camille Roqueplan's (no.57) brother, Nestor, on its editorial board; a similar group for *L'Artiste*, founded in 1830; and Arnold Scheffer of the *Revue Français*. With the exception of *Le Figaro* and Scheffer, who cogently defended the new school, these critics argued a centrist viewpoint, usually but not invariably sympathetic to Britain. The more numerous and hostile faction, who attacked the younger French and British artists with equal ferocity, featured Delécluze, writing for the otherwise moderate *Journal des Débats*; Charles Farcy, one of the founders of the reactionary *Journal des Artistes*; Anne-Louis Girodet's biographer Pierre Coupin of the *Révue Encyclopédique*; and Fabien Pillet of the *Moniteur Universel*.[39]

The most articulate of the ultra-nationalists was the already cited Delécluze, David's pupil and biographer, whom Sainte-Beuve later ridiculed as a 'model of bourgeois probity'[40] and Stendhal nicknamed 'stagnant water'. Nevertheless, both these authors and many others frequented Delécluze's Sunday salon where aesthetic issues were ardently debated, and aspiring authors like Prosper Mérimée and Alfred de Musset (no.164) were encouraged to recite their latest creations. Delécluze himself moved to London in 1826 and struggled earnestly for six months to comprehend every level of British culture. His journal for the years 1824–8 remains a remarkable account of the factional disputes of the period and the vagueness of the doctrines then circulating. Much to his credit, he recognised the superannuation of David's theories and the feebleness of his imitators by 1824. However, Kean's performance as Richard III in May 1828 confirmed his fear that to be moved the English temperament required 'a material and brutal representation of the soul's maladies and the body's sufferings'.[41] From there he reasoned that all of Europe had succumbed to a similar craving for the piquant, extravagant and hideous as antidotes to ennui. Byron's arrogant scepticism simply reinforced that perception. For Delécluze, the moral opposition of ugly and beautiful was equivalent to that of northern and southern cultures or of Shakespeare and Homer.

In the twentieth instalment of his critique of the 1824 Salon, Delécluze identified himself as the spokesperson for the *juste milieu*, coining an expression that would soon become synonymous with the politics of the July Monarchy after the Revolution of 1830, but which he employed to identify a philosophical haven between the extremes he was witnessing in the contemporary art world. Those polarities he labelled Homeric and Shakespearean, and he elected landscape painting as the genre with which to define his terms. Achille Michallon (no.43) was Homeric because he subordinated transient visual effects to a virtuous narrative component situated within a carefully staged landscape. The

Shakespeareans, Constable (fig.9), Bonington, Thales Fielding, Vernet and Jean-Bruno Gassies (fig.10), animated their compositions throughout, either with colour, brushwork or diaphanous perspective, at the expense of subject exposition, and often failed to have any subject at all other than rude nature. Despite his promise to compromise, Delécluze insisted on promoting the traditional *paysage historique* as the model for landscape painters in the face of resounding public apathy. The naturalism implicit in such theory was that of a Virgilian idyll or a delightful vision by Claude, 'perfect abstractions of the visible images of things'.[42] Delécluze would sustain this position steadfastly throughout his life, but as early as 1819 he recognised that French landscape painting had 'degenerated into practice, into routine, into dubious and often false colouring',[43] and he correctly identified the source of the problem in the system that sent artists to Italy only to have them return and squander their careers following recipes or copying Old Masters instead of nature.

Baudelaire would later stigmatise that class of painting as 'morality applied to nature'. Despite some misgivings, Delécluze would have gladly agreed, for he perceived the alternative British models, with their lack of edifying subject matter and their facile techniques, as proof of a depraved indifference to the viewer's right to a rational and ideal distillation of the physical world. The imagined laxity of execution that actually gave British pictures their optical veracity revealed, according to the reactionary French faction, a poverty of elevated ideas and a coarse commercialism. Other less delicate critics would accuse Constable of forgoing the use of brushes and either hurling a sponge at his canvas or simply smearing raw pigments with a palette knife.[44] With regard to this insensitivity to the peculiarly French aesthetics of finish, the British School had its defenders. Nodier openly acknowledged the superiority of British landscape technique for emotive effect.[45] Similarly, Pichot mediated: 'At fifteen paces, the landscapes of Constable, Callcott etc. are admirable … I am not certain at how many paces distant the pictures of Claude, Watteau etc. are masterpieces, but have not all pictures a given distance beyond which their illusion vanishes?'[46]

Like Delécluze, whom he would savage in a series of articles for the *Morning Chronicle*, William Hazlitt had trained as a painter and was steeped in its history. He too perceived in the execution of certain British landscapists like Turner, a particular mercenary interest, but one coerced by the circumstances of modern economic reality. Unlike Delécluze, he had no confidence in his own generation to revive the great traditions of the Renaissance. The best poets and painters, he contended, appeared at a moment when society was 'comparatively barbarous', leaping at once 'from the first rude dawn of invention to their meridian height' but

fig.11
Anne-Louis Girodet
The Deluge
1806
Oil on canvas
Musée du Louvre

declining rapidly afterwards.[47] Neither the British nor the French possessed the sensibility to regain the dazzling lustre of their antecedents, the French because they were too governed by erudite rules and prejudices, the British because they were too preoccupied with bravura execution and gaudy chromatic fantasies that enthralled an untutored eye.[48] Because of his scepticism, Hazlitt was unwittingly the most perceptive commentator on what constituted the redeeming idiosyncrasies of the two schools.

Hazlitt arrived in Paris in August 1824, shortly after the opening of the Salon. In response to the initial reviews in the French press, he submitted for publication in October not a commentary on the French and British artists then exhibiting, but a spiteful attack on the treasures by David and his pupils then hanging in the Luxembourg Palace.[49] Girodet's celebrated *Deluge* (fig.11) was bombastic and unnatural, while David was neither a romantic nor a revolutionary with his 'little, finical manner, without beauty, grandeur or effect … a bad *translation* of sculpture'. However, he did admire Delacroix's *Barque of Dante* (Louvre) as revealing a sensitive eye for Rubens and for nature. Hazlitt's opinion of modern French painting evolved over several decades, following his first Paris visit in 1802, and paralleled the maturing of his theories, which he published in a series of journal articles during the first years of the Bourbon Restoration. The French, he claimed, 'have no idea of cadence in any of the arts – of the rise and fall of the passions – of the elevations and depressions of hope or fear in poetry – of alternate light and shade in pictures – all is reduced … to dry and systematic prosing'.[50] But he primarily abhorred their academy and the constraints it placed on the free progress of genius. Genius, whether innate or learned, was the power of original observation and invention, and it came not from copying old masters or casts. In his view, the sixteenth-century Venetian manner of painting, merging broad masses of colour and light and attention to naturalistic detail, was the apotheosis of achievement.

For Delécluze and Hazlitt, the pleasures afforded by painting were therefore quite distinct. Delécluze believed that the subject of a picture radically shaped the emotional response and dictated careful descriptive execution. For Hazlitt and a growing number of French theorists, these pleasures were independent of ethical and philosophical deliberations. The most vulgar, shocking and unpleasant vignettes in real life or literature could become subjects of beauty in a painting because their disagreeable traits were irrelevant to the appreciation of the artist's purely formal inventions. Thirty years later, Delacroix would reason similarly with regard to the inherent beauty of Géricault's otherwise bizarre studies of body parts (no.13). The Davidian system stressed cogitation and the need for a

communicable technique subordinate to that purpose. Whether it captured a landscape or a portrait, that technique demanded laborious preparatory studies and an extremely subtle wet-in-wet application of many transparent layers of pigment carefully blended with a fine touch. When David supposedly commented, upon viewing Géricault's *Chasseur de la Garde* (Louvre), that he did not recognise the 'hand' responsible, he was acknowledging not only his first encounter with a new artist's technique, but also its divergence from the academic 'house style'. British painters sought effect, or what Delacroix referred to as that 'bridge set up between the mind of the artist and that of the beholder', for which execution was equal to the conception but primarily, as it had been with Titian and Veronese, 'wholly a matter of feeling carried out by each master in his own way, or rather in a way that his instinct suggested, following the bent of his genius'.[51] Colours, volumes and space created by optical rather than mechanical blending were integral to the success of painterly effect on the imagination.

At the 1827 Salon, critical attention shifted from Constable, who had sent only one picture, *The Cornfield* (fig.12), towards French paintings in the so-called Anglo-Venetian style, most of them monumental illustrations to British literature. These included Delacroix's *Sardanapalus* (no.78); Eugène Devéria's *Birth of Henri IV*; Camille Roqueplan's *Marée d'Equinoxe* (no.57); and Louis Boulanger's and Vernet's *Mazeppa* subjects (no.53). Of the British contributors, the President of the Royal Academy again commanded the most critical notice. Where Lawrence had exhibited only minor portraits in 1824, to the 1827 event he submitted a very significant example of his powers, *Master Charles William Lambton* (no.50), and his delightfully disarming *Duchesse de Berry* (fig.46). A cautious early notice in *Le Figaro* set the tone for subsequent discussion, at first criticising the artist for bathing the Byronic Lambton boy in the light of day while a moon hovers behind the foliage, but succumbing ultimately to the gracious pose, delicious colour, expressive head and animated carnation.[52] Pierre Coupin countered that while the expression of the head was amazing, the portrait would not stand comparison with those of Girodet (no.102) or Ingres (no.51), where 'every section is treated with equal exceptional care'. Auguste Jal issued a virtual essay on *Master Lambton*, concluding that it was an irreproachable masterpiece.[53] Stendhal detested Lawrence's work but in his remarks he vacillated, as was his stratagem whenever addressing British art: 'Lawrence designs ridiculously … but the eyes he gave to this beautiful child will not soon be forgotten.'[54] Repeatedly raised by the reviewers was the issue of probity – the notion that the British and their French supporters were defrauding the public with careless execution masquerading as originality.[55] An ambivalent compliment came from a mutual friend of

Hazlitt and Delécluze, the artist Léonor Mérimée. In a letter of March 1828 to his student Simon Jacques Rochard, he expressed disdain for the pictures Delacroix was then exhibiting in both capitals. He was certain that Delacroix would never initiate a revolution, because he could not imitate truthfully at least the essential parts of his compositions, whereas Lawrence, for all his failings in the portrait of Lambton, had accomplished at least that in the head of his sitter.[56]

With regard to Delacroix's legacy, Mérimée could not have been further from the mark, for he was the very engine of revolution that would transform French painting. He was also the most touched by British art and literature. Delacroix's oeuvre, his collected correspondence and his journal profusely attest to the richness of his experience of both. His most inspired illustrations to Scott, Byron and Shakespeare are unquestionably some of the most profound ever painted. In London in 1825 (fig.24), his theatrical amusements included an operatic version of Scott's *Rob Roy*, and a production of Carl Maria von Weber's *Der Freischütz* featuring the scenery by two future masters of the British school, Clarkson Stanfield and David Roberts. 'They better understand here the effect of the theatre on people,' he wrote. Kean, of course, mesmerised Delacroix, who attended performances of *Richard III*, *Othello* and *The Merchant of Venice*. Shakespeare, he allowed, was truly the 'father of their arts' but, like Delécluze, he sensed 'in the blood of this people something savage and ferocious which can be hideous'.[57] A visit to David Wilkie's studio and the sight of his sketch for *John Knox Preaching* (no.72) inspired compositional elements in the oils *Faust and Mephistopheles* (fig.8) and *Murder of the Bishop of Liège* (no.59). The Wilkie sketch he remembered for decades as a *tour de force* of painterly aptitude and a model for how a 'work of the soul' might be complete without being highly finished. Wilkie in turn would visit Delacroix in Paris on his return from Spain in June 1828 and again astound his French colleague with his ability to alter his style dramatically in response to what he had experienced during his intervening three years abroad.[58] Lawrence had been the paragon of politesse whom Delacroix would recall fondly throughout his career, while Etty and Thomas Phillips were also cordial hosts. Etty too would visit Delacroix in Paris in 1830. However, Delacroix's close friendship with Bonington, which commenced during the 1825 trip and lasted for the final three years of that artist's life, radically influenced his own painting techniques, as it would those of many of his contemporaries. 'With regard to colour,' Gautier admitted, 'the revolution in painting proceeded from Bonington just as the literary revolution proceeded from Shakespeare'; he also believed that Delacroix 'received from him the light that illuminates his *Giaour and Hassan* and that blazes in such superb fashion in *Sardanapalus*'.[59] Without

question, Bonington and Delacroix shared a moment of intense mutual inspiration as brief and as significant to the history of painting as would be the comparable collaboration between Gauguin and Van Gogh at Arles.

The very last entry Delacroix wrote in his journal, on 22 June 1863, began with the statement: 'The first quality in a picture is to be a delight for the eyes.' For an artist who often pondered complex literary and psychological ideas for decades before attempting to translate them into paint, this was a remarkably nonchalant comment on the importance of subject matter to his art. However, he firmly believed that the creator needed to control the creation, and that the first impression of a painting ought to parallel the experience of entering a Gothic cathedral. The abstract forms and the brilliant colours of a stained-glass window or a painted canvas should satisfy the viewer's fundamental need for harmony and beauty before any subject reveals itself. Delacroix maintained this conviction throughout his career, but it apparently originated in that period when British painting techniques, especially those of Bonington, Wilkie and Lawrence, were paramount in his mind. 'One can find in other modern masters,' he wrote to the critic Théophile Thoré, 'qualities of strength and precision superior to those in Bonington's pictures, but no one in this modern school, and possibly even before, has possessed that lightness of touch which, particularly in the watercolours, makes his work a type of diamond that flatters and ravishes the eye, independently of any subject.'[60] Bonington's earliest training as a watercolourist, like that of Turner and many other British artists, had radically conditioned his approach to oil painting. It is also clear from Delacroix's correspondence and journal, that Bonington's watercolours figured prominently in his perception of his friend's genius. Undoubtedly, as a vehicle for liberating technique and for narrowing the gulf separating inspiration from actualisation, watercolour painting appealed to Delacroix's temperament and ambitions during the 1820s. His later oil paintings evidenced a vivid range of colours, but their close-valued hues often created decoratively homogeneous surfaces. His 'Anglo-Venetian' style of the 1820s, as it was then called, and which the *Combat Between the Giaour and Hassan* (no.76) or *Reclining Odalisque* (no.79) powerfully describe, is more visually striking because of the brilliant contrasts of light and dark tones, and the depth achieved by the fractured application of impasted highlights both over and under translucent glazes. It is an approach that recalls both advanced British watercolour technique and Constable's method of painting foregrounds in his 'six-footers'.[61] Delacroix's touch is often remarkably rapid and precise, thanks to the use of copal varnish as a medium, which dried quickly to a high transparency and thus encouraged the quality of spontaneity and layering so admired in watercolours. Whether Bonington introduced Delacroix to that technical nicety, as is often claimed, is less important than the realisation that two exceptional talents, and no insignificant number of gifted painters in their circle, were engaged fervently in the constructive collaboration that Géricault had prescribed to Vernet.

For all of the subsequent literature describing Delacroix and his generation as the champions of colour over line, of effect over uniformity, of individualism over system, of all that constitutes the foundation of a revolutionary direction in painting and was extolled by everyone from Baudelaire to Van Gogh, surprisingly little recognition has been accorded the crucial role of British art in that crusade. Nor has anyone particularly noted the striking and far from coincidental parallels between Delacroix's most important theoretical writings, the proposed 'Dictionary of Art' that occupies much of his journal in the 1850s, and Hazlitt's published critiques of Joshua Reynolds and art academies some three decades earlier. Audiences today generally associate the great strides towards modernism with later French movements such as Impressionism, yet it is manifest that those movements found their source in the intellectual tumult and shared purpose of the 1820s. For Delacroix, Romanticism was 'a reaction against a school, a call for artistic freedom, a return to a larger tradition'. For Stendhal, it was the art form that gave pleasure to people in their own time as opposed to that which gave pleasure to their great-grandparents. 'To say the word Romanticism,' Baudelaire wrote, 'is to say modern art – that is, intimacy, spirituality, colour, aspiration towards the infinite, expressed by every means available to the arts.' The example of the British painters Constable, Lawrence, Wilkie, Turner and Bonington looms large behind all of those pronouncements.

Print Culture and the Illustration of History
An Anglo-French Perspective

Stephen Bann

Traditional rivalry between France and Britain reached a point of crisis in the mid-eighteenth century, when the Seven Years War succeeded in consolidating British naval power throughout the world, and radically reduced the extent of French colonial possessions. Meanwhile, over the second half of the century, Britain began the widespread transformation of her manufacturing economy which would later be termed the Industrial Revolution. France, on the other hand, was launched on the long process of intellectual and political liberation which led to the Revolution of 1789 and the subsequent fall of the Bourbon monarchy. After the newly aroused French nation had fought off its belligerent neighbours and survived the ordeals of the Terror, power was concentrated in the hands of the brilliant young Corsican general Napoleon Bonaparte, whose aim of creating a Continental empire in Europe inevitably brought renewed conflict with Britain as a world power.

This may seem an unlikely scenario for cultural contacts between the two nations. Nevertheless, cultural interchange between France and Britain was at its most intense during the period that elapsed between the fall of the Empire in 1814/15 and the July Revolution of 1830, when the elder branch of the Bourbon dynasty was supplanted by the cadet branch of the Dukes of Orleans. This was the result of a number of closely interlocking factors. Within the European coalition that had exiled Napoleon to Elba in 1814, and thwarted his unexpected return in 1815 at the Battle of Waterloo, Britain was the closest nation geographically, and by far the most inquisitive about French customs and institutions. Many French émigrés, including the new Bourbon monarch Louis XVIII, had spent long periods of exile in Britain. The new French government was designed as a constitutional monarchy, with the royal power being mitigated by an elected national assembly and a chamber of peers that were both clearly derived from the British precedent. Historical analogies between this new French experiment in restraining civil conflict and the British experience of revolution and restoration in the seventeenth century were frequently made at the time, and became the basis for textual commentary and visual illustration. British history was a mirror into which the French could gaze, replacing Cromwell with Napoleon, and comparing the uncertain prospects of their own Bourbon rulers with the fate of the unlucky Stuarts.

Yet it was not just concern about the future of the French crown that drew Britain and France together in this period. The dynamism of British industrial development and the ideological ferment of the French revolution jointly fed into the culture of the Romantic movement. However, when France was finally relieved of the burden of Napoleonic ambitions in 1815, it was also widely recognised that she needed to be free of the conservative constraints that still governed much artistic production, as regards both

technique and subject matter. British writers like Walter Scott and Lord Byron provided vivid historical recreations and timeless myths to inspire the new generation of artists. British painters such as John Constable, Richard Parkes Bonington and Thomas Lawrence galvanised practitioners and critics alike, who admired their pictorial verve and freedom from inhibition in handling the medium. No less important, British printmakers showed the way to diversifying and popularising techniques, and so cater for the new mass market for prints, illustrated books and magazines that differentiated the Romantic epoch from all its predecessors. This essay will demonstrate some of the ways in which these factors interacted.

Waterloo gave the signal for British travellers to disembark on French soil once again. The troops of the Duke of Wellington were in occupation until early in 1818, but they proved just the vanguard of a host of short-term tourists and longer-term residents who flocked to the other side of the Channel. Pierre-Jean de Béranger, the most popular French poet and songwriter of the day, caught the mood of reciprocal curiosity as early as August 1814 with his satirical poem on the 'Anglomane': 'Despite their hats being really ugly,/ *God dam*! Me I like the English.'[1] Even the well-advertised hardships of the crossing from Dover to Calais, which Walter Scott himself noted lugubriously after his visit in 1815, were not enough to stem the flow. There soon arose a minor genre of coloured prints that recorded the solemn, sentimental and ridiculous antics of the invading sightseers.[2] But it would be wrong to take these caricatures as indicative of a superficial interaction between the two cultures. British visitors had already showed their enthusiasm for French travel in 1803, after the abortive Peace of Amiens. The critic and essayist William Hazlitt was one of them, and he never forgot having seen artistic treasures from the whole of Europe gathered together in the Musée Napoléon at the Louvre. In Britain, there was still nothing comparable. Though a large part of the booty that had been garnered throughout Europe returned to its former owners after 1815, the Louvre remained a prime attraction.

Yet arguably the drama of Napoleon's Continental wars had masked a convergence between British and French visual cultures that was already developing from 1800 onwards, despite the conflict. Neoclassicism was the official style of the Empire, as it had been for the Revolution that went before. But this did not stop the Empress Josephine being an assiduous collector of British prints, or taking advantage of the Peace of Amiens to order plants from English nurseries for her English-style garden at La Malmaison. Throughout most of the revolutionary period, the President of the Royal Academy was the American-born Benjamin West, both a staunch Bonapartist and an admirer of the Louvre, who maintained relations with his counterparts in the Académie des Beaux-Arts in France. The interruptions caused by war were outweighed by the new opportunities for patronage and dealing that opened up simultaneously through diplomatic and commercial channels. When the Bonington family moved from Nottingham to Calais in 1817/18, it would take advantage of a well-established Anglo-French artistic centre offering scope for the exploitation of new techniques as well as new selling opportunities.[3]

Bonington himself is the paradigm case of a British-born artist who, despite his brief career, profoundly affected the development of the Romantic generation of French artists. Attached to one of the most prestigious academic studios (handed down from Jacques-Louis David to his pupil Antoine-Jean Gros), he showed fellow students like Eugène Delacroix and Paul Delaroche the possibilities of colourful and spontaneous sketching in gouache and watercolour. The example of Bonington points to the many-layered interaction taking place during these years. It was a process affecting both the grand academic tradition of the Paris Salon, and the more flexible modes of painting and sketching in which the British were pioneers. It showed up in the great contemporary projects of publication, involving new techniques like lithography, that originated in Bavaria, and steel engraving, which was pioneered essentially in Britain. These were challenging the traditional burin engraving cherished by the French Academy. In so far as such projects invariably involved exciting new material, these developments in print technique were furthermore linked to the publication of new literary and historical texts emanating from British poets and novelists. Both the poems of Byron and the novels of Scott acquired European-wide celebrity over this period, but it was notably in France that visual artists responded with striking and innovatory representations of many of their key scenes and motifs. The growth of a culture of illustration, employing a range of different strategies for complementing word with image, was no less radical a development than the catalytic effect of British history and literature on the Paris Salon, whose jury still attempted to police admissible types of subject matter in line with the traditional superiority of classical mythology and biblical themes.

I propose to look closely at three distinct yet related examples, in which French artists responded to (and interacted with) the challenge of British Romanticism. Each involved a shift in visual techniques in addition to broader cultural and historical ramifications. First, I take the genre of the published and illustrated 'voyage', which was the appropriate contemporary form for disseminating new knowledge about foreign historical sites, and which also favoured the development of novel visual techniques in their representation. Second, I look briefly at one of the major

poetic subjects of the period, Byron's *Mazeppa*, suggesting why the poem became emblematic for a number of major French painters, as well as encouraging them to compose their oil sketches with a special freedom. This will lead to a discussion of the third example, the historical genre paintings of Paul Delaroche, who was not only to the fore in adopting British historical themes, but also adapted the visual form that they had acquired from British printmakers, as a preliminary basis for his work.

Taking 'voyages' in the literal sense, we certainly know more about British artists visiting France during this period than about French artists visiting Britain. Even Théodore Géricault's lengthy visits to London in 1820 and 1821 are sparsely documented. Géricault did indeed complete several lithographs involving English themes that were published by the print editor Charles Hullmandel. His companion on the first of these journeys, Nicolas Charlet, was a young prodigy from Gros's studio, already celebrated for the precocious lithographs that he had produced in the Paris studio of Charles de Lasteyrie. But the net result of Charlet's own visit seems to have been hardly more than a print of a fishwife smoking a pipe, jocularly entitled *La Nymphe de la Tamise* (The Nymph of the Thames) and two studies of an English 'Milord' shown before and after his catastrophic losses at the gaming table.[4] Paul Delaroche's visit to London in 1827, which must have stimulated his remarkable sequence of paintings on British historical themes shown at the Salon between 1827 and 1837, appears to have left virtually no documentary trace.

British artists, however, not only voyaged to France, but went with the intention of publishing the record of their voyages. One example is the *Letters Written During a Tour through Normandy, Britanny and Other Parts of France*, in 1818 by Mrs Charles Stothard, which included 'numerous engravings after drawings' by her husband, the son of the noted British painter, Thomas Stothard. Mrs Stothard is quite comical in protesting her objectivity, 'divesting [herself] of any Gallic or Antigallic prejudices'.[5] She dilates on the attractions of the Paris museums,[6] but her main aim, in addition to commenting on the 'present manners of the French nation', is to note in her journey throughout Normandy and Britanny 'such vestiges of antiquity as are illustrative of the ancient chronicles'. It is the presence of treasures like the Bayeux Tapestry that appear to have attracted her to France, and 'the number, extent, and extraordinary beauty of the churches' that she admits to having most impressed her.[7] Her husband Charles's sketches, mostly picturesque landscapes engraved in aquatint, echo this fascination with medieval remains, and occasionally venture a reconstruction of a significant historical event, such as 'Harold taking the Oath before

fig. 13

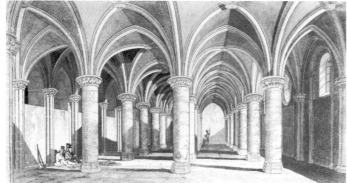

fig. 14

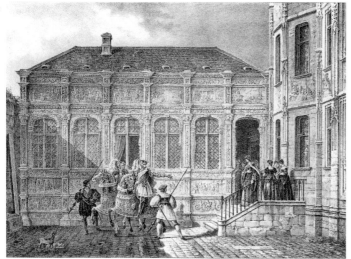

William'.[8] Mrs Stothard refers during her description of Caen to the 'excellent work of Mr Cotman'.[9] Before her book was published in 1820, there had indeed been an opportunity to see the first-fruits of John Sell Cotman's expeditions of 1817, 1818 and 1819, collected in his *Architectural Antiquities of Normandy* (1819–22; fig.13). A superb draughtsman and artist in watercolours, Cotman seems to have taken up the technique of etching partly in a bid to emulate Charles Stothard's reputation as an antiquarian topographer, and his delicate use of etched line against the white ground of the paper certainly achieves a crisper impression than the tonal effects obtained in the aquatints after Stothard's drawings. Yet Cotman's plates were not assembled for their aesthetic effect, but as an aid to the historical study of the province of Normandy – a subject upon which his patron, Dawson Turner, held decidedly strong views. Cotman's meticulous images, supplemented by his careful descriptions and precise measurements in the text, were pressganged into Turner's campaign, in the name of history, against 'the wildest extravagancies of absurd fiction' perpetrated by the French.[10]

It is obvious that the novel achievement of the *Voyages pittoresques et romantiques dans l'ancienne France*, which began publication in 1820, owed much to this British tradition of antiquarian topography. The list of subscribers (the customary way of financing such major publishing ventures at that time) to its first volume included, among other British names, Cotman's irascible patron Dawson Turner, the architect Augustus Charles Pugin and the Marquis of Stafford (later Duke of Sutherland), whose magnificent picture collection was already rich in French paintings from the Orléans collection. The list of contributing artists at the outset comprised already well-known academic painters like Horace Vernet, Alexandre-Evariste Fragonard and Louis Watelet, as well as artists involved with forms of spectacle like the stage-designer Ciceri and Louis Daguerre, inventor of the diorama and future pioneer of photography. All of these superior talents were however harnessed to the recently perfected print-making technique of lithography. As one of the three editors of the *Voyages*, Charles Nodier, remarked in his Preface to the first volume: 'More free, more original, more rapid than the burin, the bold crayon of the lithographer seems to have been invented for fixing the free, original and rapid inspirations of the traveller who gives an account of his sensations.'[11]

A comparison of prints from Cotman's *Normandy* and the *Voyages* shows the revolutionary effects that were obtained through the new technique. Cotman's etched *Mount St Michel* comes across as a piece of crystal-clear architectural documentation, whilst the view of the *Galerie de l'Hôtel du Bourgtheroulde* in Rouen by Augustin Lemaître uses the soft lithographic crayon to create a highly atmospheric little

scene (figs.13, 14). It is likely that the uniformed soldiers portrayed by Cotman would have been British, part of Wellington's occupying force. Lemaître, by comparison, has chosen to people the courtyard of the Renaissance hôtel with men and women in period dress, encouraging us to eavesdrop a scene of knightly dalliance from the distant past.

Yet it would be wrong to insist too much on the distinction between fact and fantasy that seems to accompany these differences in printmaking technique. If Cotman made no attempt to conceal the contemporary context of his architectural view, Nodier and his fellow editors were also selecting an architectural setting that enshrined a message about the historic relationship between Britain and France. On the bas-reliefs visible in the courtyard of the hôtel, we can observe a series of scenes depicting the celebrated meeting between Henry VIII and the French King Francis I at the Field of the Cloth of Gold, near Calais. Five lithographs showing close-ups of these reliefs, after drawings by Evariste Fragonard, follow directly after Lemaître's print. Both British and French publications are therefore focusing on Normandy not just as any old French province, but as the privileged domain where the two nations were closely embroiled throughout much of their earlier history.

This is just one proof of the deeper historical content that underlies the common Anglo-French preoccupation with Normandy in the Romantic period. Yet the technical differences just noted are no less significant. The new direction taken by the French lithographic artists represented in the *Voyages* marks a divergence from British printmaking that would become all the more pronounced with time. The 'free', 'original' and 'rapid' treatment associated with lithography would become the hallmark of French topography, as indeed it would become the prime identifying characteristic of the whole French landscape tradition, from the Barbizon School through to Impressionism. But British engraving had its own significant future role to play. As early as 1833, the German art historian Franz Kugler remarked that, in landscape printmaking, the French had assumed the lead in lithography, but the English still retained it in steel engraving. The English, according to him, had perfected a technique that was ideal for representing the 'fantastic cloud heavens of the North', whilst the French had chosen one suited to the 'clear light of their hotter land'.[12] The publication of *The Rivers of France From Drawings by J.M.W. Turner RA* in 1840 indeed conclusively demonstrated this capacity of the steel engraving to create miniature prospects equivalent to the sublime visual effects of Turner's sketches.

As was suggested, both British and French images of Normandy took for granted a genuine involvement in the history of the former province whose significance had been revived in the light of the recent conflict. Although the

fig. 15

fig.15
Charles Thompson, after Antoine
Johannot
Meutre de Duc Jean
(from Prosper de Barante, *Histoire
des Ducs de Bourgogne*, 6th edn,
Vol.III, 1842)
Wood-block engraving
Private Collection

fig.16
Horace Vernet
Mazeppa
1826
Oil sketch on canvas
Kunsthalle, Bremen

etching and aquatint techniques used to print the drawings of Cotman and Stothard were superseded in France by the new lithography, British engravers continued to exercise a vital role in the visual representation and diffusion of Romantic historical culture. The long residence in France of the English printmaker Charles Thompson and his brother James facilitated the production of amply illustrated editions of books like Prosper de Barante's *Histoire des Ducs de Bourgogne*, appearing in the late 1830s with wood-block engravings by the Thompsons, after such leading French artists of the Romantic school as Alexandre-Gabriel Decamps, Paul Delaroche, Eugène Déveria, Ary Scheffer and Alfred and Antoine Johannot (fig.15). No less eager to punctuate the narrative with lively visual renderings of historical action were the publishers of the only comparable history to vie with Barante's popularity in the early Romantic period: Augustin Thierry's *Histoire de la Conquête de l'Angleterre par les Normands* (originally appearing in 1826). Here, though illustrations followed the model of those in the *Ducs de Bourgogne*, the 'atlas' accompanying the fifth edition in 1839 showed a reversion to the finesse of French burin engraving. Detailed maps of Britain, France and Normandy, not to mention a visual record of the Bayeux Tapestry, were supplied by the burin engraver Ambroise Tardieu.

By this later stage, the enduring influence of the *Voyages* is clear. The details taken from the engravings by Maillard, which demonstrate the differences between Saxon and Norman architecture, are obviously copied from Louis-Jules-Frédéric Villeneuve and Auguste-Xavier Leprince's extensive lithographic survey of the Abbey of St Georges de Bocherville in the *Voyages*. Here indeed was a building that condensed the shared historical experience of the two nations, the very spot where William the Conqueror's body was laid out before his funeral, and also a place strongly associated with the Bâtard de Dunois, companion-in-arms of Joan of Arc. Nodier had been keen to show his respect for English architectural parlance, as well as his own aesthetic appreciation of the building, when he justified its extensive coverage in the *Voyages*: 'There are few churches in ancient France and ancient Christendom whose ensemble is, to use a charming English expression, more chaste in the artist's eyes.'[13]

If we turn from the particular conjunction of topography and historical culture represented by the *Voyages* to the mainstream of French Romantic painting, the connections between subject matter and advances in technique are no less clear. Once again, and indeed to a much more obvious extent, there is a strong impulse supplied by a British tradition involving visual, literary and historical strands. The French artists did not simply borrow themes from British Romantic poets. They used them to force the pace of artistic change.

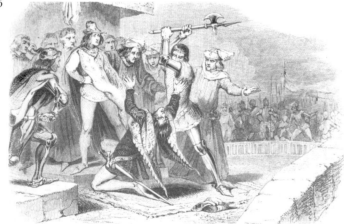

Byron published his poem *Mazeppa* for the first time in 1819, and it was translated into French in the collected edition of his works which appeared in Paris between 1821 and 1824. It was already replete with French associations, since the opening 'Advertisement' in this edition ascribed the source of the story to Voltaire's *Histoire de Charles XII*. Moreover there was a clear contemporary significance in Byron's decision to expand the remarkable tale supposedly told by an aged Prince of the Ukraine to a Swedish king who had invaded Russia. Byron began his poem by evoking the 'thunderbolt' effect of the news of Napoleon's disastrous retreat from Moscow, and at one stage volunteered a note on the Emperor to be published together with the poem.[14]

Yet if Napoleon's Russian campaign suggested a new context for the story summarised by Voltaire, Byron's extended treatment of the tale of Mazeppa (the future Hetman or Prince) leaves it far behind. This is the account of a journey, from Poland to the flat plains of the Ukraine. But the rider is powerless to guide his horse, being a young page from the King's court who has been stripped naked and bound to the steed at the behest of a jealous and powerful husband. The poem recounts with insistent detail this rollicking ride of the 'wild horse' that obeys only its homing instinct and so eventually returns to its native land, only to drop dead under its human cargo upon arrival. Throughout the journey, the exposure and vulnerability of the young Mazeppa is continually emphasised: 'But no – my bound and slender frame / Was nothing to his angry might.'[15]

It is not difficult to see why Géricault was attracted by this stupendous theme. He had picked up a number of subjects from Byron's poetry, some perhaps as early as 1819–20, and used them for drawings and oil paintings, as well as a series of related lithographs, carried out in collaboration with the young artist Eugène Lami, which appeared in 1823.[16] The motif of the wounded rider and the wild horse descends, however, in a direct line from some of his own notable paintings of the previous decade: the *Wounded Cuirassier*, shown at the Salon of 1814 after the first Restoration of the Bourbons, and particularly the abortive series on the 'Course de chevaux libres' undertaken at Rome in 1817. Consistent with these later studies in which riderless horses strive for freedom from human restraint, Géricault has chosen to illustrate the very moment in Byron's poem where Mazeppa's mount succeeds in emerging out of the river 'Up the repelling bank'.[17] In the French text accompanying the lithograph, the shimmering effects of the crayon (with which Géricault is believed to have personally retouched the work) take on a special significance : 'Le coursier tente de s'élancer sur le rivage qui semble la repousser, ses poils et sa crinière sont *luisants et humides* [my italics].'

In the mid-1820s, perceptions of Byron's work were overshadowed by the tragedy of the poet's own death at Missolonghi, whilst fighting for Greek independence, in the same year as Géricault's. Both these factors working in conjunction may have encouraged Horace Vernet, a close friend of Géricault, to choose the Byronic theme for a series of paintings composed in 1825–6. The first of these, completed in 1825, was destroyed in the same year by a fire in the Louvre. However, the subsequent oil sketch, signed and dated 1826, and the two paintings from the same year now in the Musée Calvet, Avignon (no.53), all incorporate a different moment from the rider's ordeal. Vernet has conflated the horse's leap across a tumultuous stream with another episode from the poem, in which the supine Mazeppa catches sight of wolves in close pursuit ('By night I heard them on the track … Behind I saw them, scarce a rood').[18] The finished oil by Vernet recaptures little of the brio of Géricault's brushwork. However, his small oil sketch in the Kunsthalle, Bremen (fig.16) uses the freedom of the technique to convey the flight of the terrified horse with long, swooping brushstrokes, as Mazeppa's white body flecked with blood is carried aloft, and the wolves close in.[19] Vernet's series by no means exhausted the interest of Byron's poem for the Romantic generation of French painters. Delacroix completed a work on the subject in 1826, and in 1828 published a lithograph reminiscent of Géricault's *Mazeppa* with the title *Cheval effrayé sortant de l'eau*.[20] The young Louis Boulanger (b.1806) made his début at the 1827 Salon with a *Mazeppa* that put the action back to the start of the page's ride ('Mazeppa is attached to an untamed horse, by the orders of the Count Palatine whom he has insulted').[21] Finally, in 1853, Théodore Chassériau, born in the year of the poem's first publication but with a fair claim to be the last French painter in the Romantic tradition, completed his own *Mazeppa* in 1853, three years before his death. Here the horse has reached its destination, and collapsed lifeless. Mazeppa is due to be rescued by Byron's 'Cossack Maid'.

The case of *Mazeppa* exemplifies one type of interchange between Britain and France in the Romantic period. Byron had provided a mythic image that galvanised French artists because it condensed heady notions of liberty and destiny in the single motif of the young and glamorous miscreant tied to the wild horse. Painters who chose to reinterpret it were not only doing homage to the martyred Byron, but implicitly acknowledging Géricault at the same time. The poetic narrative offered different points of entry, and the theme could be tested across a range of media: Salon painting, oil sketch, drawing and lithographic print. It is this very diversity of outcomes, and the fact that the less formal means of representation may often be the most vivid and effective, that characterise the new openness of Romantic culture.

Paul Delaroche stands somewhat apart from the many instances of literary or historicising themes adopted from Britain. Delaroche was a pioneer because he worked not

simply on British historical themes, but on already existing representations of those themes. There is overwhelming evidence that he took note of the ways in which British printmakers interpreted the events of their history, before he produced his own distinctive variant images, with both the scale and the visual effect carefully calculated for Salon display. The compliment was returned since Delaroche was highly successful in obtaining commissions from foreign, and specifically British collectors, like the Second Duke of Sutherland in the 1830s. He also benefited particularly from the services of important contemporary British printmakers like S.W. Reynolds and George Maile working in mezzotint, or *manière noire*. Orthodox French burin engravers had been fighting a rearguard action against this technique for some decades, since they considered that its quasi-automatic creation of dark tonal areas was too facile, and could not compete with the rigour and brilliance of the pure burin. It was indeed Reynolds and Maile who were instrumental in bringing Delaroche's work to international prominence (fig.17). Their entrepreneurial skills must also have prompted Delaroche's future dealer, Adolphe Goupil, into developing the first worldwide distribution network for fine reproductive prints.

Delaroche's way of working with existing visual sources was not fully understood in his time. In fact, it was virtually presented as a form of plagiarism by the prominent critic who

fig. 18

fig. 17

first drew attention to the practice. In his review of the Salon of 1834, Gustave Planche noted the outstanding success of Delaroche's *Jane Grey* (no.55), but asked if the work had 'the merit of originality'. His own answer was categorical. 'Either I am very much mistaken, or the answer is no. There is in the illustrations to *David Hume* a design by Opie, engraved by Skelton, and published in 1795 by Bowyr [*sic*] Pall Mall, which represents the death of Mary Stuart (fig.5)... I ask, is there not a striking analogy between the work of Opie and that of M. Paul Delaroche?'[22] Planche went on to underline the point by implying that other compositions by Delaroche – perhaps all of them – had been put together in the same underhand way. His *Death of Elizabeth*, shown at the Salon of 1827–8, was 'the literal reproduction of a design by R. Smirke, engraved in London by Neagle ... I leave to the scholars the task of discovering whether other compositions by the master also originated in prints.'[23]

Planche's comments provoke an important question about the interpretation of nineteenth-century art in general, which was first raised by Michael Fried in his pioneering essay, 'Manet's Sources', in 1969.[24] Clearly contemporary critics, in Manet's case as previously in that of Delaroche, thought differently from present-day art historians about the issue of 'sources'. Yet, as Fried implies, we have only recently got to the point of comprehending such a complex relationship as that of Manet to his predecessors, and cannot just dismiss as naive the nineteenth-century notion of 'originality'. There is no room here for a full discussion of this issue as regards Romantic painting, and Delaroche in particular. But as it bears very directly on the question of Anglo-French interchange (and as new evidence has recently come to light in a specific case cited by Planche), I shall make a brief review of Delaroche's debt to British sources, and their possible significance in this context.

It is clear that Delaroche visited Britain in 1827, and more than likely that the visit enabled him to lay the basis for the sequence of major paintings involving British historical themes that commenced with the late arrival of his *Death of Elizabeth* at the 1827–8 Salon. A tantalising note in the *Illustrated London News* explained much later that he came to London expressly to superintend the ordering of period furniture and costume for his *Princes in the Tower* (1831 Salon), and to 'visit the scene of [that] picture'.[25] Planche's point about the similarity between Neagle's print after Smirke, *Queen Elizabeth Appointing her Successor*, and the *Death of Elizabeth*, presumably painted directly on his return, has been generally accepted. But the recent discovery of an oil sketch which must represent an intermediate stage in this transfer of motifs makes the process appear much clearer and more significant (figs.18–20).[26]

Delaroche's strategy seems to have been to keep remarkably close to the general disposition of Smirke's

fig. 19

fig. 20

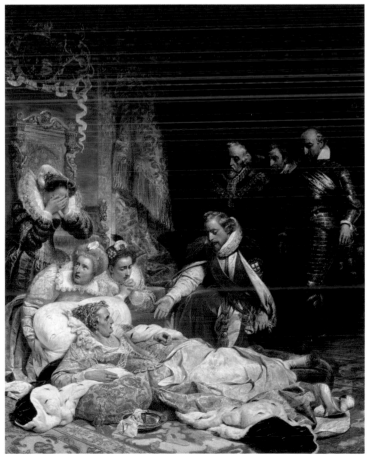

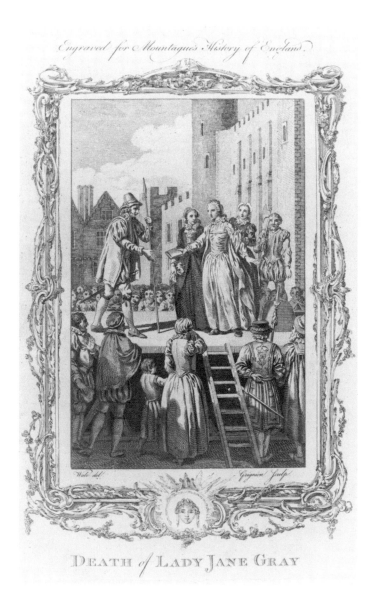

Engraved for Mountague's History of England.

DEATH of LADY JANE GRAY

figures, though he adds an additional, grieving lady-in-waiting, and embellishes the figure of the dying queen with a rakishly perched crown and an indiscreetly protruding left breast. Yet his addition of sumptuous texture and brilliant colour contrast has completely transformed the printed source. Delaroche has no doubt been looking at the oil sketches of Bonington, his former fellow student in the studio of Gros, who may perhaps have encouraged him to make the trip. His arrangement of heavy curtains to envelop the space, and his colouristic treatment of the sumptuous robes of the most prominent figures, bring about a full-blown Romantic revision of the austere monochrome of Neagle's burin version. In the final painting, however, he reverses the composition in line with what we may presume to have been Smirke's original picture. He retains many features of the sketch, such as the scarlet, gold-embroidered curtain and the sumptuous costume of the kneeling Secretary Cecil. But the queen herself has emerged as much less risqué, and finer definition has been given to what a Paris critic later aptly called her 'expression of an eagle wounded to death'.[27]

If we return to Planche's comment on *Jane Grey*, the brief answer is that he is justified in mentioning William Skelton's engraving after John Opie, but wrong to imply that it had been Delaroche's single, or indeed main, source. Opie and Skelton themselves had access to earlier source material, and many of the features that they included (and Planche detailed) were not 'original' to them. There is, for example, a contemporary drawing of the execution of Mary Queen of Scots, from the papers of the diplomat Robert Beale, who carried the death warrant to Fotheringay Castle, which includes, for example, two attendant ladies as featured in Opie (and noted by Planche).[28] We cannot show that Opie, or Delaroche, knew of the existence of this drawing, or of later images derived from it. But it does seem likely that Delaroche was acquainted with a more recent published source that did specifically represent the *Death of Lady Jane Gray* [*sic*] (fig.21). This image, engraved by Charles Grignion after Samuel Wale for *Mountague's History of England* (*c.*1770), places together on a raised platform the Lieutenant of the Tower, the executioner and two attendant ladies accompanying the victim. Lady Jane Grey herself is, of course, standing upright rather than kneeling, as in Delaroche's painting (and Opie's *Mary Stuart*). However one of the drawings by Delaroche for *Jane Grey* indicates that he at one point envisaged her as a standing figure.[29] Moreover the French illustrated periodical *Magasin universel* included in an article on the painting's appearance at the 1834 Salon a wood-block print of an untraced *Death of Lady Jane Grey After an English Painter*, bearing similarities to Grignion as well as to Delaroche's final composition (fig.22).

The short response to Planche is thus that Delaroche almost certainly did consult British prints, but that Skelton's

fig.22
F. L. Wall
*Death of Lady Jane Grey After an
English Painter*
(from *Magasin universel*, 5 June
1834)
Wood-block engraving
Private Collection

print after Opie was not the only one, or perhaps the most important. What must also be stressed is the attention that Delaroche paid to a pictorial tradition of martyrdom represented by masters such as Veronese and Peter Paul Rubens. Veronese's great *Martyrdom of St George*, from Verona, and Rubens' painting on the same subject, originally in Lier in the Low Countries, both figured among the many works brought to Paris on the orders of Napoleon. Both show figures equivalent to the Lieutenant who guides the arms of Jane Grey.

To sum up, Delaroche was an assiduous student of paintings and prints from many periods. But he studied British print sources in conjunction with the religious paintings of the Old Masters in order to provide icons for his own times. Precisely because Jane Grey was an innocent victim, not subject to the historical controversy about the guilt of Mary Queen of Scots, she could serve as a historical figure who took the place of a martyred saint. Honoré de Balzac had asked in 1831: 'Have the executioners not sometimes wept over the virgins whose blonde heads had to be cut off at a signal from the Revolution?'[30] Delaroche's painting provided an occasion for the French public to experience this mood of self-interrogation, since parallel events from the history of Britain provided the requisite distance for reflection upon the recent history, and future destiny, of France.

'Historicism', that is, the choice of scenes and anecdotes from past or present historical writings, is an aspect of Romantic painting which is still relatively unappreciated, and perhaps misunderstood. The essential point is that, in so many cases, the apparently remote historical instance masks a contemporary historical issue which is too close, or too raw, for direct referencing. In this respect, historicism betokens an essentially public form of art that addresses the political realities of the age and so exists at the other end of the scale from the subjective mythmaking that I have associated with Mazeppa. In facilitating these opportunities for moral reflection anchored in historical circumstance – as well as in providing energising myths of selfhood – British history and culture was a crucial and continuing resource for French artists throughout the early Romantic period.

(Mort de Jane Grey d'après un peintre anglais.)

Chronology

Rachel Meredith

Year	Visual Arts	Literature/Music/Drama	Political/Social Events
1800	Antoine-Jean Gros returns to Paris from Italy and is employed by Napoleon to record his military campaigns.	Publication of the second edition of *Lyrical Ballads*, with William Wordsworth's radical *Preface*. First performance of Friedrich von Schiller's *Mary Stuart*.	Napoleon Bonaparte crosses the Alps by the St Bernard Pass. Austria defeated at Marengo. Ireland enters into political union with England.
1801	Jacques-Louis David paints *Napoleon Crossing the Great Saint Bernard Pass*. Jean-Auguste-Dominique Ingres wins Prix de Rome.	Publication of René de Chateaubriand's *Atala*.	William Pitt resigns as Prime Minister and is succeeded by Henry Addington. Jean-Antoine Chaptal (no.51) founds the Société d'Encouragement pour l'Industrie Nationale in France. Accession of Alexander I in Russia. First British Census: population of Britain 10.5 million. Population of France 27.4 million.
1802	John Constable first exhibits at Royal Academy. J.M.W. Turner makes first trip to Paris en route to the Alps. Dominique-Vivant Denon appointed curator of Musée Napoléon (Louvre). François-Marius Granet settles in Italy. Birth of Richard Parkes Bonington. Death of Thomas Girtin.	Publication of Chateaubriand's *Spirit of Christianity*. The critic William Hazlitt visits Paris. Birth of Victor Hugo.	Napoleon becomes Life Consul of France. Peace of Amiens; brief period of cross-Channel travel encourages the British to visit Paris. Creation of Chambers of Commerce and establishment of lycées in France. Horse racing introduced to Goodwood.
1803	Birth of Paul Huet, Alexandre-Gabriel Decamps, Eugène Isabey and Thomas Shotter Boys.	Birth of Prosper Mérimée.	War with France resumes; widespread fear of cross-Channel invasion. Franco-Spanish alliance formed. Louisiana bought by USA from France.
1804	William Blake begins *Jerusalem*.	Birth of George Sand.	Pitt returns as Prime Minister in Britain. Napoleon crowned Emperor of the French.
1805	David Wilkie moves to London from his native Scotland. British Institution and Society of Painters in Watercolours both founded in London.	Publication of Walter Scott's *The Lay of the Last Minstrel* and Chateaubriand's *René*.	Formation of Third Coalition against France. Nelson killed in the Battle of Trafalgar, where the French and Spanish fleets are destroyed. Napoleon defeats Austro-Russian army at Austerlitz and shatters Third Coalition.
1806	Ingres travels to Italy. His portrait of *Napoleon I on His Imperial Throne* outrages the Salon critics. Wilkie's *Village Politicians* celebrated at the Royal Academy.	Publication of Lord Byron's *Fugitive Pieces* and Scott's *Ballads* and *Lyrical Pieces*.	Turkey declares war on Britain. British army defeats French army in Calabria. Battles of Jena and Auerstadt; Napoleon enters Berlin. Death of Pitt and of Charles James Fox; Lord Grenville becomes Prime Minister in Britain.
1807	William Etty, William Collins and Wilkie become friends. David completes *The Coronation of Napoleon*.	Publication of Byron's *Hours of Idleness* and Madame de Staël's *Corinne*.	Napoleon defeats Russia in the Battle of Eylau. France invades Spain and Portugal.
1808	Gros wins commission to paint *Napoleon on the Battlefield of Eylau* (no.47). Birth of Narcisse Diaz.	Publication of Scott's *Marmion*, Johann Wolfgang von Goethe's *Faust part I* and Rudolf Ackermann's *Microcosm of London*. Birth of Gérard de Nerval and Honoré Daumier.	Napoleon proclaims Joseph Bonaparte as King of Spain. Peninsular War begins. Banque de France incorporated.
1809	Blake organises his own retrospective in London.	Publication of Byron's *English Bards and Scotch Reviewers*. The *Quarterly Review*, the principal Tory journal, is founded. Birth of Alfred, Lord Tennyson and Edgar Allan Poe.	Arthur Wellesley, now Duke of Wellington, commands British forces in Portugal. Spencer Perceval ministry in Britain. Napoleon divorces Josephine and is excommunicated by Pope Pius VII, who is later arrested and imprisoned. Birth of Charles Darwin. Death of British political writer Thomas Paine.

Year	Visual Arts	Literature/Music/Drama	Political/Social Events
1810	Achille-Etna Michallon enters the Ecole des Beaux-Arts. Francisco de Goya begins *Disasters of War*.	Publication of Scott's *The Lady of the Lake*. Birth of Alfred de Musset and Frédéric Chopin.	Napoleon marries Archduchess Marie Louise of Austria. Tsar Alexander authorises trade with Britain, breaking Continental blockade. George III declared insane.
1811	James Ward elected Royal Academician. Birth of Jules Dupré.	Publication of Jane Austen's *Sense and Sensibility* (anonymously) and Scott's *The Vision of Don Roderick*. Birth of Théophile Gautier.	George, Prince of Wales, made Prince Regent. Birth of son to Marie Louise; made king of Rome. Luddite uprisings in Britain. Massacre of the Mamelukes in Cairo.
1812	First appearance of Théodore Géricault and Ary Scheffer at Paris Salon. The impresario William Bullock opens his London Museum in Piccadilly, which becomes known as the Egyptian Hall. Birth of Théodore Rousseau.	First two Cantos of Byron's *Childe Harold's Pilgrimage* published. Birth of Charles Dickens.	USA declares war on Britain. Wellington enters Madrid after defeating French at Salamanca. Napoleon invades Russia but later retreats after considerable losses. Lord Liverpool's administration in power until 1827. Food and anti-conscription riots in France. Luddite reform bill in Britain.
1813	Dulwich Picture Gallery (designed by John Soane) open to public one day a week; England's first public art gallery.	Publication of Byron's *The Bride of Abydos* and *The Giaour*; Scott's *Rokeby*; and Austen's *Pride and Prejudice*. Robert Southey appointed Poet Laureate after Scott declines the honour. Birth of Giuseppe Verdi and Richard Wagner.	Fourth coalition begins to form between Russia, Prussia, Austria and Britain. Spain is liberated. Wellington defeats French at Vitoria and crosses into France. Napoleon defeated at Battle of Leipzig, marking the end of the French Empire east of the Rhine. East India Co. loses its monopoly of Indian trade. Sectarian riots in Belfast.
1814	Augustus Wall Callcott visits Paris and contacts a number of French painters including Gros, David, François-Gérard and Anne-Louis Girodet. Wilkie, Haydon and John Crome also visit Paris. Géricault exhibits *The Wounded Cuirassier* at the Salon.	Publication of Byron's *The Corsair* (10,000 copies sold immediately), *Lara* and *The Ode to Napoleon*. Scott's *Waverley*, the first historical novel, published anonymously. Steam-powered printing presses introduced at *The Times*.	Allied armies enter Paris. Napoleon abdicates and is exiled to Elba; Bourbon monarchy restored. The First Treaty of Paris between France and allied powers; Constitutional charter issued; substantial voting power given to the upper middle classes and large landowners in France. End of war between Britain and USA. Stephenson builds first steam locomotive.
1815	Turner exhibits *Crossing the Brook* (no.44) at the Royal Academy. Edwin Landseer exhibits for first time at the Royal Academy.	Publication of Byron's *Hebrew Melodies* and Scott's *Guy Mannering*, *The Lord of the Isles* and *The Field of Waterloo*.	'Hundred Days' of Louis XVIII's exile from Paris, following Napoleon's escape from Elba. Britain defeats France at the Battle of Waterloo. Napoleon exiled to St Helena. Second Restoration and White Terror in France. Second Treaty of Paris. A law against seditious speeches and writings strengthens the gag on the press in France. Maintenance of subsidy on grain through Corn Law in England.
1816	First Competition for 'Grand Historical Painting' held at the British Institution. Guillaume Guillon-Lethière exhibits his colossal *Judgment of Brutus* at Bullock's Egyptian Hall. Elgin Marbles exhibited in the British Museum. Etty makes first of three visits to Paris. David exiled to Brussels. Géricault travels to Italy.	Publication of Austen's *Emma* (anonymously); Byron's *The Prisoner of Chillon*, Canto III of *Childe Harold* and *The Siege of Corinth*; Samuel Taylor Coleridge's *Christabel and Other Poems*; and Scott's *The Antiquary*. Byron makes final departure from England. Birth of Charlotte Brontë. Gioacchino Antonio Rossini's *Otello*.	Post-war economic depression in Britain. 'Spa fields riot' in London. Shipwreck of the French frigate *Medusa* off West coast of Africa. First parliamentary elections in France.
1817	Louis Francia returns to Calais. Bonington's family moves to France. First Prix de Rome for landscape painting awarded to Michallon. John Sell Cotman tours Normandy. Société des amis des arts reconstituted in Paris.	Publication of Byron's *Manfred* and *The Lament of Tasso*; Scott's *Rob Roy* and *Harold the Dauntless*; and Hazlitt's *The Characters of Shakespeare's Plays* and *The Roundtable*. *Blackwood's Magazine*, the Scottish literary journal, published. Stendhal visits London. Death of Jane Austen. Narrative account of the *Medusa* shipwreck by Alexandre Corréard and Jean-Baptiste-Henri Savigny published in Paris.	Grain riots in France.

Year	Visual Arts	Literature/Music/Drama	Political/Social Events
1818	Turner exhibits *Field of Waterloo* (no.48) at the Royal Academy. Prado Museum established in Spain.	Publication of Mary Shelley's *Frankenstein*; Austen's *Northanger Abbey* and *Persuasion*; Canto IV of Byron's *Childe Harold*; Hazlitt's *Lectures on the English Poets*; John Keats's *Endymion*; Scott's *The Heart of Midlothian*. Shelley's final departure from England. English translation of Corréard and Savigny narrative account of the *Medusa* shipwreck published in London.	European alliance; Congress of Aix-la-Chapelle. End of the Allied occupation of France. Motion for Parliamentary reform in Britain defeated. Birth of Karl Marx.
1819	Géricault exhibits *The Raft of the Medusa* in Paris Salon (see no.19), along with Horace Vernet's *Marine. Pirate Skirmish. Sunrise* (no.29). François-Marius Granet triumphs with his *Interior of the Capuchin Church*, Rome. Vernet's lithograph, *The Corsair*, is first recorded French illustration of Byron. Constable exhibits his first 'six-footer', *The White Horse* (no.40). Turner visits Italy; Samuel Prout tours Normandy. Birth of John Ruskin.	Publication of Hugo's *Odes*; Byron's *Mazeppa* and the first two Cantos of *Don Juan*; and Scott's *The Bride of Lammermoor* and *Ivanhoe*. First French translation of Byron's *The Giaour* is published. Premier of Rossini's *La donna del lago*.	Reform: Six Acts passed against radical political Unions; press censorship in Britain. Peterloo Massacre in Manchester. Birth of Victoria, later Queen of England. East India Company founds Singapore settlement. William Parry's expedition to the Arctic.
1820	Death of Benjamin West; Thomas Lawrence succeeds as President of the Royal Academy. Géricault exhibits *The Raft of the Medusa* in Bullock's Egyptian Hall, London. With Vernet, he visits David in Brussels. The Messrs Marshall's *Grand Peristrephic Panorama of the Shipwreck of the Medusa French Frigate with the Fatal Raft* tours Scotland and concludes in Dublin in 1821. Bonington, Huet, Camille Roqueplan, Eugène Lami and Paul Delaroche enrols in Gros's atelier. Bonington meets Delacroix while copying in the Louvre.	Scott is knighted; *Ivanhoe* is published in Paris. Publication of Keats's *Lamia, The Eve of St Agnes, Hyperion and Other Poems*; Scott's *The Abbot* and *The Monastery*; Shelley's *Prometheus Unbound and Other Poems*; Wordsworth's *The River Duddon*; and Alphonse de Lamartine's *Méditations poétiques*. Dramatised versions of *Ivanhoe* are staged at the Covent Garden, Surrey and Coburg Theatres in London. Birth of Anne Brontë. Isadore Taylor, Charles Nodier and Alphonse de Cailleux begin publishing *Voyages pittoresques et romantiques dans l'ancienne France*.	Death of George III; accession of George IV. Trial of Queen Caroline. Dissolution of Parliament in England. Assassination of the Duc de Berri in Paris. Richelieu ministry in France. The 'Ultraconservatives' assume power in France. Revolts in Spain and Italy against the Bourbons. Naples forms a Republic. Revolution in Portugal.
1821	Géricault spends most of the year in London; he publishes a series of twelve lithographs, *Various Subjects Drawn from the Life and on Stone*. Wilkie visits Paris. Publication of Cotman's *Architectural Antiquities of Normandy*.	Publication of Byron's *Cain*, Cantos III–V of *Don Juan* and *Marino Faliero*; Hazlitt's *Table Talk*; Scott's *Kenilworth*; Shelley's *Adonais*; Charles Nodier's *Smarra*; and Pierre-Jean de Béranger's *Chansons*, for which he is later imprisoned. Premier of Carl Maria von Weber's *Der Freischütz*. Nodier and Isabey tour England and Scotland. Birth of Charles Baudelaire, Gustave Flaubert and Fyodor Mikhailovich Dostoevsky. Death of Keats.	Villèle ministry in France. Greek War of Independence begins. Death of Napoleon on St Helena. Death of Queen Caroline. Famine in Ireland.
1822	Wilkie completes *The Chelsea Pensioners Reading the Waterloo Dispatch* (no.49), which creates a sensation when shown at the Royal Academy. At the Paris Salon, Gros exhibits *Bacchus and Ariadne* (no.67); Louis-Léopold Boilly, *Distribution of Wine* (no.88). Michallon's *Landscape Inspired by a View of Frascati* (no.43) acquired for Louis XVIII. Bonington and Delacroix make their first Salon appearances. Protesting against the Salon jury, Vernet mounts a retrospective of his work in his studio. He then visits London. Opening of Paris diorama by Charles Bouton and Louis Daguerre. John Arrowsmith visits Constable in London. David exhibits a version of his *Coronation of Napoleon* in London. Thomas Rowlandson's *Dr Syntax* published in French. Madame Hulin and Claude Schroth open a gallery for modern painting in Paris that will prosper until 1834. Death of Michallon.	Publication of Scott's *The Fortunes of Nigel, The Pirate* and *Peveril of the Peak*; Shelley's *Hellas*; Thomas de Quincey's *Confessions of an English Opium Eater*; Hugo's *Odes*; Wordsworth's *Ecclesiastical Sketches*; Fenimore Cooper's *Pioneers*; and Nodier's *Trilby*. Launch of *Sunday Times* in Britain. Unsuccessful attempt to introduce Shakespeare to Paris prompts Stendhal to publish *Racine and Shakespeare*. Amadée Pichot tours Britain. Death of Shelley in Italy.	Greece declares Independence. Turks capture island of Chios and massacre 23,000 Greeks. Chateaubriand named Ambassador to London. Congress of Verona convenes to decide the partition of Europe and the fate of Spain.

Year	Visual Arts	Literature/Music/Drama	Political/Social Events
1823	The first British diorama opens in Regent's Park. Brothers Thales, Newton and Theodore Fielding share a studio with Delacroix in Paris. Gihaut brothers publish lithographic series, *Etudes des Chevaux*, executed by Léon Cogniet and Joseph Volmar after Géricault's designs. Delacroix records seeing a Constable painting in Regnier's studio.	Publication of Cantos VI–XIV of Byron's *Don Juan*; Hazlitt's *Liber Amoris*; Scott's *Quentin Durward*; Lamartine's *Nouvelles Meditations Poétiques*; a French translation of Goethe's *Faust*; and Hugo's first romance, *Han d'Islande*. Hugo, Nodier et al. launch the romantic journal *La Muse Français*. Premier of Auber's and Scribe's *Kenilworth* in Paris.	France and Spain at war. Byron sails to Greece to participate in the Greek Revolution.
1824	Bonington and Alexandre-Marie Colin paint at Dunkirk. Formation of Society of British Artists. Constable exhibits *The Hay Wain, View on the Stour* (no.5) and *Hampstead Heath* at the British Salon in Paris and is awarded a gold medal, along with Bonington and Copley Fielding. Thomas Lawrence awarded the Légion d'Honneur. Gros exhibits *Jean-Antoine Chaptal* (no.103); Lawrence, *Duc de Richelieu* (no.104); Daguerre, a version of *The Ruins of Holyrood Chapel* (no.42); Géricault, *Village Forge* (no.100); Girodet, *Madame de Reiset* (no.102); and Ingres, *Entry into Paris of the Dauphin* (no.71). Delacroix creates a sensation with his *Massacres at Chios* (fig.45). Crome, Wilkie and Haydon travel to Paris. Lawrence exhibits the *Calmady Children* (no.105) at the Royal Academy. C.R. Leslie and Edwin Landseer visit Walter Scott at Abbotsford. National Gallery, London founded; Wilkie's *The Village Holiday* (no.89) becomes first example of a living artist's work to enter its collection. Death of Géricault and Girodet.	Death of Byron at Missolonghi. Publication of Cantos V–XVI of Byron's *Don Juan*; James Hogg's *Confessions of a Justified Sinner*; Scott's *Redgauntlet* and *St Ronan's Well*; and Heinrich Heine's *Harz Journey*. *Westminster Review* and *Le Globe* newspaper founded. Nodier appointed Librarian of the Arsenal by Charles X. Nodier establishes the literary clique Cénacle de l'Arsenal. Ludwig van Beethoven finishes his Ninth Symphony.	Charles X succeeds Louis XVIII as King of France. Athenaeum Club founded in London. Le Cercle de l'Union, the first gentlemen's club in France, founded.
1825	Constable paints two versions of *Branch Hill Pond* (no.114); one is sent to Paris. He exhibits *The White Horse* (no.40) at the Salon in Lille. Bonington, Delacroix, Colin, Augustin Enfantin, Isabey and other French artists travel together to London in the summer. Bonington and Isabey tour Normandy coast. Bonington and Huet tour the River Seine. Daguerre's diorama *Holyrood Chapel* (no.42) is displayed in London. Lawrence dispatched to Paris by George IV to paint a portrait of Charles X and his son Louis, Duc d'Angoulême; he brings with him the portrait of the *Calmady Children* (no.105); *Master Lambton* (no.50) is exhibited at the Royal Academy. Wilkie again in Paris. Camille Corot makes first visit to Italy. David dies in Brussels.	Publication of Hazlitt's *The Spirit of the Age*; Coleridge's *Aids to Reflection*; Scott's *The Betrothed*; Honoré de Balzac's *Wann-Chlore*; Augustin Thierry's *Histoire de la conquête de l'Angleterre*; and Pichot's *Voyage Historique et litteraire en Angleterre et en Ecosse*. John Murray publishes *The Works of Lord Byron* in six volumes. Pichot begins publication of *Vues pittoresque de l'Ecosse*.	The first steam-locomotive railway opens: Stockton to Darlington. The ministry repeals the Six Acts and anti-trade union legislation in Britain. Financial crash in Britain. Sacrilege becomes a capital offence in France. Indemnity bill also passed compensating victims for losses sustained during the Revolution. Coronation of Charles X at Reims. Death of Comte de Claude-Henri de Rouvroy Saint-Simon.
1826	David's studio sale fuels the debate between Romantics and Classicists. Delacroix paints *Louis-Auguste Schwiter* (no.52). His *Combat Between the Giaour and Hassan* (no.76) and *Greece on the Ruins of Missolonghi* (no.8) are submitted to the *Exhibition for the Benefit of the Greeks* at the Galerie Lebrun, along with Cogniet's *Eskimo Woman* (no.36); Colin's *The Giaour Contemplating the Dead Hassan* (no.77) and *Othello and Desdemona* (no.65); Gros's *Sketch for the Battlefield of Eylau* and *Bacchus and Ariadne* (nos.47, 67); Roqueplan's *Marée d'Equinoxe* (no.57); and Boilly's *Distribution of Wine and Food on the Champs-Elysées* (no.88). Bonington exhibits for the first time in London (no.41) at the British Institution; shares a studio with Delacroix before travelling to Venice in the summer.	Publication of Scott's *Woodstock*; Alfred de Vigny's *Cinq-Mars*; Benjamin Disraeli's *Vivian Grey*; Chateaubriand's *Natchez*; James Fenimore Cooper's *Last of the Mohicans*. Scott's financial ruin brought on by the bankruptcy of his British publisher. But in Paris, Charles Gosselin begins publishing an illustrated edition of the complete works, while Robert Cadell and Scott introduce an illustrated English edition of *Waverley*. Prosper Mérimée and Etienne Delécluze visit Hazlitt in London. Scott visits Paris and attends Rossini's adaptation of *Ivanhoe*.	Economic depression in France. Missolonghi falls to the Turks.

Year	Visual Arts	Literature/Music/Drama	Political/Social Events
1827	At the Paris Salon, Constable exhibits *The Cornfield*; Lawrence, *Master Lambton* (no.50) and *Duchesse de Berry*; Pierre Révoil, *René of Anjou* (no.70); Isabey, *Honfleur, Low Tide* (no.127); Ingres, *Comte de Pastoret* (no.51); Corot, *The Roman Compagna* (no.45); Cogniet *Eskimo Woman* (no.36); Vernet, *Mazeppa and the Wolves* (no.53); and Roqueplan, *Marée d'Equinoxe* (no.57). Delacroix shocks the critics with his *Death of Sardanapalus*, but his portrait of *Louis-Auguste Schwiter* and *Combat Between the Giaour and Hassan* (nos.52, 76) are rejected by the Salon jury. Delaroche visits London. Newton Fielding appointed drawing master to household of Duc d'Orléans. Death of Augustin Enfantin and Blake. Oil paints are sold in tubes, facilitating painting outside.	Successful introduction of Shakespeare to Paris at the Théâtre-Français. Publication of Scott's *Chronicles of the Canongate* and *The Life of Napoleon Bonaparte*; François Pierre Guillaume Guizot's *Histoire de la Révolution d'Angleterre*; and Hugo's *Preface to Cromwell*. Scott acknowledges authorship of the *Waverley* novels. Delacroix executes the lithographic illustrations for Charles Motte's edition of *Faust*. Baedeker publishes travel guides. Death of Beethoven.	Fall of the Lord Liverpool ministry in Britain; George Canning becomes Prime Minister. National Guard dissolved in France. Turkish fleet destroyed in Battle of Navarino. Treaty of London declares Greek independence.
1828	Delacroix's first London exhibition is at the British Institution. Bonington exhibits for the last time in London and Paris. William Hobday organises an exhibition of French and British painting in his Gallery of Modern Art in London and invites contributions from Delacroix, Vernet, Isabey, Leopold Robert, Scheffer and Auguste, Comte de Forbin. Colin visits Scotland. Henri Gauguin opens the Musée Colbert. Birth of Dante Gabriel Rossetti. Death of Bonington and Goya.	Publication of the first series of Scott's *Tales of a Grandfather*; Hazlitt's *Life of Napoleon Bonaparte*; Irving's *Christopher Columbus*; and Edward Bulwer's gospel of dandyism, *Pelham*. *Athenaeum* and the *Spectator* founded. Birth of Leo Tolstoy and Henrik Ibsen. Hugo's drama *Amy Robsart* opens in Paris. Hector Berlioz composes the *Waverley Overture*.	Viscomte de Martignac in power in France. French expeditionary force authorised to invade Peloponnese. At request of French government, Decamps departs for Greece to commemorate the Battle of Navarino. Wellington becomes Prime Minister in Britain.
1829	Constable elected Royal Academician. Bonington studio sale in London. Vernet assumes directorship of French Academy in Rome (until 1834). Exhibition of modern art organised for the benefit of cholera victims at the Musée Colbert. Henri Monnier and Eugène Lami publish *Voyage en Angleterre*. William Callow moves to Paris; remains until 1840. Birth of John Everett Millais.	Publication of F. R. de Toreinx, *Histoire du Romantisme en France*; Balzac's *Les Chouans*; Scott's *Anne of Geierstein*; Pückler-Muskau's *Tour in England, Ireland and Wales*; Hugo's *Les Orientales*; Mérimée's *Chronique du règne de Charles IX*; and Guizot's *History of Civilisation in France*. The society journal *La Mode* is launched. Alexandre Dumas stages *Henri III et son cour*. Premiers of Rossini's last opera, *William Tell*, and of Gaetano Donizetti's *Kenilworth*.	Polignac ministry dominates in France. Turks agree to withdraw from Greece. Catholic Emancipation granted in Britain. Stephenson introduces his steam engine, *Rocket*.
1830	Etty visits Delacroix in Paris. Probable visit to London by Roqueplan. Colin exhibits six paintings at the British Institution. Delacroix exhibits *Murder of the Bishop of Liège* (no.59) at the Royal Academy. Circulation of David Lucas's mezzotints for Constable's *English Landscape* in London and Paris. Death of Lawrence. Birth of Camille Pissarro.	Publication of Coleridge's *On the Constitution of Church and State*; John Galt's *The Life of Lord Byron*; Stendhal's *The Red and the Black*. *L'Artiste*, a liberal art journal, founded in France. Hugo stages *Hernani*. First performance of Berlioz's *Symphonie fantastique*. Death of William Hazlitt.	Abolition of freedom of the press by Prince Polignac in France. July Revolution in Paris. Louis Philippe, Duc d'Orléans, becomes King of France following abdication of Charles X. Lafitte ministry in France; limited extension of the franchise. France commences its conquest of Algiers; beginning of French Empire in North Africa. Death of George IV; accession of William IV. Wellington Ministry collapses; Earl Grey becomes Prime Minister in Britain. Liverpool to Manchester railway opens. Greece becomes a free kingdom. A version of croquet is developed in France; English visitors bring the game home.
1831	Delaroche creates a sensation at the 1831 Paris Salon with *Princes in the Tower* and *Cromwell Viewing the Body of Charles I*. Delacroix exhibits *Liberty Leading the People*. Rousseau, Antoine-Louis Barye, Diaz and Dupré exhibit for first time, at same Salon.	Delécluze publishes *On the Barbarism of the Times* attacking the Anglo-French school and the influence of British art in France. Publication of Hugo's *Notre Dame of Paris* and Balzac's *Fatal Skin*. Giacomo Meyerbeer's *Robert le Diable* staged at the Paris opera; Berlioz conducts *King Lear* and *Rob Roy*. Frédéric Chopin and Heine settle in Paris.	Whigs introduce Reform Bill into new Parliament, but it is defeated in House of Lords. National Union of the Working Classes founded in London with assistance from Robert Owen. Ministry of Auguste Casimir-Périer in France. Riot of weavers in Lyons. British Association for the Advancement of Science founded in York. Charles Darwin sails on *HMS Beagle* for scientific survey of South America, New Zealand and Australia. Michael Faraday discovers electromagnetic induction.

Year	Visual Arts	Literature/Music/Drama	Political/Social Events
1832	Turner exhibits *Childe Harold's Pilgrimage* (no.133) and Etty, *Phaedria and Cymochles* (no.66) at the Royal Academy. Delacroix accompanies French delegation to Morocco. Birth of Edouard Manet.	Publication of Disraeli's *Contarini Fleming*; Goethe's *Faust II*; Sand's *Indiana*; Irving's *Alhambra*; and Tennyson's *Poems*, including 'The Lady of Shallot'. Murray begins publishing *The Works of Lord Byron: with his Letters and Journals, and his Life*, by Thomas Moore, Esq. *Penny Magazine* and *Le Charivari* begin publication. Birth of Lewis Carroll. Death of Scott and Goethe.	Reform Act enlarges franchise and restructures representation in British Parliament. Cholera epidemic sweeps through Europe from Middle East. Britain proclaims sovereignty over Falkland Islands. The Duchesse de Berry fails to inspire a revolution in France. Morse invents the telegraph.
1833	Paris Salon established as an annual event.	Publication of Balzac's *Eugénie Grandet*. Harriet Smithson marries Hector Berlioz in Paris.	Factory Act limits child labour in Britain. The Primary Education Law passed by Guizot in France. East India Company ceases trading. Slavery in the British Empire abolished.
1834	Delaroche exhibits *The Execution of Lady Jane Grey* (no.55) at the Paris Salon. Dupré visits England. Birth of William Morris, Edgar Degas and James McNeill Whistler.	Publication of Lady Blessington's *Conversations with Lord Byron*; Balzac's *Père Goriot*; and Hugo's *The Hunchback of Notre Dame*. Death of Coleridge.	The Tories, under Robert Peel, take office in Britain. Poor Law Amendment Act. Great revolts in Paris and Lyons signal climax of the radical movement in France. Laws against Associations passed. Founding of the London Statistical Society. Emancipation Bill takes effect in Britain. Britain authorises colonisation of South Australia. Jockey-Club founded in Paris.
1835	Martin exhibits *The Deluge* (no.56) at the Paris Salon and is awarded a gold medal. Gros commits suicide.	Publication of Mary Shelley's *Lodore*; Gautier's *Mademoiselle de Maupin*; Alfred de Musset's *Confession d'un enfant du siècle*; and Vigny's *Chatterton*. Premier in Naples of Donizetti's *Lucia di Lammermoor*.	Whigs in power in Britain under Melbourne. Municipal Reform Act extends local government franchise to all ratepayers in Britain. Ministry of Duc de Broglie in France. Press law passed restricting publications and banning direct attacks on the regime or the monarch. Alexis de Tocqueville begins publishing *Democracy in America*.
1836	Scheffer organises studio exhibition of paintings by Huet, Rousseau and Dupré after their rejection by Salon jury. The Art Union of London founded. Charles Jacque in London working as a wood engraver.	Publication of Heine's *The Romantic School*; Alexandre Dumas's *Kean*.	First ministry of Adolph Thiers; succeeded by Comte Louis Molé. Founding of London Working Men's Association by William Lovett. Foundation of the Botanical Society.
1837	Death of John Constable. Huet named drawing master to Duchesse d'Orléans.	Publication of Dickens's *Pickwick Papers* and *Oliver Twist* (monthly); Disraeli's *Henrietta Temple* and *Venetia*; J.G. Lockhart's *Life of Sir Walter Scott*; Robert Browning's *Strafford*; and Thomas Carlyle's *The French Revolution*. Balzac begins writing *Lost Illusions*.	Death of William IV; accession of Queen Victoria to British throne. Civil registration begins in England. France's first railway line is laid between Paris and St-Germain-en-Laye.
1838	Delacroix completes *Fanatics of Tangier* (no.84). Daguerre invents photography. The Spanish Gallery opens in the Louvre. Lewis in Paris; exhibits Spanish watercolours at the Salon.	Publication of Dickens's *Nicholas Nickleby* (monthly) and Edward William Lane's translation of *Thousand and One Nights* (*Arabian Nights*).	People's Charter drafted and Anti-Corn Law League established in Britain. English Historical Society founded. Completion of the London & Birmingham Railway and the Great Western Railway. Establishment of the Public Record Office in Britain. The *Great Western*, Isambard Kingdom Brunel's steamship, crosses the Atlantic.
1839	Birth of Paul Cézanne. Claude Schroth, the foremost French dealer in modern art for two decades, declares bankruptcy.	Publication of Stendhal's *La Chartreuse de Parme*.	Chartist Riots in Britain. Treaty of London recognises Belgian independence and guarantees its neutrality. Social unrest in France provoked by economic slump. First Opium War between Britain and China. Cunard shipping line established.
1840	Birth of Claude Monet and Auguste Rodin. Death of Caspar David Friedrich.	Publication of Dickens's *The Old Curiosity Shop* (weekly). Birth of Thomas Hardy and Emile Zola. Birth of Pyotr Tchaikovsky.	Queen Victoria marries Prince Albert. Britain secures sovereignty over New Zealand. Thiers Ministry in France; succeeded by Duc de Dalmatie. Napoleon's body is returned from St Helena and interred at Les Invalides in Paris. Charles Barry begins rebuilding Houses of Parliament; completed in 1860. Nelson's column erected in Trafalgar Square.

Catalogue

Abbreviations and Notes

Authorship is indicated as follows:

PN Patrick Noon
DBB David Blayney Brown
CR Christine Riding
MW Marie Watteau

Foreign titles of works are given in English translation.

Measurements are given in centimetres, height before width, followed by inches in brackets. Three-dimensional objects, such as books, are given height by width by depth.

'References' lists the contemporary reviews of the work of art. These references, and those in the main text, are cited in shortened form, and provided in full in the Abbreviated References section on p.286.

'London/New York/Minneapolis only' indicates the work is exhibited in that venue only.

Introduction
Crossing the Channel

David Blayney Brown

Portraits by Eugène Delacroix and Thales Fielding of each other (nos.1, 2) introduce the cross-Channel relationships celebrated in this exhibition. Among the British artists who not only visited Paris but worked there too, Fielding also smoothed Delacroix's path in London in 1825, along with their mutual friend Richard Parkes Bonington. Bonington was still largely unknown when he first exhibited in London the following year (no.41) and, as is apparent from a letter of 1825 from his sometime teacher Louis Francia to his London colleague John Thomas Smith, had needed introductions from a well-connected Frenchman. Francia also introduced Bonington's travelling companion, Alexandre-Marie Colin, 'who will agree with everything you say for he does not speak a word of English'. Francia recommended them 'as though they were really my brothers… I am sure that their acquaintance will give pleasure to all parties.'[1]

Contacts between French and British colleagues resumed as soon as hostilities first ceased in 1814. John Crome's visit to Paris that year, his call on Jacques-Louis David and contribution to the Salon belie the lingering impression of this Norwich-based painter as a provincial. His view of the Boulevard des Italiens (no.3) is the first notable British picture of the 'enemy' capital. He lodged nearby in the rue Vivienne, soon to be at the heart of Paris's British quarter, near Galignani's bookshop and the smartest cafés. The Anglophile Carle Vernet observed the prosperous British in Paris, parading their strange fashions, with amusement (no.4). David Wilkie, also in Paris in 1814, told his friend Benjamin Robert Haydon that he recognised them because they looked as if they had a balance at their bankers. Although indeed vastly richer, even in the depression of the mid-1820s, London grew more slowly on its French visitors. Delacroix wondered if he had fallen among savages; Théodore Géricault's London lithographs exposed the travails of the modern Babylon (nos.13, 14, 15). Their response to its art and culture, however, was passionate, as this exhibition shows.

Crome, like most of his compatriots, took a dim view of the state of French art at the end of the Empire. When his son followed him to France in 1816, he dryly reported: 'I believe he is not petrified from having seen the French School. He says in his letter something about Tea-Tray painters.'[2] But if young French artists proved more receptive to their British colleagues than the British were to the School of David, it was because many of them would have agreed. Delacroix's generation looked to British artists to radicalise their processes and subject matter, whether in public exhibitions or in London's great private galleries like those of the Marquis of Stafford (no.12). British literature was as liberating as British art. Walter Scott, one of the most popular authors of the age, created a symbiotic relationship between modern literature and history. His novels put Scotland on the

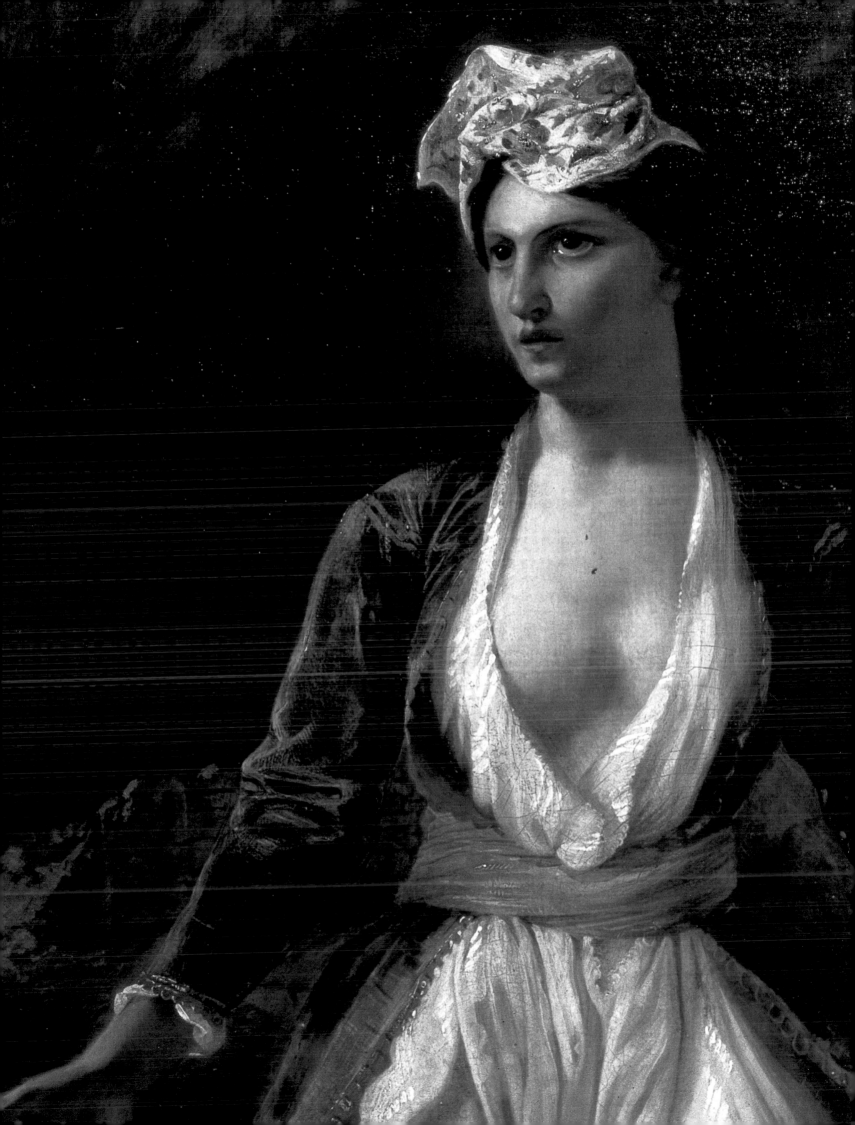

Overleaf:
Eugène Delacroix
Greece on the Ruins of Missolonghi
1826
(no.8, detail)

fig.23
Englemann, after Alexandre-
Evariste Fragonard
*Monument Druidique dans la
Forest de Trie, près de Gisors*
(from *Voyages pittoresques et
romantiques dans l'ancienne
France*, Vol. 1, 1820)
Private Collection

fig.24
Eugène Delacroix
View in Green Park
1825
Watercolour
Private Collection

fig.23

Romantic map, and among its French visitors was Isadore (later Baron) Taylor, the principal author of the famous *Voyages pittoresques*, which studied the historic architecture of France itself (no.10, fig.23). Crome's Norwich colleague John Sell Cotman documented the antiquities of Normandy (no.11). The antiquarian tour was only one aspect of the Romantic historiography fuelled by Scott's novels; Paul Delaroche's historical pictures, often on British themes, were another (no.9). No less popular, Byron's *Oriental Tales* played to the contemporary issue of Greek independence. Delacroix's *Greece on the Ruins of Missolonghi* (no.8) was at once a wake-up call to Greek sympathisers and a tribute to the poet.

Byron inspired some of Delacroix's most challenging pictures, assaults on the political or artistic establishments that put him at the head of the young Romantics. Yet while Delacroix chose Byronic Orientalism as one vehicle for his attack, among painters it was John Constable, the most conservative and stay-at-home of men, who did most to liberate his technique. It remains a mystery whether Delacroix ever met Constable, as he certainly did J.M.W. Turner. But he was sufficiently impressed by his works in the 1824 Salon (no.5) to rework his own *Massacres at Chios* in the same exhibition – one of those extraordinary moments when sparks leap from one great painter to another. For Delacroix, Constable's influence was above all technical. The impact of Constable's naturalism on French landscape painting is a subject in itself; here, we show his *View on the Stour* with the gold medal he won at the Salon (no.6). Thomas Lawrence, who posed as great a challenge to French portraiture, and Bonington were similarly honoured.

By exhibiting *The Raft of the Medusa* in London in 1820 (see no.19), Géricault sought a new and sympathetic audience. How many masterpieces of French Romanticism were also shown in London, as this catalogue describes, will come as a revelation to many today. In Paris, the 1824 Salon marked a peak of British influence that would transform French painting in the decades ahead. Delacroix later recanted some of his initial enthusiasm, and who is to say how that of Géricault might have been tempered by age or experience? What they saw in British art was not always the height of sophistication. Rather, for a generation exhausted by defeat and the grandiosities of a school irredeemably associated with a lost cause, it offered a promise of renewal. There really was a time when British art, for better or worse, seemed the epitome of the modern.

fig.24

1
Eugène Delacroix (1798–1863)
Portrait of Thales Fielding c.1824

Oil on canvas
32.3 x 24.8 (12¾ x 9¾)
Private Collection

2
Thales Fielding (1793–1837)
Portrait of Eugène Delacroix
c.1825

Oil on canvas
34.3 x 27.3 (13½ x 10¾)
Private Collection

Thales Fielding was one of five brothers with professional ties to France. With his brothers Theodore and Newton (no.165), he was brought to Paris by the Swiss publisher J.-F. d'Osterwald in 1821 as an illustrator for his *Voyages pittoresques en Sicile* (1821–6) and *Excursions sur les côtes et dans les ports de France* (no.10). In 1823 Delacroix joined their rue Jacob atelier, where he probably painted this portrait of Thales and possibly one of Newton. Copley Fielding, ultimately the most accomplished painter of the family, exhibited nine works at the 1824 Salon and was awarded a gold medal. He would also exhibit, with Newton, at the 1837 Douai Salon. Copley instructed Raymond Soulier, Delacroix's friend and lifelong correspondent, in the art of watercolour painting, and it was Soulier who initially piqued Delacroix's interest in the medium. From Delacroix's journal, we know that Thales advised him on the landscape background for his *Massacres at Chios* (fig.45), while Delacroix assisted his friend in the execution of his watercolour *Macbeth and the Witches* (untraced).

Thales left Paris in October 1824, relinquishing the studio to Delacroix and his brother Newton. Most authorities would date this portrait to before Thales's departure, or to 1825 during Delacroix's visit to London, when he was much in the company of the Fieldings. Ultimately the actual date of the sitting is of less interest than the fact that Thales the landscape painter would send this portrait of a French artist relatively unknown in England to the Royal Academy in 1827 as his only exhibit. The discordant red ribbon of the Légion d'Honneur in Delacroix's lapel is a later addition, as he received that accolade only in 1831.

Delacroix's portrait of Fielding poses similar questions of dating to Fielding's portrait, but the most plausible scenario is that it was painted while the two artists were sharing the same studio. The fluid application of paint and the effort to animate the eyes of his sitter, a characteristic of Thomas Lawrence's style that he venerated, would argue for a date of execution between the opening of the Salon in August 1824 and Fielding's departure in October. A memento of a friendship, it combines the unfinished quality of a sketch with a forceful characterisation of the head. As informal portraiture, it anticipates several of Delacroix's most acclaimed studies, including his self-portrait of 1837. Delacroix retained the picture until his death, when it passed into the collection of Baron Charles Rivet, who had also befriended the Fieldings in his youth. PN

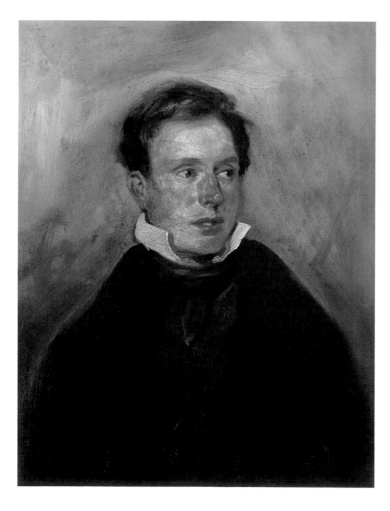

3

John Crome (1768–1821)
*Paris – Italian Boulevard
(Boulevard des Italiens)* 1815

Oil on canvas
54.5 x 87.3 (21½ x 34⅜)
Private Collection on loan to Norwich Castle
Museum & Art Gallery
London only

Crome was the leading figure in the Norwich School and became President of the Norwich Society of Artists. Originally trained by the portraitist William Beechey, he turned to landscape, basing his style on Dutch seventeenth-century pictures in Norwich private collections.

Crome visited Paris in 1814, during which time he exhibited a *Vue des environs de Norwich* at the Salon in November (a taste of modern British landscape painting a whole decade before the 1824 'Salon des Anglais'), studied in the Louvre and bought pictures for his second business as a dealer and restorer. This was one of three pictures based on the visit and, according to a correspondent in a Norwich newspaper in 1860, 'the greater part was painted on the spot'. When exhibited at the Norwich Society in 1815, the picture caused a 'sensation', both as a 'subject very different from those he had hitherto been painting' and, one assumes, as a fresh and first-hand record of Paris. By 1821, it had been acquired by Crome's patron Hudson Gurney, who had himself visited Paris in 1814 and also during the Peace of Amiens in 1802. In Paris, Crome lodged at 17 rue Vivienne near the Boulevard des Italiens, which was already the city's most fashionable street. Crome, as his picture shows, found it a good hunting-ground for pictures. In Paris, he

also made contact with colleagues at the highest level and perhaps approached Louis-Léopold Boilly, by whom he had sold a 'Drawing, finely coloured' in Yarmouth in 1812, and whose own Parisian street scenes show a similar bustle, animation and acute observation (see nos.87, 88). DBB

4
Carle Vernet (1758–1836)
The English in Paris 1814

Pen and ink, watercolour and bodycolour
35 x 55.5 (14⅜ x 22¼)
Signed, lower right: *Carle Vernet*
Hazlitt, Gooden & Fox

Carle Vernet was the father of Horace Vernet and the first teacher of Géricault. He was accomplished in every genre and scale of painting, much like his son, but his true genius was for sporting art and candid depictions of modern life. His earliest satires of fashion were the brilliant series of aquatints, *Incroyables et merveilleuses*, published in 1797. His substantial lithographic portfolios of sporting and horse subjects were well known in London, which he visited periodically during his long career.

British tourists swarmed across the Channel shortly after the temporary peace in 1814. Fashion and female beauty were topics of instant dispute. The painter William Owen, after a five-week visit to Paris in October 1814, reported to Joseph Farington that: 'The dislike of the English appeared manifest … In dress, those who from England or other countries differed from them were the objects of censure' (*Diary,* XIII, p.4599). Benjamin Robert Haydon, travelling with David Wilkie, was equally critical when he reported how rapturous it had been to find an English woman at the Cirque Olympique. 'The manners of French women are fascinating,' he continued, 'but I have never seen one yet without a beard, which destroyed the effect of their sparkling eyes. As to their forms –

skeletons wrapped in lace and muslin and fringe' (*Diary,* I, p.362).

French caricatures of their visitors appeared almost immediately and in profusion. Delacroix's early satire of the British occupation forces (fig.25) appeared in October 1815. Many of the curious tourists, especially painters, rushed to see the looted masterpieces assembled by Napoleon in the Louvre before their repatriation to Italy. It has been suggested that Vernet's drawing depicts visitors to an exhibition or gallery, probably the Louvre. The artist has certainly captured one of the national traits most noted by French visitors to London – the upper classes tended to be indistinguishable in dress and attitude when promenading or attending church, confining ostentatious displays of wealth to private gatherings. PN

fig.25
Eugène Delacroix
Le Bagage de Campagne
c.1816
Etching
The Fitzwilliam Museum,
Cambridge

53

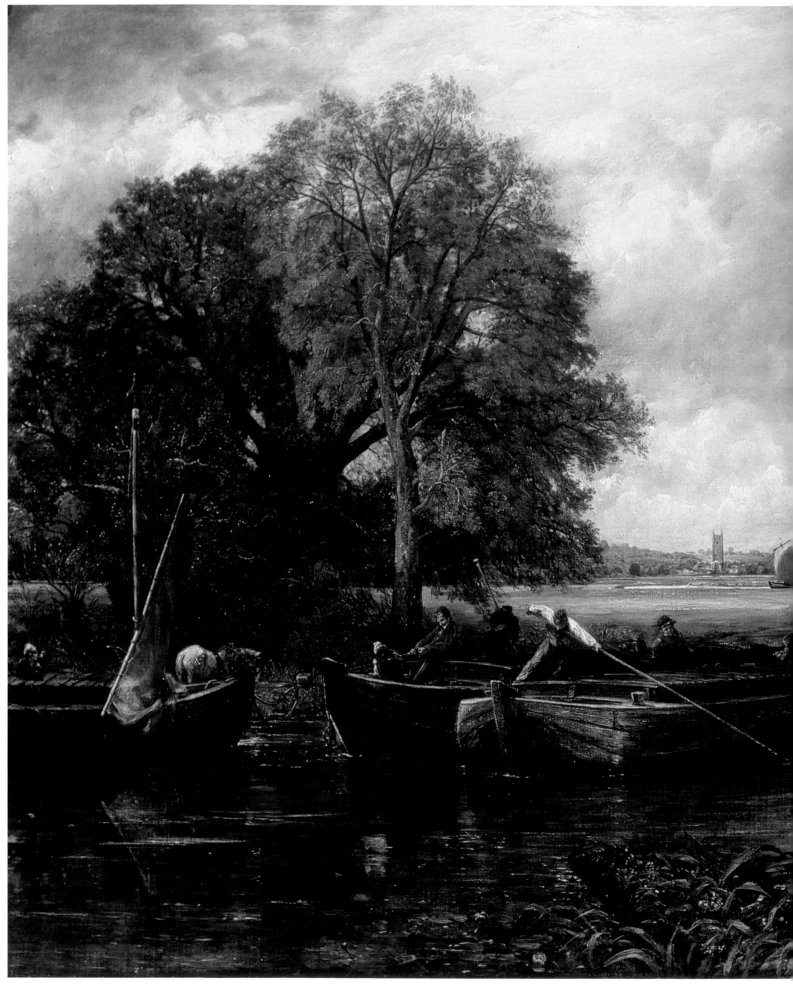

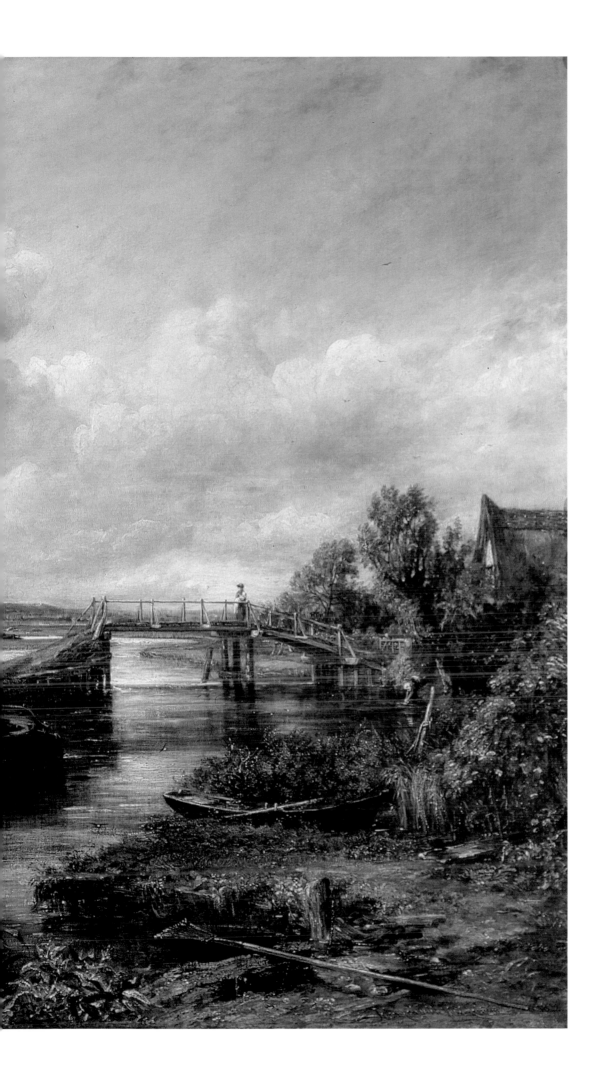

5 (*overleaf*)
John Constable (1776–1837)
View on the Stour near Dedham
1822

Oil on canvas
129.5 x 188 (51 x 74)
Signed and dated, lower right: *John Constable pinx. London. 1822*
References: For contemporary British reviews, see Ivy, 1991, pp.93–111; Jal, *Salon*, 1824, pp.292ff.; Stendhal, 1824 (16 October 1824); Delécluze, 1824 (30 November 1824), p.3; Huet, *Huet*, p.95.
The Huntington Library, Art Collections and Botanical Gardens

6
Gold Medal Awarded by King Charles X to John Constable 1824

Gold/gold plated
4.5 (1¾) diameter
Inscribed on obverse: *Exposition / au / Salon de 1824 / Mr Constable / Peintre / de Paysage*
The National Gallery, London
London only
[Not illustrated]

Constable's father, a prosperous miller, reluctantly consented to his entering the Royal Academy Schools in 1799, the same year that J.M.W. Turner was elected an associate member. He would subsequently define, with Turner, the highest pitch of Romantic landscape painting, but it would be decades before he achieved comparable recognition. Constable first exhibited at the Royal Academy in 1802. In 1808, he commenced a period of intense *plein-air* oil sketching and by 1814 was painting finished pictures entirely out of doors in the Stour Valley around Dedham in Essex. After moving to London in 1816, Constable exhibited his first six-foot (two-metre) studio picture, *The White Horse* (no.40), which assured his election as associate member of the Royal Academy in 1819. With Lawrence and Bonington, he created a sensation at the 1824 Paris Salon, exhibiting *The Hay Wain* (fig.9) and this *View on the Stour*, which had previously featured in the Royal Academy (1822) and the British Institution (1823). In 1825 he sent *The White Horse* to the Lille Salon, and in 1827 he was again represented in Paris by a single entry, *The Cornfield* (fig.12). At the Douai Salon that year, the *View on the Stour* was again displayed. After his election as full Academician in 1829, Constable consolidated his reputation through writing and lecturing, publishing *English Landscape* (1830–2) in collaboration with the mezzotint engraver David Lucas. His late masterworks, more expressionistic than naturalistic, had no circulation in France except as mezzotint reproductions.

The history of Constable's introduction to French artists, well documented in correspondence and diaries, began in 1821 with the visits of Amadée Pichot, Charles Nodier and Géricault to the Royal Academy exhibition, where Constable's principal entry was *The Hay Wain*. John Arrowsmith, the brother-in-law of Louis Daguerre (no.42), partly on the advice of these acquaintances, travelled to London in April 1822 and offered Constable £70 – half the artist's asking price – for *The Hay Wain*, which was then on view at the British Institution. Arrowsmith intended to include it in the next Salon, but Constable refused the offer as derisive. In January 1824, 'the Frenchman' offered to buy *The Hay Wain* and *View on the Stour*, which he had seen at the Royal Academy. By April, Constable had settled on £250 for the pair and added a small seapiece 'into the bargain'. He was no doubt moved by Arrowsmith's assurance that the French nation would purchase one or other of the 'six-footers'. In May, Constable mused prophetically to his friend Archdeacon John Fisher that one of the 'six-footers' was ready to

ship and 'cannot fail of melting the stony hearts of the French painters'.

Arrowsmith returned at the end of the month with the dealer Claude Schroth, who was also in London to acquire works of British art for the Salon, and ordered three Hampstead views on the spot. A few days later, Constable reported to Fisher that he was busy painting seven small pictures for Paris in addition to the two large and three smaller paintings already shipped. Delacroix confessed exhaustion after seeing Géricault's *Medusa* and the five Constables with Arrowsmith on 19 June. On the same day, Arrowsmith wrote to Constable that 'no objects of art were ever more praised than your pictures'. By July, much of the Paris art community had flocked to the dealer's gallery for a view of the two prospective Salon entries. The battle lines were drawn even before the opening of the exhibition as a hostile press launched its first attacks.

When the Salon opened on 25 August, the British artist was represented by *The Hay Wain*, *Stour* and a *Hampstead Heath*. As confirmed by numerous sources, the Comte de Forbin had afforded his British guests every courtesy in hanging their pictures advantageously but, after considerable agitation by French artists, Constable's large landscapes were moved to 'two prime places in the principal room'. The critical response was too lengthy and lathered to be described as polite dalliance with a foreigner. The prevailing French school had been rattled to its foundation. That *The Hay Wain* now resides in London rather than Paris resulted from the avarice of Arrowsmith, who insisted on selling the pair when de Forbin could purchase only one. Constable, Bonington and Copley Fielding were all honoured at the conclusion of the Salon with gold medals of the first class. For Constable it was probably the vindication of a life's struggle.

In August 1825, Constable wrote to his patron Francis Darby (see no.114) to say that one of his large pictures had been sold in Paris to 'a nobleman, a great collector, I know not whom'. Although Louis-Joseph-Auguste Coutan was no noble, he was certainly one of the greatest French collectors of his age, and it was perhaps his purchase of the *Stour* to which Constable alluded. Coutan dedicated his fortune and final years to collecting modern art for his house on the Place Vendôme. A significant portion of his collection was auctioned immediately after his death in February 1830. Works of the British school, including this major Constable and eleven pictures by Bonington, figured in his cabinet, along with David, Delacroix, Gros, Girodet, Ingres and Michallon (see nos.65, 79, 99). PN

7
Richard Parkes Bonington
(1802–1828)
A Fishmarket Near Boulogne 1824

Oil on canvas
82.2 x 122.6 (32⅜ x 48¼)
References: Delécluze, 1824 (30 November),
pp.2–3; Jal, 1824, p.417; Coupin, 1824, pp.316ff.
Yale Center for British Art, Paul Mellon
Collection

Bonington was a principal mediator between
the French and British schools in the 1820s.
Born in Nottingham, he moved with his family,
first to Calais in 1817, where he studied
informally with Louis Francia, and then to Paris
in 1818, where he enrolled in the atelier of Gros.
His fellow pupils included Paul Delaroche,
Eugène Lami, Camille Roqueplan and Paul
Huet. Academic figure painting and the rigours
of the French system of training were anathema
to Bonington, and he soon abandoned that
tedium for a programme of self-tuition in
naturalistic landscape painting.

In 1821, Bonington made the first of several
tours of Normandy. Two watercolours from this
trip received favourable notice when exhibited
at the 1822 Salon. Watercolour painting was
not much practised in France, but Bonington's
novel technique soon attracted both collectors
and imitators. For the next two years, he
worked almost exclusively in watercolour and
lithography, producing topographical and
antiquarian illustrations for numerous Paris
publishers (see nos.144–6) and the new
bourgeois bankers and merchants of the
faubourgs.

In February 1824, Bonington and
Alexandre-Marie Colin left Paris for Dunkirk.
It was during a productive sojourn of nearly
a year that Bonington concentrated on the
marine oil paintings that gained him instant
notoriety and a gold medal at the Salon in
August. *A Fishmarket Near Boulogne* was
Bonington's most ambitious and arguably his
most influential marine painting, a spirited
exercise in naturalism without parallel in
contemporary French practice. In his review
of the Salon, Auguste Jal would allow that
Bonington had generated a mania, and that
'his paintings are, from a distance of several
feet, the accent of nature, but they are, in truth,
only sketches'. Etienne Delécluze was less
critical of the formal innovations than of the
challenge posed by the mundane subject of the
Fishmarket to the traditional interests of
historical landscape: 'I would even avow that
I prefer a bad failure at depicting the bay of
Naples to a pile of pike executed by the most
able master.'

James Carpenter (d.1852), the first recorded
owner of this painting, was a successful London
bookseller and publisher, an early patron of
Constable, and the father-in-law of portraitist
Margaret Carpenter, who exhibited at the 1827
Salon. Carpenter promoted Bonington's
posthumous reputation through lithographic
facsimiles, *A Series of Subjects from the Works
of the Late R.P. Bonington* (London, 1829–30).
Several elaborate reproductive engravings of
1831 also published by Carpenter attest to the
perceived importance of this picture. PN

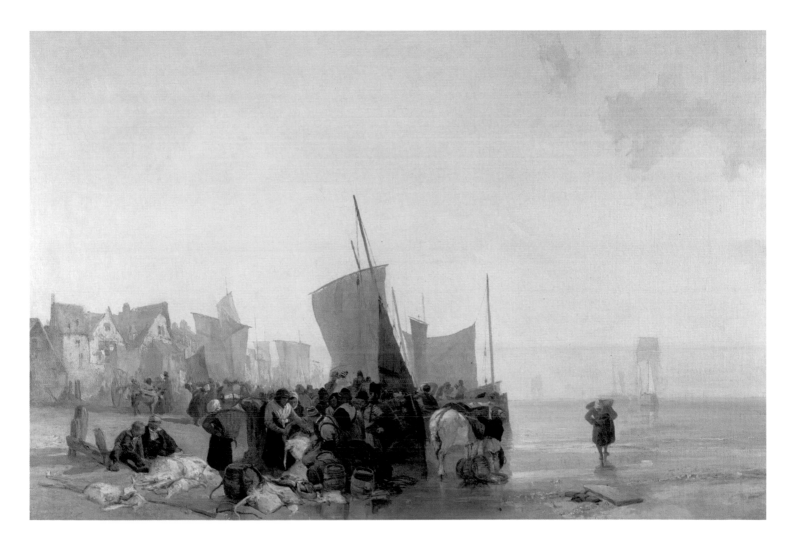

8

Eugène Delacroix (1798–1863)
Greece on the Ruins of Missolonghi
1826

Oil on canvas
213 x 142 (83⅞ x 55⅞)
Signed lower left: *Eug. Delacroix*
References: Delacroix, *Correspondence*, I,
p.407; III, p.84 n.1; p.112 n.1; IV, p.24 n.1; p.59
n.1; p.277 n.1; Hugo, *Oeuvre Complètes*, II,
p.984 (*Exposition de tableaux au profit des
Grecs: la nouvelle école de peinture*, August
1826); Boutard, 1826, p.3; Anonymous,
'Hobday's Gallery of Modern Art', *Athenaeum*,
18 June 1828, p.538; F., *Musée Colbert*, p.322.
Bordeaux, Musée des Beaux-Arts
London and Minneapolis only

Following Géricault's death in 1824, Eugène Delacroix was immediately acknowledged as the titular head of the French Romantics, a role which discomfited him but which was inescapable after the rancorous reception of such seminal works as *Massacres at Chios* (1824 Salon) and *The Death of Sardanapalus* (1827 Salon). He had enrolled in Pierre-Narcisse Guérin's studio in 1815, but like Colin, Ary Scheffer and other young painters, had gradually adopted Géricault as a mentor and even posed for one of the figures in *The Raft of the Medusa*. He would meet Bonington while both were copying in the Louvre, but their friendship, one of the most important in Delacroix's professional life, would not intensify until their visit to London in 1825 and their subsequent cohabitation of Delacroix's studio during 1826. Of the French painters of his generation, he was unquestionably the most avid Anglophile, with an ample knowledge of British history, literature, theatre and aesthetic theory.

Delacroix had little interest in illustrating contemporary history, with the significant exception of the Greek War of Independence (1821–32) that furnished several important concepts, often with Byronic associations. The Turks had besieged the town of Missolonghi for nearly a year before it finally fell in late April 1826, almost two years to the day after Byron's death there from uremic poisoning. In a final desperate act, the Greek defenders exploded their powder magazines, killing themselves and many of their adversaries. Although often perceived as a tribute to Byron, this allegory was primarily Delacroix's immediate response to the accounts of the Missolonghi catastrophe. As it was also submitted to the second instalment of the Galerie Lebrun exhibition in support of Greek relief that summer (see p.96), it should be interpreted not as an allegory of defeat, but as an appeal for redress. Of the hundreds of images documenting the tragedy of the war, this remains the most poignant, precisely because it transcends reportage.

The critic Jean-Baptiste Boutard wrote at length on the picture, recognising its originality and the artist's ability to express the pathos of the event with dignity and power. The arm beneath the rubble and the Egyptian mercenary in the background, he took for symbols of an entire population 'enslaved by slaves' and eminently poetic, but he regretted that Delacroix's technique lacked academic discipline.

In June 1828, Delacroix sent the picture to an exhibition at William Hobday's Gallery of Modern Art in London (see p.97). The previous February he had made his public debut in England with *The Execution of the*

Doge Marino Faliero (fig.6), a work much admired in the British press. His British hosts were not as pleased with the Greek allegory, primarily because of its gloomy palette, and the following year it was back in the artist's studio, after which it would be exhibited in consecutive exhibitions at the Musée Colbert (1829, I, no.7; II, no.138; 1830, I, no.90; II, no.195). PN

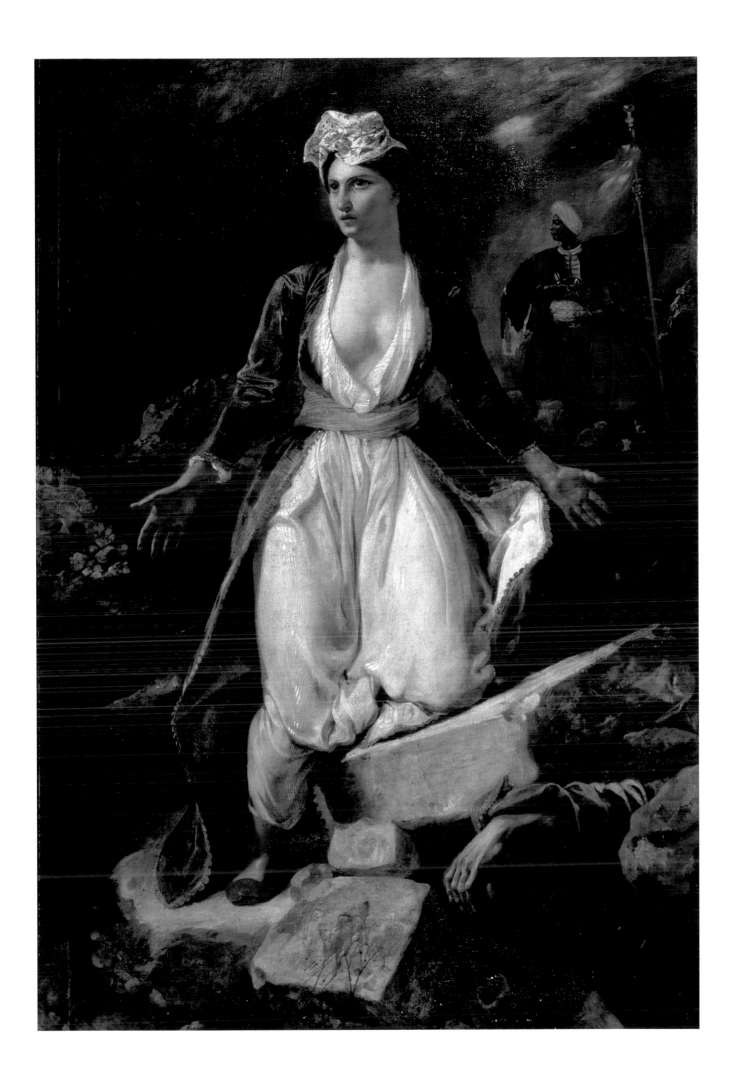

9
Anon., after Paul Delaroche
(1797–1856)
The Earl of Strafford on his Way to Execution c.1845

Hand-coloured lithograph
25.5 x 22 (10 x 8)
From William Spooner's series of 'Historical Subjects'
Stephen Bann
London only

Delaroche was one of the leading history painters of his generation and the one who was most engaged with British history. His ambitions as an artist were first channelled towards landscape in the studio of Louis-Etienne Watelet. By 1818 he had entered Gros's atelier, where his fellow students included Bonington, Eugène Lami and Camille Roqueplan. He exhibited at the Salon from 1822, his work moving away from an initial debt to Gros towards a forceful and engaging narrative style that avoided both the icy restraint of Neoclassicism and the turbulence of Delacroix and the Romantics.

Delaroche's approach was announced to great success in the 1824 Salon with his *Joan of Arc and the Cardinal of Winchester* (Rouen, Musée des Beaux-Arts, fig.38). His first major account of an aspect of British and French history, this actually rewrote it by inventing a confrontation between a French martyr-victim and a Satanic British authority-figure who threatens her with damnation. While some of Delaroche's audience might have found this a tempting interpretation of recent history, many of his subsequent works on British themes investigated the evolution of the democracy that his French contemporaries largely admired. Hence his interest in the English Civil War – its culmination in regicide had obvious French resonance – and the clash of Crown and Parliament, inherited and elected authority. Although Delaroche generally denied any intentional parallels with French history, the obvious equations here (Charles I and Louis XVI; Cromwell and Napoleon) were widely recognised – for example by Heinrich Heine, who called Delaroche 'court painter to all the beheaded majesties'. His last exhibited historical subjects, shown in 1837 before he ceased to send to the Salon, were pendant pictures of the condemned Strafford – shown in this lithograph – and Charles I, taunted by Cromwell's soldiers. The picture of Strafford was bought by the Second Duke of Sutherland, that of Charles I by the Duke's brother, Lord Francis Egerton, later Earl of Ellesmere who, recommending Delaroche's work, noted that 'people fall down in fits before his *Execution of Lady Jane Grey*' (no.55). The king's minister, Thomas Wentworth, Earl of Strafford, has been condemned to death in Parliament, and Charles has been forced to sign his death warrant. On his way to execution from his cell in the Tower he pauses before the window of Archbishop Laud's cell. Laud's spiritual comfort has been refused him in prison, but Strafford now begs his blessing and the old man reaches through the grill to deliver it. Little known in France, the events were explained in the Salon catalogue. DBB

THE EARL OF STRAFFORD ON HIS WAY TO EXECUTION,
Receiving the benediction of his friend the Archbishop Laud.
12th May 1640.

London - Published by William Spooner, 377 Strand

10

Isadore-Justin-Severin Taylor
(1789–1879)
Voyages pittoresques et romantiques dans l'ancienne France 1820–63

26 Vols., Vol.1: *Normandie*, Paris 1820, plate 12.
The British Library
London only
[Not illustrated]

Of Irish descent, Taylor was a man of many parts; soldier, diplomat, artist, dramatist, manager of the Théâtre Français – where he championed the Romantics and put on Victor Hugo's *Hernani* in 1830 – philanthropist and traveller. He was ennobled by Charles X in 1825 and served Louis-Philippe as Inspecteur-Général des Beaux-Arts. A tour of Scotland in 1821 was a formative experience, followed by trips as far afield as Egypt, Africa and Greece, while his extensive tours in France, with his friends Charles Nodier and Alphonse de Cailleux, secretary-general of the Musées royaux, resulted in their famous collaboration, the *Voyages pittoresques*, a pioneering work of architectural and antiquarian scholarship and conservation. It paralleled similar studies in Britain, and was illustrated with lithographs after many contemporary artists including Richard Parkes Bonington. DBB

fig.26
Englemann, after Jean-Baptiste Isabey
Caveau de l'Eglise de Notre Dame, renferant les débris des tombeaux des Comtes d'Cu
(from *Voyages pittoresques et romantiques dans l'ancienne France*, Vol.1, 1820)
Yale Center for British Art, Paul Mellon Collection

11

John Sell Cotman (1782–1842)
Architectural Antiquities
of Normandy

Published Yarmouth 1822, plate 49/50
Inscribed and dated: *Sketched July 24 181 D*
1819
The British Library
London only

A masterly watercolourist with a highly
distinctive style, Cotman abandoned a
promising career in London to settle in
Norfolk, teaching and exhibiting with the
Norwich Society of Artists, of which he became
President in 1811. Cotman visited Normandy in
1817, 1818 and 1820. With his colleagues from
Norwich, including John Berney Crome – John
Crome's son – who preceded him in 1816, he
was among the first wave of British artists to
discover the region. Encouraged by his patrons
Dawson Turner and Hudson Gurney (no.3), he
planned an ambitious series of plates, etched by
himself from his own drawings, *Antiquities of*
Normandy, which concentrated on its historic
architecture, as well as a 'Splendid Book' on its
scenery. The latter never materialised, but
Cotman devoted enormous care to the castles
and churches whose rich historical associations
– from William the Conqueror to Richard the
Lionheart – were as meaningful for the British
as for the French themselves. Sadly, Cotman's
painstaking and expensive work fell prey to
cheaper, mass-produced competititors. DBB

12

William Young Ottley
(1771–1836)
*Engravings of the most noble
Marquis of Stafford's Collection of
Pictures in London, arranged
according to Schools and in
Chronological order with Remarks
on each Picture* 1818

Vols.3 and 4 of 4
42.5 x 33 x 4 (16¾ x 13 x 1½)
Private Collection
London only
[Not illustrated]

The gallery of the Marquis of Stafford (later
First Duke of Sutherland) at Cleveland House
in London was one of the capital's principal
private collections and contained important
modern British pictures by artists including
Turner and James Ward. It was closely
associated with France, containing pictures
acquired from the Orléans collection in the
1790s, and later being supplemented with
works from the collections of Marshal Soult
and the Duc de Berry, historical portraits from
the personal collection of Alexandre Lenoir,
founder of the Musée des Monuments
Français, and Delaroche's *The Earl of Strafford
on his Way to Execution* (no.9) – the fruits of
two years its then owner, the Second Duke of
Sutherland, spent in Paris, 1835–7. The Second
Duke moved his share of the collection to
Stafford House (now Lancaster House). The
collection was regularly opened and would
have been seen by many of the French artists
who visited London. Ottley's book, shown here
in what is presumed to be Turner's copy, was
the most sumptuous of the private collection
catalogues issued at this period. DBB

Théodore Géricault (1791–1824)
Three plates from
*Various Subjects Drawn from Life
and on Stone by J.* [sic] *Géricault*

13

*Pity the Sorrows of a Poor Old Man
Whose Trembling Limbs have
Borne him to your Door* 1821

Lithograph on paper
Published 1 Feb. 1821
31.5 x 37.4 (12⅜ x 14¾)
The British Museum, London
London only

14

A Paralytic Woman 1821

Lithograph on paper
Published 1 April 1821
22.5 x 31.7 (8⅞ x 12½)
The Museum of London
London only

15

Entrance to the Adelphi Wharf
c. 1824

Lithograph on paper
26.7 x 31 (10½ x 12¼)
Guildhall Library, Corporation of London
London only

Géricault first took up lithography, particularly associated with British artists, in 1817, no doubt encouraged by Horace Vernet's enthusiasm. In London in 1820 his friend Nicolas Charlet helped him with a lithographic hand-out for visitors to *The Raft of the Medusa* on display at the Egyptian Hall, and seems to have encouraged him with other plates. However, the expert printer Charles Hullmandel prompted him to explore the medium in earnest, and for him and the publishers Rodwell & Martin he prepared his *Various Subjects*, the first public distillations of his London experience. A cover sheet, charmingly illustrated with the cart that had brought the *Medusa* to London, and twelve plates were issued in the spring of 1821, seven being dated 1 February, the rest up to May. Contrary to Géricault's hopes they proved a commercial failure, but still rank with the supreme achievements of nineteenth-century lithography. Four types of subject are contrasted throughout: the urban poor, blacksmiths and farriers, working horses and thoroughbreds. While undoubtedly influenced by British genre and sporting art, they are unique in their objectivity. The scenes of distress have often been taken as evidence of Géricault's own state of mind, but poverty and vagrancy were matters of debate in London at the time. John Thomas Smith, artist and Keeper of the Print Room at the British Museum, had issued his set of etchings, *Vagabondiana: or, Anecdotes of Mendicant*

Wanderers through the Streets of London; with Portraits of the Most Remarkable drawn from the Life, in 1817. Géricault had perhaps known these plates.

The title of the first plate shown here comes from an English nursery rhyme and was presumably added by the publishers; Géricault shows an old man who has collapsed outside a Southwark baker's shop within walking distance of St Paul's Cathedral. Though drawings related to *A Paralytic Woman* show a hearse, it is not made explicit in the print whether the carriage passing behind the victim in her improvised wheelchair is part of a funeral procession, or indeed whether Géricault intended a parable of human life from childhood – the little girl with her wooden horse who is hurried away from the distressing sight by her older companion – to disease and death; a contrast of poverty and wealth, confinement and motion; or none of these things. In the third print shown here, one is struck above all by the nobility of the great dray horses and of Géricault's mastery of the tonal and textural potential of lithography in the sheen of their coats and the rough brick wall. Such effects exploit the lithographic chalks but also correspond to the painterly qualities Géricault admired in British painting. Géricault's friend C.R. Cockerell particularly admired *A Paralytic Woman* and the 'poor beggar', noting: 'When works of art attain the utmost perfection they are eminently calculated to awaken thoughts of energy and virtue.' DBB

13

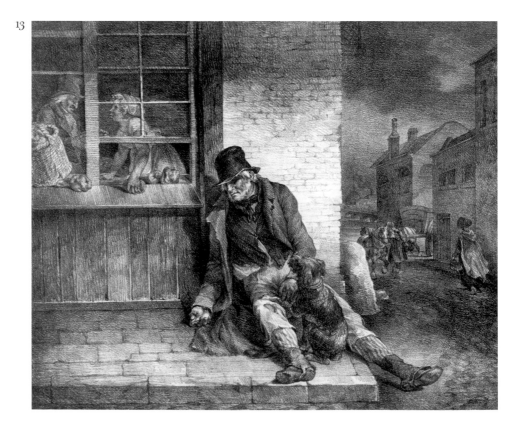

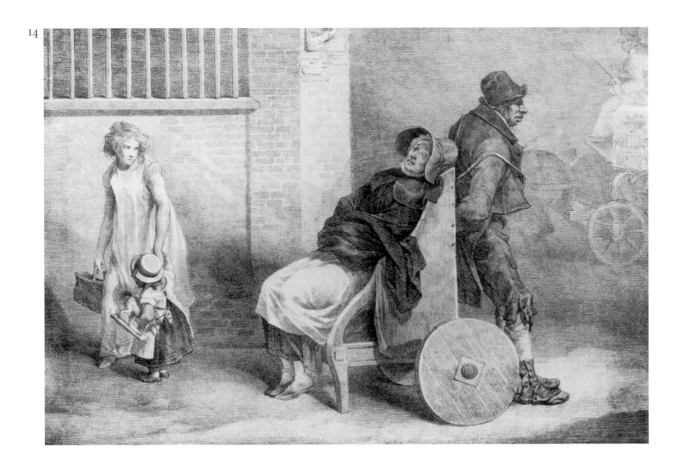

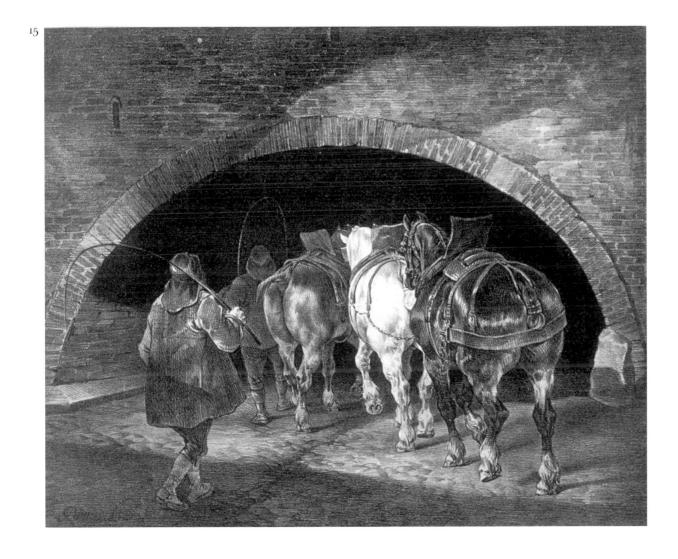

The Raft of the Medusa in Britain
Audience and Context

Christine Riding

In the second week of June 1820, the following advertisement appeared in prominent London newspapers:

MONSIEUR JERRICAULT'S GREAT PICTURE, 24 feet long by 18 feet high, representing the Surviving Crew of the Medusa *French Frigate on the Raft, just descrying the Vessel that rescued them from their dreadful situation: this magnificent picture excited universal interest and admiration at the last exhibition of the Louvre, and is now open for public inspection in the Roman Gallery, at the Egyptian Hall, Piccadilly: the public attention is respectfully invited to this chef-d'oeuvre of foreign art. Admission* 1s. *Description* 6d.

In fact Géricault's painting divided critics at the Paris Salon of 1819. But it certainly excited interest, not only because of its size and unconventionality, but also the notoriety of its subject. The story of the *Medusa* shipwreck off the West Coast of Africa in July 1816 and the horrifying experiences of one hundred and fifty soldiers, sailors and passengers abandoned on a raft for thirteen days, was one of the sensations of the post-Napoleonic Wars period. Indeed the episode, only a year after defeat at Waterloo and with British troops still occupying areas of France, was extremely embarrassing and, as events unfolded, compromising to the Restoration government. The purpose of the expedition was to re-establish the French colony in Senegal and thus the nation's territorial ambitions in Africa. That the outward journey should end in betrayal, mutiny, starvation and cannibalism, with a collective death toll of over one hundred and forty people was not an auspicious beginning. And worse, the tragedy was due to the incompetence of the Royalist captain, Hugues Duroys de Chaumareys, the selfish disregard of Julien Schmaltz, the newly appointed governor of Senegal and the breakdown of discipline among the crew and soldiers. That an official cover-up was attempted, including a lenient sentence for de Chaumareys, added insult to injury, resulting in a narrative account by two raft survivors, Alexandre Corréard and Jean-Baptiste-Henri Savigny, published in Paris in 1817 (nos.17, 18). Full of lurid detail and recriminations, the narrative became a bestseller. The *Medusa* debacle had turned into a national scandal. At precisely the same time, Géricault was searching for a contentious contemporary subject to monumentalise on canvas. By early 1818 he had made the acquaintance of Corréard and Savigny. And it was their emotive account of the shipwreck that inspired his painting.

Only three years after the event itself, the French authorities and public were confronted with *The Raft of the Medusa*. It was subversive on numerous levels. A shipwreck scene was considered a genre subject and thus generally confined to a modest scale: the dimensions of the *Medusa* alone proclaimed it as grand history painting. As such, according to the artistic conventions of the day, the painting

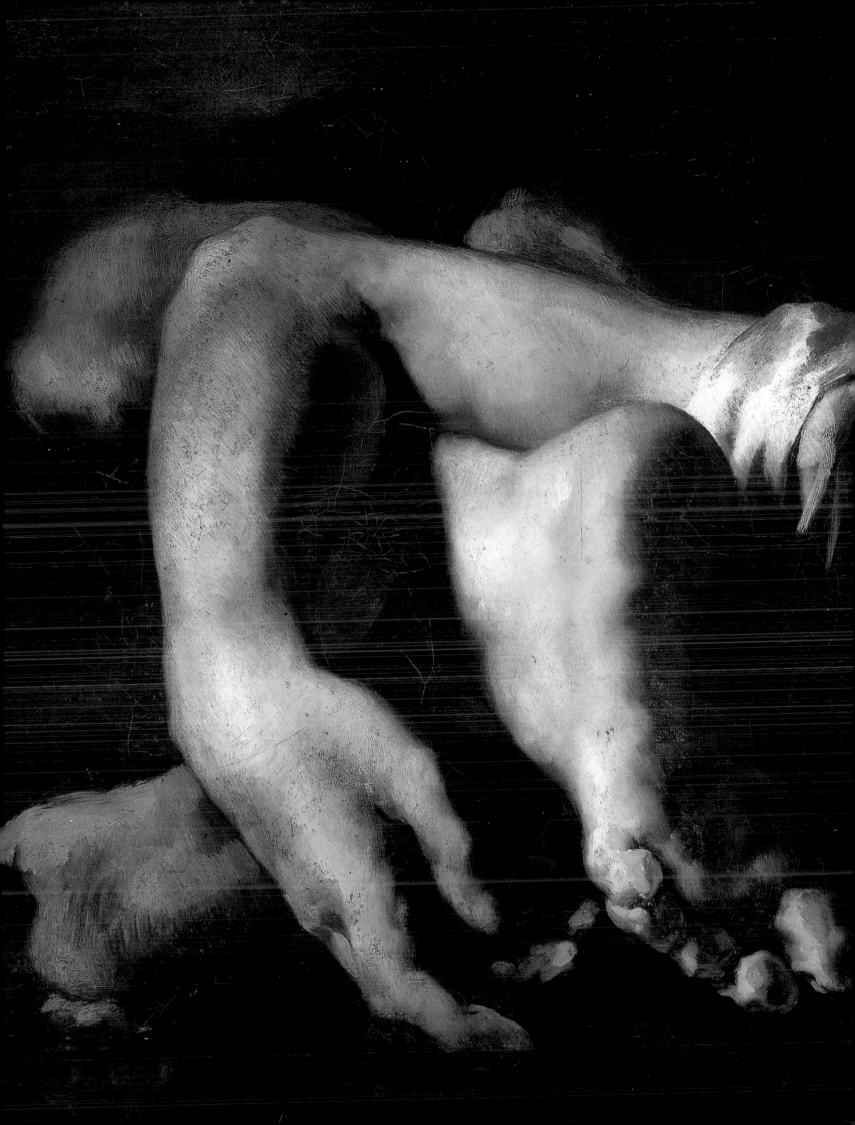

should have engaged with an elevated subject of profound moral or national significance for the edification of society: the *Medusa* was emphatically neither. In Antoine-Jean Gros's epic Napoleonic scenes, such as the *Battlefield of Eylau* (no.47) or the *Plague at Jaffa* (1804), contemporary human suffering had served to emphasise the heroism and compassion of the Emperor himself. Seemingly bereft of a hero or cause, the *Medusa* at best represented vain hope and pointless suffering and at worst, the basic human instinct to survive, which had superseded all moral considerations and plunged civilised man into barbarism. Yet the composition abounds with classical and Old Master references, most poignantly the heroic male nude. Given the context, both in terms of the ignoble subject and the obsequiousness of the official art that dominated the walls of the 1819 Salon, these elements instil the *Medusa* with a cynicism which further subverts the role of history painting as a signifier of national identity and pride. No wonder the French were baffled by it. But what about its British audience?

On the basis that the direct consequences of the shipwreck were relevant only in France, it has been commented that in London the painting was devoid of political implications and thus appreciated as a subject negotiated as 'high art'. Clearly the exhibition of a major example of contemporary French art, irrespective of subject, was a significant event in its own right. And true, the tension between the Royalists and the Liberals in France, although of interest to the government, was unlikely to concern the average Briton. But was it possible for a British audience to have an objective viewpoint when confronted by this loaded painting? In the context of the time, one might say that the British were predisposed to take a particular interest in the *Medusa*, both as a self-consciously maritime people and in view of the recent wars and long-standing imperial rivalry with France. During the entire eighteenth century, British ships had covered the globe, exploring, trading, colonising or fighting. By 1815, British territorial gains were so extensive that the empire included one-fifth of the world's inhabitants: conversely French territories had shrunk dramatically, hence the importance of the Senegal expedition. How ironic that it should be a British garrison waiting for the *Medusa* convoy to arrive for the official handover of the colony. Indeed the courtesy and compassion shown by the officers towards the raft survivors, mentioned in Corréard and Savigny's narrative, were noted by British commentators as 'a beautiful relief' to the 'selfishness and brutality' otherwise demonstrated by Frenchmen (fig.28).[1] As will be shown, this readiness to put a patriotic slant on the *Medusa* story underlines that although formal hostilities had ceased, scoring moral points off the old enemy continued.

The *Medusa* Shipwreck: Entertainment and Propaganda

Visual culture was bound up in issues of war and dominion, no more so than during the Napoleonic Wars, when the public's hunger for news and information was sated and sustained by new and adapted forms of pictorial and theatrical entertainment. Land and sea battles were translated into panoramas allowing a broad public to engage with the epic events of their day whilst astounding viewers with the illusion of reality and the sheer scale of the representation. In the competitive theatre world, where the panorama was both a decisive influence and a rival for the public's attention, military re-enactments and celebrations became ever more complex and spectacular. In 1803–4, at London's Sadler's Wells, the 'Aquatic theatre', a 90-foot (30-metre) tank holding 8,000 cubic feet (283 cubic metres) of water was installed on which naval battles were presented. Not surprisingly the Battle of Trafalgar was staged there only months after the event itself, in 1806. Post-1815, entertainments of recent events, especially Allied victories, were augmented by numerous exhibitions and even self-styled museums set up in London and elsewhere, of battle scenes and memorabilia, and in particular anything associated with Napoleon himself, including his famous charger, Marengo (see no.97), and his armoured coach taken on the evening of the Battle of Waterloo. With novelty and topicality at a premium, showmen and theatre managers continued to keep a watchful eye on current events or cultural developments that had caught the public's interest. Thus painters were by no means alone in responding to the Walter Scott phenomenon: incarnations of *Ivanhoe*, for example, were speedily devised and staged at London's Covent Garden, Surrey and Royal Coburg theatres in early 1820.

The entertainment business was inextricably linked with the printed word. Nowhere was this more clearly demonstrated than with the voyage narrative, one of the most popular and therefore powerful genres of literature at this time. Approximately two thousand voyage narratives, revised editions and abridgements were published in Britain from the early 1700s through to the Napoleonic Wars. These included translations of major voyages by other European countries, which were easy targets for a pro-British slant, underlining that voyage narratives functioned as propaganda as well as education and entertainment. While the British public exercised a seemingly insatiable appetite for any account of maritime activity, what fired the collective imagination was the sensational. Seafaring, after all, was an exceptionally dangerous profession and was ripe for adventure, disaster and controversy. For the armchair traveller, man voyaging into the unknown, distanced from regulating social structures, and struggling with the sublime forces of Nature, had all the potential menace and horror of

Gothic fiction. Not surprisingly shipwreck amounted to a national obsession, with the storm-tossed ship as one of the defining motifs of the period, experienced second hand through narratives and informed fiction: from Daniel Defoe's enduringly popular *Robinson Crusoe* and William Falconer's *The Shipwreck* to Samuel Taylor Coleridge's *Ancient Mariner* and so on. Byron's grisly shipwreck passage in *Don Juan*, contemporaneous with Géricault's *Medusa* and with which parallels are drawn, was based on actual accounts. The symbiosis of the voyage and Gothic horror also resonates in Mary Shelley's *Frankenstein*, published in 1818, where the eponymous 'hero' meets his death, both physical and spiritual, pursuing the monster to the Arctic region.

Given the opportunity for sublime spectacle, shipwreck was a mainstay of visual culture. From Philippe-Jacques de Loutherbourg's first performance of the *Eidophusikon* (an animated stage-set) in 1781, 'Storm at Sea and Shipwreck' was to feature as strongly in theatre productions and commercial shows as it did at the Royal Academy annual exhibition. In 1820, for example, one theatrical presentation boasted 'an Immense Ship 40 feet long! Fully manned, Struck by a Thunderbolt & Sunk, completely from the View of the Audience'.[2] But as commentators were quick to point out, drowning was swift in comparison to the fate that awaited those that survived the shipwreck itself, whether at the hands of savages (torture and cannibalism) or worse, the agonies of starvation, which may induce 'civilised Westerners' to prey on each other. Yet to succumb was considered an abomination. Indeed those in France who sought to discredit Corréard and Savigny focused on their 'guilt' as cannibals. In Britain, the exposure to moral and physical danger at sea was turned to patriotic advantage. Because, as J.G. Dalyell opined, it 'materially contributes to the formation of character'. Thus British sailors, fortified by courage and endurance, 'are invariably the first in matters of the most daring enterprise'.[3]

In this context Corréard and Savigny's narrative was a gift to patriotic sentiment because it showcased the ineptitude and lack of moral fibre promoted as alien to native seafarers. Excerpts from the first edition, as well as Savigny's report of 1816, were printed by British newspapers. By early 1818 a full English translation was published in London and later that year an abridged version in Dublin. At the same time a pamphlet appeared in London. Given the sensational language of the introduction, replete with 'a mass of human suffering', survivors 'feeding on the Dead Bodies of their Unhappy Comrades', it was clearly produced with the broadest audience in mind.[4] All these translations, as with later versions, make clear that the *Medusa* story was an affront to the civilised world. The pamphlet asserted that 'In all the history of perils and sufferings encountered at sea ... there is assuredly no darker page than that which contains the narrative of the shipwreck of the Medusa'.[5] The opportunity

to compare and contrast national traits via the *Medusa* shipwreck was given a boost because at the same time in 1816 a potentially similar drama was unfolding for a British navy ship, the *Alceste*. Returning from China, the ship ran aground on an uncharted reef. A raft was made for supplies, not people. And despite the ensuing dangers, order was maintained and everyone survived. In the same year as Corréard and Savigny's, a narrative was published by the ship's surgeon, John MacLeod, which effectively celebrates the British character in adversity. 'Under all the depressing circumstances attending shipwreck,' MacLeod enthused, 'of hunger, thirst, and fatigue; and menaced by a ruthless foe; it was glorious to see the British spirit staunch and unsubdued', the shipwrecked saved from 'all the horrors of anarchy and confusion' by the 'personal example' of their captain, Murray Maxwell.[6] What a contrast to Corréard and Savigny's bitter recriminations. It was for this reason, according to the Dublin edition, that the *Medusa* narrative

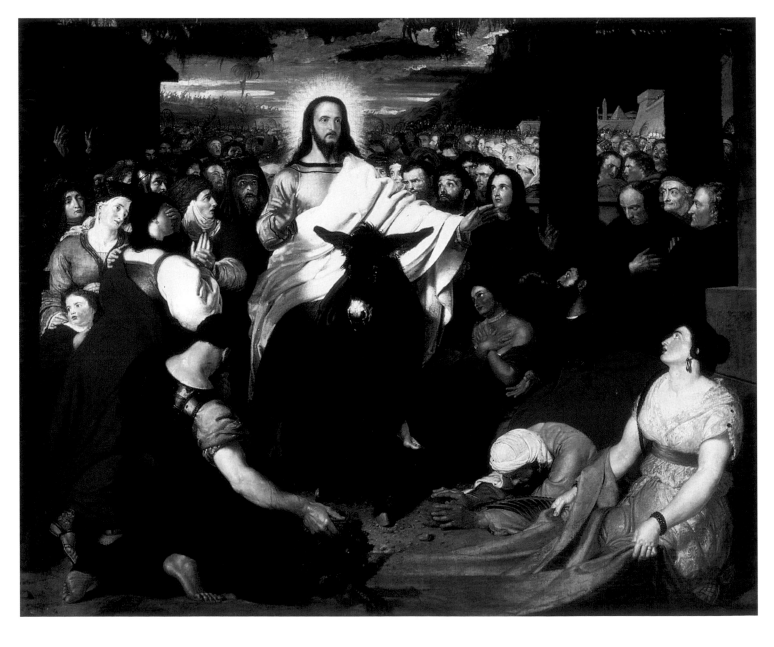

had a greater claim to public attention, because it provided 'a comparison highly creditable to the British Navy', demonstrating 'the superiority of that profession to which we owe so much of our wealth, our glory, and our peace'.[7] That the *Medusa/Alceste* juxtaposition continued is underlined by an 1822 publication of both narratives in a single volume.[8]

Given this patriotic preamble, British audiences were surely primed into viewing Géricault's painting with a degree of national self-congratulation. But the story of the *Medusa* in London is also about art as public spectacle and sublime horror as a marketable commodity. Over and above art-exhibition goers, what lured visitors in their thousands through the doors of the Egyptian Hall was undoubtedly the thrill of coming face to face with, as one reviewer stated, the 'dreadful wreck' that 'was still so fresh in everybody's mind'.[9] Exactly how marketable the *Medusa* story was in the name of entertainment is demonstrated by the extraordinary circumstance of a painting, play and panorama conceived from Corréard and Savigny's narrative within a year of each other, and on offer to the British public in 1820. These were William Moncrieff's *The Shipwreck of the* Medusa*: Or, The Fatal Raft* that opened at the Royal Coburg Theatre (now the Old Vic) on 29 May 1820, and Messrs Marshall's *Grand Marine Peristrephic Panorama of the Shipwreck of the* Medusa *French Frigate with the Fatal Raft*, which toured Scotland in 1820 before arriving in Dublin in 1821, where it clashed with the onward tour of Géricault's *Medusa*. The painting was thus not an isolated art-world event, but part of a '*Medusa* season' in British visual culture.

Exhibiting *The Raft of the Medusa*

After the Paris Salon, Géricault decided to travel abroad. Although London was not his first choice of destination the opportunity to exhibit the *Medusa* to a new and receptive audience was clearly too good to miss, especially as the painting remained unsold and unseen, rolled up in the studio of his friend, Léon Cogniet (no.36). But Géricault may also have had a political motive in taking the painting to London with regards to the slave trade. The French governor, Julien Schmaltz, had allowed the trade to resume clandestinely after he had taken formal charge of Senegal in January 1817. Géricault was working on his ideas for his painting at the time the second edition of Savigny and Corréard's narrative was published in 1818, which contains an impassioned argument by Corréard for the future of France's colonial ambitions in Africa based on the abolition of slavery. Géricault shared Corréard's abolitionist sympathies. And his selection of a black man for the apex of the composition was a loaded and controversial decision. This has led art historians to interpret the painting as a quasi-manifesto for Corréard's views. Given the abolitionist agenda the cultural historian Albert Boime has suggested that the exhibition of Géricault's

Medusa in London in 1820 was timed specifically to coincide with British anti-slavery agitation (no.30).[10] The idea to exhibit at the Egyptian Hall seems to have come from Auguste Lethière, whose father, Guillaume Lethière, had exhibited *Brutus Condemning his Sons* there in 1816. The hall's proprietor, the enterprising William Bullock, had brought his collection of natural and artificial curiosities to London in 1809, setting up in Piccadilly. By the following year Bullock's museum was already being touted as 'the most fashionable place of amusement in London'.[11] In 1812 he opened a brand new exhibition hall. Its official title was the London Museum, but it was immediately known as the Egyptian Hall, due to its distinctive Egyptian-style façade. Bullock diversified the entertainments in 1816 to include, for example, Napoleon's coach, mentioned above, as well as installing a themed room called the Roman Gallery. The temporary centrepiece of this display was Lethière's aforementioned *Brutus*. Thus the *Medusa* was not presented to the public in a shrine to 'high art' or a crowded Salon but in a diverse entertainment forum and occasional auction house.

Exhibiting fine art as a commercial venture was not new to London. One-man shows and later one-painting shows had been a feature of the capital's cultural scene since the 1770s, sometimes prompted in opposition to the Royal Academy or, in the case of history painting, as a means of compensating for the lack of state and private patronage. The significant development from the 1790s was the regularity with which large-scale paintings, albeit rare in British art, were exhibited in this manner. Without the massive state support available in France, those British artists compelled to foray into the ruinously expensive world of grand history painting were forced – with few exceptions – to do so speculatively. Given the paucity of options, private exhibitions did (on the whole) make financial sense, with artists often making a tidy sum on the proceeds taken from entrance charges and gaining important press coverage through advertisements and reviews. Beginning with John Singleton Copley's *Siege of Gibraltar* in 1791, a succession of works by Benjamin West, James Ward, Benjamin Robert Haydon, John Martin, Francis Danby and others, engaging with national or biblical subjects, made their appearance in London. Whilst prestigious in their own right, undoubtedly the popular appeal of these paintings, described by Thomas Boase as the 'cult of immensity', was linked to the tremendous contemporary vogue for the panorama, first patented by Robert Barker in 1787, and its numerous derivations, such as the diorama (no.42).[12] Indeed the demarcation between a large-scale painting and a panorama was arguably indiscernible in the popular perception. Thus some visitors may well have viewed the *Medusa* in these terms, perhaps encouraged to do so by Bullock. Certainly the prominence of

the painting's dimensions in the press advertisement suggests that in the contemporary entertainment world, size mattered. As cultural historians have noted, the relative failure of the painting's exhibition in Dublin the following year may well have resulted from the public's preference for the Marshalls' panorama, which boasted 5 scenes on 300 metres (1,000 feet) of canvas, against which the *Medusa*'s 7 metres (24 feet), ignoring Géricault's intellectual ambitions and superior artistic ability, may have seemed a little puny.

The Egyptian Hall was one of the few London venues that could accommodate large-scale paintings. Bullock exploited the situation by renting out exhibition space, as in the case of Haydon, or financing the whole venture, as in the case of Géricault. In doing so, the Egyptian Hall entered the ongoing debate surrounding the impact that such exhibitions had on perceptions of art. To some, they epitomised flagrant commercialism, reducing high art to the squalid level of mass entertainment. In 1820, Haydon exhibited *Christ's Entry into Jerusalem* (fig. 27) at the Egyptian Hall. Blaming the apathy of the government and public bodies towards history painters, the *London Magazine* described the artist as having been reduced to advertising himself like a 'quack doctor' through 'descriptive catalogues, advertisements, and posting bills' in order to 'squeeze support from the shillings of the people'.[13] Others, however, viewed exhibitions of grand history painting, whatever the context, as a positive step both for public taste and for native artists. Reviewing the *Medusa* exhibition, a writer in the *Globe* noted that this was the third 'historical work from the continental school' exhibited at the Egyptian Hall (*Brutus* of 1816, Jean-Baptiste Wicar's *Raising of the Widow's Son at Nain* of 1817, *Medusa* of 1820), each 'a favourable specimen to convey … the modern station of French art'.[14] The *Literary Gazette* went further, stating that 'great praise' was due to Bullock 'for procuring us such opportunities for examination and comparison of the two national schools: if he continues to bring over *chefs d'ouvre* [sic] of French painters, he will do as good a thing as could be done to advance British art. Emulation is a noble teacher.'[15] Although evidently admired, Géricault's painting had little immediate impact on British artists, Danby's *Sunset at Sea after a Storm* of 1824 (no.28) being a notable exception, as well as J.M.W. Turner's *Disaster at Sea* of c.1835 (no.30), which interestingly highlights an example of British cruelty.

The private view for Géricault's *Medusa* was held on Saturday 10 June and was well attended. The *Globe* noticed amongst 'the throng', 'the Marquis of STAFFORD, the Bishops of ELY and CARLISLE, Sir Thomas Baring, Bart, and a number of the most eminent Patrons of the Fine Arts, together with several Members of the Royal Academy'.[16] The exhibition opened to the public the following Monday. By the closing date at the end of December, about 40,000 people had paid a visit. Bullock's tireless promotion had paid off.

And Géricault, who took a percentage of the takings, was about 18,000 francs the richer. Not surprisingly the *Medusa* was reviewed in most of the major London newspapers and journals. And the reaction was, on the whole, extremely favourable, bordering on effusive. In Paris, published criticisms of the painting (in part influenced by political affiliations) concentrated on, as Lorenz Eitner has observed, its 'sombre monochromy, its inappropriate monumentality, its lack of an "interesting" narrative, and its failure to dwell on the vastness of the ocean'.[17] Over and above the subject of the *Medusa* itself, which all British reviewers agreed 'would be well for the naval character of France to have blotted from her maritime annals', the only significant fault found with the painting in London was that it bore 'the marks of that cold pedantic school of which David may be considered the founder'. However, *The Times* thought that Géricault's 'powerful talent' had 'broken through the trammels of his system'.[18] Unlike in Paris, there was thus open recognition that the *Medusa* signalled a departure in French art. As the *Morning Post* opined: 'This work far exceeds anything we have seen of the school to which it belongs … There is more of nature, of the grand simplicity of art, and of true expression, than is usual with the highest of the modern French painters.'[19] To be fair, some French reviewers were thrown into raptures over Géricault's energy and daring, with the words 'verve', 'truth' and 'boldness' littering the most emphatic of notices.

What undoubtedly assisted British reviewers in their appreciation of the painting was the manner in which it was exhibited. Despite the Roman Gallery's grand size (18 by 9 metres/60 by 29 feet), the *Medusa*, hung relatively close to the ground, would have made a breathtaking spectacle, the viewer positioned as the composition dictates at a close vantage-point on the edge of the raft itself, thus blurring the line between spectator and participant. At the Louvre, Géricault had elected to hang the painting high in the monumental Salon Carré, a mistake he soon acknowledged on seeing his painting lifted into position. Despite its scale, the *Medusa*'s emotional power comes from an intimate engagement with the canvas, as Delacroix's celebrated reaction testifies. Having studied the painting by candlelight in the confines of Géricault's studio, he walked into the street and broke into a terrified run. A similar engagement with the sublime horror of the painting pervades critical responses in London. 'In this tremendous picture of human sufferings,' observed the *Literary Gazette*, 'the bold hand of the artist has laid bare the details of the horrid facts, with the severity of M. Angelo and the gloom of Caravaggio.'[20] And the reviewer in the *Examiner* confessed that he had 'never been more penetrated in heart by any performance of the pencil': 'We never left one more reluctantly, or thought of it more after we had left it, with a charmed melancholy. The impression can

never forsake us.'[21] The connection that both French and British reviewers made with the painting was that of Ugolino, whose death by starvation with his children and grandchildren, imprisoned in a Pisan tower, was a gruesome story from Dante's *Inferno*, much favoured by artists and poets at the time primarily because of the inference in the text that Ugolino resorted to cannibalism. Géricault had briefly contemplated the subject for his painting, and perhaps added the so-called 'Father' figure in the foreground of the composition knowing that the Ugolino connection would be made, thus extending the narrative of the single canvas (no.26). Similarly Byron made reference to Ugolino in *Don Juan* (no.27). And both represent the shipwrecked as having descended, like Ugolino, into a living Hell.

Unlike Géricault's painting, Moncrieff's play *The Shipwreck of the Medusa* was created specifically to entertain the British public, making his treatment of the *Medusa* shipwreck especially significant. Clearly Moncrieff aimed to capitalise on the sensationalism of the *Medusa* wreck, but mediated through the conventions of melodrama and given a patriotic agenda by the introduction of a British sailor, Jack Gallant (the boatswain on the *Medusa*), the character based on the honest, jargon-speaking sailors of popular fiction. Jack Gallant's role in the play was to act as a reminder of both the superiority of native seamanship and the honourable, fearless character of the British sailor. But more specifically, he acted as a corrective to the societal chaos of Corréard and Savigny's narrative. Thus when the issue of cannibalism arises, Jack rallies the survivors to die rather than commit such an atrocity. And when all hope appears to have vanished, Jack elects to scuttle the raft to save them from a lingering death, at which point the rescue ship appears. Thus via Providence and British pluck, disaster was averted. Evidently the play gratified existing notions of national character. But it also acted as an antidote to the irredeemable suffering and despair of the original narrative, and by extension Géricault's painting: an opportunity, it would seem, for civilised society to step back from the abyss. In the context of the time, who else but a British sailor should engineer this redemption?

16

Horace Vernet (1789–1863)
Portrait of Théodore Géricault
c.1822–3

Oil on canvas
47.3 x 38.4 (18⅝ x 15⅛)
The Metropolitan Museum of Art, New York.
Purchase, Gift of Joanne Toor Cummings, by
exchange, 1998

Most portraits of Géricault were posthumous, and were either idealised or portrayed him in the emaciated agony of his final illness. Vernet, on the other hand, has presented an image of his close friend neither dandified, as in Géricault's early self-portrait of 1808, nor as a martyr to his art, as in Léon Cogniet's 1824 sketch of the artist infirm and Ary Scheffer's well-known *Géricault on His Deathbed* (Louvre). The last appeared in the 1824 Salon and in London four years later at an exhibition at Hobday's Gallery.

The dating of this particular portrait is disputed, with many considering it posthumous. Most recently, Gary Tinterow has assigned it to the same period as another Vernet lithographic portrait of Géricault, which depicts him ill in his studio in 1823 but standing and wearing a similar head *fichu* (shawl). Vernet has executed this probing likeness with an ease and transparency unexpected in French portraiture. Since the characterisation seems too penetrating to be based on a recollection, it is probable that Vernet painted this portrait from the life in February 1823. PN

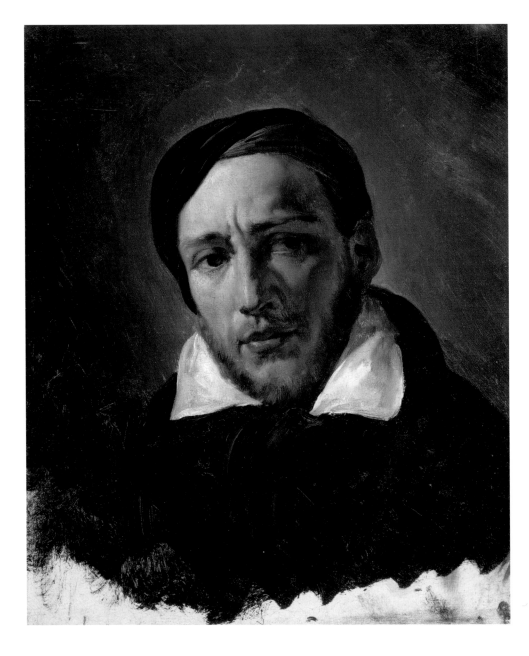

Jean-Baptiste-Henri Savigny (1793–1843) and **Alexandre Corréard** (1788–1857)

17

Narrative of a Voyage to Senegal in 1816; Comprising an Account of the Shipwreck of the Medusa

First English edition, London 1818, plate 2
The British Library
London only

18

Naufrage de la Frégate la Méduse

Third edition, Paris 1821, plate 4
Plate 4, The British Library
London only

The *Medusa* was the flagship of a convoy carrying soldiers and official settlers to Senegal. Savigny was the ship's surgeon and Corréard an engineer and geographer. After running aground on 2 July 1816, the *Medusa* was abandoned. Two hundred and fifty passengers were placed in lifeboats, leaving the rest to a makeshift raft which, it was agreed, would be towed. In the haste to get to shore, the ropes were untied, leaving the 149 men and one woman stranded. The situation on the raft soon broke down, with outbreaks of mutiny from the second day, and by the fourth, all survivors were practising cannibalism. By the eighth day, fifteen men remained, who survived for another week until their rescue by the *Argus* brig. Five died shortly afterwards, leaving ten survivors of the original one hundred and fifty.

Unfortunately for the French Naval ministry, busily underplaying the disaster, several survivors made their way back to France demanding justice and compensation. A report by Savigny was unofficially published on 13 September. He and Corréard then collaborated on an expanded narrative, which aimed primarily to expose the incompetence and treachery of the captain, as well as downplay their own part in the subsequent atrocities. The first edition appeared in Paris in November 1817. In 1818, *Le Radeau de la Méduse* by Paulin Anglas de Praviel, an officer on the *Medusa*, was published, which purported to be impartial but set out to undermine their version of events and to emphasise the survivors' 'crime' of cannibalism.

The third edition of Corréard and Savigny's narrative (1821) includes eight illustrations, four of which are after watercolours by Géricault that were owned by Corréard. The fourth plate follows the composition of Géricault's painting and is accompanied by a description by the authors. CR

17

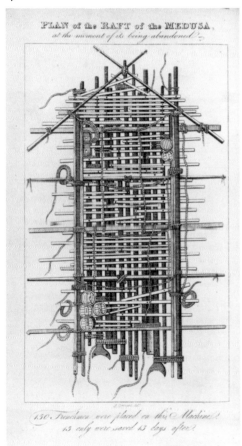

18

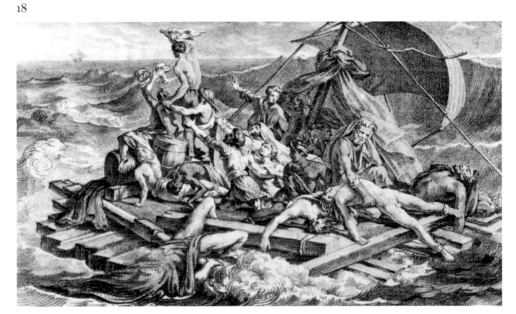

fig.28
Englemann, after Théodore Géricault
English Officers and the Survivors of the Medusa
(from *Naufrage de la Frégate La Méduse*, Paris 1821)
The British Library, London

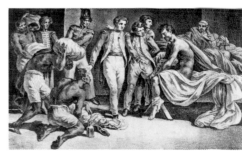

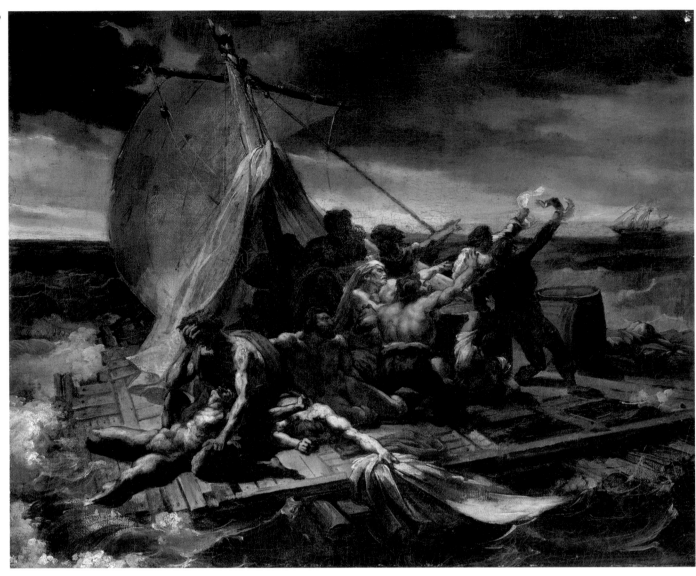

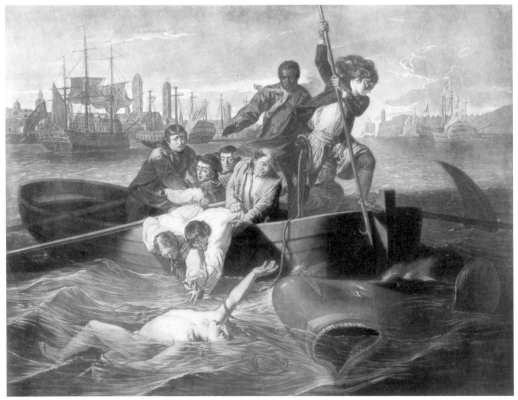

19 (*overleaf*)
**Pierre-Désiré Guillemet
(1827–1878) and Etienne-
Antoine-Eugène Ronjat, after
Théodore Géricault**
The Raft of the Medusa 1859–60

Oil on canvas
493 x 717 (194 x 282¼)
Musée de Picardie, Amiens

20
Théodore Géricault (1791–1824)
*First Study for the Raft of the
Medusa* 1819

Oil on canvas
38.1 x 45.7 (15 x 18)
Musée du Louvre, département des peintures

21
Valentine Green (1739–1813)
after John Singleton Copley
*A Youth Rescued from a Shark
(Watson and the Shark)*

Mezzotint, published 31 May 1779
46.5 x 60.5 (18¼ x 23⅞)
The British Museum, London
London only

Neither Géricault nor his friend Horace Vernet were supporters of the Restoration government. Indeed it may have been Vernet that introduced Géricault to Corréard and Savigny. Thus Géricault had a political agenda in selecting the controversial *Medusa* shipwreck as a subject, as well as seeking the challenge of translating a contemporary subject with 'ordinary men' as protagonists into grand history painting.

Géricault developed ideas for a number of scenes, including the mutiny against the officers, cannibalism and the final rescue. But it was the first sighting of the *Argus*, prior to rescue, that he decided on, represented in several preparatory oil sketches, including the near definitive composition of no.20. In Corréard and Savigny's narrative, the passage concludes:

For about half an hour, we were suspended between hope and fear; some thought they saw the ship become larger, and others affirmed that its course carried it from us: those latter were the only ones whose eyes were not fascinated by hope, for the brig disappeared. From the delirium of joy, we fell into profound despondency [sic] *and grief.*

Géricault could have selected a more politically controversial episode, in particular the abandonment of the raft by those in command. Given that his contemporaries would have been familiar with the main events of the *Medusa* disaster, he elected instead to show the results of this action with the survivors cast as hapless victims. As the *Globe* reviewer acknowledged, Géricault 'selected a time when the ruin of the raft may be said to be complete', thus embracing the episodes of abandonment, mutiny and so on, but focusing on the crushing moment when all hope appeared to have gone.

Géricault's *Medusa* is a complex fusion of Old Master and contemporary references, observations from nature and the artist's own imagination. Michelangelo, in particular his *Last Judgement*, which Géricault had 'trembled' before on his recent visit to Italy, was a powerful influence. Géricault clearly took his lead from Antoine-Jean Gros in monumental-ising a contemporary event, such as the *Battlefield of Eylau* (no.47). And certain figures were perhaps indebted to specific modern paintings or prints, for example Henry Fuseli's *Ugolino in the Tower* (no.26) for the so-called 'Father and Son' group.

Shipwreck was a popular subject in European art at this time. But Géricault's painting was unusual both in terms of the enormous scale of the work (shipwreck scenes were usually executed on a modest, or

occasionally larger scale as shown by Claude-Joseph Vernet or J.M.W. Turner) and the emphasis that he placed on the shipwrecked rather than the seascape. For this reason, it has been suggested that Géricault may have known John Singleton Copley's *Watson and the Shark* (1779), via the engraving shown here (no.21). The human drama of a group of men attempting to rescue a boy from a shark attack certainly dominates the composition in a way that was then unique in British art, as well as being a contemporary event given the status of history painting.

The fact that Géricault's painting was included at a state-sponsored Salon underlines the complexities of French politics at that time. Clearly the subject was subversive and would only have been attempted on such a scale by an artist, like Géricault, who had independent means. The *Medusa* was not acquired by the government until after Géricault's death, in November 1824. The scale copy included here was executed by two French academicians in 1859–60 because the condition of the original was deteriorating due to Géricault's experimentation with paints. CR

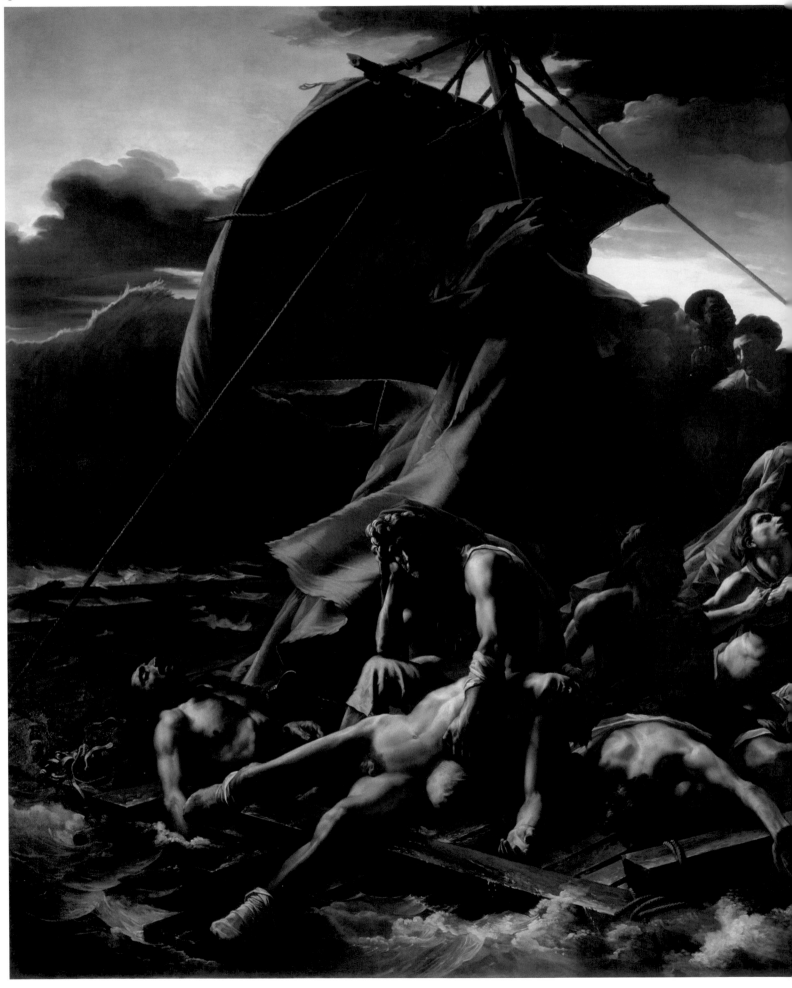

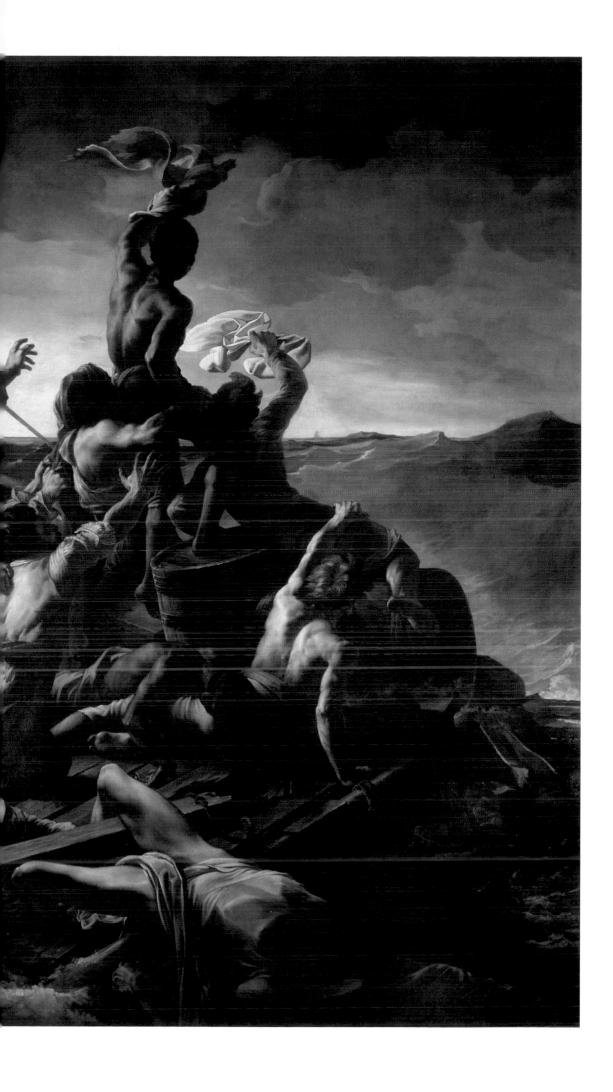

Théodore Géricault
(1791–1824)

22
*Head of a Man (called
Alexandre Corréard)* 1818

Oil on canvas
41.3 x 33 (16¼ x 13)
Curtis Galleries, Minneapolis, MN

23
*Portrait Study c.*1818–19

Oil on canvas
46.7 x 38.4 (18⅜ x 15⅛)
The J. Paul Getty Museum, Los Angeles

(overleaf)
24
*Study of Severed Heads c.*1818

Oil on canvas
50 x 61 (19¾ x 24)
Nationalmuseum, Stockholm

25
*Study of Truncated Limbs
c.*1818–19

Oil on canvas
52 x 64 (20½ x 25¼)
Musée Fabre, Montpellier

Although Géricault executed numerous preparatory drawings and figure studies for the *Medusa*, the limited number of oils suggests that, once he had finalised the general composition, he worked out most of the figures directly on the canvas. He did execute some portraits of his models. No.23, for example, has been identified as that of Joseph, a professional model who was used by Géricault for the figure signalling at the top of the painting. The sitter in no.22 was long thought to be Corréard himself, although the portrait is markedly different from the figure of the engineer in the *Medusa*. In the third edition of the narrative, the authors identify themselves, Corréard being the figure at the base of the mast pointing out the distant ship to Savigny.

22

Géricault also painted studies of heads and limbs in his own studio. Although none of these were used in the finished painting, Géricault was clearly engaging, at close quarters, with the death and decay that surrounded the raft survivors. The male head in no.24, which features in a number of studies, was obtained by Géricault from a prison-cum-lunatic asylum. According to Charles Clément, the female head was that of 'a little hunchback who posed in the studios'. As Lorenz Eitner has noted, this suggests that the study was completed from life but presented as from a corpse. The severed arm and legs in no.25 were painted by Géricault in several studies from different viewpoints. While no.24 might be described as grisly, no.25 transcends mere horror to achieve an aesthetic, sensuous quality that belies the macabre subject. Indeed no.25 is generally agreed to be the 'fragment de Géricault' that provoked Delacroix's celebrated response in 1857, in which he described the study as 'truly sublime' and 'the best argument in favour of Beauty, as it was intended'. CR

23

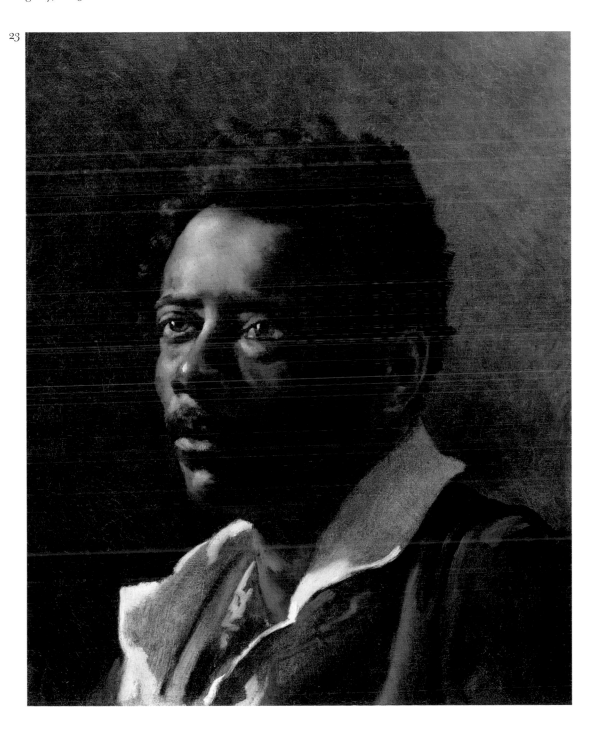

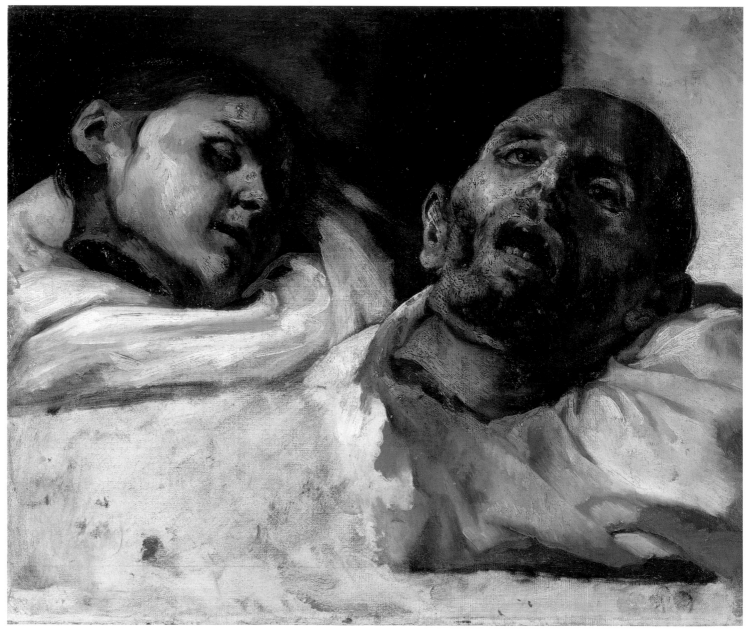

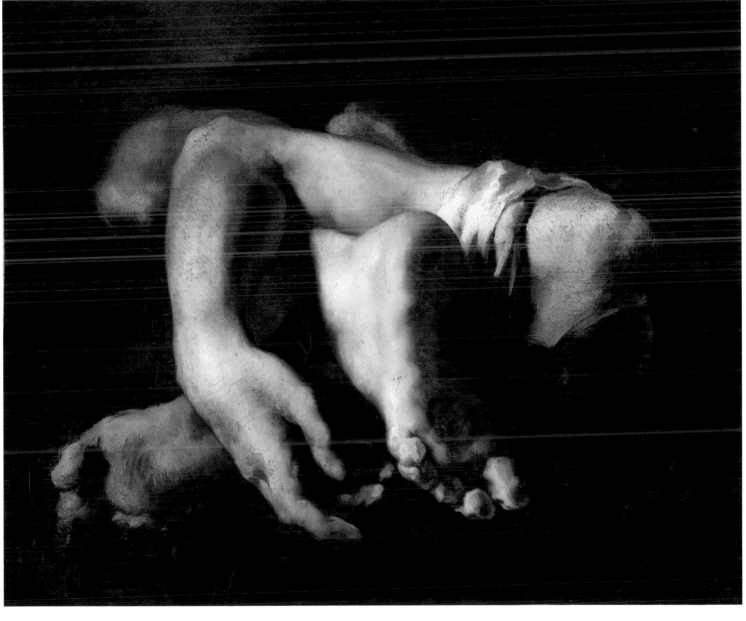

26
Moses Haughton,
after Henry Fuseli
Ugolino. Bereft of Tears I Inward Turn'd to Stone 1809

Etching, published 20 February 1809
51 x 37.5 (20⅛ x 14¾)
The British Museum, London
London only

27
Lord Byron (1788–1824)
Don Juan, Cantos I and II

First edition, London 1819
John Murray
London only [Not illustrated]

While developing his ideas for the final composition of the *Medusa*, Géricault executed a drawing concerning the outbreak of cannibalism. It was this aspect of the *Medusa* story that most horrified contemporaries and was therefore difficult to depict without provoking disgust. This may have swayed Géricault into selecting a less controversial episode. De Praviel's *Medusa* publication of 1818 described the survivors at the point of rescue, 'lying on the boards, hands and mouth still dripping with the blood of their unhappy victims, shreds of flesh hanging from the raft's mast'. No such details feature in Géricault's painting, suggesting that he sought both to elevate the subject and remove details that would compromise a sympathetic response towards the survivors.

Reviewers made connections between the *Medusa* and the story of Ugolino from Dante's *Inferno*. The *Globe* remarked that Géricault's 'personification of horror … baffles description; there is one figure of an old man, who still retains at his feet the dead body of his son, that is full of appalling expression. It is the very countenance of Ugolino's despair, which REYNOLDS pourtrayed [sic] with an effect finely forcible indeed.' Although the reviewer referred to Joshua Reynolds's *Ugolino* of 1773, Fuseli's depiction of the subject relates more convincingly to Géricault's figures and may have been known to him via the etching included here (no.26).

Ugolino was a loaded reference because of the suggestion in Dante's text that he resorted to cannibalism once his family had starved to death. In addition Ugolino tells his story to Dante while gnawing on the head of his imprisoner, which Byron alludes to in the shipwreck passage of *Don Juan* (Canto II, 1819):

If foes be food in hell, at sea
'Tis surely fair to dine upon our friends
When shipwreck's short allowance grows scanty,
Without being much more horrible than Dante.

In formulating the shipwreck passage, Byron made use of numerous voyage narratives including his grandfather Admiral John Byron's account of the *Wager* shipwreck (1768). It is possible, given the topicality of the *Medusa* disaster, that he also read Savigny and Corréard's narrative. Parallels can be drawn between the contemporaneous poem and painting, not least the shipwrecked being tricked by circumstance into false hope, leading to profound despair. Géricault must have anticipated the connection that contemporaries would make between Ugolino and the 'Father' figure, thus engaging with cannibalism by more subtle and compassionate means than Byron. The contrast between Géricault and Byron on this subject was noted by a British reviewer of the Paris Salon of 1819. 'Lord Byron', he observed, 'has striven to add to the anti-picturesque by the wantoness [sic] of his fancy; Mr. Gericault, in endeavouring to avoid this effect, has weakened the interest of the passage', a comment that suggests that Byron went too far but Géricault not far enough. CR

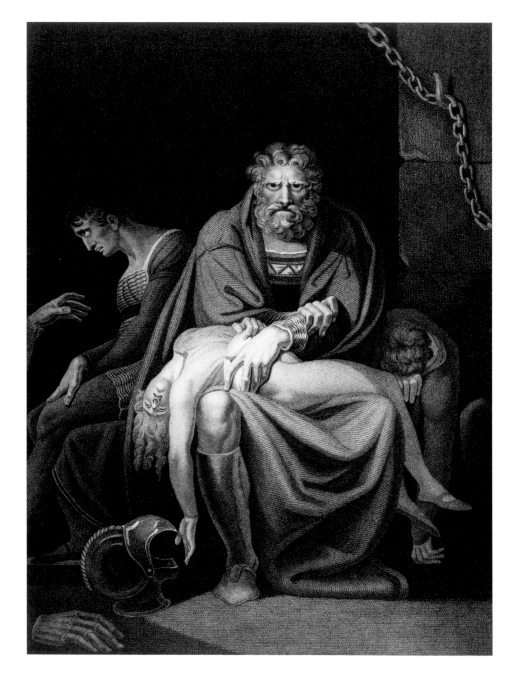

28
Francis Danby (1793–1861)
Sunset at Sea after a Storm 1824

Oil on canvas
89.6 x 142.9 (33 x 46¼)
Bristol Museums and Art Gallery

This picture, which established Danby's reputation, first appeared at the Royal Academy in 1824, where Danby had been exhibiting one major historical landscape painting each year since 1821. The *Literary Gazette* (19 June 1824) took exception to the 'violent opposition of light and colour' that 'not only offends against all within the neighbourhood of his [Danby's] station, but against truth and nature'. Its reappearance at the British Institution the following year guaranteed its exposure to the French painters who had travelled to London that summer to study the British school at first hand.

After struggling as a landscape and genre painter in Bristol, Danby moved to London encumbered by debt in 1824. The immediate sale of this picture to Thomas Lawrence presaged his election as an associate Royal Academician the following year. Danby himself recognised the public's 'rage for novelty', and to the next Royal Academy exhibition he sent a gigantic *Delivery of Israel Out of Egypt* (Harris Museum). Antagonism between Danby and John Martin exploded in 1826 when the former accused the latter of plagiarising his *Opening of the Sixth Seal* (National Gallery, Ireland) for the first version of Martin's *Deluge* (no.56).

Danby's *Sunset at Sea* appears to have been inspired by a verbal description of Géricault's picture. In December 1829, he wrote from Paris that Géricault's *Medusa* was 'the finest and grandest historical picture I have ever seen', and 'though I had never seen it in England I highly respected it for I had heard it described and most highly praised by a man of the first taste… I stored what he said of this picture up in my memory'. He later described the *Medusa* as 'awfully sublime, yet not an atom deviating from the truth to nature; indeed, its truth is its sublimity'. Danby returned to Paris in 1836 to find British art popular and his own reputation secure. Indeed, the critic Gustave Planche referred to Danby in his Salon reviews of the early 1830s as if he were a household name; however, as with Martin, the artist's works were familiar to French audiences primarily through prints. PN

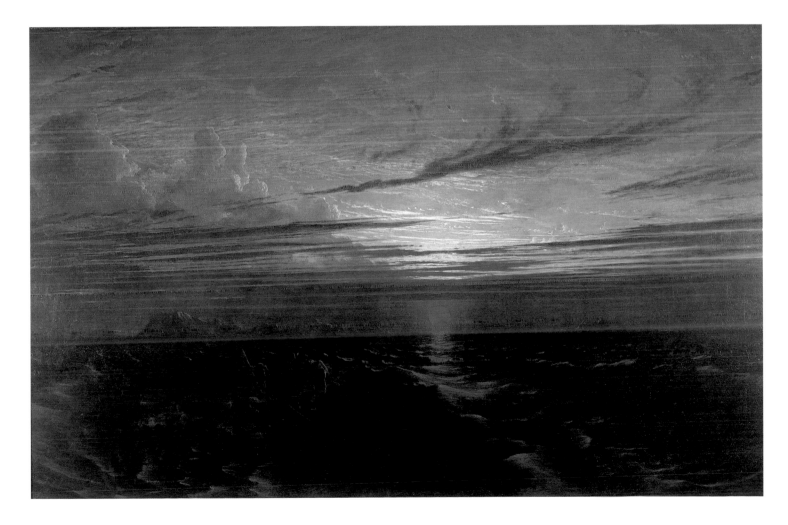

29
Horace Vernet (1789–1863)
Marine. Pirate Skirmish. Sunrise 1818

Signed and dated, lower right: *Horace Vernet 1818*
Oil on canvas, 72 x 103.2 (28¾ x 41¼)
References: Keratry, 1820, p.42; Jouy, *Vernet*, 1822, pp.50–3, 120; Thiers, 1822, p.104; Vatout, 1824, II, no.26; Vatout, 1826, IV, pp.307–8, no.117.
Art Gallery of Ontario, Toronto

Vernet was one of the most prolific, facile and diversified talents of his time. His supporters and detractors were equal both in number and intemperance, with their responses often aroused as much by political as by aesthetic considerations. The son of Carle (no.4) and grandson of Claude-Joseph Vernet, two of France's most renowned painters, his role as standard bearer for the new generation of Romantics was fully expected, especially after the death of Géricault, yet only for a very brief moment realised. Along with Géricault, he trained in the studio of his father. One of the pioneer lithographers, Vernet appears to have taught Géricault that medium. He was also an exceptional satirist and fashion-plate designer in the tradition of his other grandfather, J.-M. Moreau le Jeune.

As a staunch Bonapartist and liberal, Vernet's often blatant promotion of the Orléans interests and opposition to conservative Bourbon policy resulted in tensions with the ministry during the Restoration, including the exclusion of some his more politically sensitive pictures from the 1822 Salon. His popularity, family connections and prodigious output nevertheless garnered him the directorship of the French Academy in Rome from 1829 to 1834. His career was further secured by the patronage of King Louis-Philippe, for whom he became the principal military and political propagandist. Largely because of his vast battle commissions for Versailles, he earned Baudelaire's scathing assessment that his painting was not art. On the other hand, Stendhal's classic definition of Romanticism as an art form that takes for its subjects the men and mores of the times was exemplified in his comparison of Vernet's *Battle of Montmirail* (1824 Salon) to the improbable display of nudity and posture in David's *Abduction of the Sabines* (Louvre).

The description of this picture in the 1819 Salon catalogue explained the action simply as an Algerian launch under attack by Europeans, as the husband of an abducted woman endeavours to pull her back to safety. The rescue vessel with soldiers confirms that the atrocities had been committed on French shores. A Tunisian *chebek* fires its cannon in support of the marauders. Barbary Coast brigands, mostly equated with Arabs and working from the safety of Algerian ports, had been the scourge of Mediterranean trade for centuries. Only with the French conquest of Algeria in 1830 would the situation be ameliorated.

To the 1819 Salon Vernet submitted sixteen pictures of all classes of subject matter, except classical. Ten of those belonged to the Duc d'Orléans, who had purchased this marine from the artist in November 1818 for 2,000 francs. Géricault's *Medusa*, of course, also featured in the 1819 Salon, and although vastly different in scale, there are definite correspondences between certain figures in both pictures. One of Géricault's early conceptions was a representation of the mutiny on the raft that preceded the rescue of survivors. Vernet would have known those studies and was possibly inspired by them to treat his own version of a desperate combat at sea. Like Géricault's picture, Vernet's also had political implications as a comment on the impotence of the Bourbon government in dealing with attacks on its populace.

When Vernet's Bonapartist leanings resulted in two of his most important pictures being rejected by the 1822 Salon jury, the artist defiantly organised a private exhibition of fifty of his paintings in his rue des Martyrs studio. The exhibition was rife with subjects of left-wing interest. The catalogue by Etienne de Jouy and Antoine Jay, in their entry on this picture, harangued the government for negotiating with 'sea vultures' and for failing to send an army against the Turks.

On another level, Vernet's orientalism, like Delacroix's, was initially inspired by literature, and although this picture does not specifically illustrate Byron, its subject would have resonated with the many Parisian readers of Byron's *The Corsair* of 1814 (see no.184). In fact, Vernet's lithograph of 1819 based on *The Corsair* is the first recorded French illustration of the British poet. PN

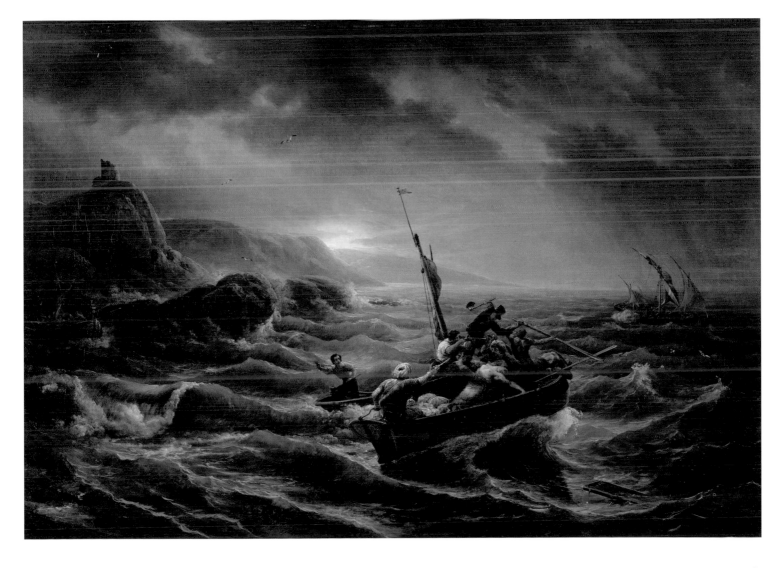

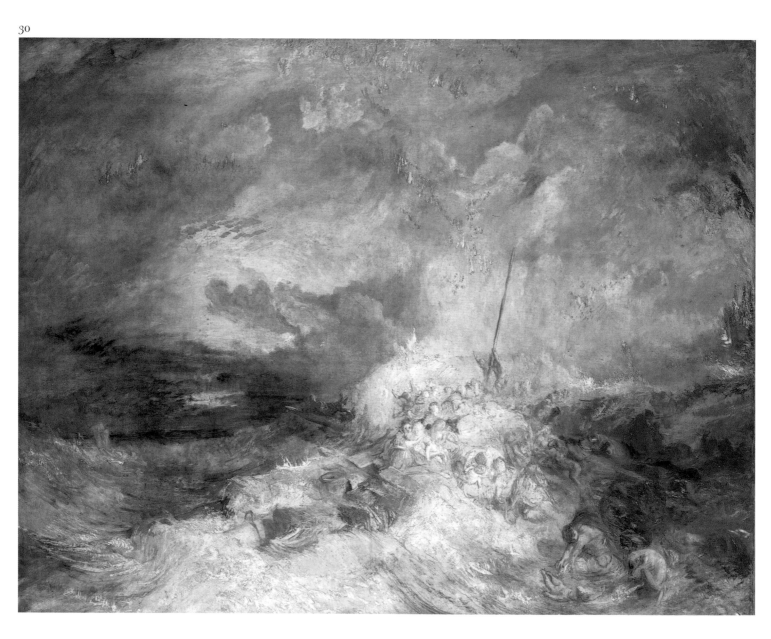

30
J.M.W. Turner (1775–1851)
A Disaster at Sea c.1835

Oil on canvas
171.4 x 220.3 (67½ x 86¾)
Tate. Bequeathed by the artist 1856

Turner was widely regarded as the greatest British painter of his generation. His professional standing was far higher than that of John Constable, and his achievement more complex and protean, by turns stunning and baffling colleagues and critics. Humbly born, the son of a London barber, he studied at the Royal Academy Schools from 1789 and was elected Academician in 1802. Having made his reputation as a watercolourist, his range as an oil painter embraced historical subjects ancient and modern, ideal and topographical landscape, marine and, in his later years, scenes of the modern industrial age that were instantly definitive. In style and colouring his work progressed from sombrely hued homages to European Old Masters – which he studied in the Louvre during the Peace of Amiens in 1802 – to vivid abstractions that at once expressed the Romantic spirit of innovation and anticipated Modernism. Among the most widely travelled of British artists, he depicted European scenery as well as Britain itself. Although a regular visitor to France, he did not develop the range of contacts that colleagues like David Wilkie, or even Constable who did not cross the Channel at all, were able to make, and struck the urbane Delacroix, whom he visited in Paris in 1829 or 1832, as resembling an English farmer. French visitors admired his work, especially in watercolour, in London, but were often dependent on graphic reproductions and sometimes mystified by his pictures in the original.

Along with many artists in London at that time, Turner probably visited the exhibition of

Géricault's *Medusa*. The dramatic pyramidal composition of the main group in no.21 suggests the influence of the painting, as perhaps does the subject itself. Indeed, the *Amphitrite* shipwreck off Boulogne in 1833 turns the tables in highlighting a British atrocity. During a storm, the ship's captain refused assistance from French rescuers, claiming that he was only authorised to land his cargo of female convicts in the Australian colony. In fact he feared that the women would escape once rescued, which would leave him financially liable. By nightfall the ship had broken up, resulting in over a hundred deaths.

A similar example of inhumanity is recorded in Turner's *Slave Ship* (1840). In 1783, the British slaveship *Zong*, bound for Jamaica, suffered an epidemic. The captain ordered the dead and dying to be thrown overboard so that he could claim the insurance. The exhibition of the *Slave Ship*, which caused a sensation at the Royal Academy, coincided with the first International Anti-Slavery Convention in London, by which point slavery had been abolished in Britain (1807) and emancipation achieved in the West Indian colonies (1833, 1838). Interestingly Albert Boime has suggested that the exhibition of the *Medusa* in London in 1820 was similarly timed to coincide with anti-slavery agitation. The new governor of Senegal had allowed the slave trade to resume in the colony, making it a focus for debate. Géricault had abolitionist sympathies (as did Corréard), a fact that is often quoted when interpreting the prominence of the black figure hailing the *Argus* in the *Medusa* painting. CR/DBB

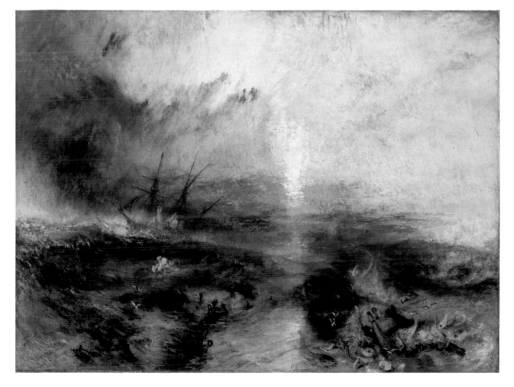

J.M.W. Turner

31

Anonymous
View of Bullock's Museum Better Known as the Egyptian Hall on Piccadilly 1815

Aquatint on paper
13.7 x 20.3 (5⅜ x 8)
Guildhall Library, Corporation of London
London only

32

Anonymous
Bullock's Museum Better Known as the Egyptian Hall, on Piccadilly 1810

Line engraving on paper
14.3 x 22.5 (5⅝ x 8⅞)
Guildhall Library, Corporation of London
London only

33

William Bullock *(fl.1795–1840)*
A Descriptive Synopsis of the Roman Gallery (in the Egyptian Hall, Piccadilly) ... Including the Picture of the Judgment of Brutus Upon his Sons, Painted by the President of the [French] Academy at Rome (M. Le Thiere) 1820

Pamphlet
The British Library
London only

31
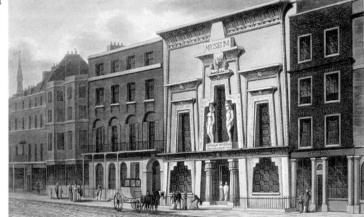

32
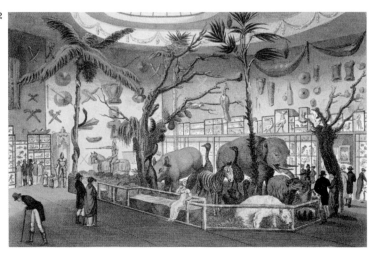

33
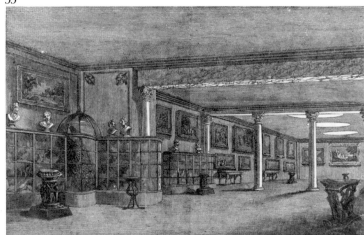

Thomas Rowlandson (1756–1827)

34

Exhibition at Bullock's Museum of Bonepartes [sic] *Carriage Taken at Waterloo* 1816

Etching on paper
23.2 x 33 (9⅛ x 13)
Guildhall Library, Corporation of London
London only

35

Mr Bullock's Exhibition of Laplanders 1822

Aquatint on paper
31.2 x 46.3 (12¼ x 18¼)
Guildhall Library, Corporation of London
London only

From 1816, the impresario William Bullock extended his permanent displays of fine art, antiquities, arms and armour, natural history, ethnography and other 'curiosities' (no.32) at the Egyptian Hall to include temporary exhibitions, beginning with Guillaume Guillon-Lethière's *Brutus* in the new Roman Gallery (no.33) and Napoleon's battlefield coach accompanied by his coachman, camp bed, travelling case and so on. The latter was a runaway success, with approximately 220,000 visitors in London (no.34).

As with the theatre world and other entertainment forums, Bullock also exploited the public's interest in voyages and explorations by showcasing distant civilisations, both ancient and modern. In 1822, for example, Bullock persuaded a family of Laplanders to come to London. Accompanied by a herd of reindeer, sledges and domestic implements, they were displayed in front of 'a panoramic view of the North Cape' at the Egyptian Hall (no.35). Fifty-eight thousand visitors came during the opening season. Panoramas (in common parlance 'panorama' came to mean any large-scale painted scene) were often employed as scene setters.

The Egyptian Hall was one of a few venues that could accommodate large-scale paintings. James Ward's gigantic *Allegory of Waterloo* was exhibited, for example, in 1821, and John Martin staged a one-man show in 1822. Haydon hired exhibiting space at the Egyptian Hall on a number of occasions. His exhibitions included *Christ's Entry into Jerusalem* (1820; fig.27), *Raising of Lazarus* (1823) and a one-man show in 1832 including *Xenophon* and *The Mock Election*. CR

34

35

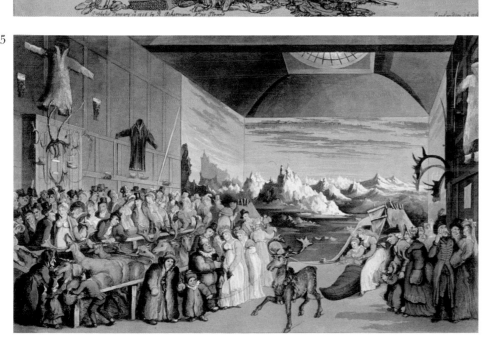

Léon Cogniet (1794–1880)
*A Woman from the Land of
Eskimos; Study from Life* 1826

Oil on canvas
42.5 x 36.5 (16¾ x 14¼)
Signed and dated, lower right: *Léon Cogniet /
1826*
The Cleveland Museum of Art, Bequest of
Noah L. Butkin 1980
Minneapolis and New York only

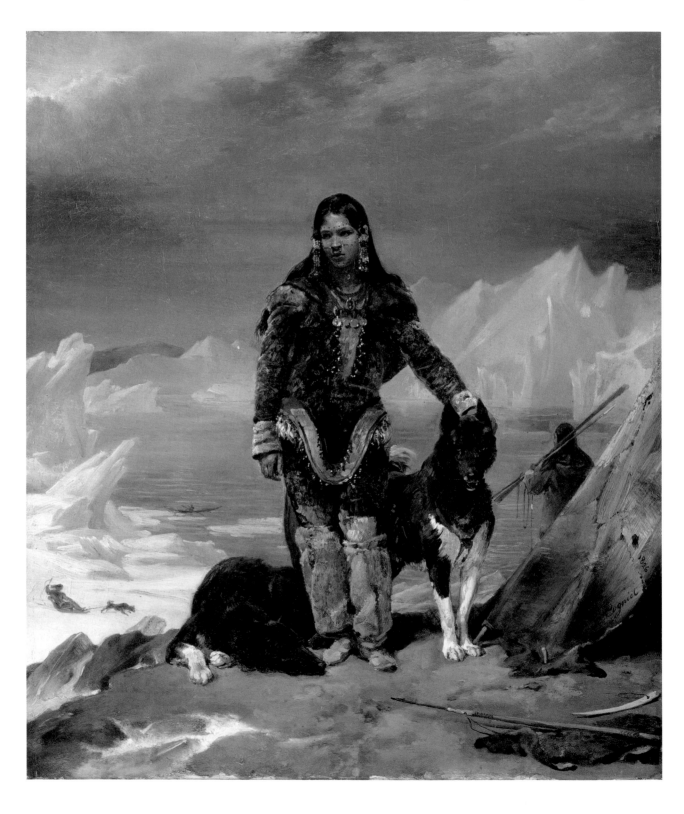

Like his friend Achille-Etna Michallon, with whom he travelled to Italy in 1817 as the recipient of the Prix de Rome for history painting, Cogniet exhibited at an early date a preference for accommodating the diverse tendencies of the art of the period to a middle ground or 'juste milieu' style. The banker Jacques Lafitte, whose tastes epitomised such eclecticism, purchased Cogniet's first masterwork, *Massacre of the Innocents* (Salon 1824) for an immense sum, only to trade it later for the overtly romantic illustration to Walter Scott's *Ivanhoe* (1828). Under the July Monarchy, Cogniet would receive numerous commissions for the grand history cycles in the Louvre and at Versailles, but in 1826 he had scarcely commenced his career.

The subject of this picture is curious for a classically trained artist manoeuvring for official recognition, yet it was precisely the exotic charms of the woman, enhanced by the artist's bravura brushwork, that so captivated Gros when the picture was first exhibited at the 1826 Galerie LeBrun exhibition. Cogniet gave the painting to Gros, but borrowed it back for the 1827 Salon. The subject was topical, for between 1821 and 1824 Captain William Parry's expeditions in search of a northwest passage were constantly in the Paris and London press, with regular features devoted to the lives and habits of the Eskimo.

On 12 May 1821, the *Literary Gazette* reported that the American Captain Haddock had brought to New York an Eskimo man, woman and child: 'Of these he made a show, and their exploits in a seal skin canoe.' By December 1825, the troupe was in Paris, having previously toured London and Europe, although by now reduced in number. The corpse of the recently deceased man, 'preserved in such a way as to still look alive', was to be displayed alongside that of a New Zealand cannibal chief. A Paris newspaper reported that the young woman 'did not have a repulsive face', and would both dance and sleigh with her dogs in front of an eighty-foot (24-metre) panorama of Baffin's Bay (Cleveland, 1999). This was unquestionably the same person portrayed by Cogniet from life sometime during the run of her performance at the Porte St-Martin in the spring of 1826.

The British were equally enamoured of such spectacles and, at Bullock's Egyptian Hall in 1822, there appeared a family of Laplanders, exhibited in their native garb with a group of reindeer before a painted view of the 'wild scenery of the north cape' (no.35). It was in this context that Géricault's *Medusa* was shown in London. PN

37

A Concise Description of Monsieur Jerricault's [sic] *Great Picture Representing the Surviving Crew of the Medusa French Frigate, After Remaining 13 Days on a Raft* [as exhibited in the Roman Gallery, Egyptian Hall, Piccadilly]

Pamphlet, London 1820
Tate Library
London only
[Not illustrated]

38

Description of Messrs. Marshalls's Grand Marine Peristrephic Panorama of the Shipwreck of the Medusa French Frigate, with the Fatal Raft

Pamphlet, Edinburgh 1820
Victoria and Albert Museum
London only
[Not illustrated]

39

William Moncrieff (1794–1857)
The Shipwreck of the Medusa; *Or, The Fatal Raft*
Royal Coburg Theatre playbill
for 19 June 1820

Victoria and Albert Museum
London only
[Not illustrated]

For important exhibits such as the *Medusa*, Bullock provided his visitors with a 'Description' at 6d. (no.37). With help from his friend Nicolas Charlet, Géricault produced a lithograph to accompany the text. He also hand-wrote some invitations to the private view. Both the *Medusa* description and the pamphlet that accompanied Messrs Marshalls's panorama (no.38) were prefaced with quotes from the poet Robert Southey and contained text based on Corréard and Savigny's narrative. That the final scene of the panorama was the first sighting of the *Argus*, rather than, for example, the survivors being rescued, suggests that Géricault's painting was of influence.

The panorama and Moncrieff's play underline the relationship between such entertainments and the theatre. The Royal Coburg Theatre playbill for 29 May described the staging as incorporating 'various Panoramic Views of the Ocean & Red Deserts of Zaara' and a 'View of the Raft sailing amidst Novel & Extensive Moving Scenery'. The Coburg's proprietors clearly sought to capitalise on the popularity of Géricault's painting by extending the play's run into late June. The theatre's play bill for 19 June, which announces the additional performances, also mentions 'the Great Picture now exhibiting in Pall Mall' (no.39). CR

Art on View
Expositions, Exhibitions and Salons

Patrick Noon

Any productive dialogue between the historically combative cultures of Britain and France required public forums in which artists could display their work and evaluate their competition. Ready access to private collections and artists' studios also facilitated more refined appreciation. In the nineteenth century, such opportunities increased as travel became commonplace, and the commercialisation of the art world advanced in both countries. At the summit of opportunities were the exhibitions sponsored by the national academies. The Paris Salon of living artists, staged in the Louvre, had the longest continuous tradition of exhibitions dating from the seventeenth century, but the schedule was erratic. Whether it would be biennial or triennial was anyone's guess before its regularisation as an annual event in 1833. Thus, the opening of the 1824 Salon was delayed inexplicably until the autumn, while the 1826 exhibition materialised only in November 1827. The July Revolution negated the 1830 presentation and, until the eleventh hour, the 1831 show was in doubt. While frustrating, such irregularity did generate a palpable excitement around the event. As Eugène Delacroix sniffed in the autumn 1827: 'painting is in the air, and everyone who wields a palette hastens to finish. The models are hard pressed, and the colour merchants delight in this Bacchic furor.'[1] At the Salons, medals were dispensed and reputations elevated (fig.30). The state purchased paintings for its regional museums and churches, and the monarch commissioned works and projects for the royal dwellings and the Luxembourg Palace, a permanent gallery of modern French art without parallel in London, although the National Gallery, founded in 1824, would offer some modern British pictures (no.89).

In contrast to France, when Delacroix first arrived in England in 1825, he observed that it was 'a country overflowing in gold', and that it sustained a system of lucrative patronage based on fair competition in the public arena with virtually no government intervention. He was referring not to the Royal Academy of Arts, founded in 1768, which held its annual exhibition of contemporary art at Somerset House under the aegis of the king, but to the many organisations of connoisseurs and artists that had been freely instituted to contest the hegemony of the Academy. These included the British Institution and the Society of Painters in Watercolours, both chartered in 1805 and sponsors of annual exhibitions, and the Society of British Artists, formed in 1824. Delacroix, Richard Parkes Bonington and Alexandre-Marie Colin first exhibited in London at the British Institution, which welcomed foreign artists. These models Delacroix and others in Paris apparently desired to imitate.[2] He was encouraged in March 1826 by Thales Fielding who wrote from London, 'you are right to start a special exhibition, as two or three years is too

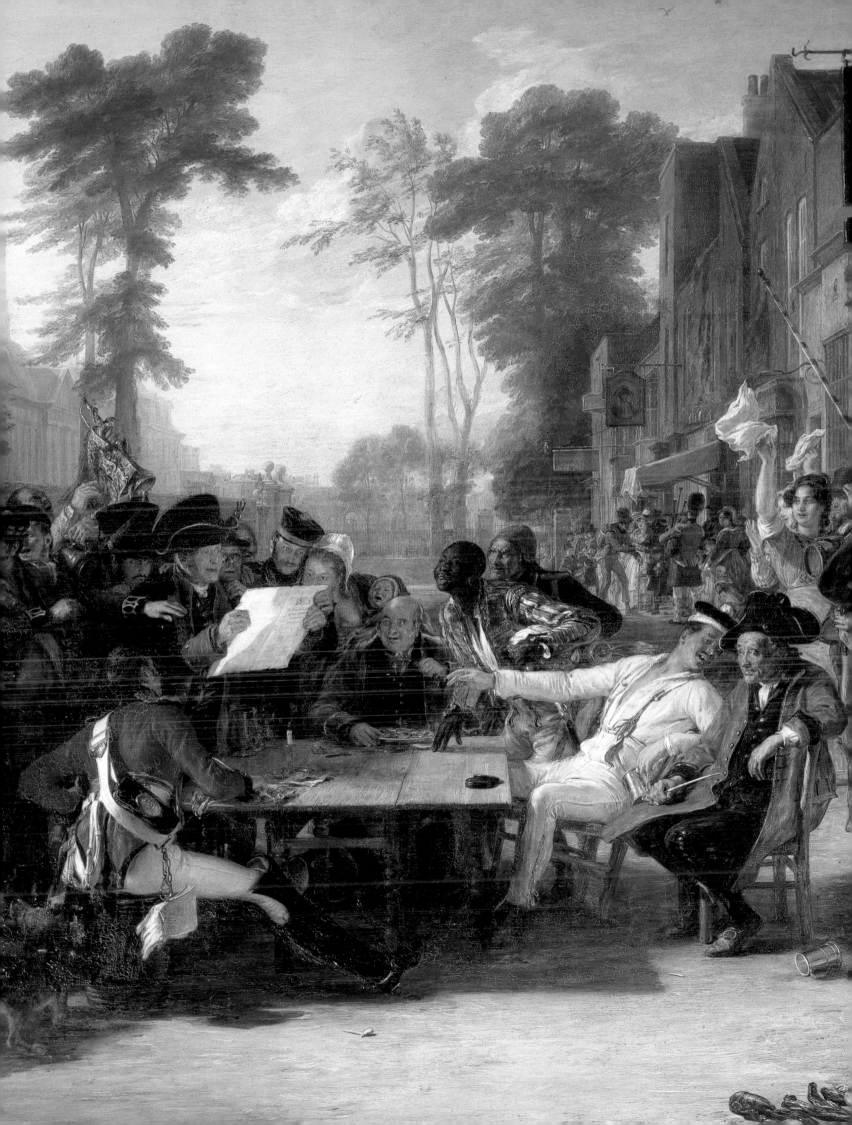

long a wait for publicly displaying works on which your livelihood depends'.[3] The risk of painting exclusively for the unpredictable Salons and their petulant juries had been well demonstrated by Théodore Géricault's failure to sell *The Raft of the Medusa* to the French government during his lifetime.

A formal association of French artists would not materialise for decades, although an alternative venue to the Salon did open at the Galerie Lebrun in May 1826 in the form of a benefit exhibition supporting the Greeks besieged at Missolonghi. Delacroix wrote in April that the event would accustom the public to paying for their aesthetic stimulation. In his initial review, Louis Vitet, the critic for the *Globe*, accused the culture ministry of cancelling the official Salon because it perceived as politically dangerous the adherents of Romanticism, who had triumphed in 1824. 'The Salon', he wrote sarcastically, 'compromises the maintenance of discipline and passive obedience among artists. Allowing them to exhibit furnishes them a livelihood ... When one earns income and is not wanting, one is not easily governed, one achieves independence like the industrialists ... This Greek exhibition signals a veritable schism between our best painters and the official protectors of their art; it is the model for a new salon.'[4] Vitet exaggerated the significance of the

fig. 30

event but not the underlying strife, and in the summer of 1827 Auguste Comte de Forbin, director of the royal museums, would press the king's minister of fine arts to follow the examples of the British and establish an annual Salon for the good of both the artists and the public.[5]

Charles Paillet's Galerie Lebrun was generally reserved for the Société des Amis des Arts and special exhibitions. The society was reconstituted in 1817 and, by 1819, six hundred shareholders were contributing one hundred francs annually for the privilege of membership. Three-quarters of the subscriptions were reserved for purchasing works of art, many from the Salons, which were subsequently exhibited by the Société and raffled to the shareholders. Another quarter of the funds commissioned two engravings after national masterpieces, impressions of which went to each shareholder. Over the decades, the vast majority of these prints were troubadour and genre themes.[6] Because it was largely composed of private collectors intent on making art affordable, and the preferred form of reproductive print – line engraving – was the most time consuming, the society wittingly or not promoted cabinet painting and populist subjects, with classicism confined to mildly erotic and non-esoteric scenes of mythological lovers. During the 1820s, the watercolours of Bonington and William Wyld

figured prominently in the society's list of acquisitions. The Art Union of London, founded in 1836, and its progeny the American Art-Union of 1840, were based on the successful formula of this French association. In France, similar societies rapidly proliferated in the provinces – Lille, Arras, Valenciennes, Douai and Cambrai – where they sponsored regular exhibitions of modern art. Some of the centres, Lille for instance, eagerly invited celebrated British contributors like John Constable and Thomas Lawrence to stir things up.[7] Scores of British and French artists who promoted *la style anglaise* rallied to these provincial exhibitions.

Fine arts dealers in Paris and London were open to speculation. The publisher of lithographic suites, Henri Gauguin, assembled nearly three hundred modern paintings for exhibition in 1829 and repeated that feat in 1830. When Gauguin acquired in 1828 the elegant Galerie Colbert for mounting temporary exhibitions, an essayist for the periodical *La Mode* distinguished between French *Expositions* and British *Exhibitions*: 'The first imply something free, general, official, the second have necessarily for their end private speculation.'[8] Indeed, Gauguin's ambition was to sell easel pictures by internationally recognised younger artists to private collectors and to profit further from admission fees. Among his British exhibitors were Bonington, Wyld and Constable. As with the Société des Amis des Arts, the prevailing taste was for 'British' anecdotal and landscape subjects, which paralleled developing trends in the official shows.

In the same year that Gauguin commenced his project, William Hobday opened his Gallery of Modern Art in London's Pall Mall with a show of British masters,[9] augmented in the summer by French pictures. This 'exhibition of novel character', to quote an *Athenaeum* correspondent, included 175 paintings. Horace Vernet was well represented by pictures of British theme, such as *Mazeppa and the Horses* and his immense *Edith Discovering the Body of Harold After the Battle of Hastings* (fig.32). The last a French observer described as 'painted quite *à l'anglaise*, that is to say, with an utter disregard of finish in all the minor parts'.[10] Delacroix exhibited *Faust and Mephistopheles* (fig.8), *Greece on the Ruins of Missolonghi* and *Combat Between the Giaour and Hassan* (nos.8, 76). Also represented were Eugène Isabey, Léopold Robert, the Comte de Forbin and Ary Scheffer. Since a number of these pictures eventually found their way to Gauguin's gallery, it is possible that he and Hobday were collaborating in their respective enterprises, neither of which survived the 1830 revolution.

In London, there were numerous opportunities to view artworks through dealers like Dominic Colnaghi, but also in the establishments of the dynastic printmaking families: the Cookes with their many J.M.W. Turner projects and frequent exhibitions; the Landseers, who were accomplished painters

fig. 31

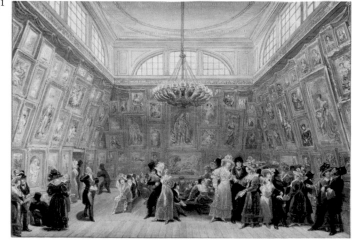

fig.32

Horace Vernet
Edith Discovering the Body of
Harold After the Battle of Hastings
1827
Oil on canvas
Musée Thomas Henry, Cherbourg

fig.33

Benjamin West
Destruction of the Beast and the
False Prophet
1804
Oil on panel
Minneapolis Institute of Arts

fig. 32

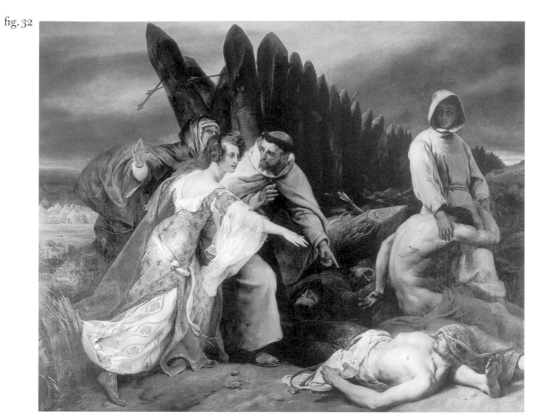

fig. 33

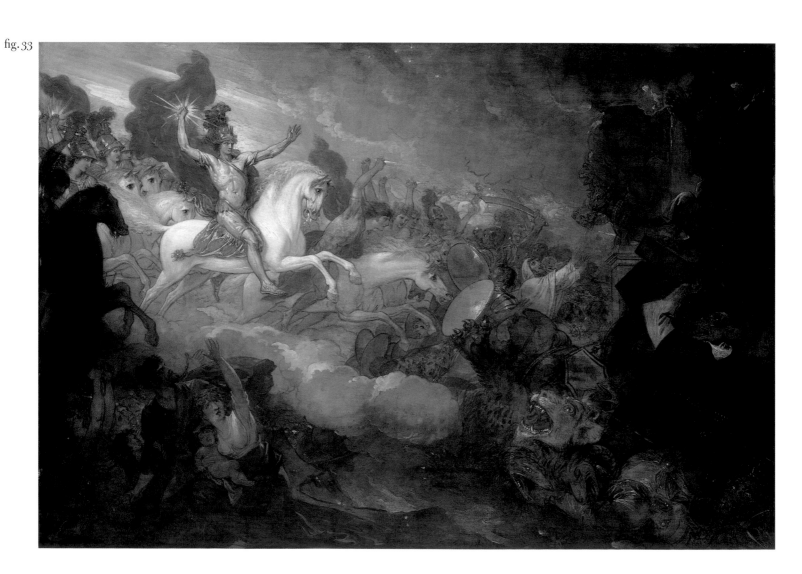

in their own right; or the Fieldings, whose activities straddled the Channel. Commercial speculation was rife at William Bullock's Egyptian Hall, erected in 1811 and the site chosen by Géricault for the presentation of his *Medusa* in 1820. Benjamin Robert Haydon's immense history paintings were regular Bullock attractions, and Louis-François Lejeune (1775–1848) exhibited twelve monumental French battle scenes there in 1828. Bullock's artistic ventures, marketed with sensationalist verve, co-mingled with the truly vulgar and exotic, and such spectacles did little to assuage French preconceptions of a gross materialism pervading the British art establishment. Nevertheless, the commercial advantages of exhibiting in London seduced even David, who rented the galleries of the Society of Painters in Watercolours to display a version of his immense *Coronation of Napoleon* (fig.2) in the winter of 1822.

For French artists with the resources to travel, London offered a banquet of cultural events in the 1820s. Delacroix would later recall: 'I passed my time in London in the midst of enchantments that offer an ardent young man the combination of a thousand masterworks and the spectacle of an extraordinary civilisation'.[11] The years during which Géricault resided in London, Bullock exhibited James Ward's gigantic *Allegory of Waterloo*, and Haydon's *Christ's Entry into Jerusalem* (fig.27). Nothing could better demonstrate the gulf separating British and French monumental painting than the juxtaposition of those pictures with the *Medusa*. In addition to the annual exhibitions, Géricault would have visited private shows of the paintings of Haydon, Thomas Lawrence, Benjamin West (fig.33) and his compatriot Jean-Baptiste Isabey, who was a successful portraitist in England. The most princely collectors, Sir John Leicester, Earl Grosvenor, the Marquis of Stafford, John Julius Angerstein, Walter Fawkes and Thomas Hope, admitted the public to their private collections during the high season. In Paris, there were fewer such opportunities, although the galleries of the Duc d'Orléans, the Duchesse de Berry, Lord Henry Seymour and Alexandre du Sommerard were accessible to foreign visitors. Baron Gérard was always a munificent host. With the exception of Horace Vernet, who was determined in 1822 to make a political statement and had the financial wherewithal to pursue that end, artists' private exhibitions were rare, although their studios were generally open to colleagues and amateurs. Typically, French collectors made the rounds of the studios or relied on a handful of experts to locate pictures for them. In the 1830s, the younger artists refused by the Academy-appointed Salon juries found welcome exhibition space in the ateliers of established painters like Scheffer.

Since venues for displaying British art in Paris were limited, the Salons remained the most viable conduit to the French public. The 1824 Salon, subsequently eulogised as the 'British Salon', offered the largest assembly of British painting in France to date. The sudden sympathy for British art was due largely to the inestimable role played by French dealers. Ample documentation has recorded the efforts of a group of loosely connected picture dealers, prescient of the impact that British art would have in France, who engineered the foreign presence in the Louvre galleries. The Comte de Forbin certainly acted officially in expediting customs clearance for many of the last-minute overseas entries. His entreaties to David Wilkie to participate were politely declined by the Scottish painter in July, although he agreed with the count's opinion that 'the arts are cosmopolitan and flourish independent of national biases'.[12] But the dealers were the primary agents and their motives were no less profit-driven than those of their colleagues in London. On the advice of Géricault and Charles Nodier, John Arrowsmith travelled to and from London negotiating the purchase of Constable's paintings for the 1824 Salon. The more diplomatic Claude Schroth, who also purchased pictures directly from Constable and other British artists that summer, would subsequently manage the auctions of many of the most important collections of Anglo-French art, including that of Louis Joseph-Auguste Coutan in 1830, and the dissolution of the modern picture dealer Madame Hulin's inventory in 1834. As advisor to the Duchesse de Berry (fig.46), Schroth undoubtedly also contributed to the patronage of British artists by that staunch Anglophile. Other dealers who trafficked in British paintings in the 1820s had mixed success. The painter Louis Auguste Gérard closed his gallery in 1827 for financial reasons, while Alphonse Giroux, whose premises had opened in 1801, boasted an inventory of predominantly modern art approaching one thousand pictures in 1827. Several print publishers, including J.-F. d'Osterwald, formed an establishment in the same year that would eventually become the famous French house of Goupil et fils.[13]

Although British works constituted only a fraction of the publicly exhibited paintings in Paris during the 1820s, they nevertheless ignited in those years a heated comparative analysis of the two cultures, while functioning as a rallying point for a French school of painting both divided and in transition. Virtually all of the pictures in this section were exhibited, in many instances together, at one of the major exhibition venues in either Paris or London. Many are icons of Romanticism. Most were the subject of the rigorous analysis and comparisons that defined the critical debate on modernism for subsequent generations of artists.

40
John Constable (1776–1837)
The White Horse 1819

Oil on canvas
131.4 x 188.3 (51¾ x 74⅛)
Signed and dated, lower left: *I C John
Constable London. F. 1819*
References: For contemporary British reviews,
see Ivy, 1991, pp.79–83, 113; *Echo du Nord*
(8, 13 Nov. 1825), p.3; *La Mémorial de la Scarpe*
(14 Aug. 1827), p.386; *Journal du Département
du Nord* (12 Sept. 1825), p.2; Chenou, 1827,
pp.80–2.
The Frick Collection, New York

Throughout 1825, Constable's reputation in Paris soared thanks to the steady stream of pictures he sent to John Arrowsmith, who maintained a 'Constable room' in his establishment, and to Claude Schroth, whose gallery was a rendezvous for modern painters. Visitations continued, and in November Constable received the artists Henri Monnier and Eugène Lami (no.63), who were in London. *The Hay Wain* apparently sold at this time for £400, although it has never been established to whom, but the generous price did not forestall Arrowsmith's bankruptcy the following spring, when he was forced to liquidate much of his stock. This effectively terminated Constable's commercial link to Paris although, according to R.B. Beckett's calculations (*Constable*, p.210), there would have been at least twenty-two Constable paintings in French collections into the 1830s as a result of the commissions in the mid-1820s. In addition to the dealers, examples were owned by Jacques-Auguste Régnier, a landscape painter; Firmin Didot, the famed printer; Coutan (no.5); and the aristocrats Vicomte de Thulusson and Marquis Chaudéon de la Valette.

There was no Paris exhibition in 1825, but the organisers of a provincial Salon at Lille lobbied the now celebrated painter for artwork. Their agent in London arranged for the shipment of two Constables in August. One was *The White Horse*, then belonging to Archdeacon John Fisher. Together with Lawrence, who sent a portrait of a gentleman, Constable again received a gold medal and considerable coverage in the local press.

Dating from 1819, this is the first of Constable's six-foot (1.8-metre) views along the River Stour, painted specifically for exhibition at the Royal Academy and entirely in the London studio. It is also the first for which the artist felt compelled to execute a preparatory oil sketch of the same dimensions. The view is towards Willy Lott's house just below Flatford Lock. Fisher's nickname for the picture, 'Life and the White Horse', alludes sardonically to perhaps the most famous history painting then in England, Benjamin West's gigantic *Death on the Pale Horse*, the final version of which was on view for much of 1818 in rooms rented by West in Pall Mall, but it also hints at Constable's ambition in tackling naturalistic landscape painting on a grand scale.

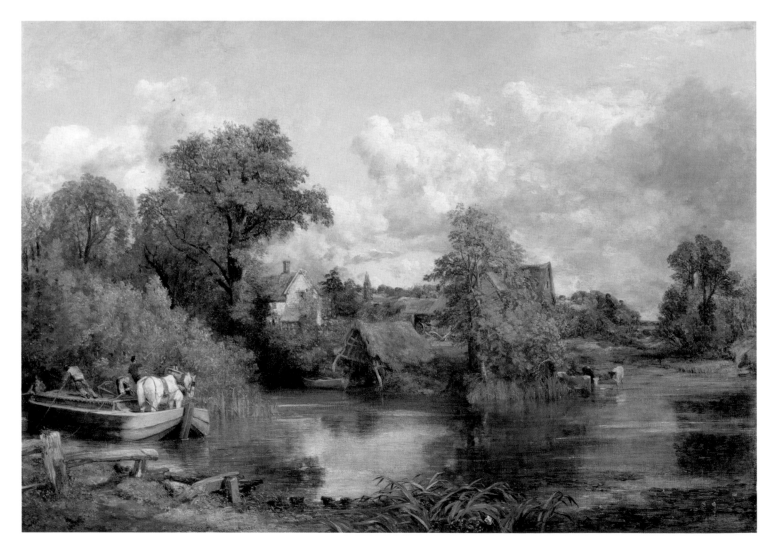

When first exhibited in London, *The White Horse* prompted Robert Hunt to write in the *Examiner* that Constable, as opposed to Turner, 'does not give a sentiment, a soul to the exterior of nature … but he gives her outward look, her complexion and physical countenance with more exactness'. This was intended as a compliment, although the same characterisation would be levelled by French critics in 1825 as the most severe censure. Delacroix saw this painting at the British Institution during his London visit that summer, when Constable is supposed to have told him 'that the superiority of the greens in his meadows resulted from their being composed of a multitude of different greens. What caused the defect of intensity and life in the greens of our landscapists is that they are made from a uniform tint' (*Journal*, 30 September 1846). This was one of the secrets of Constable's colouring that Delacroix had probably already deduced in 1824. PN

41
Richard Parkes Bonington
(1802–1828)
French Coast with Fishermen
c.1825

Oil on canvas
64.1 x 97.2 (25¼ x 38¼)
Private Collection

This brilliant *mélange* of genre and marine landscape introduced Bonington to his English audience at the British Institution in February 1826. Until then, he had been virtually unknown in his native country. During his unheralded visit to London the previous summer, he had surmised the prevailing taste for genre and landscape, and the coast scenes submitted to the 1826 exhibition found immediate buyers in two of the governors of the British Institution, the Countess de Grey and Sir George Warrender. They also prompted commissions from two other governors, the Marquess of Lansdowne and the Earl Grosvenor.

Entrenched in the Bonington myth is the anecdote that the pictures were mistaken by the London press as the work of William Collins (no.90), who painted similar subjects; however, the first published review in the *Literary Gazette* (4 February) made no such error in reporting authorship: 'Who is R.P. Bonnington [*sic*]? We never saw his name in any catalogue before and yet here are pictures which would grace the foremost name in landscape art. Sunshine, perspective, vigour; a fine sense of beauty in disposing of the colours, whether in masses or in small bits; – these are extraordinary ornaments in the rooms.'

Such was the stunning success of this first debut that within two weeks of the exhibition's opening, the librarian to Lord Holland passed on the advice of Augustus Wall Callcott that his master and the Sixth Duke of Bedford, then travelling in France, should 'go to the atelier of an English artist at Paris, a Mr. Bonington … who is making a great deal of money there by small landscapes, I think which are in great request among the Parisians' (Ms. Letter, British Library). The Duke of Bedford responded quickly by purchasing one oil and commissioning a second, which later figured in the 1827 Royal Academy exhibition. PN

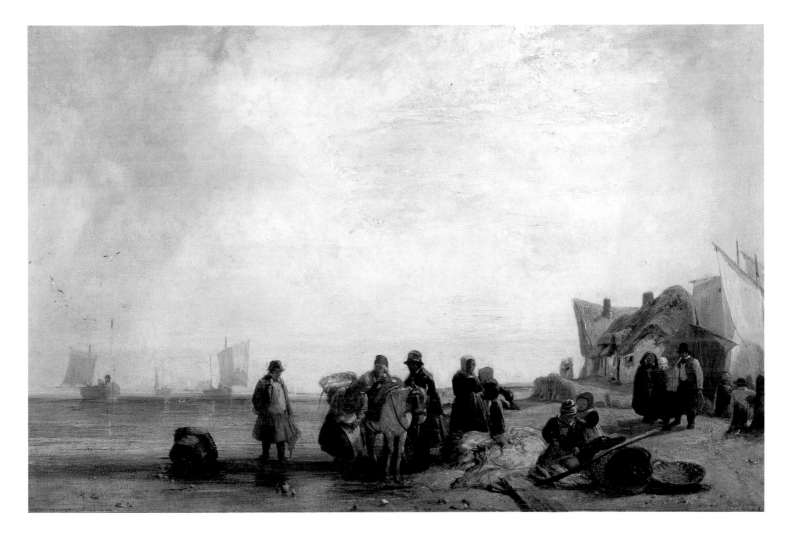

42

Louis-Jacques-Mandé Daguerre (1787–1851)
Ruins of the Chapel at Holyrood by Moonlight 1824

Oil on canvas
211 x 257 (82 x 103)
References: *Salon* references are to the
untraced version: Delécluze, Salon 1824
(5 Sept. 1824); Anon., *Drapeau Blanc*, 1824
(24 Sept. 1824), p.4; Mély-Janin, 1824
(17 Oct. 1824), p.3; Thiers, *Salon* 1824
(19 Oct. 1824), p.4; *Oriflamme*, 1824, II,
pp.82 ff.; Jal, *Salon* 1824, pp.238–40.
Board of Trustees of the National Museums
& Galleries on Merseyside (the Walker,
Liverpool)

Daguerre's earliest training as an architectural draughtsman and opera set designer admirably prepared him for his career as an impresario of populist spectacles: first, as assistant to the panorama master Pierre Prévost; next, as the partner of another Prévost protégé, Charles Bouton, in the invention of the diorama; and finally, as the discoverer of the first photographic process in 1837. The Paris Diorama, which he opened in July 1822, was so successful that Daguerre entrusted his brothers-in-law, John and Charles Arrowsmith, with establishing a London branch in Regent's Park, which opened to the public in September 1823. Additional houses rapidly emerged in Liverpool, Manchester, Dublin and Edinburgh. The changing displays originated in Paris, with Bouton and Daguerre sharing equal responsibility for the artistic programme.

The diorama was the ultimate form of optical deception. Immense 14 by 21-metre (45 by 70-foot) pictures, dwarfing even Géricault's *Medusa*, were painted on transparent linen and lit from both the front and rear, making it possible to transform the picture over a period of approximately fifteen minutes by altering the colour and the direction of the illumination onto this surface. Live animals and other props were sprinkled about the proscenium to enhance the illusion of reality. Amazed audiences were transported to the most magical and remote locales.

Both the Paris and London establishments offered two concurrent dioramas. Invariably, one was a landscape and the second an architectural interior, which allowed for dramatic contrasts of light and shadow and often phantasmagorical effects. Daguerre's *Holyrood Chapel* was one of the earliest architectural dioramas, which opened in Paris in October 1823 before moving to London for most of 1825, then to Liverpool, Dublin and Edinburgh, where it closed in May 1830. Holyrood House in Edinburgh had special resonance for the French in both remote and more recent history. It was the site of the many misfortunes of Mary Queen of Scots in the sixteenth century. It was also the home in exile of Charles X and Louise Polignac, Duchesse de Grammont, who died there in 1803. The two principal special effects of Daguerre's subject were the gradual appearance of moonlight followed by the mysterious emergence of a mourning female, the 'Comtesse de L', who places a lamp on the tomb of her friend, the Duchesse de Grammont.

A second easel version, which included the figure of the Comtesse de L, appeared at the 1824 Salon and garnered Daguerre the Légion d'Honneur from a grateful Charles X. Eric Adams (*Danby*, p.75) claimed that this diorama was seen by Danby in London and inspired his *Sunset Through a Ruined Abbey* (Tate). Daguerre's influence might also be claimed for the cavernous interiors of Delacroix's *Murder of the Bishop of Liège* and *Interior of a Dominican Convent* (no.60). PN

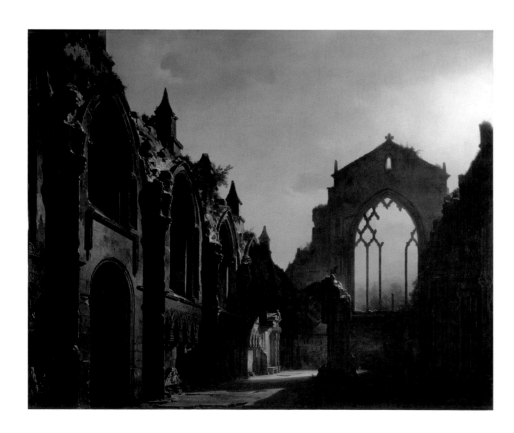

43
Achille-Etna Michallon
(1796–1822)
Landscape Inspired by a View of Frascati 1822

Oil on canvas
127 x 171 (50 x 68)
Signed and dated, lower left: *Michallon / 1822*
Musée du Louvre, département des peintures

Like Richard Parkes Bonington, Michallon died prematurely of a lung ailment, several weeks shy of his twenty-sixth birthday. Had those two artists survived the decade in which they began to dominate the emerging school of French landscape painters, the history of that school might well have had an entirely different complexion. Michallon was immersed in the Parisian establishment, studying with both Jacques-Louis David and Pierre-Henri de Valenciennes. About 1812, he entered the atelier of Jean-Victor Bertin, paragon of the classical landscape tradition.

So as to afford landscape painting a moral imperative and stature, the Academy proposed in 1815 that the government establish a *Prix de Rome* for landscape similar to that already in existence for history painting. The winner would be a government pensioner at the Villa Medici for four years. The initial competitors in 1817 numbered Michallon, his atelier associates François-Alexandre Pernot and Jean-Charles Rémond, François-Edmé Riçois, Antoine-Félix Boisselier (no.137) and Paul Delaroche (no.55). The examination was tripartite. The first stage required the execution of an *esquisse* or sketch for a historical landscape. The second, the *Concours de l'arbre*, lasted six days, during which the contestants painted, from memory, a picture that featured a tree as its dominant motif and a narrative subject in which the figures had to be 'at least four inches in height'. The final stage of this torturous and inflexible process was the painting of a finished historical landscape, the subject determined by the jury. Michallon's 'tree' exercise, *A Woman Struck by Lightning*, and his principal entry,

Democritus and the Abderites, have both survived. Michallon routed the competition, with Boisselier finishing a distant second. In December 1817, he began four years of intense study in Italy. After returning to Paris, he opened his studio in January 1822 to students, including Camille Corot. The following summer the artist succumbed to pneumonia.

During his brief career, Michallon exhibited eleven paintings at the Paris Salon, all historical landscapes, with the exception of this souvenir of Frascati, a pastoral landscape acquired for Louis XVIII at the 1822 exhibition. As Pomèrade has observed (1994, p.157), it differs little from Corot's 'Souvenirs' in its synthesis of a naturalist sensibility and of the poetic reverie so much vaunted in academic theory. Although similar to Bertin or Boisselier in his academicism, Michallon was consistently more sensitive to natural phenomena, especially light. It should not surprise that Corot actually copied this picture about 1830 when he too was grappling with similar issues. Despite his prominent position among the rising artists of the academic camp, Michallon's critical fortunes were mixed. For the ultra-conservatives like Delécluze, in search of a new Poussin or Claude, he was too realistic, and for the new generation enchanted by the example of British and Dutch naturalism, his compositions were too ideal. PN

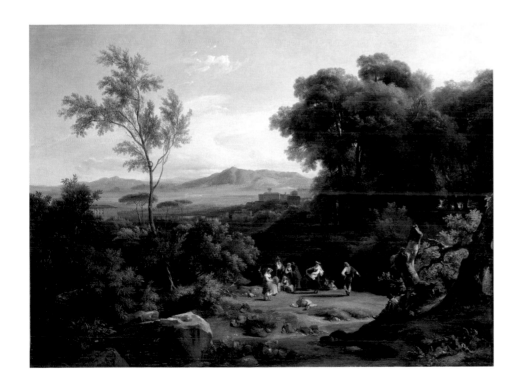

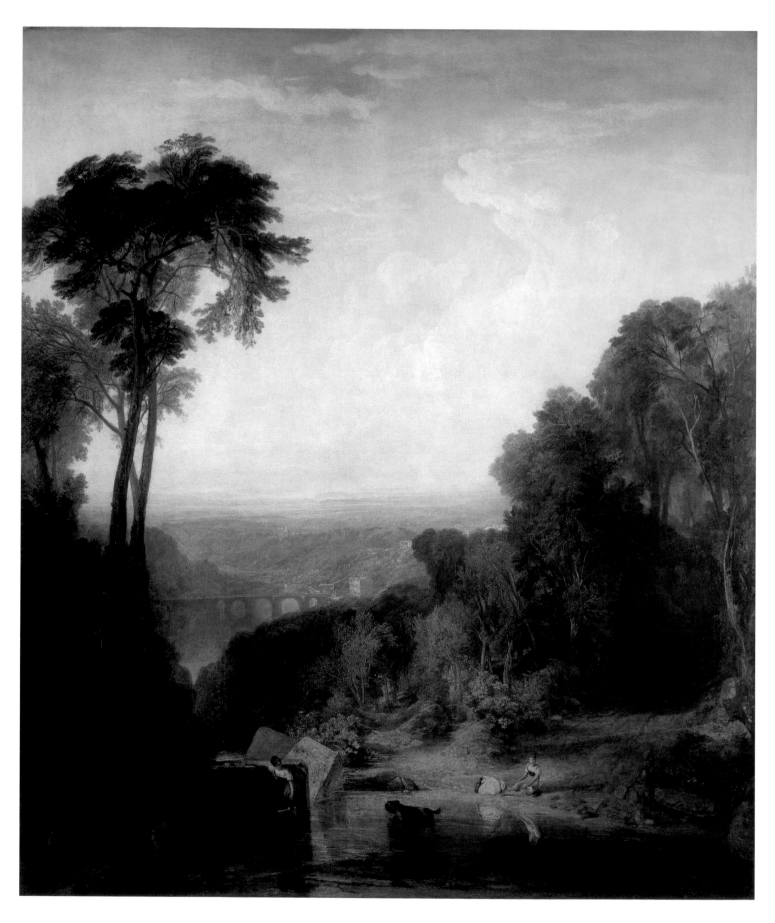

44
J.M.W. Turner (1775–1851)
Crossing the Brook exh. 1815

Oil on canvas
193 x 165.1 (76 x 65)
References: for contemporary reviews see
Butlin & Joll, *Turner*, p. 93, no. 130; Farington,
Diary, 5 June 1815.
Tate. Bequeathed by the artist 1856

Exhibited at the Royal Academy in 1815, this picture was one of Turner's most impressive essays in the style of classical landscape originating with Claude, the French Old Master whose works were most admired and collected in Britain. A view towards Plymouth Sound from the River Tamar , and based on drawings made on a Devon tour in 1813, it gives the English scenery a decidedly Italianate character in every respect save its lighting and colour, still relatively cool in contrast to the higher key of the pictures Turner painted after seeing Italy for the first time in 1819.

The title, as suggested by Eric Shanes, may have been borrowed from Joshua Reynolds's picture of the same name shown in the retrospective of his work at the British Institution in 1813. Reynolds had been born in Plymouth. While it perfectly fits the subject, in which two girls – supposedly Turner's daughters – wade through a stream, it also perhaps suggests a bridging of the English landscape and European cultural traditions that was again possible after Waterloo.

Turner's evocations of Claude were contested territory among critics and connoisseurs in Britain. While many admired them as triumphs of the national school, proof that it could now compete with the greatest masters, conservative observers believed they departed too far from their model and, as Turner grew older, others felt that they were becoming old-fashioned. This picture was attacked for '*pea-green* insipidity' by the connoisseur Sir George Beaumont (Farington, *Diary*, 5 June 1815). Although otherwise widely praised in the Academy, it did not sell, being returned to the artist, who showed it again in his own gallery in 1835. As for French artists, while the classical tradition was still strongly reflected in their work, it was for this very reason that they found Constable's naturalism more refreshing. DBB

45
Jean-Baptiste-Camille Corot
(1796–1875)
The Roman Campagna 1830–1

Oil on canvas
69.3 x 95 (26 x 37⅜)
Signed lower right: *Corot*
References: F., *Salon* 1827 (2 March 1828),
p.138; Delécluze, 1827 (5 April 1828), p.2;
Société des gens de lettres et d'artistes (1828),
p.103.
Kunsthaus, Zurich, Geschenk G.A. Hahnloser-
Hotz zur Erinnerung

Corot was in his early twenties before his
parents would allow him to pursue studies in
painting, first with Michallon and then with
Jean-Victor Bertin, both proponents of
historical landscape, the principles of which
would inform Corot's art throughout his career.
In pursuit of his dream, he embarked on the
first and longest of his three visits to Italy in
November 1825. Working mostly in Rome and
its environs, Corot adhered to the academic
practice of constantly sketching in oils from the
motif. He returned to Paris in the summer of
1828 with several hundred oil studies (nos.135,
139) and a fully mature style.

From Rome, Corot submitted two paintings
of equal dimensions to the 1827 Salon, *Bridge at
Narni* (Ottawa) and this *Roman Campagna*,
also called *La Cervera*. An anonymous critic
took exception to the 'violet tints and choppy
tones' and the nondescript site of the latter.
Etienne Delécluze was complimentary in
passing: 'A View taken at Narni and a
Campagna of Rome by Corot nicely recall the
mix of grace and severity of which the terrain of
Italy offers so many examples.' His intuitive

pairing of the pictures actually described
Corot's intent, for they are unquestionably
pendants, the *Narni* representing a sun-bathed
morning scene and the *Campagna* a stormy
late-day counterpoint. As Pomèrade recently
argued, Corot was following a venerable
academic tradition of depicting the times of day
but, more to the point, he was also contrasting a
view of Claudian 'grace' with one of
Poussinesque 'severity', as a way of
demonstrating his skill, his knowledge of
precedent and his mastery of Valencienne's
precepts as transmitted to him by Michallon
(Pomèrade, 1996–7). Corot painted this picture
in the studio based on sketches and his memory
of observed natural phenomena. Yet he brought
to his final conception a degree of realism that
the entrenched conventions of the ideal
landscape tradition did not always
accommodate. PN

46
Paul Huet (1803–1869)
View of Rouen from Mont-aux-Malades 1831

Oil on canvas
195 x 225 (78 x 90)
Signed and dated, lower centre: *P. Huet 1831*
References: Planche, *Salon 1833*, pp.179, 220;
Delécluze, 1833 (1 May 1833), p.2; Anon.,
L'Artiste, 1833, pp.58, 145; Jal, 1833, pp.361–2;
Pillet, *Salon 1833*, p.1354; Lenormant, 1833,
p.97; Planche, *Salon 1834*, p.262.
Rouen, Musée des Beaux-Arts

Of the French artists who promoted the new naturalism in landscape painting prior to the July Monarchy, Huet was the most influential and the least acknowledged in subsequent literature. Like Bonington, his attendance at Gros's atelier between 1819 and 1822 was irregular as he pursued his landscape studies in the field. From 1822, he sketched regularly in the Compiègne forest (no.115) and, in November of that year, he met Delacroix, who remained a constant supporter. It is generally accepted that Huet painted much of the landscape in Delacroix's *Portrait of Louis-Auguste Schwiter* of 1826 (no.52). His acquaintance with Bonington began in Gros's atelier, but their friendship burgeoned only in 1825. The impression on Huet of the British landscapes shown at the 1824 Salon was indelible, although he continually sought to temper the British manner with inspiration from a range of Old Master sources. He did not exhibit in 1824, and of the eight paintings submitted to the 1827 Salon jury, only one was accepted for exhibition. Huet's fortunes improved in the 1830s when he received decisive recognition from a number of influential critics.

Passionate by nature, Huet admitted difficulty in painting directly from the motif, and for his finished canvases he invariably forced himself to reflect for some time before commencing. As a consequence his major pictures are often grandiose in scale and laboriously worked. Huet articulated his ambitions as a landscape painter in his autobiographical recollections to Théophile Silvestre in 1854: 'If art is the expression of an epoque, perhaps more than anyone else have I offered the reflection of the anxious, dreamy and dramatic poetry of my time ... I always wanted a picture to be a spiritual conception, based it is true completely on nature, but a conception which amounts to more than a morsel or a study.'

View of Rouen is one of Huet's most ambitious Salon pictures. Most critics admired its transparency and breadth. Etienne Delécluze chastised Huet as 'the painter who has been the most faithful to the principles of Constable, Turner, Daniell and by extension Watteau ... he totally neglects design'. Gustave Planche contended that the regeneration of landscape painting in France lay in Huet's destiny. For this picture, however, he had mixed feelings: 'The *View of Rouen* can do battle with Turner ... but the execution is too rudimentary... too profusely strewn with emeralds, rubies and topazes.'

The view is from the neighbouring heights of Mont-aux-Malades to the west of the city, looking east. A watercolour panorama of Rouen by Huet, looking west from Bon-Secours (no.146), is possibly contemporary in date. The view from Mont-aux-Malades, while less picturesque, is considerably more daring in its expansive sky. The relationship of the picture to Huet's lost diorama subject of the same title is uncertain. Like Daguerre's *Holyrood Chapel* (no.42), it probably represents a repetition executed for a more traditional arena such as the Salon. At the end of 1829, Huet was commissioned to paint views of Rouen and of the Château d'Arques for the Diorama Montesquieu in Paris. PN

47
Antoine-Jean Gros (1771–1835)
Napoleon on the Battlefield of Eylau 1807

Oil on canvas
104.9 x 145.1 (41 x 57)
Signed and dated, lower centre: *Gros 1807*
References: *Le Moniteur* (2 April 1807),
pp.107–9; Boutard, 1826, p.3.
Toledo Museum of Art; Purchased with funds
from the Libbey Endowment, Gift of Edward
Drummond Libbey

Gros entered David's studio shortly after Anne-Louis Girodet (no.102). Unlike his friend and colleague, he failed to win the Prix de Rome, but with David's assistance he travelled independently to Italy in 1793. In Milan, he sketched Napoleon and later established his reputation with the portrait *Bonaparte on the Bridge at Arcole, 17 November 1796* (Versailles). After returning to Paris in 1800, he was much employed by Napoleon to chronicle his military exploits. *Bonaparte Visiting the Plague Victims at Jaffa* of 1804 (Louvre) was the first of a series of propagandist triumphs at the Salons. In 1812 he began the frescoes for the Pantheon linking Napoleon to the dynasties of Clovis, Charlemagne and Louis IX, completed only in 1824. Throughout much of the Restoration, Gros was the official portrait painter to Louis XVIII and Charles X, as well as being the most influential art professor in Paris.

The Battle of Eylau in Silesia, between the French and the combined armies of Prussia and Russia, occurred on 8 February 1807. With nearly 25,000 dead and wounded, the carnage was horrific and the victory for Napoleon hardly glorious or decisive. In April, the Emperor announced a competition for a picture to commemorate his compassion in the aftermath of the battle, when he brought medical aid to the enemy wounded. The Toledo version shown here is the actual competition entry submitted by Gros and on the basis of which he won the commission to paint the large canvas now in the Louvre. The Louvre picture was presented at the 1808 Salon, together with David's monumental *Coronation of Napoleon* (fig.2).

Gros's *Eylau* was another legitimisation of Napoleonic authority. The emperor appears as a demi-god dispensing clemency and succour to a defeated army. The Salon picture was recognised at the time as the wellspring of Romantic painting in France. The early critics had difficulty understanding the idiosyncratic composition forged of disparate episodes – the beatified Bonaparte and his entourage, the anti-classical heap of ignoble dead and dying in the foreground, the vignettes of doctors attending to anguished individuals with particularised faces – but Delacroix's generation was attracted to that very quality. 'This sinister picture,' Delacroix wrote, 'formed of a hundred pictures, seems to pull the spirit and eye in every direction … It is perhaps the artist's most beautiful conception, and also the most magnificent and assuredly the most exact portrait ever made of Napoleon' (*Gros*, p.184).

Arnold Scheffer, in his review of the 1827 Salon, reflected on Gros's significance to the history of the French school, observing that David's lack of colour and movement had suited 'the abstract idea of liberty, the dominant idea of the revolution', but that the intoxication of military glory and a cry for modernity at the beginning of the century compelled Gros to improvise an original style of 'admirable colour, compositional movement comparable to Rubens, and freedom of execution'. It was the early, contra-David Gros that younger artists admired, not the conservative reactionary of the *Bacchus and Ariadne* (no.67). Not surprisingly, the *esquisses* for all of Gros's first triumphs, including the Toledo picture, appeared a year earlier in the politically charged Galerie LeBrun exhibition for the benefit of Greek independence. PN

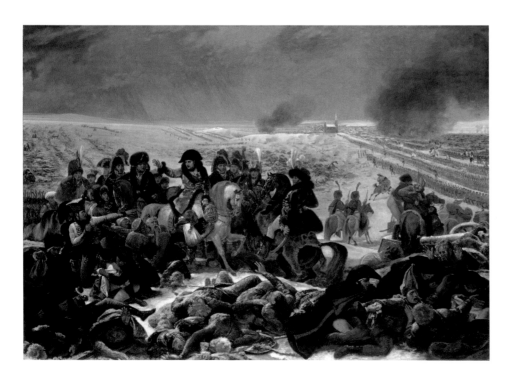

48
J.M.W. Turner (1775–1851)
The Field of Waterloo exh. 1818

Oil on canvas
147.3 x 238.8 (58 x 94)
References: for contemporary reviews see
Butlin & Joll, *Turner*, pp. 104–5, no. 138.
Tate. Bequeathed by the artist 1856

The defeat of Napoleon by Allied armies under the Duke of Wellington on 18 June 1815 was the defining event of its time. It produced an outburst of patriotism in Britain, and a clamour for suitable commemorations. The British Institution announced a competition for a 'Grand Historical Painting', with a premium of the immense sum of £1,000. The results, submitted in 1816, were excessively chauvinistic, and served to expose how unsuited British artists were to the rhetoric supposedly required of such a great national theme. David Wilkie, looking back on the event, would find a unique and happy solution (no.49). Turner likewise avoided the battle itself, but instead – more controversially – imagined its immediate aftermath, at night when the field was covered with dead and dying, and women came to tend them or to look for loved ones. In the background, the farm of Hougoumont still burns, and flares – fired to deter thieves – light up the sky.

Turner researched the subject on the spot in the summer of 1817, and exhibited the picture in the Royal Academy the following year. His notes – '4,000 killed here', or 'the great carnage ... of the Cuirassiers by the Guards' – made in his sketchbooks, testify to his impressions of waste and suffering. It is interesting to speculate whether post-war visitors to Paris had brought

Turner descriptions of Gros's *Battlefield of Eylau* (no.47), with its similar conception of the aftermath of battle and jumble of bodies in the foreground. His immediate source, however, was Byron's passage on Waterloo in *Childe Harold's Pilgrimage*, concluding with a vivid picture of 'friend, foe, in one red burial blent', which he quoted in the Academy catalogue. This compassion for the slain of both sides and failure to celebrate a national victory was, not surprisingly, contentious. Walter Scott attacked Byron for an almost treasonable impartiality, while Turner's picture was praised by the radical *Examiner* but written off as 'abortive' by the *Literary Chronicle* and 'a drunken hubbub on an illumination night' by the *Annals of the Fine Arts* (both in Butlin and Joll, *Turner*, p.105). These negative opinions, however, were clearly not passed on to Scott's nephew John Gibson Lockhart who, discussing Turner's illustrations for his uncle's *Life of Napoleon* in August 1832, wrote that 'Turner painted Waterloo magnificently long ago' (Warrell, 1999–2000, p.47). Turner went on to paint a further five pictures on Byronic themes or texts and illustrate editions of his writings (no.133).
DBB

49
David Wilkie (1785–1841)
The Chelsea Pensioners Reading the Waterloo Dispatch 1822

Oil on wood
97 x 158 (38¼ x 62¼)
Signed and dated 1822
References: *Gazette of Fashion* (4 May 1822), p. 31; *Manchester Iris* (4 May 1822), p. 301; *London Magazine*, (May 1822), p. 47; *New Monthly Magazine*, (1822), p. 219; *Atheneaum* (1831), p. 666.
Apsley House, The Wellington Museum, London (Trustees of the V&A), the Collection of the First Duke of Wellington in his London home, open to the public
London only

This epoch-making picture, painted for the Duke of Wellington, was Wilkie's masterpiece and a sensation in the Royal Academy in 1822. In 1816, the Duke had asked Wilkie for a scene of old soldiers reminiscing outside an inn and, while both probably agreed that these should be Chelsea Pensioners at one of their haunts near the Chelsea Royal Hospital, the Duke appears to have made no connection with his victory at Waterloo the previous year. It was Wilkie's own idea to show the Pensioners receiving the news of the victory, thus honouring his patron. The Duke was, however, consulted as the composition evolved. It was he who asked for the inclusion of younger serving soldiers as well as veterans, while the motif of the Waterloo gazette was developed by Wilkie from his own early idea of a man reading a newspaper to act as a focal point for the picture.

Like Turner before him (no.48), Wilkie has not painted the battle itself. While Turner depicted its aftermath, Wilkie shows its announcement and celebration, thus treating a national subject in inclusive and democratic terms. Its real hero may be Wellington, but at the moment depicted he is still in Belgium, and instead it is the ordinary, private soldiers, whose varied experience of campaigns over half a century or more, including the Duke's own – and even that of the dog Old Duke, who had followed the army in the Peninsular – culminated in Waterloo itself. Wilkie included sixty figures in the picture, and wrote an elaborate catalogue description of their identities and past service. In the Academy, the picture was hung beneath portraits by Thomas Lawrence of Wellington and by John Jackson of the Duke of York, and the whole patriotic ensemble was so besieged by enthusiastic crowds that rails had to be put up to protect it. The work made a profound impression on Géricault, who first saw it in progress in Wilkie's studio in the spring of 1821, and again, if not before, on 1 December 1821, when he visited with his friend Jules-Robert Auguste and the architect C.R. Cockerell, whom he had met in Rome. In his account of new British painting, written to Horace Vernet on 1 May, it is not altogether clear whether Géricault was describing the picture in progress or one of Wilkie's preparatory sketches, since he called it 'a small picture, of a very simple subject', and – either to spare the feelings of his Bonapartist friend or because he had himself not been told what the real subject was – he referred only to the celebration of 'a victory' rather than Waterloo. It is also puzzling that his remarks appear to be based on what he had seen at the Royal Academy, so one wonders if he had in fact conflated his impressions of *Chelsea Pensioners* in Wilkie's studio and a smaller

Newsmongers of 1821 (fig.34), which was indeed on exhibition. Whatever the case, his admiration was clear enough: 'How useful [for French artists] … to show the touching expressions in Wilkie's work … He has varied all these characters with much feeling. I shall mention to you only the one figure that seemed the most perfect to me, and whose pose and expression bring tears to the eye, however one might resist. It is the wife of a soldier who, thinking only of her husband, scans the list of the dead with an unquiet, haggard eye … Your imagination will tell you what her distraught face expresses' (Géricault in Clément, 1974, pp.199–203). On its second appearance at the British Institution in 1825, Wilkie's picture was seen by Delacroix, Bonington and Colin. DBB

fig.34
David Wilkie
The Newsmongers
1821
Oil on mahogany
Tate

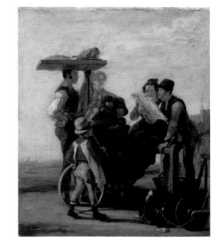

50

Thomas Lawrence (1769 – 1830)
Master Charles William Lambton
1825

Oil on canvas
137.2 x 111.8 (54 x 44)
References: *Literary Gazette* (30 April 1825),
p.283, (21 May 1825), p.329; *Monthly Magazine*
(June 1825); Coupin, 1827, p.316; Anon., *Le
Figaro*, 1827 (19 Nov.), p.811; Delécluze, 1827
(20 Dec.); Jal, 1827, pp.79–83, 228; Anon.,
L'Observateur 1828 (12 Jan.), p.7; Farcy, *Salon
1827* (4 May 1828), p.274; Stendhal, *Revue
trimestrielle* (July–Oct. 1828); Anon, *Journal
des Artistes* (14 Feb. 1830), pp.134–6; Planche,
Salon 1831, p.10; Gautier, 1856.
Private Collection

Lawrence belonged to that generation of British artists isolated from the Continent during most of their professional careers. And, like every other British novelty of which the French had been deprived until the Restoration, his work, when finally experienced at first hand, aroused in his neighbours extremes of adulation and loathing.

The son of an innkeeper with few scruples and too many creditors, Lawrence led a peripatetic childhood in the West Country before settling in London in 1787. Lacking formal education and virtually self-taught as a portraitist, he entered the Royal Academy schools but abandoned his studies when portrait commissions streamed in following his first public exhibition that year. His ascendancy as successor to Joshua Reynolds was guaranteed in 1790 when he exhibited his greatest female portrait, the brashly and ingeniously contrived *Elizabeth Farren* (Metropolitan Museum of Art).

From 1814 the Prince Regent monopolised Lawrence with commissions for a gallery of portraits of the allied commanders and heads of state (Waterloo Chamber, Windsor Castle). Like Anthony Van Dyck, Lawrence was the portrayer of an aristocracy totally at ease with its privilege. The Waterloo Chamber would occupy the artist for years and would necessitate his first trip abroad to Paris in September 1815, followed by a more protracted visit to Aix-la-Chapelle and Rome between September 1818 and March 1820, when he painted his celebrated portrait of *Pius VII*. On his return from Italy in 1820, he succeeded Benjamin West as President of the Royal Academy.

During the last decade of his life, Lawrence was one of the most acclaimed artists in Europe. In his capacity as PRA, he was ever hospitable to foreign artists, including Géricault and Delacroix. Delacroix visited his studio in July 1825, while the more reticent Bonington postponed that favour until the spring of 1828. Lawrence admired the prodigiously talented British painter and acquired a number of his pictures (no.138).

When shown at the Royal Academy in 1825, this portrait of the son of John Lambton, later First Earl of Durham, competed for attention with more swagger Lawrence portraits, including *Mrs Peel* (Frick Collection) and a full-length of Wellington. Consequently the critical response, although positive, was not effusive. When the picture appeared in the Paris Salon two years later, together with Lawrence's portrait of *Marie-Caroline, Duchesse de Berry* (fig.46), the critical clamour was astounding in both its copiousness and hostility. The persistence of this Byronic icon in the collective

French memory is attested by the many references to it in the Salon reviews of the 1830s. As late as 1856, Théophile Gautier would write with a tinge of sarcasm:

We recall the portrait of young Lambton, by Lawrence, which ... caused a prodigious sensation: that camellia carnation, those eyes so silky and so brilliant, that pearly visage so sombre and clear it conjures the look of the young Byron; that precocious dreamer astonished many Parisians, who believed they had before them a creation borne of the fantasy of a poetic brush.

PN

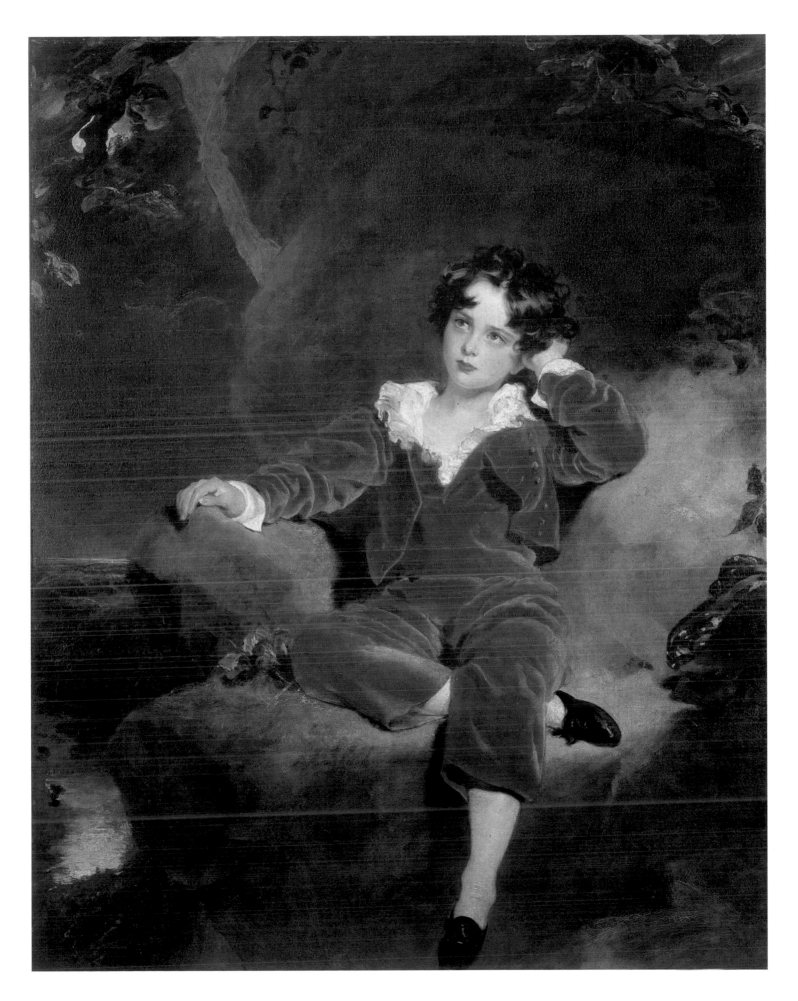

A. M. DE PASTORET
ÆTAT. 32.

51

Jean-Auguste-Dominique Ingres (1780–1867)

Amédée-David, Comte de Pastoret
1826

Oil on canvas
103 x 83.5 (40½ x 32⅞)
Signed and dated, lower left: *Ingres 1826*
References: Figaro, 1827, p.927; *Pandore*, 1827;
Coupin, 1827, p.864; Béraud, 1827, p.150;
Delécluze, 1827 (23 Dec.); Farcy, *Salon 1827*,
pp.19, 65–8; Jal, 1827, pp.291–2; Vergnaud,
1828, p.20.
The Art Institute of Chicago, Estate of Dorothy
Eckhart Williams, Robert Allerton, Bertha E.
Brown, and Major Acquisitions endowments
London and Minneapolis only

Ingres entered the atelier of David in 1797 where he met Girodet, François Gérard and Gros and studied alongside Delécluze, François-Marius Granet and Pierre Révoil. In 1801, he won the Prix de Rome; however, his stay at the academy was delayed for five years. The novel 'archaism' of Ingres's hyper-realistic style, as evidenced in his *Portrait of Napoleon on His Imperial Throne* of 1806 (Paris, Musée de l'Armée), outraged the critics at the 1806 Salon. He shortly departed for Italy, where he remained until 1824, conceived many of his most memorable large-scale decorations and executed an exceptional series of portraits in both oils and graphite. The drawings were especially admired by the English colony in Rome. Conscious of the burgeoning popularity of troubadour painting following the Restoration, he exhibited a series of easel pictures in that genre, of which *Henri IV and the Spanish Ambassador* (1824 Salon) enjoyed international recognition and several imitators, including Bonington. Among his other submissions in 1824 was the Raphaelesque *Vow of Louis XIII* (Montauban), which secured Ingres's triumphal return to Paris. Ingres's style now appeared infinitely preferable in academic circles to the ideas of the younger Romantics.

One of his staunchest sponsors was the ultra-conservative Amédée-David, Comte de Pastoret (1791–1857). A promising bureaucrat under Napoleon, he rallied to the Bourbons in 1814 and reaffirmed his allegiance by commissioning from Ingres in 1821 a history painting that alluded to his family's longstanding support of the monarchy, *Entry into Paris of the Dauphin* (no.71). During the Restoration he held a number of prestigious posts. At the time this portrait was finished, he was Conseiller d'Etat Extraordinaire. He wears the uniform of that position and the cross of the Légion d'Honneur. Pastoret would fall from grace in 1830 for refusing to pledge fidelity to the Orleanist regime, but in 1826 he was at the pinnacle of his prestige. The inscription at the upper right would suggest that the portrait was begun in 1823, when the sitter was thirty-two years old, and finished only in 1826. The source for Pastoret's distinctive pose was Agnolo Bronzino's *Portrait of a Young Man* (Metropolitan Museum) of *c*.1540.

Ingres's close friend Delécluze boasted in his 1827 Salon review that 'although the details are expressed with a care that might appear minute, nevertheless this portrait holds its own at a distance and crushes everything around it'. Not everyone agreed, and Armand Vergnaud criticised the absence of life in the sitter's features and the 'precious and stuffy technique that seems only to have *Ingresised* Raphael'. We could offer no more telling exposé of the gulf that separated the extremes of the British and French schools than the pairing of this portrait with Lawrence's *Master Lambton*, a point stressed by Pierre Coupin and others. PN

52
Eugène Delacroix (1798–1863)
Louis-Auguste Schwiter c.1826

Oil on canvas
217.8 x 143.5 (85¾ x 56½)
Signed, lower left: *Eug Delacroix*.
References: Jal, 1827, p.14; Vergnaud, 1828, p.10.
The National Gallery, London

Similar to Delacroix's lithographic bust-length portrait of the sitter from 1826, this full-length painting undoubtedly dates to the same year. It was an ambitious venture for the artist, whose previous portraits were head-and-shoulder exercises for family and friends (no.1). Paul Huet, according to tradition and on the evidence of the actual work, almost certainly assisted in the painting of the distant landscape. That Huet and not Bonington furnished this service suggests that the portrait was probably painted in the summer after Bonington had departed Delacroix's studio for Italy.

Louis-Auguste Schwiter (1805–1889) was a portrait painter in his own right, exhibiting at the Salon annually from 1831 and at the Royal Academy in London on four occasions. A staunch Anglophile, he visited London regularly, often to study British pictures, and perhaps as early as 1825 with Delacroix. Schwiter's personal art collection was composed largely of eighteenth-century prints after British portraits and French rococo paintings, including a Watteau and a Chardin, both bequeathed to him by Delacroix. His indebtedness to Lawrence's manner was a leitmotif of the critical response to his own work throughout the 1830s, and he is known to have painted a copy of Lawrence's portrait of Benjamin West.

The demeanour of this twenty-one-year-old is that of a dandy aspiring to perfection through the simplicity of his impeccable dress. According to Baudelaire, Delacroix often reminisced that 'in his youth, he had thrown himself with delight into the material vanities of dandyism, and … how, with the collaboration of Bonington, he had laboured to introduce a taste for English cut in clothes and shoes among the youths of fashion'. Planche cited the insurmountable obstacle to painterly invention posed by the drab frock coat and top hat. Only Lawrence, he argued, had been able to invest modern costume with the same interest as his faces. In his portrait of Schwiter, Delacroix paid overt homage to Lawrence, whom he had visited in London the previous summer and whose full-length portrait of Charles X he had admired in Paris as recently as November 1825.

Delacroix's picture was rejected by the Salon jury in October 1827, thus preventing, until now, its hanging in one exhibition with Ingres's *Pastoret* and Lawrence's *Master Lambton*. In a letter written shortly after the opening of the Salon, Delacroix advised Schwiter, then in Nancy, to return to the capital, since the Lambton portrait he had so admired as a mezzotint was actually in the exhibition. PN

53 (overleaf)
Horace Vernet (1789–1863)
Mazeppa and the Wolves 1826

Signed and dated, lower right: *H. Vernet fecit 1826*
Oil on canvas
100.5 x 139.5 (39½ x 54⅞)
References: Jal, 1827, pp.339–44; *Le Figaro*, 13 Nov. 1827, p.785; 12 Jan. 1828, p.2.; *Le Globe*, 22 Dec. 1827, p.73.
Musée Calvet, Avignon, France

In 1826, the Musée Calvet in Avignon honoured the Vernet family by naming a gallery after the native Claude-Joseph. Both Carle and Horace offered paintings to the museum to commemorate the occasion. Horace promised an illustration to the last of Byron's oriental tales, *Mazeppa* (1819), ignoring the request of the museum's curator for a subject from the life of Petrarch. The Ukrainian page Ivan Mazeppa (*c*.1632–1709) was raised in the Polish court. According to legend, recorded first by Voltaire and then re-interpreted by Byron in 1819, he was caught *in flagrante delicto* with the wife of Count Palatine. His punishment was to be lashed naked to the back of a wild horse and sent careering through dangerous woods and uninhabited plains. After recovering from his travails but not his humiliation, he left Poland and embraced the cause of Ukrainian nationalism.

For Byron, the legend paralleled many of the events of his own life which, like the poem, was condemned as immoral in England; however, for his French admirers *Mazeppa* came to symbolise the suffering of ostracised genius. Géricault in 1823 and Delacroix in 1824 preceded Vernet in illustrating this poem, although both chose a less graphic episode. In 1825, Vernet painted *Mazeppa and the Horses* (destroyed), but for the Avignon commission he chose the episode of *Mazeppa and the Wolves*. The first version was damaged in the studio during a sword fight and a second, identical version, exhibited here, was instantly produced to replace it, although both pictures eventually went to Avignon. One of these versions, together with *Mazeppa and the Horses*, appeared in the 1827 Salon. In general, the critics preferred the episode with wolves. *Le Figaro* assumed a hostile stance, complaining that both conceptions lacked the 'soul and poetry' of Byron. *Le Globe*, on the other hand, found Vernet's landscape sublimely terrifying and elevating, even if the wolves were melodramatic.

Following the Salon, Vernet sent *Mazeppa and the Horses* and his monumental *Edith Discovering the Body of Harold After the Battle of Hastings* (fig.32) to an exhibition at William Hobday's Gallery of Modern Art in London. The critic for the *London Weekly Review* likened the first to Thomas Woodward's interpretation, then on view at the Royal Academy, and suggested that the British artist had borrowed heavily from Vernet. Copies of both *Mazeppa* subjects by John Frederick Herring (1795–1865) date from 1833 (fig. 35), and Rishel has noted the probable influence of Vernet's *Mazeppa and the Wolves* on Edwin Landseer's *Hunted Stag* (Tate) also of 1833 (Philadelphia, *Landseer*). PN

fig.35
John Frederick Herring, after Horace Vernet
Mazeppa Surrounded by Horses
c.1833
Oil on canvas
Tate

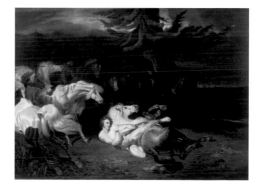

53

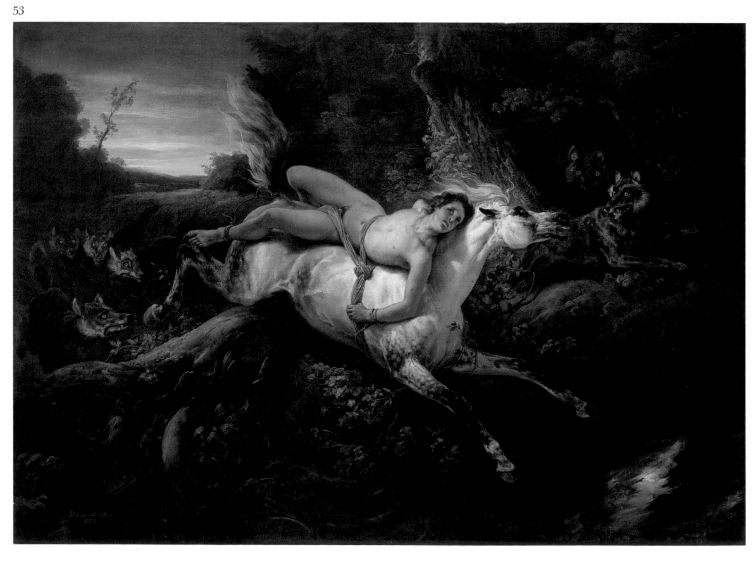

54
Edwin Landseer (1802–1873)
The Hunting of Chevy Chase
1825–6

Oil on canvas
143.5 x 170.8 (56½ x 67¼)
References: *Examiner*, 21 May 1826, p.323;
Literary Gazette, 27 May 1826, p.331;
Examiner, 18 Feb. 1827, p.99; *The Times*,
26 April 1826, p.3b.
Birmingham Museums and Art Gallery.
Presented by the National Art Collections
Fund

John Landseer was one of the most influential engravers of the nineteenth century. Of his seven children, five became artists. Edwin, the youngest boy, would be the most celebrated. Born in the same year as Bonington and arguably even more precocious, he began drawing the lions, primates and other exotic fauna in Edward Cross's menagerie at Exeter Change in London at the age of five. By 1815, he was studying in the studio of Benjamin Robert Haydon, who encouraged his animal painting and gave him the confidence to imbue that genre with the grand pretensions of history painting.

Landseer enrolled in the Royal Academy schools in 1816, where he expanded his knowledge of anatomy under the famed Sir Charles Bell. He continued to assist Haydon with such major pictures as *Christ's Entry into Jerusalem* (fig.27). Géricault was much impressed by Landseer's contributions to the London exhibitions he visited in 1820 and 1821. Such was his meteoric rise that at the time of his majority Landseer could boast among his collectors many of the first names in British patronage. Although he would visit Paris only briefly in 1840, he was probably the most admired British artist in France at the time of his death.

With C.R. Leslie, Landseer travelled in 1824 to Abbotsford, where he passed ten days with Walter Scott. Painter and author became staunch mutual advocates. Landseer would return annually to Scotland, which became his principal source of inspiration and subjects. *The Hunting of Chevy Chase* was the most important commission to result from Landseer's initial trip, and probably secured him his associate membership in the Royal Academy when exhibited in 1826. The popular *Ballad of Chevy Chase*, published by Thomas Percy in 1765, recounted the feud of the late Middle Ages between the English Percy, Earl of Northumberland and the Scottish Earl Douglas, and their eventual annihilation. Northumberland's notice to Douglas that he intended to hunt on Chevy Chase, land claimed by his Scottish nemesis, provoked a battle in which both nobles were killed.

For this picture, commissioned by the Duke of Bedford, Landseer elected to illustrate Northumberland's hunt. A study for a pendant picture, never executed, shows the body of Northumberland prostrate on his dead horse and surrounded by slain deer and distraught widows. In both, Landseer consciously avoided depicting the carnage of a medieval battle, a gruesome task from which few French artists would have shied. Elements of the composition derive directly from Flemish staghunts, and from Peter Paul Rubens's *Wolf and Fox Hunt*, then in Lord Ashburton's collection, of which Landseer executed a small copy (fig.36). Delacroix, likewise, either in Paris in 1824 or in London in 1825, made a watercolour copy (Montpellier) of the left side of the same Rubens. Landseer's technique was indebted to a close scientific examination of Rubens's sketches and finished pictures. Most of his foreground and animals were painted with the thinnest oil washes, over which parallel hatches of greater opacity furnished details and modelling. It was a technical device of Rubens that promoted facility, translucency and brilliance, early perceived by Landseer and much later put to good use by Delacroix in the series of lion hunts that he would also paint in emulation of Rubens in his later years. PN

fig.36
Edwin Landseer
Copy after Rubens's *Wolf and Fox
Hunt* 1824–6
Oil on wood
The Metropolitan Museum of Art,
Catherine Lorillard Wolfe
Collection 1990, Wolfe Fund 1990

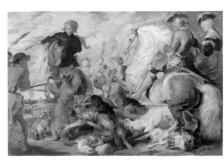

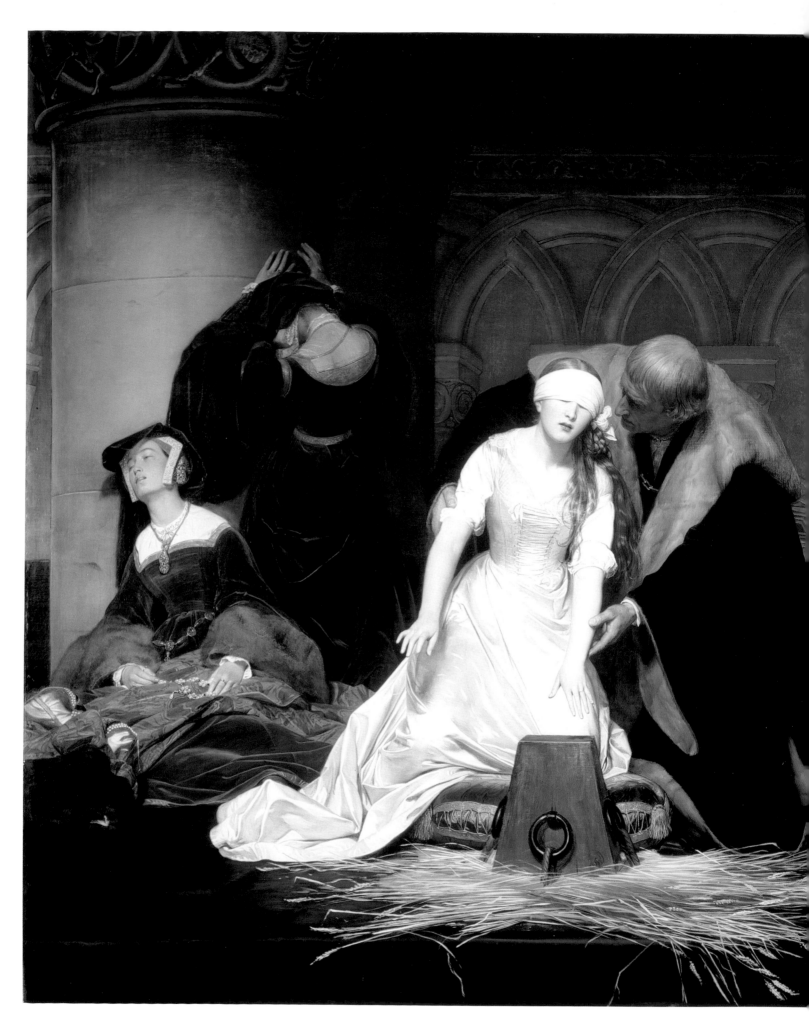

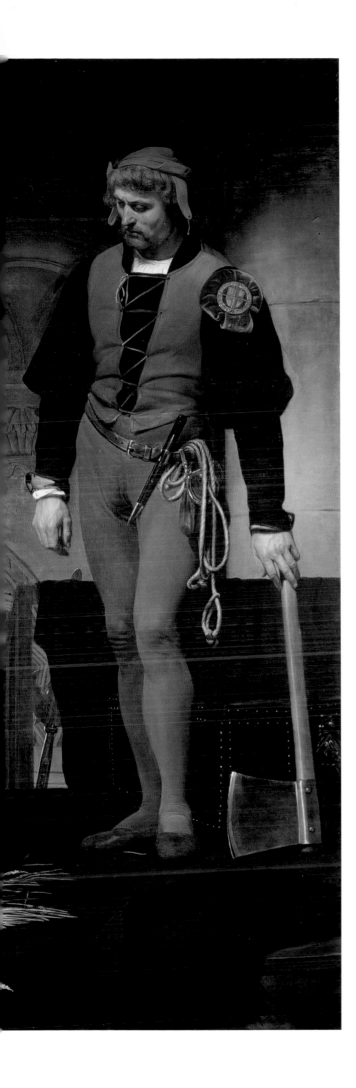

Paul Delaroche (1797–1856)
The Execution of Lady Jane Grey
1833

Oil on canvas
246 x 297 (96 ⅞ x 117)
The National Gallery, London

Already owned by the Russian Prince Anatole
Demidoff when it was shown at the Salon of
1834, this picture caused an immediate
sensation and remains outstanding in
Delaroche's work for its dramatic immediacy.
Lady Jane Grey had been Queen of England for
nine days, succeeding Edward VI, before being
imprisoned by order of her cousin Mary, the
future Queen, and executed on 12 February
1554, at the Tower of London. These facts were
set out in the Salon catalogue, which also
quoted a description of the event from a
Protestant martyrology of 1558. For the French,
her fate brought memories of the Revolution
and the execution of Marie-Antoinette, while
for the British she was often presented as
scholarly and saintly, a child-victim.

For Delaroche's use of earlier British
graphic sources, see Bann, *passim*, pp.26–7.
More recently C.R. Leslie's picture of her being
prevailed upon to accept the Crown, painted
for the Duke of Bedford (Woburn Abbey), had
been exhibited in 1827, five years after the
publication of George Howard's *Lady Jane
Grey and her Times*. Delaroche presumably saw
Leslie's picture when he visited London in 1827
– apparently specifically to research details of
the Tower for this picture and for that of the
young princes. His own conception is
characteristically vivid and convincing in its
interpretation of what he believed to be
historical fact. From some deep dungeon, Jane
gropes her way towards the block – and
towards viewers of the picture who thus feel
themselves involved in the action – guided by
the Constable of the Tower. Her confusion in
her blindfold follows the account in
Delaroche's sixteenth-century source, in which
she cries: 'What shall I do now? Where is the
block?' The painter's powerfully emotive
realisation overcomes such anachronisms as
the earlier, Holbein-like costumes of her two
gentlewomen. Reviewing the picture in the
Salon, Philippe Burty wrote: 'It is your heart
and your intelligence which are moved. It is
your soul to which the painter has spoken'
(quoted by Duffy, *Delaroche*, p.12). DBB

56

John Martin (1789–1854)
The Deluge 1834

Oil on canvas
168.3 x 258.4 (66 x 102)
Signed and dated: *John Martin 1834*
References: Anon., *L'Artiste*, 1835, pp.64, 97;
Gautier, 1837; Anon., *L'Artiste*, 1837, p.243;
Delécluze, 1855, p.89.
Yale Center for British Art, Paul Mellon
Collection

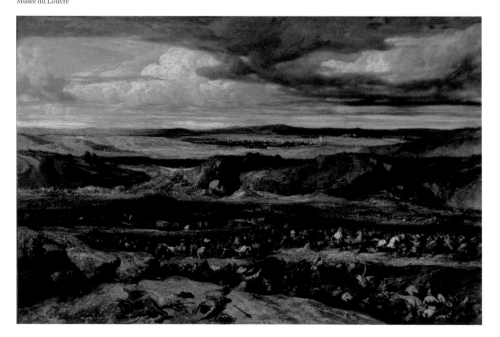

Martin's earliest paintings of 1807 were small classical landscapes imitative of Claude and of J.M.W. Turner's *Liber Studiorum*. Exaggerated backlighting of ruins in many of these works often created contrasts that anticipate the optical artifices of Louis Daguerre's (no.42) dioramas. If *Sadak in Search of the Waters of Oblivion* (St Louis; 1812) introduced his signature taste for diminutive figures engulfed by vast natural or architectural compositions, *Belshazzar's Feast* of 1821 (Yale) represented a new and exceedingly popular refinement of the apocalyptic sublime, uniting scrupulous biblical and archeological research with sensational perspective. In the 1820s, Martin designed and engraved nearly one hundred mezzotint illustrations to the Bible and to Milton's *Paradise Lost*. This was an unparalleled use of that medium and the principal vehicle for the establishment of his fame abroad. His 'perspectival diorama' of Isambard Kingdom Brunel's Thames (Rotherhithe) Tunnel also amazed Parisian crowds in 1830.

Martin's first version of *The Deluge* appeared at the British Institution in 1826. Antediluvian interests were in the air. A brochure accompanying the publication of a mezzotint reproduction in 1828 further explained the biblical, scientific and literary sources for his conception, with Byron's poem *Heaven and Earth* (1821) playing an inspirational role not dissimilar to that of his *Sardanapalus* for Delacroix (no.78). An impression of the mezzotint was one of several prints sent to Charles X, who authorised a gold medal for the artist in 1829.

Martin considered this more spectacular oil version of 1834 his favourite picture, and he submitted it to the 1835 Paris Salon, where he was honoured with yet another gold medal and a set of Sèvres porcelain from Louis-Philippe. The larger intellectual context for this picture was the lively debate among theologians and scientists on the accuracy of biblical sources, and the attempts by French geologists under Baron Georges Cuvier to mitigate the findings of the Scottish school under James Hutton that the earth was actually millions of years old. Cuvier, who visited Martin's studio while the artist was painting this version, agreed with his scientific analysis of the Flood's origins, which Martin has illustrated as a catastrophic conjunction of sun, moon and a comet. From Genesis he borrowed ideas for the figure groupings.

In France, Martin enjoyed a respect for his imaginative powers that bordered on adulation. His influence on Sainte-Beuve, Gautier and Victor Hugo's immediate circle has been thoroughly documented, but it was an influence derived from their reading of the mezzotints. The paintings tended to disappoint reviewers because they lacked the detail of the monochrome prints. Nevertheless, *L'Artiste* (1835, p.97) lavished praise on *The Deluge*:

Martin is as implacable as Destiny. He heaps water on fire, he shakes rocks at their base, he elevates the sea and lowers the sky: is there any way for the human species not to be crushed in this meeting? All is lugubrious, livid, horrible.

In the year Martin was finishing *The Deluge*, Alexandre-Gabriel Decamps exhibited at the Salon his most ambitious history painting, *Battle of Marius Against the Cimbrains* (fig.37). Gustave Planche considered Decamps's painting a work of extraordinary grandeur and invention, and challenged all comparisons to Martin: 'Martin takes pleasure only in a nameless, embryonic, confused poetry that excites the imagination to elation, but which never leaves a durable impression in the soul.' After further analysis, however, he admitted that both artists similarly defied the conventions of historical painting in that 'their heroes so called are the masses; and for the masses there is no premier plane' (*Salon* 1834, p. 249). This would have been further appreciated by French viewers who could compare celebrated treatments of the Deluge by Nicolas Poussin and Anne-Louis Girodet (fig.11) with Martin's 'historical' representation. To paraphrase Amadée Pichot, in Girodet's conception we 'tremble for a few solitary victims', whereas in Martin's the entire human race is devastated. Planche's disparagement of Martin's technique was perhaps justifiable, but the British artist's impact on Decamps, at least in the conception of his masterwork, is inescapable. PN

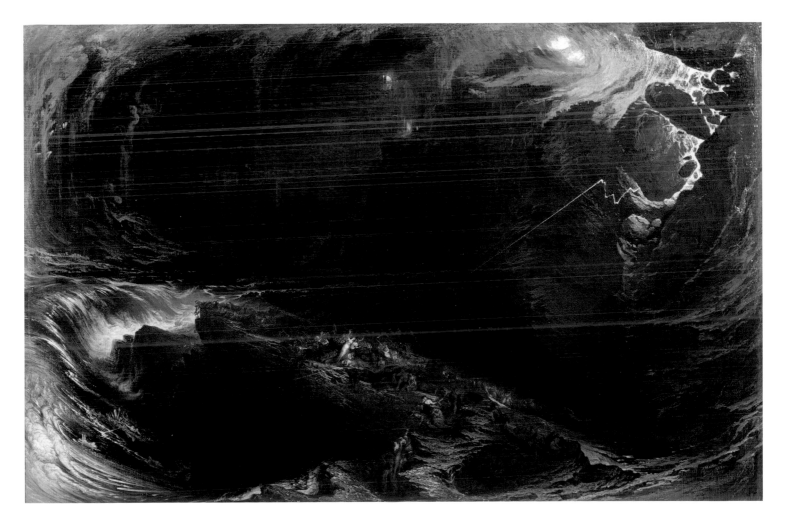

Literature and History:
Shakespeare, Scott, Byron and Genre Historique

David Blayney Brown

Hardly had Allied troops dispersed from Paris after their victory in 1815, than new invasions took place – of the city's theatres, bookshops and libraries. The bookshop Galignani sold and translated the latest British authors, and in 1820 the *Journal des débats* rather resented the 'telegraph' that seemed to connect Covent Garden to the Théâtre-Français.[1] Shakespearean actors from London met with catcalls in 1822 but cheers in 1827–8, and that chunks of Stendhal's pamphlet *Racine and Shakespeare* – provoked by the disaster of 1822 and comparing the two playwrights to Jean Racine's disadvantage – were lifted from Dr Johnson at least proved that imitation was the sincerest form of flattery.[2] Victor Hugo attempted his own British historical plays, *Cromwell* (1827), with its preface extolling Shakespeare, and *Amy Robsart* (1828), which featured a Falstaffian character, Flibbertygibbet, and costumes by Delacroix. The great classical actor Talma, bored with the roles of a lifetime, encouraged Hugo's next historical effort, *Hernani* (1830), set in old Castile. *Cromwell* and *Amy* were flops, *Hernani* a *succès de scandale*, whose audiences of Romantics and traditionalists fought nightly battles. The Romantics won. Meanwhile, Walter Scott's historical novels and Lord Byron's poetry conquered Paris. 'Esprit de Lord Byron' was a fashionable eau de Cologne after the poet's death, and as early as 1818 Stendhal defined himself as a 'furious romantic … for Shakespeare against Racine, and for Lord Byron against Boileau'.[3]

These were far from the only British authors to reach a French audience. Alfred de Vigny's tragedy about the poet Thomas Chatterton was staged in 1835, while Gothic novels, Edward Young's *Night Thoughts* and James Macpherson's Ossian epic, whose mythic Scotland preceded Scott's more convincing reconstructions, were all familiar. But Scott and Byron opened new paths and were the most avidly read, illustrated and debated. Scott's evocations of olden times appealed to the Restoration's underlying conservatism, while Byron offered Romantic rebels an anarchic alternative to the Catholic and legitimist nostalgia of a writer like René de Chateaubriand. Although Stendhal claimed that Byron was 'very milord', prouder of his ancestry than his poetry,[4] he was sufficiently pleased with his brief acquaintance with the poet to pretend that Byron had written a historical epic, on 'Castruccio Castracani, the Napoleon of the Middle Age', in his company.[5] In truth Byron was far more disaffected and radical than Stendhal, so much so that unlike Scott he refused to visit Restoration Paris at all. He despised the Bourbon monarchy, but also disagreed with his natural fraternity of French liberals on one fundamental point, their belief that Britain was a cradle of freedom and justice. It was this, as much as the related taste for its literature and drama, which attracted them to British history.

By bringing their own agendas to bear, French painters often saw more in British authors than their British

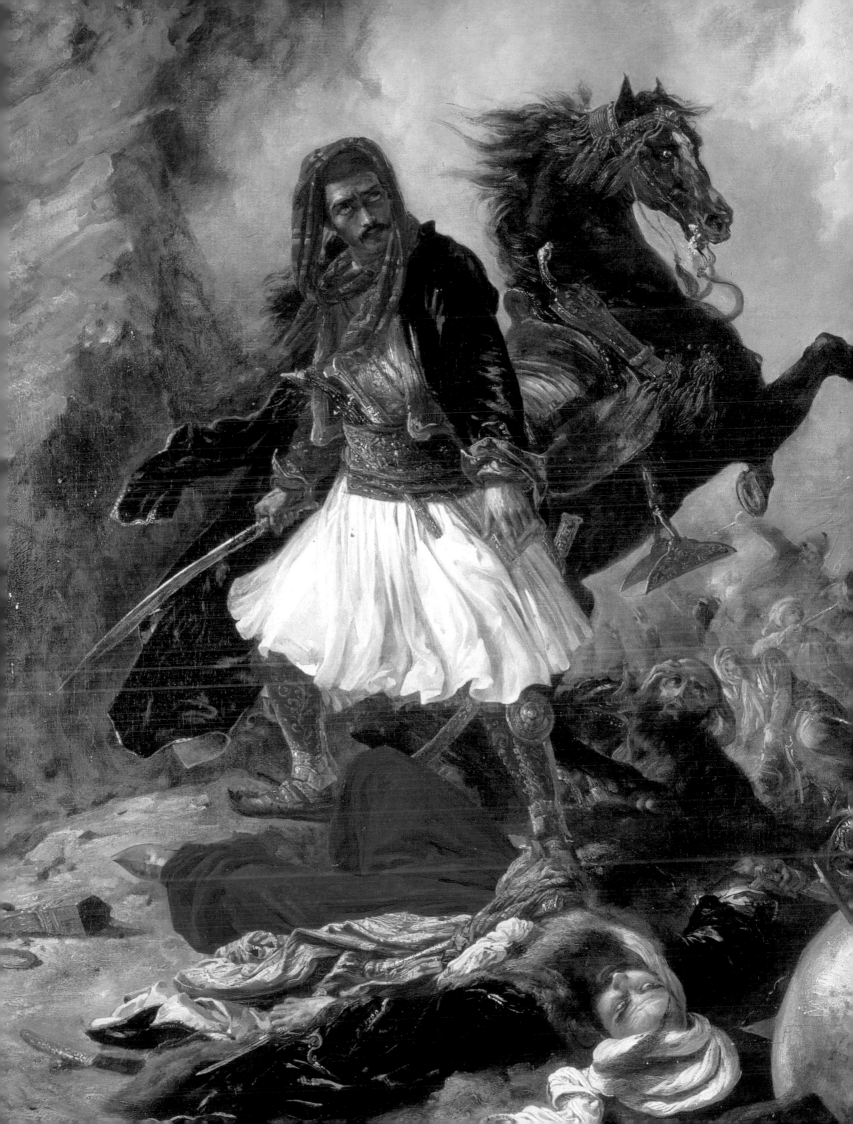

colleagues.[6] Edwin Landseer's scene of old Border rivalries, *The Hunting of Chevy Chase* (no.54), was steeped in the spirit of Scott. J.M.W. Turner's *Childe Harold's Pilgrimage – Italy* (no.133) shared its vision of a decayed but beautiful South with Byron's most famous work.[7] But both evoked a largely aesthetic nostalgia: Landseer the hunting scenes of Peter Paul Rubens or Snyders, Turner the ideal Italy of Claude. Louis Daguerre, however, appealed to Charles X, who had lived there in exile, as well as to the wider Scott mania, by choosing Holyrood Palace as the subject of a diorama and a picture for the 1824 Salon (no.42). Byron's Oriental tales were adopted by liberal Philhellenes disgusted by their government's half-hearted support for Greek independence. Horace Vernet led the way with an illustration of *The Corsair* in 1819. *The Giaour* was taken up by Théodore Géricault before the Greek war broke out (no.85), while scenes from it by Eugène Delacroix (no.76) and Alexandre-Marie Colin (no.77) were shown in aid of Greek relief at the Galerie Lebrun in 1826 and in London as tributes to the poet. Delacroix, the most conspicuous Byronist among French painters in the 1820s, turned to his history plays for major Salon works. His most shocking early picture, *The Death of Sardanapalus* (no.78), was a slap in the face to the establishment, as strident a manifesto for his Romanticism as Hugo's *Cromwell* preface.

Delacroix's and Richard Parkes Bonington's experience in London in 1825 was crucial to their development of historical and literary themes. Bonington's first oils of such subjects date from this time, while Delacroix admired an oil sketch by David Wilkie of *The Preaching of Knox Before the Lords of Congregation* (no.72). This key moment from the Scottish Reformation was not a Scott subject, though Delacroix perhaps assumed it was; moreover Wilkie's sketch showed all the painterly fluency he admired in British painting. As a visit to Rouen cathedral in 1814 and his correspondence on *Knox* show, the Presbyterian Wilkie was not immune to Catholic nostalgia. For Delacroix, however, Gothic melodrama and grotesque – all good for stirring up the classical tradition – were the main attractions of ecclesiastical or monkish themes.[8] When Charles X was promoting Throne and Altar, Delacroix's *Murder of the Bishop of Liège* (fig.39, no.59), from Scott's *Quentin Durward* and based on Wilkie's *Knox*, was shocking in its contempt for a prelate. His *Interior of a Dominican Convent, Madrid* is a scene of torture, taken from the anti-Catholic novel *Melmoth the Wanderer* by the Irishman Charles Maturin (no.60). In Bonington's *Quentin Durward at Liège* (no.58), a grimacing mob surrounds the hero. Both painters had looked at medieval church architecture and relief sculpture, but their Gothicism is irreverent, free of nostalgia for a supposed 'age of faith'.

While conservative critics blamed such 'decadent' works on an emergent 'Shakespearean Romantic' school,[9]

fig. 38

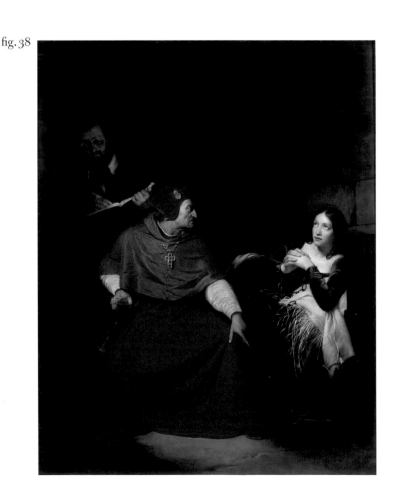

Delacroix's reading of Maturin shows how widely he and his friends trawled for an iconography to mark them out from the classical tradition: not only Shakespeare, Scott and Byron but the dramatist Nicholas Rowe and Robert Burns among the British; the Germans Gottfried Bürger, Friedrich von Schiller and Johann Wolfgang von Goethe ; and the Spaniard Miguel de Cervantes, whose *Don Quixote* appeared a Romantic *avant la lettre*. With the exception of his pictures of the Greek war, Delacroix was at this time essentially a painter of literature. Classics and popular works were all grist to his mill, and his choice of themes and interpretations was always distinctive. Historical settings vied with sheer sensationalism in their potential for pictorial experiment.

Byron always said he wrote historical plays, not political ones, thus sidestepping any contemporary analogies his audiences might draw. But for many in France, the past was nothing if not politically charged and, immense as the influence of Byron, Scott and Shakespeare was on the Romantics, it cannot account for the depth of their historical passion. Rather, literature and the pictures it inspired interacted with historical sensibilities already emerging at the start of the century. The brutal suppression of the past and its monuments of Crown and Church that accompanied the Revolution soon produced a reaction. Alexandre Lenoir's Musée des Monuments Français, opened in 1795, endorsed by Napoleon and on every Paris visitor's itinerary (including Wilkie's in 1814), fostered historical and Catholic yearnings far more than its curator had intended. Its relics helped inspire the self-styled 'aristocrats' among Jacques-Louis David's students – Fleury Richard, Pierre Révoil and Auguste de Forbin – to invent the intimate 'Troubadour' genre of painting. An admirer, Vivant Denon, director of the Musée Napoleon, christened it 'anecdotal history' and commended it to the Emperor as 'peculiarly French'.[10] These painters' favourite time was the Middle Ages, and their repertoire of scenes of benign feudalism came into its own after 1815. In 1817 François Gérard triumphed with his *Entry of Henri IV into Paris* (no.73), a royal commission celebrating the origins of the ruling dynasty and the recent return of Louis XVIII. Forbin sprang from an ancient Provençal family, and Révoil's 1820 *René of Anjou After Passing the Night at the Château of Palamède de Forbin* (no.70) proclaimed his friend's ancestry and his own loyalty to the restored monarchy. Jean-Auguste-Dominique Ingres's *Entry into Paris of the Dauphin* of 1821 (no.71) did the same for its patron, the Comte de Pastoret (no.51).

Ingres's picture matched stylistic primitivism to its subject and harnessed both to the cause of the modern Bourbons. In the 1824 Salon, it must have seemed from a different planet than the vibrant, painterly works from Britain that so excited other young artists, or indeed from *Joan of Arc and the Cardinal of Winchester* (fig.38), the first popularly successful picture by Paul Delaroche, who by the 1830s epitomised what was called '*genre historique*' and held a more sceptical attitude to authority than that of the Bourbon loyalists. Rich stylistic and conceptual variations were now appearing, and Ingres's archaism struck some as preferable to Delacroix's modernism – on view in the *Massacres at Chios* – while Delaroche was praised for a stylistic middle way and his direct appeal to emotion, analogous to the drama or the novel. Already in 1824, Adolphe Thiers drew a parallel between historicism, Scott's stories and certain modern pictures.[11] No less apparent were parallels between past and present. Explicit in Ingres's picture, they seemed implicit in Delaroche's, with Joan being shown as the innocent victim of an obdurate English persecutor. Thiers praised the work as true to national character.

The reinvention of the peasant Maid of Orléans who won victory for the French Crown, as a national heroine, was typical of the reassessment of the national past that followed the collapse of 1815; royalists and their liberal opponents alike hoped that history might explain past errors, reconcile the nation and suggest lessons for the future. Later the July Monarchy would promote 'all the glories of France' – even Napoleon's. Painters of history now had unparalleled opportunities.[12] But their investigations were not confined to French history alone. Though Delaroche, like Byron, denied that comparisons were intentional, hardly anyone else failed to connect his scenes from the Civil War (no.9) or the bloody history of the British Crown (no.55) with the revolutions of 1789 or 1830. That Britain was now victorious, rich and a liberal democracy, its free spirit manifest in its writing and painting, made its past traumas all the more interesting. Yet it was for the same reasons that Britain saw no comparable soul-searching, and France the most penetrating depictions of British history as well as her own.

fig. 39

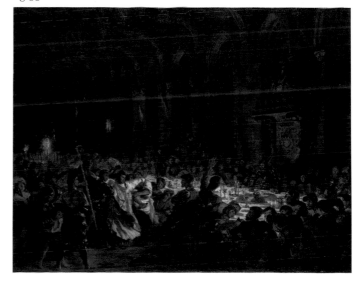

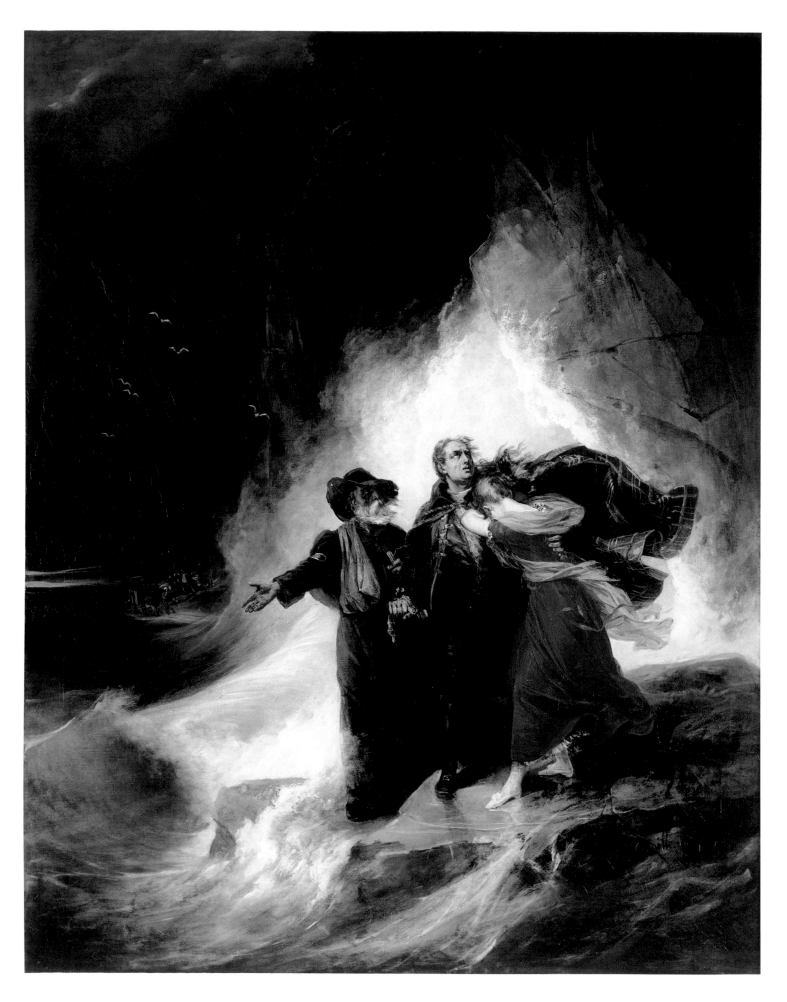

57
Camille Roqueplan (1800–1855)
Marée d'Equinoxe (The Antiquary)
1826

Oil on canvas
183 x 146 (72 x 57½)
References: Vittet, 1826 (23 Nov. 1826), p.232;
Anon., *Le Figaro*, 1827 (7 Nov. 1827), pp.763–4;
Delécluze, 1827 (7 Jan. and 25 April 1828);
Anon., *L'Observateur* (22 Dec. 1827), pp.500–1;
Jal, 1827, p.364; Vergnaud, 1828, p.15; Anon.,
1827 Salon, p.38; Anon. *La France chrétienne*
(31 Jan. 1828), pp.2–3; *L'Artiste* 1 (1831), p.296;
Gautier, 1855, II, p.51; Gautier, *Romantisme*,
p.194.
Chi Mei Museum, Taiwan

Born in Provence, Roqueplan enrolled with
Gros in 1818 and began sketching near Paris
with Paul Huet. However, of Gros's pupils, it
was Bonington who most influenced his future
orientation. His first Salon entries were
landscapes, but in 1827 his paintings were
remarkable for their ambitious scale and varied
subjects. During the next fifteen years he would
experiment with every category of painting
from portraiture to battle scenes, but it was his
genre pictures that most seduced his
audiences. He probably visited London in
1830. His powers and health began to fail after
1840, and he was unable to satisfy a commission
with Delacroix to decorate the Chamber of
Peers in the Luxembourg Palace. He is
arguably the French painter whose work best
illustrates the tremendous diversity of
influences and interests experienced by artists
in the first half of the nineteenth century.

For his third Salon appearance in 1827,
Roqueplan submitted seven pictures, four of
which were inspired by Walter Scott's novels.
Although the *Death of the Spy Morris* (Lille) is
the better known, this recently rediscovered
illustration to *The Antiquary* was the most
admired at the time. The subject relates one of
Scott's most dramatic passages. A wealthy
Scottish antiquary, Sir Arthur Wardour and his
daughter Isabella, stroll the shore, ignorant that
the strongest tides of the year will occur that
evening. Soon threatened by the rising sea, they
are joined by the old mendicant, Edie
Ochiltree. The baron offers him a fortune if he
can save them, but he, pointing to the menacing
waves, declares 'our fortunes will soon be
equal'.

Although earlier exhibited with other Scott
subjects at the Galerie Lebrun in 1826, it was not
until the 1827 Salon, and then again with the
Société des Amis des Arts in 1831, that the
picture was acclaimed as a paradigm of the new
Romantic sensibility. All of literate Paris had
read the novel, and the artist's judicious choice
of subject, which underscored the equality of
all men facing imminent destruction, boosted
the picture's popularity. Most critics admired
Roqueplan's conception of the tragic scene,
although Delécluze objected to the setting,
finding the cause of the terror more visible than
its effects on the characters. Others found fault
with the costumes and the artist's indifference
to details of Scott's text.

Despite the gold medal this picture would
secure him, Roqueplan did not repeat the
formula. *Marée d'Equinoxe* was the first and
nearly the last of his paintings with grand
figures and dramatic pretensions. Three
reproductive prints, published between 1827
and 1832 and exhibited at several Salons, testify
to the enduring popularity of this image. MW

58
Richard Parkes Bonington
(1802–1828)
Quentin Durward at Liège 1828

Oil on canvas
63.7 x 51.9 (25⅛ x 20⅜)
Nottingham City Museums & Galleries

The reception of the first French translation of Walter Scott's *Quentin Durward* in May 1823 was fervent. The novel vividly portrayed one of the most tumultuous epochs of French history, when the modern nation state was superseding feudalism in the fifteenth century. Victor Hugo, enamoured of this new genre of historical narrative, aggressively defended Scott's publication in *La Muse Française* (June 1823). However, the liberal historian François Guizot, in his *General History of Civilization in Modern Europe* of 1829–32, would criticise Scott's portrayal of the burgomasters of Liège as 'comic bourgeois, fat, indolent, without experience or boldness', rather than as valiant defenders of civic virtues. His assessment was celebrated at the time, not so much for its criticism of Scott, but for its implicit elevation of the bourgeoisie to the status of the great heroic class of history.

Bonington's painting illustrates the episode when Durward, wearing the blue bonnet of the Scotch archers, is mistaken by the Liègeois as

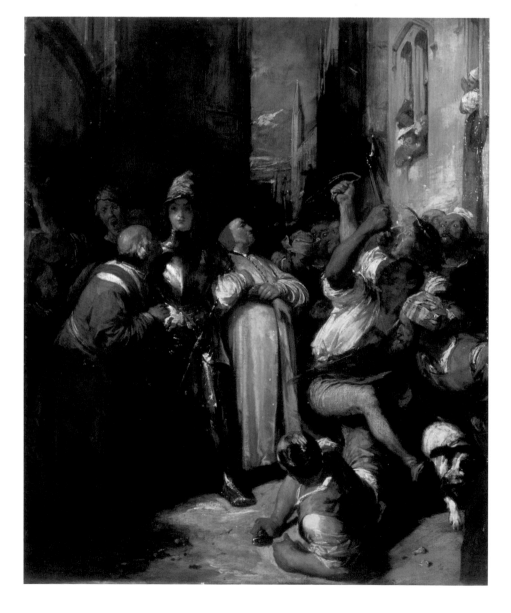

part of an advance army sent by Louis XI to assist in their rebellion against the duc de Bourgogne. Despite his protests, the politically naive Durward is paraded like a saviour between two burgomasters, Pavillon and Rouslaer. Durward, as realised by Scott and here by Bonington, is essentially a non-hero. He has a tinge of Don Quixote's misplaced enthusiasm and, like his esteemed predecessor, remains a parody of the historical virtues extolled by the troubadour tradition.

This is the most ambitious of Bonington's history paintings. Duncan Macmillan (1993, pp.297ff.) has related the picture to Wilkie's *Village Holiday* (no.89), with its principal group of three interlocked figures consciously alluding to the Earl of Shaftesbury's famous discourse on *The Judgment of Hercules* as a model for historical composition. There is merit in this argument, especially since Bonington would have seen Wilkie's picture during his first London visit in 1825; yet Bonington's historicism was closer in spirit to that espoused by French writing and painting than to British theory, with which he was only marginally familiar.

In this picture, Bonington observed historical decorum by seeking prototypes in well-known Flemish sources, including Rubens and Jacob Jordaen, as well as the bas-reliefs of the choir screen at Amiens Cathedral, which dates to the last years of Louis XI's reign. The concluding section of the screen, *St Firmin Paraded through the Streets of Amiens*, furnished compositional and figure models. In fact, the entire *mise-en-scène* immediately evokes the Gothicism of late fifteenth-century religious imagery.

By paraphrasing works of art contemporary with the narrative or of complementary national origin, Bonington achieved a historical authenticity beyond the mere details of costume. In the complexity of its allusions, the Nottingham oil transcends the standard literary illustrations of the period, offering a more radical form of imaging than attempted by either the troubadour painters or Paul Delaroche (no.55), but which has parallels in the work of Ingres (no.71) and Delacroix (no.60). On a more private level, it is a tour de force of iconoclastic wit that would have appealed to Bonington's closest friends, all the more if, as seems likely, he used his self-portrait for the features of Durward. Delacroix had previously portrayed himself as Ravenswood (Louvre) and, according to a letter from Thales Fielding dated 15 February 1828 (Getty Research Institute), had also included his portrait with those of Titian and the Bellini brothers, in his *Execution of the Doge Marino Faliero* (fig.6). PN

59
Eugène Delacroix (1798–1863)
Sketch for the Murder of the Bishop of Liège 1827

Oil on canvas
60 x 72.5 (23½ x 28½)
Lyon, Musée des Beaux-Arts

This is the preparatory study, executed in 1827, for the picture nearly twice its size now in the Louvre (fig.39), completed in 1829 and exhibited at the Musée Colbert, then at the Royal Academy in London in 1830 and the Paris Salon in 1831. Its genesis, however, undoubtedly spanned the period when Bonington was painting his *Quentin Durward at Liège* (no.58), and the two pictures should be viewed in the broader context of the relationship between these artists. Delacroix depicts the episode in Scott's novel *Quentin Durward* when William de la Marck, with the aid of the rebellious Liègeois, seizes the bishop's palace. At a riotous celebration he has the bishop slaughtered by the butcher Blok, who is also prominent in Bonington's picture. Delacroix had jotted notes on possible *Quentin Durward* subjects in one of the sketchbooks he was using in London in May 1825, and it was the visual material

gathered that summer that ultimately shaped his final interpretation. This would include sketches for the interior elevation of the palace drawn at Westminster Hall and the recollection of Wilkie's oil sketch for *John Knox Preaching* (no.72). Delacroix fretted that Wilkie would ruin his superb sketch in attempting to finish it. Ultimately at issue was the challenge of sustaining the spontaneity of such sketches in a finished work.

The influence of Rembrandt on Delacroix's effort was first proposed by Gautier (1855, p.178) who also observed that the Louvre version was 'left by the artist at precisely the moment when another brush stroke would have spoiled everything'. Most French critics admired the dramatic effect but still dismissed the final painting as unfinished. Not surprisingly, English critics were more enthusiastic and indifferent to arguments about facture. PN

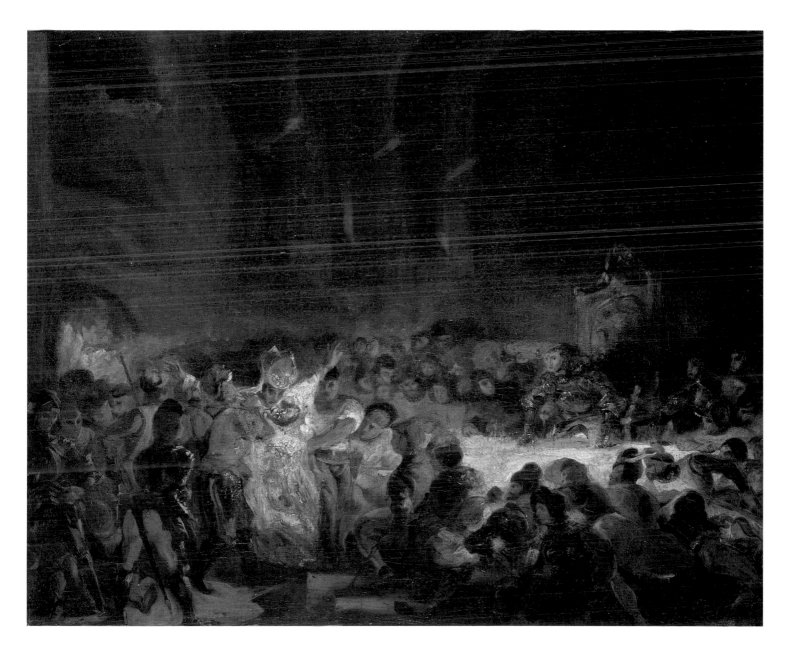

60

Eugène Delacroix (1798–1863)
Interior of a Dominican Convent, Madrid 1831

Oil on canvas
130.2 x 161.9 (51¼ x 63¾)
Signed and dated, lower centre: *Eug. Delacroix 1831*
References: Planche *Salon* 1834, p.246; Delécluze, 1834 (8 March 1834); Tardieu, 1834 (30 March 1834); Gautier, 1834 (April 1834), p.19; Sazerac, 1834, pp.140–1.
Philadelphia Museum of Art, Purchased with the W.P. Wilstach Fund, 1894

Charles Maturin (1780–1824) was an Irish Protestant minister with a talent for composing horrific Gothic novels, of which *Melmoth the Wanderer* was the most notorious and successful. A caustic review appeared in the *Literary Gazette* (18 November 1820) on its publication in London dismissing it as a fable 'stinking of infernal sulphur … out-Byroning Byron'. A French translation was available within months, while a theatrical adaptation was launched at the Cirque Olympique in March 1824. That probably prompted Delacroix to inscribe in his journal on 4 April an *aide-mémoire* to compose a series of designs for the novel, but not until 1831 did he commence this illustration for one of the Melmoth stories. As Athanassoglou-Kallmyer has recently observed, he was intimately associated at that time with a radical group of Romantic writers – Gautier, Charles Nodier, Pétrus Borel, Hugo, Balzac, and Gérard de Nerval – for whom diabolism and the grotesque were elixirs that would reform the arts.

The hero in Maturin's story, Alonzo Moncada, is the illegitimate son of the Duchess of Moncada. His parents force him into a monastery in Madrid to redeem their sin. The monks ceaselessly persecute him for his rebellious nature and, in the scene chosen by Delacroix, he is flogged and hauled, half-deranged, before a sadistic bishop. The architecture is not Spanish, but the interior of the Palais de Justice at Rouen, which Delacroix sketched in 1831. The final picture was exhibited in the 1834 Salon, prompting Gustave Planche to conclude that it was 'very likely the figures were added a long time after the architecture was painted'. On the other hand, the picture is dated 1831 and the affinities in composition, palette and violent action between it and the *Murder of the Bishop of Liège* (1831 Salon; fig.36) might have persuaded the artist to postpone its unveiling to a later date.

Benign depictions of monks within medieval cloisters had been the staple of François-Marius Granet (no.68), Charles Renoux (no.132), Louis Daguerre (no.42) and the many illustrators of Isadore Taylor's *Voyages pittoresques*. Gautier went so far as to place Delacroix's picture 'above all that Granet has accomplished, for its grave and melancholy colour', and its superior figures. Hilaire Sazerac (1834) observed the crucial distinction between those more antiquarian exercises and Delacroix's painterly manipulation of that popular genre to denigrate religious fanaticism. PN

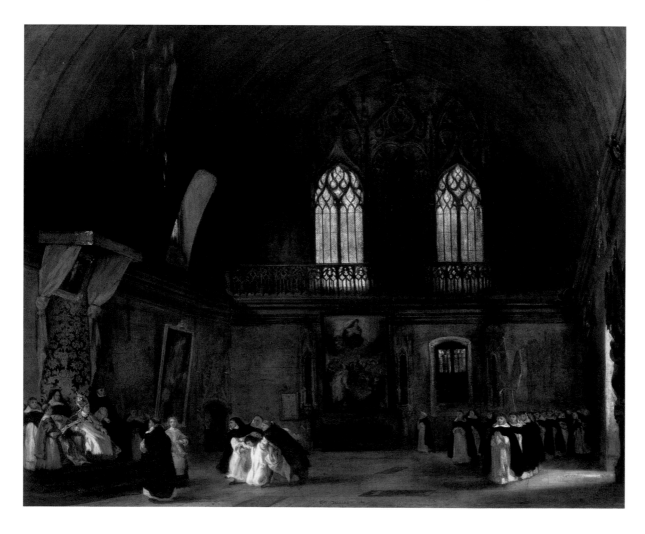

61

Richard Parkes Bonington
(1802–1828)

*Knight and Page (Goetz von
Berlichingen) c.1826*

Oil on canvas
46.5 x 38 (18¼ x 15)
Yale Center For British Art, Paul Mellon
Collection

In 1991, I proposed that this picture illustrated Johann Wolfgang von Goethe's seminal *Sturm und Drang* tragedy, *Goetz von Berlichingen* (1773), which dramatised a German warlord's defence of his feudal privileges against the reforms of Emperor Maximilian. Among Bonington's circle, Goethe's tragedy was a paradigm of what a renovated French drama should endeavour to merge; namely, the historicism of Walter Scott's prose and the emotive force of Shakespearean drama. Scott had actually translated the play into English in 1799. As Alfred de Rémusat observed in *Le Globe* on 28 June 1828: 'Goethe's play is the first attempt, the first example of this imaginative return to the Middle Ages, of this taste for Gothic and national paintings, which today invades all the arts.' A Delacroix watercolour illustration to the play of *c.*1826-7 represents Goetz attended by his page, George (no.181).

It was not until he shared a studio with Delacroix in the winter of 1825-6 that

Bonington seriously considered painting historical and literary illustrations. His habitual practice in painting figure subjects was first to assay the idea in watercolour or sepia, and then, with little further reflection, execute the oil *en premier coup*. However, when repeating the composition in oils, he thoroughly researched his theme and borrowed portraits and other details of dress or setting from works of art thematically related to his subject and of the same historical moment. This effectively infused 'local colour', or the ambience of specific time and place, into the representation. Accordingly, Andrea del Verrochio's bronze equestrian portrait of one of Italy's most famous generals, Bartolemmeo Colleoni (1400–1475), furnished the facial features for Goethe's anachronistic *condottiere*. His armour is based on a suit in the collection of Samuel Meyrick, while his pose and costume ensemble derive from Hans Burgkmair's *Der Weisskunig* woodcuts, which celebrate the life of Maximilian.

In his will, Delacroix bequeathed this picture to Baron Charles Rivet. It was probably painted in his presence in Bonington's rue des Martyrs studio in the autumn 1826. The circumstances by which it came into his possession are perhaps implied in the passage he recorded in his journal on New Year's Eve 1856:

Some talents come into the world fully armed and prepared. The kind of pleasure men of experience find in their work must have existed since the beginning of time. I mean a sense of mastery, sureness of touch going hand in hand with clear ideas, Bonington had it, but especially in his hand. His hand was so skilled that it ran ahead of his ideas. He altered his pictures because he had such facility that everything he put on canvas was charming. Yet the details did not always hold together, and his tentative efforts to get back the general effect sometimes caused him to abandon a picture after he began it. Note that another element, colour, is crucial to this type of improvisation.

PN

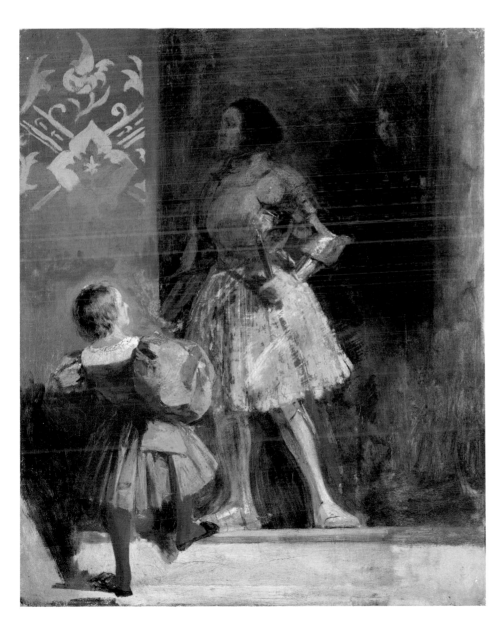

62

Eugène Delacroix (1798–1863)
*Charles VI and Odette de
Champdivers*, c.1825

Oil on canvas
35.6 x 27.3 (14 x 10¾)
Signed, upper left: *E. Delacroix*
Private Collection, courtesy of Richard
L. Feigen & Co., New York

Charles VI (1368–1422) ascended the French throne at the age of twelve. His cousin was René of Anjou (no.70) and his brother Louis d'Orléans (fig.43). Delacroix chose to represent an intimate episode in the mad king's later life, during which he threatens violence with his sword only to be subdued by his retainers and his mistress Odette de Champdivers, who supplanted his wife, Isabelle of Bavaria, after the onset of his insanity. The earliest and most notorious instance of his mental illness, which manifested itself in bouts of extreme violence and is alluded to here, occurred in 1392 when, on a punitive mission in Brittany, the king mistook the members of his own retinue for enemies and slew four with his sword. It was an episode familiar from Jean Froissart's chronicles and frequently recounted in the historical sources that Delacroix studied. Most biographical accounts of this monarch identify Odette as the only

person who could calm the king in his moments of fury.

Like Bonington and Ingres, Delacroix would breath new life into the Troubadour genre with his unique interpretations of French medieval history and British literature during the 1820s. This picture is usually dated to the autumn of 1825. It is certainly more advanced in portraying madness than Delacroix's earlier *Don Quixote in his Library* of April 1824, approaching Bonington's quiescent interpretation of *Don Quixote in His Study* (1825; Nottingham) and the more clinical spirit of Gericault's monomaniac portraits (nos.81, 82). Nonetheless, the painting bears little resemblance stylistically to the work that Delacroix would shortly paint in the company of Bonington at the end of the year; rather, it seems the artist has deliberately emulated the precise and elaborate finish and the jewel-like colours of medieval manuscripts. PN

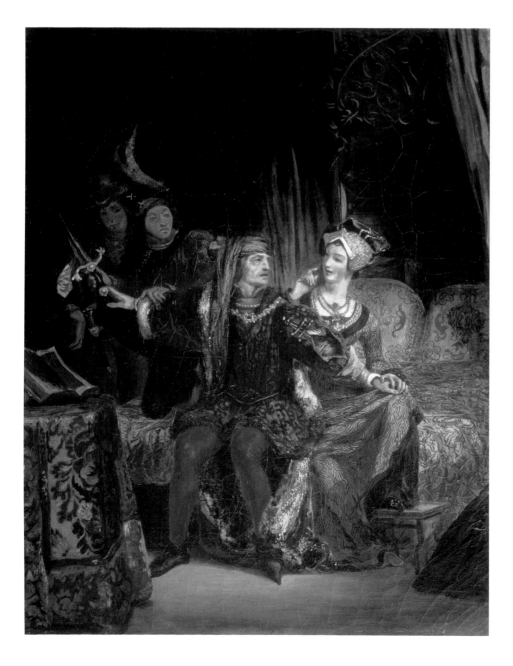

63

Ary Scheffer (1795–1858)
The Dead Pass Swiftly (Lenora)
*c.*1825–9

Oil on canvas
59 x 76 (23½ x 30¼)
Signed, lower left: *Ary Scheffer*
Exhibitions: Musée Colbert 1829, II, no.151.
Lille, Palais des Beaux Arts
Minneapolis and New York only

Although born in Dordrecht, Scheffer settled in Paris in 1811 where he briefly studied with Pierre Guérin (1774–1833). His first Salon appearance was in 1812, but he almost abandoned his profession in 1819 when his *Burghers of Calais* invited extreme critical abuse. Scheffer later acknowledged with gratitude François Gérard's (no.73) intervention on his behalf. With his brothers he cast his fortune with the French *carbonnerie*, a radical republican group that elected General de La Fayette as its President in 1821 and his brother Arnold Scheffer as its Secretary. Within a year Ary was drawing master to the children of the duc d'Orléans and the unofficial portraitist to the next monarch of France. His *Gaston de Foix at Ravenna* at the 1824 Salon placed him in Delacroix's camp as a history painter, but in his review of that Salon, Adolphe Thiers saw in Scheffer's mastery of sentimental genre the quintessence of his genius and of modernity. At the 1827 Salon, Greek subjects dominated his presentation, while after 1830 literary illustrations were the norm. In that category he truly excelled. His position of privilege under the July Monarchy enabled Scheffer to help younger painters like Théodore Rousseau and Jules Dupré.

The German poet Gottfried August Bürger's (1747–94) ballad *The Dead Pass Swiftly (Lenora)* of 1773 was his most influential poem, exciting a plethora of interpretations in music, verse, paint and graphic art. German by descent, Scheffer naturally gravitated towards that nation's great proto-Romantic authors, finding in Göethe, Schiller and Bürger a wellspring of inspiration. Lenora, failing to recognise her fiancé Wilhelm among the soldiers returning from a war, commits blasphemy. An armoured soldier whom she takes for Wilhelm appears at her door the next evening and promises to wed her before dawn. They ride furiously through the night hounded by grisly spirits. At sunrise, they reach a graveyard where Wilhelm's true identity as a ghastly skeleton beneath his disguise is revealed to the hapless Lenora, as she is dragged by her seducer into the infernal regions.

At the 1831 Salon, Scheffer exhibited a painting illustrating the first part of the poem, *Return of the Army*. This Lille picture, exhibited at the Musée Colbert in 1829, is an earlier conception, closer in date to Delacroix's equally macabre *Tam-O'Shanter* of 1825. Its very sketchy quality has prompted some scholars to consider it a sketch, but the artist's intent was to exploit a loose technique for the purpose of manufacturing a morbid nocturnal ambience. The suggestion that Lenora has been affianced to an eternal void is brilliant. It is this appeal to the emotions and imagination that distinguishes Scheffer's interpretation from Horace Vernet's more literal and tediously detailed illustration of the graveyard scene of 1839 (fig.40). PN

fig.40
Horace Vernet
La Ballade de Lénore
1839
Oil on canvas
Musée des Beaux-Arts, Nantes

64
Charles Robert Leslie
(1794–1859)
Slender, with the Assistance of
Shallow, courting Anne Page, from
'The Merry Wives of Windsor' 1825

Oil on canvas
67.7 x 77.5 (26½ x 30½)
Yale Center for British Art, Paul Mellon Fund

Born in London of American parents and initially much influenced by Benjamin West and Washington Allston, Leslie chose not to follow them as history painters but to explore a lighter vein of anecdotal history and literary subjects 'in which either the humour or the beauty struck his fancy' (Cunningham, *Lives*, III, p.346). Walter Scott admired his picture *May Day Revels in the Time of Queen Elizabeth* exhibited in 1821, while *Sancho Panza in the Apartment of the Duchess* (Petworth) shown in 1824 was the first of a number of pictures Leslie painted for the Earl of Egremont, who considered him 'the Hogarth of elegant life'. This Shakespearean picture was exhibited the following year, when Bonington and Delacroix were in London, and was the likely inspiration for Bonington's *Anne Page and Slender* (Wallace Collection), probably painted the following winter, 1825–6. Leslie's picture, typically, looks like a costume piece, very much of its own time, while Bonington's follows later French Troubadour painting in being more rigorously archaising, and adapting historical research – in this case poses and costumes from plates in Joseph Strutt's *Complete View of the Dress and Habits of the People of England* (1796–9). DBB

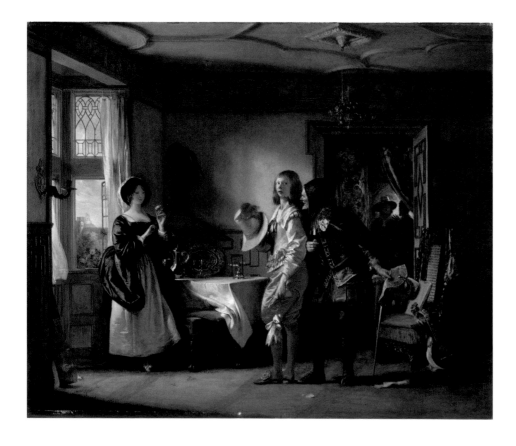

65

Alexandre-Marie Colin
(1798–1873)
Othello and Desdemona, 1825

Oil on canvas
50.8 x 61 (20 x 24)
Signed and dated, lower left: *Colin 1825*
References: C., *Galerie Lebrun*, p.3.
New Orleans Museum of Art: Museum
Purchase, The Bert Piso Fund

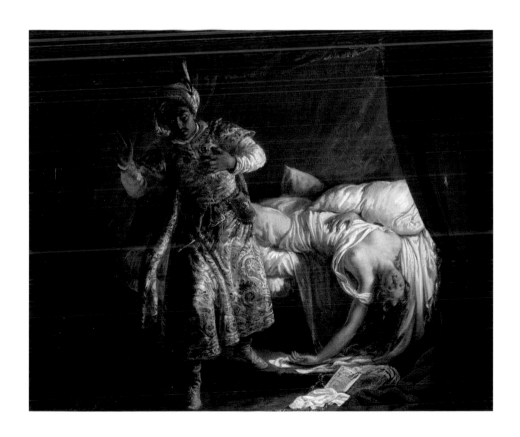

Colin was an artist of immense yet ultimately unrealised promise. Virtually disregarded today, he was, in the 1820s, one of the most determined and original interpreters of British literature and a beguiling virtuoso technician. A Parisian, he entered the Ecole des Beaux-Arts in 1814 as a pupil of Girodet, but soon gravitated towards Géricault. By 1820, Colin was on intimate terms with Delacroix and Bonington; to the latter, he remained especially devoted. The extraordinary range of his interests is reflected in the pictures he submitted to the successive Salons in the 1820s – portraits and illustrations to the famous Gothic novelist 'Monk' Lewis in 1822, marine views in 1824, Italian genre subjects and scenes from Daniel Defoe, Goethe and Shakespeare in 1827. Equally comprehensive were the many folios of prints that he was commissioned to produce, including illustrations to Byron.

In the spring of 1824, Bonington and Colin painted marine subjects at Dunkirk. Of his 1824 Salon entries, Auguste Jal noted that Colin was 'marching in the path of Bonington', and urged him to 'guard against laxity'. In late May 1825, they travelled to London. Delacroix would later recall in a letter to Colin (3 May 1861) 'the most vivid memories … when we and others met together – under all kinds of circumstances – in England'. Clearly these artists were much in each other's company those few precious weeks, visiting studios, museums, exhibitions and the best private collections. In addition, Delacroix wrote of a steady diet of Shakespeare, Rossini and Carl Maria von Weber. Rossini's opera *Otello*, with the beloved Malibran as Desdemona (no.106), had been quite the rage in Paris from its first performance in 1821. In July 1822 an English troupe performed Shakespeare's *Othello* at the Porte-St-Martin theatre in Paris, but it is unlikely that Colin attended that performance, since a lithographic illustration by him, dated 1823, shows Othello threatening his terrified spouse with a knife. That scenario, absent in Shakespeare, follows Jean-François Ducis's 1792 adaptation of the play, which was the preferred stage version in France prior to the arrival of the English actors. Colin's picture, dated 1825, was probably painted then shortly after his return from London, where he attended a production of the play, with Edmund Kean in the lead role. It is relatively faithful to Shakespeare's text. Othello, having smothered Desdemona, hears both the frantic entreaties of the maid Emilia in the antechamber and the final lament of his expiring wife. Delacroix's earliest illustration to *Othello*, a small *Desdemona and Emilia*, dates to the same year, I.J.A. Coutan probably purchased Colin's picture at the 1826 Galerie Lebrun exhibition.

Othello was rarely illustrated in France, but Gros had explored the same scene in an 1804 drawing. His pose for the tragic heroine is identical to that by Colin, and is probably derived from the 1781 version of Johann Heinrich Fuseli's *Nightmare*. Possibly Colin knew the Gros drawing. He certainly knew one of the many prints after Fuseli's picture, a ubiquitous image in France, for in 1823 he also published a series of satirical lithographs, *L'Album Comique de pathologie pittoresque*, with a plate that blatantly pastiched Fuseli's composition.

Like every artist of his generation Colin relied on prints for details of costume and architecture, for poses and even for entire compositions. The sale following his death included oil sketches after Fuseli's plates for Boydell's *Shakespeare Gallery*. Other surviving drawings by Colin indicate that he also plundered Bowyer's illustrated edition of Hume's *History of England*, which was Delaroche's primary mine of ideas. PN

66

William Etty (1787–1849)
Phaedria and Cymochles on the Idle Lake 1832

Oil on panel
62.5 x 76 (24½ x 30)
References: *The Athenaeum*, no.5, 16 June 1832,
p.388; *Literary Gazette*, 26 May 1832, p.329.
Princeton University Art Museum. Gift of
Benjamin Sonnenberg
Minneapolis and New York only

As an artist, William Etty was slow to mature, having wasted seven years of his youth apprenticed to a Hull newspaper. In 1807 he entered the Royal Academy schools, where his fellow students would include William Collins and David Wilkie. Later that year he also entered Lawrence's studio. Etty's early ambition to practise history painting was uncommon for an English artist and was piqued, in part, by his fixation with the female form. 'All human beauty is concentrated in women', he would profess, and for the remainder of his career he endeavoured to nurture that axiom through his art and his assiduity at the life class. Indeed, Etty was probably the British artist most sympathetic to the principles and aims of David's school, even though his own practice generated a radically different product.

The first of Etty's numerous visits to Paris occurred in 1816 while en route to Italy. On the return leg of this journey he enrolled briefly in the studio of Jean-Baptiste Regnault, which proved an unhappy adventure. In more serene moments, he copied Charles Lebrun's *Battles* in the Louvre. Etty made an extended tour of France and Italy in 1822–3. Thereafter followed nearly a year in Venice before he was again in Paris, from where he offered Lawrence a cogent assessment of Continental art:

Painting on the Continent is more or less dilutions of the French manière. *The efforts the French make are indeed great ... There is an agreeable choice of subject, a daring excursion into the regions of history and poetry, a knowledge of drawing and details, and occasionally something in colour very respectable (not often); that altogether leaves an impression of power.*

His experiences in Italy, and probably France, convinced Etty that history painting was moribund in England, and shortly after his return he commenced the first of nine large canvases, which he hoped would prove an exception. His *Combat: Woman Pleading for the Vanquished* (Edinburgh) was a sensation at the 1825 Royal Academy and might have brought the artist to Delacroix's attention.

Phaedria and Cymochles on the Idle Lake is the smallest of the pictures submitted by Etty to the Royal Academy in 1832. It was accompanied by several lines from Edmund Spenser's *Faerie Queene* (Book II, Canto VI). Spenser conceived his work as an epic of twelve poems, each of which defined, in the person of an individual knight, one of the twelve moral virtues. Book II describes the legend of Sir Guyon, who personifies Temperance. Neither his foil, Cymochles, who embodies Loose Living, nor Phaedria, whose dubious distinction is Wantonness, are among Spenser's pantheon of the chaste. Small wonder that the critics queried Etty's choice of subject. The *Athenaeum*, in particular, noted the lasciviousness of Etty's exhibits that year. For a version exhibited in 1835 (Forbes Collection), Etty invented less suggestive poses for the two figures, although he appended to that picture a more graphic verse from Spenser.

Irrespective of its potential eroticism, this picture documents with extraordinary clarity the hallmarks of Etty's mature style, which relied for its brilliant colour effects on the optical mixture and contrast of a few pigments judiciously mixed with white and swiftly applied. His medium was a glaze composed of an equal mixture of the rapid drying agent sugar-of-lead water, mastic varnish and linseed oil, and usually deployed over a watercolour lay-in on white ground and extensive underdrawing. The translucency of effect and bravura application, which came from years of copying Rubens and the Venetians, astounded his French peers. In both palette and execution, the spontaneous, choppy application of pigment in the background and water anticipate remarkably Delacroix's later Algiers coastal landscapes. Since his friendship with Etty was one of Delacroix's cherished memories, it is impossible to ignore the probable influence of the British artist on his French admirer. The prevalence of copal varnish as a medium in Delacroix's pictures immediately following his return from London in 1825 might also owe something to his acquaintance with Etty, whose studio he visited.

A comparison with Gros's *Bacchus and Ariadne* of 1821 (no.67) is also illuminating. Where Etty chose an ideal subject, he refrained from idealising the form of his protagonists. Gros has created types that are beyond common experience, whereas Etty has literally transcribed his naturalistic life studies into the idealised context of epic poetry. This disparity, however, was often incomprehensible to both his French and British audiences. PN

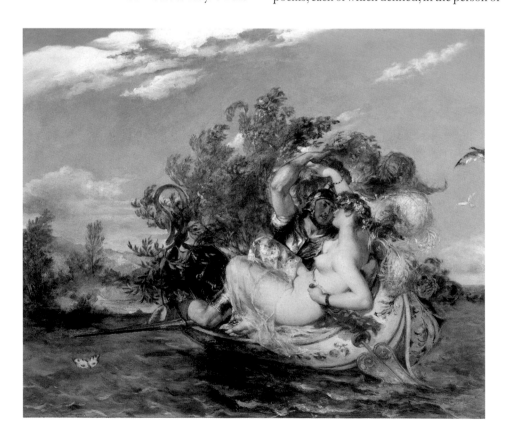

67
Antoine-Jean Gros (1771–1835)
Bacchus and Ariadne 1821

Oil on canvas
86 x 101.3 (33⅞ x 39⅞)
References: (Ottawa version) Delécluze, 1822;
R., *Salon* 1822, pp.1–3; *Journal de Paris*, 1 May
1822; Boutard, 1826, p.3; Delacroix, *Gros*,
p.194.
Phoenix Art Museum, Museum purchase with
funds provided by an anonymous donor
Minneapolis and New York only

With David's exile to Brussels in 1816, Gros inherited not only his students but the self-inflicted task of perpetuating his doctrines, to which Gros himself had scarcely adhered in his finest earlier work. Delacroix much later was to attribute Gros's self-effacing 'fall from the sublime' and eventual suicide to the moment he embraced David's pedagogic role. David's pressure on Gros to reject modern themes and produce painting based on mythology or ancient history was relentless, and he eventually went so far as to engineer a commission from one of his own patrons for a painting of mythological lovers to complement his own *Telemachus and Eucharis* of 1818 (Getty Museum) in that same patron's collection. This version of *Bacchus and Ariadne* was indeed commissioned by Count Erwin von Shoenborn in 1820. A slightly more mechanical replica (Ottawa) was exhibited at the 1822 Salon and at the Galerie Lebrun in 1826 with the title, *Ariadne, Abandoned by Theseus on the Isle of Naxos, is Taken in and Consoled by Bacchus*. A pencil sketch of the composition inscribed 'Gros Brux[elles] 1821' suggests that the idea for the picture was hatched collaboratively during Gros's visit to David that year. But there is nothing of David's lyricism and melancholy in Gros's explicitly sensual lovers. The sentimentality of Ariadne's head, with the contrasting gentle smile and coy tear, is thoroughly offset by the frontal display of her seductive torso and languid pose, which makes it clear that despite her previous lover's

abandonment, an agreeable alternative was within arm's reach. Erotic subjects increased dramatically in number during the Restoration as a means of compensating for the decline of official commissions of history painting, and this insatiable interest of the private sector informs Gros's conception no less than Delacroix's more licentious easel pictures (nos.79, 80).

In 1822, the Salon critic for the *Débats* complained about the monotonous rose flesh tints; the system of half-figures being inappropriate to history paintings; and the head of Bacchus as too academic. She, on the other hand, was exquisite in every regard. For Etienne Delécluze the subject meant little; the merit resided in the artist's conceptualisation. Like others he objected to the format and the palette, but was impressed by the delicacy of the execution and the finesse with which Gros captured Ariadne's emotional equivocation. Nevertheless, his staunch belief in mythological subjects as vehicles for promoting ideas of spiritual and sensual innocence was sufficiently challenged for him to worry that Gros's approach might 'misdirect his students'. PN

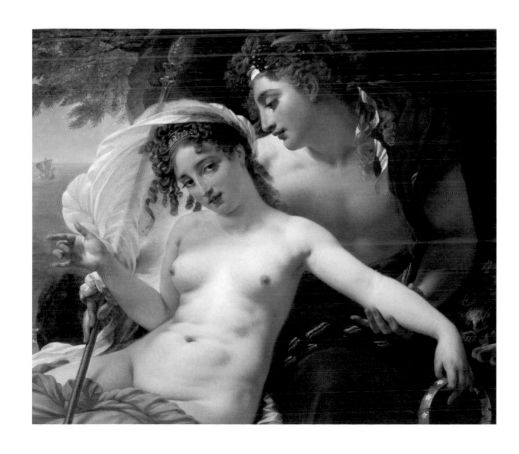

68

François-Marius Granet
(1775–1849)
Monks on the Terrace of the Certosa
in Capri c.1820

Oil on canvas
73 x 99 (28¾ x 39)
Private Collection

Granet was one of many talented French artists to emerge from the provinces in the late eighteenth century. With Auguste de Forbin, future director of the royal museums, he became David's pupil in 1798, but gained more from his study of Dutch and Flemish paintings in the Louvre and from his close association with compatriots from Lyons, especially Pierre Révoil (no.70). With those colleagues he shared a commitment to Catholicism and the Middle Ages. His earliest Salon pictures were views of interiors of Paris cloisters. Financially assisted by De Forbin, he travelled to Italy in 1802, where he remained happily until 1824, supporting himself by the sale of paintings depicting the architectural ruins of ancient Rome. Following the staggering success of his *Choir of the Capuchin Church in Rome* (Metropolitan Museum), purchased by Caroline Murat, the Queen of Naples, in 1814, elaborate perspective views of vaulted interiors, dramatic chiaroscuro and melancholic monastic themes dominated his production. A larger version of the *Choir*, now in the Hermitage, appeared at the 1819 Salon, and the popularity of the subject with readers of Gothic romances was such that Granet and his studio produced at least a dozen more examples.

Versions were exhibited at the British Institution in 1827, attracting 'much attention by its extraordinary display of perspective and of management of light' (*Literary Gazette*, 7 July 1827, p.443) and at the Royal Academy in 1833. Others were acquired directly from the artist by British tourists in Rome. The Prince Regent ordered a copy for Carlton House as early as 1819. Such, in fact, was Granet's success in

England that De Forbin would write from London in April 1821 that he was more famous there than in Paris.

On the evidence of style, Granet is unquestionably the author of the present picture, although several replicas by Franz Ludwig Catel (1778–1856), including variants with nuns, have clouded the discussion of attribution. The relationship between the two artists is vague. Both frequented the salon of Elizabeth, Duchess of Devonshire (1759–1824), following her arrival in Italy in 1811. Catel also arrived in Rome that year. Granet is known to have employed a studio of capable assistants who replicated his more popular inventions for the tourists. However, it seems unlikely that Catel would have functioned in such a capacity at that date. That he had access to Granet's studio is apparent. Whether his replicas of the senior artist's composition were authorised requires further investigation.

The Certosa was a Carthusian monastary founded in 1371 in the hills overlooking Capri. Like other monasteries in Italy, it was closed by Joseph Bonaparte in 1807. As in the *Choir of the Capuchin Church*, Granet has recreated an imaginary scene within a real architectural setting that was, at the time of painting, in disrepair. It has often been observed that the quiescence of Granet's depictions of monastic life have their surest parallel in the works of Caspar David Friedrich. But Granet would not have known the German's work. If a source were indeed needed for the extraordinary juxtaposition of the moonlit seascape and the artificially illuminated cloister in this picture, not to mention the complex perspective systems resulting from this deliberate contrast, a more plausible candidate would be Joseph Wright of Derby, whose major pictures in this vein circulated the Continent in mezzotint reproduction. PN

69
Alexandre-Evariste Fragonard
(1780–1855)
Burial of a Monk c. 1820

Oil on canvas
72.7 x 91.1 (28⅝ x 35⅞)
Signed, lower right: *A. Fragonard*
Wheelock Whitney, New York

Fragonard had the distinct advantage of being both son and pupil of one of the eighteenth-century's most gifted painters, Jean-Honoré Fragonard, and nephew of the eminent genre painter Marguerite Gérard. He also studied with David and, from this medley of disparate influences, he forged a unique decorative style adaptable to any scale and most categories of subject. He was, in other words, an artistic confection that Britain could never hope to produce. The themes of his earliest paintings celebrated Neoclassicism and the Empire, and like Ingres, he turned to troubadour subjects with the Restoration. He seemed never to want for major commissions, from church altarpieces to ceiling decorations for the Musée Charles X. He was particularly attracted to the history of Francis I, although his *Battle of Marignan* (1836), commissioned for Versailles, is a thinly veiled reprise of Gros's *Eylau* of 1808 (no.47). Fragonard's taste in literature and theatre was thoroughly romantic and Anglo-Scottish, and he designed historical costumes with exceptional verisimilitude. He was the most prolific of Isadore Taylor's illustrators for the *Voyages pittoresques*. Dating is always difficult with Fragonard, but a lithograph of 1820 for Taylor's Normandy volume,

illustrating a monastic burial, might be related to this painting.

Granet's *Choir of the Capuchin Church in Rome* (1814) elevated the profile of an entire class of monastic genre subjects. Fragonard's picture, however, is the theatrical interpretation of a scene in a yet to be identified novel or melodrama. The Gothic novels and plays of Mathew Lewis, Charles Maturin (no.60) and Anne Radcliffe had become fashionable in the 1810s, spawning both imitators and illustrators. In this unusually elaborate composition for the artist, Fragonard appears to describe the discovery of a corpse in a sepulchre that has just been opened to receive the remains of a deceased older monk. The dramatic contrasts of light and shadow afforded by such crypt subjects were a significant part of their appeal, but Fragonard was especially adept at exploiting them for sensational effect. In his proclivity for these subjects, he followed the example of the Lyonnais school, especially Fleury-François Richard (1777–1852) and Pierre Révoil (no.70), and their Dutch antecedents, as well as the diorama masters like Daguerre. PN

70

Pierre Henri Révoil (1776–1824)
René of Anjou After Passing the Night at the Château of Palamède de Forbin c.1827

Oil on canvas
83.8 x 104.1 (33 x 41)
Signed, lower centre: *P. Revoil*
References: Jal, 1827, p.350.
Joseph C. Canizaro

The troubadour style in France emerged from a *mélange* of impulses, among which were the revival of interest in Dutch art, the opening of Alexandre Lenoir's Musée des Monuments Français in 1795 with its treasury of Gothic artifacts, and a profound curiosity for the Middle Ages as a source of national pride. When it initially appeared in the 1802 Salon, this type of painting was dubbed anecdotal genre. Its originality lay in its attempt to reform eighteenth-century genre by introducing themes from the lives of eminent historical figures, and thereby also bridge the hierarchy between genre and history painting. Fleury-François Richard and Pierre Révoil, both natives of Lyon and pupils of David in the late 1790s, would become its principal exponents. Often porcelain-like in finish, assiduously researched as to the factual details of costume, place and effigy, small in format, and sentimental in the choice of medieval or Renaissance subject, the troubadour style achieved immediate favour with the Empress Josephine and later the Duchesse de Berry.

The 1827 Salon catalogue described the subject of the present picture at length. Having passed the night at the chateau of Palamède de Forbin in Provence, King René the Good of Anjou (1409–80), pleased with the hospitality, traced his portrait on the vestibule door with the inscription: 'This is the effigy of René, King of Sicily.' The picture was commissioned in 1820 by Palamède's descendant and Révoil's old friend, Auguste Comte de Forbin, Director of the Royal Museums and himself a practitioner of the troubadour style, with the intent that it be purchased by Louis XVIII. The iconography was apparently meant to flatter Louis XVIII's patronage of both the arts and the Comte de Forbin, and to convey obliquely Forbin's own gratitude to his monarch. In keeping with the demands of the new historicism for narrative accuracy, Révoil pored over manuscripts in the Bibliothèque Nationale thought to be the reminiscences of King Réne.

René of Anjou is one of the most ravishing pictures of the troubadour genre to have survived. While many of the subjects depicted by Richard and Révoil before the Restoration inspired imitations by painters of the stature of Ingres, Daguerre and Bonington through the 1820s, their highly polished technique and almost pedantic erudition gradually alienated critics and audiences alike. Delécluze, for instance, would lament as early as October 1820 in the *Lycée Française* that 'Révoil and those he inspires tend to paint still-life'. PN

71
Jean-Auguste-Dominique Ingres (1780–1867)
Entry into Paris of the Dauphin, the Future Charles V 1821

Oil on canvas
44.5 x 53.3 (17½ x 21)
Signed and dated, lower left: *J. Ingres 1821*
References: Anon., *Drapeau Blanc*, 1824 (11 Dec. 1824), p.3; Coupin, *Salon 1824*, p.590; Jal, *Salon 1824*, p.355; Stendhal, *Salon 1824* (23 Nov. 1824).
Wadsworth Atheneum, Museum of Art, Hartford, CT. Gift of Paul Rosenberg and Company

Commissioned in Florence in 1821 by the Comte de Pastoret (no.51), this painting is one of the most 'medieval' of Ingres's small historical and literary easel pictures, and it rejuvenated, if briefly, the flagging troubadour style in a brilliant and original manner. To appreciate its novelty one need only compare it to François Gérard's *Henri IV* (no.73).

The subject is the triumphant return to Paris in 1358 of the Duke of Normandy, later Charles V, after his suppression of the Jacquerie, or peasants' rebellion. Jean Froissart's chronicles furnished Ingres with a description of the event. The future monarch was also credited with the restoration of national unity after decades of failed military campaigns against the English. Parallels between the two 'restorations' were explicit, as was the Comte de Pastoret's motive for commissioning this subject: he claimed direct descent from Jean Pastourel, the first president of the Parliament of Paris, who remained loyal to Charles and is here represented as the central figure in red greeting his sovereign's return.

The painting's first public presentation was at the 1824 exhibition. It was undoubtedly one of the 'vile farrago of Bourbon-Restoration pictures' to which William Hazlitt referred in his *Notes* that autumn. In his 1827 Salon review, Arnold Scheffer astutely noted that Ingres's reappearance on the Paris art scene in 1824 was startling because his style was as opposed to David as it was to Delacroix; it was a style that combined respect for Raphael, the knowledge of medieval illuminations and the

meticulousness of the German school. Auguste Jal, however, remained guarded in his assessment of Ingres's merits, and in a direct attack on this oil questioned his persistent 'outré and Gothic manner … he seems to be not of our century; he speaks to us in the language of Ronsard, and is astonished that we do not understand'.

Ingres's intention at this time was indeed to create an Italianate style of painting, comparable to the Nazarenes and derived ultimately from Raphael, but his elliptical processional arrangement owes its immediate inspiration to Jean Fouquet's fifteenth-century illuminations for the *Grandes Chroniques des Rois en France*. Details of costume, portraiture and heraldry were also meticulously researched from antiquarian sources, while poses for specific figures recall the Florentine masterworks of Andrea Mantegna and Fra Angelico.

Ingres's use of Froissart, his archaeological exactitude, his layers of allusions and his inspired appropriation of a chronologically precise compositional type as a solution to the problem of organising a medieval crowd scene were almost certainly responsible for inspiring Bonington's very similar approach to his most important literary subject, *Quentin Durward at Liège* (no.58). Their styles of execution, however, were diametrically opposed. PN

72
David Wilkie (1785–1841)
The Preaching of Knox Before the
Lords of Congregation, 10 June 1559
c. 1822–32

Oil on canvas
49.5 x 62.2 (19½ x 24½)
National Trust, Petworth House

In Paris in 1814, Wilkie was 'exceedingly mortified' to discover his hostess had never heard of Scotland (Cunningham, *Wilkie*, I, p.413). Walter Scott's novels, and his own reputation, would soon correct her omission. Wilkie was an avid reader of Scott, and his view of Scotland as a 'volume of history' was surely influenced by the author, since he expressed it to Sir George Beaumont shortly after he visited Abbotsford in 1817 (ibid. II, p.6). Scott's *The Monastery* and *The Abbot* of 1820 concerns the Scottish Reformation and its fanatical Presbyterian leader, John Knox. The following year, Wilkie made a chalk drawing of Knox preaching (Fitzwilliam Museum, Cambridge), an early idea for this composition. The subject, Knox's sermon at St Andrew's, which sounded the death-knell of Catholic religion and government in Scotland, was actually taken by Wilkie from Thomas McCrie's *Life of John Knox* (1813), but was one he was eager to submit for Scott's approval. He hoped, also, that it would bring a royal commission and, in 1822, when he went north to witness George IV's visit to Edinburgh, he took this oil sketch with him, to show both Scott and the king. Scott admired the work, the king did not, and it was after a decade of ill-health and travel abroad that Wilkie exhibited the finished version, which was bought by Robert Peel (Tate). The sketch was acquired by the Earl of Egremont. Wilkie also began two versions of a 'companion' subject, *Knox Preaching at Calder House* (National Gallery of Scotland).

As the son of a Presbyterian minister, Wilkie's sympathies might be expected to lie

with Knox, but his attitude to the Reformation seems to have been ambivalent, while the dramatic appeal of the subject lay not only in the preacher's fiery magnetism, but in the range of reactions it aroused. The shock and rage of the Catholic bishops opposite Knox contrast with the zealous concentration of the Protestant lords beneath them. Between the opposing groups, in an oasis of light, is the Countess of Argyll, whose own sympathies lay between the reformers and her natural sister, Mary Queen of Scots. It had been a high mass in Rouen cathedral in 1814 – at exactly the time when full Sunday observance was restored by Louis XVIII – that first opened Wilkie's eyes to the beauties of Catholic ritual. His travels in Italy and Spain, in the years when he was developing his ideas for the picture, confirmed his first impressions, and he described how he enriched Knox's pulpit with carvings of 'Saints, Apostles and Martyrs' as 'no bad indication of some of the labour which his preaching destroyed' (ibid. III, p.47).

Wilkie researched the background for the picture in Scotland, while the visualisation of Knox owed much to a charismatic preacher of his own day, his friend Edward Irving, whose fire-and-brimstone sermons were given at the Caledonian Chapel in London's Hatton Garden. For the dramatic composition, however, Wilkie drew on a Parisian memory of Peter Paul Rubens's *Coronation of Marie de Medici* (Louvre), which he saw in the Luxembourg in 1814. Delacroix saw Wilkie's oil sketch in London in 1825, and wrote to J.P. Pierrot: 'I can't express to you how beautiful it is, but I'm afraid he will spoil it; it is a fatal mania' (*Correspondence*, I, p.160). For its impact on Delacroix's own work, see nos.59, 180. DBB

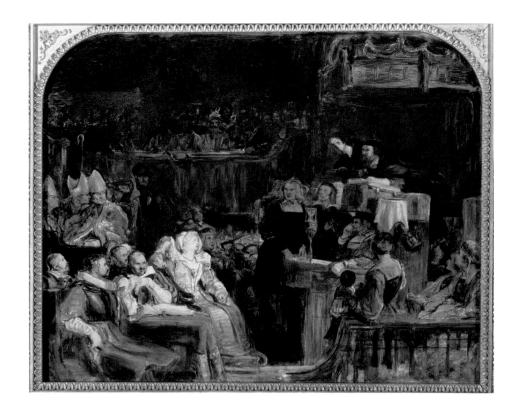

73
François Gérard (1770–1837)
Sketch for The Entry of Henri IV into Paris, 22 March 1594 1815–16

Oil on canvas
61 x 134.1 (24 x 52¾)
Private Collection, courtesy of Richard
L. Feigen & Co., New York

Gérard was the only painter to rival Thomas Lawrence in his gentility, advocacy of fellow artists and international stature during this era. The precocious student entered David's studio in 1786 and remained under that artist's protection through the Revolution. His initial Salon successes were portraits and, from 1800, imperial commissions, including *Ossian Invoking the Phantoms with His Harp* of 1800 (La Malmaison). He was to the Consulate and Empire what Lawrence was to the Regency, the principal chronicler of its fashionable elite. And like his English peer, he warmly welcomed foreign artists to his weekly salons. Gérard was also a highly prized history painter. *Psyche and Amour* of c.1798 (Louvre) and *Sainte Thérèse* of 1827 (Maison Marie-Thérèse) are two of his canonic images in that mode.

This is a preparatory study for the immense canvas now at Versailles, commissioned by Louis XVIII to replace Gérard's own *Battle of Austerlitz* of 1810 in the Tuileries Palace. Loosely based on the tenth canto of Voltaire's *Henriade* (1723), the large version was shown to tremendous critical approbation at the 1817 Salon. It follows closely the details of the sketch, with one notable exception – the king is more humanised in the final work by the removal of his helmet. Révoil's celebrated, and much imitated, *Henri IV Playing with his Children* of 1817 (Pau), appeared in the same exhibition, together with a dozen other illustrations from this monarch's life. As the founder of the restored Bourbon dynasty, Henri IV was the logical source of inspiration for a propagandising machine intended to legitimise the new regime. Entering Paris in March 1594 after a protracted civil war, he was

immediately hailed as the restorer of national unity. To underscore historical parallels, the picture was withheld from the opening of the Salon in April, arriving only on the second anniversary in July of Louis XVIII's return to Paris after the Hundred Days.

Gérard's intentions were brilliantly analysed by Ruth Kaufmann (1975, pp.790ff), who observed that the principal challenge confronting Louis XVIII and his moderate ministers was to reconcile the idea of legitimate monarchy with the political realities of post-Revolution France. Gérard managed this by introducing into his Baroque composition a series of episodes that respected the grandeur of the monarch whilst acknowledging the crucial role played by the bourgeoisie in his entitlement. In recognition of his accomplishment, Gérard was named First Painter to the King. While visiting Paris in November 1823, William Etty gave Thomas Lawrence an excoriating opinion of Gérard's picture, wondering 'how any man with Paolo Veronese and Rubens at his elbow could mix up such a nauseous draught of colour!'

At the same moment, Wilkie was working on a sketch for his monumental composition *Entrance of George IV at Holyrood House* (HM the Queen), the only contemporary British picture to address a parallel subject matter; namely, the celebration of the reconciliation under a constitutional monarchy of historically fractious parties within the same kingdom. Indeed, there are certain figure arrangements in Wilkie's picture that suggest more than a passing awareness of Gérard's famous painting.
PN

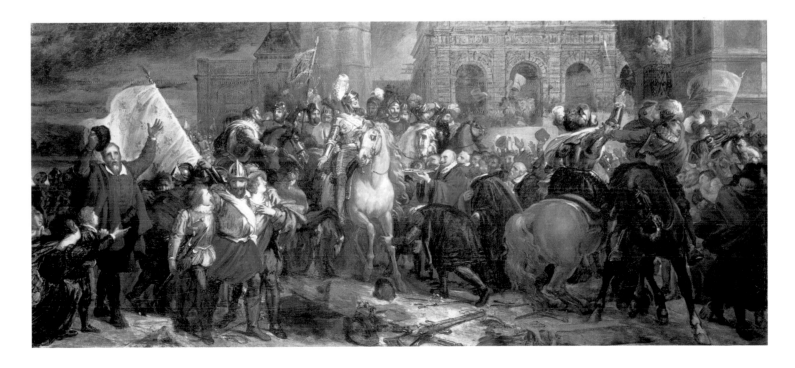

74
J. M. W. Turner (1775–1851)

Watteau Study by Fresnoy's Rules
exh. 1831

Oil on oak panel
40 x 69.2 (15¾ x 27¼)
References: for contemporary reviews see
Butlin & Joll, *Turner*, p.192, no. 340.
Tate. Bequeathed by the artist 1856
London only

fig.41
Richard Parkes Bonington
Henri III
before 1828
Oil on canvas
The Wallace Collection

While Turner regarded Claude as supreme among French painters, and indeed among Old Masters generally, he was also a lover of Jean-Antoine Watteau's pictures. Perhaps because he had visited London, Watteau (1684–1721) was widely admired in Britain. In France, by contrast, he was still reviled as a product of the decadent *ancien régime* and a revival was only to be found in the most advanced Romantic circles. In a joint tribute, Turner added a parade of Watteau-like figures to his Claudean landscape, *England: Richmond Hill, on the Prince Regent's Birthday* (Tate; Royal Academy 1819). In Turner's small oil of 1822, *What You Will!* (Private Collection), the likeness to Watteau's outdoor *fêtes galantes* is whole-hearted and extends to the technique and colouring, and even the title is surely a pun on the artist's name. A later Watteauesque garden scene, *Boccaccio relating the Tale of the Birdcage* (Tate) appeared in the Royal Academy in 1828 together with Bonington's first historical subject shown in London, *Henri III* (fig.41). A reviewer in the *Literary Gazette* preferred the Bonington, which he compared to Scott's historical novels, and thought Turner too aggressive in his competition with the earlier painter: 'Watteau … Be quiet! Here is your match.'

In this picture, shown at the Royal Academy in 1831, Turner moved from pastiche of Watteau to a depiction of the artist himself working in his studio according to a pictorial principle stated by the theorist, C.-A. du Fresnoy. Fresnoy's seventeenth-century verse treatise,

De Arte Graphica, had been translated into English by William Mason in 1783. Turner quoted it in the Academy catalogue: 'White, when it shines with unstained lustre clear, / May bring an object back, or bring it near.'

In the background, Turner included two of Watteau's works in London, *Les Plaisirs du Bal*, belonging to the poet Samuel Rogers and *La Lorgneur* in the Dulwich Gallery, while other props illustrate the message; a light, almost bare canvas recedes behind the darker figure of the artist while a piece of white cloth advances against darker objects behind it. As a composition, the picture owes little to Watteau, save perhaps the group of female admirers who watch the artist at work. It does however follow the pattern of imaginatively treated pictures of artists – already an established genre in France, taken up by Ingres, Granet and Delaroche among many others, and also applied by Turner to Raphael or Rembrandt. In none of these inventions was he much troubled by historical fact or anachronisms of detail or style; in this case the composition – specifically the placing of the artist at his easel – may have been adapted from a picture by the caricaturist Thomas Patch belonging to Lord Egremont at Petworth, in which a monkey-painter is watched by a group of Grand Tourists. In adapting it, Turner intended no disrespect to Watteau, but a nod to a collection from which he had learned so much; the Earl's own Watteau was among the likely sources for Turner's *What You Will!* For the *Watteau Study*, Turner painted a companion picture of Lord Egremont's ancestor Lord Percy (Tate), which alludes to portraits by Van Dyck in his collection at Petworth, and Ian Warrell has suggested that both pictures may have been intended for the White and Gold Room in the house, where the Van Dycks then hung. This room is notable for its fine, white-painted French rococo-style panelling. DBB

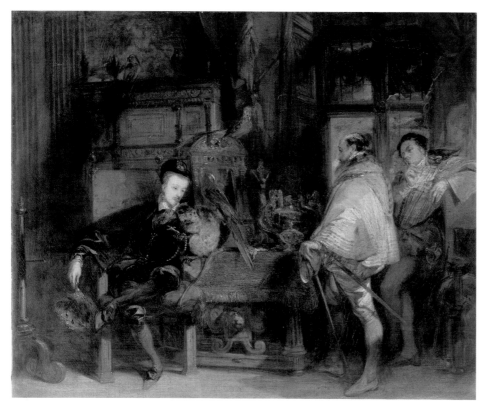

75
David Wilkie (1785–1841)
Josephine and the Fortune Teller
1837

Oil on canvas
211 x 158 (83⅛ x 62¼)
National Gallery of Scotland
London only

Josephine was painted at the instigation of Wilkie's friend William Knighton (George IV's private secretary and Keeper of the Privy Purse), for the Conservative MP John Abel Smith. It was one of two historical pictures of royal women at pivotal moments in their lives shown by Wilkie in the 1837 Academy, the other being *Mary Queen of Scots Escaping from Loch Leven Castle*. That Wilkie associated the two pictures is clear from the fact that a study for *Josephine* occurs on the verso of one for *Mary* (Birmingham City Art Gallery). Both pictures may have been inspired by earlier visits to places associated with their subjects. Wilkie had visited Mary's apartments at Holyrood in 1817, and he had seen Malmaison, Josephine's house near Paris, in 1814, less than a month after the former Empress's death.

For his picture of Josephine, Wilkie chose an episode from her youth on the island of Martinique, when a maid tending her hair predicted that one day she would wear a crown. In the Academy catalogue he quoted from Louis-Antoine Fauvelet de Bourienne's *Memoire* of the Empress, of which an English translation appeared in 1830; he may also have consulted John Memes's *Memoirs of the Empress Josephine* (first published 1831), written in the subject's own voice. Besides his memories and reading, he would have been aware of his friend Benjamin Robert Haydon's obsession with Napoleon and his numerous pictures of him 'musing' on his achievements; and of the interest in Napoleon of prominent figures like the architect John Soane and Lord Egremont. Wilkie surely shared the fatalistic British view of Napoleon as having been impelled by Destiny and brought down by Nemesis. His biographer Cunningham decribed the picture as a 'romantic scene', one of Wilkie's historical works 'on humbler themes, or whose subjects are sufficiently remote to justify a more poetic treatment' (Cunningham, *Wilkie*, III, p.508). He considered its sentiment, composition and colouring to be triumphs of the British School, but its qualities are also close to French painting. Wilkie would have seen Josephine's (admittedly much smaller) Troubadour pictures and other works of anecdotal history at Malmaison. His closest prototype, however, must have been Pierre-Paul Prud'hon's portrait of Josephine (Louvre), then still hanging at the end of the picture gallery. According to Haydon, accompanying Wilkie in 1814, their guide forbade any copying of the pictures, but the pose of Wilkie's figure is clearly based on an accurate recollection of Prud'hon's work. Prud'hon was, moreover, among the painters Wilkie and Haydon visited while in Paris. His picture, in progress during the Empress's divorce, was widely interpreted as an image of despair – an abandoned wife finding consolation beneath the trees of her park, her broken heart suggested by the crimson of her shawl. Haydon, on a visit without Wilkie to Rambouillet, the house of her successor Marie-Louise, reported that the servants told him of the second Empress's sad wanderings in the grounds, left alone by her husband. These impressions, doubtless combined with those of Knighton on his own visit to Malmaison in 1828, that the once 'happy abode of Josephine' had become 'a complete emblem of fallen greatness' (*Memoirs*, 1838, II, pp.13–14), lend a poignant irony to Wilkie's depiction of the young girl's foretaste of power. DBB

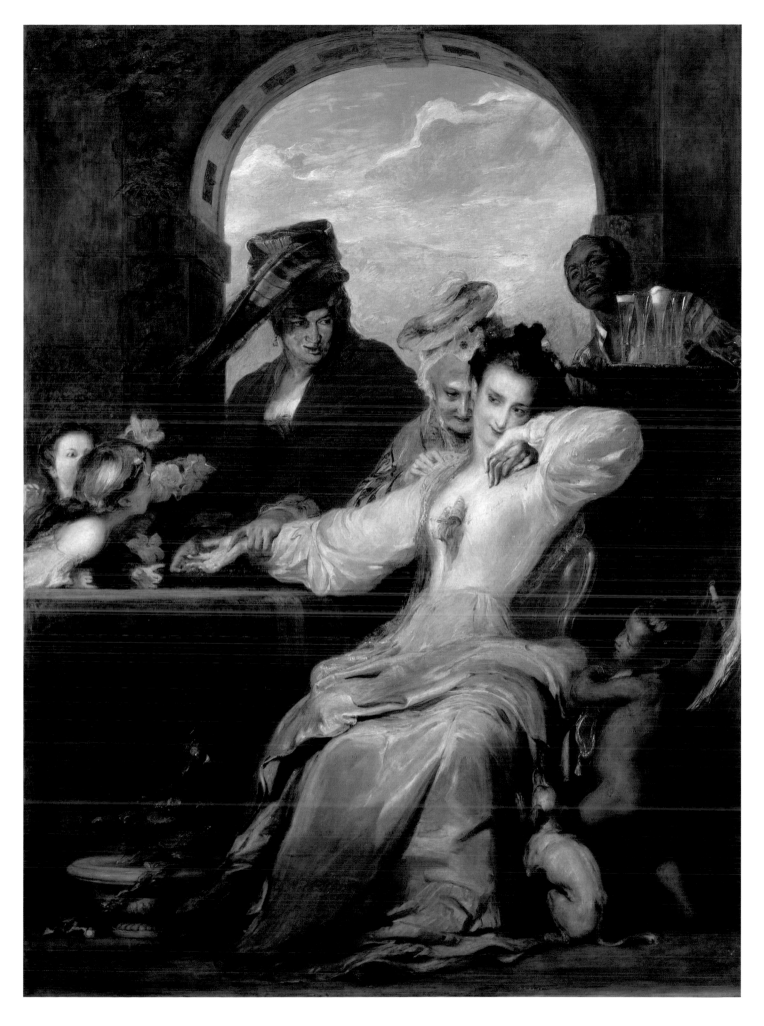

76
Eugène Delacroix (1798–1863)
Combat Between the Giaour and Hassan 1826

Oil on canvas
59.6 x 73.4 (23½ x 28⅞)
Signed lower left: *Eug. Delacroix*
Provenance: Alexandre Dumas père, *c*.1827 to
May 1848, when sold to Charles Mahler.
References: Delacroix, *Correspondance*, I,
p.184 n.1, p.407; IV, p.160, n.1; *Le Mémorial de
la Scarpe*, 14 Aug. 1827; Chenou, 1827, pp.82–4;
Anon., 'Hobday's Gallery of Modern Art',
Athenaeum, 18 June 1828, p.538; E. Delécluze,
'Ouverture du Musée Colbert', *Journal des
débats*, 7 Nov. 1829; A. Dumas père, 'Eugène
Delacroix', *Le Monde Illustré*, 22 Aug. 1863,
p.124; Gautier, *Romantisme*, pp.211–12.
The Art Institute of Chicago. Gift of Mrs
Bertha Palmer Thorne, Mrs Rose Movius
Palmer, Mr and Mrs Arthur M. Wood, and Mr
and Mrs Gordon Palmer

The Giaour, the first of Byron's *Oriental Tales*,
relates the conflict between a seventeenth-
century Christian warrior, or Giaour, and his
Turkish adversary, Hassan, who has put to
death the former's mistress, Leila, a slave who
had fled Hassan's harem. The Giaour's men
ambush Hassan's entourage and the two
leaders engage in mortal combat, with the
Giaour emerging triumphant but ultimately
unrequited in his vengeance. One of two oil
versions of this subject, this Chicago picture
illustrates the following verse:

*Thus join the bands, whom mutual wrong,
And fate, and fury, drive along.*
…
True foes, once met, are join'd till death.

The Giaour was one of the first poems by Byron
mentioned in Delacroix's journal and an epic to
which he returned constantly. In addition to the
two depictions of the combat are numerous
illustrations of its aftermath. This picture was
executed in May or June of 1826 and submitted
to the second rotation of the Galerie Lebrun
Exhibition for the Benefit of the Greeks, where it
joined a number of pictures by artists who had
been working in Delacroix's studio that spring
and who had forged a common style dependent
on British models and their own technical
experimentation. As Théophile Gautier later
observed: 'The two *Combats of the Giaour and
Pasha* … have a freshness, an eclat and a
limpidity in which one senses the influence
of Bonington.'

In his later pictures, Delacroix deployed a
wider and more vivid range of colours, but his
close-valued hues created a more decorative
patterning. The 'Anglo-Venetian' style of the
1820s, as it was then called, is more visually
striking because of the brilliant contrasts of
light and dark tones and the fractured
application of impasted highlights over thinly
painted grounds and under translucent glazes,
which recall Bonington's advanced
watercolour technique (no.183). The touch also
seems rapid and assured, thanks to the use of
copal varnish as a medium, which dried quickly
to a high transparency and thus encouraged the
quality of spontaneity so admired in the
watercolour medium.

Of the large number of pictures submitted
by Delacroix to the 1827 Salon, this and the
Portrait of Louis-Auguste Schwiter (no.52) were
rejected, although a *Scene from the Actual War
Between the Greeks and the Turks* of 1826
(Winterthur) was accepted. Since that title was
by Delacroix, he might have intended the two
similarly sized combat scenes as pendants. In
reflecting on that exhibition, Etienne Delécluze
likened Delacroix's *Christ in the Garden of
Olives* to a 'Rubens fricassée' with angels
resembling pretty English girls, and
complained that:

*All our modern artists have followed the lead of
the English portraits; they colour too brilliantly,
are pretentious in their effects, have
compositions in which modern Greeks, with
their vile costumes and arrogance, are in the
midst of horses under a leaden sky, as if Greece
were the same latitude as Edinburgh; all of these
paintings are insufferably monotonous, and
certainly more monotonous … than the
productions of David's school, which imitated
the antique (Journal, p.483).*

Despite the Salon rejection, Delacroix sent
the *Giaour* in June, together with *Greece on the
Ruins of Missolonghi* (no.8) and *Faust and
Mephistopheles* (fig.8) to a contemporary art
exhibition organised by Hobday's Gallery in
London. The *Athenaeum* critic found in the
Giaour 'clever and effective handling, and fine
rich colour'. PN

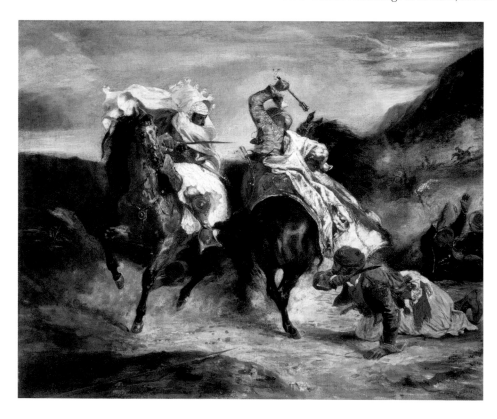

77
Alexandre-Marie Colin
(1798–1873)
The Giaour Contemplating the Dead Hassan 1826

Oil on canvas
99.7 x 81.3 (40 x 32½)
Signed and dated, lower centre: *A Colin / 1826*
Exhibitions: Galerie Lebrun, 1826, I a,b, no.32; I c, no.31; Cambrai, 1826, no.78; Musée Colbert, 1829, I, no.68; II, no.87; Musée Colbert, 1830, I, no.221.
References: C., *Galerie Lebrun*, p.3; Vitet, Galerie Lebrun (2 Sept. 1826), p.44; F., *Musée Colbert* (29 Nov. 1829), p.338.
Private Collection

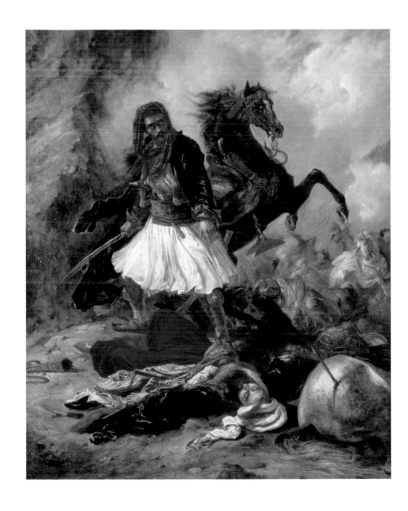

Byron, as much as the Greek War of Independence, remained a principal British source of inspiration for Colin. *The Giaour Contemplating the Dead Hassan* was painted in 1826 and exhibited at the Galerie Lebrun in May. Colin also sent to that exhibition *An Episode from the Present War in Greece* (Private Collection), which depicted a contemporary slaughter of Greek soldiers and civilians by Turks but was accompanied by verse from Byron's *Siege of Corinth*, another of the *Oriental Tales*.

Colin created this *Giaour* subject at precisely the moment that Delacroix dispatched his equally original and passionate *Combat Between the Giaour and Hassan* (no.76), and Bonington was sharing his studio (fig. 41). One of Delacroix's illustrations to the aftermath of this combat was an oil of *c.*1829 that was shown, with Colin's picture, at the Musée Colbert the next year. It eschews the histrionics of his friend's interpretation and emphasises the tragedy of the violent hatred , 'the tortures of that inward hell', to which both warriors fell victim. Horace Vernet, on the other hand, flagrantly appropriated Colin's composition for a painting he submitted to the 1827 Salon.

The gory detail of the severed hand of the dead Hassan clutching the sabre appears to be unique to Colin's representation of this scene and confirms that he was relying not on Amadée Pichot's translation, but on Byron's original text (lines 655–74):

With sabre shiver'd to the hilt,
Yet dripping with the blood he spilt;
Yet strain'd within the sever'd hand –
Which quivers round that faithless brand

As prescribed by Byron, the Giaour's costume is that of the Suliots, or Albanian Christians, who had been banished from their native region in western Epirus after their defeat in 1822 by Ali Pasha. It was the costume worn by Byron for his portrait by Thomas Phillips, and by Count Demetrius de Palatiano, a quasi-Byronic adventurer who passed through Paris in late 1825 and posed in Delacroix's studio for a number of artists, including Colin, Bonington and Huet. The model for the Giaour's features might also be the same person who posed for both Bonington and Delacroix at this time (Noon, *Bonington*, fig.37). All of these correspondences suggest that if Colin did not actually paint this picture in Delacroix's studio, he was constantly in the company of his friends during its genesis. This would indeed account for the striking similarities in the three artists' palettes at this moment, their adroit use of glazes and varnishes and their bravura execution, which Colin, at least, would never again achieve with such success. There is considerable pentiment throughout his picture. The most important indicates that the Giaour's sabre originally went straight down towards the prostrate corpse, as in Delacroix's watercolour and Colin's second, smaller version of the subject (1831 Salon), and that the Giaour's foot rested on Hassan's body, also as he appears in Horace Vernet's pastiche and Colin's engraved version and his *Historical Illustrations of Lord Byron's Works* (Paris & London, 1833).

In their first review of the Galerie Lebrun exhibition, the *Journal des Débats* singled out only a few artists for favourable notice, including Colin, who was 'destined to paint powerful scenes of pathos'. When reviewing the Musée Colbert exhibition three years later, Charles Farcy lamented that despite the incontestable talent this picture demonstrated, Colin seemed intent on following the deleterious manner of Delacroix. The latter's *Greece on the Ruins of Missolonghi, Murder of the Bishop of Liège* and *Combat Between the Giaour and Hassan* (nos.8, 59, 76) were again sharing wall space with Colin's paintings. PN

78
Eugène Delacroix (1798–1863)
Death of Sardanapalus (Reduced Version) c.1846

Oil on canvas
73.7 x 82.4 (29 x 32½)
Philadelphia Museum of Art, The Henry
P. McIlhenny Collection in memory of Frances
P. McIlhenny, 1986

Sardanapalus, King of Assyria, faced with defeat by insurgent armies in his palace at Nineveh in 612 BC, ordered the destruction of his possessions on his own funeral pyre. Delacroix appears to have consulted several literary sources, both ancient and modern, for the subject of his most famous and controversial picture. *Death of Sardanapalus* of 1827 (Louvre), 'my massacre no.2' as he facetiously dubbed it, is the defining monument of high Romantic painting in France. Almost every year of his professional life Delacroix painted some theme from Byron. It was Byron, after all, who awakened in him 'that insatiable desire to create'. Even though the concluding massacre imagined by Delacroix does not correspond to the finale described by Byron in his drama *Sardanapalus* (1821), the picture is no less a tribute to his British idol.

Exhibited at the second instalment of the 1827–8 Salon, the painting launched a radical assault on conventional pictorial modes. Philippe Burty, Théophile Gautier and many others have recognised that the *Death of Sardanapalus* offered manifest proof of a profound influence of British painting on Delacroix's art. Most recent scholars acknowledge the probable influence of William Etty's voluptuous nudes (no.80), J.M.W. Turner's and John Martin's catastrophic sublime (no.56) and the exotica of William Daniell's Indian views, as well as Rubens and Gros and a host of archaeological sources – Etruscan, Persian, Persepolitan – for the architecture, costumes and physiognomies of his figures. On the technical side, Delacroix claims to have sketched in the picture with distemper, as was Bonington's practice at this time. He then alternated and layered areas of thickly applied paint with others of the thinnest glazes, often saturated with varnish, producing visual effects not unlike those of his mixed watercolour and gouache paintings of the same year. For the first time his preparatory studies included pastels that further encouraged the blond and luminous tonality of watercolour, with which he now strove to invest his oils. Most of these qualities are retained in the reduced version exhibited here, which Delacroix painted for himself prior to selling the original picture to the English collector John Wilson in 1846.

The painting's spatial anomalies, lack of intelligible narrative, broad and vibrant facture, and exceptionally violent subject matter invited universal condemnation from the critics and a threat from the Minister of Fine Arts that the artist had better mend his ways or forfeit all hope of government patronage. A typical response was Léonor Mérimée's private opinion that it was 'a potboiler with neither top nor bottom … a vast colourful sketch lacking sense' (Ephrussi, 1891). Louis Vitet condemned it outright in *Le Globe* as a 'kaleidoscopic improvisation … truncated on four sides'. Both *Le Figaro* and Victor Hugo praised the energy and colour of the painting, but regretted that Delacroix had not elucidated the plot by introducing flames, as would Louis Boulanger in his Hugo- and Martin-inspired *Le Feu du Ciel* (1828). PN

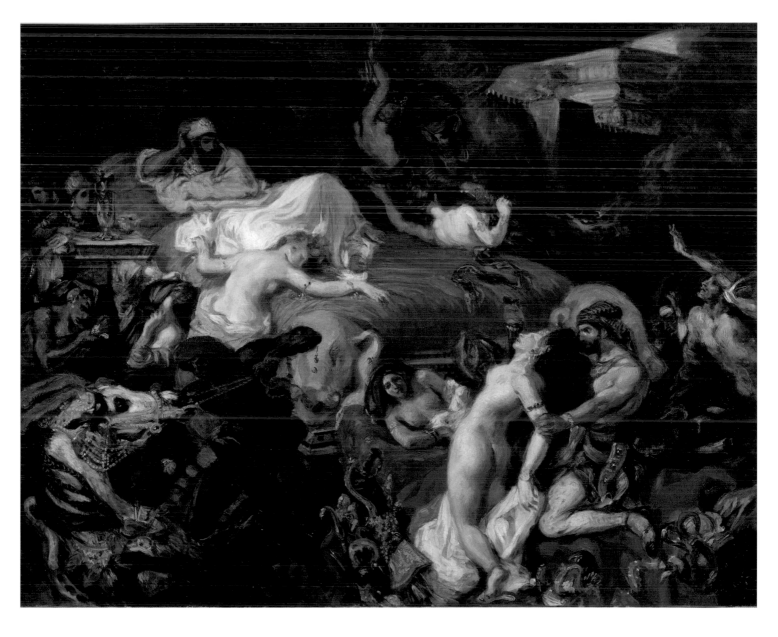

79
Eugène Delacroix (1798–1863)
Odalisque Reclining on a Divan
*c.*1827

Oil on canvas
37.8 x 46.4 (14⅞ x 18¼)
Signed lower right: *Eug. Delacroix*
The Syndics of the Fitzwilliam Museum, Cambridge

Delacroix painted more nudes that were not academy studies in the 1820s than at any other time in his life, and these complement the sexual preoccupations that enliven his journal entries. His friends Frédéric Leblond and Louis Coutan (no.5) appear to have commissioned or assembled groups, with representations ranging from evocations of Byron's sultry orientalism to lewd subjects drawn from Seigneur de Brantôme that mock the moralising pretensions of the troubadour style. *Odalisque Reclining on a Divan* belonged originally to Coutan, who also commissioned Ingres's *Interior of the Harem* (Louvre) in 1828, possibly as its pendant. Such seemingly jarring aesthetic matches were Coutan's pleasure; he also owned Ingres's and Bonington's representations of *Henri IV and the Spanish Ambassador*.

The mild erotica of Géricault, Jules-Robert Auguste (fig.42) and Ingres anticipated and perhaps even inspired Delacroix's own efforts, but they little prepare one for the mood of sexual expectancy and abandon that characterises this *Odalisque*. The foreground yataghan and hookah, while identifying the woman as an Eastern concubine, scarcely distract from the carnal nature of the conception. The colouring in this and the near contemporary *Woman With Parrot* of *c.*1826 (Lyon), also a Coutan picture, has been described repeatedly as resembling Bonington's jewel-like and Venetian palette. Although Bonington also attempted such

subjects in 1827, in direct response to Delacroix's example and often for his friend's patrons, he generally confined himself to watercolours and to more sanitised illustrations of popular literature, such as Jean-François Marmontel's *Les Incas* of 1777.

The dating of this picture has varied, although Johnson (*Delacroix*, I, p.10) has noted compelling stylistic similarities with pictures of the mid-1820s. The definitive pose study is on a sheet with other studies that appear to be after Rubens and are not without relevance to *Sardanapalus* and the Faust lithographs. The unexpected limpidity in the flesh and in the deeper tones of the drapery is what also distinguishes *Sardanapalus*. And what Gautier observed of that painting applies equally here: 'At this time, the English school unquestionably preoccupied Delacroix, who studied Lawrence a great deal. *The Death of Sardanapalus*, among others, presents a certain bluish and reddish range, certain transparencies set off by abrupt impasto like the force of oil applied to watercolour, which recall the palette of the British masters.' The sophisticated watercolour technique Delacroix learned from Bonington had found a brilliant translation into oils. Finally, there may be some truth to Alfred Robaut's calling this a study only; it is likely that Delacroix painted this work as a technical experiment just prior to the larger challenge of *Sardanapalus*. PN

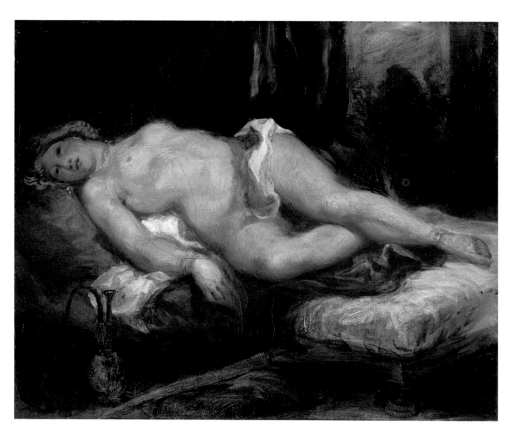

fig.42
Jules-Robert Auguste
The Girlfriends
*c.*1820s
Gouache
Musée du Louvre

80

William Etty (1787–1849)

Candaules, King of Lydia, Shews his Wife by Stealth to Gyges, One of his Ministers, as She Goes to Bed exh. 1830

oil on canvas
45.1 x 55.9 (17¾ x 22)
References: *Literary Gazette*, 22 May 1830, p.339.
Tate. Presented by Robert Vernon, 1847

This painting illustrates an episode first recounted by Herodotus in his life of Candaules, the last Heraclid King of Lydia. The king was proud of his wife's beauty and insisted on showing her unveiled charms, without her knowledge, to his minister Gyges. The queen, however, espied Gyges stealing from her chamber. The next day she commanded him to choose either death or murdering Candaules and sharing her bed and kingdom. Gyges opted for the latter and became the founder of the dynasty of the Mermnadae, c.715 BC.

Etty exhibited this picture at the Royal Academy with an acknowledgment in the catalogue of the classical source for his narrative, but this must have been a stratagem to validate the choice of a subject offensive to conventional morality. The *Literary Gazette* found its 'debasing sensuality' disgraceful and asked, 'have we not enough of the voluptuous from the pencils of foreign artists?' But a more immediate and probable literary source for *Candaules* was Seigneur de Brantôme's seventeenth-century account in *Lives of Fair and Gallant Ladies*. Brantôme had embellished the Candaules story with the speculation that Gyges, on seeing the queen naked, fell madly in love with her, thus making it easier for her to plot her revenge on her husband. Something of that implied chemistry is evident in Etty's interpretation.

Since there was no English translation of Brantôme, Etty would have relied on the recently published Monmerqué edition of 1822, which had similarly afforded Delacroix with ideas for two even more salacious pictures, *A Lady and her Valet* of c.1825 and *Louis d'Orléans Showing his Mistress* (fig.43). Brantôme's account of Louis d'Orléans immediately follows that of Gyges. Although Etty had spent time in Paris in 1822–3 and therefore could have found this source himself, it is more probable that Delacroix introduced him to it during the French artist's visit to Etty's London studio in 1825. Etty certainly visited Delacroix in Paris in the summer of 1830, but this would have occurred after the Tate picture had been completed. PN

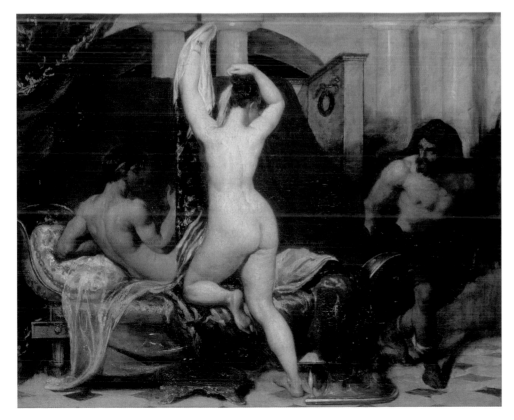

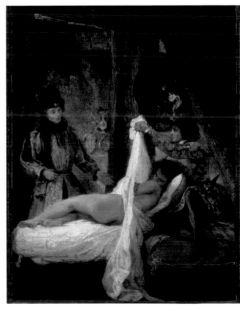

fig.43
Eugène Delacroix
Louis d'Orléans Showing his Mistress
c.1825–6
Oil on canvas
Thyssen-Bornemisza Collection, Madrid

The School of Modern Life:
History, Genre, Portraiture, Animals

David Blayney Brown

Théodore Géricault hoped that the 'colour and effect', and 'portraits … landscapes and genres, and animals' that he saw in London in 1821 might become a 'school' for the French.[1] Arnold Scheffer, surveying the next year's Salon, already sensed the dawn of a 'new era' in the proliferation of genre works. While the influence of David Wilkie, the most innovative genre painter of his generation, was now being felt in France, Scheffer related this development to the civil niceties that had returned with peace.[2] The rise of 'secondary' genres, such as portraiture or scenes of familiar life, would be as marked in the 1820s as a change towards painterly handling – though they did not always coincide. Conservative critics lamented both, as they did the vogue for anecdotal history, as a sign of decadence. For others they were a rebirth. On all sides they were attributed to British example – and whether this was really always true matters less than that it was believed. Géricault in London in 1821, Eugène Delacroix there in 1825, and visitors to the 1824 Salon were amazed and excited by British artists' handling of paint, and the range of their subject matter.

The collapse of classical art and the appearance of more 'modern' subject matter – together with a commensurate spontaneity of handling – is often attributed to the rise of new patrons, the parvenu society that emerged in France under the Empire, or the British entrepreneurs enriched by the recent war. Of the many flaws to this argument only a few can be mentioned here. Though constantly challenged, Neoclassicism had remained the official Napoleonic style. Genre – specifically the narrative pictures of Wilkie (fig.44) or Louis-Léopold Boilly (nos.87, 88)– was welcomed as enthusiastically by aristocratic or even royal collectors as by new ones, as was landscape; while newcomers were understandably pleased to have their portraits painted with the same élan as aristocrats. While, as Patrick Noon demonstrates (*passim*, p.4), patronage and collecting increasingly came from the private rather than the public realm, many of the most advanced collectors were very grand indeed. Moreover, what seemed new in the 1820s was sometimes less so than it was fashionable to think. While diversification of subjects really took off in France under the Restoration, artists such as Jean-Baptiste Greuze, Jean-Baptiste-Siméon Chardin, Jean-Baptiste Oudry or Alexandre-François Desportes, whose narratives, animals or still life pushed academic boundaries, had flourished under the *ancien régime*. When it came to the manner in which pictures were painted, only collective amnesia could justify the notions that a colouristic, painterly style was new or a British monopoly. However discredited their mythologies or erotica now seemed, what of François Boucher, Nicolas Lancret, Jean-Antoine Watteau or Jean-François de Troy?

Such biased national stereotyping was conditioned by politics. For many French artists and critics in the 1820s, even

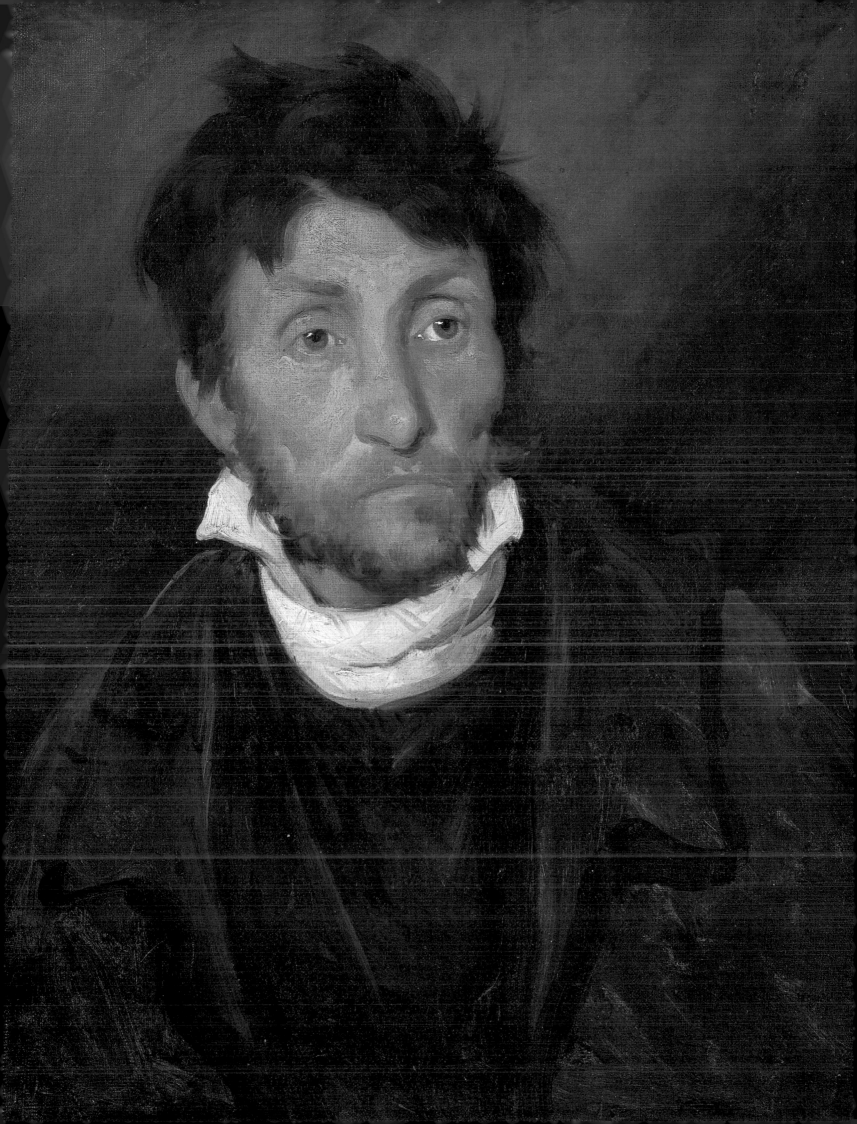

Overleaf:
Théodore Géricault
Monomania: Portrait of a
Kleptomaniac
c.1819/22
(no.81, detail)

fig.44
David Wilkie
The Blind Fiddler
1806
Oil on mahogany
Tate

fig.45
Eugène Delacroix
Massacres at Chios
1824
Oil on canvas
Musée du Louvre

fig. 44

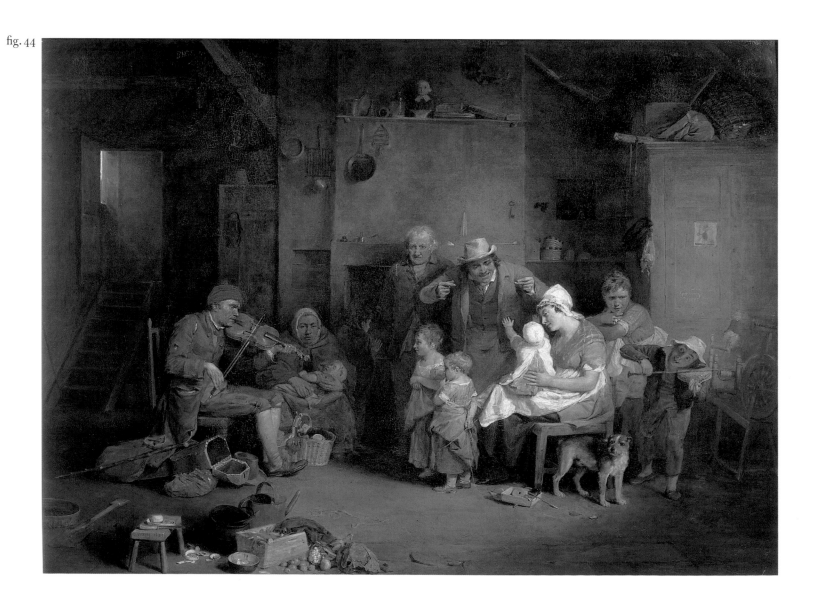

pictures by the recent enemy were preferable to their own eighteenth-century predecessors. While Watteau was revered and imitated in Britain (no.74), only a single picture by him, *The Embarkation for Cythera*, was then allowed to hang in the Louvre – and the critic Etienne Delécluze compared Delacroix's *Massacres at Chios* (fig.45) with it as equally odious. In an atmosphere of national collapse, and near-desperate search for renewal, it was perhaps inevitable to fall a little in love with the conquerors. The British, for their part, were mostly proud that the classical tradition, and the academic hierarchy of subject matter, had never taken deep root in their country. It was a proof of liberty, and they found it easy to damn Jacques-Louis David's style and subjects as instruments of autocracy. Yet they also complained that the lack of state or public patronage in Britain left them vulnerable to the free market, and their vilification of David contained a good deal of jealousy. David, on the other hand, had envied their independence, while Géricault, Delacroix and many of their contemporaries sent work to London – the vaunted capital of freedom as well as lucre.

Just as David was a more complex painter than the British imagined, so it is striking how much leeway for innovation Napoleonic patronage had in fact allowed. While anecdotal history had begun under the Empire, the painting of modern history had also been transformed. Antoine-Jean Gros's *Battlefield of Eylau*, in the Salon of 1808 (no.47), broke new ground in its grim realism and balance of empathy between the Emperor – suddenly vulnerable before events almost

fig. 45

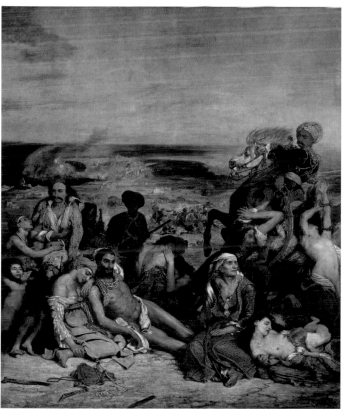

beyond his control – and his victims. Moving as it is, Turner's *Field of Waterloo* (no.48), taking its cue from Byron's lament for the dead of both sides in *Childe Harold's Pilgrimage*, adds nothing to the humanity of Gros's work, and falls far short in psychological insight. Both pictures present a decisive contemporary event largely or wholly through the sufferings of common soldiers, a key departure from the emblematic heroes of traditional history painting. Yet while undoubtedly subversive, they do not subvert that art itself. Géricault, on the other hand, painted *The Raft of the Medusa* (see no.19) in despair, both at the incompetence of the Restoration government and at the resulting absence of suitable subjects for national celebration. Exposing individual suffering on the monumental scale of public art, it was an ironic comment on the great style of history to which he had once aspired.

Géricault's experiences in London heightened his sense of the individual predicament, whether seen in the capital's destitute underclass – the subjects of some of his great London lithographs (nos.13–15) – or in the subtle characterisation and expression deployed in Wilkie's pictures. Back in Paris, his studies of trauma painted for Dr Georget (nos.81, 82) explored extremes of expression in real victims of their troubled times rather than the standard types of the academy. Géricault died too soon to respond to the modern epic of the Greek War of Independence, but his fellow Anglophile Delacroix could now confront contemporary events and, as a bonus, invoke his love of Byron. The poet's death there while serving in the Greek cause was a subtext of Delacroix's *Greece on the Ruins of Missolonghi* (no.8), another work in which the sufferings of a nation are borne by a single individual, even if, in this case, the painter had to imagine her. Stendhal reprimanded Delacroix for not enlisting in the war himself, but at least here was an artist concerned with the present; as the critic Auguste Jal remarked of Delacroix's earlier *Massacres at Chios* (fig. 45), enough of the ancient Greeks; it was the modern ones who mattered.

With Byron and Gros, a key source for Delacroix's imagined Orient was the sculptor Jules-Robert Auguste, who had travelled there. Auguste was with Géricault in London, and became friendly with Wilkie, who later frequented his lively Romantic salon in Paris. He was probably an early source for Wilkie's interest in the East, and thus for his final journey to the Holy Land where he planned to paint biblical subjects reanimated by characters and scenery drawn from life. Meanwhile Wilkie, having done more than any other artist to establish the century's fashion for genre, had already reinvented himself as a history painter, but in a thoroughly contemporary manner. His masterpiece, which Géricault and Auguste saw in his studio, was *The Chelsea Pensioners Reading the Waterloo Dispatch* (no.49). While genre was the

prime beneficiary of the breakdown of academic history painting on both sides of the Channel, Wilkie showed it could reflect national events, as the announcement of victory ripples through a crowd of veteran soldiers.

Wilkie's emergence in London with complex narratives like *The Village Holiday* (no.89), combining his acute observations of human nature with Dutch pictorial traditions, had been one of the decisive artistic developments of the century. The initial verdict of a Parisian print-dealer that his work was 'not historical enough' for his clients proved a grave misjudgment; Abraham Raimbach's plate of his *Village Politicians* won a gold medal when shown at the Salon[3] and Wilkie was not, in any case, without parallel. Martin Drolling's interior scenes (admittedly less subtly nuanced) had been popular under the Empire, and narratives by Boilly predate the first appearance of prints after Wilkie in France. They built on the French tradition of Greuze, but also on the same Dutch sources and study of human expression that informed Wilkie's work, and Boilly attracted the same reputation as a modern David Teniers the Younger. It is hard, however, not to see the influence of Wilkie's earlier pictures in Boilly's *Distribution of Wine and Food*, with its implicit critique of drink, shown in 1822 (no.88).

Although at first suspect in Paris, genre was soon institutionalised in both capitals. Wilkie was promoted by London's most influential (and conservative) connoisseurs, and became the first modern artist to enter the new National Gallery. Wilkie politely declined Auguste de Forbin's invitation to send to the 1824 Salon, but Boilly's pictures were bought by modernist collectors such as the Duc de Berry and the Duc d'Orléans, while Forbin acquired works of 'lesser' genres for the national collection – though his enemies accused him of neglecting serious art. Forbin also promoted the portraitist Thomas Lawrence when the English style was under attack. Lawrence, with Constable and Bonington, won a gold medal for his French exhibits, while his *Charles Lambton* (no.50) appeared in the salon of 1827, and other glamorous and boldly painted portraits were sent to Paris for engraving. He painted Charles X, the Duc de Richelieu (no.104) and the Duchesse de Berry (fig. 46) (Forbin owned his own version of the latter). Dazzling and shocking in equal measure, no painter so epitomised what was now believed to be the English style, so divided opinion, or provoked such conflicting outcomes in French painting. While portraits exhibited by Gros (no.103) and Ingres in 1824 and 1827 (no.51) maintained proper French discipline against the slapdash interloper from London, Delacroix painted his *Louis-Auguste Schwiter* (no.52) under Lawrence's spell, and saw it rejected from the 1827 Salon for his pains.

With genre and portraiture, animal and sporting painting was the other area in which the British seemed supreme – to

fig. 46

the relative exclusion of earlier French *animaliers*. Carle Vernet showed Géricault prints by Stubbs before he visited London, and Géricault shared an enthusiasm with Delacroix for the more energised and Rubensian work of James Ward and James Northcote. Ward's great *Boa Serpent, Liboya, Seizing His Prey* (no.83) was to be seen in the Stafford gallery, but while this would have chimed with Géricault's sense of suffering and his abolitionist sympathies, the working horses of the metropolis and the thoroughbreds of the Turf, the activities of grooms, farriers and jockeys, and a sporting culture that permeated all classes, injected a realism and spirit into his London work that was not to be found in such a work of high art. Indeed he now preferred to 'lock myself in the stables',[4] and in London he lodged with the horse-dealer Adam Elmore, as did Delacroix in 1825.

In his report on the 1821 Royal Academy to Horace Vernet, Géricault singled out Edwin Landseer, then only eighteen and exhibiting a rat-catching scene, for special praise. In 1824, Landseer's *The Cat's Paw* (no.94) was shown in London. Though taken from Jean de La Fontaine, it won him the *Examiner*'s praise as the 'Shakespeare of animal expression'.[5] For many Romantics, animal energies or cunning revealed a primordial state lost to mankind, and Byron's tale of Mazeppa tied to the wild horse became a metaphor for Reason's submission to Nature. Mazeppa was also, as Romantic readers sensed, one of Byron's self-portraits. Horace Vernet's pictures of Mazeppa pursued by wolves in the 1826 Salon (no.53), with its echoes of Stubbs, suggests the thrill and mad career into the unknown that his generation felt when swept away by British art; no less suggestive, perhaps, was its companion (fig.16), in which Mazeppa comes to rest among the horses, as Géricault had in England.

fig. 47

Théodore Géricault (1791–1824)

81
Monomania: Portrait of a Kleptomaniac c.1819/22

Oil on canvas
61.2 x 50.2 (24⅛ x 19¾)
Museum voor Schone Kunsten, Gent

82
Monomania: Portrait of an Excessively Jealous Woman c.1819/22

Oil on canvas
72 x 58 (28¾ x 23¼)
Lyon, Musée des Beaux-Arts

Modern audiences value Géricault's five surviving portraits of the insane as almost the equal of *The Raft of the Medusa* in the status they confer as a group on the non-heroes of modern life. Louis Viardot reported that ten such portraits of inmates at the Bicêtre and La Salpêtrière asylums had been painted between 1820 and 1824, probably for Dr Etienne-Jean Georget (1795–1824), a protégé of the great psychiatrist, Etienne Esquirol (1772–1840). Esquirol had pioneered the study of 'monomania'. Those afflicted with this disease seemed normal in every respect except for one pathological fixation.

Most commentators have placed the five surviving Géricault oils in the tradition followed by Esquirol of documenting, through physiognomical drawings of his patients, the facial evidence of their disease and its progress; hence one plausible explanation for the 'topographical' rendering of facial detail by the artist. Géricault's sitters were not those in the conventional sense of portraiture, which enlivened a countenance by flattery and animation. Lawrence's aim was to make an aristocratic dullard appear interesting; Géricault's was to capture a snapshot for later scientific analysis. Most agree that his was an impersonal and objective realism, born of the clinical prerequisites of the commission; perhaps, but considering the artist's own fragile mental health and the history of insanity in his mother's family, he was undoubtedly more invested emotionally in the oblique gazes of his sitters than subsequent scholarly interpretation would allow. In assessing their relevance to the artist, we need recall the description of Géricault's mental state that Charles Cockerell noted in his diary after the last of their several meetings in London: 'His deep feeling of pity, the pathetique, at the same time vigour, fire and animation of his works … Lying torpid days and weeks then rising to violent exertions. Riding tearing driving exposing himself to heat cold violence of all sorts' (Bazin, *Géricault*, I, p.65).

Precise dating of these works is probably impossible and ultimately irrelevant. Philippe Grunchec (*Géricault*, p.123) and Lorenz Eitner (*Géricault*, 1983, p.241) placed the portraits immediately after the artist's return to Paris in late December 1821, arguing for the stylistic influence of British portraitists, especially Lawrence. Similarly, Susan Lodge (1965) signalled a 'pathos' suggestive of Wilkie and the expressive faces in *Chelsea Pensioners* (no.49), over which Géricault had enthused to Horace Vernet. Duncan Macmillan (1996) has persuasively connected Géricault's interest in the realism of psychology and expression to the Scottish rationalists, especially John and Charles Bell, whose illustrated treatises on anatomy and the anatomy of expression had so influenced Wilkie but were also known to Géricault before he visited London. Christopher Sells (1986) has shown that Géricault was briefly in London in the spring of 1819, thus introducing the prospect of an earlier dating without compromising Eitner's stylistic argument. Since Géricault suffered a mental disorder in October 1819, he could have been Georget's patient that winter and painted the portraits in that instant.

Géricault certainly admired Lawrence's bravura style, but the rapid *alla prima* touch of the monomaniac studies, the spare treatment of background and clothing in contrast with the richer pigmentation of the faces, is of another class of execution, having more to do with the nature of the commission than with any attempt to imitate British technique. PN

81

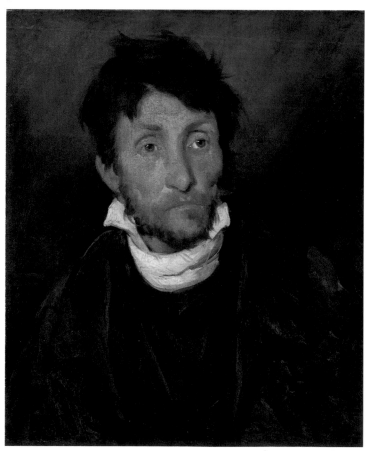

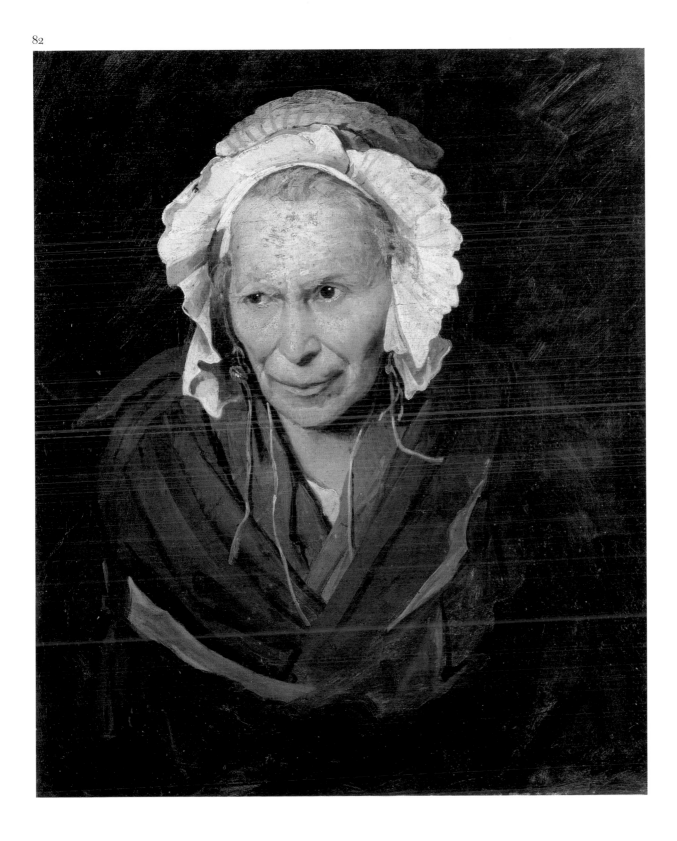

83

James Ward (1769–1859)
Study for 'The Boa Serpent,
Liboya, Seizing His Prey' c.1804

Oil on canvas
83.8 x 119.4 (33 x 47)
Yale Center for British Art, Paul Mellon
Collection

fig.48
James Ward
The Boa Serpent, Liboya, Seizing
His Prey
*c.*1804
Oil on canvas
Private Collection

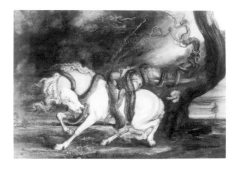

This preparatory study is for the figure of a black rider encoiled by a giant boa constrictor and pulled to certain death from the back of his horse in Ward's life-sized painting of the subject. Ward undertook that ambitious picture at the urging of Benjamin West, who admired his preparatory composition study (fig.48). The final version was rejected by the Royal Academy in 1805 but accepted for the British Institution the following February. This and other modern pictures were lost in a shipwreck in 1811. The finished study remained with the artist until 1822, when he sent it to the Royal Academy exhibition and identified the horse as a portrait of Adonis, favourite charger of the recently deceased George III. The study was purchased by the Marquess of Stafford (see no.12).

Whether Ward's picture had symbolic meaning is uncertain, but it was conceived against a backdrop of intense abolitionist fervour in Britain, which would culminate with the end of the slave trade there in 1807, and the ongoing slave revolt against the French in Haiti that was at its most fierce in 1802–3. Géricault's

neighbour and friend, Colonel Bro, had served in that theatre. His stories of the struggle would inspire Géricault's own interest in abolitionist subjects, as well as his heroic representation of blacks in desperate circumstances, be they armed combat or adrift at sea as in *The Raft of the Medusa*.

It is conjectural but likely that Antoine-Louis Barye knew Ward's composition when he modelled two bronzes in the 1830s of similar subjects: *North African Horseman Surprised by a Serpent* and *Greek Rider Seized by a Python*. In the former, as in this study by Ward, the facial expression of the frenzied rider derives from a close reading of the illustrations and text of Charles Bell's *Essays on the Anatomy of Expression in Painting* (London, 1806); in particular, the descriptions of a man 'forcibly subdued' and 'in the utmost extremity of pain'. Ward would have attended Bell's lectures at the Royal Academy in the years he was contemplating his own picture. PN

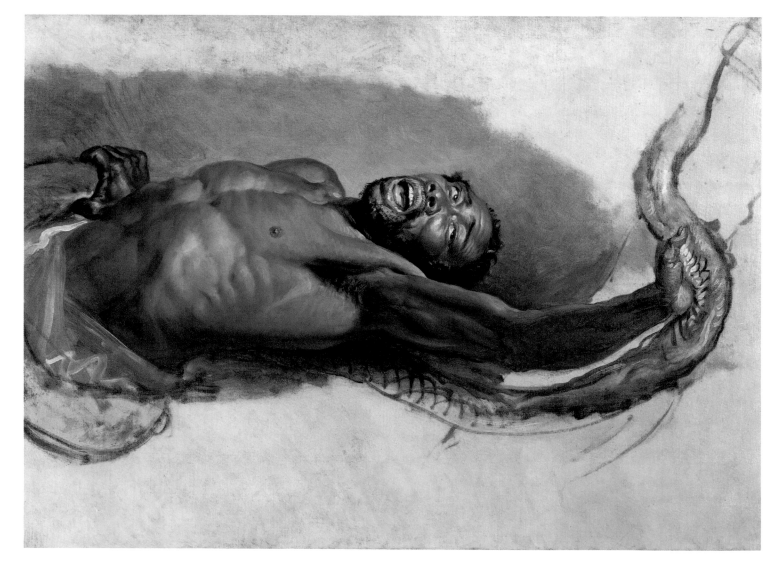

84 (overleaf)
Eugène Delacroix (1798–1863)
Fanatics of Tangier 1838

Oil on canvas
95.6 x 128.6 (37⅝ x 50⅝)
Signed and dated lower right: *EUG DELACROIX. 1838*
References: Huard, 1838 (18 March 1838), p.134; *Charivari* (6 March 1838); Delécluze, 1838 (8 March 1838); Haussard, 1838; Decamps, 1838; Gautier, 1838; Tardieu, 1838; Mercey, 1838, p.385; Thoré, 1838 (4 March 1838), p.55; Planche, *Salon* 1838, pp.109ff.; *Le Constitutionnel*, 5 April 1838, p.1; D.D., *The Times*, 5 April 1838; *L'Artiste*, no.15, 1838, p.71; Gautier, 1855, p.181; Gautier, *Romantisme*, p.213.
Minneapolis Institute of Arts, Bequest of J. Jerome Hill

In contrast to Delacroix's imagined Near East, inspired by literature, North Africa was 'as beautiful as antiquity', a fit substitute for the Italy he would never visit and the sham Athens and Rome of Neoclassical invention. 'The heroes of David and Co.,' he wrote from Tangiers, 'with their rose pink limbs would cut a sorry figure beside these children of the sun' (*Correspondance*, I, p.319). Delacroix travelled to Morocco as part of a French delegation under Charles, Count de Mornay to negotiate a treaty with the Sultan. The voyage commenced in January 1832 and lasted six months. 'I'm like a man in a dream, seeing things he fears will vanish from him', he exclaimed on arrival in Morocco (*Correspondance*, I, p.307).

While in Tangiers, Delacroix encountered members of the Aïssaoua, a religious brotherhood of Sufism. Annually in August, members of this sect converged on their founder's funerary monument in Meknes, raising funds and converts in the cities en route. It has been argued that since Delacroix left Tangiers in June, he would not have witnessed such a procession, yet there is sufficient evidence to confirm some first-hand knowledge of their convulsive behaviour. His earliest treatment of the full subject was one of eighteen finished watercolours executed as a commemorative album for de Mornay in July 1832. De Mornay later reported that he and the artist had witnessed the scene from an attic, having hidden for fear they would be detected and butchered.

For the 1838 Salon catalogue, Delacroix drafted a brief description of the sect and their periodic rampages through the towns. He was working on this picture as early as February 1837. In this same year Alexandre-Gabriel Decamps finished his *Punishment of the Hooks* (Wallace Collection), 'an incomparable image of musulman barbarity' (Blanc, 1869). Dewey Mosbey conjectured (1977) that Delacroix was responding to Decamps's picture, which it superficially resembles in its frieze-like arrangement of figures set off against high walls. Indeed, Delacroix has exaggerated the scale of the architecture from his watercolour version. The ferocity of Delacroix's brushwork, however, is a far cry from Decamps's more measured touch.

Critical reaction to the picture was overshadowed by the response to his *Medea Enraged* of 1838 (Lille). Frédéric de Mercey praised the artist's genius for capturing the most appropriate attitudes for his figures. Gustave Planche, however, imagined a 'frightful abyss' between the beauty of *Medea* and the unfinished character of the *Fanatics*, which he complimented for its many attractive qualities but dismissed ultimately as a confused sketch with 'not a single figure logically constructed or capable of walking'. Etienne Delécluze once again found a strawman in the deceased Thomas Lawrence. Nevertheless, numerous pentimenti and the fact that the artist worked on this picture over the course of a year confirm the considerable effort he invested in it. On the other hand, a review of the Salon in *The Times* described Delacroix's picture as the most outstanding in the show, even if the subject was disturbing. PN

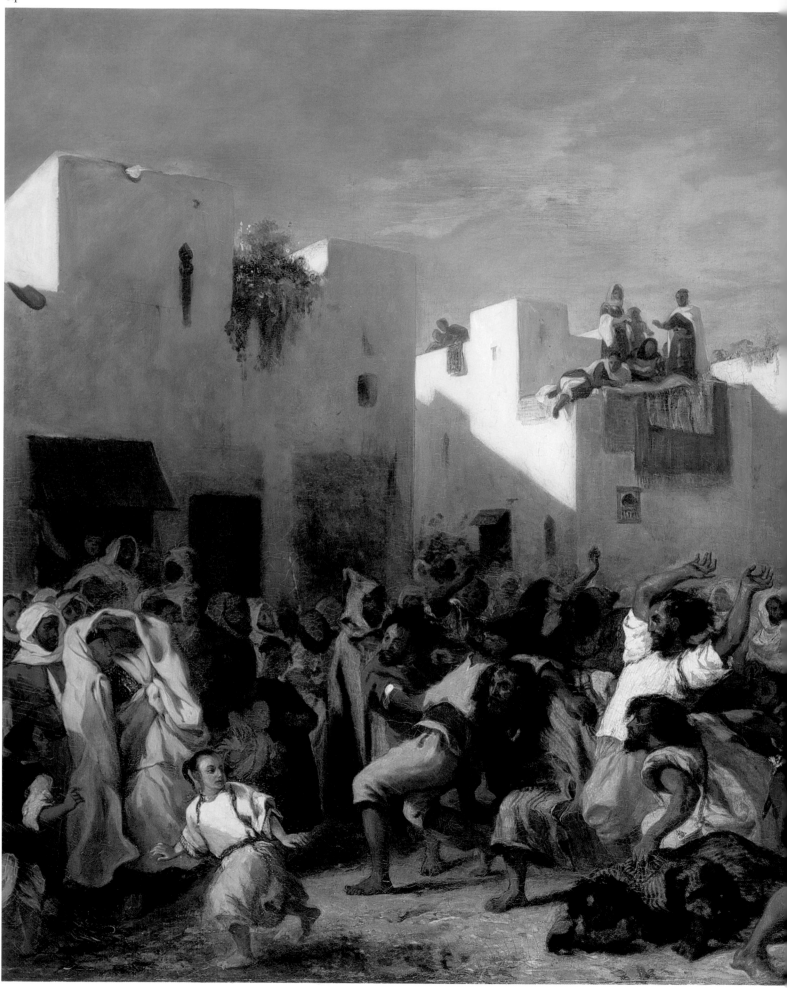

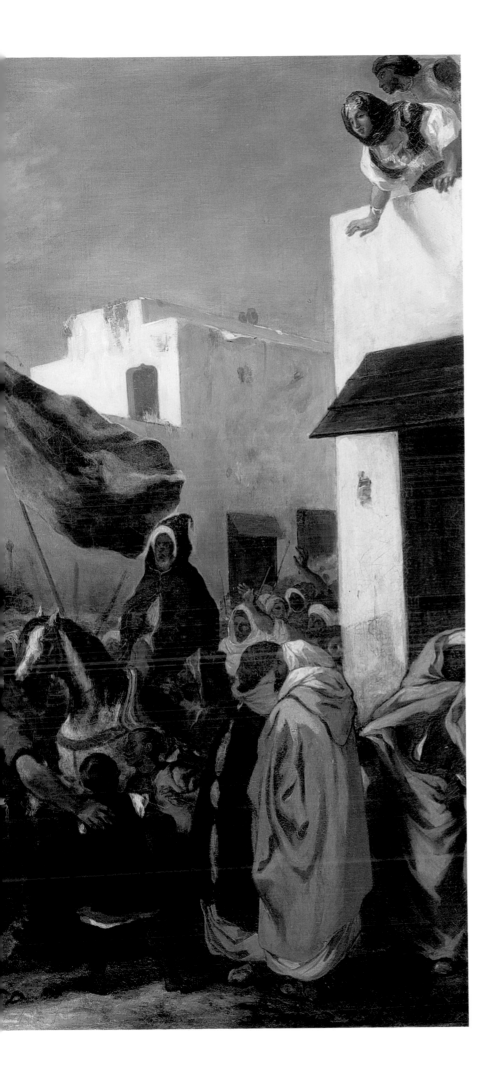

Paul Huet (1803–1869)

85

Storm at the End of the Day,
or The Cavalier c.1825–6

Oil on canvas
50 x 65.5 (19⅝ x 25¾)
Signed, lower left: *P. Huet*
References: Planche, *Salon 1831*, pp.95ff., 150;
Anon., *L'Artiste*, 1831, p.177; Jal, 1831, p.219.
Musée départemental de L'Oise, Beauvais
London and Minneapolis only

86

Storm at the End of the Day,
or The Cavalier 1827

Oil on canvas
100.3 x 148.6 (39½ x 58½)
Signed and dated, lower right: *Paul Huet 1827*
References: Planche, *Salon 1831*, pp.95ff., 150;
Anon., *L'Artiste*, 1831, pp.210, 252, 272; Jal,
1831, p.219.
Richard L. Feigen & Co., New York
New York only

These oils represent important variants of a
subject to which Huet returned frequently. It is
likely that both were in the group of seven
pictures rejected by the Salon jury in 1827.
The earlier version in Beauvais has been
consistently dated 1821–2 incorrectly, probably
because of René Paul Huet's claim that this was
his father's first painting. However, his avowed
interest was in establishing the chronological
primacy of Huet's originality as a landscape
painter. An oil sketch by Bonington (fig.49)
depicting the same site and similar atmospheric
conditions was almost certainly painted in
Huet's company, so similar are the two works in
palette and touch. Bonington's finished
watercolour of his composition can be dated
*c.*1825–6 on compelling stylistic evidence, and
there is no reason to query that proposed date
for his oil sketch as well. Bonington and Huet
toured the Channel coast for the first time
shortly after August 1825. There exist
numerous other instances of Huet and
Bonington painting virtually identical pictures
in 1825–6.

85

As for the subject, Pierre Miquel observed that Huet's brother, René, never returned from the Battle of Dresden of 1813, thus implying a poignant personal eulogy (*Huet*, p.42). The uniform of the horseman suggests a Napoleonic context, and the plight of the soldiers of the disbanded Grand Army was fodder for Géricault and many others at this moment. In fact, one of Huet's sharpest memories from his youth was Géricault's famous lithograph *Charette des blessés* of 1818. But the harsh realism of Géricault's depictions of wounded soldiers has been transformed by Huet into a purely poetic reverie. He visualises instead the post-Napoleonic sentiment of 'inexpressible malaise' which pervades Alfred de Musset's (no.164) *Confession d'un enfant du siècle* of 1835. The Salon etiquette pasted to the face of the picture confirms that Huet exhibited this painting in 1831 with a passage from Victor Hugo's *A un passant* (*Odes and Ballades*, 1826). He was introduced to the poet in the mid 1820s and probably painted this picture in 1825–6 as a specific illustration to Hugo's verse, which was composed on 22 October 1825.

The slightly later and more elaborate version of this subject was also exhibited at the 1831 Salon. Painted in 1827, its sombre air needs to be appreciated in the context of Huet's distressed financial situation and fragile health that year. The horseman is now a knight-errant from some vague historical period, completely dwarfed by a landscape that merges elements of Huet's conscientious 1820s *plein-air* work and his obvious grappling with the anomalous influences of John Martin and John Constable. It is also more evocative of Hugo's ballad, which dwells on the perils of crossing a vaporous plain infested with brigands and sorcerers. This attempt at an 'elevated naturalism' was warmly commended in *L'Artiste*, although earlier the same critic had observed ambivalently that 'it is Watteau, and the English landscapists that Huet loves'.

Aside from technical issues, the critics were clearly at a loss as to how to respond to Huet's more imaginative compositions. Auguste Jal nevertheless perceived that Huet's aim was to explore his perceptions, not conventional modes of historical landscape or the model of Poussin, nor even the blunt naturalism of the British, and that, like Delacroix, he would experiment with extremes to achieve this. At the very end of his life, when he seemed haunted by forebodings of death, Huet revived the larger cavalier composition in an etching. PN

fig.49
Richard Parkes Bonington
Wagon in a Landscape
c.1825
Oil on canvas
Private Collection

86

Louis Léopold Boilly (1761–1845)

87
Moving Day 1822

Oil on canvas
73 x 92 (28¾ x 36⅛)
Signed and dated, lower right: *L. Boilly 1822*
References: Delécluze, 1822 (11 June 1822),
p.824.
The Art Institute of Chicago, Harold
Stuart Fund
Minneapolis and New York only

88
Distribution of Wine and Food on the Champs-Elysées 1822

Oil on canvas
97 x 129 (38 x 51½)
Signed and dated, lower right: *Boilly 1822*
References: Delécluze, 1822 (11 June 1822),
p.824.
Paris, Musée Carnavalet. Histoire de Paris
London only

Boilly offers many parallels to the young David Wilkie. He was also originally from the provinces, settling in Paris only in 1785. He would have known Wilkie's pictures through engravings, but not until his own style had been well established. Both artists were adept at characterisation although, with Boilly, expression too often bordered on stereotype or caricature. Portraiture and humorous genre were his strengths and, like Wilkie, his reputation spread rapidly through the medium of reproductive prints. His polished technique was also based on a sensitive appreciation of Dutch masters, but unlike Wilkie he never evolved his style of execution beyond those specific influences, although his later manner did favour very complex figure arrangements out of doors. Boilly's humorous suite of lithographs *Les Grimaces* of 1823 are mainstream caricature with roots in eighteenth-century English practice.

For Arnold Scheffer, among others, the genre pictures by his brother Ary (no.63), by Prud'hon and by Boilly marked the pivotal 1822 Salon as a new era for the only type of painting 'that conforms to the modern tendency of the national spirit'. The national spirit, as manifested in Boilly's *Distribution of Wine and Food*, was criticised in the *Literary Gazette* (26 May 1821) by a French correspondent:

The people of Paris love to be amused ... and they delight in the public festivals given by the Bourbons. The good people never suspect ... that they are themselves exhibited for public entertainment ... thus degrading, instead of ennobling the human species.

A predilection for such social commentary had almost cost Boilly his life during the Terror, but throughout his career he maintained a journalistic, if not critical, perspective on the mores of his era.

The *Distribution of Wine* records an annual event in the Champs-Elysées, the consequences of which are both depicted and implied in Boilly's elaborate composition of isolated incidents. The distraction of a tumultuous crowd diffuses the moralising tone of Wilkie's similar narrative in *The Village Holiday* (no.89). Boilly unsuccessfully petitioned the government to buy this painting. Like many of his major Salon works, it remained in his possession until his death. Similarly, he naïvely speculated that the government would buy *Moving Day* as a model for public instruction, despite its awkward reference to the dislocations of the lower classes caused by the inequities of rental housing in Paris. PN

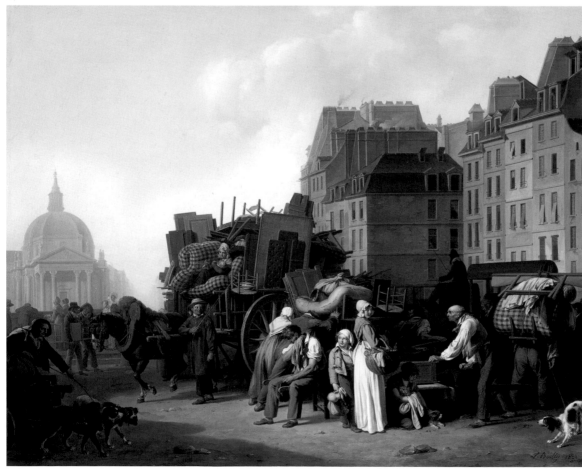

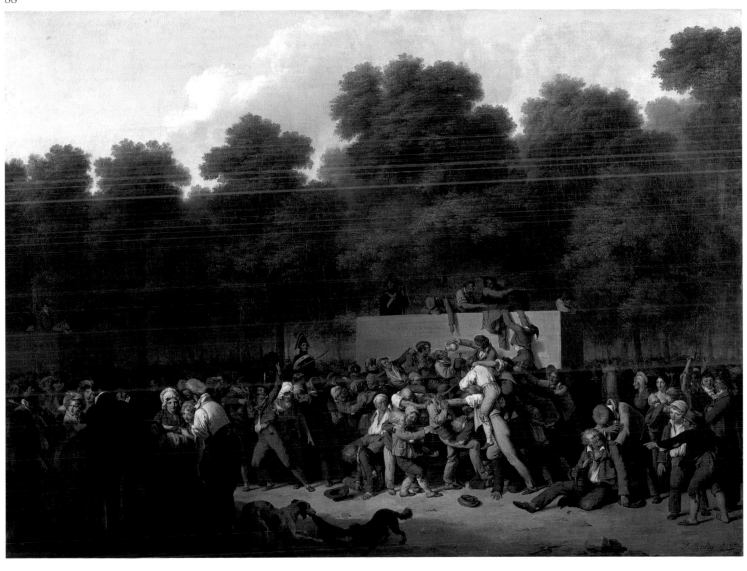

89
David Wilkie (1785–1841)
The Village Holiday 1809–11

Oil on canvas
94 x 127.6 (37 x 50¼)
Signed and dated 1811
References: *Examiner*, 3 May 1812, pp. 282–3.
Tate. Purchased 1824

Wilkie's reputation was first made with works of narrative genre, which were an immediate success following his move to London from his native Scotland in 1805. *The Village Holiday* was bought by the collector John Julius Angerstein. The picture was included in a one-man show held by Wilkie in 1812, and came properly into the public domain in 1824, when it became the first example of a living artist to enter the National Gallery with the Angerstein collection. It would thus have been accessible to the French artists who visited London in 1825.

William Hogarth's moral series, *Marriage à la Mode* (1743–5), was also included in the transfer of Angerstein pictures to the National Gallery, and Wilkie was often considered a latter-day Hogarth for pictures like this, poised between humour and pathos, sentiment and censure. It was Wilkie's achievement to modernise and democratise the moral concerns once confined to history painting. Here, the issue is strong drink, and whether it should be condemned or indulged. Will the man pulled from the inn by his wife and children follow obediently, or stay with his drunken friends? The consequences of a wrong decision are made plain in the right foreground, in the person of a collapsed inebriate whom Wilkie had recalled from his walks round London. Showing the artist Joseph Farington a sketch for the picture, Wilkie pointed out 'a man drunk and laid down, with a few spectators looking at him as an object of disgust, and even, he said, "His dog seemed to look ashamed of

him." This he called the moral part of his picture, and he took it from what he happened to see in the street' (Farington, *Diary*, 22 May 1809). Later, William Hazlitt would note the appeal of Wilkie's pictures as 'diaries, or minutes of what is passing constantly about us' ('On the Works of Hogarth – On the Grand and Familiar Style of Painting', *Lectures on the English Comic Writers*, 1819). While Géricault or Delacroix admired the realism and directness of British writing and painting, Wilkie was in fact influenced in his handling of the chain of action and effect throughout the picture, as well as its warm colouring and refined finish, by Jean-Antoine Watteau.

Wilkie originally called the picture 'The Public House Door', and it may have been Angerstein who advised the change of title, aware of the contentious nature of the subject. The new title was in fact a misnomer, since this is not a rural scene but set on the outskirts of London, the inn being based on one at Paddington, and other buildings on 'houses at Brompton'. Wilkie emphasised the moral of the piece by attaching a quotation from Hector MacNeill's vernacular poem, *Scotland's Skaith: or the History o' Will and Jean*, which tells the story of a family destroyed by a drunken husband:

On ae hand drink's deadly poison,
Bare ilk firm resolve awa',
On the 'ither, Jean's condition
Rave his very heart in twa.

DBB

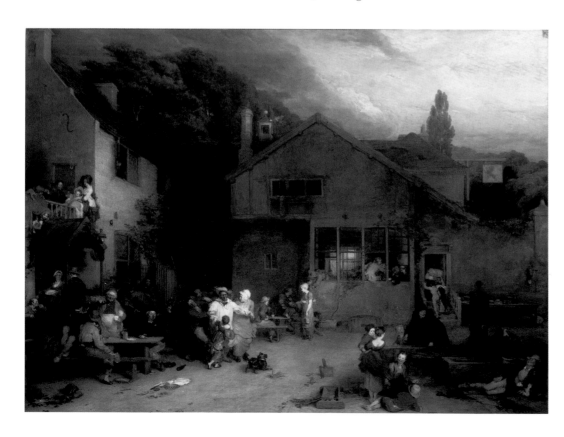

172

90
William Collins (1788–1847)
A Frost Scene 1827

Oil on canvas
84 x 109.3 (33 x 43)
References: *Literary Gazette*, 9 June 1827,
p.361; Collins, *Life*, pp.270–3, 279–81, 291;
Cunningham, *Wilkie*, II, p.445; Beckett,
Constable, pp.292–3; Blanc, 1869, p.6.
Yale Center for British Art, Paul Mellon
Collection

The professional career of William Collins was not unlike that of Antoine-Félix Boisselier (no.137). Both artists were popular and dependable exhibitors, well trained in the principles of their respective academies and rarely advancing those ideas beyond conventional expectations. By the 1810s, Collins had established a following among the foremost collectors of modern British art which, in conjunction with his election as a Royal Academician in 1820, rankled Constable, who later admitted to despising Collins for both his pretensions and his sentimental genre subjects. 'Far too pretty to be natural', he observed (Constable, *Correspondence*, IV, p.287). Collins visited Paris in 1817 and began painting French coastal scenes with fishing folk, which were frequently confused with Bonington's similar subjects. It is likely that those two artists knew each other, especially since Collins married the sister of Margaret Carpenter, portrait painter and daughter-in-law of Bonington's primary patron in the trade, James Carpenter. He was also an intimate friend of David Wilkie, who wrote many of his most interesting reflections on art in his letters to Collins from Europe. Although he visited the Paris Salon in 1824, Collins does not appear to have ever exhibited abroad.

A Frost Scene was commissioned in the autumn of 1825 by Sir Robert Peel, who paid a remarkable five hundred guineas. This was twice the amount offered by the French state for Géricault's *Medusa* and a sum much discussed in the London art world. Collins began the picture in March 1826. Something of his intentions might be inferred from his journal entry in which he observed of the Dutch school that they preserved the spirit of their work by painting fast: 'nothing can replace the want of that vigour and freshness, which things done quickly (with a constant reference to nature) necessarily possess.' The virtues of facility again enter the journal observations slightly later in the year, in a meditation that might have been written by Delacroix: 'the real lover of painting derives the highest gratification from this very sort of execution. However highly finished a picture may be the beauty of execution is in fact lost when ... it requires a magnifying-glass to enjoy.' Despite his stated intentions, Collins spent months bringing this picture to completion, ever fearful that the final work might not live up to expectations. PN

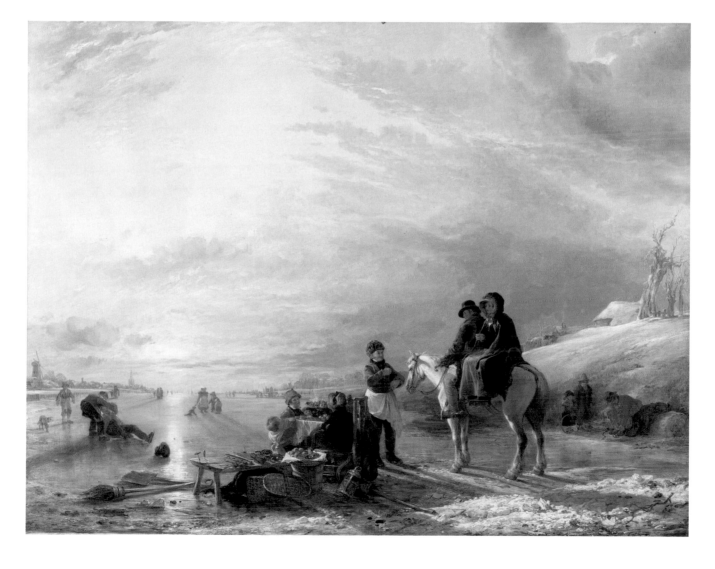

Alexandre-Gabriel Decamps
(1803–1860)

91
Ferreting Hare 1830

Oil on canvas
31 x 48.3 (12¼ x 19)
Signed and dated, lower left: *Decamps 1830*
Private Collection

92
Deer Hunting c.1830

Oil on canvas
31 x 48.3 (12¼ x 19)
Signed, right: *Decamps*
Private Collection

Decamps was an exact contemporary of Huet, Eugène Isabey and Camille Roqueplan, and his professional life had some notable parallels to that of Bonington. Like Bonington and Huet, he tired quickly of the academic regimen and savoured his independence. His earliest oils of 1821–3 are small, thickly impasted and predominately genre. In March 1824, Delacroix visited his studio and recorded in his journal 'execrable painting'; nevertheless, he would develop a sincere appreciation for Decamps's talent and, in a famous passage in his journal from 1855, when he extolled the virtues of British art, he exempted Decamps from his condemnation of the 'dreary French school'. Decamps exhibited publicly for the first time at the 1827 Salon. His two oils, *Hunting Lapwings* and *A Janissary*, were well received by the critics. The former blatantly borrows its landscape composition from Bonington's *Near Mantes* (fig.57). Since Bonington probably painted that picture in the spring of 1826, Decamps probably saw it in Delacroix's studio.

In 1829 Decamps commenced a series of hunting scenes similar to the pair exhibited here. The vogue for such British-inspired subjects undoubtedly determined his course. Of Decamps's mature style, which they epitomise in their subtle manipulation of impasto and glazing, Paul Mantz observed that 'the manner in which the colour, very charged with oil, is extended on the canvas, recalls the procedure of a watercolourist' (1881). This was, in effect, the oil technique developed by Bonington, Delacroix and Colin in the mid-1820s, both to confound the distinction between media and to mimic in their oils the brilliant translucency peculiar to watercolour. On more than one occasion in the 1830s, Gustave Planche, who otherwise admired Decamps, would chastise him for endeavouring to make his oil paintings resemble his watercolours. Yet it was precisely the novelty and force of Decamps's technique that accounted for his tremendous popular success. As Honoré Balzac observed in *A Commission in Lunacy*, 'Decamps has in his brush what Paganini has in his bow – a magnificently communicative power'. PN

91

92

93
Horace Vernet (1789–1863)
Hunting in the Pontine Marshes
c.1833

Oil on canvas
100.3 x 137.2 (39½ x 54)
Signed and dated, lower left: *H. Vernet / Rome 1833*
References: Farcy, *Salon* 1831 (7 Aug. 1837), p.100; Pillet, *Salon* 1831 (28 July 1831); *L'Artiste* II (1831), p.30; Planche, *Salon* 1831, pp.120–1.
National Gallery of Art, Washington, Chester Dale Fund

In 1829, Vernet began a six-year appointment in Rome as Director of the French Academy. To the 1831 Salon, he submitted a *Departure for the Hunt in the Pontine Marshes* (untraced), and to the sixth supplement of that vast exhibition he sent *Forest Studies: same number*. Several commentators confirmed that this late entry consisted of two major landscapes. Charles Farcy identified them as *Two Views of the Interior of the Laurentine Forest, near Ostia*, while Fabien Pillet provided the detailed description that enables us to identify the present painting, or a version, with one of those pictures. The site, however, is almost certainly the Pontine Marshes south of Rome near the coast, then still a pestilential wasteland.

Vernet was an avid sportsman, and frequently pursued various activities near Rome. Of the Pontine region, he wrote to the Comte de Forbin: 'I have never seen anything more majestic. Here man has never spoiled the order of nature. The trees flourish and perish in exuberant variety thanks to the freedom they enjoy' (Eitner, 2000). Pure landscapes are rare in Vernet's oeuvre, and Eitner interpreted the picture, in the light of these comments, as extolling the virtues of a natural state of existence. Contemporary critics, however, universally condemned his dabbling in a genre in which they felt he was unqualified to practise. It had become a platitude of critical writing that Vernet was undisciplined, both in his technical application and in his pretension to master every subject. Pillet offered the most considered, if ultimately unfavourable, assessment of the picture, likening it to a stage set for an opera about bards and druids. Gustave Planche (*Salon 1833*, p.204) was especially disdainful. 'Let us admit,' he wrote, 'without even expecting of him the energy, the grace, or the éclat of Géricault, Prud'hon and Bonington … that his painting is mediocre, with only negative qualities'. No one seems to have appreciated the seventeenth-century flavour of Vernet's impenetrable forest, nor did they relate it to the respectable traditions of training in the very school that Vernet headed (see no.108). PN

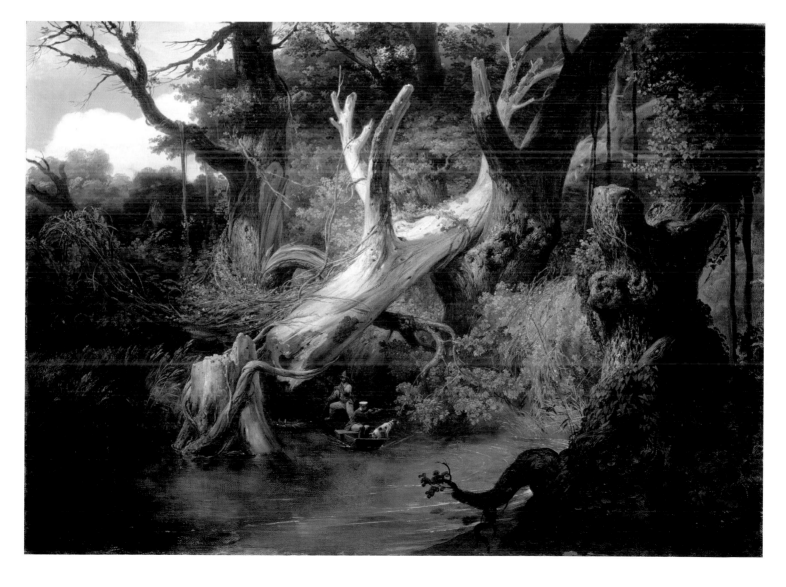

94
Edwin Landseer (1802–1873)
The Cat's Paw 1824

Oil on panel
75.6 x 69.8 (29¾ x 27½)
References: *Literary Gazette*, 31 Jan. 1824, p.74;
14 Feb. 1824, p.106; *Examiner*, 29 Jan. 1824,
pp.139–40; *Somerset House Gazette*, 1824, I,
p.275.
Minneapolis Institute of Arts, Gift of Dr Roger
L. Anderson in memory of Agnes Lynch
Anderson

fig. 50

fig. 51

Among Landseer's earliest exhibition pieces
was a subject of similar genre, *Impertinent
Puppies Dismissed by a Monkey*, shown at the
Royal Academy in 1821. In 1827, Landseer's
brother Thomas published an engraving of
the painting, thus affording it even wider
circulation, as well as his own creation,
Monkeyana, or Men in Miniature (fig.50).
A second monkey picture from 1821, *The
Dancing Lesson* (untraced), depicted a primate
and a poodle forced to dance by a whip-
brandishing street entertainer. Neither of these
compositions, however, prepare one for the
affront of this painting, which remains one of
Landseer's most controversial works. Haydon
(*Diary*, II, p.466), in a fit of pique over
Landseer's ingratitude to him, condemned it
when it appeared at the British Institution in
1824 as 'a first symptom of decay – not of decay,
but of vice in style'.

Landseer's early anthropomorphic
representations of animals reflected his love
of the fabulists Aesop, John Gay and Jean de
La Fontaine. La Fontaine was enjoying a
renaissance, with numerous illustrated editions
appearing in the 1820s. *The Cat's Paw*
illustrates a La Fontaine fable in which a
monkey, the personification of duplicity, folly
and cruel cunning, persuades a cat to pull hot
chestnuts from a stove. It is the origin of the
term 'cat's-paw' to describe anyone who is
duped by another person. The fable itself
scarcely justifies Landseer's fierce
interpretation, although seventeenth-century
prototypes, and in particular the works of
Abraham Hondius and Frans Snyders, are
remarkably close in spirit. The preponderant
taste for Flemish pictures in London at the
time, and Landseer's desire to associate his art
with them, might explain his choice of subject.
But by placing the narrative in a domestic
setting replete with kittens, the evidence of
mundane chores brutally interrupted and the
suggestion of violation, the artist has loaded
the painting with psychological meaning that
is rare in the animalier tradition. In the
seventeenth century, such anthropomorphic
illustrations were meant to stigmatise the
foibles of human nature. In the nineteenth
century most artists, like Alexandre-Gabriel
Decamps (fig.51), opted similarly for
picturesque and humorous representations of
simians in human guise, often for pointed social
satire, but rarely for probing sinister human
impulses. Decamps's own 1847 representation
of this fable (Louvre) actually depicts a monkey
docilely eating the chestnuts that the cat is
pulling from the hearth uncoerced.

The Cat's Paw was the best known of
Landseer's early pictures. Engraved
reproductions undoubtedly contributed to its
sustained notoriety abroad and may, in fact,
have prompted Decamps to paint his version.
The critic for the *Literary Gazette* hit on the
paradox and power of such works as this, or
Géricault's *Study of Truncated Limbs* (no.25);
namely, an exquisite beauty of composition
and technique at odds with abhorrent
subject matter.

A decade later in France, and especially
through the influence of Decamps, monkeyana
and animalier subjects achieved a genuine
vogue, for they were perceived as laudable
assaults on the monotony of the academic
tradition and precious expressions of artistic
individuality. But there were also very tangible
polarities between Landseer's approach to
representing animals and that of his French
colleagues, of whom Théophile Gautier would
remark in 1855 that, like the Dutch, they only
considered the animal from the purely
picturesque point of view, whereas Landseer
'gives his beloved animals soul, thought, poetry
and passion'. PN

fig.50
Thomas Landseer
Monkeyana, or Men in Miniature
1827
Etching
Yale Center for British Art, Paul
Mellon Collection

fig.51
Alexandre-Gabriel Decamps
The Experts
1837
Oil on canvas
The Metropolitan Museum of Art,
H.O. Havemeyer Collection,
Bequest of Mrs H.O. Havemeyer,
1929

95
Sawrey Gilpin (1733–1807)
Horses in a Thunderstorm 1797/8

Oil on canvas
84.6 x 127.7 (33 x 49)
Signed and dated: *S:Gilpin 1798*
Royal Academy of Arts, London

The son of an amateur artist and pupil of the marine painter Samuel Scott, Gilpin rose to prominence in the London art world as a painter of animals and sporting subjects. Modern interest in his brother, the Revd William Gilpin, the prolix theorist of the Picturesque, has overshadowed his accomplishments, and he is too often viewed as a follower of George Stubbs, rather than as a precursor of the dramatic realism of James Ward (no.97). Although his *métier* was the portrayal of horses and other domestic animals, he was, like his younger contemporary Carle Vernet (no.4), quite ingenious in finding literary and historical subjects that allowed him to elevate the stature of those genres, such as *Gulliver Among the Houyhnhnms* of 1769 and *The Election of Darius, Upon the Neighing of his Horse*.

Although offered as his Diploma Picture upon his election as Royal Academician in 1797 before its completion in 1798, *Horses in a Thunderstorm* was not ready for exhibition until 1799. It recalls Vernet's 1798 Salon entry, *The Frightened Horse* (Avignon), although neither artist would have known the other's specific work. However, Géricault would have seen Gilpin's picture in the Royal Academy galleries during his London visit, and it is

certain that Delacroix had more than a passing interest, since he undertook to paint for Louis-Auguste Schwiter in 1825 a watercolour copy (Budapest) of the horse rearing in the middle distance. PN

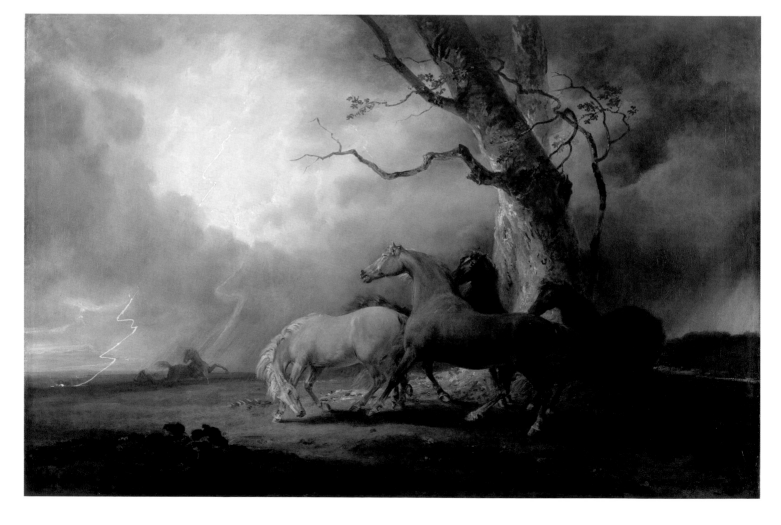

96
Théodore Géricault (1791–1824)
Horse Frightened by a Storm
c.1821–2

Oil on canvas
48.9 x 60.3 (19 x 24)
The National Gallery, London

This is the largest of the artist's horse pictures and, according to Germain Bazin, his masterpiece in this genre, surpassing in beauty even the *Epsom Derby* of 1821 (fig.47), and likewise painted in England (*Géricault*, VI, p.26). The last observation, at least, could be supported by the stylistic evidence. The query often posed as to whether it was Carle Vernet's or Sawrey Gilpin's rendering of *Horses in a Thunderstorm* (no.95) that influenced Géricault has no answer, since the artist certainly knew both works prior to painting this. Furthermore, the composition of the Géricault bears little resemblance to those antecedents; rather, with the exception of the high drama of the thunderbolts, it conforms to a type of horse portraiture common in both countries from the eighteenth century and practised with resolute conviction in the 1820s by Carle and Horace Vernet in Paris and James Ward in London. PN

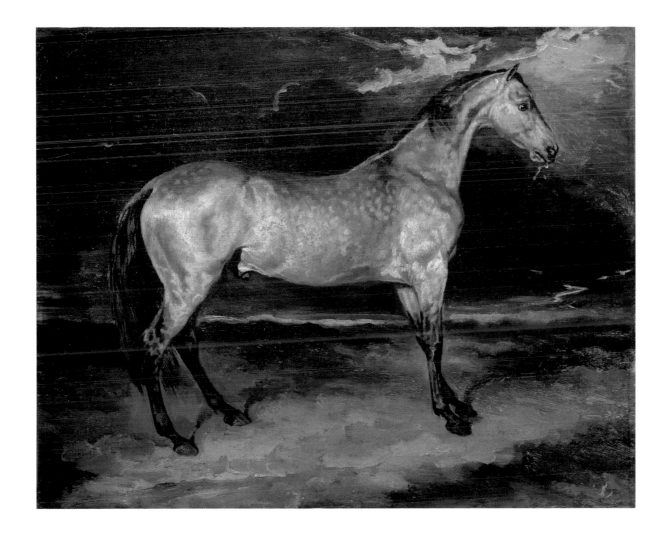

97
James Ward (1769–1859)
Marengo 1824

Oil on panel
81.9 x 109.9 (32¼ x 43¼)
Signed and dated: *J. Ward R.A. 1824*
Duke of Northumberland, Alnwick Castle

Like Horace Vernet and Landseer, Ward was a versatile artist, although he is invariably associated with animal painting and especially with portraits of thoroughbreds and bloodstock. He abandoned a lucrative practice as an engraver for painting around 1790. He then broadcast his pretensions and his indebtedness to Rubens and George Stubbs with an important oil of 1803, *Bulls Fighting, with a Distant View of St Donats* (V&A), while his *Boa Serpent, Liboya, Seizing His Prey* (see no.83) of 1805 anticipates the compositions of some later French illustrations of *Mazeppa*, especially Louis Boulanger's *Mazeppa Tied to His Horse* of 1827 (Rouen) and several Antoine-Louis Barye bronzes. As always with Ward, the elemental struggles of man against beast or beast against beast are conceived in the most agitated terms, and his application of paint to linen is as tortured in its beauty as that of Vincent Van Gogh.

In 1811 Ward was elected Royal Academician. His immense *Allegory of Waterloo* (destroyed), dwarfing even Géricault's *Medusa*, required six years to finish, and proved a

critical and financial disaster for the artist. Far happier allegories of the confrontation were the two pendant horse portraits painted for the Duke of Northumberland: this depiction of Napoleon's charger Marengo and another of Wellington's Copenhagen. The artist himself acknowledged that the forbidding landscape was symbolic when *Marengo* was exhibited at the Royal Academy in 1826. The charger Copenhagen presides calmly over a lush and well-ordered pastoral countryside.

Marengo had campaigned with Napoleon from 1800, and was captured at Waterloo and taken to London. Three years after Napoleon's death in exile, Ward portrays the charger as a marooned animal terrified by the prospect of imminent darkness. A reproduction of *Marengo* figured in Ward's series of fourteen lithographs, *Celebrated Horses*, which he began publishing in 1823 with Charles Hullmandel. PN

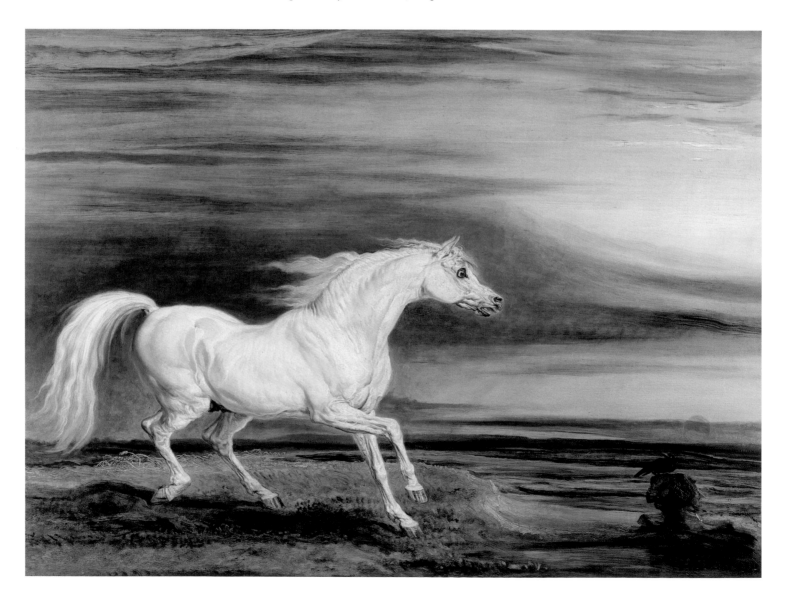

98
Alfred De Dreux (1810–1860)
The Intruder 1846

Oil on canvas
126 x 94 (49½ x 37)
Signed and dated, lower right: *Alfred DeDreux*
1846
Private Collection

Alfred De Dreux was the closest approximation to a British sporting artist to emerge in France in the early nineteenth century and, not surprisingly, his art was profoundly indebted to British masters. Géricault, who painted his portrait twice as a child, loomed large in his initial training, owing to his intimate friendship with De Dreux's uncle. One of his earliest paintings of 1825 was a reprise of Géricault's *Mazeppa*. He first exhibited at the 1831 Salon with steeplechase and stable scenes and, although he would paint several historical subjects in which horses figure prominently, most of his prodigious output were contemporary scenes of the chase and the course, and equestrian portraits of the *beau monde*. His most famous picture, *The Flight*, sentimentalises such powerful precursors as Léon Cogniet's *Rape of Rebecca* of 1808 and Ary Scheffer's *The Dead Pass Swiftly (Lenora)* (no.63).

De Dreux visited Britain in 1844 with King Louis-Philippe, and the sporting and animal painting he studied had immediate consequences for his art. The white stallion in *The Intruder* has been described as a portrait of Tamerlan, the favourite Arabian belonging to the Algerian Emir, Abd-el-Kader. The dapple grey on the left was a mainstay of the French cavalry, and this might support a highly romantic interpretation of the picture as an allegory of that defiant Emir besieged by hostile, presumably French, forces. The saddled but riderless horse and the foreground articles of clothing suggest some symbolic meaning, but it should be observed that the Emir did not surrender to the French army in Morocco until December 1847.

The violent exertions of combative horses was a subject that preoccupied Géricault, although Stubbs's much earlier *Horses Fighting in a Landscape* of 1781, engraved by George Townley Stubbs, and similar essays by Sawrey Gilpin and James Ward are other likely sources of inspiration for both French painters.
PN

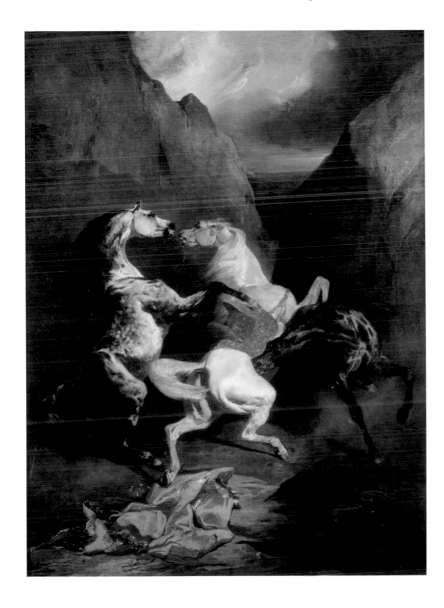

99
Théodore Géricault (1791–1824)
Horse with Jockey Up c.1821–2

Oil on canvas
36.8 x 46.3 (15 x 18)
Virginia Museum of Fine Arts, Richmond,
Collection of Mr. and Mrs. Paul Mellon

Géricault wrote to his friend Pierre-Joseph Dedreux-Dorcy in 1821 that, by means of his lithography and the commissions that might result from their circulation among the British connoisseurs, he hoped to return to Paris 'covered with gold'. 'To the devil', he wrote, 'with all those Sacred Hearts of Jesus', referring to a commission for an altarpiece awarded by the state in lieu of its purchasing the *Raft*. 'That's work for starving beggars,' he continued, 'I renounce the buskin [antiquity] and Scripture, to lock myself in the stables'.

Géricault considered sporting and equine art as saleable commodities, at least in the circles with which he associated thanks to his London host, the horse merchant Adam Elmore (1784–1849). The most important commission to result from the London stay was Elmore's *Epsom Derby* (fig.47), a composition much indebted to British models, especially Henry Alken (no.170). The artist's intent had been to compete with British

favourites on their own terms. In that narrow sense, it is a singularly bold document in the history of this period, and a testimonial to Géricault's unique temperament, as no other artist of either school attempted such an accommodation or challenge.

Horse with Jockey Up is one of the few other pictures generally believed to have been painted in England, although it first appeared in the possession of the remarkable collector Louis-Joseph-Auguste Coutan (no.5). Whether he purchased the picture from stock or at the 1826 Galerie Lebrun exhibition (1826, II, no.79), or commissioned it from drawings is unknown. Coutan also owned Géricault's three preparatory oil sketches for the *Epsom Derby* and the identically sized *Stable Boys and Post Horses* of 1822 (Louvre). A similar subject, *Cheval Anglais monté par un jockey*, figures in Géricault's lithographic *Suite de huits petites pièces* (1823). PN

100
Théodore Géricault (1791–1824)
The Village Forge 1821–3

Oil on canvas
49.5 x 58.4 (19½ x 23)
Signed, lower left: *Géricault*
References: *Oriflamme*, 1824, p.83; Jal, 1824,
pp.187–8; *Revue Critique* 1824, p.103; Mély-
Janin, 1824 (18 Jan. 1825), p.2.
Wadsworth Atheneum Museum of Art,
Hartford, CT. The Ella Gallup Sumner and
Mary Catlin Sumner Collection Fund

The critic for the *Oriflamme* wrote at length on this picture and its pendant *Stable Boys and Post Horses* of 1822 (Louvre), both of which had been submitted posthumously to the 1824 Salon:

See this horse at the door of a village forge, how its nature is bursting with life! … nothing is lacking in these morsels, neither for life nor for truth, nor for execution; the touch is free, fresh, nice, the colour strong, warm.. his works will always serve as a model.

Indeed, the critic's objective assessment of the artist's intent is in direct opposition to Régis Michel's recent appreciation of these pictures as dehumanised vehicles of stark analytical realism (Paris, *Géricault*, 1991) or to the lugubrious sentiment that modern scholars often read into them.

In his Salon review, Mély-Janin also lavished praise on Géricault's depictions of draught horses and farriers, claiming that the masterwork in this genre was the signboard actually painted by Géricault in 1814 for a blacksmith at Roquencourt (Zurich). With its Herculean farrier, the Zurich picture has been described as the proletarian version of the monumental *Wounded Cuirassier* (Louvre) and the first introduction of the French working classes into history painting. By contrast, this forge scene possibly evolves its more domestic timbre from famous British models like Joseph Wright of Derby's *A Farrier's Shop* (1771) and the several versions of his *Blacksmith's Shop* (1771–3), all of which existed in mezzotints that were still for sale in London in the 1820s. In retrospect it may surprise, but at the time of his death in January 1824, Géricault was most esteemed in France for his animal and horse paintings, undoubtedly because these were the subjects that were constantly circulating after his return from London. PN

101

Théodore Géricault (1791–1824)
Beer Cart in a Brewery Yard
c. 1822–3

Oil on canvas
59.7 x 73.3 (24 x 29)
Museum of Art, Rhode Island School of
Design, Providence Museum Works of Art
Fund

The dating of this picture, like most of Géricault's later works, has been much argued. Charles Clément claimed it was painted for Dr Biett in 1818 shortly before Géricault began the *Medusa* (1868, pp.79, 300). Lorenz Eitner placed it on the eve of the first departure for London, and further noted that it had probably been given to Dr Biett, not specifically painted for him, in gratitude for the care he offered the artist in his last illness (*Géricault*, p.205). But the similarities of its subject matter and of its massive architectural setting to such indisputable London period works as *The Coal Wagon* (no.167) and the lithographs for both *Various Studies* (1821) and *Etudes de Chevaux* (1823), support Sylvain Laveissière's most recent assignment of the picture to the years 1822–3 (Paris, *Géricault* 1991). Its only recorded exhibition was in 1826 at the Galerie Lebrun.

In his tireless explorations of London, the German Prince Pückler in July 1827 'turned his cab to Barclay's brewery, which the vastness of its dimensions renders almost romantic and which is one of the most curious sights in London'. The brewery produced nearly fifteen thousand barrels of beer daily and 'a hundred and fifty horses, like elephants, one of which can draw a hundred hundred-weight are daily employed in carrying out the barrels' (*Tour*, p.197). The *Beer Cart* is probably a souvenir of Géricault's similar experience of London's vast commercial quarters.

In his review of the 1824 Salon, the critic for the *Oriflamme* justly observed Géricault's passion for all manner of horses, including those of the harness. The same critic further noted the difference between such stolid draught horses and the agitated couriers and rearing chargers in Horace Vernet's battle pictures and Géricault's own earlier equestrian subjects. Géricault indeed had a late predilection, perhaps born of his military and then London experiences, for the massive, unexalted animals that transported everything from the goods of modern industry to the weapons and victims of war. The horse in his art had become, by its very mundane routines, a symbol of the post-Napoleonic order. PN

102

Anne-Louis Girodet-Trioson
(1767–1824)

Portrait of Colette-Désirée-Thérèse de Reiset (1782–1850) 1823

Oil on canvas
60.3 x 49.5 (23¾ x 19½)
Signed and dated, upper right: *G-T/1823*
References: Stendhal, 1824 (1 Nov. 1824);
Coupin, 1824 (Nov. 1824), pp.597–8; Mély-
Janin, 1824 (1 Dec. 1824), p.4; Coupin, *Girodet*,
pl.xii.
The Metropolitan Museum of Art, New York.
Purchase, Gifts of Joanne Toor Cummings, Mr
and Mrs Richard Rodgers, Raymonde Paul,
and Estate of Dorothy Lichtensteiger, by
exchange, 1999

Girodet was an apprentice to David and, after several unsuccessful attempts, won the Prix de Rome in 1789. Early Salon sensations included *Ossian: The Apotheosis of French Heroes* of 1802 (Malmaison) and *The Deluge* of 1806 (fig.11), which virtually guaranteed his reputation for posterity, even had he not contributed so brilliantly to late Imperial propaganda with machines like the *Revolt of Cairo* of 1810 (Versailles). His output after 1815 declined precipitously.

Girodet was in demand as a portraitist throughout his career. In addition to this example, he sent two martial full-lengths to his last Salon in 1824. Stendhal noted that he rendered his accessories with spirit but that, like most French artists, he had no command of chiaroscuro. Marie Mély-Janin, on the other hand, was all enthusiasm for the exquisite touch and 'purity of brush' that recalled his earliest masterpieces. Pierre Coupin, the artist's future biographer, in dismissing Lawrence's portraits (no.104), observed of *M. de Reiset*:

Not long ago, someone maliciously placed next to Lawrence's Portrait of a Woman *another by Girodet ... These are two systems diametrically opposed ... [here] we admire the delicate brushwork that renders the softness of the fur, the workmanship of the lace and fabrics.*

The critic for the *Literary Gazette* (20 Nov. 1824, p.746), with obvious first-hand knowledge of Girodet's portrait and Gros's *Comte Chaptal* (no.103), retaliated in Lawrence's defence:

Of portrait painting the French know absolutely nothing. Even the best of their portraits are miserable things. All the accessories, all which ought to be the subordinate parts of the picture, the fur and the lace, and the curtains and the inkstand and the table legs and the marble pavement are painted with wasteful care and painful accuracy ... There is total ignorance of that noble quality, breadth, both in colour and effect.

Extensive correspondence with Madame de Reiset indicates that her original desire was for a full-length portrait replete with embellishments. However, the artist persuaded her to settle for this more dispatchable and less expensive half-length. The velour dress was the sitter's suggestion, while the artist insisted on black, so as to 'give the carnations greater effect and freshness'. PN

103

Antoine-Jean Gros (1771–1835)
Jean-Antoine Chaptal, Comte de Chanteloup 1824

Oil on canvas
136.5 x 114.3 (53¾ x 45)
Signed and dated, lower left: *Gros / 1824*
References: Mély-Janin, 1824 (28 Aug. 1824),
p.4; Anon., *Drapeau Blanc*, 1824 (13 Sept.
1824), p.3; Delécluze, 1824 (28 Sept. and 16
Oct. 1824); Coupin, 1824, p.595; Chauvin,
1824, pp.10–11; Jal, 1824, p.331.
The Cleveland Museum of Art, Leonard
C. Hanna, Jr. Fund

Chaptal (1756–1832) was a veritable 'man of
parts'. A trained chemist, he helped reform
French commerce and industry after the
Revolution and, like John Martin in England,
threw himself into social and technological
improvements. This ultimately brought him a
peerage and membership of the Institut de
France. The dossiers on his table allude to his
many projects as minister of the interior from
1800. This formal portrait of the scientist,
writing his memoirs and bedecked in the robes
of the Académie Française, the sash of the
Order of St-Michel and his Légion d'Honneur
decorations, was commissioned by the sitter,
probably for the Société d'Encouragement
pour l'Industrie Nationale. Chaptal had
founded that society in 1801 and remained its
president until his death.

This was the only painting submitted by
Gros to the 1824 Salon. Pierre Coupin
explained the probable cause as Gros's intense
involvement with the decorations of the
Pantheon cupola, which were finally unveiled
in November and for which he received his
barony. His under-representation in this pivotal
exhibition was much lamented, but the critics
welcomed this morsel as proof that David's
adherents still flourished to rebut British
influence. Etienne Delécluze summed up the
appreciation: 'the beautiful portrait of M.
Chaptal by Gros, and two historical portraits by
Girodet, form a nice idea of the doctrine of
David's school … Gros, guided by sane
practices and gifted with delicate taste, does not
try to dazzle in works of this genre by resorting
to a forced expression.' This last was clearly an
allusion to Lawrence's portrait of Richelieu
(no.104). PN

104
Thomas Lawrence (1769–1830)
Armand-Emmanuel du Plessis, duc de Richelieu 1822

Oil on canvas
89 x 79 (35½ x 31½)
References: Stendhal, 1824 (10 Oct. 1824);
Delécluze, 1824 (16 Oct. and 1 Nov. 1824);
Literary Gazette, 20 Nov. 1824, pp.746–7;
Coupin, 1824, (Nov. 1824), pp.597–8; (Feb.
1825), p.334; Jal, 1824, pp.45–7.
Sorbonne, Chancellerie des Universités, Paris
London and Minneapolis only
[Not exhibited]

Richelieu (1766–1822), a staunch royalist and twice premier of France, was responsible for successfully negotiating at the Congress of Aix-la-Chapelle in 1818 the withdrawal of the Allied occupation forces from France and the inclusion of his country in a new alliance with Britain, Prussia, Russia and Austria.

This portrait was commissioned by Richelieu's sister shortly after his death in 1822. It derives from the three-quarter-length portrait of Richelieu ordered in 1818 by George IV for the Waterloo Chamber at Windsor Castle and painted from life by Lawrence at Aix-la-Chapelle. At the invitation of the French government to exhibit at the 1824 Salon, Lawrence surprisingly sent only two relatively minor works, the *Portrait of Mrs John Scandrett Harford* (Private Collection) and this replica, representing an important French diplomat. Louis Hersent's portrait of the duke was also in the same Salon. Washington Irving, then in Paris, wrote to C.R. Leslie, saying that the French were ignoring Lawrence's two

pictures, but he appears to have been unaware of the critical skirmishes in the journals.

'However poor the portrait of Richelieu by Sir Thomas Lawrence,' Stendhal wrote, 'it captures a bit more of the physiognomy than Mr Hersent's. Lawrence's manner is the burden of inspired negligence.' In November, Pierre Coupin launched the first of a succession of attacks on Lawrence, in which he articulated the objections of the ministerial faction to all British art. Etienne Delécluze had little patience with oil portraiture of any school, preferring the Greek model of idealised statuary, yet he admired Gros's finesse in his portrait of the Comte Chaptal (no.103), and cautioned French painters to guard against the 'haziness of the British school'.

Not all French observers of British art agreed with the assessment that Lawrence sacrificed too much detail for general effect. François Gérard's friend and fellow artist, Jacques-Luc Barbier-Walbonne, while visiting London in 1822, admitted that 'Despite their faults, their pictures erase ours ... Our school appears pedantic and hard next to theirs ... in their portraits, everything is sacrificed for the head and I strongly believe they are correct in doing so' (Dorbec, 1913). PN

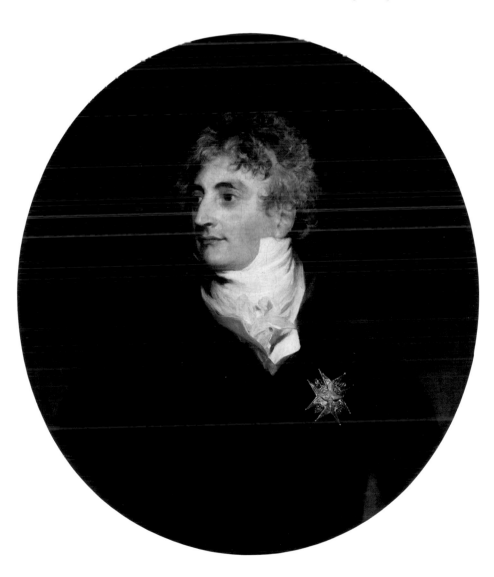

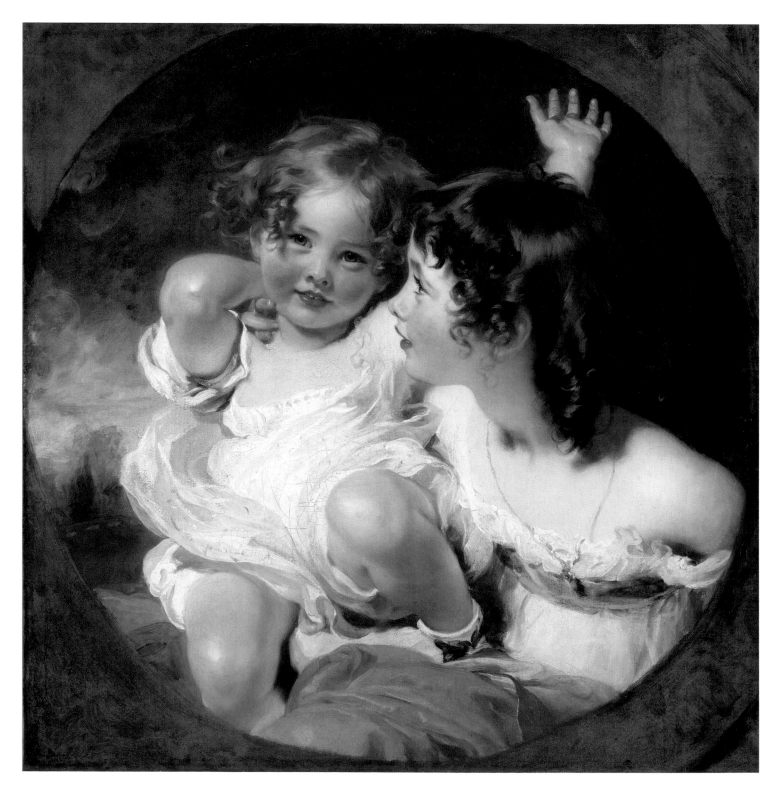

105

Thomas Lawrence (1769–1830)
Portraits of Emily and Laura Anne,
the Children of Charles B. Calmady
1823–4

Oil on canvas
78.4 x 76.5 (30⅞ x 30⅛)
References: *Literary Gazette*, 1 May 1824,
p.282; 8 May 1824, p.298; Raimbach, 1843,
p.128.
The Metropolitan Museum of Art, New York.
Bequest of Collis P. Huntington, 1900

In this portrait of Emily (1818–1906) and Laura
Anne (1820–94) Calmady, Lawrence created a
brilliant archetype of childhood innocence.
The engraver Frederick Christian Lewis
suggested to Mrs Charles Calmady of Langdon
Hall in Devon, in the summer of 1823, that
Lawrence paint her daughters. When exhibited
at the Royal Academy in 1824, the British press
was enthusiastic. The *Literary Gazette* wrote:
'There must be in art, as in writing, the *con*
amore, the inspired hour … It is a focus of
talent and a gem of art. Powerful and glittering
as it is in execution, the playful and beautiful
sentiment that shines through all is its greatest
charm.' Others compared the artist to
Correggio, and the portraits to 'the loveliest
angel-groupings that ever the Italian school
produced', which might have been more to
Lawrence's intentions.

George IV's request to view the picture
at Windsor Castle in October 1824 greatly
enhanced its celebrity. In the autumn of 1825,
the King dispatched Lawrence to Paris to paint
the portrait of the recently crowned Charles X
and his son, Louis, Duc d'Angoulême, for the
Waterloo Chamber. According to Abraham
Raimbach, who was then in Paris with David
Wilkie, Lawrence had the Calmady portrait
sent over, where it was seen by a number of
artists including Delacroix, and lithographed
for circulation in France. One month earlier,
Delacroix had visited the British artist in his
London studio. In a letter dated 1 August, he
described Lawrence as 'the flower of politesse
and a veritable painter of great men … No one
has ever done eyes, women's especially, like
Lawrence, and those half-opened mouths [are]
of a perfect charm. He is inimitable.' For
Delacroix in the 1820s, the British painter was a
master to be emulated, as he clearly attempted
in his portrait of *Louis-Auguste Schwiter*
(no.52). His 1829 essay on Lawrence remains
one of the most enthusiastic tributes to an artist
by a contemporary. PN

106
Henri Decaisne (1779–1852)
La Malibran as Desdemona 1830

Oil on canvas
138 x 105 (54½ x 41½)
References: Jal, 1831, pp.107, 194–9;
Lenormant, 1831, p.60; Planche, *Salon* 1831,
p.38; Delécluze, 1831 (7 May 1831), p.2, and
1833 (2 May 1833), p.1.
Paris, Musée Carnavalet, Histoire de Paris
Minneapolis and New York only

Of the French portraitists who came under Lawrence's spell in the 1820s, Decaisne was the most gifted. His varied interests included historical and literary subjects often drawn from British sources, melodramatic genre and portraiture. His style could approach that of David and then veer unexpectedly towards William Etty, without loss of power or individuality, undoubtedly a benefit of having studied with both Girodet and Gros in Paris. His sitter for this portrait, Maria Malibran Garcia (1808–36), was one of France's most celebrated mezzo-sopranos. He has portrayed her in the role of Desdemona in Rossini's operatic adaptation of Shakespeare's *Othello*, which she had made her own as early as 1825. In February 1829, the *Literary Gazette* reported from Paris that since Malibran had succeeded in insulting all the English ladies in that city by performing a concert that lampooned British

singing, there would be attempts to bar her from the London Opera houses. Nevertheless, she triumphed as Desdemona at the King's Theatre, London, in April. Prince Pückler, who saw her perform in January, wrote that 'her style of singing appeared to me quite American – that is, free, daring and republican' (*Tour*, II, p.295).

Decaisne sent this portrait to the Royal Academy in 1830, the year of Lawrence's death, and to the Paris Salon in 1831. Etienne Delécluze, Auguste Jal and Charles Lenormant all criticised his predilection for Lawrence's broad facture, although they admired the likeness. PN

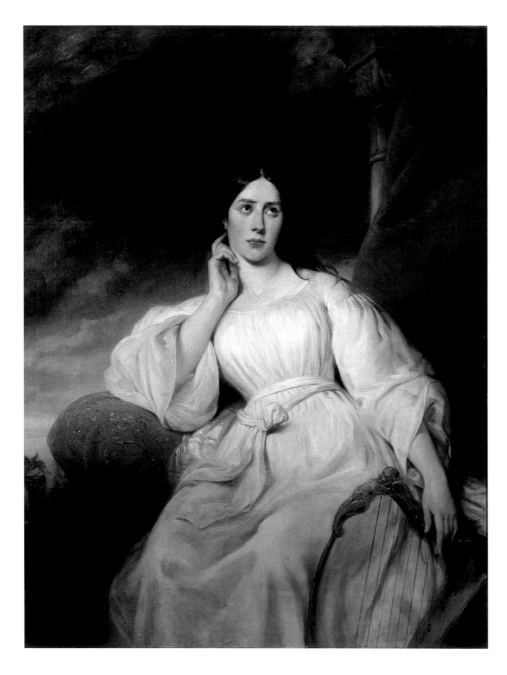

107
George Hayter (1792–1871)
Portrait of Lady Caroline Montagu
1831

Oil on canvas
196.2 x 146.7 (77¼ x 57¾)
Signed and dated 1831
Elvehjem Museum of Art, University of
Wisconsin-Madison, Evjue Foundation
Grant purchase in honor of Mrs. Frederick
W. Miller, 1993
London only

Caroline Montagu was the daughter of William, Fifth Duke of Manchester. In 1828, she married John James Calcraft, MP for Wareham, Dorset. She appears to have posed for this portrait in the guise of some literary or dramatic persona, as her costume is a *mélange* of fashionable British evening dress and the gaily coloured aprons and head veils of Neapolitan peasants. The surrounding terrain and accoutrements have domestic and piratical associations, and while it is not an identification without inconsistencies, we here propose that the sitter elected to have herself represented as Haidée, the tragic lover in Byron's epic satire *Don Juan*. Canto II, which recounts Don Juan's horrific shipwreck, episodes of cannibalism, and his eventual resuscitation on a craggy Aegean island by a beautiful pirate's daughter, was published in 1819, the year that Géricault exhibited *The Raft of the Medusa*. Stanzas one

hundred to one hundred and thirty describe Haidée in minute detail as the 'lady of the cave', with her 'many-coloured, finely spun' dress and her resplendent jewellery. Lady Caroline's costume and the figures in the background also recall the many popular genre paintings of Italian peasants and brigands that littered the walls of the Louvre and the Royal Academy during the 1820s and guaranteed the fortunes of such painters as Léopold Robert and Charles Eastlake (no.136).

Hayter, born into a family of portraitists, studied at the Royal Academy from 1808. After a stint in Italy from 1815 to 1819, history painting and portraiture in oils became his *métier*. Among the principal pictures of this period was his *Banditti of Kurdistan Assisting Georgians in Carrying off Circassian Women* (lost), a thoroughly French romantic conception possibly inspired by Colin's *Episode from the Present War in Greece* (1826) or similar modern images of Eastern rapine that Hayter would have admired at the Galerie Lebrun in 1826, as he passed through Paris en route to Italy. He unsuccessfully attempted to raffle that picture in Paris in 1828 before sending it to the British Institution in 1829. Hayter remained in Paris until July 1831, painting portraits of the French and British nobility. He exhibited at least five portraits at the 1831 Salon, although *Lady Caroline Montagu* does not appear to have been one of them. It was probably commissioned after his return to London that autumn. In 1838 Hayter became Portrait and Historical Painter to Queen Victoria.

With regard to the 1831 Salon portraitists, Hayter, Decaisne and Charles-Emile Champmartin were clearly competing for the title of Lawrence's successor. The critic for *L'Artiste* (1831, p.216) was surprisingly acrimonious, describing Decaisne as an excellent imitator, but Hayter a mere victim, of Lawrence's manner. PN

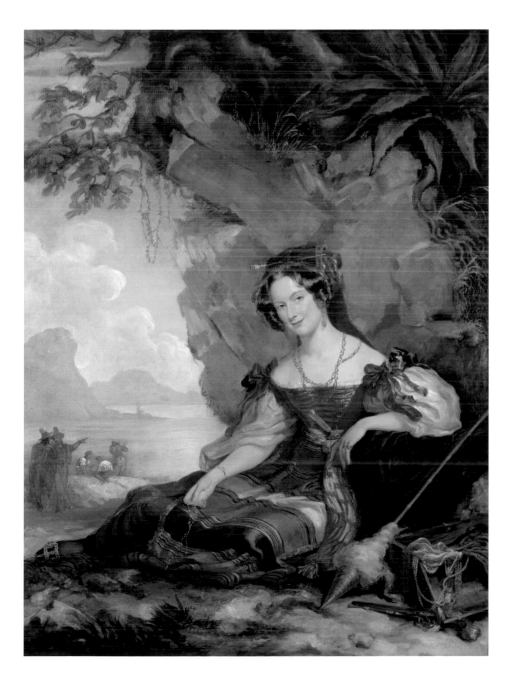

'The Finest Poetic Descriptions': *Landscape Painting in France and Great Britain*

Patrick Noon

It is not certainly without a feeling of mortification, that I thus proclaim the superiority of the English landscape painters over ours. But I do not doubt that our artists will sooner or later feel convinced of the necessity of copying nature rather than models. To produce varied and powerful effects of perspective and of light and shade, while at the same time due attention is paid to the minutest details, appears to be the secret of the English landscape painters. The eye dwells for a moment on the foregrounds of their pictures, which are finished with clearness and delicacy, without being laboured; but the wonderful effects of their distances and skies rivet attention, and seem to realise the finest poetic descriptions.

Thus was the opinion voiced by Amadée Pichot in his widely respected *Historical and Literary Tour of a Foreigner in England and Scotland* of 1825.[1] This assiduous translator of Byron and Walter Scott had an intimate knowledge of British art and a profound appreciation for its painters, especially J.M.W. Turner, whose technical inventions he admired and seems to be describing with concision. Théodore Géricault had expressed a similar admiration for John Constable's *The Hay Wain* and, in general, few on either side of the Channel would dispute the originality of the British school and the marked divergence of its aims from those of the more codified French approach to landscape. Since the preponderance of paintings exhibited by British artists in France were landscapes, the question arises as to what extent and in what fashion did British landscape practice, highly sophisticated by the time of the Restoration, influence the course of French painting during and after the 1820s. What, indeed, did the critic Gustave Planche mean when he declared in 1831: 'The old [French] landscape school is battered and ruined beyond recovery ... Landscape now aspires to a high, vague, but real and natural poetry: its will, its power, the means it employs are those of the Lake School, of Wordsworth and Coleridge.'[2]

The testimony of seminal artists offers a logical place to begin any analysis. Delacroix's first response to Constable and his consequent reworking of the background of his *Massacres at Chios* in 1824 are legendary.[3] 'Constable and Turner', he wrote to the critic Théophile Silvestre in 1858, 'were veritable reformers ... Our school greatly profited from their example'.[4] Camille Corot in later life admitted that his encounters in 1821, when still a draper's apprentice, with Bonington's river landscapes in the window of a Paris gallery were at least an inspirational if not a formative influence:

No one thought of landscape painting in those days; ... the artist had captured for the first time the effects that had always touched me when I discovered them in nature and that were rarely painted. I was astonished. His small picture was for me a revelation. I discerned its sincerity and from that day I was firm in my resolution to become a painter.[5]

The technique of British painters fascinated Delacroix, whereas Corot sought to emulate their sentiment. On the other hand, Paul Huet's biographer and son, René-Paul, and Gustave Planche campaigned for decades to discredit the prevailing opinion that Huet's art was shaped by Bonington, Constable or Turner, despite the artist's own admission that it was British painting which first showed him how to merge his innate naturalistic vision and the poetry of the old masters. Late in life he recollected copying merely two British pictures, Constable's *The Hay Wain* and an unidentified Bonington landscape. Yet evidence of his very numerous copies after British artists contradicts these claims and confirms a level of engagement that might only be expected during this decade of great ferment. Although many did not actually visit Britain until much later, Huet and his French contemporaries were thoroughly versed in the styles of its best landscape painters, either from first-hand examination of pictures exhibited in Paris, from descriptions furnished by friends who had visited London, or from the

fig. 52

fig. 53

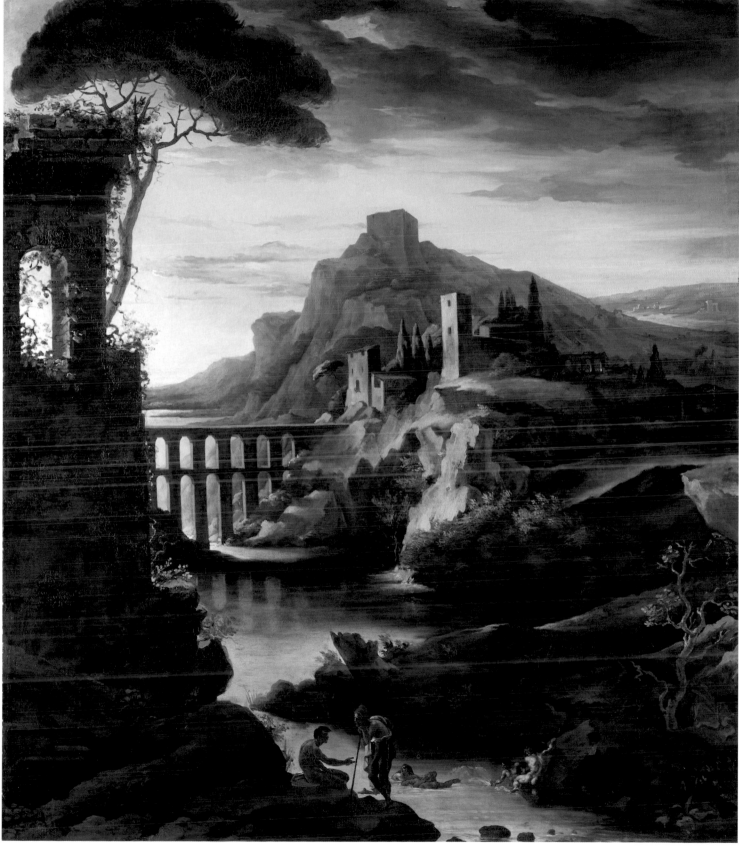

many engravings after Turner and others extensively circulated in France. Huet bluntly conceded the impact of Constable's 1824 Salon appearance on their earliest reflections:

It was the first time perhaps that one felt the freshness, that one saw a luxuriant, verdant nature, without blackness, crudity or mannerisms. A cottage half hidden in the shade of beautiful and fresh trees, a limpid brook traversed at a ford by a wagon, the countryside of London humid with English atmosphere.[6]

Huet's pivotal first masterpiece of 1826, *Caretaker's Cottage in the Forest of Compiègne* (no. 115), while decidedly a work of his and not Constable's or Bonington's genius, nevertheless is almost inconceivable without their example, both for its character and its technique.

Adolphe Thiers would claim in 1824 that the French were feeble landscape painters because they were inept at genres that required 'an honest and spontaneous copying from nature without attempts to embellish it'. They were never content to paint their own skies but always looked to Italy: 'We go there, spend months, and return to produce false and insignificant souvenirs … the British don't dream of a better world, they copy what they see and paint the truth.'[7] For the majority of French critics, nature had to be artificially posed to accommodate an elevated subject from mythology, literature or nature, the last being without exception an Italian site. Even Stendhal would have preferred to see Constable apply his magic to a majestic Alpine view rather than a hay cart and brook, while Delécluze deplored the indecorous still life of fish in the foreground of Bonington's truly magical *A Fishmarket Near Boulogne* (no.7).

Plein-air sketching, part of every French painter's regime (nos.108–110), encouraged spontaneity and careful observation of natural light and colour, but these qualities often disappeared in final studio productions, when prescribed rules of composition obtruded – planar would replace atmospheric recession, detail upon detail pervaded every inch of the finish, and skies were schematised according to set formulae. The autobiographical immediacy of the direct response to nature was diminished so as to sustain the traditional relationship between the sketch and the finished picture as a staged process that would guarantee both mediation of the experience and the probity of diligent application. The *paysage historique*, perfected in the eighteenth century by Pierre-Henri Valenciennes, ossified in the vision of his immediate heirs, those capable but long forgotten academics like Jean-Victor Bertin, Pierre Chauvin and Antoine-Félix Boisselier (no.137). If their works expressed a poetic sentiment, it derived not from nature, but from a venerated archetype. The rules governing the prestigious Prix de Rome competition, extended to include landscape in 1817, further institutionalised such values and

expectations. At the very moment that naturalism was in the ascendance, the notion that a student should paint a tree from memory or compose a landscape scene of Greece or Italy, two places he had probably never visited, rather than transcribing actual experiences of nature, has impressed many observers, then and now, with its absurdity; however, memory, tradition and craftsmanship, not empiricism, were the aims of the French pedagogic machine. As Gros conceded, his job was to prepare students for a competition that cherished inflexible rules and conformity of purpose. Only Géricault, in an uncharacteristic foray into monumental decorative landscape (fig.53), briefly reclaimed the gravity and originality of the classical tradition.

The objective of British naturalism was a scrupulous fidelity to observable, often commonplace phenomena, like the dissolution of distant objects shrouded in mist or a meadow steeped in the sultry humidity of a summer's day. More important, it aimed to maintain the illusion of *unmediated* transcription in the finished work as much as possible. As one French observer said admiringly of Constable, 'he only wanted to be natural … to realise, not counterfeit, a site'.[8] The objective of such 'realising' was ultimately to engage the spectator's fancy in a manner consistent with that extolled by William Hazlitt, when he observed somewhat poetically of a real circumstance in his essay *Why Distant Objects Please*: 'Where the landscape fades from the dull sight, we fill the thin, viewless space with shapes of unknown good, and tinge the hazy prospect with hopes and wishes and more charming fears.'[9] Consciously or not, he was paraphrasing Denis Diderot who had written a generation earlier, specifically with regard to painting, that beautiful sketches were more pleasing than laboured pictures because they were indeterminate, springing from passionate inspiration yet exciting a child-like reverie. But the French position by 1814 was reactionary. Reviewing a picture by the British artist John Glover then exhibiting at the Salon, *Paysage composé, des bergers en repose*, which Glover purportedly painted in the Louvre under the inspiration of Claude, the critic Delpech attacked his use of atmospheric perspective as 'a mere artifice for dispensing with the precise and pure rendering of form'.[10] Again, it was the process rather than the overall effect that counted, and there is little poetry in process.

Startling as such a notion might be to an 1820s Parisian, British painters reasserted the importance of individual subjectivity as the new criterion for judging landscape art. They troubled their French colleagues, or so it seemed, to leave everything to chance, when the bedrock of Neoclassical theory had been the belief that the idealised and completely legible elements in a landscape should be disposed with calculation and not by the fortuitous movements of the brush. The new naturalism of Wordsworth's generation,

recognised by Pichot and Planche, called for a dynamic interaction between an individual mind and an observable but protean world. It was at once more scientific and more sensate. While it was the duty of the modern artist to mirror the natural world, the *poetry* of landscape painting as a high art resided more significantly in the artist's ability to communicate subjective impressions before those phenomena, however trivial or sublime they might be. That a landscape description of any mundane site could be a vehicle of profound sentiment because an artist willed it so was anathema to French academic thinking, but precisely the lesson absorbed by her youngest painters as a consequence of their encounters with British painting and poetry. Although most of the works in this section were chosen for their stylistic affinities, it would be misguided to seek a consensus of style among the artists of the two schools, because there is none within each school. Most French painters maturing in the 1820s tried their hand at aping the execution of Constable or Bonington, the latter probably more so because his bravura handling seduced by its deceptive air of improvisation. But the new generation of French artists rapidly developed their own modes of naturalistic imaging, often as original as their British models.

Finally, a growing receptivity among French audiences to a more compelling naturalism in their landscape paintings was not solely the result of increased familiarity with British easel pictures. It was undoubtedly abetted by the popular public entertainments that combined illusionistic painting with topography and dramatic special effects – the 'Amas', as one visitor to Paris dubbed the diorama, cosmorama and panorama. The panorama, of British invention, which surrounded the viewer with a three-hundred-and-sixty degree view of a city or landscape, had been popular in Paris since 1799 (fig.54). Even Delécluze was enchanted by its illusory 'dreamy horizons'.[11] It has been suggested that such spectacles forced the palettes, scale and execution of painters to extremes, but the evidence of such influence is difficult to quantify.[12] On the other hand, the crowded and gilded conditions under which pictures were exhibited in the major exhibitions at the Royal Academy and Paris Salon, and the need for paintings to be visually strident in order to attract notice, did affect the way pictures were conceived, presented and appreciated.

108
Achille-Etna Michallon
(1796–1822)
The Fallen Oak Branch,
Fontainebleau c.1816

Oil on canvas laid on card
41.9 x 52.1 (16½ x 20½)
Minneapolis Institute of Arts, The Margaret G.
Deal Fund and Gift of the Paintings Council

The tradition of landscape theory in France stipulated that an artist carefully study nature in its parts and details and then compose the elements into an idealised whole. This process of study and selection was meant to distil the most poetic and moral sentiments. Similar theory was familiar in Britain but rarely enforced with the rigour of French pedagogy. Michallon painted this study in the forest at Fontainebleau, probably as a preparatory exercise for his first major picture, *The Oak and the Reed* dated 1816 (Fitzwilliam), an illustration to a de La Fontaine fable. Such studies would also have primed him for the *Concours de l'arbre* segment of the important 1817 *Prix de Rome* competition, for which he submitted *A Woman Struck by Lightning* (Louvre). The last illustrated a passage in *The Seasons*, a celebrated work of the eighteenth-century Scottish poet James Thomson, which describes a figure crushed by a huge tree limb.

As a picturesque element, the blasted oak had a long pedigree in western painting.

This particular study might well illustrate an observation in Gérard de Lairesse's *Grand Livre des Peintres* (Paris, 1787), in which the author claimed that 'with a bit of twisted and gnarled oak trunk, I have all that is needed to compose the most beautiful setting imaginable, by adding to it only a slight, vague background'. Michallon's surviving oeuvre contains numerous tree studies, yet few have the scale and intensity of this tour de force of naturalistic observation. PN

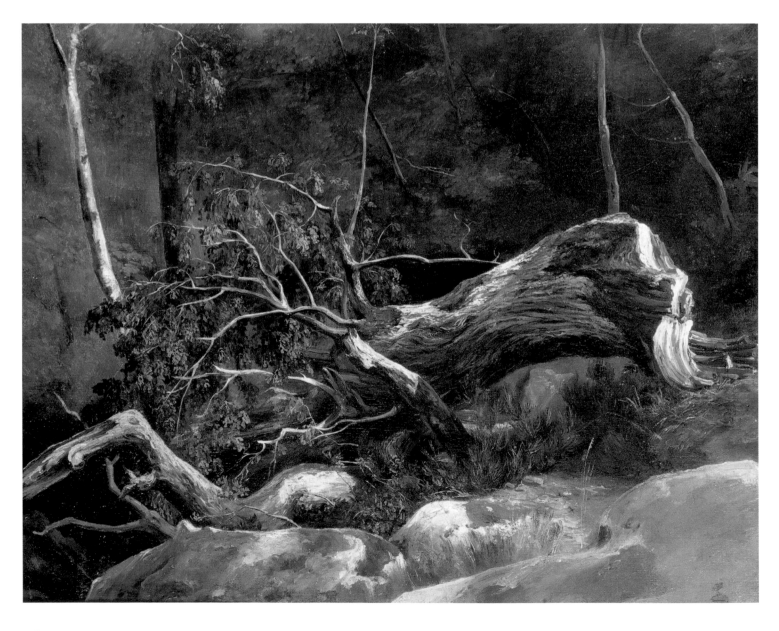

109

Augustin Enfantin (1793–1827)
An Artist Painting in the Forest of Fontainebleau c.1825

Oil on paper mounted on canvas
26.7 x 34.3 (10½ x 13½)
Inscribed on the verso: *Enfantin – l'artiste 1025*
Private Collection
Minneapolis and New York only

Enfantin was among a score of talented painters to die prematurely in the 1820s. The sale of his studio effects on 3 March 1828 was introduced by a meagre biographical note, signed 'P.E.', probably the informed testament of his brother, Barthélemy-Prosper. According to this source, Augustin studied with Jean-Victor Bertin, but he was ultimately self-taught. The earliest dated works are sepia sketches near Paris of 1821. Watercolours record a Normandy tour in 1823, possibly undertaken with Bonington. The following year, he painted at Fontainebleau and toured the Dauphiné in France and Switzerland. In the summer of 1825 he was in England with Delacroix and Bonington, where he mostly recorded the sites around London, including Hampstead Heath. Delacroix claims to have found him copying Constable, and indeed, lot 199 of the studio sale was an unfinished oil study after Constable titled *Environs de London*. Other works resulting from the English sojourn included an oil, *View of Richmond*, and a suite of six lithographs, *Facsimiles de Croquis faits en Angleterre* (1825).

The following year, the Auvergne was Enfantin's destination, while in 1827 he painted at Fontainebleau, before embarking for Naples. He died at Paestum in October from a fever. Several works were submitted on his behalf posthumously to the second instalment of the 1827 Paris Salon.

Enfantin's watercolour and sepia drawings are similar in style to Bonington's more circumscribed earlier work. His oil sketches, however, have the same fluid, but precise application of paint that one finds in Bonington's *plein-air* studies of 1825. Very few of the 135 oil sketches in the artist's sale are identified today, and undoubtedly most are masquerading under more commercial attributions. An *Ancienne Carrière à Montmartre*, very like Bonington in palette and touch but often attributed to Théodore Rousseau (Schulman, no.102), is unquestionably one such 'lost' work. PN

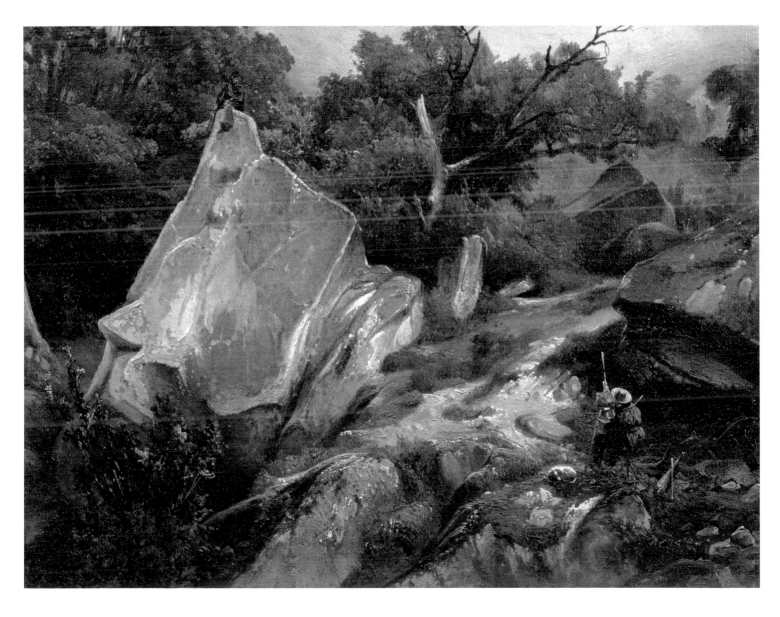

110

Richard Parkes Bonington
(1802–1828)
Near Rouen c.1825

Oil on millboard
27.9 x 33 (11 x 13)
The Metropolitan Museum of Art, New York.
Purchase, Gift of Joanne Toor Cummings, by
exchange, 2001

In August 1825, on the return leg of his first trip to London, Bonington toured the Normandy coast with Eugène Isabey as far as Trouville before returning to Paris. Later that autumn, he again ventured from Paris, this time in the company of Paul Huet, working at various sites in the environs of Rouen, Mantes and the château of the Duchesse de Berry at Rosny-sur-Seine. This sketch with Rouen in the distance dates to that tour. It was painted *en plein air* on a type of commercially prepared millboard that Bonington had discovered in London that summer and would insist on using whenever sketching out of doors. Conventional French practice was to sketch on paper pasted to a stretched canvas. This composition demonstrates strong affinities to the dense forest interiors near Compiègne that Huet favoured at this time. Bonington, however, is far less agitated in his touch. PN

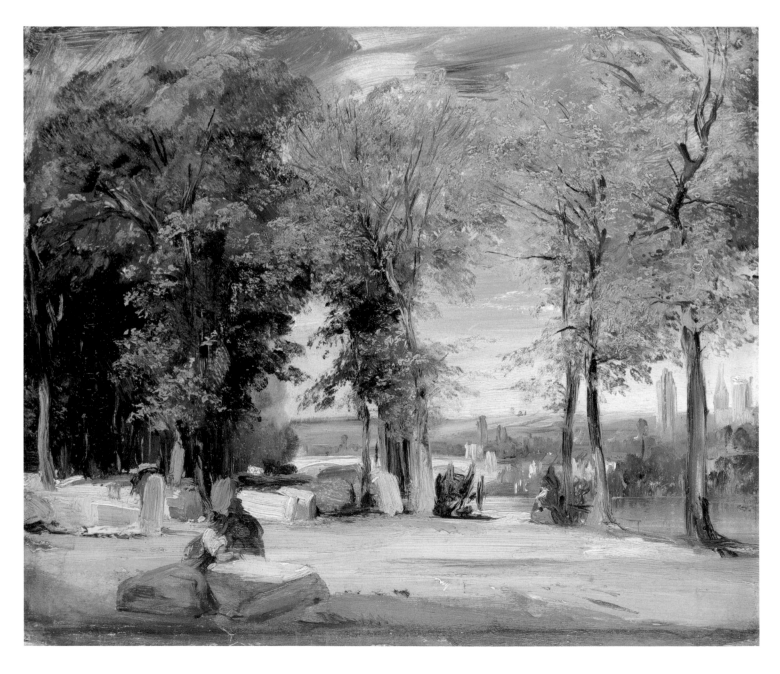

III

J.M.W. Turner (1775–1851)
*Rouen: A View from the Left Bank
in the Faubourg St.-Sever* ?1827–8

Oil on canvas
60.3 x 98.7 (23¾ x 38⅞)
Tate. Bequeathed by the artist 1856

fig.55
J.M.W. Turner
Harbour of Dieppe
1825
Oil on canvas
Frick Collection, New York

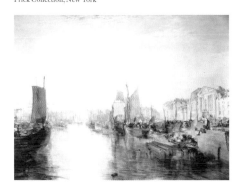

In his later decades, Turner became a frequent visitor to France, and French subjects appeared among his Royal Academy exhibits, as well as generating some of the most popular prints after his work. His grandest later painting of France, *Harbour of Dieppe (Changement de Domicile)* (fig.55) was exhibited in 1825, the year of Delacroix's and Bonington's visits to London. Based on a visit to the port at the end of a tour of the Meuse and Mosel rivers in 1824, its large size, subject and bilingual title might prompt speculation that Turner had thought of sending it to join other British pictures at the 1824 Salon. In the event, however, Turner did not contribute to the Salon. He also experimented with other French compositions which he did not finish. Long thought to be an Italian subject painted in Rome during Turner's second visit in 1828, this oil sketch has recently been identified by Ian Warrell as a view of Rouen (1999–2000, pp.28–30). Along with several other such sketches including one of Dieppe, all similarly identified as Italian or classical compositions for many years, it actually refers back to a visit to Paris in 1821, when Turner travelled to the capital from Dieppe via Rouen. This was his first visit to France post-Waterloo. Drawings of the scenery made that year provided the basis for these later oils, while their classical or pastoral character evokes pictures by Claude to which – having taken relatively little notice of them in 1802 – he

gave particular attention when he reached Paris and the Louvre. While there is no certain evidence for dating these oil studies of French subjects, their Claudean atmosphere may, as Warrell has further suggested, be an argument for placing them just before Turner's second Italian visit in 1828, painted in anticipation of the Roman landscape to come. It shows Turner ploughing a different furrow from the younger artists on both sides of the Channel, whose *Voyages pittoresques* were exploring the architectural or antiquarian character of French scenery.

Rouen, in particular, was newly appreciated for its wealth of medieval and Gothic buildings. While Turner made many drawings of these, here he loses the cathedral and other buildings in hazy light and focuses instead on the shady grass and avenues of trees of the Seine's south bank in the Faubourg St-Sever. The figures at their ease beneath the trees suggest a Jean-Antoine Watteau *fête galante* – probably another reason for dating the study near Turner's other Watteau paraphrases of the late 1820s (no.74). Turner's experimentation with Rouen subjects in oil may have been prompted by the exhibition of a diorama of the city by Charles-Marie Bouton in London in 1826, as well as by its popularity with British artists and travellers. DBB

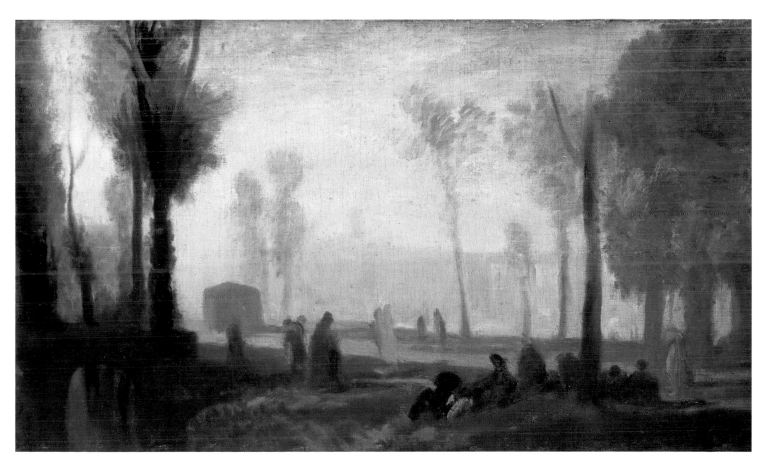

112
Richard Parkes Bonington
(1802–1828)
A Distant View of St-Omer c.1824

Oil on canvas
31.4 x 43.8 (12⅜ x 17¼)
Tate. Bequeathed by George Salting 1910

This picture represents a distant view of St-Omer from the Boulogne–Calais road, with the ecclesiastical monuments of the town punctuating the horizon. The cool tonality and vigorous brushwork typify the style evolved by Bonington during the first months of his residency at Dunkirk in 1824. Similar views appear frequently in Louis Francia's (no.143) work, and the two friends were undoubtedly much in each other's company this year.

Such Dutch-inspired town prospects figure prominently in Bonington's earliest exhibition and graphic works, and the inevitable comparison with the oils of Georges Michel (fig.56), who sought inspiration in like sources, is perhaps overplayed. It is unlikely that Bonington knew the senior French painter personally, whose style, at any rate, was more nostalgically rococo than naturalistic in its creamy application of paint. The earliest history of this oil is unrecorded, but a lithographic copy of 1851 published in Paris indicates that it belonged initially to a French collector. Ferdinand Victor Amedée, Comte de Faucigny-Lucinge (1789–1866), a central figure of the Bourbon restoration, owned a nearly identical version in sepia. PN

fig.56
Georges Michel
Landscape near Paris
c.1830
Oil on canvas
Cleveland Museum of Art

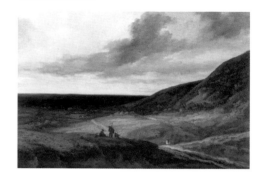

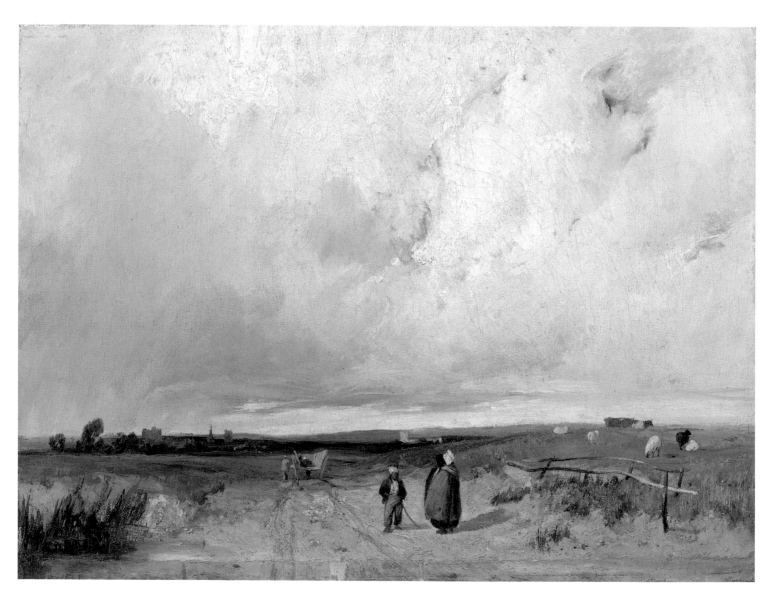

113

Théodore Rousseau (1812–1867)
View Towards Saint-Ouen from Batignolles c.1828

Oil on paper on canvas
23.2 x 40.6 (9⅛ x 16)
Signed, lower left: *T.H. Rousseau*
The Metropolitan Museum of Art, New York.
The Friedsam Collection, Bequest of Michael
Friedsam, 1931

After painting from nature a small oil of the *Telegraph Station at Montmartre* (Boulogne) about 1826, Rousseau was permitted by his parents to enrol in the atelier of Jean-Charles Rémond and to study also with the history painter Guillaume Guillon-Lethière. Rémond had just returned from Italy where he had been studying since 1821. Rousseau would have little sympathy for Rémond's academic aesthetic, but his oil sketches, especially those executed from nature in the Auvergne during an extended visit to the region in 1830, are often indistinguishable in style from his teacher's Italian sketches. Rousseau abandoned his quest for the Prix de Rome in 1829 and devoted himself to the study of the French countryside. By the mid-1830s, his name would become synonymous with the forest of Fontainebleau and the seditious landscape artists of the Barbizon school.

Sterling and Salinger (1966) dated this small jewel painted in the suburbs of Paris to about 1830, while Schulman assigned it inexplicably to *c.*1832–4. Herbert (1962) has argued for an even earlier date of *c.*1828, which is the most credible on the stylistic evidence. It exhibits the precise touch of the Boulogne *Telegraph Station* but a more advanced richness in the impasto. The broad, but opaque and chalky, colouration of the sky proclaims its indebtedness to Salomon van Ruysdael and other Dutch paintings in the Louvre, which

Rousseau was constantly copying in the late 1820s. That feature is slightly inconsistent with the luminous foreground, which is Constable-inspired and probably painted out of doors. PN

114
John Constable (1776–1837)
Branch Hill Pond, Hampstead Heath 1825

Oil on canvas
62.2 x 78.1 (24½ x 30¾)
Virginia Museum of Fine Arts, Richmond, The Adolph D. and Wilkins C. Wilkins Collection

Hampstead, on the northwestern outskirts of London, was a haunt for authors and artists seeking the solitude of the country but with ready access to the city. Its counterpart in Paris was Montmartre, where Vernet, Géricault and eventually Bonington sought refuge. From 1819 to 1826, Constable rented summer accommodation in Hampstead, where he was able to revive a programme of *plein-air* study. His earliest dated oil of a Hampstead scene is a sketch of October 1819, similar in composition to the present picture.

This oil is an exact replica of a painting in the Oscar Reinhart Museum that had been commissioned by Claude Schroth and sent to Paris in December 1824. Constable wrote to his friend Archdeacon John Fisher: 'I have painted two of my best landscapes for Mr Schroth. They will soon go, but I have copied them, so that it is immaterial which is sent away.' The two versions are indeed virtually identical. This one was purchased from the artist by his patron Francis Darby in 1825. *Branch Hill Pond, Hampstead Heath* was among the landscapes praised by Comte Auguste de Forbin and undoubtedly seen by a host of French painters, despite the fact that it, and its pendant *Child's Hill: Harrow in the Distance* (Private), had arrived too late for inclusion in the Salon.

In April 1825 the Prince de Polignac, French ambassador to Britain, presented Constable with the gold medal he had been awarded by Charles X. Several weeks later Schroth sent Constable a letter claiming that his pictures were much admired, more so even than the Salon paintings, because their smaller size made them 'seem more highly finished'. He then offered the artist advice on the three new works being painted for him: 'Please render your skies very simply, your foreground as detailed as possible; in general, Paris collectors love to see highly finished the things that appear immediately to their eyes, also foregrounds expressing the sentiment of a Wynants call forth their admiration.' British critics were no less demanding on this score. Of the *View on the Stour* (no.5), one commentator wished that 'more attention were paid to the individuality of his plants and foliage in the foreground' (*Literary Gazette*, 8 June 1822, p.361).

Constable exhibited this version at the Royal Academy in 1825, where it also would have been studied closely by the many French artists visiting London that summer. It was possibly this very painting that Delacroix found Augustin Enfantin 'busy copying' when he arrived in London. PN

115
Paul Huet (1803–1869)
*The Caretaker's Cottage in the
Forest of Compiègne* 1826

Oil on canvas
116 x 148 (45½ x 58¼)
Signed and dated, lower right: *Paul Huet 1826*
Minneapolis Institute of Arts, The John R. Van
Derlip Fund, by exchange

The argument that Huet and his British
contemporaries were evolving independently
in parallel courses from common inspiration in
Dutch and Flemish sources is insupportable on
the existing evidence. They were indeed
investigating similar traditions of landscape
painting, but they were thoroughly familiar
with each other's interests and innovations.
This painting is Huet's most ambitious early
work and a *mélange* of the different styles that
vied for his attention at this moment. His
passion for Watteau and Rubens may account
for some aspects of the brushstroke and palette;
yet those influences are expertly tempered by a
naturalism of observed light and detail deriving
from a profound appreciation of the Constables
exhibited in Paris two years earlier as well as his
own work from nature. The treatment of the
foreground is a mirror of Constable's technique
in his *View on the Stour* (no.5), but there is a
vivacity and daring in the application of the
paint across the entire surface of the canvas
that has more in common with Bonington.

The subject has a distant relative in
Rembrandt's *Cottage with White Paling*, of
which Bonington painted an improvisation in
oils that Huet copied faithfully in 1825-6
(fig.52). Jacob van Ruisdael and Meindert
Hobbema are other conspicuous sources. A
number of similar subjects by Huet, in a variety
of media, are known, yet this is the only one
identifiable with a specific site, the royal
hunting preserve at Compiègne. This picture
does not appear to have been exhibited by Huet
in his lifetime, but it was the source for one of
Huet's more ambitious prints in the series *Six
Etchings* (1833). PN

116
Richard Parkes Bonington
(1802–1828)
View on the Seine c.1825

Oil on millboard
30.5 x 40 (12 x 15¾)
Virginia Museum of Fine Arts, Richmond, Gift
of Mrs. Lincoln Davies in memory of her son,
George Cole Scott

Immediately following Bonington's London visit in 1825, his landscapes became both more varied in subject and more complex in technique. The tranquil marines that had been his mainstay yielded to serene canal and river views along the lower reaches of the Seine. The shift in subject matter may owe something to his growing friendship with Huet and to his continuing investigations of Dutch landscape paintings in the Louvre, but the *contre-jour* effects, the sinuous trees with feathered crowns, and the dramatic chiaroscuro and colouring of these river views are primarily a consequence of his first encounter with Turner's oils and watercolours. Prior to this, Turner's work was known in France through engravings. The impact of Bonington's free interpretations of Turner's style on his French contemporaries and on the subsequent development of French landscape painting has been underestimated. The most ambitious of these river scenes, *Near Mantes* (fig.57), may provide a clue as to their general locale. Baron Charles Rivet's nearby château was a frequent

retreat for Bonington and his friends on their numerous sketching expeditions.

Prince Anatole Demidoff amassed one of the most extraordinary collections of pictures and decorative arts of all periods. With a vast inherited fortune, he began collecting in 1834, purchasing, together with this Bonington, Delaroche's *Lady Jane Grey* (no.55). PN

fig.57
Richard Parkes Bonington
Near Mantes
1826
Oil on canvas
Taft Museum of Art, Cincinnati,
Ohio

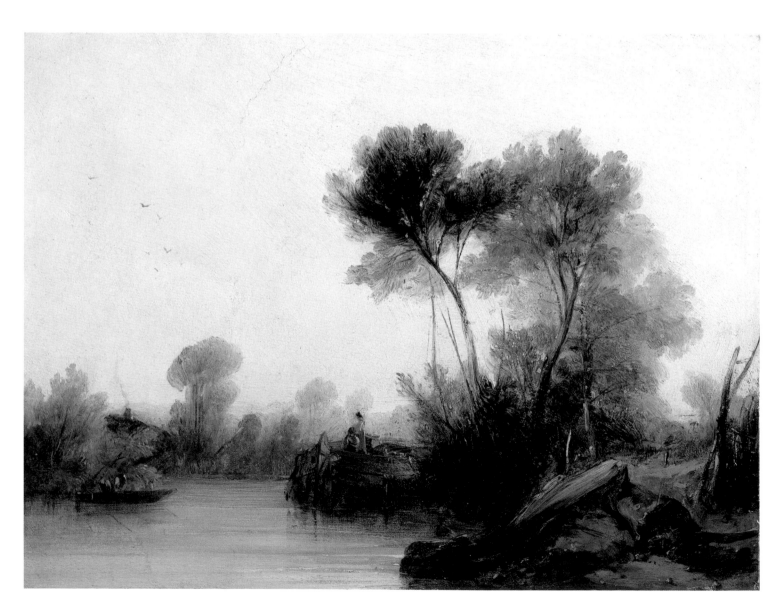

117
Théodore Rousseau (1812–1867)
The Old Park at Saint-Cloud
*c.*1831

Oil on canvas
66.6 x 82.5 (25½ x 31⅞)
Signed, lower right: *TH. Rousseau*
National Gallery of Canada, Ottawa. Purchased
1977

Michel Schulman has dated this picture 1831, the year that Rousseau first exhibited at the Salon. Ambitious in scale, it is also substantially different in style from the other two sketches by this artist in our exhibition (nos.113, 118). The brushwork is exceptionally vigorous but controlled, and the exploration of natural light both complex and subtle. The overall impression is that Rousseau was coming to terms in this essay, which he probably viewed as a finished picture, with both Constable's seemingly scientific observation and Bonington's unperturbed bravura or, more precisely, with Paul Huet's interpretation of Bonington's style. This would support Schulman's dating, as Rousseau met Huet at Honfleur that year and probably also sketched with him at Saint-Cloud, which was one of Huet's favorite haunts. That the picture was executed almost entirely *en plein air* seems highly probable, as large areas are thinly painted over loose graphite underdrawing,

and the artist's touch has the immediacy of a sensation transcribed instinctively. The mature Rousseau's favourite organisational device of silhouetting the skeletal pattern of tree limbs against bright sky is already evident in this early work and probably derives from Huet.

Rousseau developed rapidly in the 1830s, attracting the notice of both influential critics and adventurous collectors. He eventually eclipsed Huet as the head of the new school, yet he very much persisted in Huet's path – through the gradual refinement of an almost tortuously complex technique – of attempting to reconcile outdoor observation and a personal meditated response. Through the 1840s he was consistently rejected from the Salons and forced to rely on friends like Ary Scheffer and Jules Dupré and the new generation of dealers that included Paul Durand-Ruel and Susse for the exhibition of his paintings. PN

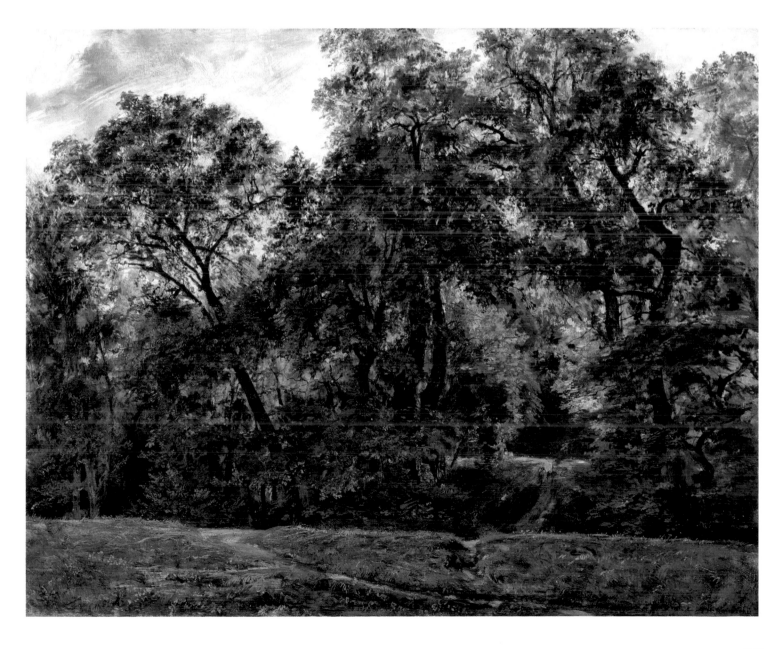

118

Théodore Rousseau (1812–1867)
Les Gorges du Bout du Monde,
Thiers, Auvergne 1830

Oil on paper on canvas
31 x 37 (12¼ x 14¾)
Signed lower left: *TH. Rousseau*
National Gallery of Art, Washington, Chester
Dale Fund

Rousseau first exhibited at the Salon in 1831 with a view titled *Site d'Auvergne*. Having renounced the Paris establishment, he toured the Auvergne in 1830, an area previously explored to good effect by Michallon and ironically promoted in 1822 by Rousseau's future nemesis Etienne Delécluze as a perfectly acceptable substitute for Italy to study landscape. An impressive number of oil sketches from this campaign have survived.

Despite scholarly disagreement, the most likely candidate for identification with Rousseau's first Salon picture is the large oil now in Rotterdam generally referred to as *Hilly Landscape with an Angler* of 1831 (fig.58). It is a 'composed landscape', probably conceived as a sop to academic expectations. The hues of the Rotterdam picture are muted, in a Dutch fashion, and reminiscent of Georges Michel; the lighting and the bridge in the middle distance struggle at a Claudian effect; the

brushwork, which one critic described as tormented, and the entire forced 'poetic' mood are surely indebted to Huet, although the introduction of a wading fisherman in the foreground is very Turnerian and engravings after the British artist are another probable influence. Whatever the pictorial archetypes, the individual motifs, such as the bridge and hillocks, derive from sketches painted on site, such as this example. This particular sketch also relates to Huet's lithograph *Pont dans les bois* (1831) and his etching *Pont en Auvergne* (1834). Rousseau's Auvergne sketches were much admired by Ary Scheffer, who arranged for their exhibition in his studio. PN

fig.58
Théodore Rousseau
Hilly Landscape with an Angler
1831
Oil on canvas
Museum Boijmans Van Beuningen,
Rotterdam

119
Narcisse Diaz (1807–1876)
Showers c.1830

Oil on panel
27 x 40.3 (10⅝ x 15⅞)
Stamped in red, lower left: *Vente/Diaz*
Private Collection
Minneapolis and New York only

Like his friend Jules Dupré and many other French landscape painters of this time, Diaz decorated porcelain before turning to oil painting about 1830. He submitted to the 1831 Salon four landscape sketches similar in dimensions to the present example, all of which were rejected. This endeared him to other *refusées* like Huet and Alexandre-Gabriel Decamps. He was subsequently a regular contributor to the Salons, his repertoire comprising mostly literary and troubadour subjects in landscape settings derived from his studies at Fontainebleau. He became the darling of the literary set, especially with Théophile Gautier, but this has unfortunately clouded his originality as a painter, which was to temper the burgeoning taste for rococo flamboyance with a more sensible naturalism.

The present sketch, which is so reminiscent of Constable's similar *plein-air* exercises, may date to just after his 1834 London visit, but it might just as reasonably be one of the rejected sketches of 1831, since Constable's example was abundantly in evidence in Paris from 1824. PN

120

John Crome (1768–1821)
The River Wensum, Norwich c.1814

Oil on panel
36.8 x 48.3 (14½ x 19)
Yale Center for British Art, Paul Mellon
Collection

During his visit to Paris in 1814, Crome deposited one painting for exhibition in the Salon, a *View near Norwich*. There are no descriptions of this picture, nor can it be identified by any other records; however, it is likely to have been painted about the time of *The River Wensum, Norwich*, in which the treatment of the foliage and sky is similar to that in one of the paintings resulting immediately from his visit, *Paris – Italian Boulevard* (no.3). Two other Continental views were products of this tour, including a *Fishmarket, Boulogne* of 1820 (Norwich), which exhibits striking if coincidental similarities to Bonington's 1824 Salon picture of a similar title (no.7).

The River Wensum, Norwich relates to a series of Crome cityscapes of the 1810s that explore various picturesque aspects of the New Mills, or water pumping stations, on the River Wensum. Two etched views by Crome of the back and front of the New Mills, dated 1812 and 1813 respectively, are similar in feel to this picture which, more so than the other views in the series, also proclaims its indebtedness to

Meindert Hobbema. With its brighter colour, its more naturalistic atmospheric perspective, and its incidental details from contemporary life, this oil is precisely the type of masterly adaptation of the Dutch tradition that younger French realists like Michallon and Huet would have found instructive. PN

121

Jules Dupré (1811–1889)
The Pond 1837

Oil on canvas
54.5 x 74 (21½ x 29⅛)
Signed and dated, lower left: *J. Dupre 1837*
Private Collection

Like many of the other French landscape painters who rose to prominence at mid-century, Dupré began his career painting porcelain. His first Salon appearance in 1831 featured three forest interiors. His preferred regions were Limousin, Berry and Normandy. With the support of an English collector, Lord Graves, he travelled to London, where he studied at the National Gallery and sketched at Southampton and Plymouth. The date for this trip is variously given as either 1832 or 1834, and Pierre Miquel further claimed that he was especially impressed by the work of Crome (*Paysage*, 2, p. 362). The most important picture to result from this stay, *Near Southampton* (Private Collection), was shown at the 1835 Salon. His closest friends at this time were Decamps, Rousseau and Lami. His fondness for subjects of cottages nestled in woods indicates a profound appreciation for Huet and Rembrandt, whom he ranked with Claude and Géricault in the pantheon of his models. Always associated with the Barbizon School, he actually spent little time at Fontainebleau, but in the 1840s he often worked with Rousseau in the south of France. Like Rousseau and Huet, he became increasingly romantic in his treatment of landscape after 1840, virtually abandoning his earliest practice of direct study from nature in favour of improvisations.

Rousseau once claimed that he learned composition from Dupré, while the latter moved closer to Rousseau's manner of applying paint in the 1840s. This picture has several of the features typical of Dupré's orchestrated arrangements, but unusual for the artist is the high horizon line, which suggests that this is a view of an actual pasture in Limousin. At this date, the painstaking precision of touch and the enchanting light that saturates the scene probably derive from a renewed interest in mastering Claude's genius and not the tight, dotted brushwork of Rousseau. Decamps's style is very much in evidence in the treatment of the sky, as might be Crome's in the foliage. *The Pond* also has the freshness of a landscape worked, at least in part, from nature. PN

122

Paul Huet (1803–1869)
The Harvest c.1835

Oil on canvas
64 x 80 (25¼ x 31½)
Signed, lower right: *Paul Huet*
Fondation Aetas Aurea, Liechtenstein

Huet's debt to Constable in this harvest scene is conspicuous, from its staccato impasting of rich pigments to its mode of composition and studied sky. Constable's *Cornfield* of 1826 (fig.12), which Huet would have seen at the 1827 Salon, is a possible source of inspiration, although *The Harvest* is likely to be later in date. The stimulus for this uncharacteristically fresh subject, which is neither mysterious nor tormented, might have been the appearance in London and Paris of David Lucas's mezzotints for Constable's *English Landscape* between 1830 and 1833, with such compositions as *A Summerland*. Lucas's mezzotint of the *Cornfield* also appeared in 1834. Gustave Planche would protest in 1836 that 'the atelier hoppers, familiar with the work of Constable and Turner through engravings, go hoarse crying that Paul Huet proceeds from the English school; we won't trouble them in their naïve belief'. Nevertheless, an oil painting in the Snite Museum, Illinois, attributed with

some authority to Huet, conscientiously copies Lucas's mezzotint of *Hadleigh Castle*, confirming that the French artist was indeed aware of the Lucas/Constable project. Lucas had been the apprentice of S.W. Reynolds, who was, after Bonington, Huet's closest friend among the British school.

The château in the distance is possibly that of the Duchesse de Berry at Rosny-sur-Seine near Mantes, a haven for artists and writers from 1818 until the Duchesse's flight to England in 1830. Huet and Bonington painted there together in 1825, and it was undoubtedly a site frequented by Huet on his regular trips to Rouen in the mid-1830s. PN

123

Jules Dupré (1811–1889)
The Estuary Farm c.1831–4

Oil on canvas
34.9 x 47 (13¾ x 18½)
Signed, lower right: *J. Dupre*
The Art Institute of Chicago, Anonymous
restricted gift in honor of John Gedo

Of the so-called 'School of 1830', the artists who rose to prominence as landscape painters during the July Monarchy, Dupré was unquestionably the most receptive to British influences. This is often attributed to his London visit in 1834, but there existed opportunities in Paris to examine pictures by British artists, especially Bonington, whose *Near Mantes* (fig.57) anticipates one of Dupré's favourite formulas. This complicates the dating of a *plein-air* sketch like *The Estuary Farm*, which closely mimics the style Bonington employed in his most relaxed sketches. The tonal range, the thick, wet-on-wet application of paint and the brilliant transcription of observed natural light owe much to both Bonington and Huet, but the serene construction of this composition, with its low horizon and trees carefully arranged against a dominant sky, is pure Bonington. It is also virtually identical in style to a picture identified by Dupré as *A View Taken in England* in the Salon of 1836 and in a lithograph for *L'Artiste*. It is uncertain whether that painting was executed in England or simply based on a sketch from the earlier visit.

The critics were hostile to a man to that picture, objecting especially to the same vigorous and broad application of thick paint that enlivens *The Estuary Farm*. PN

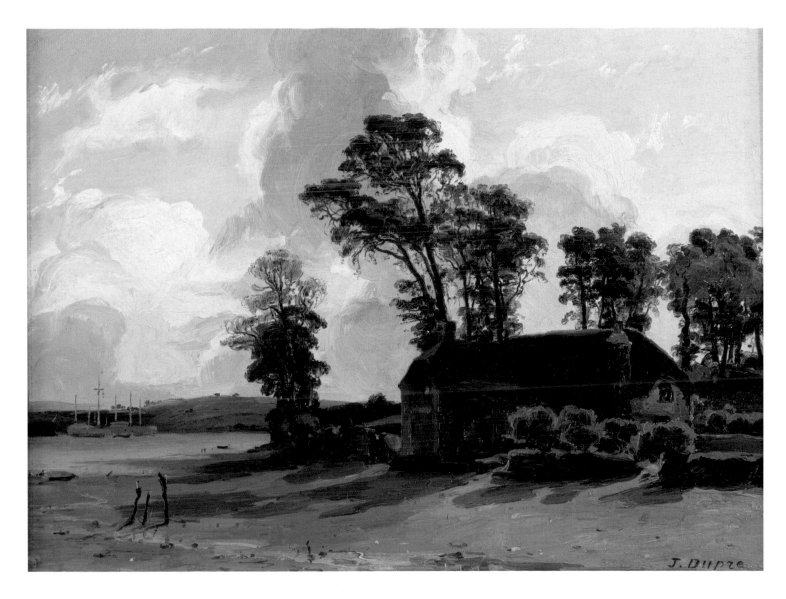

124
Augustus Wall Callcott
(1779–1844)
Littlehampton Pier 1811–12

Oil on canvas
106.7 x 141 (42 x 55½)
Tate. Presented by Robert Vernon 1847
London only

During his lifetime, Callcott was regarded as one of the leading British artists, a serious rival to Turner, who was a close friend. Callcott's reputation was first made in the early years of the century, with landscapes and marines broadly in the classical or picturesque idiom, but marked by subtle atmospherics which attracted comparison with Turner. *Littlehampton Pier*, exhibited at the Royal Academy in 1812, was bought by Sir John Leicester for his private gallery of modern British art, which he hoped might one day form the basis for a national gallery. This was not to be and, on his death, his pictures were sold, the Callcott being bought by another collector of contemporary art, Robert Vernon. Vernon went on to own eleven pictures by Callcott, a measure of the artist's high standing in those days. It was Vernon's collection, bequeathed to the National Gallery in 1847, which laid the foundations for the public display of the national school. Leicester's collection, however, hung in a special gallery in his house in Hill Street, Mayfair, was while it lasted one of

the best places in London to see the range of modern British art, and Bonington and Colin paid a visit in 1825.

The simplicity and tonal harmony of this coastal scene, which modernised earlier Dutch marine painting, help to explain why Callcott was so enthusiastic about similar subjects by Bonington when they first appeared in London, recommending his own patron the Duke of Bedford to add one to his collection (see no.41). Callcott had made earlier contact with a number of leading French painters on a visit to Paris in 1814 (his journal of the visit is in the Bodleian Library, Oxford, and contains lively, if biased impressions of their work and of the city itself). François Gérard, who – wisely perhaps – would not let him in at first, is dismissed as 'horrible … tame and imbecile … no pretensions whatever to anything', while David has 'a most abominable theatrical style, not one hundredth part as good as [Benjamin] West'. DBB

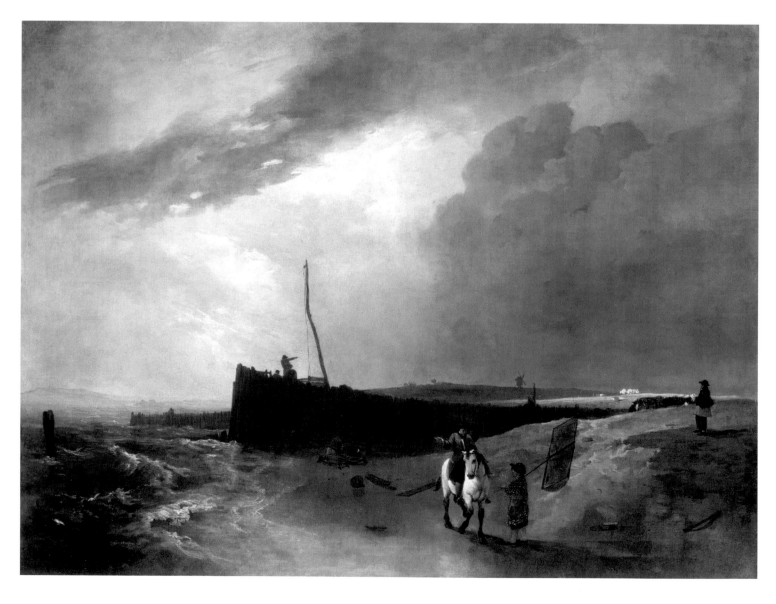

125

Horace Vernet (1789–1863)
The Wave c.1825

Oil on canvas
49.5 x 61 (19½ x 24)
Signed, lower right: *H. Vernet/MV*
[? monogram]
Private Collection
Minneapolis and New York only

Vernet's account books reveal a flurry of sales of small marines and sporting art to Claude Schroth around the years of intense Anglomania in Paris, 1823–6. One such picture dated 1825, *Marine: Combat Between Greeks and Turks* (Hermitage) exhibited at the Galerie Lebrun in 1826, is virtually identical in handling, palette and size to this example. Another *Marine*, showing the victims of a shipwreck helped ashore in a violent sea (Private Collection), also relates to this group. When exhibited in 1980 (Paris, *Vernet*), it was noted of *The Wave* that the apparent absence of anecdote, unusual for Vernet, anticipated the stark naturalism of Gustave Courbet; however, the subject of this picture is actually the attempted rescue of a shipwreck victim clinging desperately to the buoy at lower left. The accentuation of natural forces and the simplification of the composition may owe something to British models or Géricault's investigations of the Deluge theme, but ultimately the subject continues a longstanding tradition that Vernet's immediate relatives had virtually defined as their own. PN

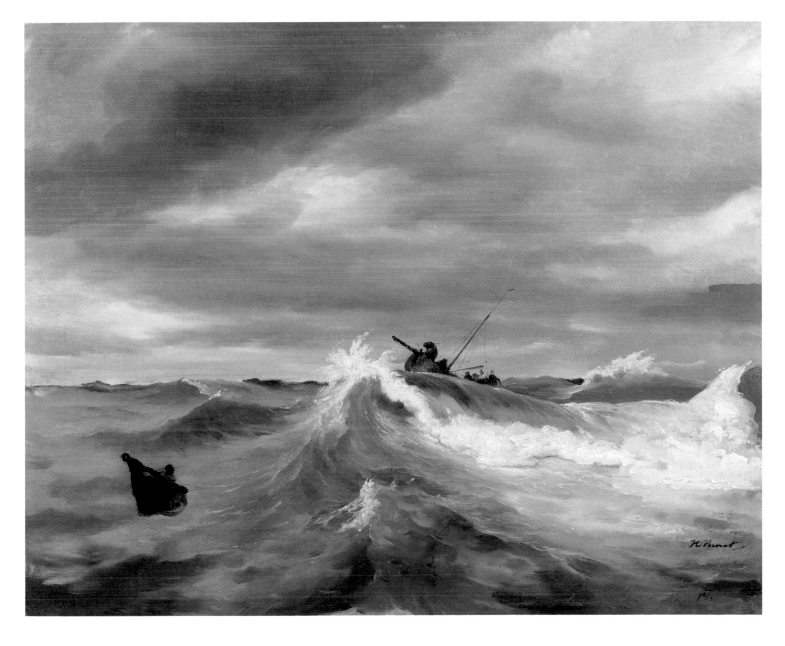

126
Richard Parkes Bonington
(1802–1828)
Near St-Valery-sur-Somme c.1825

Oil on canvas
80 x 121 (31½ x 47⅝)
National Trust, Anglesey Abbey (Fairhaven Collection)
London only

Baron Charles Rivet, Bonington's friend and pupil, offered *Near St-Valery-sur-Somme* to the Louvre shortly after Bonington's death, but the Comte de Forbin rejected the gesture on the grounds that the figures were unfinished. The obvious absence of the horse's forelegs resulted from the artist having repositioned the boy to the left. Other pentiment suggest a sweeping revision of the original composition and include buildings painted out in the distance; a large anchor in the left foreground; an entire figure, near the basket and barrel, similar to the central fisherman; and various corrections to clothing and poses. In contrast to *French Coast with Fishermen* (no.41), the artist has here radically reduced the foreground staffage, thus creating the 'classic' Bonington composition with its luminous expanse of sky balanced only by minimal vertical accents of isolated figures or beached vessels. It was a formula that would sustain the reputations of many an imitator in France and England.

The buildings and quays in this picture recur in numerous Bonington watercolours definitively identified as St-Valery-sur-Somme or its nearby port suburb of La Ferté, a favourite haunt of Bonington, Huet, Isabey and Boys. PN

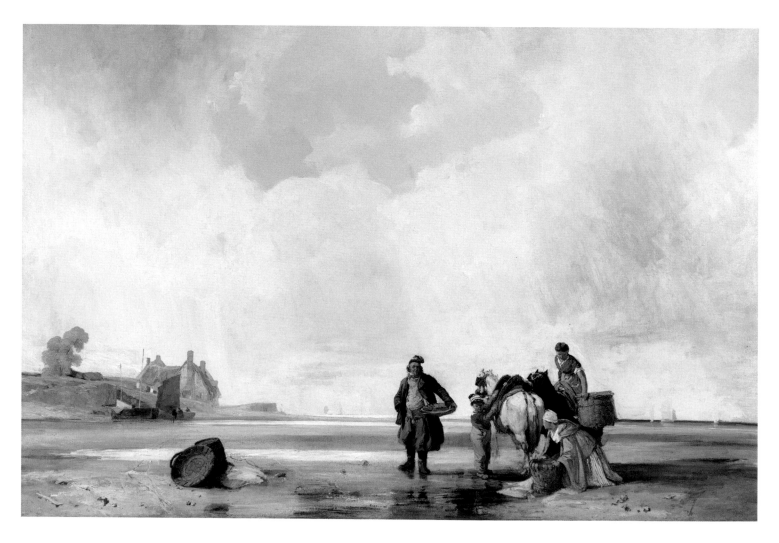

127

Eugène Isabey (1803–1886)
Honfleur, Low Tide 1827

Oil on canvas
71.5 x 90.5 (28½ x 36¼)
Signed and dated, lower right: *E. Isabey 1827*
References: Farcy, *Salon* 1827 (2 December
1827), p.766; Thiers, *Le Globe*, 22 Dec. 1827,
p.73; Jal, 1827, p.181.
Private Collection

Isabey dominated marine painting in France during the July Monarchy (1830–48) and directly linked the British Romantics to the proto-Impressionists Eugène Boudin and Johan Barthold Jongkind. He was the son and student of Jean-Baptiste Isabey, David's stellar pupil, who was intimate with the Vernets, Gérard, Géricault and the Duchesse de Berry, functioned as court painter to the Bourbon kings, and is today recognised as one of the unsurpassed miniature portraitists in the history of that medium. Both Isabeys were prolific and exceptional lithographers.

As his father was orchestrating a retrospective exhibition of his own work in London, Eugène made the first of countless visits to Normandy in 1820 with Charles Nodier, Isadore Taylor and Alphonse de Cailleux. He also accompanied Nodier on a two-month tour of England and Scotland the following winter. Like his father, he would become a copious illustrator of their *Voyages pittoresques*. Pierre Miquel (*Isabey*) cited two separate accounts that Bonington was instrumental in persuading Eugène to become a professional artist despite his father's objections. His initial marine watercolours of 1821 are stylistically closer to Géricault and Eugène Lami than to British models, although by mid-decade his work is almost indistinguishable from that of Bonington.

Isabey again visited London in June 1825 with a phalanx of young French painters. On the return voyage in August, he worked briefly in Calais with Louis Francia, Bonington, Colin and Delacroix, before embarking on a tour of the Channel coast as far as Trouville with Bonington.

Isabey's oil paintings of the 1820s are mostly untraced. Those exhibited in 1824 were described by Auguste Jal as small marines in the English manner, yet 'firmer' in their effects. Four marine oils were exhibited at the 1827 Salon, when Isabey was awarded a gold medal. Charles Farcy dismissed them as more facile than talented, but Adolphe Thiers had the good sense to see in them a fresh alternative to the eighteenth-century pastiches foisted on the public by Théodore Gudin and Louis Garneray. Jal was especially taken with the seductive tone of a picture titled *Beach at Honfleur*.

A painting of the scale of this example was probably one of those Salon entries. If so, the dimensions match those of either the *Beach at Honfleur* or the picture titled in the catalogue *Beach at Trouville*, which belonged to the Duchesse de Berry. The former seems most plausible on the evidence of the depicted architecture and terrain. Isabey had spent much of the summer of 1826 sketching at Honfleur and its environs. In June 1828, he again toured the coast between Honfleur and Trouville. His companions were Huet and Charles Mozin (no.130). PN

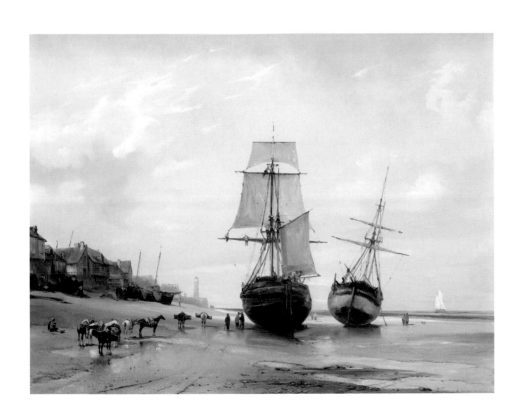

128

J.M.W. Turner (1775–1851)
Calais Sands, Low Water,
Poissards Collecting Bait 1830

Oil on canvas
73 x 107 (28¾ x 42⅛)
References: for contemporary reviews see
Butlin & Joll, *Turner*, pp. 187–8, no. 334.
Bury Art Gallery and Museum

As one of the main ports of entry to France for British travellers, Calais was seen by Turner on a number of occasions, from his first trip across the Channel to Paris and the Alps in 1802. One of his most impressive early marine pictures had been *Calais Pier* of 1803 (National Gallery), depicting a landing in squally weather. Later, Turner's frequent travels to Continental Europe took him to the town in 1819, 1824, 1826 and 1828. During the 1820s, he was gathering ideas for a set of views of Channel ports which, had it been completed, would certainly have included Calais, and there are a number of drawings of it and of nearby Boulogne of this period. The town appeared in the background of a large sea-piece exhibited in 1827, *Now For the Painter (Rope), Passengers Going on Board* (Manchester City Art Galleries), and in this tranquil beach scene shown at the Royal Academy in 1830. Turner had been greatly impressed by Bonington's scenes on the French coast, exhibited in London from 1826 (no.41), and may have seen other works by the artist in the studio sale held in London in 1829, following his death the previous year. Just as Bonington had spoken of Turner 'constantly' after seeing his work in 1825, so Turner had identified Bonington as

one of the most promising of his younger contemporaries. John Gage (1972, no.264) was the first to suggest that this beautiful but grave composition, with its sinking sun reflected in sands glistening at low tide, was a tribute to Bonington. DBB

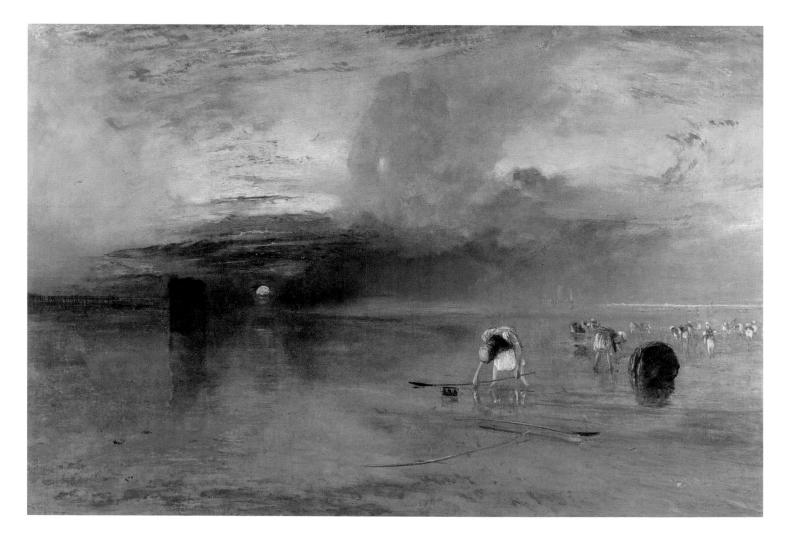

129
Camille Roqueplan (1800–1855)
Coast Scene with Figures 1831

Oil on canvas
38 x 65 (15 x 26)
References: Delécluze, 1831 (14 May 1831), p.2;
Farcy, *Salon* 1831 (26 June 1831), p.477;
Planche, *Salon* 1831, pp.91–4; Lenormant,
1831, p.87.
Montpellier, Musée Fabre

This 1831 Salon entry falls between the categories of landscape and genre. On a beach at sunset, three affluent strollers surround a woman who paints the portrait of a shrimper. The coastal village on the left and the cliffs in the distance identify the site as the northern coast of France.

Roqueplan, who demonstrated early in his career a pronounced taste for natural phenomena such as sunsets and moonlight, and was always considered an accomplished colourist, has employed a shimmering palette. The composition, with its figures set against a large expanse of sky, immediately evokes seventeenth-century Dutch landscapes, in particular those of Ludolph Bachuyzen and Wilhelm van de Velde. On this northern influence is superimposed a certain rococo preciousness in the grouping of the figures. In his anecdotal genre scenes, Roqueplan often dressed his figures in historical costumes, following Bonington's example. Here he does not hesitate to mingle women dressed in the romantic mode with men in the costumes of Louis XIII. If the artist took as his starting point visual reality, he also profited from the new freedom of the period by abandoning himself to his fantasies and by confounding genres, social status and even historical epochs.

To the 1831 Salon, Roqueplan submitted fourteen pictures, which confirmed the broad range of his interests and techniques. The critics, who preferred to typecast artists, were somewhat disconcerted by his diversity; nonetheless, the usually severe Gustave Planche was generous:

Camille Roqueplan is an ingenious and talented painter, formed by Bonington's example, less true, less conscientious, less poetic than that master, but, all in all, to the same degree varied in his compositions, delightful in his choice of subjects, so adept in disguising problems of execution, which he seems to conjure away … Roqueplan sees nature quickly, does not ponder it long, and is little concerned with idealising it. However, he often succeeds in copying her with rare talent, as evidenced by the charming sketches he has shown this year.

MW

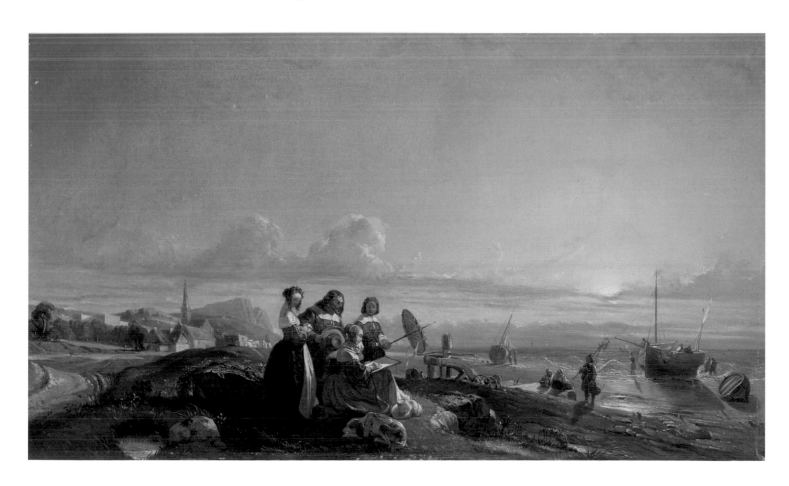

130
Charles Mozin (1806–1862)
Harbour in Normandy, Low Tide
1828

Oil on canvas
72.5 x 98 (28½ x 38⅝)
Signed and dated: *C. Mozin 1828*
Private Collection

Although this marine painter is most often associated with Trouville, he was actually born into a family of affluent Parisian musicians. He studied briefly with Xavier Leprince and exhibited two small marines at the 1824 Salon that withstood comparison with the paintings of the fashionable marine artist, Théodore Gudin. Charles Farcy described his pictures at the 1827 Salon, one of which was identified as having been painted entirely out of doors, as 'too sensible' in colouring and 'too broad' in handling, which adequately if dismissively characterises Mozin's often blunt naturalism. Farcy would also write of Mozin's marines exhibited at the Musée Colbert in 1829 that they were 'worthy of Bonington, whose manner they much resemble'. In the 1820s, Mozin was certainly one of the rising stars of the popular cadre of marine painters – as well as Isabey, Huet and Eugène LePoittevin – who had aligned themselves with the English manner, for although his choice of subjects owed much to Leprince, his execution was decidedly in Bonington's debt.

The identification of the site in this picture is uncertain, but St-Valery-sur-Somme, the coastal village frequented by Bonington and Isabey, is plausible. Mozin had exhibited a marine of that title in the 1827 Salon. PN

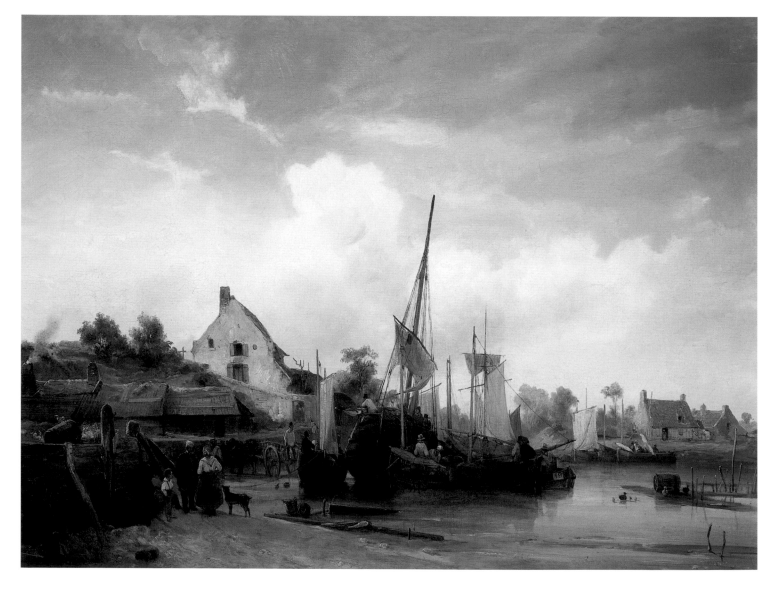

131

Samuel Prout (1783–1852)
The Chapel of St Joseph of
*Arimathea, Glastonbury c.*1818

Oil on wood
30.5 x 39.4 (12 x 15½)
Tate. Presented by Herbert Powell through the
National Art Collections Fund 1919

Prout exemplified the professional
tourist/topographer of the Romantic era. For
most of his career, which began under the
tutelage of the antiquarian publisher John
Britton, he recorded the architectural
monuments of Europe. Like François-Marius
Granet, he treasured the associations and
picturesque charm of Gothic architecture. He
conducted his first of several tours of northern
France in 1819. Louis Francia (no.143)
probably introduced him to Bonington, for the
three artists were sketching together at St-
Omer in 1823. By 1824, when he appeared with
other British artists at the Salon, Prout was the
best known of the English antiquarian
draughtsmen in France, and the dealers
Osterwald, Schroth and John Arrowsmith
eagerly stocked his watercolours. He also
contributed lithographs to Isadore Taylor's
Voyages pittoresques.

Prout toured the Continent incessantly and
was especially instrumental in promoting the
attractions of both Normandy and northern
Italy. Well versed in French art, he wrote from
Paris in 1833 of his desire to purchase prints of
Granet's interiors and 'odds and ends of this
description, which I can stick onto my

churches'. In addition to his illustrated tours,
he also produced numerous drawing manuals,
which enjoyed some circulation in France. In
the opinion of John Ruskin, Prout was the
perfect instrument for recording the genuine
character of a particular place, even if he were
not the most fastidious of draughtsmen. He was
also admired in both France and Britain for his
devotion to recording the ancient monuments
of Christianity that were threatened by neglect
and avarice. In France, opposition to the
pervasive dismantling of older buildings for
dressed stone was a stance on which voices as
factional as those of Victor Hugo and Etienne
Delécluze passionately agreed.

Prout's oil paintings are extremely rare.
Richard Lockett (1985) dates the present
example to *c.*1818, or just prior to his first
Continental tour. It thus anticipates the many
illustrations of similar monuments in France
included in the *Voyages pittoresques*. Most of the
architectural detail was drawn rather than
painted on a panel with a prepared white
ground, and the overall effect is one of verve
and attractive transparency similar to that in his
watercolours. PN

132

Charles Caius Renoux
(1795–1846)
Pilgrim Before a Tomb 1828

Oil on canvas
73 x 92 (28¾ x 36¼)
Signed and dated, lower left: *Renoux / 1828*
Musée de Grenoble

Little is known of Renoux's career beyond his regular exhibition of Gothic interiors and ruins at the Salons from 1822 to 1843 and his participation in Louis Philippe's Versailles decorations. In 1824, he collaborated with Xavier Leprince in painting a view of the interior of Alexandre du Sommerard's house at Pantin. Du Sommerard, the pre-eminent collector of medieval art in Paris, owned seven of the pictures exhibited by Renoux at the 1824 Salon. The ruins in this picture are probably an actual site, yet to be identified.

In his prospectus for the first volume of the *Voyages pittoresques* (no.10), Charles Nodier wrote that he and his co-authors, together with an army of talented architectural draftsmen, were beginning 'not just a voyage of discovery, but a voyage of impressions'. The twenty-six folio volumes that comprised that monumental publication set new standards for the writing of history and dispelled, through its abundant lithographic illustrations, the perception of Gothic art as something barbarous or savage. It helped put an end to the wanton destruction of medieval monuments in France, raised the level of appreciation for provincial customs, and generated enthusiasm for a tradition well established in Britain, namely the picturesque tour. Unlike many of the British architectural topographers, John Sell Cotman and Samuel Prout, for instance (nos.11, 131), who coolly situated a monument in its contemporary context, those working for Taylor, including Renoux, Alexandre-Evariste Fragonard and Louis Daguerre (no.42), often followed François-Marius Granet's (no.68) lead and the anecdotal prose of Nodier's text in introducing religious scenes or figures that appeared to have a narrative function. In most cases, as in the present painting, it is the melancholy of the eighteenth-century cult of ruins, emanating from the poetry of Thomas Gray, and the nostalgia for a more spiritual age that is evoked.

PN

133

J.M.W. Turner (1775–1851)
Childe Harold's Pilgrimage – Italy
exh. 1832

Oil on canvas
142.2 x 248.3 (56 x 97¾)
References: for contemporary reviews see
Butlin & Joll, *Turner*, pp. 193–4, no. 342.
Tate. Bequeathed by the artist 1856
London only

Turner was a great admirer of Byron, whose poetry he felt spoke for many of the messages implicit in his own art. Besides preparing a set of landscape illustrations to Byron's works for engraving, and others for John Murray's edition of Byron's *Life and Works* (1832–3), he attached quotations from the poet to six of his exhibited paintings. While these were not necessarily all painted specifically as illustrations to texts, being capable of independent life without them, this practice nevertheless acknowledged a strong sense of affinity between painter and poet. However, they seem never to have met, and Turner's interest in Byron was strongest after his death, focusing mainly on Byron's writings on the Mediterranean world, and on his most famous poem, *Childe Harold's Pilgrimage* (1812–18). In this picture, exhibited at the Royal Academy in 1832 with lines from Canto IV of the poem, Turner offered a definitive statement of the Romantic view of Italy which painter and poet shared, a country sadly fallen from its ancient glory but redeemed by its natural beauty, a 'garden of the world/ … Thy ruin graced/ With an immaculate charm which cannot be defaced'.

Turner had visited Italy for the first time in 1819 and returned in 1828, when he rented a studio in Rome and exhibited pictures he had painted there to his international colleagues, including the various French artists then in the city. Italy, ancient and modern, was one of the main themes of his exhibited pictures in the 1830s. When, as here, these depicted the classical Italy of Rome, the Campagna or the south and were couched in the compositional tradition of Claude, they perhaps contributed to a perception that Turner was becoming outmoded. But a picture such as this was no longer a conventional interpretation of Claude. Its complex, multiple perspectives are more perplexing than inviting, the vegetation rich and over-ripe. Turner may have been trying to express the melancholy, sated temperament of Byron and his poetic *alter ego*, Childe Harold, as well as a mutual impression of Italy. Whatever the case, the brilliant colour, unique in painting at the time, was his attempt to convey the reality of what he saw there. For the *Morning Post* the picture was 'more gorgeous than true … Dame Nature never wore so meretricious a robe'; its critic defended Claude's example against 'certain pilgrims of art, who would persuade us that there are no colours beyond the Alps but the colours of the rainbow' (cited by Butlin and Joll, *Turner*, p.194). DBB

134
Achille-Etna Michallon
(1796–1822)
Waterfall at Mont-Doré, Auvergne
1818

Oil on canvas
41.3 x 56.2 (16¼ x 22⅛)
Signed and dated, lower left: *Michallon / 1818*
The Metropolitan Museum of Art. Purchase,
Wolfe Fund and Nancy Richardson Gift, 1994

As the first pensioner at the French Academy's Villa Medici in Rome specialising in landscape, Michallon's obligations to the school were somewhat vague, and he seems to have reverted to the time-honoured custom of abandoning the study of antique sculpture in favour of sketching out of doors. Among the foreign artists active in Italy at this time, the German Nazerenes offered the most coherent counterpoint to their French peers. But Michallon also frequented the English salons, so it is quite possible that he met J.M.W. Turner in Rome in 1819. In that year, he exhibited with the other French students his historical landscape *The Death of Roland* (Louvre), the landscape component of which was also based on sketches and recollections of the Auvergne. The following May he visited Sicily. Some of the resulting drawings were engraved for J.-F. d'Osterwald's *Voyage pittoresque en Sicile* (1822–6), a project to which Bonington and a host of other British and French artists contributed.

Monte-Doré is a popular spa resort in the Massif Central region of France. This picture is generally dated to shortly after the artist's arrival in Rome. The prominence afforded the gnarled trees in the foreground and the taut precision of the execution employed in their definition relate it immediately to the tree studies and competition essays of the preceding year (no.108); yet, despite the contrivance of the composition and the meticulous finish, a remarkable breadth results from the virtuoso marriage of controlled touch and of a grasp of naturalistic light and atmospheric perspective. Bonington and Corot, among others, undoubtedly matured quickly as a consequence of examining such brilliant exercises in the 1822 exhibition and in the sale of Michallon's studio, which offered the curious of Paris over 450 lots of pictures and drawings. PN

135
Jean-Baptiste-Camille Corot
(1796–1875)
The Upper Falls, Terni 1826

Oil on paper mounted on panel
26.7 x 30.8 (10½ x 12⅛)
Stamped, lower right: *Vente / Corot*; wax seal,
verso: *Vente Corot*
Wheelock Whitney, New York

Byron's *Childe Harold* (Canto IV) gives a full-blown romantic response to this waterfall:

The roar of waters! – from the headlong height
Velino cleaves the wave-worn precipice;
The fall of waters! Rapid as the light
The flashing mass foams shaking the abyss.

This verse was appended to the first published illustration of a Byronic text by J.M.W. Turner, an engraving after Turner's representation of the falls for James Hakewell's *Picturesque Tour of Italy* (1819).

The Upper Falls, Terni is one of the most ravishing and least known of the several hundred oil sketches painted by Corot during his first visit to Italy. The artist sketched at Terni between July and September 1826, producing several views of its famous Cascata delle Marmore. This example of the upper cataract is exceptional in its empirical grasp of sunlight and the freshness of its colours. Corot was undoubtedly familiar with Michallon's similar paintings at Terni and Mont-Doré (no.134), and the dramatic effects offered by light glistening off cascading water, but there is nothing overtly sublime in this particular response to a site that normally evoked strong emotional reactions. Rather, the artist has worked painstakingly on recording optical phenomena and subtleties of chromatic range in a fluid and tactile manner. PN

136

Charles Lock Eastlake
(1793–1865)
The Colosseum from the Campo Vaccino 1822

Oil on canvas
52.7 x 64.8 (20¾ x 25½)
Tate. Presented by the Friends of the Tate Gallery 1964

Eastlake studied under Benjamin Robert Haydon and at the Royal Academy Schools, and made a promising start as a painter of history, historical genre and landscape in the first decades of the century. Later, he turned to a career of arts administration, becoming Secretary of the Fine Arts Commission in 1841, President of the Royal Academy in 1850 and Director of the National Gallery in 1851. In 1815 he sold his picture of *Napoleon on Board the Bellerophon in Plymouth Sound* (National Maritime Museum) for a thousand guineas, and on the proceeds was able to move to Italy for several years, basing himself in Rome. His painting of the Colosseum, made for Greville Howard, derived from his regular practice of outdoor study from nature which, carried on even in the heat of high summer, won him the nickname of 'the Salamander'. On a visit to Paris in 1815 and on his way to Italy in 1816, Eastlake had become acquainted with the Louvre's curator of antiquities, Ennio Visconti, whose introductions and those of his two

brothers in Rome smoothed his way into an international circle of artists including the sculptors Antonio Canova and Bertel Thorwaldsen, and the German Nazarenes. At the invitation of Charles Thévénin, of the French Academy at the Villa Medici, he joined the *pensionnaires* in drawing and sketching, in their excursions painting outdoors, and at their *conversazioni* on Wednesday evenings. There, or through his friend the architect and archaeologist C.R. Cockerell, he could have met Géricault, who arrived in Rome for about a year in September 1816, and Jules-Robert Auguste. The French artists made contact with Cockerell in Rome and were later reunited with him on their visit to London, calling on Wilkie together to see his *Chelsea Pensioners* (no.49). Eastlake was also a friend of Turner, helping to prepare the ground for his stay in Rome in 1819, and sharing a house with him and reporting home on his Roman exhibition in 1828. DBB

137
Antoine-Félix Boisselier
(1790–1857)
View of the Colosseum from the Orti Farnesiani 1833

Oil on canvas
74.3 x 97.8 (29¼ x 38½)
Signed and dated, on the wall: *AFBoisselier/1833*
Minneapolis Institute of Arts, Gift of Wheelock Whitney III

Boisselier was a fellow pupil of Michallon (no.43). He finished second to Michallon in the first competition for the Prix de Rome for historical landscape in 1817, but would eventually travel extensively in Italy and northern Europe. Historical landscape paintings like the *Death of Bayard* (1822) were typical of his many Salon entries. He never visited Britain, and one of his few recorded British subjects *Macbeth and Banquo* (1837 Salon; Angoulême) transports its Scottish protagonists to a fantastic Alpine forest. An anonymous critic reviewing the 1824 Salon observed that the artist 'has elevated historical landscape to new heights, and allows us to hope that we will find in him the worthy successor of Michallon'. This was not to transpire, as Boisselier plodded his trade amidst a score of other lacklustre heirs of Pierre-Henri Valencienne's legacy. Nevertheless, he was one of the more refined practitioners of this class of stylised painting, as this view in Rome attests, with its splendid midday light and strident, enamel-like colouring. Eastlake's similar view (no.136) is broader in its handling of details and less rigid in its perspectival system, relying more on aerial than planer recession, and therein was a principal point of divergence between the conservative camps of the French and British schools. PN

138
Richard Parkes Bonington
(1802–1828)
Lerici c.1828

Oil on millboard
35.6 x 45.7 (14 x 18)
Richard L. Feigen, New York

In the spring of 1826, Bonington left Delacroix's studio and moved to his own accommodation at 11 rue des Martyrs, a building formerly occupied by Horace Vernet. Shortly thereafter he departed for northern Italy in the company of his friend and pupil, Charles Rivet. Since it was the Italy of Shakespeare and Byron that fascinated Bonington, he raced towards Venice. In the course of one month, he produced a substantial number of sketches of the principal Venetian monuments and views. These furnished him with studies for the major exhibition pictures he would send to the Salon and to the Royal Academy in 1828. As one of the earliest nineteenth-century artists to depict Venice in its faded splendour, Bonington appears to have influenced the way many French writers, including Chateaubriand, romanticised the city.

After leaving Venice at the end of May, Bonington and Rivet travelled to Padua, Florence, Lerici, Genoa and Turin. This view incorporates the medieval castle and port of Lerici on the gulf of Spezzia. The friends spent several days there before advancing to nearby Porto Venere on 7 June. These environs had Byronic associations, and it was here that Percy Bysshe Shelley spent the last months of his life in 1822. The subsequent popularity of engravings after Bonington's view undoubtedly owed something to this connection with the drowned poet.

Two oil versions of this composition, a sketch and this painting, were in Bonington's studio at his death. This elaborately composed version, with its figure of Rivet sketching in the foreground, was intended as a finished picture, probably commenced in spring 1828 and unclaimed at the time of the artist's death. It was purchased at Bonington's studio sale by Thomas Lawrence. PN

139
Jean-Baptiste-Camille Corot
(1796–1875)
View from the Farnese Gardens:
Morning 1826

Oil on paper mounted on canvas
24.8 x 40 (9¾ x 15¾)
Stamped lower left: *Vente / Corot*; dated, lower
right: *mars 1826*
The Phillips Collection, Washington, DC
Minneapolis and New York only

The Farnese Gardens were popular with every landscape painter in Rome, as they offered the best vantage point from which to depict the ancient city and its ruins. This is one of three studies from the gardens painted by Corot for the most part in the open air at different times of the day over the course of two weeks in March 1826. This was a novel method of proceeding not recommended by the theorists, with the results in marked contrast to both a *plein-air* sketch (no.135), usually dispatched at one sitting, and a 'composed' landscape (no.45) painted in the studio. In effect, each was a finished painting worked entirely outdoors, and as such might have impressed both Constable and Monet, but they were not works that Corot intended for public exhibition.

During the month when Corot executed his suite of pictures, he wrote to his friend Abel Osmond:

You can't imagine the weather we are having in Rome ... I have been awakened each morning by the sun striking the wall of my room. It is always beautiful, but the sun also spreads a despairing light for me. I feel all the impotence of my palette (Moreau-Nélaton, *Corot*, I, p.15).

Despite his self-doubts, Corot exhibits in these studies a painterly breadth in both the application of his pigments and the distribution of his lights that astounds. PN

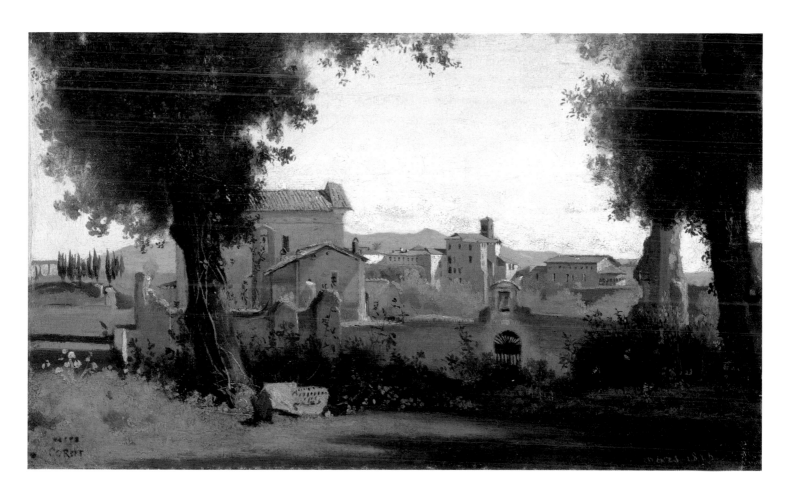

140

Jacques-Raymond Brascassat
(1804–1867)
View of Marino, Morning 1826

Oil on canvas
43.5 x 58.5 (17⅛ x 23)
Signed, dated, and inscribed, lower right: *RB
1826 Marino*
Musée des Beaux-Arts, Orléans, France

One of several precocious artists from Bordeaux in this exhibition, Brascassat studied initially with a minor pupil of Jean-Victor Bertin. Like most landscape draughtsmen of his generation, he furnished J.-F. d'Osterwald with material for his many illustrated travel books. In the 1825 competition for the Prix de Rome for historical landscape, he finished second to André Giroux, but ahead of Camille Roqueplan. The jury, however, was divided, and through the intervention of the Duchesse de Berry, Brascassat received from the king a half-pension for four years' study in Rome, where he met Camille Corot among other *pensionnaires*.

In 1827, Brascassat sent a history subject and four landscapes from Rome to the Salon, including a larger version (destroyed) of this composition. After returning to Paris in 1830, he worked closely with Antoine-Louis Barye, whose interests in animal subjects undoubtedly influenced the future course of his career. Although he would continue to submit Italian views to the Salons, by 1837 his pictures were predominantly landscapes in which domestic animals played a significant role, often as dramatic combatants in the tradition of George Stubbs and James Ward. His masterwork in this genre, *Bulls Fighting* (Nantes), was commenced shortly after his only recorded visit to London in 1835. Ward's monumental painting of that theme (Victoria and Albert) probably furnished the immediate inspiration. Charles Baudelaire considered him a tiresome *pasticheur* of Flemish seventeenth-century sources, but Huet described Michallon and Brascassat as the only academic landscape painters worthy of study.

This view at Marino is a brilliant exercise in *plein-air* painting brought to subtle completion in the studio. The palette does indeed capture the cool light of early morning, as suggested in the title, and the attention to detail is lively and assured. As a work that endeavours to present a composed view which nonetheless preserves the virtues of the spontaneous open-air sketch, it shares the sensibility and method of such near-contemporary essays as Bonington's *Lerici* of 1828 and Corot's *View from the Farnese Gardens: Morning* of 1826 (no.139). PN

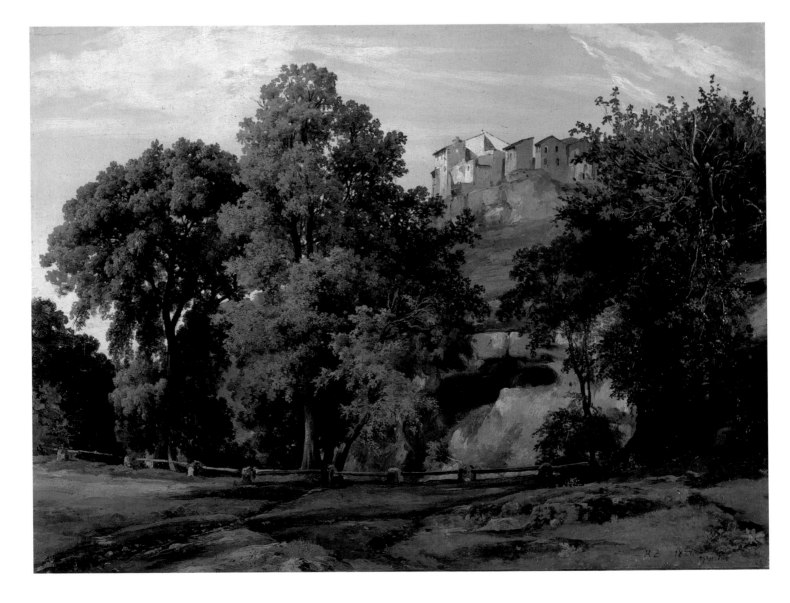

141
Richard Parkes Bonington
(1802–1828)
Corso Sant'Anastasia, Verona 1828

Oil on millboard
65.1 x 44.1 (25⅝ x 17⅜)
Yale Center for British Art, Paul Mellon
Collection

Barely two weeks out of Paris en route to Italy, Bonington and Charles Rivet reached Verona on 16 April 1826, where they remained for several days. Rivet furnished some idea of the difficulties in travelling with an Englishman set in the peculiar habits of his country:

En route, I suffer rude usages. First, our friend B. imagines that he doesn't need to learn the language, so the necessities of life fall to me. Furthermore, he has the pretentiousness to dine with tea, and it happened in a small hole called Coccaglia that no one understood what I wanted when asking for a faience vase in which to put boiling water, and we were brought a soup tureen with steaming water. With that came a bad cake de sabayon and potatoes; so then he demands beefsteak with loud cries; he has a dread of Italian cuisine ... Verona is a very picturesque city: it would take eight days of assiduous work to see everything; I doubt that Venice can be more extraordinary (Ms letter, Private Collection, 18 April).

This view is of the main street of Verona towards the Baroque palace of Count Scipio Maffei (d.1755), the Veronese historian and literato, which faces the Piazza dell'Erbe. In the years immediately following his death, this was one of Bonington's most celebrated topographical compositions, spawning versions by many of England's foremost professional watercolourists. From his own hand have survived several studies executed on site, a watercolour and a smaller oil version shipped to the London dealer Dominic Colnaghi in October 1827. The version shown here incorporates the processional motif and specific figures from the artist's most important 1827 Salon entry, *View of the Ducal Palace* ('Tate), and it is almost certainly the last picture Bonington painted before his final illness in July 1828. One of the few finished oils to be auctioned at his sale in 1829, it was acquired by the Marquess of Stafford, whose collection Bonington had visited in 1825.

Bonington's larger Italian pictures at the 1827–8 Salon such as the *Ducal Palace* generally met with critical success. *Le Figaro* would describe their 'great charm of perspective', and the 'great skill in the hand that has traced all the figures, disposed all the details with infinite grace'. Auguste Jal was likewise flattering: 'Bonington is a clever fellow ... Vivacity, firmness, effect, colour, breadth of touch, all are here ... the figures are only sketched, but so grandly! I prefer this manner of figure drawing to Granet's.' The allusion to François-Marius Granet is telling. Scenes of religious ritual and monastic life had made Granet's reputation by this date, and Bonington's dalliance with similar themes, but stripped of Granet's Gothic-novel mysticism, was an overt challenge to the pre-eminence of the senior artist. PN

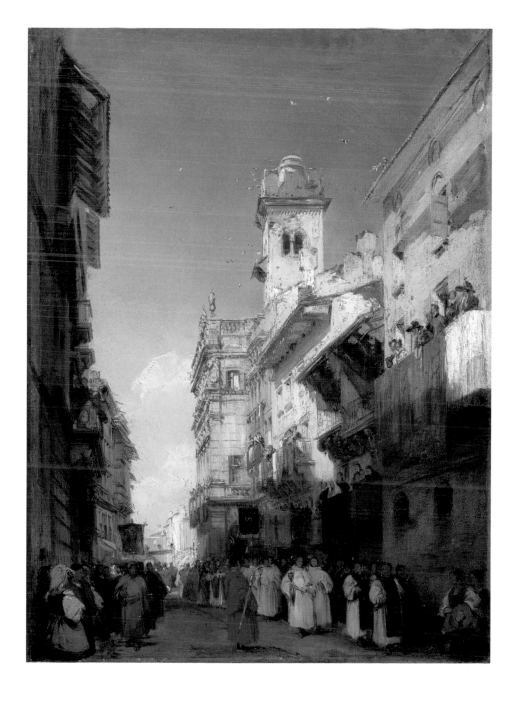

Diamonds that Flatter and Ravish the Eye: *The Ascendancy of Watercolour*

Patrick Noon

The British excelled in the art of watercolour and in the various intaglio printmaking processes used in its reproduction, all of which they had pioneered since the eighteenth century to considerable international acclaim. Often dubbed the 'British medium', watercolour was practised in France during the first two decades of the nineteenth century with some regularity and skill, but with little genius or measurable patronage. Conversely, the formation of the Society of Painters in Watercolours in London in 1805 guaranteed the popular success of the art in Britain, just as it galvanised a market in the public sphere that would remain relatively secure from the vicissitudes of government sponsorship and institutional vetting (fig.59). The Society's first group exhibition in 1807 was nevertheless a radical venture. It was launched in a divisive critical climate; namely, the rather bitter rhetorical contest then being waged between on the one hand the enfranchised proponents of traditional history painting based on ideal or classicising prototypes, with its demands for design over colour and for moralising on a grand scale, and, on the other, a private sector of connoisseurs who held that the ultimate goal of painting was the imitation of visible appearances by the most expeditious means. A similar contest dominated the critical discourse in Restoration Paris.

Of the approximately fifty British works listed in the 1824 Salon catalogue, three-quarters were watercolour paintings. Many of these had the sophistication and imposing scale that London viewers had grown accustomed to expect but which shocked unwary French critics. Prior to 1824 the French establishment, and much of its public, conceived of watercolour as a medium for tinting line drawings, such as Carle Vernet's brilliant satire of 1814 (no.4). This traditional prejudice, which British artists had routed through their annual exhibitions and their technical bravura, was augmented by the xenophobic and gender-biased criticism of the ultra-conservatives, Etienne Delécluze and Charles Farcy. In the first instalment of his lengthy 1824 review, Delécluze warned that those artists who '*drew* in watercolours for the ladies' rather than '*painted* in oils for posterity' would ruin themselves and the school. A frivolous pastime, watercolour was deemed incompatible with vital creative expression. In a later essay, Delécluze specifically targeted a watercolour by Thales Fielding illustrating *Macbeth and the Witches on the Heath* of 1824 as an opportunity to launch another attack on the 'Shakespearean proclivities of the modern school'.[1] Stendhal countered with his famous defence of Fielding's originality:

I have little time for watercolour, it is a meagre genre, but the apology is also a minor thing when compared to an epic poem and often La Fontaine is as immortal as Homer ... I discern in this watercolour a high poetic lesson; namely, how supernatural beings ought to be presented to the imagination.

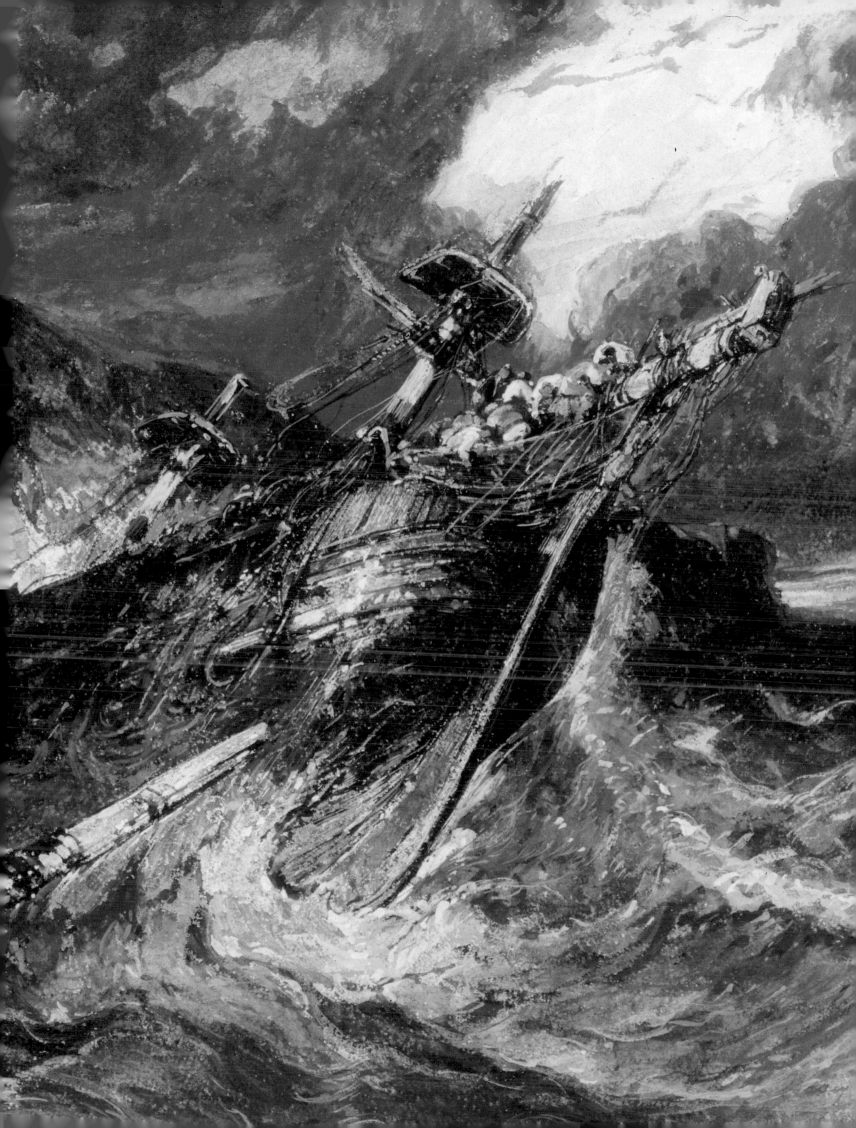

fig. 59

We see the witches in a stormy, black mist as distinctly as is necessary to confirm their existence ... In a year I will remember this poor little watercolour of barely two square feet, and I will have forgotten, as will the public, those immense canvases that tapestry the Salon; this is how a modest La Fontaine fable overwhelms a tragedy by La Harpe. In the arts, one must touch profoundly and leave a memento.[2]

A critical maelstrom revolving around a watercolour by a minor draughtsman may seem disproportionate, but Fielding's work embodied in its content and technique all that Delécluze and his clique held repugnant – horrific subjects, the absence of drawing, sombre northern landscape, and especially its assault on the hierarchy of media. 'Small album drawings greatly damage our serious painters', Delécluze wrote, and in this view he had an unlikely ally in Auguste Jal, who was otherwise disposed to innovation.[3]

A hostile press, however, could not suppress the groundswell of interest in watercolours that was already in evidence before 1824. Considerable credit for its popularisation in France is due to private dealers, like Claude Schroth, Madame Hulin, Alphonse Giroux, and René Beauboeuf, who stocked their shop windows with British examples, and to publishers like J.-F. d'Osterwald, who pandered to the fashion for sumptuously illustrated travel books by importing British draughtsmen and engravers for the task (nos.143–5). Many of his commissioned watercolours found their way into the 1820s Salons and were then dispersed at auctions to individuals eager to fill their albums. There was a total of over two hundred lots of French and British watercolours in Osterwald's and Hulin's inventory auctions, in 1823 and 1834 respectively. Many of Osterwald's British artists remained in France after their period of employment and secured influential positions as drawing masters to the patrician and middle classes, thus enhancing the stature and exposure of their *métier*. French artists travelling to London after 1814 had ample opportunity to see the extraordinary advances of the British school at their annual exhibitions and in the commercial galleries of the specialised dealers. Just as Géricault had turned to lithography after his London sojourn, Delacroix clearly perceived watercolour painting as a potentially lucrative pursuit following his stay in 1825. He wrote to Thales Fielding in early 1826, requesting copies of the articles of association for the Society of Painters in Watercolours, with the ambition of forming a similar group in Paris. Two years later, he alerted Fielding of his desire to consign his watercolours in London galleries. Since 'albums were the rage', Fielding advised that the sheets should not exceed seven by ten inches (18 by 25cm), and the medium be pure watercolour, as the amateurs disliked gouache 'except for highlights'. Historical and figure subjects, he claimed, were

fig. 60

Gare les Album

also not much favoured, and he urged his friend to introduce a bit of landscape whenever possible.[4]

The accumulation of watercolours in albums, a well-established practice in Britain by 1820, rapidly captivated the French (fig.60). 'Everyone felt bound to have an album and everyone felt also bound to fill it in some shape as the others', recalled Bonington's friend James Roberts. Albums were simply one manifestation of the emerging commercial clout of an entirely new rank of collectors. As Jal conceded in 1824: 'There are only five galleries in France that can hold a capital production of historical painting; there are six hundred private cabinets in which can be ranged fine studies, precious drawings, and pretty pictures.'[5] Despite the artist Henri Monnier's dismissal of the album addicts as a 'frightful race who wear you out with their insignificance',[6] the mania produced many exceptional collections. In 1826, Mrs George Haldimand, wife of a London financier, commissioned the distinguished watercolour artist George Fennel Robson to assemble such an album, which numbered over one hundred brilliant examples by 1828.[7] Her rivals in Paris included the Countess Demidoff and Louis-Joseph-Auguste Coutan, who amassed splendid collections without discriminating between schools. Others adopted a thematic or monographic focus. Lewis Brown, the Bordeaux wine merchant whose consuming passion was for Bonington, travelled throughout Europe with his precious album of watercolours by that artist, while Félix Feuillet, the anglophile critic who published under the nom de plume 'Leaves de Conches', was particularly proud of the several hundred illustrations to Jean de La Fontaine that he had commissioned from scores of international artists. Most of these albums no longer exist, but an especially sumptuous example, compiled as a wedding present for the Duc and Duchesse de Montpensier by Louis Philippe's children, all of whom studied watercolour with British masters, remained intact until recently.[8]

By 1831 the notably expanded watercolour section of the Paris Salons attracted more extensive coverage from the reviewers. In 1834, Feuillet's journal, *L'Artiste*, published several spirited defences of the medium, in which they reiterated Stendhal's admonition that the issues of scale and materials must never overshadow that of expressive integrity. Watercolour, it was argued, had rescued the visual arts from the vacuity of monumental history painting, and had contributed markedly to the artistic education of the masses through its portability, affordability and ease of comprehension. The critic Charles Farcy continued to insist on the 'purity and lightness' of the wash drawing, but that position, and Fielding's earlier recommendations to Delacroix, actually contradicted prevailing trends, insofar as the most elaborate technical manipulations were now coveted by both artists and patrons. As one London wag observed in 1831:

The new powers which have been developed in the violin by Paganini are scarcely less matter of astonishment ... than those discovered of late in the use of watercolours ... The eye of the far greater part of English collectors luxuriates in colour ... Vocal musicians complain of screwing up the instruments above concert pitch. So it is with graphic art; every year screws colouring up to a higher scale according to exhibition pitch.[9]

He would have found a sympathetic ear in Delécluze, who complained in the same year that French watercolourists 'with the aid of well prepared English colours and gums have tried like them to make paintings as vigorous as oils'. Alexandre-Gabriel Decamps especially 'exaggerates the intensity of his colours ... [and] resembles a musician playing a trombone in a boudoir'.[10]

Much of the periodical literature in both countries after 1830 recognised Britain's historical significance in the development of watercolour painting, yet they attributed its modern rejuvenation to the Anglo-French-trained Richard Parkes Bonington. Not that Bonington acted alone or even in a superior fashion to other artists. It was simply that his prodigious skills mesmerised his contemporaries and subdued all the critics. 'In that genre, which was an English novelty then,' Delacroix admitted, 'he had an astonishing ability'. Between 1826 and 1828 when they were virtually sharing studios, Bonington and Delacroix, and the artists of their entourage – Huet, Colin, Roqueplan, Decamps, Antoine-Louis Barye, Thomas Shotter Boys, Eugène Isabey and Charles Gleyre – defined a new relationship between watercolour and oil painting that had lasting ramifications for French art. The painterly sophistication, the 'colour and effect', of Bonington's late watercolour technique startled even British observers accustomed to such éclat, whereas in Delacroix's finished watercolours of 1827 (fig. 61), there emerged for the first time a splendid equilibrium between transparent washes and the bold, gestural marking of opaque gouache. In the decades following Bonington's death in 1828, the popularity of watercolour painting in France soared, although fifty years would elapse before French artists achieved Delacroix's dream of forming a society of watercolourists comparable to those in Britain.

142
John Varley (1778–1842)
Suburbs of an Ancient City 1808

Watercolour on paper
72.2 x 96.5 (28½ x 38)
Signed and dated, lower right: *J. Varley/1808*
Tate. Presented by the Patrons of British Art
through the Friends of the Tate Gallery 1990

Varley was one of the founding members of the Society of Painters in Watercolours in 1805. He exhibited there annually both topographical and imaginary landscapes of a type popularised by sketching clubs like the Society for the Study of Epic and Pastoral Design, founded in the same year that Varley exhibited *Suburbs of an Ancient City* at the Society of Painters in Watercolours. Grand in scale for a watercolour of this date, it certainly illustrates the principal aspirations of these various societies. As would Géricault a decade later (fig.53), Varley appears to have borrowed his staffage figures from engravings after Michelangelo, thus introducing added gravity to an already geometrically austere image derived from Nicolas Poussin.

The British watercolourists represented at the 1824 Salon by J.-F. d'Osterwald included several of his draughtsmen for *Voyage pittoresque en Sicile* (1822), Copley Fielding, Henry Gastineau, Charles Wild and Varley. Varley's two entries were a view in Ireland and a drawing simply titled 'a composition', suggesting that it was an imaginary landscape

such as this example. By that date, Varley was one of Britain's most respected drawing masters and an artist of recognised originality.
PN

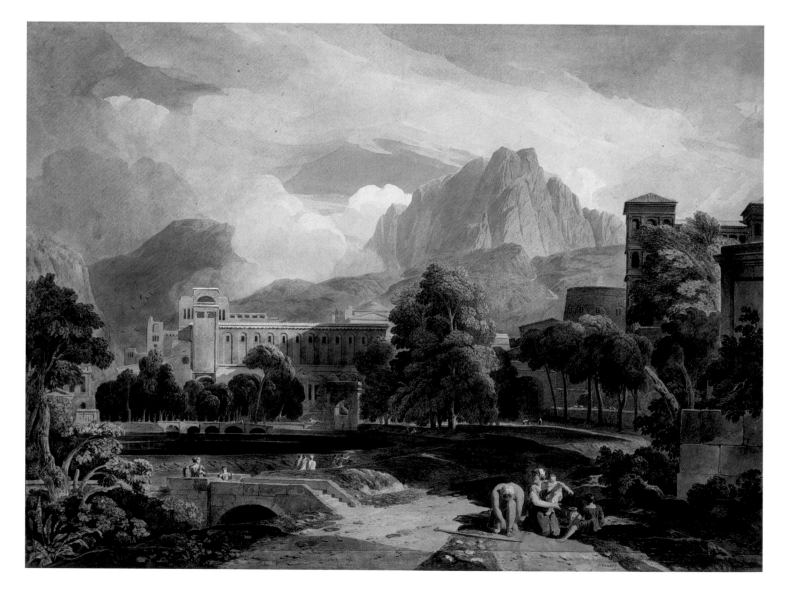

143
Louis Francia (1772–1839)
The Pont de la Concorde and Tuileries Palace from the Cours de la Reine 1823

Watercolour with scratching out over graphite heightened with white bodycolour on wove paper
16.8 x 27 (6½ x 10½)
Signed and dated, lower left: *L. Francia / 1823*
Yale Center for British Art, Paul Mellon Fund
London and Minneapolis only

Francia spent his formative years as an artist from 1789 to 1817 within the orbit of England's most advanced landscape painters, but especially Thomas Girtin, whose style he introduced to Europe. With the Restoration he returned to Calais and practised as a drawing master and occasional art dealer.

In addition to teaching Bonington, William Wyld and scores of French watercolour painters and lithographers, Francia was a crucial link in the ongoing dialogue between French and British art in the 1820s. His strategic position in Calais brought him in contact with anyone travelling between the two countries. Bonington, Delacroix and Eugène Isabey stayed with him in 1825. He did not isolate himself in the provinces, however, and was often in Paris.

A nearly exact study for this watercolour belongs to a group of elaborate graphite sketches of Parisian architecture and topography that Francia probably drew for a projected publication of engraved or lithographic views of the city. PN

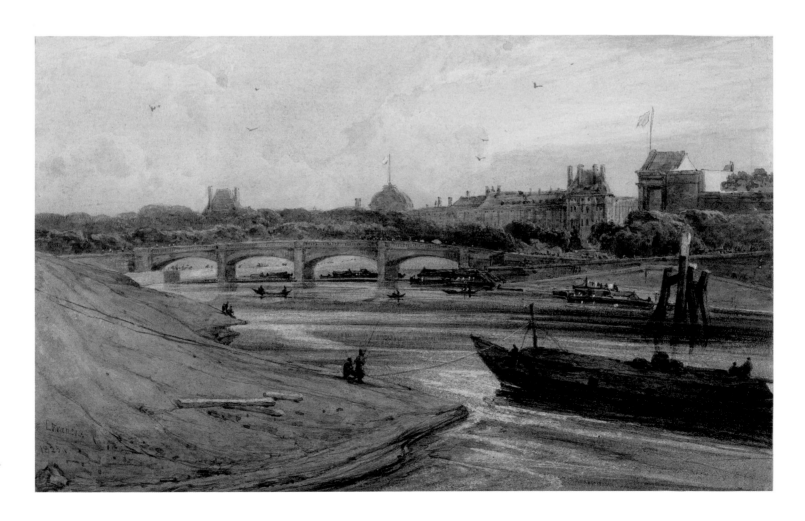

Richard Parkes Bonington
(1802–1828)

144
Rouen from Bon-Secours 1821–2

Watercolour
14.7 x 23 (5¾ x 9)
The Metropolitan Museum of Art, New York,
David T. Schiff Gift, Harry G. Sperling Fund,
and Karen B. Cohen Fund, 1996
New York only

145
St-Valery-sur-Somme c.1823

Watercolour
19.2 x 28.5 (8 x 11)
Signed, lower right: *RPB*
Private Collection

In 1823, J.-F. d'Osterwald launched an ambitious publication, *Excursions sur les côtes et dans les ports de France*, with a text by N.-J. Lefebvre-Duruflé and illustrations by primarily Swiss and British draughtsmen, which offered the French public some of the earliest representations of the picturesque fishing ports that dotted the Channel coast.

In cataloguing the Osterwald project, Col. J.R. Abbey (*Travels*) listed forty-one hand-coloured aquatint plates issued between 1823 and 1825. Since aquatint was a process rarely employed in France, and since Osterwald was intent on promoting both it and the British fashion for landscape painting in watercolour, the publisher was compelled to rely on foreign etchers imported for this and several other projects. These specialists included the Fielding brothers, who between them etched twenty-eight of the plates. Of the ten watercolourists employed, Bonington was second in the number of views contributed.

The composition of *Rouen from Bon-Secours*, engraved by Thales Fielding, was one of Bonington's illustrations for the first volume of *Excursions*. It differs from this watercolour in minor details of the landscape and in the foreground figures. Another, untraced, watercolour version of this sheet was engraved in aquatint by Georges Himley, but again with different figures. Yet another version with variant figures was engraved by William Cooke for *Friendship's Offering* in 1826. This appealing panorama of Rouen was obviously one of Bonington's most popular commissions. The present example dates to the artist's first Normandy tour in 1821–2 and is probably the primary version later repeated for the Osterwald commission.

The success of the first volume of *Excursions* prompted Osterwald to undertake in 1825 a second publication dedicated to the

ports of Picardy. Although never published, a unique copy of the first instalment, with two Bonington plates, is in the Bibliothèque Nationale, Paris. Additional aquatint plates submitted to the censors in 1825 included this view of St-Valery-sur-Somme, engraved by Thales Fielding. The watercolour itself, however, was probably executed earlier on the basis of sketches drawn during one of Bonington's regular tours of the coast.

Osterwald sent five *Excursion* engravings to the 1823 Salon at Douai, including views by Fielding and Bonington. Although not individually identified, many of Bonington's watercolours for Osterwald's publications were also exhibited under the publisher's name at the 1822 and 1824 Salons. PN

144

145

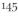
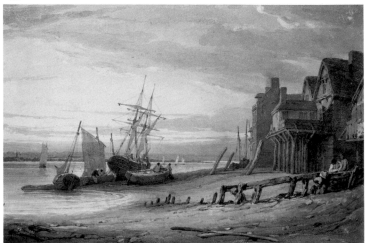

146
Paul Huet (1803–1869)
Rouen from Bon-Secours c.1829–31

Watercolour over graphite
19.5 x 29.2 (7¾ x 11½)
The Whitworth Art Gallery, The University of
Manchester

Huet made his first excursion to Rouen in 1818
and would return there almost annually for the
next twenty years. Although formerly
attributed to Théodore Rousseau, whom Huet
met in 1831 in Normandy, this watercolour is
typical stylistically of Huet's *plein-air* studies.
A Rousseau chalk study from a similar vantage
point does exist, but his early watercolours are
timid by comparison to the painterly and
atmospheric handling in this sheet and far more
dependent on pen and ink.

This view is in the opposite direction from
the panoramic oil (no.46) executed by Huet in
1831, although it may relate indirectly to the
preparatory work for Huet's lost Rouen
diorama of 1829. Huet was one of the few
French landscape painters to consistently
employ watercolour as a medium both for
study and for finished works of art. PN

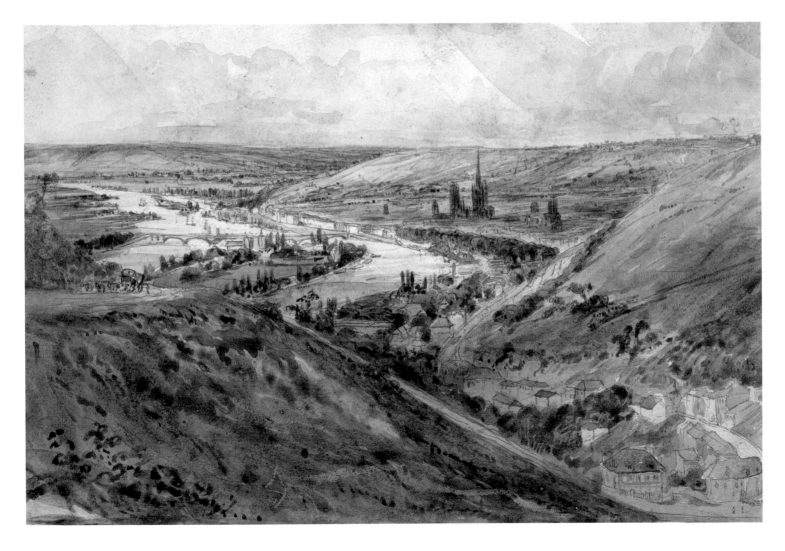

Paul Huet (1803–1869)

147
Richard Parkes Bonington
(1802–1828)
The Abbey St-Amand, Rouen
c.1827–8

Watercolour, bodycolour over graphite
19.2 x 12.6 (7⅝ x 5)
Yale Center for British Art, Paul Mellon Fund
Minneapolis and New York only

Bonington began his professional career as a topographer and delineator of Gothic architectural monuments. In 1824, he published his ten lithographic plates, *Restes et fragmens d'architecture du moyen age*. That same year he submitted his *morceau de réception* for Isadore Taylor's *Voyages pittoresques,* the *Rue du Gros-Horloge, Rouen*, which was immediately hailed as a masterwork of romantic lithography when exhibited at the 1824 Salon. Bonington would contribute four additional lithographs to the same volume, much of which is devoted to Rouen, a city enthusiastically described by Charles Nodier as the 'Herculaneum of the Middle Ages'.

The Abbey St-Amand was established by Robert, Duke of Normandy in the eleventh century. By the 1820s, it had fallen into disuse. A lithograph, similar in composition to this watercolour, was contributed by Alexandre-Evariste Fragonard to Taylor's second Normandy volume. In the accompanying text, Nodier launched into a vicious assault on the state for allowing such precious antiquities to be 'prostituted to the most vile usages and sacrificed to the most vile interests'. A similar view of the Abbey also appears as plate XI in Thomas Shotter Boys's superb folio of chromolithographs, *Picturesque Architecture* of 1839 (no.150), in which that artist described the heterogeneous complex of buildings as inhabited by 'motley groups of tenants'. Certain elements of his composition that are peculiar to Bonington's earlier view suggest that Boys used this watercolour, or a free copy of it, as a model for his own lithograph. He was especially close to Bonington at this time, and such appropriations of his mentor's designs were both common and expected.

This watercolour is one of the most splendid and best preserved of Bonington's rare, late architectural views. It was possibly painted in Rouen when the artist passed through that city en route to London in the spring of 1827. PN

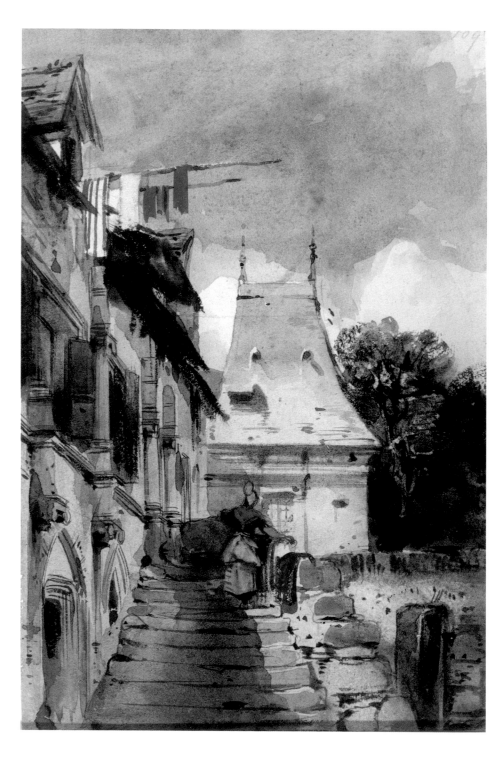

148
David Cox (1783–1859)
Tour d'Horloge, Rouen 1829

Pencil and watercolour on paper
34.3 x 25.7 (13½ x 10⅛)
Tate. Presented by the National Art Collections
Fund (Herbert Powell Bequest) 1967

David Cox trained as a scene painter but abandoned that profession when he fell in with Varley's (no.142) circle of landscape painters about 1804. Committing to a career as a watercolourist, he made the first of many Welsh tours in 1805 and was elected a member of the Society of Painters in Watercolours in 1813. His popular drawing manuals brought a modicum of financial security. Cox was an insular artist like Constable, preferring the countryside of Britain, but he toured Flanders in 1826 and northern France in 1829, where he spent a week with Francia (no.143) at Calais before passing to Paris via Rouen.

The fourteenth-century Gros Horloge stands at the centre of Rouen's medieval commercial artery and is one of the city's principal landmarks. Cox chose a prospect looking east towards the cathedral. He would not have known Bonington's watercolour of a similar composition, but the latter's lithograph for Taylor's *Voyages pittoresques*, published in 1824, was acknowledged at the time as a masterwork of atmospheric effect. As with most of Cox's French sheets, this drawing has colour annotations and considerable graphite underdrawing, but the watercolour washes dominate and create the impression of a finished work. PN

149
Thomas Shotter Boys
(1803–1874)
The Seine and Palace of the Tuileries, with the Pont Royal
*c.*1831

Watercolour and gouache on paper
20 x 29.5 (8 x 11½)
Signed, lower right: *Boys*
Tate. Presented by the National Art Collections
Fund (Herbert Powell Bequest) 1967

When his apprenticeship to the engraver George Cooke ended in 1823, Boys moved to Paris where he soon became Bonington's protégé. He continued to work for Cooke and exhibited four reproductive engravings at the Paris Salon of 1827–8. With Bonington's tutelage his professional interests shifted to watercolour painting. While many of Boys's first watercolours tend to be copies of other artists' works, especially Bonington's popular Italian subjects, he developed an independent style by 1830. His most enduring legacy is the scores of *plein-air* and finished watercolours that date to his Paris years from 1831 to 1837. As an exhibitor at the Salons from 1833 to 1835, he contributed substantially to the revival of watercolour painting in France. His studio in the rue de Bouloi was a rendezvous for British visitors to Paris. In the early 1830s, he shared that facility with William Callow (nos.151, 152), the architect Ambrose Poynter, the sculptor Henri de Triqueti, and a group of minor French illustrators. At the same time, Boys mastered the art of lithography, contributing to Taylor's *Voyages pittoresques* and collaborating with A. Rouargue on the publication *Architecture pittoresque dessinée d'après nature* (1835).

An engraving after this watercolour appeared in the *Keepsake Français* (Paris, 1831). Panoramic views of the Pont Royal from the opposite direction, as in Callow's and Wyld's watercolours (nos.152, 153), were also a favourite Boys subject. PN

150
Thomas Shotter Boys
(1803–1874)
*St Etienne du Mont and the
Pantheon* 1833

Watercolour and bodycolour
32 x 24.5 (12⅝ x 9⅝)
Signed and dated, lower right: *Thos Boys 1833*
Private Collection

As early as 1830, Boys had planned a portfolio of etched views of Paris 'as it is', but abandoned that idea in favour of a publication of twenty-six chromolithographs, *Picturesque Architecture in Paris, Ghent, Antwerp, Rouen, etc.* (1839). This topographical folio of colour-printed lithographs, derived from Boys's watercolours and produced with the technical assistance of Charles Hullmandel, ranks as one of the most innovative ventures in the history of printmaking. William Callow delivered a copy in person to Louis-Philippe, who offered his personal commendation and a diamond ring. Equally successful with the public and the French monarch was Boys's publication *Original Views of London As It Is* (1842).

The chromolithograph to which the composition of this watercolour closely relates was plate 20 in *Picturesque Architecture*. It is one of the most strikingly original in its perspective and in its management of the diverse architectural mix that constitutes the charm of Paris. The chromolithograph differs substantially from the drawing, however, in that it represents the view at night by moonlight. The effect was chosen for didactic rather than poetic reasons, to illustrate the extraordinary technical capabilities of the new medium. This watercolour was probably exhibited at the 1834 Paris Salon. PN

William Callow (1812–1908)

151
View of Paris from Charenton 1834

Watercolour
11.7 x 32.9 (4⅝ x 13)
Yale Center for British Art, Paul Mellon
Collection
London and Minneapolis only

152
Pont Royal, Paris c.1834

Watercolour touched with white and gum
arabic on wove paper
33.7 x 50.3 (13¼ x 19¾)
Signed, lower right: *W. Callow*
Yale Center for British Art, Paul Mellon
Collection
Minneapolis and New York only

In 1825 Callow began an apprenticeship as an engraver to the Fielding family, initially under Theodore, for whom he had been colouring prints since 1823, then Thales (no.2) after 1825. He was sent to Paris in 1829 to assist their brother Newton (no.165) with illustrations for various publishers. He later credited Newton with teaching him the technical complexities of watercolour painting, but like so many of the landscape draughtsmen of his generation, he formed his style in emulation of Bonington. Through Fielding, he was introduced to Delacroix's circle and to Boys. In 1831 he collaborated with Boys in a project to illustrate the picturesque architecture of Paris, although this never materialised, and by 1833 he was sharing Boys's studio in the rue de Bouloi. That summer he visited Royaumont with Louis Schwiter (no.52), who would remain a close friend and influential advocate. A Delacroix sketchbook (Louvre), in use over several decades, includes several brown-wash landscape drawings executed by Callow dated 1832 and 1833, and echoes of Callow's flawless synthesis of precise observation and facile execution reverberate through his friend's landscape watercolours of the 1830s and 1840s.

Between 1834 and 1841, Callow contributed watercolours annually to the Salons, winning a gold medal in 1840. In 1834, the critics especially praised his *View of the Thames at Richmond*. Shortly after the opening of that Salon, he was appointed to succeed Newton Fielding as drawing master to Louis-Philippe's children, a position he held for seven years. Other influential students included many of the aristocrats who had earlier patronised Bonington, such as the Comte de Faucigny and the Viscomte de Rouget. He was also quite active in the provincial Salons, garnering silver and gold medals at Cambrai and Rouen. As a result of such exposure and his extensive

network of clients, patrons and fellow artists, Callow was arguably the most influential British artist active in Paris in the 1830s, but his significant contribution to the mounting appreciation of both landscape and watercolour painting in France has not been adequately recognised.

View of Paris from Charenton is typical of the brisk, wash style that Callow practised during his frequent visits to the Paris suburbs to gather material for Boys and for his own more elaborate exhibition pieces. Such exquisite *plein-air* sketches are often indistinguishable from similar exercises by Delacroix (fig.62) and Huet. The more finished *Pont Royal, Paris* represents an ambitious attempt to imitate Turner's complex technique of the 1820s (no.158). Callow admitted a passion for Turner in his formative years. He makes no mention in his autobiography of having encountered Turner during the latter's visit to Paris in 1832, but he would definitely have indulged this interest, as had Bonington a decade earlier, during a brief visit to London in July 1833. Turner was also present at the meeting of the Artists' and Amateurs' Conversazione on 3 July, which Callow attended with Boys and members of the Cooke family. This watercolour probably dates to shortly after Callow's return from that visit. PN

151

fig.62
Eugène Delacroix
View of London from Greenwich
1825–7
Watercolour
Musée du Louvre

152

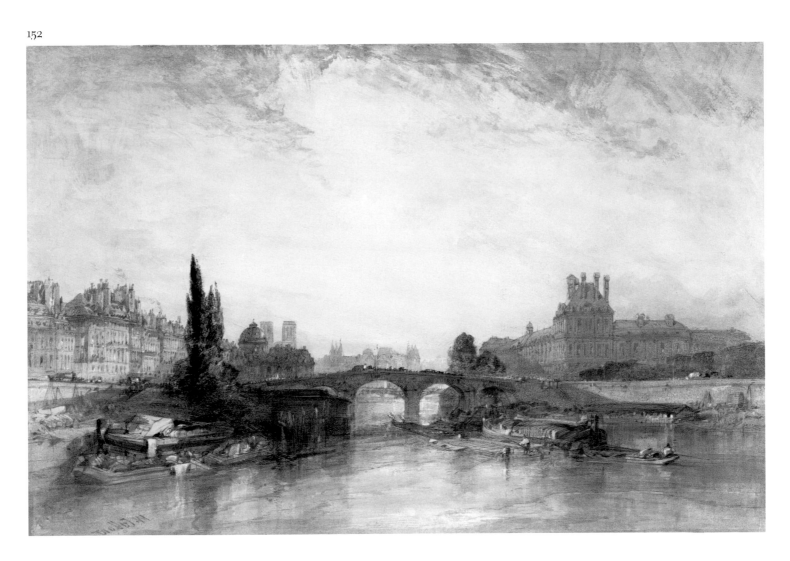

153
William Wyld (1806–1889)
The Pont Royal c.1835

Watercolour and bodycolour
32.4 x 50.2 (12¾ x 19¾)
Signed lower left: *W. Wyld*
M. & R. Tullock, Courtesy of Hammond Smith
London only

Wyld was an attaché to the British delegation in Calais before he became a student of Louis Francia (no.143). Bonington's influence is apparent in his earliest watercolours. Although Wyld claims never to have met his countryman, he was an intimate friend and business acquaintance of Bonington's foremost patron, the Bordeaux wine merchant Lewis Brown. Like William Callow, Wyld evolved an elaborate and at times overly fastidious exhibition style. In 1833 he travelled to Algiers, from where he accompanied Horace Vernet to Rome and toured Italy. Although Wyld passed most of his professional life in France, he became the favourite watercolourist of Queen Victoria, for whom he produced a great number of elaborate topographical views in both countries. The panoramic format, meticulous detail and glowing atmospheric shroud of this example are hallmarks of his mature style.

Wyld made his public debut in Paris at the fourth instalment of an exhibition organised for the benefit of cholera victims at the Musée Colbert in May 1830. During the next decade, his watercolours appeared regularly in the Salons. Wyld was extremely successful in France and would receive gold medals at the 1839 and 1841 Salons. PN

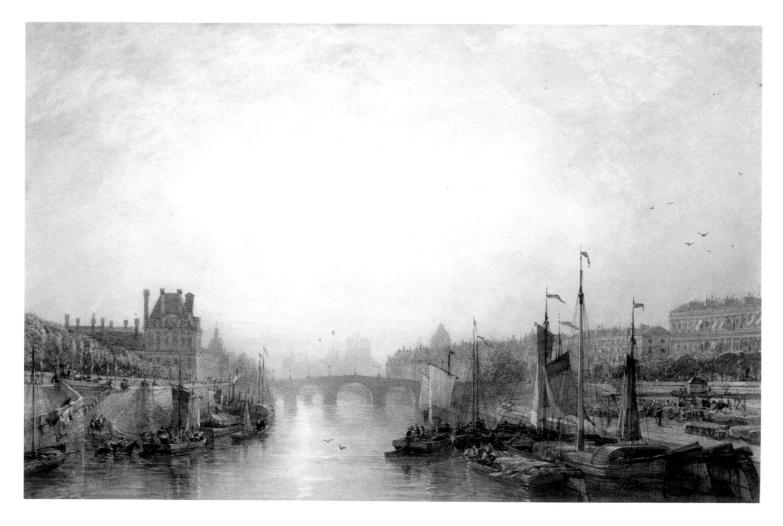

154
J.M.W. Turner (1775–1851)
Rouen, Looking Upriver c.1832

Gouache and watercolour on paper
14 x 19.2 (5½ x 7⅝)
Tate. Bequeathed by the artist 1856

One of Turner's major projects undertaken during the 1820s was a series of views of the Rivers Loire and Seine, to be published by Charles Heath. In recognition of the fashion of the time for illustrated annuals or 'keepsake' books to catch the Christmas market, these were first advertised as Turner's *Annual Tours*, although their published titles were *Wanderings by the Loire* (1833) and *Wanderings by the Seine* (two volumes, 1834 and 1835). Later, the views were assembled in one volume as *The Rivers of France*. The engravings of Turner's specially prepared watercolours were accompanied by letterpress by Leitch Ritchie. The books were aimed mainly at the middle-class travellers who were now flocking across the Channel.

Rouen was a key subject of the Seine series. For British travellers who landed at Dieppe, it was the most important and interesting stop on the way to Paris; by this time it was also served by steamers. Turner's view, looking upstream, achieves its comprehensive effect by optical illusion, conflating far more the cathedral, the abbey church of St-Ouen, the new riverside buildings and Pont d'Angoulême behind the old bridge of boats, Mont Ste Catherine – into its small space than could really be seen from a single viewpoint. It was engraved for the first Seine volume by Robert Brandard. DBB

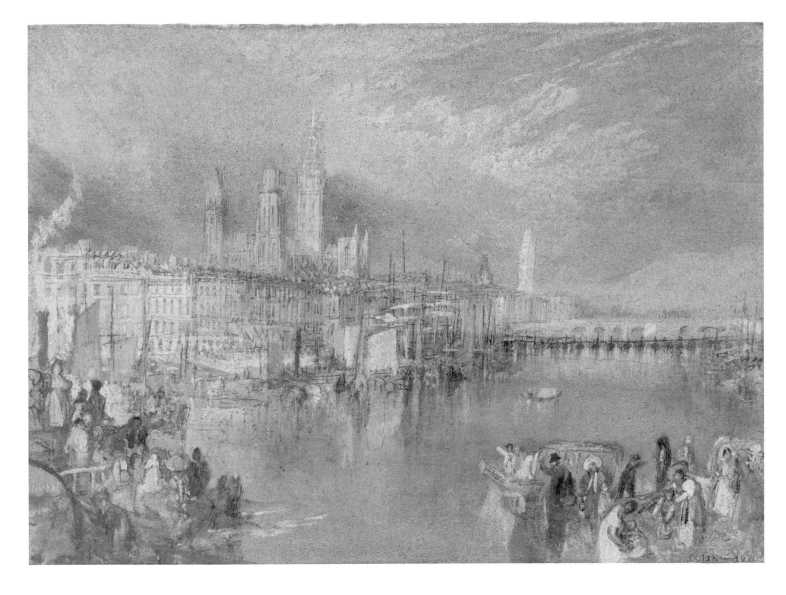

155

J.M.W.Turner (1775–1851)
Lillebonne, Looking Towards the Seine c.1832

Gouache and watercolour on paper
14.1 x 19.1 (5½ x 7½)
Tate. Bequeathed by the artist 1856

Lillebonne is set some distance back from the north bank of the River Seine, in a 'golden valley' opening into the mouth of the river. With its château and Roman amphitheatre, it was an important historical centre, and had been the rallying point for William the Conqueror before his invasion of England. The links between British history and Normandy were of special interest to Romantic historians and antiquarians, and this must account for Turner's allocation of two Lillebonne subjects to the first volume of the *Seine* illustrated annuals. This one, which was engraved by Thomas Jeavons, shows the château at the centre, the amphitheatre to its left and the church of Notre Dame on the right. In a typical fusion of the varied aspects of modern life with landscape and history, Turner shows both harvesters pausing from their work in the fields and the smoking chimney of a new factory. DBB

J.M.W.Turner (1775–1851)

156
J.M.W. Turner (1775–1851)
Paris: The Pont Neuf and Ile de la Cité c.1833

Gouache and watercolour on paper
14.3 x 18.8 (5⅝ x 7⅜)
Tate. Bequeathed by the artist 1856

Inevitably, Paris marked a significant climax of Turner's series of River Seine views. He visited the capital on at least seven occasions, but gave it closest scrutiny in 1832, when he was collecting material for the second volume (1835) of the *Seine* illustrated annual. It was either that year, or more probably during an earlier stay in the city in 1829, that he visited Delacroix in his studio on the Quai Voltaire. Delacroix was already familiar with Turner's topographical work from his London visit in 1825, and one wonders what he would have made of a view such as this, ostensibly showing the Seine a short distance upstream from his studio but in fact not literally achievable at all. Engraved by William Miller, this was one of five Paris scenes to appear in the 1835 volume. Here, as in his view of Rouen (no.154), Turner has constructed an elaborate perspective conceit to bring as much of the city as possible into his view, as well as its varied inhabitants – soldiers, tradespeople, strollers, coach passengers, boatmen and riverside laundresses – who crowd on and around the *quai*. His combination of a series of on-the-spot drawings

is explained by Ian Warrell (1999–2000, p.235). The very metropolitan energy and bustle of Turner's Paris views prompted Leitch Ritchie, in his commentary on another subject in the series, to muse on the liberating effect of the Parisian crowd on the more reserved British: 'wandering like a spirit, lonely and silent, through the throng, we have often wished that we could exchange the taciturn, meditative manner of our country for the restless happy buoyancy of the Parisian.' DBB

157
Paul Huet (1803–1869)
Cannes 1839

Watercolour, bodycolour, scraping, sanding
and stopping out, with gum arabic
31 x 47 (12½ x 18¾)
Minneapolis Institute of Arts, The William
Hood Dunwoody Fund

In 1837 Huet was named drawing master to the
Duchesse d'Orléans. The following year, as a
result of his wife's failing health, he made his
first visit to Nice, where the atmosphere and
colours reminded him of Titian and Alexandre-
Gabriel Decamps. While there, the Duc
d'Orléans commissioned for two thousand
francs a grand series of finished watercolours of
the major cities in the south of France, of which
this is one example.

Huet probably made a preliminary sketch
for this watercolour when he visited Cannes in
May 1839. It is uncertain how many
watercolours were actually produced for the
Duc, although an impressive group were on the
market at the same time as this Turnerian
example. In his command of an array of
complicated techniques and by the variety of
his compositional inventions, Huet produced
a stunning topographical suite that could stand
comparison with the most accomplished
productions of his British contemporaries,
including Turner's numerous series of English
coastal views and Bonington's contributions to
J.-F. d'Osterwald's Normandy project (no.144).
PN

158

J.M.W. Turner (1775–1851)
Margate from the Sea: Whiting Fishing 1822

Watercolour, gouache, gum arabic, scraping and rubbing out
41.9 x 64.8 (16½ x 25½)
Signed and dated lower l.: *J M W Turner RA 1822*
Private Collection

Turner's watercolours had reached a peak of technical virtuosity by the 1820s, and were regarded as extraordinary achievements for their tonal brilliance and atmospherics. They were sought after as original works, and for translation into prints. This luminous view of Margate was one of a series of marine watercolours commissioned by the engraver and publisher W.B. Cooke between 1822 and 1824. His plan to issue mezzotint engravings of them, entitled 'Marine Views', never came to fruition, but the engraver Thomas Lupton produced a highly expressive plate of this watercolour. The subject was dear to Turner, who regularly visited Margate, now becoming a thriving coastal resort as well as a busy fishing port. Though intended mainly for reproduction, Turner painted it on the scale of an exhibition watercolour and flooded it with morning light both in the sky and reflected in the water, celebrating its arrival by the morning gun fired from the guardship in the distance on the left.

Besides assembling their own Turner watercolours, the Cookes organised loan exhibitions of other watercolours by the artist from 1822 to 1824. Their connections proved especially useful to Bonington and Alexandre-Marie Colin in London in 1825, for the engraver

Abraham Raimbach seems to have asked the Cookes to obtain introductions for the visitors from Paris to see the collections of Walter Fawkes, Sir John Leicester and the Marquis of Stafford, all of which contained important Turners – watercolours being especially numerous in Fawkes's case – as well as other British artists. Bonington's handling of watercolour became more experimental and richly coloured under Turner's influence. This example, which he would certainly have seen, provides the first concrete – as opposed to coincidental – parallel between the two artists' techniques and treatment of coastal subject matter. Bonington owned an impression of Lupton's plate. Other French admirers of Turner's watercolours at this time included Charles Nodier, who presumably saw examples set aside in the Cookes' workshop in London on his way to Scotland in 1821, and Amadée Pichot, who was shown some by the printmaker Charles Hullmandel in 1825. DBB

159
William Daniell (1769–1837)
Windsor Castle from near Brocas Meadow 1827

Watercolour, pen and ink over graphite with scraping out on wove paper, laid down on original mount, with borders in pen and blue/grey ink
30.8 x 50.3 (12⅛ x 19¾)
Signed and dated, lower left: *W. Daniell / 1827*
References: Jal, 1827, pp.17–18; Delécluze, 1827 (28 April 1828), p.2.
Yale Center For British Art, Paul Mellon Collection

Daniell was the nephew and pupil of Thomas Daniell. He charted the entire British coast in 1812, which resulted in a monumental publication of topographical aquatints, *A Voyage Round Great Britain* (1814–25), a publication that undoubtedly inspired Osterwald in Paris a few years later (no.145). In 1822, William was elected a full member of the Royal Academy. His only appearance in France was at the 1827 Salon, where his works generated a greater sensation than Constable's.

This is one of twelve *Views of Windsor, Eton and Virginia Water*, reproduced in aquatint and published by Daniell between 1827 and 1830. It was probably one of the original watercolours exhibited by the artist in Paris in 1827, together with several oil paintings of Indian subjects. Auguste Jal was highly critical of the British artists exhibiting in 1827, arguing that the jury had favoured them over French applicants. He was especially annoyed that Delacroix's portrait of Louis-Auguste Schwiter (no.52) was rejected. The oils by Constable and Daniell were dismissed as inconceivably negligent and coarse, and the only works by Daniell that Jal considered worthy of review were his watercolours. Jal's response was typical but knee-jerk, since the jury's acceptance of one Constable, one Lawrence and a few Daniells had little connection with their rejection of several major Delacroix's and

virtually all of Paul Huet's paintings. The jury's reaction to British artists was, in fact, as harsh as it had been to their supporters in the French school. It simply echoed the conservative *retranchement* that pervaded the cultural and political institutions in France at that moment.
PN

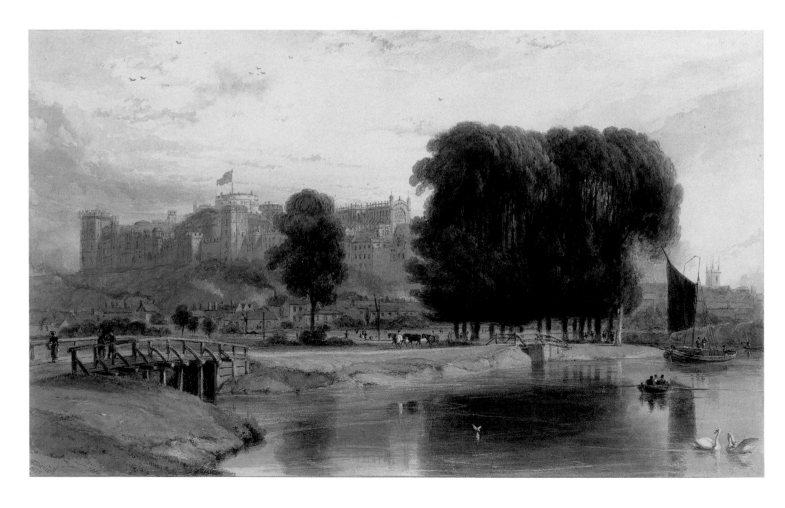

160
Jules Joyant (1803–1854)
*San Giorgio Maggiore from the Dogana, Venice c.*1830

Watercolour on wove paper
18 x 26.5 (7⅛ x 10½)
Signed, lower right: *J. Joyant*
The British Museum, London
London only

During his lifetime, Bonington attracted a host of casual students in watercolour, many of whom would become distinguished painters and teachers. Charles Gleyre, Adrian Dauzats and Joyant are a few of the non-British artists in this category. Joyant studied initially with the academic landscape painter Xavier Bidauld. He met Bonington around 1828 and was so impressed by his Venetian pictures that he determined to visit the city the following year. For the remainder of his professional life, he would send views of Venice to the Salons. His oil, *Courtyard of the Doge's Palace* (Salon 1838), Planche would describe as 'a work painted with rare solidity' and the éclat of Bonington.

Joyant's studio sale contained hundreds of Italian sketches and paintings and numerous copies of Bonington. Acknowledging his debt to the British artist, he would later recall that: 'During Bonington's lifetime Madame Hulin was known to be very partial to his drawings, and I have no doubt she decided to purchase several of mine because they reminded her of those of my master in watercolours.' This example is probably an early work, before Joyant became too reliant on Canaletto's staffage and 'precision'. The execution and

palette also recall Thomas Shotter Boys's watercolours of 1830. PN

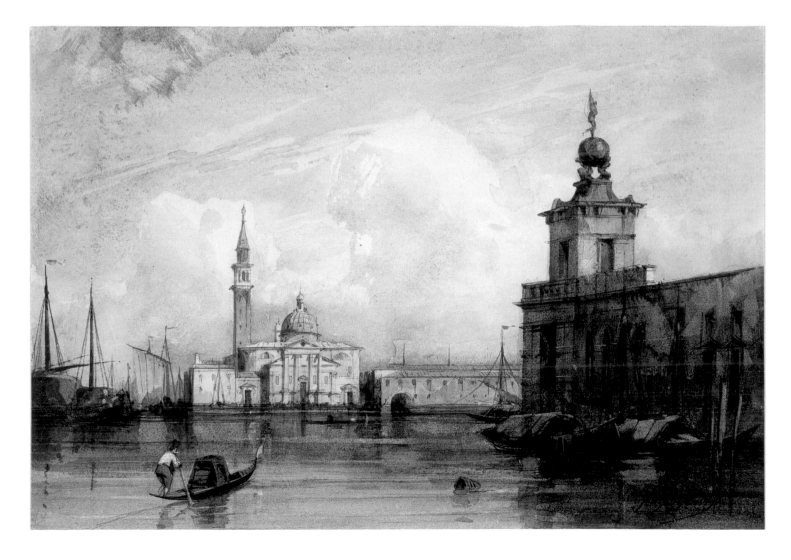

161
Camille Roqueplan (1800–1855)
A Shipwreck c.1825–30

Watercolour and bodycolour
18 x 26.6 (7 x 10½)
Signed, lower right: *Camille Roqueplan*
Musée des Beaux-Arts et de la Dentelle, Calais
Minneapolis and New York only

Marine paintings feature in Roqueplan's oeuvre from his earliest years. This example unquestionably dates to his youth. The violent seas and agitated skies of Normandy were as inspiring to him as the beaches of his native Provence and the relentless calm of the Mediterranean. Titles of his exhibited pictures indicate that he toured Normandy and Brittany frequently during the 1820s.

From 1825 to 1830, Roqueplan focused particularly on marine subjects, including the depiction of the ocean's more threatening aspects, as in *Marée d'Equinoxe* (no.57). The historian Charles Blanc's (1869) assessment of Roqueplan's achievement was most apt: 'When others wanted to be prodigious, eccentric, wild, bizarre, he was content to be charming … As for marines, he painted them in an original and excellent manner somewhere between the precise and tranquil finesse of Bonington and the flickering brilliance of Isabey.' MW

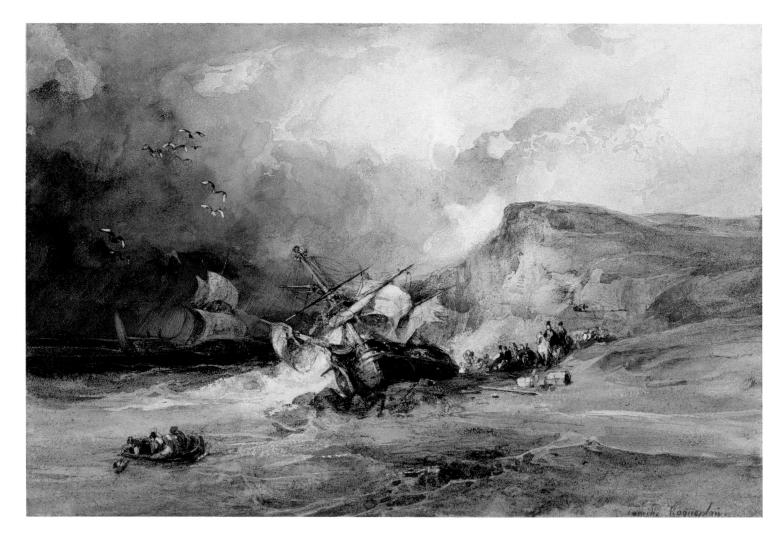

162

Eugène Isabey (1803–1886)
A Shipwreck 1838

Gouache and charcoal
29.5 x 40.4 (11½ x 16)
Signed and dated, lower right: *E. Isabey 1838*
Van Gogh Museum, Amsterdam
London only

Depictions of shipwrecks were plentiful in
Isabey's oeuvre, especially in the 1830s, and
would reappear with regularity until well past
the moment when they were utterly unstylish.
Popular and prevalent as the theme was in the
early nineteenth century, neither Britain nor
France could claim ascendancy in the
depiction of disasters at sea, as both countries
had respectable traditions of representing such
dramas from the eighteenth century. What was
essentially British in derivation, however, was
Isabey's bold mixing of several water-based
media to create a work with the visual force of
an oil painting. The composition of this highly
wrought watercolour is anticipated by that of
an Isabey lithograph, *Brig Aground*, dated
1836. PN

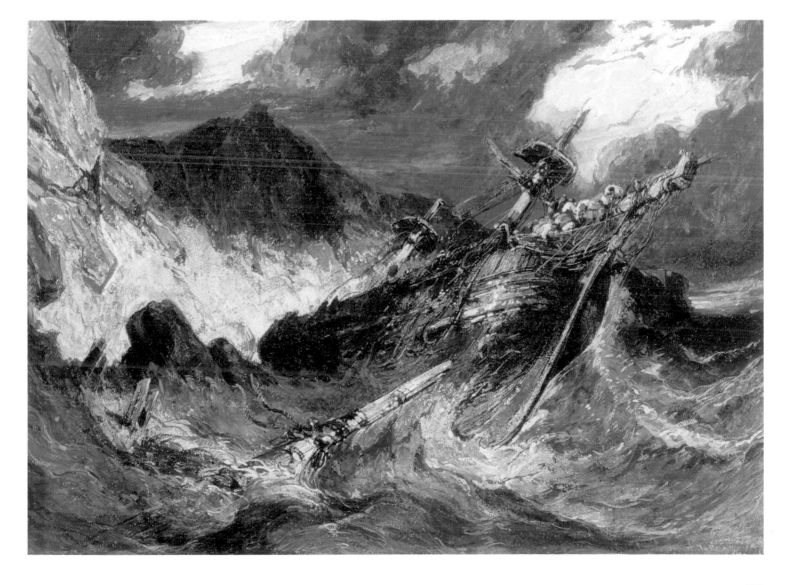

163
Eugène Lami (1800–1890)
Hunting at Chantilly 1829

Watercolour and gouache on paper
20.2 x 34.8 (8 x 13¾)
Signed and dated, lower right: *Eugene Lami
1829*
Private Collection

Lami studied with Horace Vernet before entering Gros's studio in 1817, where he befriended Bonington and Delaroche. His earliest illustrations were of military subjects. In 1823 he collaborated with Géricault on a series of lithographic illustrations of Byron's work. At Bonington's urging he visited England in 1826–7 and subsequently produced two sets of lithographs, including a humorous *Voyages en Angleterre* of 1829–30 (fig.63). Other notable projects of the 1820s included vignettes to Amadée Pichot's *Vues pittoresques en Ecosse* (1826) and nine designs for Charles Gosselin's ongoing *Oeuvres complètes de Walter Scott* (1826–8).

Chantilly, hereditary estate of the Condé line descending from Henri IV, was a Bourbon stronghold until 1830. It was already legendary for its English hunts in the preceding century. Following the Restoration, the Duc de Bourbon, a passionate Anglophile, re-established the hunt and constructed an English garden on the ruins of Le Nôtre's seventeenth-century classical French park immediately adjacent to the château. In 1834, the Jockey Club, known more formally as the *Société d'encouragement pour l'amélioration des races de chevaux en France*, sanctioned an official race course on the grounds. Lami was to be the 'unofficial' chronicler of its history.

This illustration of a stag hunt is dated to the same year as Lami's famous series of

lithographs, *Quadrille de Marie Stuart* (1829), which commemorated the historical costume ball hosted by the Duchesse de Berry on the eve of the Bourbon collapse. *Hunting at Chantilly* is one of his earliest essays in what would become a lucrative genre for the artist. Its inspiration amongst the plethora of comparable works by Henry Alken and other British sporting artists is conceded, but the dazzling and balanced manipulation of both transparent and opaque watercolours, and Lami's exquisite draughtsmanship, have few parallels in the British school. PN

fig.63
Eugène Lami
*Voyages en Angleterre (*also known
as *Souvenirs de Londres), Paris*
1829–30
No. 9, *Les Boxeurs*
Lithograph
Yale Center for British Art, Paul
Mellon Collection

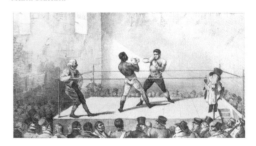

164
Eugène Lami (1800–1890)
Alfred de Musset 1828

Watercolour
25.4 × 20.3 (10 × 8)
Signed, lower right: *Eug. L.*
Inscribed: *Chez Mme Panckoukes. 1828 / Alf. De Musset / Le Cap Ferrier*[?]
Mr & Mrs Hamilton
Robinson, Jr.

The poet and playwright Alfred de Musset (1810–1857) was no less a dandy than Lami. In the year that this lively sketch was drawn, Musset published his first ballad and his reworking of Thomas de Quincey's *Confessions of an Opium Eater*, which would shortly inspire Hector Berlioz's *Symphonie Fantastique* (1830). His first collection of poems, *Contes d'Espagne et d'Italie* (1829), gained him entrée to Victor Hugo's circle. *Confession d'un Enfant du Siècle* (1835), the brilliant autobiographical account of the malaise afflicting his generation, followed his volatile affair with George Sand. Lami would eventually illustrate the 1883 edition of Musset's complete works.

The Madame Panckoucke cited in the inscription and presumably Musset's insistent dance partner was undoubtedly the spouse of Charles Panckoucke (1780–1853), proprietor of the influential newspaper *Le Moniteur Universel*. A finished watercolour, now untraced, appears to have resulted from this sketch from the life.

After the July Revolution, Lami squandered much of his formidable talent as an oil painter on battle scenes for Versailles, and he would follow Louis-Philippe into exile in London in 1848. A consummate socialite, he flourished for decades as one of the more astute chroniclers of both French and British society. Charles Baudelaire would describe him as 'the poet of dandyism, almost English in his love of things aristocratic'. Prince Anatole Demidoff, a devoted patron, voiced a similar opinion: 'Lami was one of the freshest and most gracious talents, totally tinged by an aristocratic perfume.' Finally, he was one of the first truly professional French watercolourists of the nineteenth century, and the founding of the Société des Aquarellistes Français in 1879 was due largely to his industry. PN

165
Newton Fielding (1799–1856) and William Callow (1812–1898)
Deerhound and Bitch Cornering a Stag 1832

Watercolour, bodycolour, scraping
and gum arabic
28.3 x 43.8 (11⅛ x 17¼)
Signed and dated, lower right: *Newton Fielding 1832*
Yale Center for British Art, Paul Mellon
Collection

Of the three Fielding brothers who moved to Paris in 1821, Newton alone remained in France after 1825 to continue the family publishing business with the assistance of English apprentices. In their professional relationships, Thales Fielding and Delacroix were inseparable. Newton was perhaps closest to Bonington, and they spent a week together in Dieppe in July 1824.

By 1827, when he concluded his work for the publisher J.-F. d'Osterwald, Newton was well established in Paris as an animalier and sporting artist. In that year he was appointed drawing master to the household of the Duc d'Orléans. His several entries of unidentified watercolours at the 1827 Salon, which belonged to Delacroix's friend Frédéric LeBlond, were attacked by the critic Charles Farcy for abusing the technical means of watercolour painting and polluting the traditional wash style with admixtures of bodycolour and gum arabic, both employed extensively in *Deerhound and Bitch Cornering a Stag*. The resentment of this deliberate attempt to blur the distinctions between oil and watercolour painting was not peculiar to France, where the hierarchy of media was especially rigid, but was often encountered in London.

Newton's animal drawings most often tend to the whimsical, although in this instance he aimed at the drama associated with a venerable theme of hounds coursing a stag to exhaustion and death. Compositions in the more compassionate spirit of Thomas Bewick appear in his aquatint set *Sporting Game*, published in Paris in 1828, and in two sets of lithographs, *Croquis de Newton Fielding* and *Animals Drawn on the Stone*, also published in Paris in 1829. This watercolour of 1832 was probably a collaboration between Newton and his apprentice William Callow, who recalled in his autobiography painting landscapes into which Newton would introduce an animal or hunt scene. Newton submitted two such watercolours to an exhibition at the Musée Colbert in 1832. PN

166
Théodore Géricault (1791–1824)
Frightened Horse, after Stubbs
c. 1821–3

Oil on paper on canvas
26.4 x 19.1 (10⅜ x 7½)
Wheelock Whitney, New York

Early in his career, Géricault drew copies of George Stubbs's series of engravings *Anatomy of a Horse*. He also appears to have made three undated oil copies after other works by Stubbs: *The Blenheim Tiger*; *Lion Attacking a White Horse* (Louvre); and this fragment, *Frightened Horse* which, together with another fragment of a lioness, once formed a copy after Benjamin Green's mezzotint *The Horse and the Lioness*. Géricault's lithograph, *Horses Fighting in a Stable* (1818), may also derive from Stubbs's celebrated depiction of a similar subject.

Géricault's initial contact with Stubbs's work was in the form of prints shown him by Carle Vernet, before he ever visited England. But as with Delacroix, the English sojourn and renewed contact with Stubbs's paintings and graphics fired the artist's imagination. While in England, Géricault probably painted *Horse Frightened by a Storm* (no.96) and executed several Stubbs-inspired lithographs of lions attacking horses. He also copied, as would Barye some years later, James Northcote's famous image of a lion crushing a snake. PN

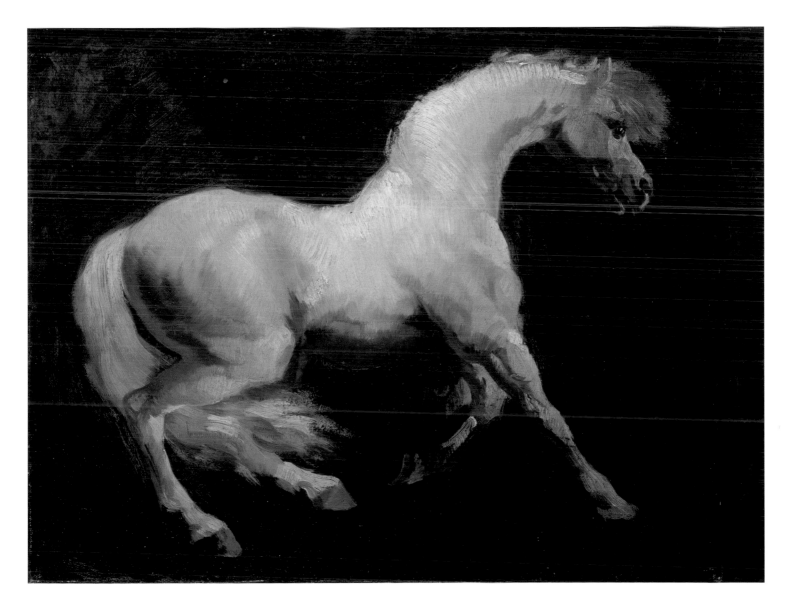

167
Théodore Géricault (1791–1824)
The Coal Wagon 1820–1

Watercolour
21.3 x 27.5 (8½ x 10⅞)
The British Museum, London
London only

This splendid watercolour relates to Géricault's *Various Subjects Drawn from the Life and on Stone* and *Etudes des Chevaux* (no.13). Although this composition did not result in a print, the subject of the coal wagon does appear in a lithograph for *Various Subjects*, and it represents a leitmotif in the artist's graphic work of the period. The inscription on the placard confirms that the terrain is the environs of London, with the city scarcely visible in the inky distance. There is a vast difference between Constable's near-contemporary interpretation of similar terrain (no.114) and Géricault's brooding, almost black, representation of the British landscape. One British critic attributed the commercial failure of Géricault's 'bold, effective and truthful drawings of English scenes and character' to their wanting the 'prettiness of manner which tickles the fancy of the English public' (*Library of the Fine Arts*, 1831, p.201).

It has been often argued that Géricault's delicate and depressed state of mind during his London period finds expression in such works; without disputing the point, it need also be recalled that London was considered by every foreign visitor as a city rendered bleak by excessive pollution. It was the purer air of French Calais that the German Prince Pückler relished in January 1829 after several years of living in Britain. 'My first morning walk in France', he wrote, 'was quite delicious. The unbroken sunshine, the clear sky I had not seen for so long, a town in which the houses are not put in eternal mourning by coal smoke and stood out bright and clear from the atmosphere' (*Tour*, p.564). PN

Théodore Géricault (1791–1824)
168
*Two Draught Horses With a
Sleeping Driver* 1822

Brown and grey wash over graphite on coarse
wove paper
29.9 x 38.2 (11¾ x 15)
The Metropolitan Museum of Art, New York.
Purchase, Joseph Pulitzer Bequest and Harry
G. Sperling Fund 1996
New York only

169
*An Old Horse and Stable Boy at
an Inn* c.1822–3

Brown and grey wash over graphite on paper
30 x 38.8 (11¾ x 15¼)
Corinne Cuéller
London and Minneapolis only

Géricault's later lithographs, offering an
unparalleled assortment of real-life themes,
were mostly sport and genre aimed at British
and French audiences familiar, at least, with the
images of horses in their different roles. As one
French visitor observed in 1833: 'The English
understand better than any other people how
to use the horse … Every age and sex practises
equitation. From the *élégant* who wants to be
admired in Hyde Park for the swiftness of his
mount to the city merchant who rents a nag for
a trip to the country on Sunday, everyone rides
horses' (Gury, *Outre-Manche*, p.853).

The second sheet is a study for the
lithograph *Vieux Cheval à la Porte d'une
Auberge* in a lithographic series *Etudes des
Chevaux*, executed by Léon Cogniet (no.36)
and Joseph Volmar after Géricault's designs
and published in Paris in April 1823. The
project involved Cogniet copying in reverse
six of the twelve lithographs from Géricault's
Various Subjects (no.167) and Volmar making
new prints after other wash drawings, with
Géricault carefully supervising the work. *Two
Draught Horses With a Sleeping Driver*,
although not used for a lithograph, certainly
relates in sentiment to the project *Etudes des
Chevaux*. PN

168

169

170
Henry Thomas Alken (1785–1851)
*Steeplechasing: Three Riders
taking a Brook* c.1825

Watercolour and graphite
26 x 36.7 (10¼ x 14½)
Yale Center for British Art, Paul Mellon
Collection

Alken was one of the most prolific sporting artists in Britain. Painter, draughtsman and engraver, he produced from 1815 onwards a profusion of hunting, racing, shooting and fishing images. All of these subjects, together with otter spearing, bear baiting and cock fighting, comprised his most ambitious set of fifty aquatints, *The National Sports of Great Britain* (1820).

Lorenz Eitner has argued convincingly for the influence of Alken's compositional formulas on Géricault's most famous sporting picture, *Epsom Derby* (fig.47), painted in England for Géricault's host, the horse trader Adam Elmore. A similar source could be found for Géricault's lithographs *La Course*, from the *Suite of Eight Small Pieces* (1823) which, like his other lithographic suites of 1822–3, show a range of horse breeds and their employment, and for the lithograph *Horse Leaping a Barrier*, from a set of seven vignettes, also of 1823. At his death, Géricault actually owned seven coloured designs by Alken and one painting of a horse race by an unidentified British artist. Susan Lodge (1965, p.620) has proposed that the designs were possibly from Alken's set of etchings *The Beauties and Defects in the Figure of the Horse* (1816), since Géricault appears to have copied one of those plates for his *Horse Leaping a Barrier*.

Alken, in turn, probably admired Géricault's first master, Carle Vernet (no.4), whose various publications – *Recueil des chevaux de tous genres* (Paris, 1811), *Divers croquis des chevaux* (Paris and London, 1821) and *Vernet's Horses* (London, 1822) – were highly prized in Britain. PN

171
Paul Huet (1803–1869)
Return from the Hunt c.1830

Watercolour and bodycolour on paper
52.5 x 34.5 (20⅝ x 13⅝)
Private Collection

This sheet ranks among the most accomplished French and British watercolours of the period. With extraordinary virtuosity, Huet has succeeded in blurring the boundaries between oil and watercolour painting, demonstrating with an authority not previously seen in France that the latter medium was indeed a vehicle for profound artistic achievement. He was one of the first, Gautier would later observe, to have made oil paint express the 'limpidity, the vapours and the transparencies of English watercolour' (1855, II, p.134). As a tour de force of execution and naturalistic observation, the work immediately suggests Constable's influence, yet in all likelihood, it was their mutual sources of admiration, Claude Lorrain and Jacob van Ruisdael, who excited this brilliant performance. In general, Huet sought in such pictures to animate the traditions of landscape painting with a new spirit of mystery and spirituality, characteristic of the music and literature of his epoch.

Cottages nestled in woods and poachers or smugglers protected by thick forests were recurrent themes in Huet's art in the late 1820s, beginning with *The Caretaker's Cottage in the Forest of Compiègne* of 1826 (no.115) and culminating with his stunning series of six etchings issued in 1833–5. The influence of these themes on British painting is perhaps apparent in the forested hunting scenes that William Callow and Newton Fielding were painting in Paris in 1832 (no.165). PN

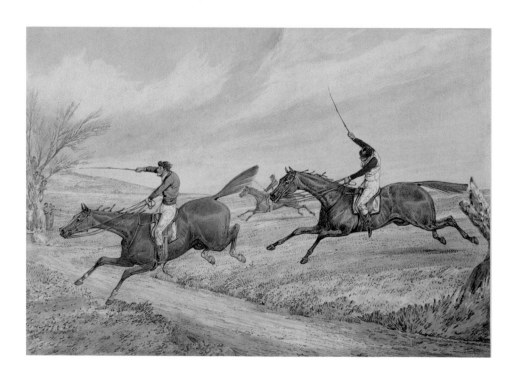

John Frederick Lewis
(1805–1876)
*Study of a Lioness c.*1824

Watercolour, bodycolour and graphite
36.5 x 42.2 (14⅜ x 16⅝)
Yale Center for British Art, Paul Mellon
Collection
Minneapolis and New York only

This life sketch by Lewis in his teenage years, anticipating his mature powers of observation and exacting execution, is related to his set of etchings of lions, *Series of Wild Animals* (London, 1824–5). The drawings for that project belonged to Thomas Lawrence and other devotees of the sporting genre such as Lord Northwick, who owned this sheet. It may also relate to preparatory work for the oil *Lion and Lioness: A Study from Nature* that Lewis exhibited at the Royal Academy in 1825.

Slightly junior to Edwin Landseer, Lewis was also raised in the milieu of an intensely creative and dynastic family of London engravers. Landseer was a childhood friend with whom he often drew the lions at Exeter Change menagerie in the Strand. His initial exhibits at the Royal Academy were animal and hunt scenes. It is uncertain when he first met

Bonington, but it was probably before 1827, when Lewis abandoned oil painting in favour of watercolour and began an itinerant existence in search of exotic subjects that lasted nearly two decades. His earlier watercolours have all the bravura and technical complexity of Bonington's best late style, which clearly inspired him. Tours of Italy in 1827 and Scotland in 1829 preceded a more protracted stay in Spain and Morocco from 1832 to 1833. On the return trip he visited William Callow and Thomas Shotter Boys in Paris and probably met Delacroix. In 1838 he embarked for Egypt via Rome and Constantinople, reaching Cairo in 1841 and settling there for ten years. On his return to London, he eventually renounced watercolour in favour of oils, but not before painting some of the most sophisticated works ever produced in that medium. PN

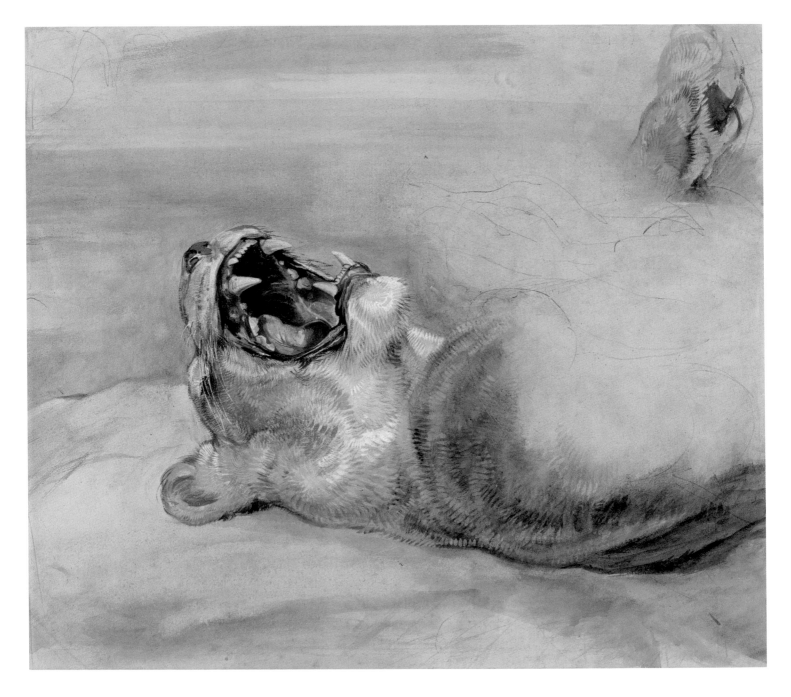

173
Eugène Delacroix (1798–1863)
Tiger Attacking a Wild Horse
c. 1828

Watercolour, bodycolour, rubbing out, gum arabic
13.7 x 20.3 (5⅜ x 8)
Signed, lower left: *Eug Delacroix*
The Metropolitan Museum of Art, New York.
Promised Gift from the Karen B. Cohen
Collection of Eugène Delacroix, in memory
of Alexandre P. Rosenberg
Minneapolis and New York only

Delacroix's prints of wild animals and horses date fairly securely to the period 1828–33, when he was studying in various menageries with Antoine-Louis Barye (nos.174, 175). A similarly treated subject of a lion devouring a horse, ultimately derived from engravings after Stubbs, also appeared as late as 1844. Stubbs's influence, initially via Géricault (no.166), is pronounced in Delacroix's early career. Delacroix at one time owned Géricault's copy of Stubbs's *Lion Attacking a White Horse* of 1820 (Louvre). Other instances of borrowing are from mezzotints after Stubbs's *Phaeton*, and *Two Horses Fighting in a Meadow*. Delacroix's well-known watercolour *Horse Frightened by Lightning* of 1828 was copied from a similar motif in Gilpin's diploma picture (no.95), while his lithograph *Wild Horse*, of the same year, is justifiably linked to British models.

A small oil of two felines stalking one another of 1829 was considered by Lee Johnson (*Delacroix*, I, no.55) as evolving directly from this watercolour, which would thus make it the earliest example of this new theme of feral combat that becomes familiar in Delacroix's later paintings and develops ultimately into the grand lion hunt scenes inspired by Rubens.

In the spring of 1828, Thales Fielding wrote to Delacroix urging him to send to London watercolours for sale to collectors (Ms. letter, Getty Research Institute). A carefully finished animal subject like this might have been intended for that market. PN

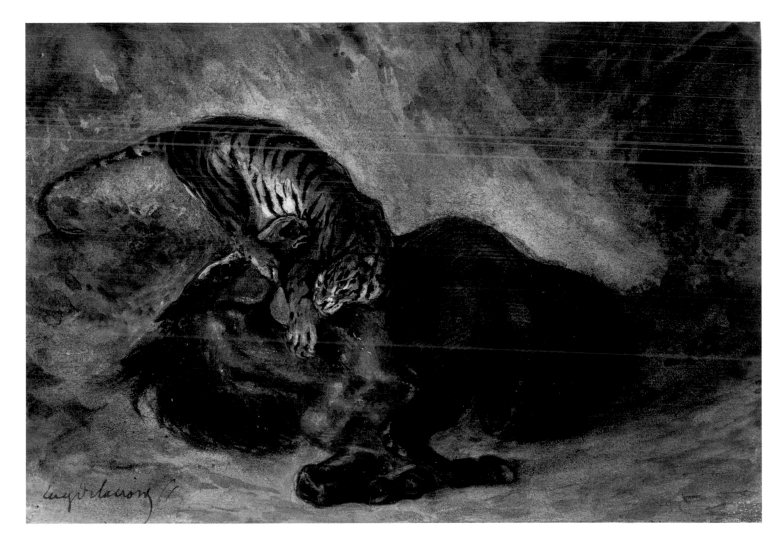

Antoine-Louis Barye (1795–1875)

174
Two Young Cape Lions c.1833

Point of brush and watercolour, gouache,
touches of gum arabic 29 x 46 (11½ x 18)
References: Anon., *L'Artiste*, 1833, p.176;
Lenormant, 1833, II, p.77.
Pierpont Morgan Library, New York, Bequest
of Alice Tully
London only

175
Bear Attacking a Bull 1830s

Watercolour on paper 21.3 x 35 (8⅜ x 13¾)
Signed, upper right: *BAYRE*
The Metropolitan Museum of Art, New York.
H.O. Havemeyer Collection, Bequest of Mrs
H.O. Havemeyer, 1929
Minneapolis and New York only

The most decorated nineteenth-century sculptor of animals and animal subjects, Barye entered the Ecole des Beaux-Arts in 1818 as a student of the French sculptor Joseph Bosio and of Gros. During his seven years at the school, he competed regularly, if unsuccessfully, for the Grand Prix de Sculpture. His interest in animal anatomy was as analytically pursued as that of Landseer and Lewis during the same years, and he began studying at various Paris menageries and zoos with Delacroix by 1827. In the summer of 1829, Delacroix and Barye were permitted to sketch the remains of a dead lion at the Jardin des Plantes. *Tiger Devouring a Ganges Crocodile*, the first of his large-scale bronze sculptures of predators locked in a Darwinian conflict of violence and death, was a sensation at the 1831 Salon.

Barye's watercolours, of which there are over two hundred recorded, generally repeat the subjects of his bronzes and make their initial appearance about 1830. His technique, while not highly sophisticated by British standards, was engagingly idiosyncratic and not without similarities to that of Alexandre-Gabriel Decamps. Philippe Burty astutely likened Barye's watercolours to 'painted low reliefs'. *L'Artiste*, in an 1831 review, praised them for 'having a design that Landseer would envy'. In 1833, Barye sent six watercolours of wild felines to the Salon, including *Two Young Cape Lions*. That example was acquired by the Duc d'Orléans.

Barye's British sources are well documented and, in addition to such obvious antecedents as Stubbs, Ward, and Daniell, include the illustrations to Edward Bennett's *The Tower Menagerie* (1829), Thomas Landseer's *Characteristic Sketches of Animals* (1830–2), James Northcote's *Lion and Snake* as engraved by S. W. Reynolds (1799), and Charles Bell's widely admired *Essays on the Anatomy of Expression in Painting* (1806). PN

174

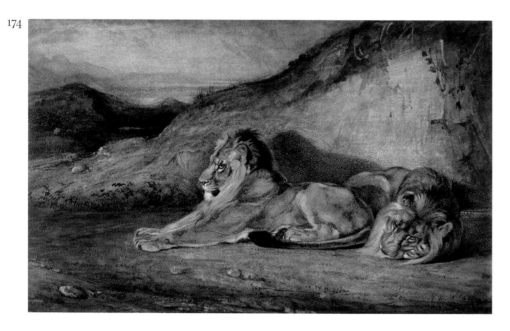

175

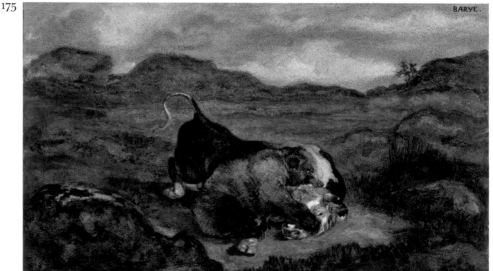

176
Jules Dupré (1811–1889)
Cottage Interior, Limousin 1835

Watercolour
24.5 x 46.5 (9⅝ x 18¼)
Signed and dated, lower right: *Jules Dupre 1835*
References: *L'Artiste*, XI (1836), p.170.
The British Museum, London
London only

This watercolour, of unexpected scale and
technical sophistication, has been identified
with that exhibited at the 1836 Salon as *Cottage
Interior, Limousin*. *L'Artiste* mentioned it in
passing as a watercolour that could rival a
painting in oils.

Robert Herbert (1962) first pointed to the
preponderant influence of Dutch genre in such
pictures, especially the paintings of David
Teniers the Younger and Adriaen van Ostade,
although engravings after David Wilkie or
Edwin Landseer might also be considered as
sources. It further recalls the watercolours of
rustic interiors popularised by William Henry
Hunt, among others, at the annual watercolour
exhibitions that Dupré would have visited
during his London visit of 1834. He would not
paint this type of genre subject again, leaving it
to the next generation of Realists to exploit, nor
would he practise watercolour painting with
any regularity. PN

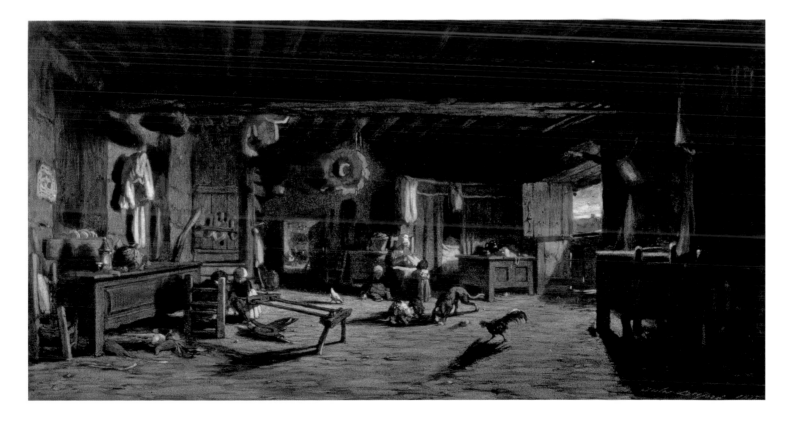

177
John Frederick Lewis
(1805–1876)
An Interior c.1834

Watercolour, gouache and gum arabic
on paper
30.2 x 37.5 (11⅞ x 14¾)
Tate. Purchased as part of the Oppé Collection
with assistance from the National Lottery
through the Heritage Lottery Fund 1996

Etienne Delécluze devoted an entire essay in 1831 to the 'barbarism of the times', wherein he chastised the 'Anglo-French school' for occupying studios that had not the masterworks of antiquity and the Renaissance on the walls, but rather 'medieval scrap iron, chinese screens, bizarre costumes and implements, and some vignettes cut from the latest Keepsakes'. This is precisely the ambience that Lewis has chosen to represent in this watercolour. Furthermore, he has incorporated two pictures within his composition, one of which reproduces a seventeenth-century Dutch artist and the second an oil version of Bonington's *Venetian Balcony* of c.1827. A tribute to both Bonington's Venetian palette and to Dutch genre painting is clearly implied.

This is possibly the watercolour that Lewis exhibited in London in 1834 with the title *An Interior*. Two other Lewis watercolours are preliminary studies. In one, he introduced

another work by Bonington, *François Ier and His Sister* of 1828. There may also be some connection to a lithograph by Delannois in *L'Artiste* in 1833. Delannois was one of several artists residing at the same Paris address as Thomas Shotter Boys (no.149), whom Lewis visited on his return from Spain in late 1833.

The larger thematic context for such a conception was the prevailing taste in the early 1830s for antiquarian interiors as one manifestation of the new historicism. That taste drew on many popular sources, starting with Walter Scott's *Antiquary* (1816); Honoré de Balzac's lengthy description of the curiosity shop in the first chapter of *The Fatal Skin* (1832); the opening of the Hôtel (now Musée) du Cluny in that same year by Alexandre Du Sommerard, and ultimately the pervasive fascination in the 1820s with the quintessential proto-romantic heroes, Don Quixote and Faust, who were always represented as antiquarians or alchemists in their respective studies. PN

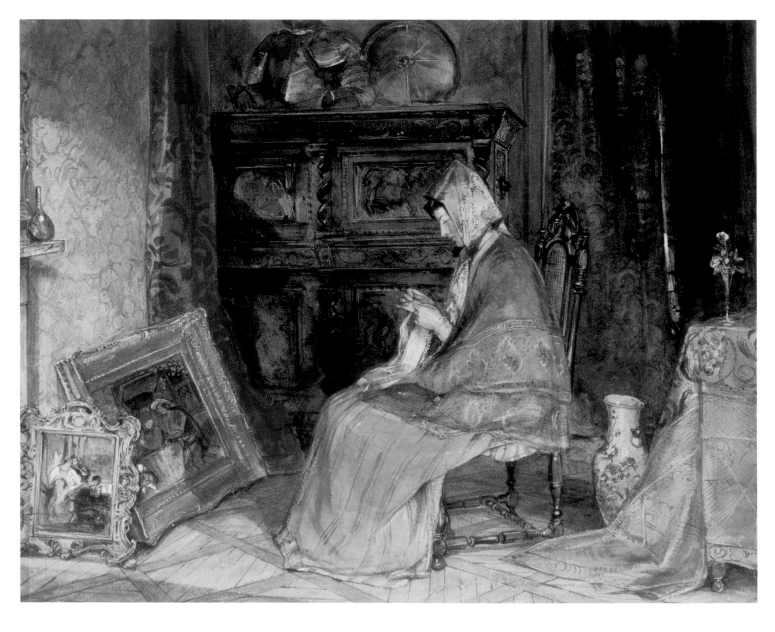

178
Edwin Landseer (1802–1873)
The Bride of Lammermoor c.1828

Oil on panel
32.4 x 24.8 (12¾ x 9¾)
Philadelphia Museum of Art, The Henry
P. McIlhenny Collection in memory of Frances
P. McIlhenny, 1986

Following Walter Scott's bankruptcy in 1826, the author and his publisher, Robert Cadell, devised a scheme of issuing a complete edition in forty-eight volumes of the *Waverley* novels, annotated by Scott and illustrated by prominent British artists. William Finden engraved this composition as the frontispiece for volume thirteen, published in 1829. The scene occurs in chapter five. Sir William Ashton and his daughter Lucy are out walking when they are charged by a wild bull. Scott likened it to the famous breed of bulls at Chillingham Castle, the ancestral estate of his and Landseer's friend the Earl of Tankerville. Such animals he described as the ferocious and untamable descendants of the savage herds that roamed the highlands from antiquity. As Lucy faints, Edgar Ravenswood appears and shoots the attacking beast. Although Ashton had

previously deprived Ravenswood of his inheritance through suspect legal manoeuvering, the two would be reconciled by Ashton's support of Edgar's courtship of Lucy. That ill-starred alliance would end in their deaths (no.179).

The Cadell edition remained the definitive collection of Scott's works in English. However, it had been preceded by Charles Gosselin's French edition of the complete works with translations by Antoine-Jean Defauconpret and Amadée Pichot, begun in 1822 and supplemented with portfolios of vignettes designed by Alexandre Desenne (1823), and of engraved views after designs by Antoine Johannot, William Finden, William Heath and Richard Westall (1826). By that date, Scott's latest novels were appearing simultaneously in French translation, so voracious was the taste of the Parisian public for his writings. Melodramas and plays also blossomed as quickly as a libretto or script could be fashioned from the newest addition to the corpus: *Guy Mannering* in 1821; *Kenilworth* and *Rob Roy* in 1822; *Ivanhoe* in 1826; Marie Mély-Janin's *Louis XI* from *Quentin Durward* in 1827; *The Bride of Lammermoor* in 1828; and Victor Hugo's *Amy Robsart* from *Kenilworth* in 1828, a colossal failure despite Delacroix's costume designs. PN

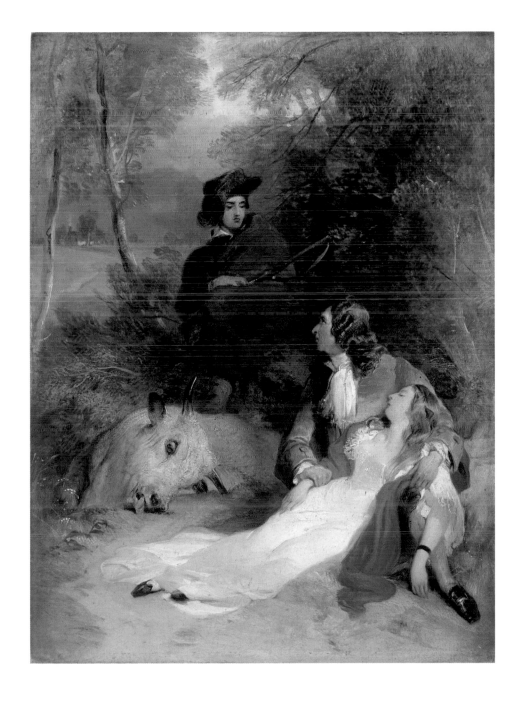

179
Eugène Delacroix (1798–1863)
Lucy Ashton's Bridal Night,
The Bride of Lammermoor c.1824

Watercolour and bodycolour, with stopping
out over graphite
19.2 x 26.5 (7½ x 10⅜)
Art Gallery of Ontario, Toronto

This watercolour illustrates an episode near the conclusion of Walter Scott's *The Bride of Lammermoor* (no.178). Lucy Ashton, having lost hope of ever marrying Edgar Ravenswood, has consented reluctantly to marry the dissipated Frank Bucklaw. On their wedding night she repeatedly stabs him. Alarmed by his shrieks, guests breach the bedroom door to find the bridegroom 'lying on the threshold … and all around was flooded with blood'. Lucy cowers in the corner of a large fireplace, 'her head-gear dishevelled; her night-clothes torn and dabbled with blood – her eyes glazed, and her features convulsed into a wild paroxysm of insanity'.

Delacroix's first reference to Scott was a journal entry of 30 December 1823, in which he mentioned the sale of his oil *The Wounded Ivanhoe* (Wrightsman Collection). Delacroix invariably turned to printed texts rather than theatrical performances when assaying subjects from Scott. In this instance, he probably relied on the new translation for Charles Gosselin's edition of the collected works issued in March 1823. Alfred Robaut's (*Delacroix*, no.104)

proposed date of 1824 for this watercolour seems reasonable on both the circumstantial and stylistic evidence. A graphite preparatory sketch for the composition is also more characteristic of Delacroix's earlier manner, and the macabre subject complements his contemporary interest in Francisco de Goya's *Los Caprichos*. His *Self-Portrait as Ravenswood* (Louvre), dated variously 1821–4, confirms a special affection for this story.

Robaut (ibid.) described this sheet as a study rather than a definitive work, but the existence of the graphite sketch would argue the opposite. The area of Lucy's torso is heavily reworked, suggesting that the artist had difficulties with the flesh tones, and the overall handling lacks the sophistication that he would gradually acquire through association with Bonington the following year. Nevertheless, as a finished watercolour, this ranks with the most extraordinary and powerful exercises of its kind in Delacroix's entire oeuvre and as a tour de force of subjective interpretation. PN

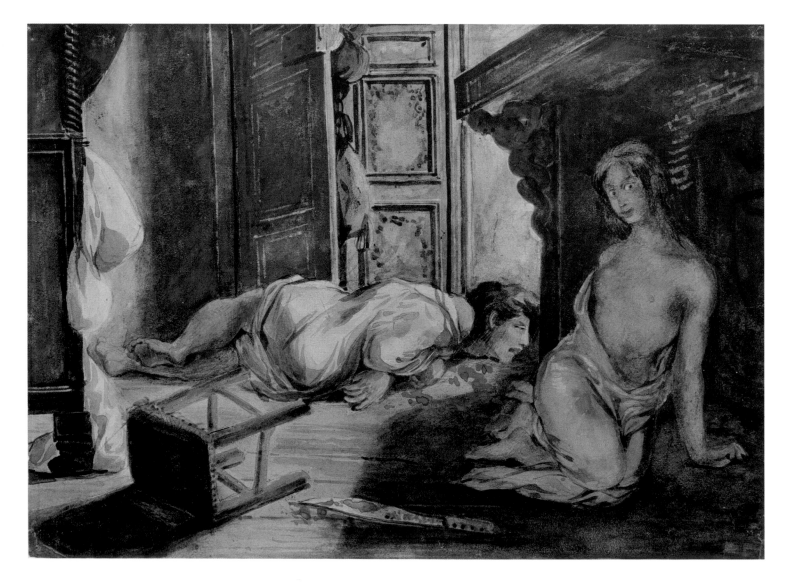

180
Eugène Delacroix (1798–1863)
*Mephistopholes Appearing Before
Faust* c.1826–7

Pen and brown ink, brown wash, over pencil
20.6 x 16.5 (8½ x 6½)
Signed, lower centre: *Eug. Delacroix*
Thaw Collection, The Pierpont Morgan
Library, New York

Friedrich Retzsch's line-engraved illustrations to Johann Wolfgang von Goethe's tragedy *Faust* furnished the original inspiration for Delacroix's similar project as early as 1821, but it was a contrived theatrical spectacle – 'an opera mixing the comic and all that is black' – attended by Delacroix in London in 1825, that propelled it to completion in late 1827. The plates were executed over several years. *Faust and Mephistopheles Galloping on Walpurgis Night* was one of two illustrations shown to Goethe in November 1826. That lithograph and *The Duel Between Valentine and Faust* relate in theme and composition to lithographs Bonington was producing also in the autumn of 1826 for Amadée Pichot's *Vues pittoresques de l'Ecosse*. During this same period Delacroix conceived two oil paintings of Faust subjects: *The Wounded Valentine* (Munich) and a version of this subject in the Wallace Collection (fig.8), which was completed before October 1827.

The artist initially intended to issue his own suite of prints, but his publisher Charles Motte persuaded him to unite them with a translation of the play by Albert Stapfler. The marriage proved a disaster and the press branded them immediately as the ideal of the 'school of the ugly'. Only François Gérard would compliment the artist in public, although the *Athenaeum* in London proclaimed the book 'one of the most splendid homages paid to a living poet'. Goethe also praised the artist as 'just the man to dive into *Faust* and extract from it probable pictures, but which no one could have imagined, full of intellect and expression, and calculated to produce powerful effects'. Goethe's remains the most astute précis of Delacroix's unique achievement.

This sepia drawing is the preparatory study for the published lithograph. The oil painting of the subject was exhibited at the 1828 Salon and later that year in London at Hobday's Gallery. The source for Faust's pose in David Wilkie's sketch for *Knox Preaching* (no.72) has long been recognised. PN

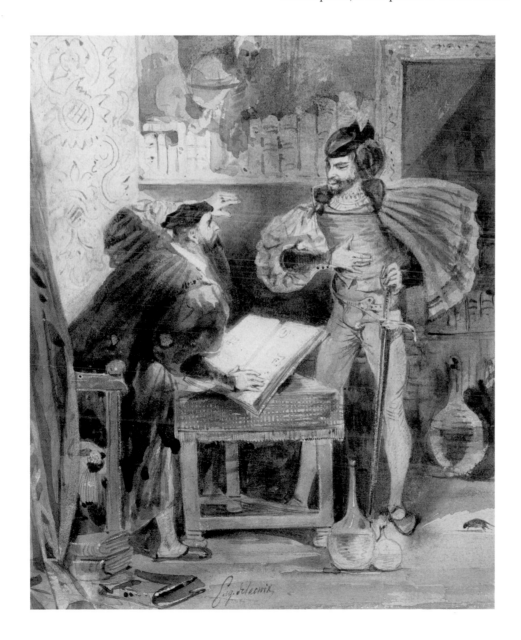

181

Eugène Delacroix (1798–1863)

An Illustration to Goetz von Berlichingen c.1826–7

Watercolour and bodycolour with stopping out
and gum arabic
21.2 x 14.2 (8⅜ x 5⅝)
Signed, lower left: *Eug Delacroix*
The Metropolitan Museum of Art, New York.
Promised Gift from the Karen B. Cohen
Collection of Eugène Delacroix, in honor of
Professor Lee Johnson
Minneapolis and New York only

This watercolour, like Bonington's oil *Knight
and Page* (no.61), which Delacroix owned,
probably illustrates Goethe's *Goetz von
Berlichingen* (1773), a historical tragedy set
during the reign of Emperor Maximilian
(1459–1519). The composition does not
describe a specific passage, but neither does
Delacroix's *Death of Sardanapalus* reconstruct
the concluding act of Byron's play.

As early as February 1824, Delacroix
proposed illustrating Goethe's play. Between
1836 and 1843 he finally designed a series of
seven lithographic plates. As would Bonington,
he plumbed Hans Burgkmair's sixteenth-
century woodcut illustrations to Maximilian's

allegorical poem *Theuerdank* (1519) for
costume ideas. On the stylistic and other
circumstantial evidence, this watercolour can
be dated *c.*1826. Conceivably Delacroix
executed it and several related works in
connection with an unrealised project for
illustrating *Goetz von Berlichingen* at that time.
The page is probably Goetz's attendant
George. The knight would be either Goetz or
Frans Lerse.

If Delacroix was largely responsible for
coaxing Bonington to broaden his repertoire to
include finished cabinet pictures of historical
and literary subjects, the English painter's
example and success as a watercolourist
undoubtedly compelled Delacroix to master a
medium that had been, until this moment,
primarily a vehicle for studies and amusement.
PN

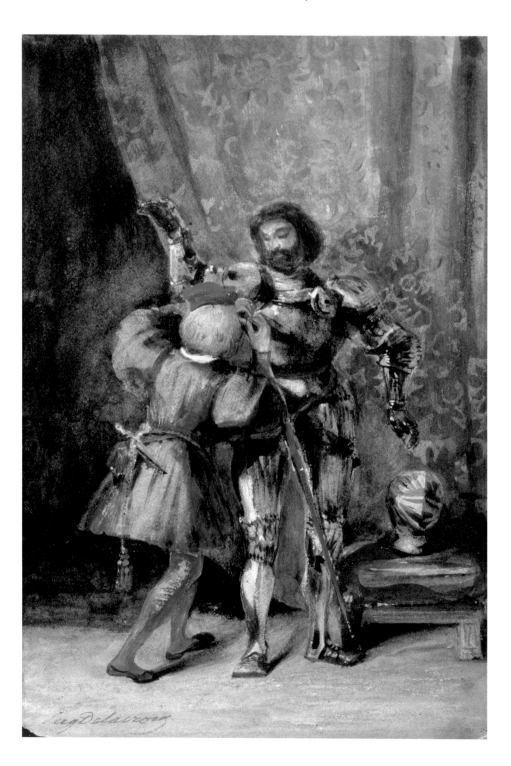

182

Camille Roqueplan (1800–1855)
The Pardon Refused (Kenilworth)
*c.*1830

Watercolour heightened with lead white, on
stiff wove paper
24.4 x 19.1 (9⅝ x 7½)
The Metropolitan Museum, New York.
Purchase, Gift of Mrs. Gardner Cassatt, by
exchange, 1998

The subject of this watercolour is taken from
chapter thirty-five of Walter Scott's *Kenilworth*
of 1821. Amy Robsart kneels before her
husband Robert Dudley, Earl of Leicester, who
pursues a double life as one of the favourites of
Queen Elizabeth I. To obtain his sovereign's
favours, he has concealed his marriage and
sequestered his spouse. Sensing mortal danger,
Amy escapes and has just arrived to seek her
husband's pardon. Contemplating his
dishevelled and sobbing wife with a severe eye,
he responds harshly: 'Alas Amy, you have
disobeyed me.'

Roqueplan was perfectly at ease in such
small-format watercolours, especially those
executed between 1825 and 1835, which were
primarily pretexts for depicting rich decors and
seductive light and colour effects. He had
previously illustrated a scene from chapter
seven of this novel as one of the lithographs he
produced in collaboration with Achille

Devéria, the brother of Eugène, for Henri
Gauguin's *Illustrations de Walter Scott* (1829).
Similarly, *The Pardon Refused* furnished the
subject for a coloured lithograph in a suite of
Roqueplan prints, *Album de douze sujets*,
published by Charles Motte in London and
Paris (1831). Roqueplan, whose lithographic
oeuvre numbered seventy pieces, experienced
considerable success with that album. In his oil
version of this composition, he used the pure
and vivid colours that recall Bonington's
chromatic audacity. *Kenilworth* was one of
Bonington's favourite Scott novels, inspiring
numerous illustrations, although his one
treatment in oils (Ashmolean) depicts a happier
moment in the relationship of these ill-fated
lovers. MW

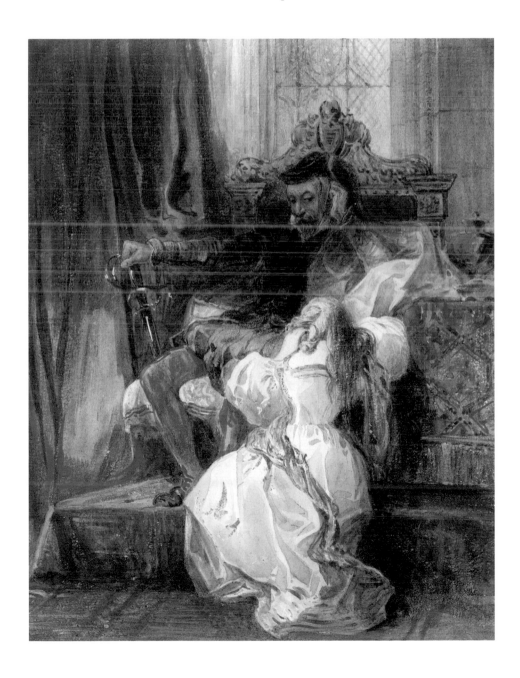

183
Richard Parkes Bonington
(1802–1828)
The Use of Tears 1827

Watercolour, bodycolour, gum arabic, over
graphite
24.8 x 17.1 (9¾ x 6¾)
Signed and dated on footstool: *R P Bonington
1827*
Yale Center for British Art, Paul Mellon Fund
Minneapolis and New York only

Two other versions of this composition have
survived: a watercolour dated 1826 (Louvre),
and a more accomplished oil of 1827 (Boston).
This example, the second watercolour, was
painted for Coutan, and has been dispatched
with the exquisite assurance of Bonington's last
exercises in that medium. The dress and
features of the old matron in both versions of
1827 recall Delacroix's oil, *Head of an Old
Woman* (fig.64), which was rejected by the
Salon jury in October 1827. The heads in both
the Bonington and Delacroix oils are too
similar for coincidence, and suggest a common
model. Philippe Burty (Johnson, *Delacroix*, I,
no.87) correctly identified her as Bonington's
elderly and devout housekeeper, to whom he
gave an oil study based on a Rembrandt
etching.

Examples of Rembrandt's treatment of the
aged were readily available for Bonington's
study in Paris, but the actual source for the
figure of the nurse in this watercolour was

Rembrandt's *Hannah and Samuel* (National
Gallery of Scotland), which Bonington, and
probably Delacroix, studied in London in 1825,
when it was part of the Stafford collection at
Bridgewater House. The source for the young
woman is the figure of the Virgin in Sebastiano
del Piombo's *Visitation* (Louvre). Delacroix
referreˇˇˇˇ the same source when painting his
oil *Henri III at the Deathbed of Marie de Clèves*.

It is unlikely that this composition has a
specific literary source; rather, it should be seen
in the context of the contemporary fascination
for elegiac poetry. The first issues of Victor
Hugo's periodical *La Muse Française*, for
instance, included many examples, such as *La
jeune malade*, *La jeune mère mourante* and
L'Enfant malade. Painters, of course, found an
equally receptive market for such morbidity.
Possible prototypes for Bonington's
conception abounded in the Salons. Pierre
Paul Prud'hon had exhibited to critical acclaim
in 1822 a picture of a father expiring in the midst
of his children, while Ary Scheffer included a
plethora of such subjects in the 1824 Salon:
A Poor Woman Taken to her Bed, *The Sick
Infant*, *The Return of the Young Invalid* and *An
Ill Mother in Front of a Church*, to cite but a few.
PN

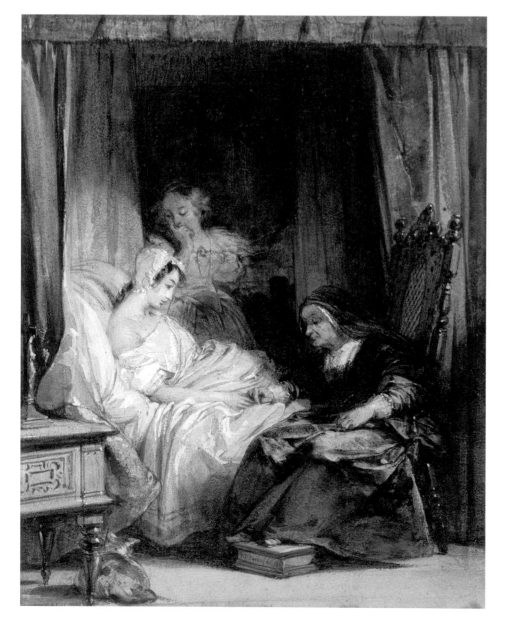

fig.64
Eugène Delacroix
Head of an Old Woman
*c.*1827
Oil on canvas
Private Collection, courtesy of
Richard L. Feigen & Co.,
New York

184
Eugène Delacroix (1798–1863)
Conrad and Gulnare (The Corsair)
1831

Watercolour, brown ink with touches of
gouache and a graphite underdrawing
24.2 x 19.2 (9½ x 7½)
Signed, lower left: *Eug Delacroix*
The J. Paul Getty Museum, Los Angeles
London and Minneapolis only

The pirate chief Conrad was a prototype of the
extravagant and enigmatic Byronic hero. He
appears in the narrative poem *The Corsair*
(1814), where he disguises himself as a dervish
and enters the palace of Sultan Seyd.
Discovered and imprisoned, he is eventually
released by the beautiful queen of the harem,
Gulnare, the scene illustrated here.

*He raised his head and dazzled with the light,
His eye seem'd dubious if he saw right:*

*What is that form? If not a shape of air,
Methinks, my jailor's face shows wondrous fair!*

Conrad returns to his native Greece and
foments rebellion against the Turks, but is
eventually killed. At his death, it is discovered
that his page is Gulnare in disguise.

Géricault selected the same episode for his
1823 suite of lithographic illustrations to Byron
(no.185). A Horace Vernet oil of Conrad alone
in his lair (1824; Wallace Collection) has the

pirate similarly posed. One of several finished
watercolours exhibited by Delacroix at the 1831
Salon, this sheet is a masterly example of the
complex watercolour style that he had
developed in tandem with Bonington several
years earlier. PN

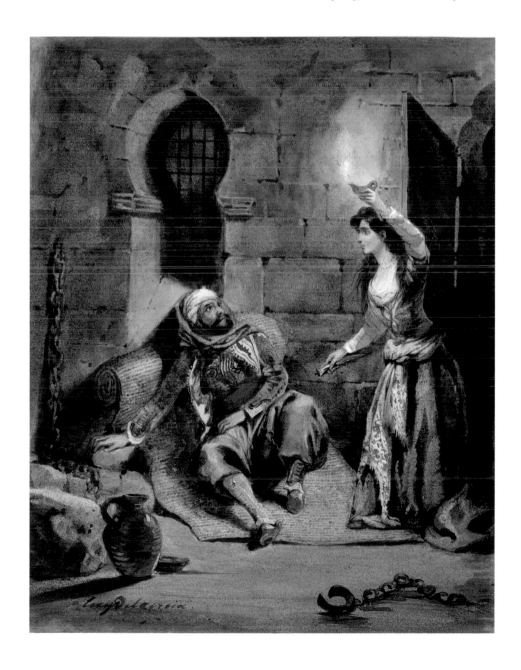

185
Théodore Géricault (1791–1824)
The Giaour c.1820

Watercolour over graphite
21.1 x 23.8 (8 x 9)
The J. Paul Getty Museum, Los Angeles
New York only

This is one of the earliest French illustrations to Byron's poem *The Giaour* of 1813, which inspired so many artists in both countries. Géricault represents several descriptive passages from the early stanzas of the poem, which recount the Giaour's precipitous flight after Hassan's discovery of his affair with his concubine, Leila, and her execution:

He raised his arm, and fiercely raised,
And sternly shook his hand on high,
As doubting to return or fly;
…
T'was but a moment that he stood,
Then sped as if by death pursued

Géricault has chosen the most psychologically intense moment of the poem, when the protagonist, a mass of conflicting emotions, pledges destruction of Hassan's house as he suppresses a suicidal urge to effect that pledge immediately. It was the neighing of his 'raven charger' that brought him to his senses.

The first French translation of the poem appeared in 1819. Lorenz Eitner (1983, p.258) and others have dated this watercolour to 1823, the year of Charles Nodier's edition of Byron's poems, with an introduction by Amadée Pichot that inspired the memorable entry in Delacroix's journal on 14 May: 'I felt again awakening in me that insatiable desire to create.' A similar lithographic treatment is unquestionably related in its dimensions to the suite of Byron illustrations executed by Géricault in collaboration with Eugène Lami in 1823. PN

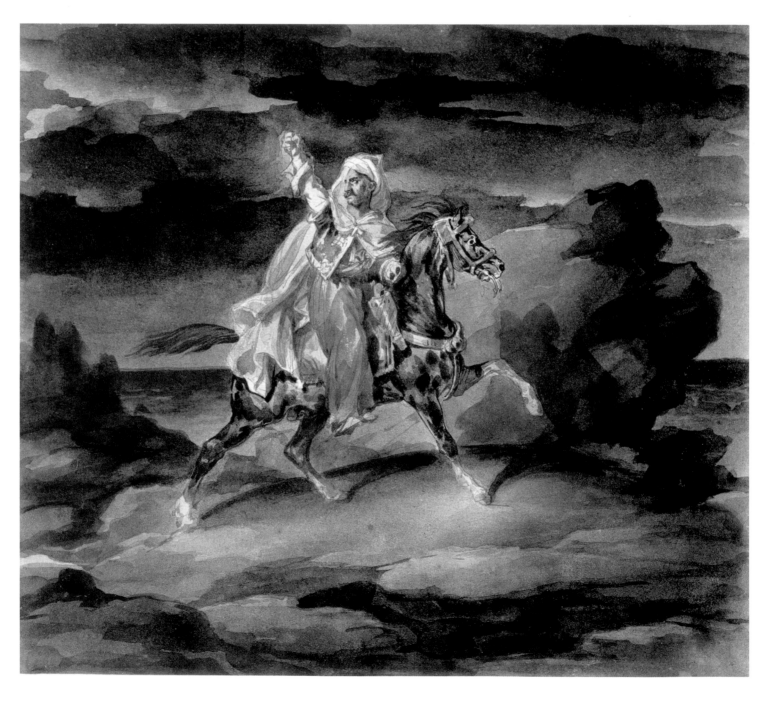

186
Théodore Géricault (1791–1824)
Mameluk in Battle c.1823

Watercolour over graphite
21.1 x 23.8 (8 x 9)
Montpellier, Musée Fabre
Minneapolis only

The Mameluke cavalry, based in Egypt, was one of the most fearsome in the East. Napoleon was so impressed by their tenacity and courage that he genuinely believed an army of ten thousand capable of destroying a Turkish force of fifty thousand. Following the French departure from Egypt, the Mamelukes agitated for their freedom, but were eventually massacred by the Turks in large numbers in Cairo in 1811, an atrocity made famous by Horace Vernet's painting of that subject in the 1819 Salon.

A company of Egyptian Mameluke soldiers in the Imperial Guard first assisted the French army in the Battle of Austerlitz in 1805, for which service they were granted a standard-bearer and trumpeter. One of Géricault's most heroic images of contemporary battle is his lithograph of 1818, *Mameluk Defending a Wounded Trumpeter*, in which an immense oriental figure shoulders a boy-like French comrade as if he were a rag doll. He returned to Mameluke subjects in 1823 with a series of watercolours that includes the present example and an ambitious illustration of the Battle of Sediman (1798), known today from an S.W. Reynolds aquatint of 1825. This revived interest in orientalism was possibly inspired by Géricault's friend Jules-Robert Auguste, who was a near neighbour in 1823, and whose collection of oriental costumes and weapons was readily available to his colleagues. PN

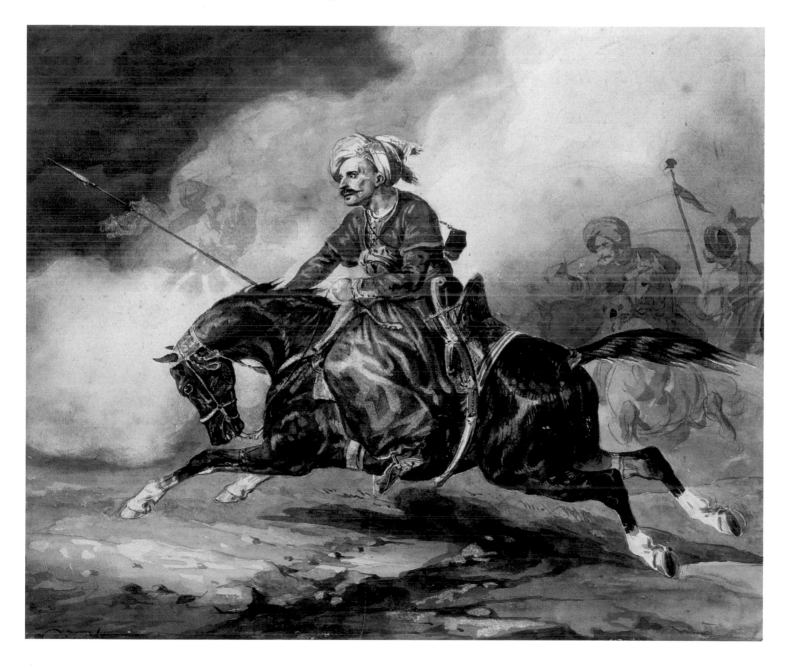

187
Alexandre-Gabriel Decamps
(1803–1860)
*Oriental Interior with Three
Figures c.*1835

Watercolour and bodycolour
21.3 x 15.6 (8⅜ x 6⅛)
Signed, lower right: *Decamps*
Roberta Olson/Alexander Johnson, New York

In the spring of 1828, Decamps and Louis Garnerey (1783–1857) departed for Greece and Smyrna on a mission for the French government, to commemorate the Battle of Navarino. Before returning to Paris in December, Decamps toured Asia Minor and North Africa, claiming the distinction of being the first French artist of his generation to do so. Despite the novelty of that experience and the potential to exploit the picturesque material he had gathered, the artist did not initially pursue orientalist subjects until the 1830s.

As a watercolourist, Decamps was almost unrivalled in France for his technical prowess and the extent to which the medium informed his work in oils. As the critic Gabriel Laviron observed in 1834: 'Everyone tries to improve their technique and to extract the best qualities from materials as inadequate as watercolour on paper, and some have achieved all the vigour of oil painting on canvas, M. Decamps among them.' He was not without critics, however, and Théophile Silvestre (1856) would ridicule what he perceived to be an obsessive complexity of technique as an end in itself.

Although impossible to date with any certainty, this sheet relates to Decamps's highly elaborate watercolours of the mid-1830s that were so appealing to both French and British collectors. PN

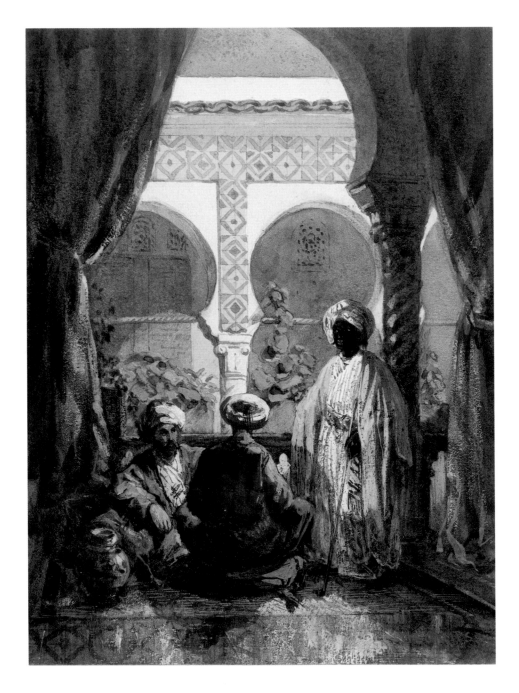

Alexandre-Gabriel Decamps
(1803–1860)

188
Alexandre-Gabriel Decamps
(1803–1860)
Greeks Ambushing Turks in a Ravine c.1833

Watercolour, bodycolour, rubbing and scraping out
31.1 x 40 (12¼ x 15¾)
Signed, lower right: *DC*
Wheelock Whitney, New York

Decamps first appeared publicly as a painter of Near Eastern subjects at the 1831 Salon, over three years after his tour of that region. Gustave Planche commended him for having waited several years before submitting such subjects because the delay seemed to result in works that balanced improvisation and rigorous meditation. This creative stew was the 'poetical reality' that Planche admired in Huet's pictures in the same Salon (no.85), and that he offered as the best possible route for French painting if it hoped to transcend both British and academic influences. As for his orientalism, it was 'the Asia that [Byron's] *Giaour*, *Bride of Abydos* and *Don Juan* have commenced to reveal to us'. Throughout his career, Decamps was praised for the Byronic 'truth' of his oriental scenes.

Decamps's first forays into watercolour painting were genre subjects painted primarily in transparent colours with liberal admixtures of gum arabic. There is a precision of touch that only Bonington could have inspired. With time, he added to this practice the repertoire of mechanical tricks such as rubbing out, scraping, dragging etc. that distinguished the methods of the British school and enliven this ambitious example. Dewey Mosby (*Decamps*, II, no.538) dated this watercolour to *c.*1833, connecting the landscape to studies sketched by Decamps during a tour in the south of France early that year in preparation for the painting of his masterpiece, *Battle of Marius Against the Cimbrians* (fig.37). The subject of Greeks attacking Turks alludes in a generic way to the events of the Greek War of Independence that had brought Decamps to that country in 1828. But it might also be relevant, apropos Planche's previously cited observation, that Byron had had the Giaour similarly ambush Hassan and his forces in a ravine. John Arrowsmith, the first recorded owner of this watercolour, was the Paris-based fine arts dealer and amateur artist who keenly promoted Constable's pictures in 1824 and who, at the 1827 Salon, exhibited his own oils, which one critic described as imitations of Bonington. He was also one of the earliest and most steadfast patrons of both Decamps and Rousseau. PN

189
John Frederick Lewis
(1805–1876)
*Murillo Painting the Virgin in the
Franciscan Convent at Seville* 1838

Watercolour, bodycolour, scratching out,
and gum arabic on card
55 x 63 (21½ x 24¾)
Signed and dated, lower right: *J. F. Lewis.
1838/Paris*
Minneapolis Institute of Arts, The David M.
Daniels Fund

This elaborate watercolour, which illustrates
the unassailable authority of British technique
in the hands of a master like Lewis, and his
unique ability to compete in scale with full-
blown history paintings in oil, was painted in
Paris during the winter of 1837–8; the artist was
en route to Rome and the Middle East. Lewis
had studied Bartolomé Esteban Murillo closely
during his visit to Spain in 1832. His patron
and companion, Richard Ford, had actually
purchased a number of Murillo pictures for
his personal collection. In addition to this
watercolour, Lewis also painted in Paris a
pendant, *Pillage of a Convent in Spain by
Guerrilla Soldiers*. The latter represented a
contemporary episode in the Spanish civil war
of 1833–9, which was extremely topical and
occupied Lewis in several major projects.
The closing of religious houses in Spain in the
late 1830s must have reminded contemporary
audiences of similar manoeuvres effected
by Napoleon in Italy three decades earlier.
The looting of Spanish convents by French
troops at the conclusion of the Peninsular War
of 1807–14 was an even more recent memory.
Whether Lewis had such allusions in mind

when he painted his pendants, and whether
he was also responding to the excitement
generated in Paris that year by the opening
of Louis Philippe's Galerie Espagnole, is not
known. The representation of Old Masters
at work had a long tradition in French painting,
but the depiction of a Spanish master was
certainly *au courant* in 1838. While in Paris,
Lewis also deposited at the Salon some of his
watercolours of Spanish bull-fighting scenes
with quotations from *Childe Harold*.

 The curious composition of *Murillo
Painting the Virgin* was almost certainly
suggested in part by Horace Vernet's *Raphael
at the Vatican* (Louvre), a painting that aroused
considerable ridicule when shown at the 1833
Salon. Lewis would have examined that
picture, which was bought from the Salon by
the state, when passing through Paris that year.
PN

190
Paul Delaroche (1797–1856)
Study for the Execution of Lady Jane Grey 1832

Watercolour on paper
18.4 x 21.9 (7¼ x 8½)
The Whitworth Art Gallery, The University of Manchester

A near-definitive study for the *Execution of Lady Jane Grey* (no.55). In the final version, Delaroche significantly changed the figure of the executioner, who holds an axe rather than the broadsword shown here. CR

Notes

Short publication titles given below are provided in full in the Abbreviated References section on p.286.

Prologue

1. Sainte-Beuve, *Nouveaux Lundis*, Paris 1863–72.

Colour and Effect: Anglo-French Painting in London and Paris

1. Reprinted in Bazin, *Géricault*, I, pp.63–4.
2. *The Collected Letters of Thomas and Jane Welsh Carlyle*, Charles Sanders, ed., III, Durham 1970, p.181 (28 Oct. 1824).
3. The travellers included Alexandre-Marie Colin, Augustin Enfantin, Eugène Isabey, Henri Monnier, Hippolyte Poterlet, Edouard Bertin, Auguste Philippe and Auguste Mayer.
4. 'Anglo-mania in France', *London Weekly Review*, 14 March 1829, p.170.
5. Gautier, 1855, II, p.47.
6. Stendhal, *Salon 1822*, p.48.
7. Farington, *Diary*, V, 1822, 1900.
8. This following a tour in 1842. The idea further elaborated in Gautier, 1855, II, p.9.
9. *Literary Gazette*, 10 Aug. 1822, p.507.
10. Heinrich Heine, *Concerning the French Stage*, Paris 1838.
11. See David Wakefield, 'Stendhal and Delécluze at the Salon of 1824', in Haskell 1974, pp.76–85.
12. *Literary Gazette*, 1 June 1820, p.427.
13. Delacroix, *Correspondence*, I, 18 June 1825, p.157. Haydon had actually begun his picture under the immediate influence of the Old Master paintings he had seen in the Louvre in 1814, *Diaries*, I, p.383 (for 19 Aug. 1814). In his later career, Haydon would be overshadowed by the success in England of Delaroche, whose pictures he described as 'too *dur*, too vulgarly real and offensively obtrusive to satisfy a refined eye', *Diaries*, IV, p.446 (for 3 Nov. 1837). David D'Angers, when visiting London in 1828, was critical of British history painting but also allowed that 'Lawrence has no equal, nor Wilkie..nor Martin', *Carnets*, I, p.8.
14. For a detailed investigation, see *Library of the Fine Arts*, I, 1831, p.314.
15. Gautier, 1855, II, p.7.
16. Ruskin, *Works*, 3, pp.382–3.
17. As the critic for *L'Artiste* astutely observed of the *Execution of Lady Jane Grey*: 'All the world understands this melodrama … it is a beautiful scene … well executed, well disposed, well arranged, well dramatised, but life, emotion, movement, the essence beyond material fact? All that seems missing.' *Drapeau blanc* (27 Dec. 1824) was one of many conservative papers to fault melodrama for the violence and horror employed by painters to move their viewers.
18. *La Muse Français*, June 1823.
19. *L'Artiste*, 1835, p.188.
20. Pichot, *Tour*, II, p.207.
21. Hazlitt, 'Sir Walter Scott, Racine, and Shakespear', *The Plain Speaker*, 1826; *Works*, 12, p.341.
22. For the various reviews see *Athenaeum*, no.94, 5 Feb. 1828, p.171; 18 June 1828, p.538; *London Weekly Review*, no.108, 16 Feb. 1828, p.108; *Literary Gazette*, 17 Feb. 1828, p.105.
23. See A.P., 'Ecole Anglais', *Journal des artistes*, 24 Feb. 1828, p.119.
24. Gautier, 1855, II, p.48.
25. See Johnson, *Delacroix*, I, nos.107–8.
26. Private Collection, Texas; see *A Brush With Shakespeare, The Bard in Painting 1788–1910*, exh. cat., Montgomery Museum of Fine Arts, 1986, no.11, pl.IV.
27. 'I don't believe the end of painting is to make one recoil in disgust … what does it matter to me that this work is skilfully executed, since it is impossible to look at it?' Coupin 1827, p.278.

28. Fuseli's primary version, of which numerous replicas exist, was exhibited at the Royal Academy in 1783. Colin's immediate source was undoubtedly one of the engraved reproductions by P.W. Tomkins (1786) or J.R. Smith (1785). Since Fuseli's death in 1825 was much covered in the press, it is not inconceivable that Colin's picture was intended as a homage to the Anglo-Swiss painter.
29. Delécluze, 1824 (5 Oct. 1824).
30. Hugo, *Cromwell*, pp.50ff.
31. Farcy's term describing Colin; Farcy, *Salon 1827*, 2 March 1828.
32. Delacroix's other magnificent speculation in this realm would be his suite of illustrations to *Hamlet*.
33. Bell, *Essays*, pp.4ff. For an excellent discussion of the influence of Scottish philosophy on French painters, especially Géricault, see Duncan Macmillan, 'Géricault et Charles Bell', in Paris, Louvre, *Géricault*, I, pp.449–63.
34. Scheffer, 1827, pp.188ff.
35. Thiers, 1822.
36. *Globe*, 8 Oct. 1824, p.48.
37. Prud'hon's picture was later examined in London at the fourth meeting of the Artists and Amateurs Conversazione in 1831; see *Library of the Fine Arts*, I, 1831, p.174.
38. Layard, *Lawrence*, pp.181–3.
39. See Pontus Grate, 'La Critique d'Art et la Bataille Romantique', *Gazette des Beaux-Arts*, no.54, 1959, pp.129–48.
40. *Nouveaux Lundis*, III, Paris 1865, p.77.
41. Delécluze, *Journal*, 26 May 1828.
42. Hazlitt, 'On Gusto', *Works*, 4, pp.77–80.
43. Delécluze, 1819, 20 Dec. 1819, p.418.
44. Anon., *Drapeau Blanc*, 15 Oct. 1824, p.4 and 12 Jan. 1825, p.5. Coupin (1824, p.314) would likewise describe Constable's landscapes and Bonington's marines as 'a false way of seeing … To go to the suburbs and faithfully copy the first field that presents itself is to misunderstand the purpose of painting. Not everything is worthy of being painted, because, essentially, not everything is worthy of being studied.'
45. Nodier, *Promenade de Dieppe aux montagnes d'Ecosse*, Paris 1821, pp.45ff.
46. Pichot, *Tour*, 2, p.185.
47. Hazlitt, 'Why the Arts are not Progressive', *Morning Chronicle*, 11 Jan. 1814; *Works*, 18, p.6.
48. 'French painters', he wrote, 'see only lines and precise differences; the English only general masses and strong effects … the one is dry, hard and minute, the other is gross, Gothic and unfinished; and they will probably remain forever satisfied with each other's defects'. 'On the Imitation of Nature', *Champion*, 25 Dec. 1814; *Works*, 18, p.74.
49. Hazlitt, *Notes*, pp.129–30: 'Racine's poetry, and Shakespeare's, however wide apart, do not absolutely prove that the French and English are a distinct race of beings, who can never properly understand one another. But the Luxembourg gallery, I think, settles this point forever – not in our favour, for we have nothing (thank god) to oppose to it, but decidedly against *them*, as a people incapable of any thing but the little, the affected, and the extravagant in works of the imagination.'
50. Ibid. p.169.
51. Delacroix, *Journal* (25 Jan. 1857).
52. Anon., *Le Figaro*, 19 Nov. 1827, p.811. British critics had similar problems with the light effects. See Oliver Meslay, 'Sir Thomas Lawrence and France', *The British Art Journal*, 3, 2002, pp.44–9.
53. Jal (1827, pp.79–83) confirmed that the Paris public were already familiar with the Lambton portrait through Samuel Cousins's mezzotint, published in April 1827 (see *Literary Gazette*, 7 April 1827, p.219). Jal also argued that the print, 'which perfectly preserves the sentiment of the original, corrects several faults for which we have reproached

Lawrence; there is firmness in the landscape and garments'.
54. Stendhal, *Mélanges*, 1827, p.150.
55. Coupin 1827, p.316.
56. See Ephrussi 1891, p.459.
57. Delacroix, *Correspondence*, 1, p.166 (1 Aug. 1825).
58. Delacroix, *Correspondence*, 4, p.57ff (31 Dec. 1858).
59. Gautier 1855.
60. Delacroix, *Correspondence*, 4, p.286 (30 Nov. 1861). For the most focused investigation of the relationship between Bonington and Delacroix, see Noon, *Bonington*, passim. The gem analogy Delacroix had employed thirty years earlier in his essay on Lawrence: 'His pictures are a type of diamond which sparkle in their settings and extinguish everything around them … his colours surround you in a magical circle.'
61. For the most thorough appreciation of Constable's technique, see Sarah Cove, 'Constable's Oil Painting Materials and Techniques', in Leslie Parris and Ian Fleming-Williams, *Constable*, exh. cat., Tate Gallery, London 1991, pp.493–529.

Print Culture and the Illustration of History: An Anglo-French Perspective

1. P.J. de Béranger, *Oeuvres complètes*, I, Paris 1834, p.155: 'Quoique leurs chapeaux sont bien laids, / God Dam! Moi j'aime les Anglais.'
2. See Christophe Lériault, *Les Anglais à Paris au 19e siècle*, exh.cat., Musée Carnavalet, Paris 1994; Scott's complaints about the sea voyage are quoted on p.22, opposite a vivid evocation of mass seasickness on the Dover packet boat.
3. See Pointon, *Bonington Circle*, pp.25ff.
4. See J.F. de La Combe, *Charlet, Sa Vie, Ses Lettres*, Paris 1856, pp.224, 245. The 'Milord' prints recently appeared in a commercial gallery in Paris, with a proof copy from the collection of Charlet's friend, Horace Vernet. The second subject, Milord after the gaming losses, appears to be identical with the print *Le Joueur*, after a drawing by Charlet, by the English engraver George Maile, which was used by Niépce in one of his first photographic experiments. See Stephen Bann, *Parallel Lines*, New Haven and London 2001, pp.98–9.
5. Mrs Charles Stothard, *Letters written during a Tour …with …engravings after drawings by Charles Stothard FSA*, London 1820, p.1.
6. Ibid. p.45.
7. Ibid. pp.2, 36.
8. Ibid. p.125.
9. Ibid. p.101.
10. See Stephen Bann, *Romanticism and the Rise of History*, New York 1995, pp.112–18.
11. *Voyages pittoresques et romantiques dans l'ancienne France*, I, Paris 1820, p.10.
12. Franz Kugler, article from *Museum 1833*, reprinted in *Kleine Schriften zür Kunstgeschichte*, III, Stuttgart 1854, p.33.
13. *Voyages pittoresques*, II, pl.109.
14. See *Lord Byron: Complete Poetical Works*, Jerome J. McGann, ed., IV, Oxford 1986, pp.172–4.
15. Ibid. p.187.
16. See *Géricault* catalogue, pp.401–3. The other choices are *Lara*, *The Bride of Abydos* and *The Giaour*.
17. *Lord Byron*, 1986, p.192.
18. Ibid. p.189.
19. Eugène de Mirecourt, *Horace Vernet*, Paris 1855, p.41.
20. See *Delacroix: Le trait romantique*, exh. cat., Bibliothèque nationale de France, Paris 1998, p.142.
21. See Pierre Sanchez and Xavier Seydoux, eds., *Les Catalogues des salons*, II, Paris 1999, p.194.
22. Gustave Planche, *Etudes sur l'Ecole Française*, I, Paris 1855, p.240.
23. Ibid.
24. The essay is republished, and framed by further

discussion, in Michael Fried, *Manet's Modernism*, Chicago and London 1996.
25. Report of 5 Feb. 1848, quoted in Bann, *Delaroche*, p.94.
26. The provenance of this painting has not been clearly established, and the signature in the bottom left-hand corner with the date 1828 has probably been added to replace a previous, authentic signature which is just visible below the Queen's foot-stool or cushion. A more likely date is 1827, in view of the fact that Delaroche's final painting was included, however late, in the 1827/28 Salon. Reference is made to a smaller picture of the *Death of Elizabeth*, given to Delaroche's friend Henri Delaborde, in the catalogue of his work made by his former student, Jules Goddé, shortly after his death in 1857. See Henri Delaborde and Jules Goddé, eds., *Oeuvre de Paul Delaroche*, Paris 1858, pl.9.
27. Edmond Texier, *Tableau de Paris*, Paris 1852, p.78.
28. British Library, Add MS 48027 f.650.
29. The drawing, in the Cabinet des dessins of the Louvre, is reproduced in Bann, *Delaroche*, which also contains much more iconographic material and discussion relevant to this painting. See p.120 pl.56; pp.119–28.
30. Quoted ibid. p.124.

Introduction
1. Francois-Louis-Thomas Francia, Letter to John Thomas Smith, 8 May 1825; formerly London art market.
2. B.M. Add. MSS.

The Raft of the Medusa in Britain
1. Charlotte Adelaide Dard, *History of the Sufferings and Misfortune of the Picard Family, after the Shipwreck of the Medusa*, translated by Patrick Maxwell in *Perils and Captivity*, Constable's Miscellany, 1827, Vol. 11, p.xviii.
2. 'Crusaders! Or Jerusalem Delivered': Playbill for the Royal Coburg Theatre, Thursday 6 April 1820 (British Library).
3. Sir John Graham Dalyell, *Shipwrecks and Disasters at Sea*, Vol. 1 (3 vols.) Edinburgh 1812, p.xiii.
4. *Narrative of the Dreadful Shipwreck of the Medusa Frigate*, London 1818, p.1.
5. Ibid. p.1.
6. John McLeod, *Narrative of a Voyage in His Majesty's late Ship Alceste*, London 1817, pp.192, 228.
7. *The Shipwreck of the French Frigate, the Medusa*, Dublin 1818, p.3.
8. *The Shipwreck of the Alceste, an English frigate in the straits of Gaspar; also, the shipwreck of the Medusa, a French frigate on the coast of Africa*, Dublin 1822.
9. *Globe*, 12 June 1820, p.3.
10. Albert Boime, *The Art of Exclusion. Representing Blacks in the Nineteenth Century*, London 1990, pp.60–1. See also Albert Alhadeff, *The Raft of the Medusa: Gericault, Art and Race*, New York 2002.
11. Richard Altick, *The Shows of London*, Cambridge, Mass. and London 1978, p.236.
12. Richard Altick, *The Shows of London*, Cambridge, Mass. and London 1978, p.186.
13. *London Magazine*, May 1820, V, p.583.
14. *Globe*, 12 June 1820, p.3.
15. *Literary Gazette, and Journal of the Belles Letters*, 1 July 1820, p.427.
16. *Globe*, 12 June 1820, p.3.
17. Eitner, *Raft*, 1972, p.58.
18. *The Times*, 22 June 1820, p.3.
19. *Morning Post*, 13 June 1820, p.3.
20. *Literary Gazette*, 1 July 1820, p.427.
21. *Examiner*, 16 July 1820, p.3.

Art on View
1. Delacroix, *Correspondance*, I, p.194.
2. Ibid. p.157.
3. Ms letter, Fielding to Delacroix, Getty Research Institute.
4. Vitet, *Le Globe*, 23 May 1826, p.1.
5. Ms letter, de Forbin to Vicomte de la Roche Foucault, dated 20 Aug. 1827, Archives des Musées Nationaux (X Salon 1824).
6. See *Statuts de la Société des amis des arts rétablie en 1817*, Paris 1820; and Léon Lagrange, 'Des Sociétés des Amis des Arts en France', *Gazette des Beaux-Arts*, 1 March 1861,

pp.291ff and 1 April 1861, pp.29ff.
7. For a thorough discussion of these organisations and the lists of exhibitors, see *Salons Retrouvés*.
8. Wright 1990, p.27.
9. *Library of the Fine Arts*, no.2, Dec. 1831, pp.384–91; *Athenaeum*, 18 June 1828, p.538; *Literary Gazette*, 7 June 1828, p.364.
10. *Athenaeum*, 1 April 1828, p.346.
11. Letter to Silvestre 31 Dec. 1858; Delacroix, *Correspondence*, IV, p.57.
12. Ms letter Wilkie to De Forbin, dated 25 July 1824, Archives des Musées Nationaux (BXV).
13. For the commercial side of the Parisian art world during the Restoration, see Whiteley 1983.

Literature and History
1. *Journal des débats*, 9 Dec. 1820.
2. Stendhal's plagiarism of Johnson's 'Preface to Shakespeare' was pointed out by Doris Langley Moore, *The Late Lord Byron*, London 1961, p.374 n.4.
3. Stendhal quoted by Philip Mansel, *Paris between Empires 1814–1852*, London 2001, p.160.
4. Stendhal, *Correspondence*, in Langley Moore 1961, pp.376, 379.
5. Ibid. p.389, for J.C. Hobhouse's contemptuous verdict on this story.
6. In the vast literature on Scott's influence on art, see especially Beth S. Wright, 'Scott's Historical Novels and French Historical Painting 1815–55', *Art Bulletin*, June 1981, pp.268–87; Wright and Joannides, *année 1982, 1984*, pp.119–32; *année 1983, 1985*, pp.95–115; Gordon, 1971, pp.34ff. On Byron, see various authors: *Lord Byron; une vie romantique*, Maison Renan-Scheffer, exh. cat., Musée de la Vie Romantique, Paris 1988, and E. Esteve, *Byron et le romantisme français. Essai sur le fortune et l'influence de l'oeuvre de Byron en France de 1812–1850*, Paris 1987.
7. See London, *Turner and Byron*.
8. See especially Atthanassoglou Kallmyer, 2001, pp.48ff; for more general accounts, Joannides, 2001, pp.130ff; and Barthelemy Jobert, 'Delacroix et la littérature: une nouvelle dimension du romantisme', in Rouen, *Delacroix*, 1998, pp.39ff.
9. Delécluze, 1824, 5 Oct. 1824; see Chaudonneret 1999, pp.80–6.
10. Denon to Napoleon, 1810; Paris, Archives Nationales, A F IV 1050, dossier 6; cited in Marie-Claude Chaudonneret, 'The Genre Anecdotique, or the Evocation of a Dream-Like Past', in New Orleans 1996.
11. Thiers, *Salon de mil huit cent vingt-quatre*, p.20; quoted by Chaudonneret 1999, p.78 n.8.
12. See especially Bann 1984; Wright 1997.

The School of Modern Life
1. Géricault to Horace Vernet, 1 May 1821, in Clément, 1867, pp.199–203.
2. Scheffer, 1827, p.198; cited by Chaudonneret, 1999, p.91; she discusses critical responses to the emergence of genre painting post-Napoleon, ibid. pp.89–91.
3. Raimbach, *Memoirs*. For prints after Wilkie in France, see Arthur S. Marks, 'Wilkie and the Reproductive Print', in Raleigh and New Haven 1987, pp.73ff.
4. Géricault to Dedreux-Dorcy, 12 Feb 1821, in Clément, 1867, p.193.
5. *Examiner*, no.839, 29 Jan 1824, pp.139–40.

'The Finest Poetic Descriptions'
1. Pichot, *Tour*, I, p.132.
2. Planche, *Salon 1831*, p.170.
3. See especially Michel Florisoone, 'Constable and the *Massacre of Scios* by Delacroix', *Journal of the Warburg and Courtauld Institute*, no.20, 1957, pp.180–5.
4. Delacroix, *Correspondence*, IV, p.60.
5. Dubuisson 1912, p.123.
6. Huet, *Huet*, 95; notes compiled for Théophile Sylvestre 1854.
7. Thiers, 1824, pp.54ff.
8. Pierre Trabaud, quoted in Gury, *Outre-Manche*, p.940.

9. Hazlitt, 'Why Distant Objects Please', *Table Talk*, 1824; *Complete Works*, 8, p.255.
10. *Journal de Paris*, 21 Nov. 1814, p.3.
11. *Journal des Débats*, 27 March 1823, p.3.
12. See Ann Bermingham, 'Landscape-O-Rama: The Exhibition Landscape at Somerset House and the Rise of Popular Landscape Entertainments', in D. Solkin et al., *Art On The Line, The Royal Academy Exhibitions at Somerset House*, London 2002, pp.127–43.

Diamonds that Flatter and Ravish the Eye
1. Delécluze, 1824, 7 Dec. 1824: 'Fielding offers a remarkable trait, namely the total lack of defined forms; only vapour … his school follows principles at odds with those of the ancient Greeks and the Renaissance Italians.'
2. Stendhal, *Mélanges*, 23 Nov. 1824.
3. Jal 1824, p.418: 'Fielding's watercolours have turned many heads in Paris … I would like to persuade my comrades that Fielding can no more be imitated by someone born in France than one can imitate the genre of [Marc-Antoine] Desaugiers when one is born on the banks of the Thames.' Marc-Antoine Desaugiers was famous for his chansons *Tableau de Paris*.
4. Undated ms. letter, Getty Research Institute.
5. Jal, 1824, p.417.
6. Monnier, 'La manie des Albums', *Le Livre des cent-et-un*, V, Paris 1832, pp.199–207.
7. Christie's, London, 18 March 1980. They were almost all 7 x 10in (18 x 25.5cm) as prescribed by Fielding.
8. Sotheby's, London, 11 June 1997.
9. *Library of the Fine Arts* I, July 1831, pp.507ff.
10. Delécluze, 1831.

Abbreviated References

Abbey, *Travels*
Abbey, J.R., *Travel in Aquatint and Lithography, 1770–1860*, 2 vols., London 1956.

Adams, *Danby*
Adams, Dr Eric, *Francis Danby: Varieties of Poetic Landscape*, New Haven and London 1973.

Aimé-Azam, *Géricault*
Aimé-Azam, Denise, *Mazeppa, Géricault et son temps*, Paris 1956.

Anon., 1827 Salon
Anonymous, *Visite au musée du Louvre ou guide de l'amateur à l'exposition etc.*, Leroi, Paris 1828.

Anon., *L'Artiste*, 1831
Anonymous, 'Salon de 1831', *L'Artiste*, I, 1831.

Anon., *L'Artiste*, 1833
Anonymous, 'Salon de 1833', *L'Artiste*, V, 1833.

Anon., *L'Artiste*, 1834
Anonymous, 'Salon de 1834', *L'Artiste*, VI, 1834.

Anon., *L'Artiste*, 1835
Anonymous, 'Salon de 1835', *L'Artiste*, IX, 1835.

Anon., *Drapeau Blanc*, 1824
F., 'Exposition de 1824', *Le Drapeau Blanc*, Paris 1824, 20 articles, 28 Aug. 1824–17 Jan. 1825.

Anon., *Le Figaro*, 1827
Anonymous, 'Figaro au Salon', *Le Figaro*, Paris 1827–8, 20 articles, 4 Nov. 1827–29 April 1828.

Anon. *La France chrétienne*, 1828
Anonymous, 'Salon de 1827', *La France chrétienne*, Paris 1828, 8 articles, 3 Jan.–8 Feb. 1828.

Anon., *L'Observateur*, 1828
Anonymous [L.N.], 'Exposition de 1828', *L'Observateur*, Paris 1827–8, 7 articles, 22 Dec. 1827–22 March 1828.

Athanassoglou-Kallmyer, 1989
Athanassoglou-Kallmyer, Nina, *French Images from the Greek War of Independence, 1821–1830*, New Haven 1989.

Athanassoglou-Kallmyer, 1990
Athanassoglou-Kallmyer, Nina, 'Liberals of the World Unite: Géricault, His Friends and *La Liberté des Peuples*', *Gazette des Beaux-Arts*, no.116, Dec. 1990, pp.227–42.

Athanassoglou-Kallmyer, 2001
Athanassoglou-Kallmyer, Nina, 'Eugène Delacroix and Popular Culture', in Beth S. Wright (ed.), *The Cambridge Companion to Delacroix*, Cambridge 2001, pp.48–68.

Bachrach, 1981
Bachrach, A.G.H., 'The Field of Waterloo and Beyond', *Turner Studies* I, 1981, pp.4–13.

Bann, 1984
Bann, Stephen, *The Clothing of Clio*, Cambridge 1984.

Bann, *Delaroche*
Bann, Stephen, *Paul Delaroche, History Painted*, Princeton 1997.

Bazin, *Géricault*
Bazin, Germain, et al., *Théodore Géricault: Étude Critique et Catalogue Raisonné*, 7 vols., Paris 1987–1994.

Bean, 1995
Bean, Thomas, 'Richard Ford as picture collector and patron in Spain', *Burlington Magazine*, Feb. 1995, pp.96–107.

Beckett, 1956
Beckett, John, 'Constable and France', *Connoisseur*, June 1956, p.254.

Beckett, *Ward*
Beckett, Oliver, *The Life and Work of James Ward, RA*, London 1995.

Beckett, *Constable*
Beckett, R.B., (ed.), *John Constable's Correspondence IV*, Suffolk 1966.

Béraud, 1827
Béraud, Anthony, *Annale de l'école française des beaux-arts*, Paris 1827.

BFAC, *Bonington*, 1937
R.P. Bonington and His Circle, exh. cat., Burlington Fine Arts Club, London 1937.

Blanc, 1869
Blanc, Charles, *Histoire de peintres de toutes les écoles: Ecole française 3*, Paris 1869.

Boime
Boime, Alfred, 'Géricault's *African Slave Trade* and the Physiognomy of the Oppressed', in Paris, Louvre, *Géricault*, II, pp.561–88.

Boime, 1991
Boime, Alfred, 'Portraying Monomaniacs to Service the Alienist's Monomania: Géricault and Georget', *The Oxford Art Journal* 14, 1991, pp.79–91.

Bona, *Vernet*
Bona, Félix de, *Une Famille de peintres: Horace Vernet et ses ancêtres*, Lille n.d.

Bonington sale 1829
Catalogue of the Pictures, Original Sketches, and Drawings of the late much admired and lamented artist, R.P. Bonington, Sotheby and Son, London, 29–30 June 1829.

Bordeaux, Paris, Athens, 1996–97
La Grèce en révolte, Delaxcroix et les peintres français 1815–1848, Musée des Beaux-Arts, Bordeaux; Musée National Eugène Delacroix, Paris; Pinacothèque Nationale, Musée Alexandre Soutzos, Athens, 1996–7.

Bouret, 1972
Bouret, Jean, *L'Ecole de Fontainebleau et le paysage français du XIXe siècle*, Paris 1972.

Boutard, 1826
Boutard, M., 'Seconde Exposition en faveur des Grecs', *Journal des Débats*, 1 Sept. 1826, pp.3–4.

Bristol, 1996
Liversidge, Michael, et al., *Imagining Rome, British Artists and Rome in the Nineteenth Century*, exh. cat., Bristol City Museum and Art Gallery, London 1996.

Brown, 1984
Brown, Roy Howard, 'The Formation of Delacroix's Hero Between 1822 and 1831', *Art Bulletin* 66, June 1984, pp.237–54.

Bryant, 1959
Bryant, Edward, 'Notes on J.A.D. Ingres's *Entry into Paris of the Dauphin, Future Charles V*', *Wadsworth Atheneum Bulletin* 3, 1959, pp.16–21.

Burty, *Huet*
Burty, Philippe, *Paul Huet: Notice biographique et critique*, Paris 1869.

Butlin and Joll, *Turner*
Butlin, Martin, and Evelyn Joll, *The Paintings of J.M.W. Turner*, 2 vols., London and New Haven 1984.

C., *Galerie Lebrun*
C., 'Exposition Des Ouvrages de Peinture au Profit des Grecs', *Journal des Débats*, 29 May 1826, pp.1–3.

Calais, *Francia*
Le Nouëne, Patrick et al., *Louis Francia, 1772–1839*, exh. cat., Musée des Beaux-Arts, Calais, 1988–9.

Cambrai, 1826
Catalogue explicatif des objets d'arts et d'industrie exposés au Salon de la ville de Cambrai depuis le 15 août jusqu'à 15 septembre 1826, Cambrai 1826

Cambridge, *Delacroix*
The Cambridge Companion to Delacroix, ed. Beth S. Wright, Cambridge 2001.

Canberra, 1996
Lloyd, Michael et al., *Turner*, National Gallery of Australia, Canberra; National Gallery of Victoria, Melbourne 1996.

Chaudonneret, 1980
Chaudonneret, Marie-Claude, *La peinture troubadour*, Paris 1980.

Chaudonneret, 1999
Chaudonneret, Marie-Claude, *L'Etat et les artistes: de la Restauration à la monarchie de Juillet (1815–1833)*, Paris 1999.

Chauvin, 1824
Chauvin, Auguste, *Salon de 1824*, Paris 1825.

Chenique, 1996
Chenique, Bruno, 'Géricault posthume', in Paris, Louvre, *Géricault*, pp.937–59.

Chenou, 1827
Chenou, J.C., *Notice sur l'exposition des produits de l'industrie et des arts qui a eu lieu à Douai en 1827*, Douai 1828.

Chiego, *Vernet*
Chiego, William, 'The Influence of Carle and Horace Vernet on the Art of Théodore Géricault', PhD Dissertation, Case Western Reserve University 1974.

Clarke, *Corot*, 1991
Clarke, Michael, *Corot and the Art of Landscape*, New York, 1991.

Cleaver, 1981
Cleaver, Dale G., 'Michallon et la théorie du paysage', *Revue du Louvre*, no.31, 1981, pp.359–66.

Clément, 1867–79
Clément, Charles, *Géricault, Etude Biographique et Critique*, Paris 1879.

Clément, 1974
Clément, Charles, *Géricault, Etude Biographique et Critique*, revd.edn., ed. Lorenz Eitner, New York 1974.

Cleveland, 1999
D'Argencourt, Louise, et al., *European Paintings of the 19th Century: The Cleveland Museum of Art Catalogue of Paintings: Part Four*, 2 vols., Cleveland 1999.

Clifford, *Crome*
Clifford, Derek and Timothy, *John Crome*, London 1968.

Collins Baker, *Crome*
Collins Baker, C.H., *Crome*, London 1920.

Collins, *Life*
Collins, Wilkie, *The Life of William Collins*, 2 vols., London 1848.

Coupin, 1824
Coupin, P.-A., 'Notice sur l'exposition des tableaux en 1824', *Revue Encyclopédique*: 23, July–Sept. 1824, pp.551–60; 24, Oct.–Dec. 1824, pp.18–40, 289–304, 589–605; 25, Jan.–March 1825, pp.310–35.

Coupin, 1827
Coupin, P.-A., 'Exposition des tableaux en 1827 et 1828', *Revue Encyclopédique*: 26, Nov. 1827, pp.526–30; 27, Jan.–March 1828, pp.302–16, 579–83, 857–69; 28, April 1828, pp.276–86.

Cundall, *Callow*
William Callow, An Autobiography, ed. H.M. Cundall, London 1908.

Cunningham, *Lives*
Cunningham, Allan, *The Lives of the Most Eminent British Painters and Sculptors*, London 1832; revd. ed. 1880.

Cunningham, *Wilkie*
Cunningham, Allan, *The Life of Sir David Wilkie*, 3 vols., London 1843.

Daguerre de Heureux, *Delacroix*
Daguerre de Heureux, A., *Delacroix*, Paris 1993.

Dargenty, *Gros*
Dargenty, G., *Le Baron Gros*, Paris 1887.

Davies, 1926
Davies, Randall, 'John Frederick Lewis, RA', *The Old Water-Colour Society's Annual* 3, 1925–6, p.32.

Dayot, *Vernet*
Dayot, Armand, *Les Vernets: Joseph, Carle, Horace*, Paris 1898.

Decamps, 1838
Decamps, Alexandre, 'Salon de 1838', *Le National*, 18 March 1838.

DeKay, *Barye*, 1889
DeKay, Charles, *The Life and Times and Antoine-Louis Barye*, New York, 1889.

Delaborde, *Delaroche*
Delaborde, Henri, 'Paul Delaroche', *Etudes sur les beaux-arts en France et en Italie*, Paris 1864, pp.261-315.

Delacroix, *Correspondance*
Correspondance générale d'Eugène Delacroix, 5 vols., ed. André Joubin, Paris 1935-8.

Delacroix, *Gros*
Delacroix, Eugène, 'Gros', *Revue des Deux-Mondes*, 1 Sept. 1848; reprinted in *Eugène Delacroix, Oeuvres Littéraires*, ed. E. Faure, Paris 1923, II, pp.163-200.

Delacroix, *Journal*
Delacroix, Eugène, *Journal de Eugène Delacroix*, 3 vols., ed. P. Flat and R. Piot, Paris 1893.

Delécluze, 1819
Delécluze, Etienne, 'Sur l'exposition des ouvrages etc.', *Le Lycée français*, Paris, 12 articles in 3 volumes, 1819.

Delécluze, 1822
Delécluse, Etienne, 'Salon de 1822', *Le Moniteur Universel*, Paris, 9 articles, 3 May-18 June 1822.

Delécluze, 1824
Delécluze, Etienne, 'Exposition du Louvre 1824', *Journal des Débats*, Paris, 26 articles, 1 Sept. 1824-19 Jan. 1825.

Delécluze, 1827
Delécluze, Etienne, 'Beaux-Arts: Salon de 1827', *Journal des Débats*, Paris, 15 articles, 5 Nov. 1827-25 April 1828.

Delécluze, 1831
Delécluze, Etienne, 'Salon de 1831', *Journal des Débats*, Paris, 16 articles, 1 May-23 July 1831.

Delécluze, 1832
Delécluze, Etienne, 'De la Barbarie de ce Temps', *Paris, ou le livre des cent-et-un*, Paris 1832, vol. 5, pp.61-80.

Delécluze, 1833
Delécluze, Etienne, 'Salon de 1833', *Journal des Débats*, Paris, 9 articles, 3 March-2 May 1833.

Delécluze, 1834
Delécluze, Etienne, 'Salon de 1834', *Journal des Débats*, Paris, 7 articles, 2 March-7 May 1834.

Delécluze, 1838
Delécluze, Etienne, 'Salon de 1838', *Journal des Débats*, Paris, 5 articles, 3 March-7 June 1838.

Delécluze, 1855
Delécluze, Etienne, *Les Beaux-Arts dans les Deux Mondes en 1855*, Paris 1856.

Delécluze, *Journal*
Journal de Delécluze, 1824-8, ed. Robert Baschet, Paris 1948.

Delteil, *Delacroix*
Delteil, Loys and Susan Strauber, *Delacroix, the Graphic Work*, San Francisco 1997.

Delteil, *Géricault*
Delteil, Loys, *Theodore Géricault*, Paris 1924.

Delteil, *Huet*
Delteil, Loys, *Paul Huet*, Paris 1924.

Detroit and Philadelphia, 1968
Romantic Art in Britain, exh. cat., Detroit Institute of Arts, Detroit; Philadelphia Art Museum, Philadelphia 1968.

Dorbec, 1910
Dorbec, Prosper, *Théodore Rousseau*, Paris 1910.

Dorbec, 1913
Dorbec, Prosper, 'Les Influences de la peinture anglaise sur le portrait en France', *Gazette des Beaux-Arts*, 1913, pp.85-102.

Douai 1823
Explication des ouvrages de peinture, dessin, sculpture, modelure, gravure, et objets d'industrie, exposés au Salon de la Ville de Douai, Douai, 6-30 July 1823.

Douai 1825
Explication des ouvrages de peinture, dessin, sculpture, modelure, gravure, et objets d'industrie, exposés au Salon de la Ville de Douai, Douai, 10 July-10 Aug., 1825.

Douai 1827
Explication des ouvrages de peinture, dessin, sculpture, modelure, gravure, et objets d'industrie, exposés au Salon de la Ville de Douai, Douai, 8 July-8 Aug. 1827.

Dubuisson 1909
Dubuisson, A., 'Richard Parkes Bonington', *La Revue de l'Art Ancien et Moderne*, 26, July-Dec. 1909, pp.81-97, 197-214, 375-92.

Dubuisson 1912
Dubuisson, A., 'Influence de Bonington et de l'école anglaise sur la peinture de paysage en France', *The Walpole Society* 2, 1912-1913, pp.111-26.

Dubuisson and Hughes
Dubuisson, A. and C.E. Hughes, *Richard Parkes Bonington: His Life and Work*, London 1924.

Duffy, *Delaroche*
Duffy, Stephen, *Paul Delaroche 1797-1856: Paintings in the Wallace Collection*, London 1997.

Duvivier, *Vernet*
Duvivier, A. St-Vincent, 'Biographie: Horace Vernet; catalogue des principales oeuvres d'Horace Vernet', *Les Beaux Arts; Revue de l'Art Ancien et Moderne* 6, 15 Feb. 1863.

Egerton, 1978
Egerton, Judy, *British Sporting and Animal Paintings in the Paul Mellon Collection*, Tate Gallery, London; Yale Center for British Art, New Haven 1978.

Egerton and Snelgrove, 1978
Egerton, Judy and Dudley Snelgrove, *British Sporting and Animal Drawings in the Paul Mellon Collection*, Tate Gallery, London; Yale Center for British Art, New Haven 1978.

Eitner, 2000
Eitner, Lorenz, *French Paintings of the Nineteenth Century, Part I: Before Impressionism. The Collections of the National Gallery of Art Systematic Catalogue*, Washington, D.C. 2000.

Eitner, *Géricault*, 1983
Eitner, Lorenz, *Géricault*, London 1983.

Eitner, *Raft*, 1972
Eitner, Lorenz, *Géricault's 'Raft of the Medusa'*, London 1972.

Edinburgh, *Delacroix*, 1964
Delacroix, exh. cat., Royal Scottish Academy, Edinburgh; Royal Academy, London 1964.

Ephrussi, 1891
Ephrussi, Charles, 'Simon Jacques Rochard', *Gazette des Beaux-Arts*, 1891, pp.441-65.

Escholier
Escholier, R., *Delacroix, peintre, graveur, écrivain*, 3 vols., Paris 1926-9.

Essen, 1992
London – World City, exh. cat., Villa Hugel, Essen 1992.

F., *Musée Colbert*
F. [Charles Farcy], 'Musée Colbert, Novembre', *Journal des Artistes*, no.2, 22 Nov. 1829, p.322.

F., *Salon 1827*
F. [Charles Farcy et al.], 'Musée Royal: Exposition de 1827', *Journal des Artistes*, 22 articles, 19 Nov. 1827-4 May 1828.

F., *Salon 1831*
F. [Charles Farcy et al.], 'Salon de 1831', *Journal des Artistes*, Paris, 17 articles, 1 May-28 Aug. 1831.

Farington, *Diary*
Farington, Joseph, *Diary 1793-1821*, 16 vols., vols. 1-6 ed. Kenneth Garlick and Angus Macintyre; vols. 7-16 ed. Katherine Cave, New Haven and London 1978-84; index Evelyn Newby 1998.

Feaver, *Martin*
Feaver, William, *The Art of John Martin*, Oxford 1975.

Figaro, 1827
'Figaro au Salon de 1827', *Le Figaro*, 18 Dec. 1827.

Finley, 1973
Finley, Gerald E., 'Turner's Illustrations to Napoleon', *Journal of the Warburg and Courtauld Institutes*, no.36, 1973.

Frankau, *Ward*
Frankau, Julia, *William Ward ARA and James Ward RA*, London 1904.

Frankfurt am Main, 1987
Eugene Delacroix, exh. cat., Städelschen Kunstinstitut, Frankfurt am Main 1987.

Fussell, *Ward*
Fussell, G.E., *James Ward: Animal Painter and His England*, London 1974.

Gaehtgens, 1978
Gaehtgens, Thomas, 'Bacchus and Ariadne by Antoine-Jean Gros', *National Gallery of Canada Bulletin*, no.2, 1978-9, pp.62-79.

Gage, 1972
Gage, John, *La peinture romantique anglaise et les préraphaélites*, exh. cat., Petit Palais, Paris 1972.

Gage, 1980
Gage, John (ed.), *Collected Correspondence of J. M. W. Turner*, London 1980.

Galassi, *Corot*
Galassi, Peter, *Corot in Italy*, New Haven and London 1991.

Galerie Lebrun, 1826, I, a, b, and c; II.
Explication des Ouvrages de peinture exposés au profit des Grecs, exh. cat., Galerie Lebrun, Paris. Three catalogues were issued for the first exhibition of 17 May to 3 July 1826. A second exhibition, with catalogue, ran from 16 July to 19 November 1826.

Garlick, *Lawrence*
Garlick, Kenneth, *Sir Thomas Lawrence*, Oxford 1989.

Gaunt and Roe, *Etty*
Gaunt, William and F. Gordon Roe, *Etty and the Nude*, Leigh-on-Sea 1943.

Gautier, 1834
Gautier, Théophile, 'Salon de 1834', *La France industrielle*, Paris 1834

Gautier, 1837
Gautier, Théophile, 'John Martynn', *La Presse*, Paris, 31 Jan. 1837.

Gautier, 1838
Gautier, Théophile, 'Exposition du Louvre', *La Presse*, Paris 1838.

Gautier, 1855
Gautier, Théophile, *Les Beaux-Arts en Europe – 1855*, 2 vols., Paris 1855.

Gautier, 1856
Gautier, Théophile, *Caprices et zigzags*, Paris 1856.

Gautier, *Romantisme*
Gautier, Théophile, *Histoire du Romantisme*, 2nd ed., Paris 1874.

Gérard, *Correspondance*
Correspondance de François Gérard: Peintre d'Histoire, Henri Gérard (ed.), Paris 1867.

Gernsheim, *Daguerre*, 1956
Gernsheim, H. and A., *L.J.M. Daguerre*, London 1956.

Gilchrist, *Etty*
Gilchrist, Alexander, *Life of William Etty, RA*, 2 vols., London 1855.

Girard, *Vernet*, 1927
Girard, J., 'Les Souvenirs des Vernets au Musée Calvet', *Mémoires de l'Académie de Vaucluse*, Vaucluse 1927.

Godfrey, 1978
Godfrey, Richard, *Printmaking in England*, London 1978.

Goldberg, *Crome*
Goldberg, Norman, *John Crome the Elder*, London 1978.

Gordon, 1971
Gordon, Catherine, 'The Illustration of Sir Walter Scott: Nineteenth-Century Enthusiasms and Adaptation', *Journal of the Warburg and Courtauld Institute*, no.34, 1971, pp.297-317.

Graves, *Landseer*
Graves, Algernon, *Catalogue of the Works of the Late Sir Edwin Landseer, RA*, London 1876.

287

Greenacre, *Danby*
 Greenacre, Francis, *Francis Danby*, exh. cat., Tate Gallery, London 1988.
Grunchec, 1976
 Grunchec, Philippe, 'L'Inventaire posthume de Théodore Géricault' *Bulletin de la société de l'histoire de l'art français*, 1978, pp.395–420.
Grunchec, 1987
 Grunchec, Philippe, *Les Concours d'esquisses peintes*, 2 vols., Paris 1986.
Grunchec, *Géricault*, 1978
 Grunchec, P., *Tout l'oeuvre peint de Géricault*, Paris 1978.
Grundy, *Ward*
 Grundy, Reginald, *James Ward, RA*, London 1909.
Gury, *Outre-Manche*
 Gury, Jacques, (ed.), *Le Voyage Outre-Manche*, Paris 1999.
Hamerton, *Turner*
 Hamerton, Philip, *The Life of J.M.W. Turner, RA*, 2 vols., London 1879.
Hamilton, 1943
 Hamilton, G.H., 'Eugène Delacroix and Lord Byron', *Gazette des Beaux-Arts*, no.23, 1943, p.104.
Hamilton, 1949
 Hamilton, G.H., 'Delacroix, Byron and the English Illustrators', *Gazette des Beaux-Arts*, no.36, 1949, p.261.
Hamilton, 1952
 Hamilton, G.H., 'Delacroix's Memorial to Byron', *Burlington Magazine*, no.94, 1952, pp.257–61.
Harding, *Works*
 Harding, James Duffield, *A Series of Subjects from the Works of the Late R.P. Bonington*, London 1829–30.
Harisse, *Boilly*
 Harisse, H., *L.L. Boilly, peintre, dessinateur et lithographe: Sa vie et son oeuvre 1761–1845*, Paris 1898.
Haskell, 1974
 Haskell, Francis (ed.), *The Artist and the Writer in France: Essays in Honor of Jean Seznac*, Oxford 1974.
Haussard, 1838
 Haussard, P., 'Salon de 1838', *Le temps*, articles of 8, 22 March and 12 April, 1838.
Haydon, *Diary*
 Haydon, Benjamin Robert, *Diary*, ed. Willard B. Pope, 5 vols., Cambridge (Mass), 1960–3.
Hazlitt, *Complete Works*
 The Complete Works of William Hazlitt, P.P. Howe (ed.), 21 vols., London 1930–4.
Hazlitt, *Notes*
 Hazlitt, William, *Notes of a Journey through France and Italy*, London, 1826, vol. 10 of *Complete Works*.
Hedberg and Hirschler, 1974
 Hedberg, G. and M. Hirschler, 'The Jerome Hill Bequest: Corot's *Silenus* and Delacroix's *Fanatics of Tangier*', *Minneapolis Institute of Arts Bulletin*, LXI, 1974, pp.93–103.
Hemingway, 1992
 Hemingway, Andrew, *Landscape Imagery and Urban Culture in Early Nineteenth-Century Britain*, Cambridge 1992.
Herbert, 1962
 Herbert, Robert, *Barbizon Revisited*, exh. cat., Museum of Fine Arts, Boston 1962.
Hobday's Gallery, 1828
 Exhibition of British and French Painting, exh. cat., Hobday's Gallery of Modern Art, London 1828.
Huard, 1838
 Huard, Etienne, 'Salon de 1838', *Journal des Artistes*, 10 articles, 4 March 6 May 1838.
Huet, *Huet*
 Paul Huet (1803–1869) d'après ses notes, sa correspondance, ses contemporains, René Paul Huet (ed.), Paris 1911.
Hugo, *Oeuvres Complètes*
 Victor Hugo: oeuvres complètes, Jean Massin (ed.), 18 vols., Paris 1967–70.
Huyghe, *Delacroix*
 Huyghe, R., *Delacroix*, London 1963.

Hyde, 1988
 Hyde, Ralph, *Panoramania*, exh. cat., Barbican Art Gallery, London 1988.
Ingamells, *Catalogue*
 Ingamells, John, *The Wallace Collection Catalogue of Pictures*, vol. 1: *British German, Italian, Spanish*; vol. 2: *French 19th Century*, London 1985.
Ingamells, *Bonington*
 Ingamells, John, *Wallace Collection Monographs: Richard Parkes Bonington*, London 1979.
Ingres 1999
 Portraits by Ingres, exh. cat., National Gallery, London; National Gallery of Art, Washington DC; Metropolitan Museum of Art, New York 1999.
Ivy, 1991
 Ivy, J., *Constable and the Critics*, London 1991.
Jal, 1824
 Jal, Auguste, *L'Artiste et le philosophe: entretiens critiques sur le salon de 1824*, Paris 1824.
Jal, 1827
 Jal, Auguste, *Esquisses, croquis, pochades ou tout ce qu'on voudra, sur le salon de 1827*, Paris 1828.
Jal, 1831
 Jal, Auguste, *Salon de 1831: Ebauches Critiques*, Paris 1831.
Jal, 1833
 Jal, Auguste, *Causeries du Louvre: Salon de 1833*, Paris 1833.
Janin, 1827
 Janin, Jules, *Salon de 1827*, Paris 1828.
Joannides, 1975
 Joannides, Paul, 'Some English Themes in the Early Work of Gros', *Burlington Magazine*, 117, Dec. 1975, pp.774ff.
Joannides, 1983
 Joannides, Paul, 'Colin, Delacroix and Byron and the Greek War of Independence', *Burlington Magazine*, Aug. 1983, pp.495–500.
Joannides, 2001
 Joannides, Paul, 'Delacroix and Modern Literature' in Beth S. Wright, *The Cambridge Companion to Delacroix*, Cambridge 2001, pp.130ff.
Jobert, 2000
 Jobert, Barthélémy, 'Delacroix et l'estampe: chronologie, techniques, collaborations', *Revue de l'Art* 127, 2000–1, pp.43–61.
Jobert, *Delacroix*
 Jobert, Barthélémy, *Delacroix*, Paris 1997.
Johnson, *David*, 1997
 Johnson, Dorothy, *Jacques-Louis David: The Farewell of Telemachus and Eucharis*, The J. Paul Getty Museum, Los Angeles 1997.
Johnson, 1970
 Johnson, Lee, 'Four Rediscovered Portraits by Delacroix', *Burlington Magazine*, no.113, Jan. 1970, pp.4–7.
Johnson, 1973
 Johnson, Lee, 'Some Historical Sketches by Delacroix', *Burlington Magazine*, no.115, July 1973, pp.672–6.
Johnson, 1976
 Johnson, Lee, 'A New Delacroix: Henri III at the Deathbed of Marie de Clèves', *Burlington Magazine*, Sept. 1976, pp.620–2.
Johnson, *Delacroix*
 Johnson, Lee, *The Paintings of Eugène Delacroix, A Critical Catalogue*, 6 vols., Oxford, 1981–9.
Johnson, *Salons*
 Johnson, Lee, 'Eugène Delacroix et les Salons', *Revue du Louvre*, no.16, 1966, p.220.
Jouy, *Vernet*, 1822
 Jouy, Etienne and Antoine Jay, *Salon d'Horace Vernet: Analyse historique et pittoresque des quarante-cinq tableaux exposés chez lui en 1822*, Paris 1822.
Jowell, 1993
 Jowell, Francis, 'Géricault's Arabian Grey', *Apollo*, May 1993, pp.287–93.
Joyant, *Joyant*
 Joyant, E., and E. Desjardins (eds.), *Jules Romain Joyant, Lettres et Tableaux d'Italie*, Paris 1936.

Kaufmann, 1975
 Kaufmann, Ruth, 'François Gérard's *Entry of Henry IV Into Paris*: The Iconography of Constitutional Monarchy', *Burlington Magazine*, no.117, 1975, pp.790–802.
Kemp, 1973
 Kemp, Martin, 'Scott and Delacroix, with some Assistance from Hugo and Bonington', in Alan Bell (ed.), *Scott Bicentenary Essays*, Edinburgh and London 1973, pp.213–27.
Keratry, 1820
 Keratry, Auguste-Hilarion, Comte de, *Annuaire de l'Ecole Française de Peinture, ou Lettres sur le Salon de 1819*, Paris 1820.
Landon, 1831
 Landon, C.P., *Annales du Musée et de l'Ecole moderne des Beaux-Arts, Salon de 1831*, Paris 1831.
Laviron, 1834
 Laviron, G., *Salon de 1834*, Paris 1834.
Lemoine, *Lami*
 Lemoine, P.-A., *Eugène Lami*, Paris 1914.
Lemonnier, *Gros*
 Lemonnier, Henry, *Gros*, Paris 1905.
Lennie, *Landseer*
 Lennie, Campbell, *Landseer: The Victorian Paragon*, London 1976.
Lennox-Boyd, 1989
 Lennox-Boyd, Christopher, et al., *George Stubbs, the Complete Engraved Works*, London 1989.
Lenormant, 1831–3
 Lenormant, Charles, *Les Artistes Contemporains, Salons de 1831 et 1833*, 2 vols., Paris 1833.
Lesage, 1997
 Lesage, Blandine, 'Achille-Etna Michallon (1796–1822), Catalogue de L'Oeuvre Peint', *Gazette des Beaux-Arts* 130, 1997, pp.101–42.
Levey, *Lawrence*, 1979
 Levey, Sir Michael, *Sir Thomas Lawrence*, exh. cat., National Portrait Gallery, London 1979.
Leymarie, *Corot*
 Leymarie, Jean, *Corot*, Geneva, 1979.
Lille 1825
 Explication des ouvrages de peinture, sculpture, gravure, lithographie et architecture des artistes vivants, exposés au Salon de Lille, Lille, 29 Aug. 1825.
Lockett, *Prout*
 Lockett, Richard, *Samuel Prout*, exh. cat., Victoria and Albert Museum, London 1985.
Lodge, 1965
 Lodge, Susan, 'Géricault in England', *Burlington Magazine*, pp.616–27.
London, *Bonington*, 1834
 Exhibition of the Paintings, Drawings and Sketches of the Late R.P. Bonington, exh. cat., Cosmorama Rooms, 209 Regent Street, London 1834.
London, *Byron*
 Byron, Victoria & Albert Museum, London 1974.
London, *Etty*, 1849
 Society of Arts, *William Etty Retrospective*, exh. cat., London 1849.
London, *Francia*, 1985
 Reed, Anthony, *Louis Francia*, London 1985.
London, Heim, *Huet*, 1969
 Paintings by Paul Huet, exh. cat., Heim Gallery, London 1969.
London, *Oppé*
 British Watercolours from the Oppé Collection, exh. cat., Tate Gallery, London 1997
London, *Romantic Landscape*
 Brown, David Blayney et al., *Romantic Landscape, The Norwich School of Painters*, exh. cat., Tate Gallery, London 2001.
London, *Tradition and Revolution*
 Wine, Humphrey, et al., *Tradition and Revolution in French Art 1700–1880*, exh. cat., National Gallery, London 1993.

London, *Turner and Byron*
 Brown, David Blayney, *Turner and Byron*, exh. cat., Tate Gallery, London 1992.
London and Washington, 1993
 The Great Age of British Watercolours, exh. cat., Royal Academy, London; National Gallery of Art, Washington, D.C. 1993
Macmillan, 1993
 Macmillan, Duncan, 'Sources of French Narrative Painting: Between Three Cultures', *Apollo Magazine*, May 1993, pp.297–303.
Macmillan, 1996
 Macmillan, Duncan, 'Géricault et Charles Bell', in Paris, Louvre, *Géricault*, 1996, I, pp.449–66.
Mainardi, 2000
 Mainardi, Patricia, 'Mazeppa', *Word & Image* 16, October 2000, pp.335–51.
Manchester, 1991
 The Rise of Landscape Painting in France: Corot to Monet, exh. cat., Currier Gallery of Art, Manchester 1991.
Mantz, 1881
 Mantz, Paul, 'Léon Cogniet', *Gazette des Beaux-Arts*, no.23, Jan. 1881, p.37.
Marmottan, *Boilly*
 Marmottan, P., *Le Peintre Louis Boilly*, Paris 1913.
Mély-Janin, 1824
 Mély-Janin, Marie, 'Salon de 1824', *La Quotidienne*, 13 articles, 28 Aug. 1824–18 Jan. 1825.
Mercey, 1838
 Mercey, Frédéric de, 'Salon de 1838', *Revue de Deux Mondes*, no.14, 1 May 1838, pp.367–408.
Millar, 1969
 Millar, Sir Oliver, *The Later Georgian Pictures in the Collection of Her Majesty the Queen*, 2 vols., London 1969.
Miller, 1940
 Miller, Margaret, 'Géricault's portraits of the insane', *Journal of the Warburg and Courtauld Institutes* IV, 1940, pp.151ff.
Miquel, *Huet*
 Miquel, Pierre, *Paul Huet, De l'aube romantique à l'aube impressioniste*, Paris 1962.
Miquel, *Isabey*
 Miquel, Pierre, *Eugène Isabey, 1803–1886; la marine au XIXe siècle*, 2 vols., Maurs-la-Jolie, 1980.
Miquel, *Paysage*
 Miquel, Pierre, *Le Paysage français au XIXe siècle, 1824–1874*, 3 vols., Maurs-la-Jolie, 1975.
Mishory, 2000
 Mishory, Alec, 'Théodore Géricault's *A Paraleytic [sic] Woman*', *Gazette des Beaux-Arts* 135, April 2000, pp.241–54.
Monkhouse, *Landseer*
 Monkhouse, Cosmo, *The Works of Sir Edwin Landseer, RA*, London 1879.
Moreau-Nélaton, *Corot*
 Moreau-Nélaton, Etienne, *Corot: Raconté par lui-même*, 2 vols., Paris 1924.
Moreau-Nélaton, *Delacroix*
 Moreau-Nélaton, Etienne, *Delacroix. Raconté par lui-même*, 2 vols., Paris 1916.
Mosby, *Decamps*
 Mosby, Dewey, *Alexandre-Gabriel Decamps 1803–1860*, 2 vols., PhD dissertation, Harvard University, 1977.
Munhall, *Granet*
 Munhall, Edgar, *François-Marius Granet, Watercolors from the Musée Granet*, exh. cat., Frick Collection, New York 1988.
Munich, 1979–80
 Zwei Jahrhunderte Englische Malerei, exh. cat., Haus der Kunst, Munich 1979–80.
Munich, *Barbizon*
 Burmester, Andreas et al., *Barbizon, Malerei der Natur – Natur der Malerei*, Munich, 1999.
Munro, *Ward*
 Munro, Jane, *James Ward RA 1769–1859*, exh. cat., Fitzwilliam Museum, Cambridge 1992.

Musée Colbert, 1829 I
 Catalogue des Tableaux et Objets d'art exposés dans le Musée Colbert, Nov. 1829, Paris.
Musée Colbert, 1829 II
 Catalogue des Tableaux et Objets d'art exposés dans le Musée Colbert, Dec. 1829, Paris.
Musée Colbert, 1830 I
 Catalogue des Tableaux et Objets d'art exposés dans le Musée Colbert, Feb. 1830, Paris.
Musée Colbert, 1830 II
 Catalogue des Tableaux et Objets d'art exposés dans le Musée Colbert, May 1830, Paris.
Musset, *Confession*
 Musset, Alfred de, *La Confession d'un enfant du siècle*, Paris 1836.
New Orleans, 1996
 Tscherny, Nadia and Guy Stair Sainty, *Romance and Chivalry*, exh. cat., New Orleans Museum of Art, New Orleans; Stair Sainty Matthiesen, New York; Taft Museum, Cincinnati 1996–7.
New York, 2000
 Romanticism and the School of Nature, Nineteenth-Century Drawings and Paintings from the Karen B. Cohen Collection, exh. cat., Metropolitan Museum of Art, New York 2000.
New York, 2001
 The World Observed: Five Centuries of Drawings from the Collection of Charles Ryskamp, exh. cat., The Morgan Library, New York 2001.
New York, *Barye*, 1994
 The Wild Kingdom of Antoine-Louis Barye, exh. cat., Wildenstein, New York 1994.
New York, *Degas*, 1997
 The Private Collection of Edgar Degas, exh. cat., Metropolitan Museum of Art, New York 1997.
New York, *Delacroix*, 1991
 Eugène Delacroix, Paintings, Drawings and Prints from North American Collections, exh. cat., Metropolitan Museum of Art, New York 1991.
New York, *Huet*, 1997
 Paul Huet, exh. cat., Haboldt and Company, New York 1997
New York, *Morocco*, 2000
 Morocco, Jews and Art in a Muslim Land, exh. cat., The Jewish Museum, New York 2000.
New York, Minneapolis, Cleveland, *Gros*, 1955
 Baron Antoine-Jean Gros, Painter of Battles: The First Romantic Painter, exh. cat., Schigmann and Co., New York; Minneapolis Institute of Arts, Minneapolis; Cleveland Art Museum, Cleveland 1955–6.
Noakes, 1978
 Noakes, Aubrey, *Ben Marshall 1768–1835*, Leigh-on-sea, 1978.
Noon, 1981
 Noon, Patrick, 'Bonington and Boys: Some Unpublished Documents at Yale', *Burlington Magazine*, no.123, May 1981, pp.294–300.
Noon, 1986
 Noon, Patrick, 'Richard Parkes Bonington: *A Fishmarket, Boulogne*', in *Essays in Honor of Paul Mellon*, National Gallery of Art, Washington, D.C. 1986, pp.239–54.
Noon, 1994
 Noon, Patrick, 'Bonington, un romantique anglais au Louvre', *La Revue du Louvre et des Musées de France*, no.43, 1994, pp.48–63.
Noon, *Bonington*
 Noon, Patrick, *Richard Parkes Bonington: On the Pleasure of Painting*, exh. cat., Yale Center for British Art, New Haven; Petit Palais, Paris 1991–2.
Norwich, 1921
 Crome Centenary Exhibition, Norwich, 1921
Norwich and London, 1968
 John Crome, exh. cat., Castle Museum Norwich; Tate Gallery, London 1968.

Nottingham, *Bonington*, 1965
 R.P. Bonington, 1802–1828, exh. cat., Castle Museum and Art Gallery, Nottingham 1965.
Oriflamme, 1824
 'Salon de 1824', *L'Oriflamme*, Paris 1824, 15 articles in 2 volumes.
Orléans, *Cogniet*
 Léon Cogniet, 1794–1880, exh. cat., Musée des Beaux-Arts, Orléans 1990.
Pandore, 1827
 'Salon de 1827', *Le Pandore*, Dec. 18, 1827.
Paris, 1855
 Exposition Universelle, exh. cat., Palais des Beaux-Arts, Paris 1855.
Paris, 1933
 Sterling, Charles, *Voyage de Delacroix au Moroc 1832 et exposition retrospective du peintre orientaliste M Auguste*, exh. cat., Musée de l'Orangerie, Paris 1933.
Paris, 1995
 Delacroix in Morocco, exh. cat., Institut du Monde Arabe, Paris 1995.
Paris, *Boilly*, 1984
 Louis Boilly, exh. cat., Musée Marmottan, Paris 1984.
Paris, *Delacroix*, 1963
 Eugène Delacroix, Exposition du Centenaire, exh. cat., Musée du Louvre, Paris 1963.
Paris, *Denon*, 1999
 Dominique Vivant Denon: l'oeil de Napoléon, exh. cat., Musée du Louvre, Paris 1999.
Paris, *Géricault*, 1924
 Trévise, duc de and Pierre Dubaut, *Exposition d'oeuvres de Géricault*, exh. cat., Hôtel Jean Charpentier, Paris 1924.
Paris, *Géricault*, 1991
 Géricault, exh. cat., Grand Palais, Paris 1991.
Paris, *Géricault*, 1998
 Géricault, Dessins et Estampes des Collections de l'Ecole des Beaux-Arts, exh. cat., Ecole Nationale Supérieure des Beaux-Arts Paris; Fitzwilliam Museum, Cambridge 1998.
Paris, *Gros*, 1936
 Gros, ses amis, ses élèves, exh. cat., Petit Palais, Paris 1936.
Paris, *Ingres*, 1967
 Ingres, exh. cat., Petit Palais, Paris 1967.
Paris, *Outre-Manche*, 1994
 D'Outre-Manche, l'art britannique dans les collections publiques françaises, exh. cat., Musée du Louvre, Paris 1994.
Paris, *Turner*, 1983
 J.M.W. Turner, exh. cat., Grand Palais, Paris 1983–4.
Paris, *Vernet*, 1980
 Horace Vernet, exh. cat., Ecole Nationale Supérieure des Beaux-Arts Paris; Académie de France, Rome 1980.
Paris, Detroit, New York, 1974–5
 French Painting, 1774–1830: The Age of Revolution, exh. cat., Grand Palais, Paris; Detroit Institute of Arts, Detroit; Metropolitan Museum of Art, New York, 1974–5.
Paris, Louvre, *Géricault*
 Michel, Régis (ed.), *Louvre Conférences et Colloques: Géricault*, 2 vols., Paris 1996.
Paris, Marais, 1981–2
 Turner en France, exh. cat., Centre Culturel du Marais, Paris 1981–2.
Paris, Petit Palais, 1972
 La Peinture Romantique Anglaise et les Préraphaélites, exh. cat., Petit Palais, Paris 1972.
Philadelphia, *Landseer*
 Sir Edwin Landseer, exh. cat., Philadelphia Museum of Art, Philadelphia, Tate Gallery, London 1982.
Pichot, *Tour*
 [Pichot, Amédée], *Historical and Literary Tour of a Foreigner in England and Scotland*, 2 vols., London 1825.
Pillet, *Salon 1831*
 Pillet, Fabien, 'Salon de 1831', *Le Moniteur Universel*, Paris 1831.
Pillet, *Salon 1833*
 Pillet, Fabien, 'Salon de 1833', *Le Moniteur Universel*, Paris 1833.

Piron, *Delacroix*
[Piron, A.], *Eugène Delacroix, sa vie et ses oeuvres*, Paris 1865.

Planche, *Salon 1831, 1833–4, 1836–8*
Planche, Gustave, *Etudes sur l'école française, 1831–1852*, 2 vols., Paris 1855.

Pointon 1986
Pointon, Marcia, ' "Vous êtes roi dan votre domaine": Bonington as a painter of Troubadour subjects', *Burlington Magazine*, Jan. 1986, pp.10–13.

Pointon, *Bonington*
Pointon, Marcia, *Bonington, Francia & Wyld*, exh. cat., Victoria & Albert Museum, London 1985.

Pointon, *Bonington Circle*
Pointon, Marcia, *The Bonington Circle*, Brighton 1985.

Pomèrade, 1994
Pomèrade, Vincent, *Achille-Etna Michallon*, exh. cat., Musée du Louvre, Paris 1994.

Pomèrade, 1996–7
Pomèrade, Vincent, *Corot*, exh. cat., The Metropolitan Museum of Art, New York, National Gallery of Canada, Ottawa, Grand Palais, Paris 1996–7.

Prendeville, 1995
Prendeville, Brendan, 'The Features of Insanity as Seen by Géricault and by Büchner', *Oxford Art Journal*, 1995, pp.96–115.

Pückler, *Tour*
Pückler-Muskau, Hermann, Fürst von, *Tour in England, Ireland and France, 1826–9*, Philadelphia, 1833 (originally published as *Briefe eines Verstorbenen*, Munich 1830, and in English in 4 vols., London 1832.

Pupil, 1985
Pupil, François, *Le Style Troubadour*, Nancy 1985.

R., *Salon 1822*.
R., 'Salon de 1822', *Journal des Débats*, 17 May 1822, Paris.

RA, *Turner*, 1974
Turner 1775–1851, exh. cat., Royal Academy and Tate Gallery, London 1974.

Raimbach, *Memoirs*
Memoirs and Recollections of the late Abraham Raimbach, Esq., M.T.S. Raimbach (ed.), London 1843.

Raleigh and New Haven, 1987
Chiego, William J., Hamish Miles and David Blayney Brown, *Sir David Wilkie of Scotland*, exh. cat., North Carolina Museum of Art, Raleigh, and Yale Center for British Art, New Haven 1987.

Redgrave 1866
Redgrave, Richard and Samuel, *A Century of British Painters*, London 1866; reprinted London 1947.

Renaud, 1997
Renaud, M.C., *Alfred de Dreux, Le Cheval, passion d'un dandy Parisien*, Paris 1997.

Richmond, 1960
Sport and the Horse, exh. cat., Virginia Museum of Fine Arts, Richmond 1960.

Robaut, *Corot*
Robaut, Alfred, *L'Oeuvre de Corot, Catalogue raisonné et illustré*, 5 vols., Paris 1905

Robaut, *Delacroix*
Robaut, Alfred, *L'Oeuvre complet de Eugène Delacroix*, Paris 1885.

Roujon, *Vernet*
Roujon, H., *Horace Vernet*, Paris 1913.

Rosenblum, *Ingres*
Rosenblum, Robert, *Jean-Auguste-Domenique Ingres*, New York 1967.

Rosenthal, *Auguste*
Rosenthal, Donald, 'Jules-Robert Auguste and the Early Romantic Circle', Ph.D. dissertation, Columbia University 1978.

Rosenthal, *Peinture Romantique*
Rosenthal, Léon, *La Peinture Romantique*, Paris n.d.

Roundell, *Boys*
Roundell, James, *Thomas Shotter Boys, 1803–1874*, London 1974.

Rouen, *Delacroix*, 1998
Delacroix, La Naissance d'un Nouveau Romantisme, exh. cat., Musée des Beaux-Arts, Rouen 1998.

Rouen, *Huet*, 1965
Paul Huet, exh. cat., Musée des Beaux-Arts, Rouen 1965.

Ruskin, *Works*
The Works of John Ruskin, E.T. Cook and Alexander Wedderburn (eds.), 39 vols., London 1903–12.

Russcol, 1985
Russcol, Diane Sue, 'English Historical Themes in French Paintings, 1815–1848', Ph.D. Dissertation, New York University 1985.

Salander O'Reilly, 1987
Theodore Géricault, exh. cat., Salander O'Reilly Galleries, New York 1987.

Salons Retrouvés
Le Nouëne, Patrick, et al., *Les Salons Retrouvés: Éclat de la Vie Artistique dans la France du Nord, 1815–1848*, 2 vols., exh. cat., Musée des Beaux-Arts et de la Dentelle, Calais; Musée des Beaux-Arts, Dunkirk; Musée de la Chartreuse, Douai 1993.

San Francisco, *Géricault*, 1989
Eitner, Lorenz and Stephen Nash, *Géricault*, exh. cat., The Fine Arts Museums, San Francisco 1989.

Sazerac, 1834
Sazerac, Hilaire, *Lettres sur le Salon de 1834*, Paris 1834.

Scheffer, 1827
[Scheffer, Arnold], 'Salon de 1827', *Revue Française*, I, Jan. 1828, pp.188–212.

Schulman, *Rousseau Drawings*
Schulman, Michel, *Théodore Rousseau (1812–1867) Catalogue Raisonné de l'Oeuvre Graphique*, Paris 1997.

Schulman, *Rousseau Paintings*
Schulman, Michel, *Théodore Rousseau (1812–1867) Catalogue Raisonné de l'Oeuvre Peint*, Paris 1999.

Sells, 1986
Sells, Christopher, 'New Light on Géricault, his Travels and his Friends, 1816–23', *Apollo*, June 1986, pp.390–5.

Sells, 1989
Sells, Christopher, 'Two Letters from Géricault to Madame Horace Vernet', *Burlington Magazine*, no.131, March 1989, pp.216–18.

Selz, *Corot*
Selz, Jean, *La Vie et l'oeuvre de Camille Corot*, Paris 1988.

Sensier, *Rousseau*
Sensier, Alfred, *Souvenirs sur Théodore Rousseau*, Paris 1872.

Sérullaz, *Delacroix*
Sérullaz, Maurice with Arlette Sérullaz, Louis-Antoine Prat, and Claudine Ganeval, *Inventaire général des dessins école française, dessins d'Eugène Delacroix, 1798–1863*, 2 vols., exh. cat., Musée du Louvre, Cabinet des Dessins, Paris 1984.

Shellem, *Daniell*
Shellem, Maurice, *India and the Daniells*, London 1979.

Shirley, *Bonington*
Shirley, The Hon. Andrew, *Bonington*, London 1940.

Siegfried, 1989
Siegfried, Susan, 'Boilly's *Moving House*: An Exact Picture of Paris', *Museum Studies*, no.15, 1989, pp.126–37.

Siegfried, 1990
Siegfried, Susan, 'The Artist as Nomadic Capitalist: The Case of Louis-Léopold Boilly', *Art History*, no.13, Dec. 1990, pp.515–41.

Silvestre, 1856
Silvestre, Théophile, *Histoires des artistes vivants, français et étrangers*, Paris 1856.

Smith, 1991
Smith, K., 'Contours of Conflict: the Giaour in Byron and Delacroix', *Athanor*, no.10, 1991, pp.39–43.

Stendhal, *Mélanges*
Beyle, Henri [Stendhal], 'Salon de 1824', 17 articles published in *Le Constitutionnel*, 29 Aug.–24 Dec. 1824; and 'Des Beaux-Arts et du Carectère Français', published in the *Revue trimestrielle*, July–Oct. 1828; both republished as *Mélanges d'art et de littérature*, Paris 1867.

Stendhal, *Salon 1822*
Beyle, Henri [Stendhal], 'Salon de 1822', in Stéphane Guégain, *Stendhal Salons*, Paris 2002.

Stephens, *Landseer*
Stephens, Frederick G., *Memoirs of Sir Edwin Landseer*, London 1874.

Sterling and Salinger, 1966
Sterling, Charles and Margaretta M. Salinger, *French Paintings, A Catalogue of the Collection of the Metropolitan Museum of Art, II*, Metropolitan Museum of Art, New York 1966.

Sutton, 1985
Sutton, Peter, 'Dawn of the Entente Cordiale', *Apollo*, Jan. 1985, pp.48–54.

Talbot, 1980
Talbot, William, 'Cogniet and Vernet at the Villa Medici', *Cleveland Museum of Art Bulletin*, no.67, 1980, pp.134–49.

Taine, *Notes*
Taine, Hippolyte, *Notes on England*, trans. W.F. Rae, New York 1872.

Tardieu, 1834
Tardieu, A., ' Salon de 1834', *Le Courrier français*, Paris 1834.

Tardieu, 1838
Tardieu, A., ' Salon de 1838', *Le Courrier français*, Paris 1838, 6 articles, 2 March–6 April.

Tardieu, 1831
Tardieu, A., *Annales du Musée de l'Ecole Moderne des Beaux-Arts: Salon de 1831*, Paris 1831.

Tate, *Romantic Movement*, 1959
The Romantic Movement, exh. cat., Tate Gallery, London 1959.

Taylor, 1955
Taylor, Basil, *Animal Painting in England*, London 1955.

Thiers, 1822
Thiers, Adolphe, *Salon de 1822: Le Constitutionel*, Paris, 9 articles, 25 April–11 June 1822.

Thiers, 1824
Thiers, Adolphe, *Salon de 1824, ou collection des articles insérés au Constitutionnel*, Paris 1824.

Thoré, 1837
Thoré, Théophile, 'Artistes Contemporains – M. Eugène Delacroix', *Le Siècle*, 25 Feb. 1837.

Thoré, 1838
Thoré, T., 'Salon de 1838', *Journal du peuple*, Paris 1838.

Thornbury, *Turner*, 1862
Thornbury, Walter, *The Life of J.M.W. Turner, RA*, 2 vols., London 1862; revised ed., 1877.

Tinterow, 1990
Tnterow, Gary, *Géricault's Heroic Landscapes*, exh. cat., Metropolitan Museum of Art, New York 1990–91.

Tripier le Franc, *Gros*
Tripier le Franc, J., *Histoire de la vie et de la mort du Baron Gros*, Paris 1880.

Tromans, 1997
Tromans, Nicholas, 'J.F. Lewis's Carlist War Subjects', *Burlington Magazine*, Nov. 1997, pp.760–5.

Vatout, 1824
Vatout, Jean, *Galerie lithographiée des tableaux de S.A.R. Monseigneur le duc d'Orléans*, Paris 1824.

Vatout, 1826
Vatout, Jean, *Notices historiques sur les tableaux de la galerie de S.A.R. Mgr. De Duc d'Orléans*, Paris 1826.

Vergeest, 2000
Vergeest, Aukje, *The French Collection, Nineteenth-Century French Paintings in Dutch Public Collections*, Amsterdam 2000.

Vergnaud 1828
Vergnaud, Armand–Denis, *Examen du Salon de 1827*, Paris 1828.

Vernet 1822
Vernet, Horace, *Salon d'Horace Vernet*, Paris 1822.

Vitet, 1826
Vitet, Louis, 'Exposition au profit des grecs', *Le Globe*, 23 Nov. 1826, p.232.

Bibliography

Waagen 1838
Waagen, G.F., *Works of Art and Artists in England*, 3 vols., London 1838.

Waagen 1854–57
Waagen, G.F., *Treasures of Art in Great Britain*, 3 vols., London 1854; supplemental vol.: *Galleries and Cabinets of Art in Great Britain*, London 1857.

Wainwright, 1989
Wainwright, Clive, *The Romantic Interior*, London 1989.

Warrell, Ian, 1999–2000
Warrell, Ian, *Turner on the Seine*, exh. cat., Tate Gallery, 1999–2000.

Washington, *Corot*, 1996
Faunce, Sarah, et al., *In the Light of Italy, Corot and Open Air Painting*, exh. cat., National Gallery of Art, Washington; Brooklyn Museum, Brooklyn; Saint Louis Art Museum, St Louis.

Watteau, *Roqueplan*
Watteau, Marie, *Camille Roqueplan: Approche Biographique*, 2 vols., Mémoire de Maîtrise d'Histoire de l'Art, Université Paris IV – Sorbonne 1999.

Whiteley, 1983
Whiteley, Linda, 'Art et commerce d'art en France avant l'époque impressioniste', *Romantisme*, no.4, 1983, pp.65–75.

Wilson-Smith, 1992
Wilson-Smith T., *Delacroix: A Life*, London 1992.

Wilton, 1977
Wilton, Andrew, *British Watercolours 1750–1850*, London 1977.

Wilton, *Turner*
Wilton, Andrew, *J.M.W. Turner, His Art and Life*, New York, 1979.

Wood, 1993
Wood, R. Derek, 'The Diorama in Great Britain in the 1820s', *History of Photography*, no.17, Autumn 1993, pp.284–95.

Wright, 1990
Wright, Beth S., 'Henri Gauguin et le musée Colbert: l'enterprise d'un directeur de galerie et d'un éditeur d'art à l'époque romantique', *Nouvelles de l'Estampe*, no.114, Dec. 1990.

Wright, 1992
Wright, Beth S., 'An Image for Imagining the Past: Delacroix, Cromwell, and Romantic Historical Painting', *Clio*, no.21, 1992, pp.243–63.

Wright, 1997
Wright, Beth S., *Painting and History During the French Restoration*, Cambridge 1997.

Wright, 2000
Wright, Beth S., 'Delaroche's Cromwell and the Historians', *Word and Image*, no.16, Jan. 2000, pp.77–90.

Wright, *Cromwell*, 1997
Wright, Beth S., 'Implacable Fathers: The Reinterpretation of Cromwell in French Texts and Images from the Seventeenth to the Nineteenth Century', *Nineteenth-Century Contexts*, no.20, 1997, pp.165–85.

Wright and Joannides
Wright, Beth S. and Paul Joannides, 'Les Romans historiques de Sir Walter Scott et la peinture française, 1822–1863', *Bulletin de la Société de l'Histoire de l'Art française*, année 1982, 1984, pp.119–132, and année 1983, 1985, pp.95–115.

York, *Etty*, 1911
Exhibition of Pictures by the Late William Etty, RA, exh. cat., Corporation Art Gallery, York 1911.

York, *Etty Centenary*
William Etty Centenary, exh. cat., City Art Gallery, York 1949.

Zerner, 1996
Zerner, Henri, 'Le Portrait, plus ou moins', in Paris, Louvre, *Géricault*, I, pp.321–34.

Zurich, *Delacroix*, 1987
Eugène Delacroix, exh. cat., Kunsthaus Zurich, Zurich; Stadtische Galerie, Frankfurt am Main 1987–8.

Atwood, William G., *The Parisian Worlds of Frédéric Chopin*, New Haven 1999.

Bann, Stephen, *The Clothing of Clio*, Cambridge 1984.

Bisson, L. A., *Amédée Pichot, A Romantic Prometheus*, Oxford n.d.

Brooks, Peter, *History Painting and Narrative, Delacroix's Moments*, Oxford 1998.

Bryan, James, 'Sir George Hayter's *Portrait of Lady Caroline Montagu*', *Elvejhem Museum of Art Bulletin*, University of Wisconsin-Madison 2000, pp.32ff.

Buruma, Ian, *Anglomania*, New York 1998.

Chenique, Bruno, 'Géricault: Une Correspondence Décapitée', in *Nouvelles Approches de l'Epistolaire*, eds. M. Ambrière and L. Chotard, Paris 1996.

Chu, Petra Ten-Doesschate and Gabriel P. Weisberg, *The Popularization of Images*, Princeton 1994.

Cooper, Douglas, 'Bonington and Quentin Durward', *Burlington Magazine*, May 1946, pp.112–17.

Cunningham, Allan, *The Lives of the Most Eminent British Painters and Sculptors*, 4 vols., London 1832.

Curtis, Atherton, *Catalogue de l'oeuvre lithographié et gravé de R. P. Bonington*, Paris 1939.

Curtis, Atherton, *Catalogue de l'oeuvre lithographié de Eugène Isabey*, Paris n.d.

Delécluze, Etienne-Jean, *Souvenirs de Soixante Années*, Paris 1862.

Delestre, J.-B., *Gros et ses ouvrages ou mémoires historiques sur la vie et les travaux de ce célèbre artiste*, Paris 1845.

Dorbec, Prosper, 'Les Paysagistes Anglais en France', *Gazette des Beaux-Arts*, Oct. 1912, pp.257–81.

Doy, Guinervere, 'Delacroix et Faust', *Nouvelles de l'estampe*, May 1975, pp.18–23.

Du Sommerard, Alexandre, *Les Arts au Moyen Age*, 10 vols., Paris 1838–46.

Farmer, Norman, 'A Moniment Forever More', in *The Faerie Queene and British Art, 1770–1950*, Princeton 1990, pp.56–63.

Foisy-AuFrère, Marie-Pierre, *La Jeanne d'Arc de Paul Delaroche*, exh. cat., Musée des Beaux-Arts, Rouen 1983.

Gage, John, *Color and Culture*, Boston 1993.

Gage, John, Anne Lyle et al., *Constable. Le choix de Lucian Freud*, exh. cat., Grand Palais, Paris 2002–3.

Gautier, Théophile, *Fusains et eaux-fortes*, Paris 1880.

Guégan, Stéphane, 'Peinture, histoire et politique: la révolution des années 1815–30', *Revue de l'Art*, 2000–1, pp.77–80.

Hanoosh, Michele, *Painting and the Journal of Eugène Delacroix*, Princeton 1995.

Haskell, Francis, 'Un Moment et ses mystères, l'art français et l'opinion anglaise dans la première moitié du xix siècle', *Revue de l'art*, 1975, pp.61–76.

Haskell, Francis, *Past and Present in Art and Taste*, New Haven and London 1987.

Hovenkamp, Jan Willem, *Mérimée et la couleur locale*, Nijmegen 1928.

Victor Hugo: oeuvres complètes, Jean Massin (ed.), 18 vols., Paris 1967–70.

Huyghe, René, et al., *Delacroix*, Paris 1963.

Ingamells, John, *The Wallace Collection Catalogue of Pictures: British German, Italian, Spanish*, I; *French 19th Century*, II, London 1985.

Johnson, Lee, 'Géricault and Delacroix seen by Cockerell', *Burlington Magazine*, Sept. 1971, pp.547–51.

Johnson, Lee, 'Delacroix and The Bride of Abydos', *Burlington Magazine*, Sept. 1972, pp.579–85.

Johnson, Lee, 'A New Delacroix: "Rebecca and the Wounded Ivanhoe"', *Burlington Magazine*, May 1984, pp.280–1.

Kaufmann, R., 'François Gérard's Entry of Henri IV into Paris: The Iconography of Constitutional Monarchy', *Burlington Magazine*, no.117, 1975, pp.794ff.

Lichenstein, Sara, *Delacroix and Raphael*, New York 1979.

Lochnan, Katherine A., 'Les Lithographies de Delacroix pour Faust et le théâtre anglais des années 1820', *Nouvelles de l'estampe*, July 1987, pp.6–13.

Long, Basil, 'The Salon of 1824', *Connoisseur*, Feb. 1924, pp.66–76.

McWilliam, Neil, (ed.), *A Bibliography of Salon Criticism in Paris from the Ancien Régime to the Restoration, 1699–1827*, Cambridge 1991.

McWilliam, Neil, (ed.), *A Bibliography of Salon Criticism in Paris from the July Monarchy to the Second Republic, 1831–1851*, Cambridge 1991.

Melcher, Edith, *The Life and Times of Henry Monnier*, Cambridge 1950.

Moers, Ellen, *The Dandy*, London 1960.

Munday, John, *Edward William Cooke, A Man of His Times*, Woodbridge 1996.

Phipps-Jackson, M., 'Two Famous Chargers, Marengo and Copenhagen', *Magazine of Art*, no.16, 1893, pp.306–7.

[Pichot, Amadée], 'Bonington et ses émules', *Revue Britannique*, July 1833, pp.159–67.

Pomarède, Vincent, *Eugène Delacroix, La Mort de Sardanapale*, Paris 1998.

Roger-Marx, Claude, 'Eugène Delacroix, his relationship with England and the English artists of his day', *Creative Art*, no.8, Jan. 1931, pp.36–41.

Rosen, Charles and Henri Zerner, *Romanticism and Realism*, New York 1984.

Rosenthal, Donald, 'Ingres, Géricault and Monsieur Auguste', *Burlington Magazine*, Jan. 1982, pp.9–14.

Sainte-Beuve, C.-A., 'Paul Huet', *Portraits contemporains*, Paris 1870, II, pp.243–8.

Schinkel, Karl Friedrich, *The English Journey: Journal of a Visit to France and Britain in 1826*, David Bindman (ed.), New Haven 1993.

Smith, Anthony, 'The "Historical Revival" in Late 18th-Century England and France', *Art History*, no.2, June 1979, pp.156–70.

Strong, Roy, *And when did you last see your father? The Victorian Painter and British History*, London 1978.

Tscherny, Nadia, 'An English Source for Delacroix's *Liberty Leading the People*', *Source*, Spring 1983, pp.9–13.

Toupet, M., 'L'Assassinat de l'Eveque de Liège par Eugène Delacroix', *Revue du Louvre*, no.13, 1963, pp.83–94.

Tromans, Nicholas, *David Wilkie: Painter of Everyday Life*, exh. cat., Dulwich College Picture Gallery, London 2002.

Vigny, Alfred de, *Cinq-Mars ou une conjuration sous Louis XIII*, 2nd ed. with preface, Paris 1827.

Wainwright, Clive, *The Romantic Interior*, New Haven and London 1989.

Whitley, William T., *Art in England 1821–1837*, Cambridge 1930.

Wright, Beth Segal, 'Scott and Shakespeare in Nineteenth-Century France: Achille Devéria's Lithographs of "Minna et Brenda" and "Les Enfants d'Edouard"', *Arts Magazine*, no.55, Feb. 1981, pp.129–33.

Wright, Beth Segal, 'The Auld Alliance in Nineteenth-Century French Painting: The Changing Concept of Mary Stuart, 1814–1833', *Arts Magazine*, no.58, March 1984, pp.97–107.

Wright, Beth Segal, 'Walter Scott et la gravure française', *Nouvelles de l'Estampe*, July 1981, pp.6–18.

Lenders and credits

Photographic Credits

Catalogue Illustrations

Amsterdam, Van Gogh Museum
Musée Calvet, Avignon. Photo: André Guerrand
© Beauvais, Musée départemental de l'Oise – Jean-Louis
 Boutillier, Amiens
Birmingham Museums & Art Gallery
© 2002 Museum of Fine Arts, Boston. All rights reserved
Bristol Museums and Art Gallery
Bury Art Gallery & Museum
Musée des Beaux-Arts et la Dentelle, Calais
Fitzwilliam Museum, Cambridge
© The Art Institute of Chicago
Chi Mei Culture Museum
Taft Museum of Art, Cincinnati, Ohio
© The Cleveland Museum of Art
Judy Cooper
Courtesy of Arturo Cuéllar, Switzerland
Courtesy of Curtis Galleries, Inc.
National Gallery of Scotland, Edinburgh/Antonia Reeve
Elvehjem Museum of Art, University of Wisconsin-Madison
Courtesy of Richard L. Feigen & Company
Ghent Museum of Fine Arts, Belgium
© Musée de Grenoble
Wadsworth Atheneum Museum of Art, Hartford, CT
Courtesy of Hazlitt, Gooden & Fox
Board of Trustees of the National Museums and Galleries
 on Merseyside (Walker Art Gallery, Liverpool)
The British Library, London
© The British Museum, London
Guildhall Library, Corporation of London
© Museum of London
© The National Gallery, London
© Royal Academy of Arts London 2002. Photo: J. Hammond
© The J. Paul Getty Museum, Los Angeles
© Musée des Beaux-Arts de Lyon – Studio Basset
Courtesy of James Mackinnon/ Robin Briault
The Whitworth Art Gallery, The University of Manchester
The Minneapolis Institute of Arts
© Musée Fabre Montpellier/ Frédéric Jaulmes
National Trust Photographic Library/ Derrick E. Witty
National Trust Photographic Library/ Christopher Hurst
New Orleans Museum of Art
Sorbonne, Chancellerie des Universités, Paris
Yale Center for British Art, New Haven
Yale Center for British Art, New Haven/ Richard Caspole
© The Frick Collection, New York
Photograph © 1992 The Metropolitan Museum of Art, NY
Photograph © 1995 The Metropolitan Museum of Art, NY
Photograph © 1997 The Metropolitan Museum of Art, NY
Photograph © 1998 The Metropolitan Museum of Art, NY
Photograph © 1999 The Metropolitan Museum of Art, NY
Photograph © 2001 The Metropolitan Museum of Art, NY
© The Pierpont Morgan Library, New York 2002

Collection of the Duke of Northumberland
© Norwich Castle Museum and Art Gallery
Nottingham City Museums & Galleries; Castle Museum &
 Art Gallery
Art Gallery of Ontario
Musée d'Orléans
Photograph © National Gallery of Canada, Ottawa
© Photothèque des musées de la ville de Paris/Joffre
© Photothèque des musées de la ville de Paris/Ladet
Philadelphia Museum of Art
Collection of Phoenix Art Museum
© 2002 Trustees of Princeton University. Photo: Bruce M.
 White
Art Gallery of Ontario/ Carlo Catenazzi
Museum of Art, Rhode Island School of Design/ Cathy Carver
© Photo RMN – P. Bernard
© Photo RMN – A. Danvers
© Photo RMN – Hervé Lewandowski
© Photo RMN – R.G. Ojeda
© Rouen, Musée des Beaux-Arts. Photo: Catherine Lancien
The Royal Collection © HM Queen Elizabeth II
The Huntington Library, Art Collection, and Botanical
 Gardens, San Marino, California/ Powerstock
Photo: The National Museum of Fine Arts, Stockholm
Tate Photography/ Andrew Dunkley/Rodney Tidnam
Tate Picture Library
Toledo Museum of Art
V&A Picture Library
© Virginia Museum of Fine Arts/Katherine Wetzel
Photograph © 2002 Board of Trustees, National Gallery
 of Art, Washington
The Phillips Collection, Washington, DC
© 2002 Kunsthaus Zürich. All Rights Reserved

Figure Illustrations

Musée Rolin, Autun/S. Prost 10
© Museum of Fine Arts, Boston 29
Kunsthalle Bremen 16
British Film Institute 54
Fitzwilliam Museum, Cambridge 25, 52
Musée Thomas Henry, Cherbourg 32
Taft Museum of Art, Cincinnati, Ohio 57
Courtesy of Simon Dickinson Ltd. 1
Richard L. Feigen & Company 64
The British Library, London 28
© The British Museum, London 18
The Museum of London 31
© The National Gallery, London 9, 12
Trustees of the Wallace Collection, London 6, 8, 41
© Museo Thyssen-Bornemisza, Madrid 43
The Minneapolis Institute of Arts 4, 33
Yale Center for British Art, New Haven 3, 5, 50, 63
© The Frick Collection, New York 55
Photograph © 1990 The Metropolitan Museum of Art,
 NY 36, 53
Photograph © 1992 The Metropolitan Museum of Art,
 NY 51
© Photo RMN – P. Bernard 38, 40, 46,
© Photo RMN – Gérard Blot 20, 30, 42, 47
© Photo RMN – Hervé Lewandowski 2, 37, 39, 45
© Photo RMN – R.G. Ojeda 11
Boijmans van Beuningen, Rotterdam 58
Tate Picture Library 34, 35, 44
Victoria and Albert Museum, London, UK/Bridgeman
 Art Library 59

Index